THE TRIAL OF
SADDAM HUSSEIN

The Trial of
SADDAM HUSSEIN

Dr. Abdul-Haq Al-Ani

Clarity Press, Inc.

ISBN: 0-932863-58-2
 978-0-932863-58-4

In-house editor: Diana G. Collier

Library of Congress Cataloging-in-Publication Data

'Ani, 'Abd al-Haqq.
 The trial of Saddam Hussein / Abdul-Haq Al-Ani.
 p. cm.
 ISBN-13: 978-0-932863-58-4
 ISBN-10: 0-932863-58-2
 1. Hussein, Saddam, 1937-2006—Trials, litigation, etc. 2. Trials (Crimes against humanity)—Iraq—Baghdad. 3. Trials (Murder)—Iraq—Baghdad. 4. Iraq. Iraqi Higher Criminal Court. I. Title.
 KMJ41.H87A55 2008
 345.567'470235—dc22

 2008008958

Clarity Press, Inc.
Ste. 469, 3277 Roswell Rd. NE
Atlanta, GA. 30305, USA
http://www.claritypress.com

To my son, Sami-Ali
and my grandchildren, Mariam, Zainab, Zahra and Hasan
who will never see the Iraq I knew.

ACKNOWLEDGMENTS

Four people, in particular, helped me during the writing of this book. They are my friends Joanne Baker, Tarik Al-Ani , James Thring, and my editor, Diana G. Collier. They provided me with encouragement, valuable comments, suggestions and corrections. Without their help, this book would not have been completed. I am indebted to them. Any factual error or failure in presentation is completely mine.

TABLE OF CONTENTS

PREFACE

Baghdad College

Though we were soon to take very different paths in life, in 1958 Ahmad Al-Chalabi and I were classmates in 2E at Baghdad College, the high school set up by the Jesuit Society in 1932 [1] where we were vying with each other in the very competitive educational culture common to the Jesuits. I still remember Ahmad as a soft-spoken, well-mannered and well-behaved, brilliant young friend. Despite my having come just ahead of him at the end of the 2E year, I believe we were close and I still have memories about that year and especially the only detention we both had at Baghdad College after he whispered a few words to me during the morning assembly.

Ahmad was not interested in politics then, but I was. Ahmad left Iraq with his family that summer not to return to it until he came back on board a US military aircraft in April 2003. His absence was a voluntary exile and I doubt if the regime would have had any problem with it, had he returned to Iraq any time before he joined the opposition. It's quite likely that the regime would not have even taken notice of his return. In fact there is a rumor among Iraqis that he donated several four-wheel drive cars to the Iraqi army after the liberation of the Faw peninsula from the Iranians. I met Ahmad in the early 1970s when he came to visit London. By that time I had become deeply involved in politics but Ahmad still showed little or no interest. It seems that Ahmad's involvement came much later in life and was of a different nature to mine, but the roots of his political affiliation of today may have been sown way back in 1958. The first indication of his interest in Iraqi politics came in his backing, as acknowledged in it, of the book of Hanna Batatu, an eminent historian writing on social change in Iraq, and primarily on the Communist Party.[2]

Baghdad College was academically one of the top high schools not only in Iraq but in the Middle East as a whole. It provided three generations of Iraqis with excellent scientific education, producing some of Iraq's top medical professionals, engineers and scientists. However, at the same time, it indoctrinated many young Iraqis in the superficial virtues of the American way of life—whether or not that indoctrination was carried out consciously or was a natural result of the rigorous discipline imposed by the

Jesuits that transformed the young boys into obedient ciphers. The young boys admitted to Baghdad College could have been classified into three categories: very bright boys who did very well at the public examination at the end of primary school; sons of any Government Official, known political figure, or tribal chief; and Christian boys who could demonstrate minimal intelligence even if they were impecunious. At that time, no division between Sunnis, Shi'a and Kurds was clear in the selection process because it set out to represent Iraq's diverse yet still, at that time, homogenous society.

It is not difficult to see how most of these young boys, some of whom came from remote parts of Iraq and stayed as boarding students, when put under the strict control of the Jesuits during the formative ages of 11-12 and 16-17, might be converted to the US way of life and end up glorifying it, with many of them today residing in the US.

In the revolutionary atmosphere of Iraq in the 1950s, it was inevitable that the administration of Baghdad College could not have escaped a challenge. I was among a group of young revolutionaries who forced a confrontation in 1961. We chose the refusal of the Principal to allow me to select a poem of my choice for the final elocution contest, in which I was a finalist every year. When I refused to accept the selection of the Principal as was usually the practice, I was expelled from the school. On the day of the elocution contest some firecrackers were hurled into the midst of the ceremony. The administration of the school reacted in its typical alarmist way: it suspended classes and sent all boys home. However, it did not stop there. During the day it contacted the US Ambassador in Baghdad who, being an early version of the insensitive, naïve Bremer, in turn contacted the Military Commander in Iraq complaining that a threat against the lives of the Jesuits had been made. By midnight, military units were raiding some twenty homes in Baghdad looking for some twenty of the brightest boys in Baghdad College. Some of us, including myself, were arrested while others escaped. It was the second time while at Baghdad College, and before having reached seventeen years of age, that I had been arrested.

It is not difficult to imagine how repugnant such stringent measures at the behest of Baghdad College and the US Ambassador were to the elite of Baghdad whose sons were among those arrested or wanted. They certainly did not approve of their boys behaving with little respect for authority, but they could not imagine that the supposedly caring and understanding educational institute in which they had placed their sons would set the Iraqi army against them. The next day General Qasim, Iraq's Prime Minister, received more telephone calls from protesting prominent Iraqis than he had ever received in one single day. He ordered the release of all those detained and termination of all further proceedings. A few days later I received a telephone call from Father Sullivan, the Principal of Baghdad College, apologizing and asking me to come back to school. That must have been

the first and only time he had ever done so. We all went back to school as heroes and graduated with high marks. During that summer Father Sullivan was demoted to a teacher of English for first year students. Baghdad College was never the same again. It had breached the trust which Iraqi society had had in it.

I am not sure whether it was its open educational system or its oppressive colonialist tactics which led to a number of fervent revolutionaries graduating from Baghdad College among the thousands of subservient obedient young men who saw glory in the US way of life. But I do know that the missionary, Father Sullivan, was just as much a colonialist as the diplomat, Paul Bremer. The scale of arrogance, insensitivity and lack of understanding in both men was boundless, and astoundingly identical. I am sure that the parallel could not have been missed by Adil Abdul-Mahdi, one of Father Sullivan's students and current Vice President of Iraq at this writing, when he, along with the other members of the so-called Iraqi Governing Council, was reminded who the master was by Paul Bremer.

Nonetheless, Baghdad College produced some revolutionaries like Miqdad Al-Ani, who in 1961 while at the College of Medicine became the founder and first president of the Ba'ath-controlled National Union of Iraqi Students; Qais As-Sammarrai (known as Abu Laiyla in the Democratic Popular Front for the Liberation of Palestine); and Imad Khadouri, the devout young Roman Catholic as I once knew him. But it is sad to acknowledge that the College had produced more than its share of colonialist servants. These are notable examples: Adil Abdul-Mahdi, who transformed from a Ba'athist, Marxist, Khomeini Islamist into, finally, an Americaphile; Ahmad Al-Chalabi was a banker and Monarchist, turned Americaphile; and Ayad Allawi, a Ba'athist, freelance intelligence agent and Americaphlie, who never completed studies at the College, and who tried to prove that he was just as subservient to his College roots as Adil and Ahmad through his total submission to the Americans in his infamous moment of tenure as a puppet Prime Minister of Iraq following the charade of transferring power to the Iraqis.

Joining the Ba'ath

I joined the Ba'ath Party early in my teens and formally left it before I finished university. The ideals that were first pronounced by Zaki Al-Arsouzi in the 1930s are as valid today as they were then. They appealed to my revolutionary vision of the future of the Arab Nation. The metamorphosis of the Ba'ath politics and practices is another matter. I left the Party formally in 1966 when the conflict within the Party led to two factions neither of which I could agree with on principle. My reason for leaving the Party was that the new leadership was so interested in assuming

power that it was willing to make deals with any power, including US and Arab reactionary regimes, in order to do so. I have always held the view that a revolutionary Party should make no deals with the imperialists. If the only way a revolutionary movement can assume power is by making deals with imperialism then it ought not to assume power.

I have had more than one dispute and argument with the Ba'athists from the 1960s to today. However, at no stage during the last thirty years did I once advocate a change of regime. I find it bizarre that many of the opponents of the Ba'ath rule, and I can name tens if not hundreds of them, who supported total sanctions against Iraq and called for a change of regime during the 1980s and 1990s, are mourning the fate of Iraq today. It is pure idiocy for anyone to think for a moment that a call for regime change would not result in the anarchy we see today. How else would a political regime whose presence had permeated the nation's institutions and social fabric for over thirty years be ousted without foreign intervention, and how could any foreign intervention be devoid of imperialist ambitions?

I returned to Iraq in 1973 after having completed my research in the nascent field of microwave communication. I had many offers to work in the Gulf but chose Iraq where I thought that I have always belonged. I was appointed a lecturer at Baghdad University but it lasted only one year. I and some 42 academics from Baghdad University were fired because we were married to foreigners. The order was so ordained in one of the Ba'ath's not so cleverly thought-out measures. It was argued then that the legislation sought to protect Iraq from being spied upon by Iraqis being enlisted for such works through their foreign spouses. The argument, if indeed credible, might have applied to people employed in sensitive sections of the state but not in every section. However, the irony of it all is that almost all Iraqis who were later to betray Iraq were married to Iraqis. I know of no one married to a foreigner who betrayed Iraq.

My expulsion on the day of the 'Baghdad University massacre', as I came to call it, ruined my life forever. I was not allowed to work in Iraq, my homeland. I was denied the ability to use my knowledge because there was no scope for microwave communication outside state employment. But things got worse. I was slowly being forced out of Iraq. The regulations in place regarding the right to work were such that those expelled from employment within the state could only be allowed to set up a private enterprise after special permission was granted. I applied and waited. In the meantime life was getting difficult. One day in the spring of 1980, after waiting and struggling, I was summoned to the Ministry of Labor and Social Services regarding my application for a special permit to work as an electrical contractor. I was met in the Minister's meeting room by someone who introduced himself as a director in the intelligence service. He praised my family's record as a nationalist family and then went on to make the

offer. I was to have the permission to work as an electrical contractor provided I spied on the foreign companies operating in Iraq which I would come across in my capacity as a contractor and report on them on a weekly basis. I realized then how debased the Party had become in allowing the intelligence services of the state to ask the Party's old guards to act as spies.

I arrived at one conclusion. It was impossible for me to stay in Iraq. Had I stayed I would have had to either report on the foreign companies and become a pathetic state agent or fail to do so and be chased by the intelligence services for my failure. Both options were unacceptable, though I understand that American businesspeople have routinely been counted upon by their government to provide it with information.[3] I was forced out of Iraq and I blame all my old Ba'athist comrades for allowing such a state to evolve.

Finland, the birthplace of my wonderful son, was kind enough to offer me the opportunity which Iraq, my beloved homeland, denied me through no fault of mine except that the Ba'ath Party of Iraq in the 1970s had perverted its ideological path. A month after I arrived in Finland, Saddam Hussein decided to roll back his submission to the Shah of Iran in signing the 1975 Agreement over the Kurds and to prevent the vocal force of the Khomeini reaching Iraq and the Gulf and thus endangering the Ba'ath's secularist-nationalist ideology and derailing the social programs and economic development at the end of its second stage.

I was opposed to the war between Iran and Iraq when it started and nothing has happened since to make me change these views. I saw it as diverting the battle against the imperialists to one between neighbors who are both targets of imperialist designs. Everything that has happened in the last twenty years has justified that fear. While Iran and Iraq were fighting and weakening each other, Israel went on to consolidate its occupation of Palestine and the Golan, attack and occupy Lebanon, and through its influence on the United States, orchestrate the blockade, invasion, occupation and destruction of Iraq with the intention to expand and cement its stay in the Middle East.[4]

I differ strongly with my Marxist friends who keep arguing that Israel is a tool of imperialism and that once the purpose of its creation is reached or its interests conflict with those of imperialism, it will be disowned. I believe that Israel is no tool of anybody. Israel is imperialist. International Zionism runs the international politics of the US and Europe. Hardly a single international decision as it relates to the Middle East has been taken in the last six decades that was not in line with the imperialist Zionist designs and interests. It follows that any action that diverts any force in the Middle East from the battle with Zionism would be serving the Zionist designs in one way or another. That is how I saw the Iraq-Iran war then and that is precisely what it turned out to be.

I left Finland to settle in England. However, my views on the war did not endear me to the regime in Baghdad. This was made very clear when, in

1988, my Iraqi passport was withdrawn, which forced me to apply for a British Travel Document, which led to a full British passport two years later.

Genocide against Iraq

Iraq's borders were drawn, not by the peoples concerned, but by a young British Captain, Percy Cox. Iraq's right to its coastline which was carved into the so-called state of Kuwait by the British in 1913, will never wither with time just as the right of the Palestinians to their homeland will not disappear until the collapse of the Zionist State. Not every injustice is sorted out over time. The ethnic cleansing of indigenous peoples from the Americas and Australia will always be a blot on the European conscience irrespective of how rosily Europe attempts to portray its contributions to these continents. The right of Iraq to its coastline could neither have been removed by Percy Cox's dictat nor by any future UN resolution adopted and imposed by the colonialists because they had no business in the first place to meddle in the matter. Iraq's right to its coastline, in what came to be known as the Kuwait sheikhdom, is a matter of survival to the whole nation and state. Thus when every Government of Iraq, from that of Nuri As-Sai'd to Saddam Hussein, declared its rejection of the carving out of Kuwait and the creation of the fictitious sheikhdom, they were all, irrespective of the differing political affiliations, demonstrating a fundamental right which all Iraqis have accepted.

Saddam Hussein's incursion into Kuwait was in line with my belief that the colonial borders were violable and ought to be removed. Further, while the Sheikh of Kuwait had supported Iraq's war efforts, allegedly on behalf of the Arabs, after the war ended it pressed for payback of its loans rather than forgiving them, and countered Iraq's efforts to raise the price of oil with a view to solving its postwar economic malaise. Further damage was caused when Kuwait embarked on stealing Iraqi oil through slant drilling at the Rumaillah oil field. However, that incursion suffered from two drawbacks. One was that Saddam Hussein could not one day argue that he had sacrificed so many young Iraqi men, including two regiments, on the day on which there was an attempt against the life of the Sheikh of Kuwait, and then attempt the next day to oust him. If the Sheikh of Kuwait were a true Arab Nationalist who had the nation's interest at heart and merited Saddam Hussein sending Iraqis to their death to protect him, it would have been a morally impossible argument for Saddam Hussein to then seek to oust him. If, on the other hand, the Sheikh of Kuwait has been, as I always believed, an imperialist stooge, then not one single drop of blood ought to have been shed to save him.

Among the infantile ideas circulating in the Arab World was the argument that the Iraq war with Iran had been to protect the Arab land in the

Gulf. But there is no such entity as Arab Land without Arab people. Land is what its inhabitants make it to be. Palestine is not Arab because it was bought by Arab tribes but because it has been inhabited by Arabs for millennia and its people want to be identified as such. The Gulf, on the other hand, has little to do with Arabism. Even when Saddam Hussein was fighting Iran allegedly on behalf of the Arab Gulf, Iraqis were not permitted to visit the Gulf Statelets. When I visited Dubai last year I felt that London was more Arab than Dubai. The demographic mess created by the British has led to the Gulf state having no identity.

I have no intention of investigating what went on during the few months of Iraq retaking Kuwait. However, what has happened in the decade that followed the incursion has been a crime the like of which has never been seen before. A policy of genocide was imposed on the whole Iraqi nation and is still ongoing. The fact that it has been imposed through the Security Council does not make it any less genocidal. The Security Council should not act outside the accepted principles of its International Law. The prohibition against genocide is one of the so called peremptory norms or the jus cogens law principle which the Oxford Dictionary of Law defines as '*so fundamental that it binds all states and does not allow any exceptions... Most authorities agree that the laws prohibiting slavery, genocide, piracy and acts of aggression or illegal use of force are jus cogens laws.*' I intend to devote a special book to the crimes committed against Iraq following the attempted retaking of Kuwait, and shall not dwell further on it here.

The fact that a policy of genocide was and is being imposed upon Iraq through the Security Council does not make it any less genocidal.

I felt very helpless witnessing the effect of the genocide that was inflicted on my people, killing and destroying all that was good in society and life in Iraq. I was infuriated by the fact that many people whom I assumed to be sensible were supporting the genocidal sanctions against Iraq simply because they believed it was going to lead to a change of regime and provide them with the mirage of democracy they were waiting for. In the early 1990s it was difficult to stand my ground against Arab Nationalists, some of whom are today blackening pages about the calamity that has befallen Iraq following the genocide of the 1990s.

The other disturbing realization was that the Ba'ath was taking the attack lying down. The Ba'athists did not, after recovering from the onslaught of 1991, formulate any plan to fight back as a means of survival. For some reason they thought that by attempting an effective and fair management of the country under the cruel sanctions regime, they would be able to wait out the assault. The Ba'athists seemed to have believed that with their remarkable success in instituting an efficient rationing system and with moneys siphoned

back in, in the names of Iraqi individuals, from the off-shore companies formed during the 1980s, they were going to be able to resist the blockade until humanity realized the ghastly atrocity that was being inflicted in its name. However, with the advent of the George W. Bush regime, the golden opportunity for Zionism to reshape the Arab World arrived and there would be no let-up. The iImperialists intended to continue the total blockade until Iraq collapsed from within. When that failed and Iraq began to recover from the impact of the sanctions, invasion and occupation became the ensuing stage in the plot.

I would have expected the Ba'ath to fight back and take the battle to the enemy. I do not intend to elaborate on what the nature of such a battle would have been and where it ought to have been fought. But it suffices to remember that the Arabs always say that 'no people have been raided inside their homes without being humiliated'. It was inconceivable that the Ba'athists still believed that they could fight another attack with a decimated conventional army. I would have expected that at least that little had been learnt by 2003.

My personal response to the genocide inflicted on Iraq took two forms. Firstly I decided to study law in order to understand the imperialist legal machination and be able to use it. I was called to the English Bar. The second action I took was to launch *The Arab Review*, a quarterly that dealt with the politics and culture of the Arab World. This venture relied fully on individual contributions both in finance and in writing. Needless to say the message was anti-imperialist. It was one of the lonely voices in England that opposed the sanctions on Iraq. The magazine was fought vigorously by all the Arab regimes and the British establishment, to the extent that I had difficulty finding a distributor for it in the UK. When my financial resources dried up, I had to stop. Although it was a very modest attempt to fight back in the capital of Zionism, I took great pride in it and it probably encouraged others to think and act on similar lines.

It seems that my magazine and my public opposition to sanctions endeared me to the Ba'athists in Baghdad. My Iraqi passport that had been withdrawn in 1988 was returned to me. Many years later I gathered the courage to make my first visit to Baghdad in 1999. I was interviewed by members of Iraq's intelligence services. In fairness to them, they were very courteous to me—it surprised me how much they knew about political activities in the UK including my writing—and they assured me that my earlier opposition to the regime had been forgiven since my nationalist credentials had been established through my defense of Iraq against the genocidal sanctions.

The destruction of Iraq did not commence in 2003 but began even prior to the genocidal blockade with the flagrant and wanton destruction of civilian infrastructure during the 1991 invasion—including, inter alia, the

incapacitation of 18 of Iraq's 20 power plants, which was a principle cause of the deterioration of public health and outbreak of epidemics due to the inability to process sewage.[5]

The semi-industrial state which the Ba'athists consolidated in 1970s and 80s was decimated by the end of 1990s. Corruption—which was unheard of and severely punished in Iraq—became the norm as people struggled to survive on a few dollars a month. The most serious aspect of such corruption was its penetration of Iraq's judiciary up to the Court of Appeal. The Party became irrelevant and the army was demoralized, to say the least.

I stayed in Baghdad between August 2000 and October 2002. Maybe it was an attempt on my part to share the suffering of my people after an exile of twenty years. It was much easier for me to compare Iraq in 2000 to the Iraq I left in 1980. There was a clear sense of apathy and despondence even among Party members. That reality was grasped by the intelligence services of the US/UK/Israel. However, what these intelligence services missed, and ended up making the wrong conclusions about, was that most Iraqis blamed them and not the regime for the calamity that had befallen them.

Saddam Hussein had reached a fatalistic conclusion about the impending end. He became a recluse, burying himself in writing novels. While people during the 1970s and part of the 80s had direct access to him through meetings and petitions, in the 1990s not even his ministers could reach him. Everything had to go through his personal secretary, Abd Hameed Mahmoud, which effectively put the latter in control of Iraq. The Arabs are too familiar with the fact that a powerful 'Hajib', gatekeeper, of the Caliphate, exercises power, itself. I had a personal experience of what that meant to ordinary Iraqis when my own effort to resolve an issue through the Iraqi justice system was thwarted by the Court, leading to financial ruin. When I petitioned Saddam Hussein on the corrupt Court decision, my petition was blocked by the gatekeeper. This was the second time, after expulsion from my work, that my life had been adversely affected by the Ba'athist rule. Although it was insignificant in comparison to what millions of Iraqis have endured during the blockade and invasion, it symbolized to me the state to which Iraq had sunk.

The Ba'ath Party owes a duty to the Arab Nation to explain its failure to mount a resistance to the "Coalition" invasion, not, admittedly, by conventional warfare, due to the obvious disparity of forces, but at least in a manner that circumstances would most recommend. While Donald Rumsfeld may have argued that the Ba'athists were key to the resistance, at least in the beginning, in all likelihood he did so merely to cover the fact that it was the Iraqi people themselves who were rising up to fight their purported liberators. It has also been rumored that Saddam Hussein

distributed weapons caches throughout Iraq for access by the people to facilitate their resistance. However, I have been advised by my high-ranking Ba'athist friends that these rumors are completely baseless. In fact Saddam Hussein was so afraid of a rebellion similar to

The Ba'ath let down the Arab Nation because it was preoccupied with the survival of the Party.

that which took place in 1991 that even anti-tank weapons were not put in the hands of the party faithful. Twice in fifty years, the Ba'ath let down the Arab Nation because it was preoccupied with the survival of the Party. Firstly in 1961 it supported the dissolution of the United Arab Republic of Egypt and Syria and secondly it handed over Iraq in 2003 to the imperialists without a fight.

Admittedly, in 2003, the Iraqi army, as a whole was not in a position to fight a classical war against the massive imperialist war machinery, backed by the industrial base of the capitalist world and the world finance institutes. It seems that the only war the Iraqi army could have fought was one of an urban-rural-guerrilla nature in which the army ought to have fought in formations of small platoons independent of each other and with absolute freedom of movement and action.

This does not mean that, against all these odds, the Iraqi army did not put up a fight. The gallant fighting of the small army unit in Um Qasr, which was dispatched there only a few days before the invasion started, has become part of Iraqi folklore. The resistance by the army in Nasiriyah to the advancing massive US army, on the outskirts of Najaf and in Babylon provide examples of the heroic stand of Iraqis in uniform. Last but not least, the two days fighting of the Republican Guards at Baghdad airport forced the US to use weapons of mass destruction[6] to eliminate the fighting force.

But the Party was nowhere to be found. Its millions of members and supporters could have stopped the US landing anywhere in Baghdad let alone on the Jamhooriyah Bridge, next to the Presidential Palace. It is true that the Party has since taken up arms and formed part of the resistance to the occupation that is naturally to be expected of any nation on Earth. However, it is fanciful for the Ba'athists today to talk about the plans that were readied to fight the invaders. It is simply untrue. There were no such plans. All that Baghdad needed was 10,000 dedicated Ba'athists to stand and fight. It would have taken the invaders a year to overcome such a number of fighters fighting on their turf. It would have been much easier to resist an invasion with a certain force than to launch an insurrection with that same force after having lost all its bases. The same force resisting today could have done more damage to the invaders during the invasion than during occupation.

I only hope the Ba'athists in Syria have learnt the Iraqi lesson and will adequately prepare for their defense when the time comes for the

invasion of Syria, which is imminent, once Security Council Resolution 1559 becomes Customary Law just as Security Council Resolution 678 did,[7] and after the Hariri Tribunal manifests itself for what it really is.

Why Did I Get Involved?

I was once asked during a BBC interview to explain the reason for my involvement in assisting the defence team of Saddam Hussein, considering I have had a bad deal at the hands of the Ba'athists. My response was that Iraq is bigger than my personal loss and bigger than Saddam Hussein. My fight against imperialism is a matter of principle. Imperialism is a universal historical phenomenon, but it remains, nevertheless, evil, whether it is Greek, Roman, Arab, Ottoman, French, British, American or Zionist. Today imperialism is European. I use the term 'European' loosely to describe the last five centuries of conquest, destruction, ethnic cleansing and exploitation of the Americas, Australia, Asia and Africa by different European navies and armies. None of these exploits could ever be explained as European self-defense. A corollary to this definition would be to refer to the US, Canada, New Zealand, Australia and Israel as European because they were created as part of the European ethnic cleansing of these continents and the setting up of European colonies. It is typical of European imperialism that the Anglo-Saxons of Australia argue that they went into East Timor to uphold human rights, and then wound up controlling over 90 percent of East Timor's oil while treating the aborigines of Australia worse than they treat their kangaroos.

For forty years I have read and heard Europeans talking about upholding their Judeo-Christian values. I have yet to hear someone explain to me what these values are and how are they related to Christ, who came from among Semitic peoples, and to whose teaching imperialism would be an anathema. I believe that people are entitled to live by the values they choose but have no right to impose them on others. The upholding of Judeo-Christian values could apply in the streets of Chicago, New York and London but not in the Tora Bora mountains of Afghanistan. Afghanistan was carpet bombed for not giving up Osama bin Laden, the alleged planner of the 9-11 attacks—though it is ignored and forgotten that the Taliban did offer to surrender him to an independent third country, if proof of his guilt were provided, and the likelihood of his receiving a fair trial assured. Aside from the illegality of this aggressive and wrongfully targeted retribution, its immorality is compounded by shifting the reasons for it in order to extend the occupation of that country—now to instill democracy, to destroy terrorism and to destroy the poppy crops—none of which would hold up in a fair court of law. If a feeble argument is made that the reason for attacking Tora Bora in 2001 was the attack on New York allegedly by some Muslims who were

mostly from Europe and Saudi Arabia and had never been to Tora Bora, then what excuse would be given for the attack on Tora Bora by the British army in September 1878? The excuse for this last question would be as phony as the excuse given for 2001.

Imperialist designs have not changed but the excuses for them have. Thus, centuries ago, people were told that it was about spreading the word of the Lord, which had to be done to save the heathens. We were not told at any time if these people had any say in whether they wanted to be saved, nor were we told where in the Gospel did its originator ask for his Word to be spread through killing. Later in the development of the practices of 'these civilized nations' the excuse became 'civilizing the barbarians'. What imperialism failed to inform us was that in the process of so-called civilizing these peoples, the last of human spirituality that existed in Africa, America and Asia was eliminated—except for Islam.

The policy of "upholding human rights" was evolved to engage the support of the European masses for their states' condemnation of and intervention in selected states, as their interests required.

The 20th century witnessed a pause and adjustment of these excuses—not because European imperialism had suddenly woken up to the horrendous crimes it was committing against the rest of humanity, but because it had its own internal wars about who was to be dominant. We all know the outcome. Out of all the 'isms', Zionism prevailed after defeating the ugly Nazism. Then we entered a new era of excuses. A new excuse was needed and it was found in upholding 'human rights'. This was intended to sound attractive for the masses in Europe so that they might support selected actions against selected states, and condemn as their states' interests required. Thus when Iraq attacks Kurdish rebels the action is labeled a crime against humanity but when Turkey attacks its Kurdish rebels, just across the border, Turkey is supported for its fight against terrorism. When I once put this question to a student of history researching Iraq at the School of Oriental and African Studies, and who two years later was presented on British Television as a "Middle East expert", he responded (without the obfuscation which would have marked a true Middle East expert) that it was because Turkey was on our side!

The 20th century witnessed many covert operations by imperialist agencies to overthrow or subvert political regimes. These covert operations have taken several forms from misinformation propaganda campaigns to economic blockades to military operations. The ousting of Mohammed Mossadaq in Iran in 1953, the toppling and assassination of Salvador Allende in 1973, the numerous attempts against Fidel Castro of Cuba and Hugo Chavez of Venezuela are only a small sample of these operations.

However, a new form of intervention by imperialists was born towards the end of the 20th century. As there no longer seems to be any need to operate covertly, interventions became overt. The first test case was the invasion of Panama in 1989, which, although launched on the American continent, was meant to gauge the reaction of the Soviet Union. The US openly invaded Panama, killed thousands of its citizens; destroyed large parts of Panama City, the capital; arrested and kidnapped Manuel Noriega, its President; and installed a puppet regime to enable it to control the Panama Canal. The US Congress passed a resolution (389-26) 'commending Bush for his handling of the invasion and expressing sadness over the loss of 23 American lives' (not a word about the thousands of Panamanians). The imperialist powers of the US, UK and France vetoed a Resolution at the Security Council condemning the invasion. There was no other reaction to the clear breach of principles held by the same imperialists to constitute international law, including the vote of the US in the Security Council, which ought to have been prohibited under Article 27 where a party to a dispute is required to abstain from voting.

When the invasion of Panama took place, Communism as an international political force was fading, the Soviet Union was in disarray, and the world was coming to terms with a single imperialist power. The US was faced with little serious opposition to its embarking on overt interventions and invasions. The invasion of Iraq in 1991, where Kuwait was used as an excuse, was not completed militarily at the time, because the US was uncertain about what might replace the existing Iraqi regime, so the decision was deferred until after the total blockade of Iraq had taken its toll.

The invasion and occupation of Iraq in 2003 signalled the dawn of a new era in which European imperialism began to openly invade sovereign states; overthrow political systems opposed to its hegemony; and install puppet regimes loyal to its overall strategy. Regime change has become an open and accepted policy despite the fact that it breaches the fundamental principle on which the post WWII order was based.

Regime change has become an open and accepted policy despite the fact that it breaches the fundamental principle on which the post WWII order was based.

I, like hundreds of millions in this world, oppose the imperialist genocidal campaign aimed at imposing its will on civilians with missiles, white phosphorous, napalm, fighters and bombers as happened over the last four years in Najaf, Fallujah, Telafer, Haditha, Imarah, Baghdad and many, many small towns and villages in Iraq. The opposition is based on a simple basic right—namely to be able to choose. Imperialism does not believe in the right of the people to choose unless that choice happens to serve its grand plan which serves the interests of its elites, and their interests alone.

The free choice of Hamas by the Palestinians to represent them was rejected by imperialism; the Hamas Government was isolated and boycotted, despite all the deafening calls for a free election we have heard from the Americans, British, French, Israelis and their like.

The invasion of Iraq differs in two main respects from the invasion of Panama. While in the case of Panama there was an attempt at the Security Council to adopt a resolution condemning the invasion, in the case of Iraq no such an attempt was even contemplated. The Security Council remained a neutral witness while a member state of the UN was being ransacked. While the invasion of Panama was carried out by the US alone, the invasion of Iraq was carried out by the US, UK, Australia, Poland and Denmark and supported later by some 33 countries which provided a number of troops to support the occupation after the initial invasion was complete.

It will be shown in Chapter 3 how the ICJ ruled that among the sources of international law it would accept the 'general principles of law recognized by civilized nations'. It seems possible that these so-called 'civilized nations' who invaded Iraq may argue in future that this action should form a recognized and acceptable custom especially since the Security Council took no measure to stop or condemn the action and the rest of the world acquiesced silently. In fact, this already forms part of an intensifying movement for the legitimization of humanitarian intervention, and the development of so-called Peace*making* force.

There are two reasons for my involvement in the trial. Firstly, it is the right of every human being to have a proper defense whatever the alleged crime. Secondly I wish to make every effort to end the occupation of Iraq and the consequent multitude of breaches of all principles regulating the conduct between member states of the UN, including setting up a Tribunal to overhaul its political system, aimed at setting a precedent that would be followed by the imperialist in other parts of the world.

My involvement in the defense of Saddam Hussein reflects two strands in the same battle—to defend Arab nationalism, however inadequately represented by the Ba'ath Party in Iraq, against the Zionist onslaught and to prevent what happened in Iraq being repeated against other hapless peoples of the world. I do not want what happened to Saddam Hussein to happen to Bashhar Al-Asad of Syria, Ahmadi Nejad of Iran or Hugo Chavez of Venezuela.

My involvement in the defense of Saddam Hussein reflects two strands in the same battle—to defend Arab nationalism and to prevent what happened in Iraq being repeated against other hapless peoples of the world.

The decision to kill Saddam Hussein was taken by George W. Bush and Tony Blair once the decision to invade Iraq was made. There may be no record of such a decision but history is not judged simply on the basis

of documents. Much of historical intent can be found in the record of action. On 7 April 2003, when Iraq was almost in the hands of the invaders, with US tanks and troops already in Baghdad, George Bush gave the order for the assassination of Saddam Hussein. The attack on the As-Sa'a Restaurant in Mansour, which killed some 17 innocent Iraqi civilians, was meant to eliminate Saddam Hussein at a time when no military purpose would have been served—since, after all, the true purposes for the invasion (the destruction of Iraqi capacity against Israel, the seizure of Iraqi oil) would still remain to be accomplished. The assassination of Saddam Hussein would nonetheless have served an important purpose. Saddam Hussein was at the center of events and his personal involvement and control over events meant that, as far as Iraq was concerned, he alone had all the secrets. When he was gone, history would be freely rewritten by the victors and not necessarily by the facts, which would be buried with him.

Eight months after the occupation of Iraq when the invaders still felt that events were arranging themselves as expected and planned, and especially that the honeymoon was not over and the resistance was as yet evolving, there was no urgent reason to kill Saddam Hussein as they could have done when they arrested him, alleging that he resisted, as they did with his two sons. The infantile political judgment of George Bush sought something more dramatic and gangster-like—humiliating him through a trial as an ordinary criminal. However, there was another purpose served by trying Saddam Hussein. It was a reminder to all Arab and Third World leaders that a similar fate awaits each and every one of them who dares to defy imperialist designs for the Arab and developing world. Any Arab leader who did not feel humiliated by the arrest, trial and execution of Saddam Hussein should read the Al-Mutanabbi saying:

> He who stoops facilitates disgrace
> No wound will pain the dead.

There was another reason for the elimination, in particular, of any Arab leader who stood up to the Zionist hegemony. There was a need to vindicate an aggression which all but erased Iraq as a political and social entity—one million dead, four million refugees and the complete destruction of Iraqi infrastructure in four years. By having Saddam executed at the hands of some Iraqis, the invaders sought to promote a vindication of their destruction of Iraq by having rid Iraq of its dictator. The political decision was made to eliminate Saddam Hussein and make him an example for others. However, some legal facade had to be put on that operation. Although both Bush and Talabani had said that they were convinced that Saddam Hussein ought to be executed, simple lynching was rather difficult to sell. A trial was required,

especially for the gullible European society that has been conditioned to believe that holding one indicates the existence of a fair and just system.

But as this book documents, none of the events related to European intervention in Iraq have been performed in accordance with the very system of international law which they established, and purported both to defend and to extend to Iraq. From the first assault on Iraq after its retreat from Kuwaiti territory, through the genocidal sanctions imposed for over a decade, to the 2003 invasion, followed by occupation, the US/UK and the so-called Coalition of the Willing—contrary to the original pretexts—sought not only to assure the elimination of WMDs, which it knew did not exist, but also to achieve regime change, and beyond that, to completely overhaul the prior institutionalization of the sovereign nation of Iraq, contrary to international law. In this attempt, they wreaked havoc throughout Iraq, committing in the process not only war crimes but other practices which might in themselves be viewed in their cumulative effect as crimes against humanity.

I have often been asked, as UK coordinator for the defense team of Saddam Hussein, how I could "defend the indefensible".

It is a question those who seek to defend the present invasion, occupation and destruction of Iraq—and even the trial and execution of its former head of state—might well be asked in turn.

How I Became Involved

Sometime towards the end of 2004, an Iraqi friend living in England contacted me enquiring about my ability and willingness to assist Raghad, the eldest daughter of Saddam Hussein, in her effort to set up an international defense team. For the reasons stated above, I agreed to assist. After contacting Raghad in Amman and assessing the need in light of the state of the defense team, I traveled to Jordan to meet her. This was the first time I had met any of Saddam Hussein's family. Anybody who has followed the media reporting on her would assume that meeting Raghad means meeting an arrogant young tyrant. In fact I saw in her the total opposite. I met a charming, well-behaved, sensible and modest young lady. We had several meetings spread over a few months during which time I noted how courteous she was while still being able to stand her ground when necessary. This was clear in her meetings with the lawyers and others involved in the defense campaign. She demonstrated an outstanding ability to comprehend complex legal issues ahead of some of the lawyers and to develop a logical deduction. Considering the circumstances and pressure she was under, having lost a husband, a father and two brothers, and now being a refugee with an unknown future who still bore responsibility for the rest of the family, I would say that she conducted herself remarkably well, and behaved with a dignity that impressed all those who met her.

We agreed that I should investigate the possibility of setting up and coordinating a defense team in the UK with a view to cooperating with other lawyers to provide international expertise to the team of mainly Iraqi lawyers undertaking the defense of her father and his comrades. There was no clear defense team yet, although there were lawyers from the US, France and Malaysia already involved.

When I contacted lawyers in the UK, I made two alarming discoveries. The first was that some lawyers were afraid to be identified with Saddam Hussein, which can only be attributed to the way the media had managed to demonize him over the previous twenty years. This fear of being identified as a "defender of the indefensible" led some lawyers to assist but only provided they could remain anonymous, and for this reason, I do not cite them here. The second was that any prominent lawyer that might be engaged in the UK expected exceptionally high fees, based on the misconception that Saddam Hussein was very rich. The assertion that the family had no money, because Saddam Hussein never set up personal bank accounts inside or outside Iraq, was not seriously believed.

The advice obtained in the UK took several forms, prominent among which was a written opinion on the illegality of the Iraqi Special Tribunal established by Paul Bremer, and the lack of jurisdiction to try the President of the Republic. The consensus among the concerned lawyers in the UK was that the proper response to the Tribunal ought to have been total boycott demonstrating non-recognition of its legality and jurisdiction. It was concluded, rightly in my opinion, that the Tribunal was destined from its inception to convict Saddam Hussein, which made it a political rather than a judicial trial.

The UK lawyers favored a total boycott of the trial to refuse recognition of its legality and jurisdiction.

The competent Malaysian team headed by Matthias Chan and the French lawyer, Andre Chamy, all agreed with and supported the consensus among the UK lawyers, spearheaded by the Irish lawyer, Desmond Doherty. The Iraqi lawyers had no role in this but the US lawyers consisting of Ramsey Clark and Curtis Doebbler were of the opinion that the case should be contested.

A few weeks before the trial started, I met Clark, Doebbler and Chamy in Paris, in response to a request from Raghad, in order to reach a unified stand on the matter. The meeting ended without any agreement. In fairness to Raghad I don't believe that she made any decision on the matter, but events took their course when the trial started and the Iraqi lawyers attended with other American lawyers accompanied by a few Arab lawyers. Although it was claimed by the defense lawyers and by Saddam Hussein that they did not recognize the Tribunal, the recognition was effective through their taking part in the proceedings. That marked the end of the involvement of the UK, the French and Malaysian lawyers.

Although my involvement was short lived, once the trial started I was chased by the media in the US, UK (the BBC's HardTalk), Australia, and Russia in addition to the Arab media. I was willing to take part because I believed that it gave me an opportunity to communicate my views on the invasion and destruction of Iraq and events up to and including my rejection of the trial.

That is also my purpose in writing this book.

ENDNOTES

[1] Following a request from the Chaldean Patriarch of Baghdad and at the direction of Pope Pius XI, a group of four American Jesuits arrived in Baghdad in 1931 and established Baghdad College as a secondary school for boys. The school was first situated in central Baghdad before moving to the beautiful location of Sulaikh in North East Baghdad. The College ran from 1932 until it was nationalized by the Iraqi State in August 1969.

[2] Batatu, H. *The Old Social Classes and New Revolutionary Movements of Iraq*, London, al-Saqi Books, 2000. Batatu says in the Preface to his book: "The photographs were obtained from the Public Security Division of Iraq's Ministry of Interior, or from the persons portrayed or their families, or through the courtesy of Michel Abu Jowda. Editor-in-chief of An-Nahar (Beirut) and Dr. Ahmad Chalabi of Iraq..")

[3] See, for example, "U.S. man convicted on Russian spy charges", CNN, December 6, 2000, http://edition.cnn.com/2000/WORLD/europe/12/06/russia.spy.02/index.html

[4] Petras, James. *The Power of Israel in the United States*, Atlanta, Clarity Press, Inc., 2006.

[5] See Boyle, Francis. *Destroying World Order: U.S. Imperialism in the Middle East Before and After September 11.* Atlanta, Clarity Press, Inc, 2004, p. 96.

[6] See interview of General ar-Rawi on Al-Jazeera, cited in Chapter 3, 'Could the SC Have Given Authority', where he reported use of such weapons. We have never had any independent reporting to the contrary.

[7] The reason why the Security Council resolution could become part of customary international law is that once it is accepted by 'civilized states' and acted upon, it becomes so. SCR 1559 opened to door to the Security Council overriding security agreements between independent states which was inadmissible prior to adopting the resolution, because according to the UN Charter, regional agreements assume supremacy over international ones.

CHAPTER 1

THE BA'ATH
AND SADDAM HUSSEIN

The Birth of Arab Nationalism

The Ottoman Empire inherited the Fertile Crescent—the area of
The Two Rivers, the Euphrates and Tigris, between the Indian Ocean and
the Mediterranean, the heart of the Muslim-Arab world—from the Abbasid
Empire which claimed the legitimacy of Caliphate authority, both temporal
and religious, from the Prophet. The Arabs of the area had little difficulty
being ruled for several centuries by the Turkic people because Islam as
taught in the Qur'an and the Prophet's *Hadith* transcends ethnicity and race,
and through the Islamic *deen*, provides a commonly held and holistic moral,
political, legal and spiritual orientation toward life.

The situation started to change in the nineteenth century as the
Empire reached its ailing age like every other empire in history, and Europe
began to reshape on the basis of the nation-state. Different ethnic
communities within the Empire began to feel a loss of common identity as
the Empire became clearly more interested in its survival than in Islam. The
Arabs realized that they were being forced into 'Turkization' when even the
teaching of Arabic was forbidden. Indeed it is accepted that, had it not been
for the Qur'an, Arabic could easily have become an archaic language like
Latin. The agitation within the Empire spread even to the Turks themselves
as the Young Turks movement called for the creation of a Turkish nation
similar to that of Germany and Italy.

When the Ottoman Empire was defeated in WWI, it was
dismembered. The Arab Middle East was taken over by the British and
French who had secretly agreed in the Sykes-Picot agreement of 1916[1] to
divide it among themselves, despite having made promises to the Arabs of
the area to create an independent Arab nation if they assisted in the defeat
of the Ottomans. Not all Arabs were gullible, as the armed resistance of the
Iraqis between 1916 and 1920 clearly demonstrated.

The yearning of young Arabs for the glory Baghdad had enjoyed in
the tenth century intensified between the two wars. They thought that the
delivery from the hands of the Ottomans into those of the British and French

was no salvation and the call for the Arabs to reclaim their destiny began to gain momentum.

The Birth of the Ba'ath

Among those Arabs was a young scholar called Zaki Al-Arsouzi (1899-1968). Zaki was born to an Alawi family in Lattikia but moved to the mainly Alawi province of Iskenderun. In 1927 he went to Paris and returned in 1930 with a PhD in philosophy from the Sorbonne. Life was not easy for a young Arab nationalist under French rule. He opposed the demands of the Turkish minority to hand over the Iskenderun province to Turkey, which occurred in 1938, as part of the imperialist's dealings with the Middle East irrespective of the wishes of its people. Iskenderun was handed to Turkey, allegedly in return for Turkey abandoning its claim over Mosul. It was Zaki Al-Arsouzi who first wrote about the Ba'ath Arabi, the resurrection of the Arab nation. His most distinguished contribution has been his book, *The Arab Genius in its Tongue*. After a short stay in Baghdad he returned at the end of 1940 and formed a group under the name of AlBa'ath AlArabi, the Arab Resurrection, which for historical purposes must be regarded as the first organization of the Ba'ath ideology. Alarsouzi's influence in the birth and development of the Ba'ath party has not, in my mind, been properly assessed, while that of his contemporary, Michel Aflaq, has received more than its share of credit. Despite his original contributions, Zaki was sidestepped and ended up not playing any role in the Party in the following decades.

Two other organizations emerged, the Arab Ba'ath Party founded in 1943 by Michel Aflaq (1910 -1989) and Salah ad-Deen Al-Bitar (1912-1980), and the Arab Socialist Party founded in 1950 by Akram Al-Hourani (1911-1996).

The first, and since considered the founding, conference of the Ba'ath Party was held between 4-7 April 1947. In 1952 both parties merged and created the Arab Socialist Ba'ath Party, commonly shortened to the Ba'ath. In 1954 a second conference ratified the merger.

In February 1958 the United Arab Republic was created from a union between Egypt and Syria. Part of the Union agreement called for all parties to be disbanded. The Syrian Regional Ba'ath was dissolved while the Pan Arab National Leadership, which controls all the Party branches in the Arab World, was maintained.

The tragedy of the Palestinians—large numbers of whom, as a result of the creation of the State of Israel, were forced to flee their homeland, ending up as refugees in the rest of the Arab world—intensified the appeal of the Ba'ath in the Arab Middle East. Branches of the Ba'ath soon sprang up in Iraq, Jordan, Lebanon, Yemen, and Sudan, and in smaller forms in other

Arab states. However, the Ba'ath remained strongest in Iraq where it ruled for over thirty years, and in Syria, where it remains in power since it took over in 1963.

The Significance of the Ba'ath

The Ba'ath ideals are not difficult to understand or easy to fault. The Ba'ath called for the liberation of the Arab nation from all foreign domination and colonialism, the unity of the Arab nation, an equitable distribution of wealth in some form of socialism, and for freedom for the masses. Whether or not these ideals have been implemented, and if not why not, is not for this short introduction to handle. However, in view of the fact that the Ba'ath has generally received biased and very subjective pro-Zionist reporting in the West, some of its main features need to be identified to facilitate a genuine understanding of the Arab world.

The Ba'ath called for the liberation of the Arab nation from all foreign domination and colonialism, the unity of the Arab nation, an equitable distribution of wealth in some form of socialism, and for freedom for the masses.

The Ba'ath evolved at the same time as the communists were gaining some ground in the Arab world. Although religion has always been powerful in the Arab world, Islamic parties at the beginning of the 20th century had little appeal among the forces that mattered at the time. Political Islam was difficult to sell. The memory of the decadent and deteriorating Ottoman Caliphate, claiming to be the inheritor of the Prophet's spiritual and temporal authority, was still fresh, and not an experience people wanted to repeat. There were not many competent Muslim scholars around to convince the people of the attraction of a state based on Islamic Shari'a.

The communists, on the other hand, had a wider appeal than Islamists among some enlightened men who were disillusioned with then-reactionary Islamic thinking which they naively claimed to be the cause of Arab backwardness. However, communist ideology as imported from Russia to the Arab world suffered from two basic drawbacks. The concept of class struggle, fundamental to Marxism and understandable to workers subjected to the textile factories of Manchester, had no resonance in the Arab world where poverty was not represented by a working class. One of the greatest failures of communist Arabs had been their attempt to explain the Arab-Zionist conflict in terms of the class struggle, arguing that the working classes of the Arabs and Zionists would unite and defeat imperialism—only to discover that the staunchest Zionists in Israel were to be found within the Jewish working class.

The second drawback came from the translated literature of Communism on religion. In dismissing the Christian Church in Europe and denouncing religion as the 'opiate of the masses', Communism was responding to the history of the Christian Church and its role in European politics. The notion was very specific to that experience, but there was no parallel to be drawn between the development of Christianity in Europe and that of Islam in the Arab world. The failure of the communists in the Arab world to appreciate this reality cost them dearly among the Arab intelligentsia. Many an Arab would point out to those communists that Imam Ali, the Prophet's cousin and son-in-law, was a greater socialist than Marx or Lenin, some thirteen centuries before them, yet was the model of a devout Muslim.

In denouncing religion as the "opiate of the masses," the Communists were responding to the history of Christianity in Europe, but Islam had not played such a role. This misunderstanding cost them dearly.

The Ba'ath succeeded where both the communists and the Islamists failed. Religious Arabs saw in the revival of the Arab nations a revival of the spirit of Islam which had been lost in the corridors of Istanbul, because Arabism has always been wrapped in Islam. Not-religious Arabs, loosely referred to as 'secular', despite the fact that secularism as known in the West has no equivalent among the Arabs, saw in the secular state called for by the Ba'ath a saviour from the non-adaptable dogma being propagated by poorly educated Muslim clerics, especially the frightening calls by the new Al-Salafis, who blindly advocated following the path of the forefathers.

The masses in the Arab world were, like their contemporaries in other parts of the world, aspiring to independence, freedom of choice and liberation from all forms of foreign interference or domination. The political regimes installed by the British and French colonialists between the two wars in some parts of the Arab world and the full occupation and colonization of other parts were anathema to these aspirations. Both the Arab communists and the Ba'athists adopted these natural aspirations of the Arabs and promised to deliver them once the political status quo was overthrown.

However, the Ba'athists had another advantage over the communists deriving from their being a fully nationalist movement. The Arab Communists were, like other communists in the rest of the world, part of the international communist movement. That meant that, however independent they claimed to be, their strategies, their tactics, their policies and even their slogans had to be in line and harmony with those of the Soviet Communists. In short, all communists in the world had to toe the line of Moscow in one way or another. A true communist may have had an argument to support such a position. For him protecting Moscow had a wider interest for the movement than defending a local national issue. This created dilemmas for the Arab Communists. It

was in the interest of Moscow's international strategy during the Cold War not to destabilize national bourgeoisie states which are more likely than not to be anti-imperialist. Thus despite having been persecuted by Nasir in Egypt and Qasim in Iraq in the 1960s, the communists in both countries were instructed by Moscow not to threaten the stability of either state.

The worst dilemma of all for the Arab Communists has always been the recognition of the State of Israel. The Arab Communists have never been able to accommodate their declared principle of opposing the imperialists' designs for the Arab world with their recognition of the imperially-created racist State of Israel at the expense of uprooting hundreds of thousands of innocent impoverished aspiring Arabs, which may partly be due to the extent of Jewish influence in the international communist movement. The Ba'athists, who were not obliged to any international ideology, were able to adopt any revolutionary stance based on the local situation, which the communists could not, and were able to capitalize on the communists' failure on Palestine.

While competing in representing the anti-imperialist aspirations of the Arab masses, both the Arab Communists and the Ba'athists succeeded equally in appealing across the sectarian, religious and ethnic divide in Arab society. Large numbers of people from different minorities joined both parties as part of a self-defense instinct to establish their credentials and not be overwhelmed by the weight of the majority, which would have favored a continuation of an Islamic Caliphate.

Thus it would not be strange to discover that the percentage of Muslim Alawis and Christians in the Syrian Ba'ath and the percentage of Muslim Sunnis and Christians in the Iraqi Ba'ath have been higher than the percentage of these groups in their respective societies.

While it has been typical of British imperial policy to empower minorities to control the majority population while themselves remaining powerless, as minorities, to activate anti-colonialist resistance, this was not the case with Iraq's minority Sunnis. The situation was complicated by Iraq's unique nature. In the early part of the 20th century Iraq was the only created state in the Arab East with a potential Shi'a Arab majority, although this has since changed with both Lebanon and Bahrain possibly claiming Shi'a majorities today. The British imperialists hoped to rely on the Sunni minority to support their puppet regime in Iraq, but this was not that easy. The Sunnis of Iraq believed that Iraq had been carved out of the Arab East and were determined to see it united with rest of the Arab world, which would have been anathema to British imperialism. On the other hand, an Iraq dominated by Shi'a would have been an alien creation in the predominantly Sunni Arab East. The Shi'a of Iraq assisted the British in concluding who their allies were when they took the religiously-correct position of opting out, leaving them in actuality relying on the politically-flawed position of backing the imperialist-supported Sunni state of Iraq.

When an objective study of the history of the Arab East in the 20th century is carried out, one fact should stand out irrespective of other successes and failures. It is that the Ba'ath had succeeded more than many nationalist parties in other countries in appealing to the whole society and uniting people across all divides. It was the Ba'ath nationalist ideology in Iraq and Syria which prevented tragedies like the sectarian Lebanese civil war, the continuous friction between Muslims and Christians in Egypt and the carnage of the 1990s in Algeria taking place in either state. At the beginning of this chapter I referred to three men who would be considered to be the founders of the Ba'ath ideology and party. When Zaki Al-Arsouzi, an Alawi Muslim, Michel Aflaq, an Orthodox Christian, and Salah ad-Deen Al-Bitar, a Sunni Muslim, got together to advocate an ideology and form a political party appealing to the entire Arab society, people from the whole of society flocked to adopt their propagated ideology and join the Party. That is the success of the Ba'ath in the Arab world if everything else failed: its ability to express and entrench the existence of the Arab nation. The disintegration of Iraq following the 2003 invasion and the overthrow of the Ba'ath is a living proof of that success and the failure of the invasion.

The Uniqueness of Iraq in the Arab-Muslim World

Iraq has long held a unique position in the development of politics and religion in the Arab World. In 710 Baghdad became the capital of the Islamic Caliphate, signaling the beginning of a long, stable and cultured society and state. It is in the rule of the Abbasid Dynasty, in one form or another, from 710 to 1258 that most Arabs take pride, even those who may feel they were oppressed—like the Hanbalis during the reign of the Abbasid Caliphate Al-Ma'moon and the Shi'a at the end of the Abbasid Dynasty and during some eras of the Ottoman rule.

The main important feature of the glory of Baghdad, which is very often neglected or unappreciated, is what Baghdad gave to Islam. All Muslims agree that Islam is based on the Qur'an and the Prophet's *Sunna*, which literally translates into what the Prophet ordained in his practice and sayings (*Hadith*). A century after the Prophet's death Muslims started compiling books on his life and practices, the books of *Sira* and on his *Hadith*. Once this stage was completed Muslim jurists began to interpret the *Shari'a*, the Laws of Allah handed down in Qur'an and *Sunna*. Many schools of Islamic jurisprudence *(Fiqh)* emerged, some of which have since slowly disappeared. Today there are four schools in the Sunni sect, *Hanafi, Shafi'i. Maliki*, and *Hanbali* and mainly two Shi'a schools, the *Ja'fari and the Ismailii*. It was in Baghdad specifically and Iraq generally that Islamic *Fiqh* was developed. Between Kufa, Samarra' and Baghdad, scholars and jurists argued and wrote. Furthermore, Iraq houses the greatest shrines for both Shi'a and Sunni. Abu

Hanifa, the assumed founder of the Hanafi sect, the largest Muslim sect today, is buried in A'dhamiyah, in the north-east of Baghdad. For the Shi'a, Iraq houses the shrines of seven of their twelve infallible Imams. A few hundred meters across the Tigris River from the shrine of Abu Hanifa is the shrine of Imam Musa Al-Kadhim, the seventh Shi'a Imam. Assume for the moment that across the road from the Vatican is the shrine of Martin Luther, and then you can imagine what Baghdad means for both Shi'a and Sunni Muslims.

That is the unique position of Iraq for Muslims all over the world. Although all Muslims look to Mecca for salvation, they also look to Iraq for spiritual guidance and inspiration. Although the religion originated in what today is Saudi Arabia, its roots are in Iraq both in jurisprudence and spirit. Every Shi'a in the world cannot but look towards Iraq for Imam Ali, Imam Hussein and the origins of *Ja'fari Fiqh*. Every Sunni looks to Iraq where Abu Hanifa is buried and his disciple Ash-Shaibani developed the Hanafi Fiqh and where the longest Sunni-dominated Arab Empire endured. Iraq belongs to the Shi'a of Iraq and the Shi'a of the Muslim world just as much as it belongs to the Sunnis.

It is misguided to talk about majority Shi'a and minority Sunnis, which seems to be the naïve approach of some of the so-called Arab World specialists in the US and the UK. Iraq could not be ruled on sectarian bases by Sunnis to the exclusion of the Shi'a whatever the number of these Shi'a may be. Equally it could not be ruled by Shi'a on sectarian bases to the exclusion of the Sunnis however small a minority the Sunnis are. Iraqi is equally Shi'a and Sunni irrespective of the percentage of each sect. The only way Iraq can survive is to have a secular state, in which both Shi'a and Sunni have absolute freedom to claim it as their own. The fear among members of both sects since the invasion, occupation and the void created by them, that the other sect is out to secure hegemony, has led to the polarization and bloody strife. This mad spiral and the likely disintegration of Iraq could only be stopped when the above fact is acknowledged and acted upon as I suggested.

The Marginalization of the Shi'a in Modern Iraq

The victors of WWI, like the victors of WWII, could not but have been opposed by the peoples of the conquered land. The modern political Iraq was created by amalgamating parts, *and certainly not all*, of the three *Wilayets* of Baghdad, Mosul and Basrah, as they existed under the Ottoman rule. It suffices to state here that most of the Wilayet of Basrah, like Kuwait and Riyadh which were part of it under the Ottoman rule, were carved out of modern Iraq.

When Britain moved to consolidate its grip on Iraq, as any colonialist would be expected to do, it appointed a puppet regime consisting of men brought from outside Iraq who would naturally rely on the colonial power for

their survival and on Iraqis of little or no principles, willing to serve any master so long as their personal ambitions were satisfied. The parallel between what happened in Iraq in the 1920s and what has happened since 2003 is impossible to miss. I do not intend to analyse what happened in Iraq following the appointment of the so-called 'Nationalist Regime' except to point out the position taken by the Shi'a of Iraq which has had a lasting impact on the politics of Iraq, the effects of which are felt even today.

For centuries the Shi'a Muslims have adopted a principle called *taqiyyah*, which means silence, acquiescence and submission to the ruler. There are several reasons to justify the adoption of this principle but it is usually attributed to a saying of the Sixth Imam, Ja'ar as-Sadiq, whose name gave rise to the sect's name, the Ja'fari. As most Shi'a follow one or another cleric, who have come to use the abhorrent title Ayatollah,[2] then these clerics wield great influence over the masses. In line with the concept of *taqiyyah*, these clerics called for the Shi'a of Iraq not to cooperate with the Iraqi government after Iraq's colonial severance from the Ottoman Empire on the ground that the new state entity was an un-Islamic State. This happened some fifty years before the Ba'ath assumed power in Iraq. It led to most Shi'a refusing to join the Iraqi army and even to being state employees. The Shi'a of Iraq became the professionals and tradesmen, while the Iraqi government was staffed with Sunnis and the Iraqi army became a Sunni establishment, some of whose officers had already served in the Ottoman army.

Along with this fact of an army staffed with mainly Sunni officers, grew another fact. The political opposition to the pro-West government was heavily staffed by Shi'a. To illustrate this fact it suffices to state that on the eve of the July 1958 military coup, the main three political parties in Iraq were led by Shi'a. Muhammad Mahdi Kubba, a Shi'a from the respectable Kubba family of Baghdad, was leader of the *Istiqlal* (Independence) Party. Fouad Ar-Rikabi, a Shi'a from Nasiriyah in southern Iraq was the General Secretary of the Ba'ath Party. Salam Adil, a Shi'a from Najaf, was the Secretary-General of the Politburo of the Iraqi Communist Party. I hasten to add that none of those three were known to harbor any sectarian feelings or attitudes nor known to have practiced in a sectarian way. They were highly liked by their comrades in their respective parties and respected inside and outside their parties for having been nationalists aspiring for the good of Iraq as a whole. On the eve of the Ba'ath's first takeover of power on 8 February 1963, the leadership of both protagonists, the Ba'ath and the Communist Parties, were predominantly Shi'a. It is, in my opinion, vital to understand the nature of Iraq's political parties up into the 1960's if there is to be a serious attempt at understanding part of the problems of today.

The Birth of the Ba'ath in Iraq

In the early 1950s, the Ba'ath ideal filtered into Iraq and spread

among young Iraqi students and professionals who were aspiring to change but were not amenable to the communist ideology that was spreading in Iraq. The Party was secretly created as a network of small cells of members which formed a *firqah*, a division. Several divisions would then form a *shu'ba*, sub-branch. Three to four sub-branches would form a *fari'*, a branch and several branches made up the Regional Command, *qiyadah qutriay'*.

The first regional Iraqi Ba'ath Conference was held in Baghdad in 1954. The conference elected a Regional Command, which was attached to the Pan Arab National Leadership in Syria, headed by a young intelligent engineer, Fouad Ar-Rikabi, from Nasiriyah in southern Iraq. Fouad Ar-Rikabi may not have been an ideologue but he was an excellent organizer. He managed in a few years to build the second largest and most organized secret party in Iraq, consisting mainly of university and high school students and young professionals such as engineers, dentists, doctors, lawyers and teachers.

My two elder brothers joined the Ba'ath Party in its early days but I was too young to join, then. However, one of the earliest memories of my political awareness happened sometime late in 1956 following the Suez fiasco. One afternoon we had security men calling at our home carrying a search and arrest warrant for my brother. Neither my father nor any of my elder brothers was home. I was sent by my mother to seek the assistance of our neighbor, Abdul-Rhaman Jawdat, a respectable soft-spoken member of the Upper Chamber in Iraq's Parliament. The security officers were courteous enough not to enter until Mr. Jawdat arrived. As the top security officer was searching through my brother's room looking for so-called seditious material, Mr. Jawdat asked him if the young man they were looking for was accused of being a communist. 'No Sir', said the security officer, 'he is a Ba'athist and these are more dangerous than the Communists'. This was my awakening call. I concluded then that the Ba'ath must be right and good for the Arab Nation. If the regime of Prime Minister Nuri As-Sai'd, which sold Palestine to the Zionists and backed Anthony Eden in his invasion of Suez, considered the Ba'ath to be dangerous, then I felt it must be the right party for the Nation.

On 14 July 1958 the Movement of Free Officers led by General Abdul-Karim Qasim launched a coup, ousting the monarch in what was a brutal, yet contained, action. The royal family, the prime minister, his son and a few others, were killed. Qasim set up a government but personally held on to real power. Among the members of the government was Fouad Ar-Rikabi, who at the age of 27 was one of the youngest Ministers in Iraq. It was an acknowledgement by Qasim and his deputy Colonel Arif of the significance of the Ba'ath in Iraqi political life, despite its having been in existence for only a few years.

Qasim genuinely tried to balance the two main trends in Iraq, namely that of communism led by the Iraqi Communist Party whose leadership had

been executed a few years earlier and Arab nationalism headed by the Ba'ath. However, Qasim's dictatorial and self-centered character did not endear him to either side. The rift between both sides spilled onto the streets and Iraq suffered a few massacres in different parts of the country. The Ba'athists along with other Arab Nationalists and a number of army officers from among the Free Officers Movement fell out with General Qasim.

I joined the Ba'ath Party immediately following the July 1958 coup as a young teenager. It represented for me then all that I was aspiring towards—full independence from foreign domination, equal distribution of wealth among the impoverished Arabs and above all the union of the nation that to me gave the most delightful thing ever—its Arabic tongue.

Enter Saddam Hussein

Fouad Ar-Rikabi and a few of his comrades in the regional leadership of the Party concluded that the only way to restore Iraq's Arab character and identity was to eliminate General Qasim. His departure would ensure the creation of an Arab Nationalist authority in Iraq. Fouad Ar-Rikabi wanted total secrecy and thus the operation was under his supervision and direction. He directed that brave young men be chosen for a special task. A few such men were recommended. Among them was a 21-year-old man from Tikrit called Saddam Hussein. He was a newcomer to the Party and had not yet become a member. It was then a time when young men joined the Party ready to do what it asked for. When Saddam was chosen he did not know what the mission was. In that, he was similar to members of revolutionary movements throughout history who have killed if they believed it served the purpose of the Revolution, trusting to their leadership to know best what that was.

The plan to assassinate Qasim was to ambush him in the narrowest part of Rasheed Street, the main trading road which used to be Baghdad's equivalent to London's Oxford Street, and attack his car as he drove back from the Ministry of Defense. The attack took place on 8 October 1959. However, it went wrong: Qasim was injured but not killed and one of the attackers was killed by friendly fire. His identity led to the finger being pointed at the Ba'athists. What followed, as would have been expected, was a crackdown on the Ba'athists in particular. Saddam Hussein was injured in his leg but managed to slip out of Iraq to Syria.

Fouad Ar-Rikabi fled Iraq with a couple of the leadership members. In Damascus Ar-Rikabi broke the Party's rules and granted Saddam Hussein full Party membership without the latter having to go through the proper membership process. There is no doubt that Ar-Rikabi thought that Saddam's bravery deserved an exception to the rules. I believe that this must have been the only incident in the history of the Party in which membership was bestowed

by the General Secretary of the leadership without having to go through the procedure as laid down in the Party's articles of association. Saddam Hussein left Syria to go to Egypt where he lived as political refugee until 1963.

In the crackdown that followed the failed attempt on Qasim's life, the Communists were given a free hand in Iraq, terrorizing, arresting and killing people. One evening my home was invaded by uniformed police, security officers and some twenty members of the People's Resistance, the Communist Party semi-militia that was terrorizing the streets of Iraq. This time they were looking for me. I was arrested and kept in prison for one month and only released with thousands of other students on the order of General Qasim on the eve of the Ramadhan *Eid*. A few months later I was summoned before a Military Tribunal and charged with endangering the security of the state—a charge based on information from my high school colleagues and political material seized the day I was arrested.

I was tried by a Military Tribunal of three army officers headed by a colonel. My defense was that the Tribunal ought to consider that along with so-called seditious Ba'ath material found on me, I had political material belonging to other parties, including the Communists. In short I was keeping myself informed. I was acquitted. However, on my way from court to my high school, I concluded that the regime of General Qasim was doomed. I thought that a political regime that charges and tries a 14-year old boy on the ground of endangering its security simply for having been in possession of political material, however seditious it might have been, must be morally, politically and legally bankrupt, and had no authority to govern.

My early involvement and experience enabled me to acquire significant insight into the Ba'ath Party functioning. I do not think there is an Iraqi Ba'athist from the 1960s whom I do not know or know of. The material in this chapter is derived from my personal knowledge and experience. If it is not derived from an incident or a meeting I have personally had, then it is derived from another Party member who has had such direct knowledge.

The Ba'ath Revolution against Qasim

There was not very much love between Fouad Ar-Rikabi, the General Secretary of the Iraqi Regional Leadership, and Michel Aflaq, the General Secretary of the Pan Arab National Leadership. Aflaq, who was conspiratorial by nature, had a golden opportunity to oust Fouad Ar-Rikabi, whom he saw as a personal threat to his authority and control of the Party. Fouad Ar-Rikabi, instead of standing his ground, wrongly, in my opinion, decided to leave the Party to Aflaq, who set up a new leadership led by Ali Salih As-Sa'di, whose membership in the Party was suspended when the attack on Qasim took place. Ali was not of Fouad's caliber but was charismatic and well liked by Party members.

Qasim turned away from the Arab Nationalists after the failed attempt on his life—thus inviting the wrath of Nasir, who was the personification of Arab Nationalism in the second half of the twentieth century. He also turned against the communists, accusing them of being anarchists and thus upsetting Moscow. He then opened a big rift with the imperialists by promulgating Law No. 80 which took away from the oil companies their assumed right to exploit some 95 percent of Iraq's land. By the end of 1962 Qasim had very few friends and no allies.

It was not difficult to see how opportune it was for any organized party with some loyal officers to launch a coup. The communists who had the right loyal men in the vital military positions around Baghdad were in the best position to mount such a coup. However, their masters in Moscow were opposed to any coup against what they termed a nationalist bourgeoisie government, of which Qasim's was one.

The Ba'ath, with the support of other smaller Arab Nationalist partners along with dissatisfied officers, planned a coup to oust Qasim and, according to them, restore the 1958 Revolution to its Arab path. When the preparations were reaching their final stages, Ali As-Sa'di was arrested. Fearing that he might confess under torture, the coup was mounted on 8 February 1963. The revolution of 14 Ramadhan, as it came to be known, was a bloody one resulting in many deaths. When the communists made the tragic mistake of taking up arms to fight it, the battle became even bloodier—not simply during the few days of securing Iraq but in the weeks that followed.

In the period between releasing Ali As-Sa'di from the prison and his arrival in Baghdad, Hazim Jawad, the second man in the Ba'ath Party took a unilateral decision that was never decided by the leadership to appoint Colonel Arif, Qasim's second man in 1958, after having elevated him to Field Marshall, to become the first President of the Iraqi Republic. When Ali As-Sa'di arrived in Baghdad it was too late to change what had been announced to the public in the name of the Revolutionary Command Council. The eldest Ba'athist officer, Ahmad Hasan Al-Bakr, became Prime Minister and Ali As-Sa'di became Minister of the Interior.

No sooner had the Ba'athists settled into power than the differences between members of the leadership began to surface. They were not about any disputes in ideology because there was very little of it beyond a few general principles of orientation. They were not disputes about dealing with their enemies as they were all equally determined to quash any opposition. The only real dispute was the aspiration to lead. It seems every member, including Ali's protégés, thought he was capable of leading and replacing Ali. But power brings temptation and intoxication. Thus the months that followed the Ba'ath ascension to power were months of conspiracy and intrigue. Everybody was conspiring against everybody but mainly against Ali. The lead figure in the conspiracy was Hazim Jawad. Among the first

public signs of serious trouble was the demotion of Ali from Minister of the Interior to Minister of Information. This bickering led to a meltdown on 13 November 1963, when the Conference of the Party was invaded by army officers, some Ba'athists and some not, who forced the Conference to appoint a new leadership, arrested Ali As-Sa'di and a few of his colleagues, and dispatched them abroad. The week between 13 and 18 November witnessed total chaos with the majority of the ordinary members of the Party demonstrating against the coup against the Party.

Aflaq arrived in Baghdad in order to solve the impasse between the factions within the Party and prevent other Arab nationalists from taking over. It seems that his intervention aggravated the matter and widened the dispute. By 18 November 1963, Field Marshall Arif used his authority as President of the Republic, to attack the Ba'ath Party; disband its National Guard; replace the Cabinet and reshape the Revolutionary Command Council by replacing the members of the Ba'ath Party with top military commanders. It was only a matter of time before those in the Party who conspired against its General Secretary, Ali As-Sa'di, found themselves either in exile or out of office. Thus ended the first episode of the Ba'ath rule in Iraq.

Disintegration and Restructuring of the Ba'ath

While the Ba'ath in Iraq was busy preparing and mounting the coup, then losing power, the Ba'ath in Syria was going through its own birth pangs. In 1961 and following the dissolution of the Party in 1958, a military action led to the dissolution of the Union and the end of the United Arab Republic. That was a real blow to the aspirations of the Arab masses and psychologically torpedoed any genuine later attempt for unity. But worse still was that some prominent Ba'athists, like Akram Al-Hourani, supported the dissolution of the Union. None of the conspirators has given any reason for acting towards dissolution of the Union beyond the excuse that some Egyptian officials misused their authority in Syria—which is hardly convincing, considering that what was at stake was the dream of generations of the Arab Nation—a dream that could not be jettisoned for the sake of breaches by some officials, however unjustifiable these breaches were. The truth is much deeper than that and has not, in my humble opinion, received proper study and analysis. The perpetrators of the Suez invasion of 1956, Israel, France and the UK, in addition to Saudi Arabia, were openly opposed to the United Arab Republic. History may tell us one day who did what in order to undermine the first attempt to unite the Arab Nation.

Following the ousting of the Ba'ath from power in Iraq, the Party divided into two factions that were loosely labeled as left and right despite the fact that there was little evidence beyond rhetoric to show what each stood for. In the absence of Ali As-Sa'di who was in forced exile in Spain,

younger Ba'athists, who were not arrested, formed a new nucleus called The Regional Organizational Committee (ROC), claiming that the rightist Talib Shibeeb and Hazim Jawad and other members of the Party leadership in cooperation with some officers, had diverted the Party from its true revolutionary path to appeasing the reactionary Arabs by a rightist agenda such as the recognition of Kuwait as an independent political entity when Qasim had refused to do so and had demanded its return to Iraq. In order to show how solid some of these beliefs were, it suffices to point out that among the Ba'athists who propagated revolutionary rhetoric in the ROC was a young student called Adil Abdul-Mahdi who claimed that Ahmad Hasan Al-Bakr was an imperialist stooge, having sided with the reactionaries in Iraq against the Ba'ath revolution. This same Adil Abdul-Mahdi is today Vice-President to Jalal Talabani, after having returned to Iraq with the imperialist invaders! I was with Adil Abdul-Mahdi in the ROC. My association with the Ba'ath Party as an organization ended with the disintegration of the ROC, though my belief in the principles espoused by Zaki Al-Arsouzi some seventy years ago has undergone little change.

On the other side of the divide, a new group claimed to represent legitimacy. This group was headed by Ahmad Hasan Al-Bakr, the ex-prime minister. Among his active young assistants was Saddam Hussein. Following the Ba'ath coup of 8 February 1963, Saddam Hussein returned to Iraq. Having been away from Iraq for four years he had no party constituency. He was appointed as a member of the Party Bureau in charge of organizing the peasants, called the Bureau of Peasants Organization. That position was not sufficient for the young ambitious Saddam Hussein who had been forced out of the arena. Thus once the Party suffered the split, he found an opportunity to assume his rightful place in it. It was obvious to him that building a new party meant strong alliances. Ahmad Hasan Al-Bakr seemed the proper ally. He was a senior Ba'ath officer who wielded great influence in the army, which was vital in any future power struggle. He had the political credentials as he was the first Ba'athist Prime Minister. Significant to this analysis was the fact that Al-Bakr, like Saddam Hussein, was from Tikrit which already had more than its share in the armed forces. An understanding developed that Al-Bakr was to keep the officers in check while Saddam Hussein used his organizational skills to rebuild the civilian wing of the Party. I shall refer to this group as the R. Ba'athist to distinguish them from the other faction I call the L. Ba'athist, as they were referred to in Iraq then, although I must emphasize these distinctions are only for identification and have little value in reality. The division and the reference to left and right followed the schism in Syria where there were more serious ideological divisions within the party than in Iraq.

The Ba'ath, 1964-1966

For reasons that have never been explained, the R. Ba'athists

assumed that they had the capability to mount a new coup and regain power from Arif. The plans for such a coup in 1964 were discovered by Arif and all top members of the Party were arrested, including Saddam Hussein. There followed a cooling off period when it seemed that the R. Ba'athists came to realize that the regime of Arif and his supporters from among the other Arab Nationalists, who were opposed to the Ba'ath, was more robust than they had assumed it to be. Then President Abdul-Salam Arif was killed in a mysterious helicopter crash—the Middle East has had a good number of helicopter crashes involving heads of states or top army officers in the last forty years. Abdul-Salam Arif was succeeded by his brother Abdul-Rahman Arif, who was an original member of the Free Officers Committee that staged the 1958 coup against the monarchy.

In Syria things had moved no less dramatically than in Iraq. Following the dissolution of the Union with Egypt in 1961, the Ba'ath re-emerged and reorganized itself under the leadership of Aflaq but with many young Ba'athists in the Syrian army challenging that leadership. In March 1963, in cooperation with other Arab nationalist officers, the Ba'ath in Syria mounted its first coup and gained power which it has retained ever since. There were several power centers within the Party, both in its civilian and military wings.

In 1966 the more revolutionary within the Syrian Ba'ath, represented by Noor Ed-Deen Al-Atasi from the civilian wing, and Salah Jideed from the military wing, took over the Party and the state, ousting Aflaq and his old guards. The split in the Syrian party had its direct effect on the Ba'ath in Iraq which, after some uncertainty, split along both lines in Syria, with the R. Ba'ath of Al-Bakr and Saddam siding with Aflaq and the other group siding with Salah Jideed. In 1966 the Ba'ath formally split into two factions with two Pan Arab Nationalist Leaderships and two regional leaderships in almost every country that has some Ba'athists in it. The situation changed slightly after the Ba'athists regained power in Iraq in 1968, when the Aflaq faction got the upper hand in the Arab national sphere, reducing the Syrian faction to a shadowy role.

The Iraqi Ba'ath, 1966-1968

The second Arif was a gentle army general who lacked the ruthlessness of his brother. His tenure was characterized by unprecedented freedom where people were able to freely express their views, views that were seriously taken into consideration by Arif once they filtered up. One such example was the total rejection by the public of any attempt to repeal Law No. 80 which was promulgated by Qasim as a first step towards the nationalization of oil. It was rumored at the time that the government of Arif was considering repealing the Law. The public outcry reached Arif and he shelved the proposal.

The movement towards liberal life and free speech within Iraq set off alarm bells in the US and among its allies in the Middle East. As a prime indicator in the region, Iraq is always to be watched vigilantly. It would be dangerous if allowed to develop because it would easily turn into a focal point of Arab awakening. It is dangerous if it is wounded because it could easily become the birthplace of discontent and a factory producing revolutionaries. One need only look at what has happened in the last four years to conclude what kind of revolutionary factory Iraq can be. Any Western so-called expert who does not appreciate the uniqueness of Iraq in the Arab World should really not get involved in advising on it.

Fearing that Iraq might fall into the hands of revolutionary Arab nationalists following the defeat of Nasser's nationalism in the 1967 war, the US embarked on an attempt to seize power from Arif through its friends in Iraq. Nasir Al-Hani, a very able academic, was the US chosen man to liaise with some army officers to mount a coup against Arif. Two men, a young officer by the name of Abdul-Razzaq An-Naif, who was deputy head of military intelligence, and General Ad-Daoud, the commander of the Republican Guards, were found ideal for the task.

Word of the impending coup got to Al-Bakr and Saddam Hussein. They decided that such an opportunity should not be missed. They approached the US-backed conspirators and made a pact with them to mount the coup and share power together. The Ba'athists were not short of army officers, in active service or outside, willing to take part against the not-so-ruthless regime of Abdul-Rahman Arif. On 17 July 1968 they stormed the Presidential Palace with the cooperation of commanders with the Republican Guards. US support came in two forms. Money was given to Nasir Al-Hani in Beirut and their Iraq agents in Iraq were directed to take part or support the coup. Arif did not resist. He handed over power and was dispatched to exile in Turkey. Ahmad Hasan Al-Bakr became the third President of the Republic of Iraq; Abdul-Razzaq An-Naif became the Prime Minister in accordance with the power-sharing agreement between the two factions. In the two weeks that followed the coup, and with a lightning speed, Al-Bakr, Saddam Hussein, and their trusted lieutenants moved Ba'athist army officers into positions of control.

On 30 July 1968, while Ad-Daoud was abroad, Saddam Hussein arrested the Prime Minster, Abdul-Razzaq An-Naif, put him on an airplane and dispatched him to Morocco. Al-Bakr appeared on television and delivered a speech accusing the ousted men of treachery and assuming exclusive power for the Ba'ath.

Contrary to what is frequently argued—that the Ba'athists came to power with the help of the CIA—it is my belief that the opposite is true. The Ba'athists *used* the CIA to come to power; they seized a golden opportunity to sweep into power along with the CIA men in Iraq and then take over from them. While it has been argued that after Saddam seized power, US

intelligence gave his minions the home addresses of communists in Baghdad and other cities in an effort to destroy the Soviet Union's influence in Iraq,[3] in actuality, when the Ba'athists took over in 1968, the Communist party was already a shadow of its former self. As for the communist persecution of 1963, Saddam Hussein was not even in Iraq at the time. He was still in Egypt. The Party of 1968 had little to do with that of 1963. In fact Saddam was shrewd enough to enlist the help of the communists by entering into a national front with them, which led later to a friendship treaty with the USSR.

The Ba'ath Party in Power, 1968-1979

The Ba'athists, who took full power in July 1968, were aware of the failure of the earlier attempt of February 1963 and were determined not to repeat it. They felt the hold on power ought to be absolute with little mercy to the enemy. The oppression was justified as necessary for building a nation. There is no dispute that the Ba'athists of 1968 were truly committed to building a strong nation with a strong economy and a strong army. Whether or not they succeeded in doing that is a matter for historians to judge.

They had to face three major issues. On the Arab scale, they had to come up with a response to the Arab defeat at the hands of Israel in June 1967, just over a year before their assumption of power. In Iraq they had to address two major problems—the future of oil exploration and the Kurdish problem. Both issues needed a solution if the rebuilding of the nation was to succeed. Revenue from oil was necessary to pay for the development plans but stability and security was fundamental before the government could consider embarking on any development.

The new power in Iraq rested with two men—President Al-Bakr, who was also the head of the Revolutionary Command Council (RCC) and the General Secretary of the Party, and his deputy in the RCC and the Party, Saddam Hussein. As Al-Bakr carried out his duties managing the government, Saddam Hussein was busy consolidating his power base

In Iraq they had to address two major problems—the future of oil exploration and the Kurdish problem.

through Party organization with the membership exploding from a few hundred on the eve of the coup to tens of thousands, and through building Iraq's first proper intelligence service. At the same time Saddam Hussein took full control of the two main files—the oil and the Kurds.

The Law of Autonomy for the Kurds

The Kurdish problem had taken a turn for the worse during Arif's rule with intensified fighting, some of which coincided, not by chance, with the

Arab-Israeli war of 1967. The Ba'athists, contrary to what the media in the US/UK has made us believe, genuinely wanted an amicable solution to the Kurdish problem. After months of negotiation between both sides, the Law of Autonomy for the Region of Iraq's Kurdistan No. 33 was promulgated on 11 March 1974. The law was revolutionary by any standard. It granted the Kurds of Iraq, the second biggest ethnic group, rights that were light years ahead of what the Kurds had received in neighboring countries such as Iran and Turkey where the majority of Kurds lived. A quick view of what the Law offered would suffice for this introduction.

The preamble acknowledged that injustices had been committed against the national aspirations of the Kurdish people and set out to rectify them by granting the Kurds autonomy within those areas of Iraq in which a majority of Kurds lived, which would be decided on the census of 1957. In recognizing their separate national and culture identity, the Law granted equal status for Kurdish and Arabic as official languages in the region and for education, with a choice for the people of the language of education. The Law created separate legislative and executive councils for the autonomous region. The legislative council, whose election was established through a separate law, was granted limited authority to legislate on cultural, developmental and local issues within the general policy of the state. The executive council consisted of administrators chosen by the head of the council who was appointed by the President of the Republic from among the elected members of the legislative council. The executive council was granted authority to administer all functions of the state within the autonomous territory except for defense and security.

For reasons that are not simple to cover in a book let alone in a short introduction, the peace did not last long. Fighting broke out again. The Ba'athists were in difficulty and the only way out was to enter into a deal with the Shah of Iran in which he was to give up his support for the Kurdish rebellion in Iraq in return for Iraq's agreeing to redraw the borders along the Shatt Al-Arab waterway in favor of Iran. Such an agreement was brokered by the Algerian President and signed there in 1975 by the Shah and Saddam Hussein. In the few weeks that followed, the Kurdish rebellion evaporated and its leader Mustafa Al-Barazani went into exile to die a broken, forgotten man. The end of the Kurdish rebellion meant the splintering of the Kurdish political movements and it took many years for them to regroup and reorganize themselves under US protection.

The Nationalization of Oil

Oil was another major task for Saddam Hussein and his advisers. The lesson of Muhammad Mussaddaq in Iran of 1952 it seems was learnt. And in any case the world had undergone changes since then due to the

checks each side in the Cold War was keeping on the other. The Ba'athists can always claim to their credit that instead of repealing Law No. 80 of General Qasim, as was contemplated during Arif's rule and, according to the Ba'athists, by some Ministers during the two weeks between 14 and 17 July 1968, they in fact nationalized the exploration and production of oil in Iraq, signaling the first full ownership by Iraq of its oil resources since its discovery.

While neighboring oil producing states kept their share of the revenue in banks in New York and London, Iraq's Ba'athists spent all the revenue on Iraq's development.

The nationalization of oil on 1 June 1972 together with the sharp rise in the price of oil led to massive revenue to Iraq on a scale it had never known before. This revenue was precisely what the ambitious development plans needed in order to be implemented. Ba'ath socialism was based on a state controlled economy. Thus while neighboring oil producing states were pumping oil and keeping their share of the revenue in banks in New York and London, which amounted to subsidizing oil in the West, Iraq's Ba'athists spent all the revenue on development.

Successful Domestic Development

There were two five-year development plans which despite their shortcomings transformed Iraq into a semi-industrialized state as described later by Ahtisaari, Assistant Secretary General of the UN, when he visited Iraq in May 1991. The development plans in short achieved the following:

1. Electricity generation by 1980 was higher than demand. One needs to compare that with the state of electricity generation in 2007 resulting from US/UK bombing of the generating stations, the total blockade of 1990-2003 which prevented building new stations, and the failure in four years of occupation to rectify the above. Rural electrification on a massive scale by the Ba'ath Government enabled delivery to the remotest parts of the country.

2. Hospitals and clinics were built and equipped that enabled absolutely free medical health to reach the remotest villages in Iraq. By the early 1980s Iraq was the best country in the Middle East for medical care to the extent that many Arabs from as far away as Yemen preferred to come to Iraq rather than fly to London for treatment.

3. Clean water reached the remotest of villages, if not through a full system then through compact units capable of producing enough

for the need of the locality.

4. Illiteracy was eradicated through legislation and compulsory classes for the elderly who had missed out on education. Iraq was the only state in the developing world that had achieved this in such a phenomenally short period.

5. Education was compulsory and free. Iraqis enjoyed good and free education from primary school to doctorate level. The Ba'ath regime's obsession with education meant that thousands of Iraqis were sent abroad to do quality research in all disciplines. It is not true that only Ba'athists enjoyed this. I, like many other non-Ba'athists including many Kurds I know personally, were beneficiaries of this opportunity. I believe that Iraq under the Ba'ath rule was the only state that provided free books to all its students for all levels of education, including university. Any student who has studied engineering or medicine in England, for example, would appreciate such benevolence.

6. Several factories producing building materials like cement and bricks were built that not only supplied the building boom in Iraq but enabled Iraq to export cement to its neighbors.

7. A new modern network of highways was built that allowed easy connection inside Iraq and with its neighbors. It must be emphasized, however, that the regime failed in any serious attempt at building a rail network.

8. A real estate bank enabled all people with limited income, which meant almost all of Iraq, to borrow money for a low rate of interest and pay it back over decades. Considering that almost all Iraqis managed to get a plot of land almost for free either from their professional organization, from their Ministry or from a cooperative, it is easy to see how hundreds of thousands of Iraqis managed to have their own roofs over their heads. The reader should be reminded here that when Bremer ruled Iraq after the occupation he dissolved the real estate bank!

By the 1980s it was easy for anybody visiting Iraq to conclude that Iraq's oil wealth was benefiting the people and that they were basking in the plenty provided under the Ba'ath rule.

It would be foolish to claim that this was done without a price. The price was limited civil liberties and freedom in general. The people in Iraq came to understand the rules of the game. You were safe if you did not

cross the red line and the red line was simple—do not get involved in any action or conspiracy against the Party or the State. There may have been exceptions to this rule but generally the rule held and people managed to get on with their lives and enjoy standards of living unknown before in Iraq without having to join the Ba'ath Party. However,

It would be foolish to claim that this was done without cost to civil liberties and to freedom in general. When it came, the retribution was severe.

if the red line were crossed, then there is no doubt that the retribution was severe.

Saddam Hussein Takes Charge: The Ba'ath 1979-1990

By the middle of 1979 Saddam Hussein believed that he had built his power base; that the Iraqi economy was sound; that the army was strong and that it was time for him to assume direct control rather than remain the second man. His success to date had led to the grand ambition that his time had come to lead the Arab Nation. Saddam Hussein saw himself as the natural inheritor of the great names of Mesopotamia and believed that he was destined to lead the Arab Nation as the natural successor Semitic group. Baghdad, which was built by Al-Mansour, inherited the glory of Babylon and Saddam Hussein felt destined to regain for it the lost glory it once had. There was a great deal of evidence to support this conviction at the time—not only in his mind but also in the minds of those who were around him.

In July 1979 he forced Ahmad Hasan Al-Bakr to step down and called on the Party to follow their natural leader, Saddam Hussein. But then, on assuming direct authority Saddam Hussein committed miscalculations that turned out to be too costly not only for himself but for Iraq and the whole of the Middle East—one of which is easier to understand than the others.

His comrades in the leadership tried to take steps to put some limits on his absolute authority, which they seemed to have envisaged by appointing a deputy to Saddam in the same way he had held authority when he was a deputy to Al-Bakr. Saddam, who had a very sharp conspiratorial sense and an aversion to power sharing, was not going to have any of this. On 22 July 1979 he summoned the National Congress of the Party during which he accused some of his comrades of conspiring against him and against the Party. He expelled over sixty members of the conference and effectively silenced any dissent within the Party.

What followed was to have an adverse effect on the Party from which, I believe, that Party never recovered. On 29 July Saddam Hussein set up a special tribunal consisting of members of the Party Leadership and the RCC to try the conspirators. On 7 August 1979 Baghdad Radio read a statement from the tribunal announcing that it had sat between 1-7 August

to try 68 conspirators and passed the following judgment: 22 were sentenced to death including five members of the Party National Leadership, 33 were sentenced to different terms of imprisonment and 3 were acquitted. On 8 August 1979 the executions were carried out by members of the Party cadre. I believe no one will ever know the truth about the alleged conspiracy against Saddam Hussein, because the main players have since died and little evidence has been kept in any case.

But wherever the truth lies, it created an unimaginable precedent. This was a Ba'ath Party executing members of its leadership in a dispute over leadership and not for treason or foreign conspiracy. No one even suggested that these people were agents of an enemy. The determination of Saddam Hussein to rid himself of any potential threat to his total control is clearly illustrated in executing Abdul-Khaliq As-Samarrai', who was a member of both the Iraqi Regional Leadership and the Pan Arab National Leadership. When he was sentenced to death, several of the National Leadership members interceded with Saddam Hussein arguing that his execution would create a dangerous precedent that could threaten any of them. However, Saddam's decision to eliminate his opponents was not even open to discussion.

The Party's massacre of 1979 was a watershed in the history of the Ba'ath in Iraq which ushered in a new era. From 1979 onwards no one dared to question anything. This meant that the leadership of Saddam Hussein acquired infallibility through fear and silence. The Party as an active element in governing Iraq was finished and the age of the regime began. People like Ali Hasan Al-Majeed, Saddam Hussein's cousin, who had had no history in the Party, assumed stronger authority and power within the regime and the Party was transformed into a rubber stamp for the regime. For all practical purposes the Party became irrelevant or as one ex-Minister friend put it one day after 2003, the Iraqi Ba'athist Party died in July 1979.

The Iraq-Iran War 1980-1988

When Saddam Hussein assumed full power, Khomeini had already taken over Iran. It may even be argued that Saddam Hussein decided to take full control because of the success of Khomeini in Iran. The Islamic movement of Khomeini, like other religious movements, believed in adhering to the true spirit of Islam and aspired to set up an Islamic state under its leadership. Such a state would have no boundaries and cross nation-states that already existed. It is not difficult to see how such an ideology would be in head-on collision with Ba'athism. The Ba'ath, as a secular national ideology, was anathema to fundamentalism, and Islamic fundamentalism was the greatest enemy to Ba'athism because it disarmed it of its strongest weapon, namely aspiring to the rebirth of the lost Arab state. The real threat from an

Islamic movement to Ba'athism arises from the fact the Arab Nation has never existed as such except within the widest context of the Muslim *Umma*. If there were a genuine attempt at uniting the Muslim *Umma* then the Ba'ath would lose its legitimacy and appeal. The Ba'ath had been arguing that Arab nationalism was the modern embodiment of Islam and pointing to the failure of Caliphate to deliver. But if a modern Muslim State could show that Islam could deliver salvation from European supremacy, then the Ba'ath would lose the argument among the inherently Arab Muslim communities.

Saddam Hussein realized this fact and appreciated that a conflict between Ba'athist Iraq and Islamic Iran was inevitable. The matter was more urgent and serious because of the fact that Arab Iraq had a majority of Shi'a and the success of Shi'a Islam in Iran was undoubtedly finding an echo among the masses of Shi'a in Iraq. The irony of it is that anti-imperialist Saddam Hussein was able to coexist with the imperialist client, the Shah of Iran, but not with the anti-imperialist Islamic leader, Ayatollah Khomeini.

By the end of 1979 Iran was at its weakest in its modern history. The army had almost disintegrated; the Islamic institutions were only beginning to materialize and the West was, if not in attack mood, then at least apprehensive. In short, apart from its rhetoric, Iran was incapable of exporting anything, let alone a revolution. Khomeini faced many pockets of serious resistance to his ideology even among the religious hierarchy who were not in unison over his theory of '*Wilayet AlFaqih*', the Authority of the Religious Jurist. The majority in the religious hierarchy in Qum differed with Khomeini and believed in the separation between religion and state. Thus in reality, the argument that Iraq had to attack Iran in 1980 because it posed a real threat to it then is completely baseless.

Some have argued that Saddam Hussein wanted to restore the status quo that existed before the Algiers Agreement of 1975 which he signed under duress to put an end to the Kurdish rebellion at a time when the Ba'ath was weak and threatened in its survival. There may be some truth in that but it would not have been enough to justify the bloody war that ensued and the unknown consequences that follow any war.

Some have argued that Iraq had to invade Iran because of the frequent attacks by the Iranians across Iraqi borders. This argument is fallacious and even if it were true, is very weak. It is fallacious because Iran did not have an army that was capable of posing any threat in a military sense to any point on the Iraq-Iran border. But even if there were such attacks and incursions, then these should not have called for a massive invasion. If a war ensued every time there were exchanges of fire across borders between neighboring states, this world would be in continuous universal war. There are many other ways for neighbors to settle disputes short of war and none of them had been exhausted before the launch of the massive push by Iraq in 1980.

There have been many Ba'athists and other Arab Nationalists

expressing the view that Iran has territorial ambitions in Iraq and the Gulf, citing the occupation of the three small islands off the coast of the United Arab Emirates as an example. It would be very naïve to deny that Iran, like almost every other state in the Middle East, has designs to change its borders but it would be foolish to portray the occupation by Iran of the three islands in the Gulf as a proof of imperialist ambitions by Iran before analyzing the security implications for Iran, should these islands, which are just off the Iranian shore, be occupied by the US, which would inevitably happen the moment the Iranians pulled out from them.

The main strategic change that was created by the Iranian Revolution has been in the relation with Israel. While the Shah of Iran was one of the closest allies of the Zionist state with Zionist sympathizers holding power and sway in Tehran, the first action of Khomeini was to sever such relations with Israel and hand over their Embassy in Tehran to Yassir Arafat. As the threat of Israel in the Middle East has been and remains the biggest threat to Arab existence, then any change adverse to Israel's interest should have been welcome by the Arabs and consolidated.

It is more disturbing for me that those who propagate such arguments about Iranian ambitions in the Middle East are quick to dismiss any talk about Turkish ambitions in the area, despite the facts indicating that Turkey has been and remains today the real threat to Arab national security. Turkey was the first Muslim state that recognized the state of Israel. If an apologist responds by saying that was done in the days after Ataturk, then what explanation would he have for the fact that the security pact with Israel was signed by the so-called Muslim Government in Turkey?

Turkey has made no secret about its intention to intervene on behalf of the Turkish minority in Kirkuk. A similar declaration by Iran on behalf of Persians in Iraq would have been identified as an indication of expansionist plans of Iran. Turkey annexed the Arab province of Iskenderun, which used to be referred to during the last century as 'the snatched province', and changed its character completely, not very different to what happened in Palestine. Yet Arabs, including the Syrians, hardly mention Iskenderun today.

Turkey's membership in NATO, which is the US tool of hegemony and confrontation, poses a great danger to Arab national security. The argument that Turkey's membership in NATO serves to integrate Turkey into the 'civilized' West does not hold because Turkey has been repeatedly denied membership in the European Union. That Turkey is permitted to hold membership in NATO, on the other hand, has simply indicated NATO's intent to use Turkey as a base of aggression against the Arabs. With the end of the Cold War and the disintegration of the Warsaw Pact, the only purpose that NATO serves today is to foster the US war against the new 'demon' for imperialism, namely Islam.

I do not subscribe to the naive description of Saddam Hussein as

being a sectarian leader. Saddam Hussein was one of few leaders in the Arab World who was aware of the possibility of this label and ensured his actions could not be depicted as having been motivated by sectarian allegiances. The fact that he was born into a Sunni family is not sufficient proof. The fact that his closest aides were Sunnis from his tribe in Tikrit should not be construed as supporting the argument of such an affiliation. He relied on, and trusted, people in very high official positions which no sectarian Sunni would contemplate. The list is too long even to begin. He was the first Muslim leader to retain a Christian, Tariq Aziz, as deputy Prime Minister for two decades. He relied on Sabah Mirza, a Shi'a Kurd, as his first companion and bodyguard. He relied on Sa'doon Hammadi, an Arab Shi'a as a Prime Minister and Speaker of Parliament. While it might well be argued that these are tokens, in the absence of real figures and statistics we can only tell by what appears to us. The majority of personnel in the Iraqi army which fought Iran were Shi'a. The percentages among junior officers is not known. It is my belief that the majority of high-ranking army officers were Sunni but that is for the reasons explained above. I also believe that the Ba'ath party membership in Baghdad was predominantly Shi'a.

To pretend that there is no sectarian divide in Iraq would be foolish, but to accuse Saddam Hussein as having promoted it is either calculated misinformation or **The cause of Saddam Hussein's war with Iran was not sectarian rift but ideological orientation.** pure ignorance. To Saddam Hussein, loyalty was a prime concern and it did not matter where it came from. I had to address this issue in order to refute the argument raised every now and then that the cause of Saddam Hussein's war with Iran was sectarian rift rather than ideological orientation.

Saddam Hussein realized the appeal of Khomeini to the masses of Shi'a in Iraq, but more importantly on the Arab side of the Gulf, Khomeini's appeal was also massive and if it went unchecked might turn the whole area into an Iranian-dominated region without Iran having to launch any military action. In short Iran would have been able to export its Islamic Revolution simply through its rhetoric and the success of its example. Saddam Hussein, who had fostered huge ambitions for the revival of the great days of the Arabs under his leadership, was not going to sit idle and let this happen after having worked tirelessly for a decade to build the New Iraq of the Ba'ath.

In Arabia and the satellite states, especially Kuwait, the rise of Islamic Iran was alarming. None of these sheikhdoms had any problem with the Shah of Iran because they all knew that in any dispute with him they could call on the US to put an end to it. Such a luxury was not available with Khomeini's Iran. Almost all of the oil-rich coastline of the Arabian Peninsula was inhabited by people of Asian and Persian origin. The Arabs on the coast were comprised of two groups, the Sunni Bedouin who were in the minority

and were put in power and supported by the imperialists, and the ordinary people, mostly Shi'a, originally from Iraq, Iran and Bahrain. It was clear to the ruling sheikhs and their servants that a swell of change was coming if the Iranian influence was not stopped. The neo-conservatives were not in control in Washington to be called upon to bomb Iran. The Cold War was still active. The sheikhs had no alternative but to rely for their defense on their lesser enemy—the Ba'ath of Iraq.

Saddam Hussein, as the leader of the Ba'ath Party which had advocated for decades that Arab reactionaries in Arabia were the greatest obstacle to the freedom and progress of the Arab Nation, had to swallow his pride and circle the Kaa'ba hand in hand with Fahd of Arabia, giving birth to the new alliance between the Iraqi Ba'ath and the Saudi family against Islamic Iran. It is debatable whether the Bedouin of Arabia and the Gulf conspired to push Iraq into action against Iran or simply grasped the opportunity and encouraged Iraq to proceed with the plan. One might even be tempted to stretch the argument and claim that the Bedouin had intended to weaken both Iran and Iraq to their advantage. Saddam Hussein was also assured of the good offices of Prince Bandar, the Saudi Ambassador in Washington. Wherever the truth lies, the fact remains that Saddam Hussein was assured of all the financial/ political support he needed.

It is with these facts in focus that we can understand how two powerful states which were both opposed to imperialism found themselves at war in September 1980, saving imperialist Zionism the need to fire a bullet or lose a soldier to rein either of them.

This was the second miscalculation of Saddam Hussein after the execution of his Party comrades that critically wounded his rule. He believed that with the US animosity towards Iran and with strong Arab support, the economically healthy, vibrant Iraq, after some few months of action, would bring Iran, already in disarray, to her knees, toppling the fundamentalist regime. Iraq would fulfill its destined role in the Gulf. While the US had a strong interest in pushing Iraq to hold back the revolutionary Islamist tides, Saddam Hussein had his own agenda, and should not be viewed as having simply been in the U.S. pocket. He believed he was the grand leader which Nasir could not be.

Indeed, attacking Iran was a calamitous miscalculation. The continuation of the war for eight years was a gift to imperialism, for two powerful nations in the Middle East who were opposed to imperialism would be fighting each other and in doing so, serving the interests of imperialism, no matter who won. And it would serve those interests further if neither won. The attack on Iran strengthened Khomeini rather than weakened him. Even remnants of the Shah's regime congregated around the Imam to defend the fatherland. It is not uncommon in history that the common objective of defending the nation unites the enemies of yesteryear. Defending Iran became

a sacred mission. The Islamists believed the Ba'athists were heathen serving the enemies of Allah, while the Shah's imperialist followers thought it was humiliating to be defeated by the inferior Arabs whom they had despised and blamed for the collapse of the Persian Empire some thirteen centuries ago at the hands of the Muslim army. Hundreds of army officers who deserted following the collapse of the Shah's regime rejoined the army and a new army was built and trained deep in Iran away from the border where tens of thousands of fanatical volunteers were pinning down the Iraqi army, with wave after wave serving as artillery fodder.

In addition to consolidating Khomeini's rule and silencing his enemies inside Iran, the war encouraged the Wahhabis in the Arab World. Being the staunch enemies of Shi'a Islam, the Wahhabis, who represent the belief of most of the Bedouin of Arabia and the Gulf, intensified their campaign in Arabia and extended it to Iraq claiming that the real threat to the Arabs is the potential of a 'Shi'a Crescent' extending between Oman and Latikkia. By the end of the 1980s the Wahhabis formed the nucleus of Al-Salafis fighting in Afghanistan before part of the Al-Salafi movement ended up breaking ranks with the Saudis and setting up the anti-imperialist movement known today as Al-Qaeda.

The Iran-Iraq war was fuelled by the US and Israel who found that the longer it went on the better it was for the imperialist agenda in the Middle East of manipulating, dominating and exploiting. There are stories of fact and fiction about who supplied what to whom. The truth and details of these supplies are irrelevant so long as we accept that it was in the interest of the imperialists to see their enemies fighting and destroying each other and if they could help in prolonging it then they were happy to oblige. The shipment of weapons from Israel to Iran was matched by US intelligence on Iranian movements passed on to Iraq, French aircraft flying on behalf of Iraq and supplies of weapons from Europe with the approval of the US. The US also ensured shipping passage in the Gulf by flagging Kuwaiti tankers under US flags.

But the most important assistance to Iraq was in the form of setting up the military industry in 1980s which meant that machinery and technology was allowed to flow into Iraq so long as Iraq was engaged in fighting Iran.

The Kuwait Disaster, 1990-

When Khomeini finally acknowledged in August 1988 the futility of the bloody war, people on both sides believed that some tranquility and sanity was about to prevail. However, as soon as the war with Iran ended, a campaign against Saddam Hussein began in the mainly Anglo-Saxon world. Suddenly the Ba'ath regime became the 'Republic of Fear' according to a 1998 book written by an Iraqi architect who had spent most of his life outside

Iraq, yet whose book contained information about the Party and its functioning which was available only to top Party members and foreign intelligence services. Ayad Allawi told me when we discussed the book that it was done by the CIA. When a convicted criminal by the name of Bazoft went to spy on Iraq's military industry, and was apprehended, accused of spying for Israel, convicted and executed, the international press gave voice to widespread western outrage, portraying him as a decent innocent reporter working free lance for *The Observer*, despite his being a college dropout with no education who had only been in the UK for two years, one of which he spent in jail.

It seems that Saddam Hussein reneged on an earlier undertaking or more likely an understanding that he was to be assisted in fighting the Iranians and building a military industry provided he would agree to peace with Israel as agreed between Egypt and Jordan, with the tacit blessing of the Saudis. The Zionist agents in the Gulf were instructed to squeeze Iraq as much as they could. Kuwait was the closest possible means for so doing, and the most likely to cause damage. It embarked on siphoning from Iraqi oil fields, pumping more oil and thus reducing the price, flooding the market with Iraqi dinars, and demanding payments of money paid to Iraq during the war with Iran.

In vain Saddam Hussein reminded the Kuwaitis of those many Iraqis whose blood had been shed to save them from the flood of the Khomeini revolution, but he ought to have known the strength of the alliance between the ruling Sabah family and Washington. No appeal to other Arab leaders resulted in any solution. Iraq was in desperate need for money to rebuild its shattered country but it was put under increasing pressure rather than helped. Then the US Ambassador in Baghdad told Saddam Hussein, before departing on her annual holiday, that the dispute with Kuwait was an Arab affair and that the US would not intervene in regional disputes.

No one will ever know how the decision to enter Kuwait was taken and who played what role in it because the main player has gone to his grave with this, among other secrets. It may be one of those secrets of history on which there is more conjecture than facts. There are many stories about the insults to Saddam Hussein's person and family that were communicated to him by his deputy, Izzet Ibrahim, which might have aggravated the situation, but the decision to move Iraqi troops across the recognized borders in Kuwait is still difficult to understand.

On 2 August 1990 as members of special forces landed by helicopters in the capital of Kuwait, Iraqi tanks were rolling across the border. The objective was to detain members of the ruling family. However, not a single member was found. Somehow despite the allegedly secret nature of the mission they all seemed to have fled into Arabia or to the USA. The outcry that followed and the flood of Security Council Resolutions under Chapter VII of the UN Charter were a clear indication of what was in store for Iraq. One might compare that to how the Security Council did not react

when Israel invaded and occupied Lebanon in 1982.

In my mind the single biggest tactical mistake of Saddam Hussein's political life was to have made this move in 1990. I am not saying that because I believe in the inviolability of Iraq's borders as created in 1922 by the British High Commissioner in Baghdad, Percy Cox,[4] or any other imperialist colonialist. I believe that all such borders are to be condemned as they were made in order to divide nations. The way the borders of Iraq were drawn by the British is beyond the scope of this book but in my research I came across irrefutable evidence that the British colonialists decided way back in the 19th century that Iraq should be denied its access to deep sea frontage. And so it came to be that Kuwait, the Arabic diminutive word for the Iraqi city of Kut, for so long a part of the *Wilayet* of Basrah, one of the three Ottoman provinces of Mesopotamia, was carved out from a mainly inland Iraq.

My dispute with Saddam Hussein regarding his foreign policies is twofold. Firstly he should not have spilled one drop of blood to save any of the rulers of Arabia and the Gulf. Secondly he ought not to have entered Kuwait at that instant in history. You cannot claim one day to protect it and invade it on the next. Even if he had made a blunder when deciding to send his army, he ought to have gauged the dangers facing him and withdrawn claiming that he had taught the rulers of Kuwait a lesson.

I would be very surprised if anyone would be able to explain at any stage in the future how Saddam Hussein believed that he was going to fight the biggest military power in the world on his own. Saddam Hussein was alone not simply militarily but politically when his Arab allies of yesterday became his enemies and took part in the massive military buildup against Iraq. The US did not need any of these armies in the military sense but needed political legitimacy, which it secured when the Arab League supported military action against Iraq. It also secured it by one of the lesser bruited false pretexts leading to war: the reported Iraqi troop build-up along the Kuwait and Saudi Arabia border. The Bush Sr. administration accused Saddam Hussein of being poised to take over Saudi Arabia. But as the *Christian Science Monitor* later reported, this primary justification for the war was a lie—one of the least known pretexts for wars that has later revealed to be untrue. When satellite image and desert military experts reviewed the "smoking gun" images, they saw a buildup of US military fighter jets, not an Iraqi troop buildup.[5]

It is impossible to believe that any advice that Iraq was capable of withstanding a US onslaught was given, and if given, believed. But as the US had supported Iraq in its war with Iran, Saddam Hussein had reason to doubt that a devastating blitz on his country would follow. He had another misconceived belief—in the ability of Arab masses to prevent such an attack.

There is one fundamental basic fact about war. Governments ensure

their supplies before embarking on it. Thus when the US embarks on attacking any state, it is guaranteed that its factories will be producing its needed hardware for as long as necessary, and that if such capacity were to be exhausted, then the civilian industry would be put to the service of war. Yet when Iraq was accepting the challenge to fight the US, it had no way of guaranteeing any supply of military hardware. Its Russian armaments were not going to be replenished, its arsenal of missiles was limited and its factories were going to be targeted in the first wave of bombing. But more importantly, not one supplier in the world of 1990 was willing to ship any equipment to it.

If Iraq's ability to stand up to the US was indeed hopeless, and Saddam Hussein had no designs on Saudi Arabia, the mystery is why he waited so long to withdraw his army from Kuwait, as the US painstakingly built up its Coalition and transported its forces to the region? At the time, the media, either at the behest of or deluded by the American war machine,[6] talked up the Iraqi army's capability, billing it as the world's fourth largest. The press presented the pending confrontation as if Saddam stood a good chance. The Palestinians were sufficiently hopeful for Arafat to stand with him. But how could anybody with basic common sense believe that Iraq, which could not produce a single weapon, would be able to resist the might and technology of the biggest super power—or that Saddam Hussein actually intended to?

The outcome is too well known. Iraq was not attacked in order to force it out of Kuwait but to stop it functioning and render it helpless. When Ahtisaari, the UN Assistant Secretary General, visited Iraq in May 1991, he said that the semi-industrialized Iraq had been bombed into the stone-age.

The Genocidal Blockade of Iraq 1991-2003

The destruction of Iraq was evil by any standard, even that of the Middle Ages. As Iraqi troops were forced out of Kuwait, some were buried alive in the desert. What happened over the next ten years was even more evil. In international law as in domestic law, once a perpetrator is found guilty, then a penalty is imposed. Once the sentence has been served, the debt is seen to have been repaid; then rehabilitation is to be effected.

However, the US/UK/Israeli imperialist alliance was not to be satisfied with an overwhelming and unrelenting victory. They set about the punishment of Iraq and its people indefinitely, without limit, without mercy. Although the blockade that was imposed on Iraq was meant to end with the withdrawal of Iraq from Kuwait, after that had been accomplished, the imperialists then shifted the demand from withdrawal to disarming Iraq and then on to the illegitimacy of the regime due to its 'human rights violations'.

The total blockade on Iraq was more sinister than the military assault. While wartime destruction has an immediate effect which may be rectified

later, the blockade had a hideous continuous adverse effect which is not publicly noticeable but more deadly than missiles. For twelve years, the US/UK maintained genocidal *total* sanctions on the people of Iraq, denying them the basic needs of life. It is impossible to argue that such measures were intended for any other purpose—including getting them to rise up against Saddam Hussein—than to harm the people of Iraq. The sanctions were so extensive that even a book of literature or a medical journal could not be sent to Iraq by post. How else would a denial of export of a book of literature assist in disarming Iraq? And there were many such items on the list of prohibitions.

All that was built in Iraq over eighty years of its modern history was dismantled brick by brick during the twelve years of blockade. No trade meant no income which meant no maintenance, let alone any new projects. The infrastructure was decimated, and health and education were reduced to shadowy services. Unemployment became rampant and poverty became the norm after the prosperity of the 1970s. It is a fallacy to accuse the Ba'ath of having brought this calamity upon the people of Iraq. It was the genocidal sanctions imposed and maintained by the US/UK which reduced the life of the Iraqis into that misery. The Ba'athists built a state but the imperialists dismantled it on the grounds that they were trying to disarm Iraq of weapons which it never had or had destroyed, the very same weapons which both the US and UK have, and have used.

> **All that was built in Iraq over eighty years of its modern history was dismantled brick by brick during the twelve years of blockade.**

The cruelest crime was not committed by the politicians in the US/UK but by the technical and professional men and women who were sent to investigate Iraq and report on its armaments. These people coldly put themselves at a distance from the truth—even as they claimed they were looking for truth and giving truthful discovery. The scientists and engineers who went to Iraq could not help but have observed that their activities were facilitating and extending genocide and yet they kept quiet about it.

Iraq was not destroyed in March 2003, but during the 12 years of blockade which any student of law would easily identify as falling within the ambit of genocide, war crimes and crimes against humanity as defined in the statute of the ICC and incorporated in the UK in the International Criminal Court Act 2001. It was clearly an instance of unwarranted and collective punishment—recognized under international law to be illegal, yet instituted by the Security Council—the like of which the world has not witnessed.

The Failure of Arab Nationalism

One problem I have had with the leaders of Arab revolutionaries over

the last forty years has been their inability to understand the scale of the battle with imperialism and that a revolution should not fight the battle set for it by imperialism on the latter's terms. The Ba'ath Party believed that it could build a revolutionary state in one small country in the Arab East, arm it with imported weapons and then wage battle against imperialism. It would be naïve to assume that the imperialists would allow such a state to develop. This is why I believe that it was wrong for the Ba'ath Party to assume power in Iraq in the 1960s just as much as I think it was wrong for Hamas to assume power in Palestine today and it would be wrong for Hizbullah to assume power in Lebanon in the near future.

There are two problems associated with revolutionary movements assuming power in any state. Firstly, there is always the danger that some true revolutionaries would be so consumed by their new administrative roles that they would lose their revolutionary zeal. Secondly, a revolutionary movement once in power would have to provide for the nation, protect it and make political deals on its behalf. However, a revolutionary movement not in power need not worry about any of these liabilities. Although the situation varies relative to time and place, I believe that a revolutionary movement should keep the masses in a revolutionary state and only assume power when it feels it has enough backing to withstand any possible attack. Thus Iraq in 1968 was not like Cuba in 1959. In 1968 the Iraqis were not in a revolutionary state and the world balance of power was anything but similar. The Ba'ath Party was small and weak on the eve of the 1968 coup. It was common knowledge among party members that when Saddam Hussein was told that the Party was weak, he used to retort that once he was in power he would form and deliver the strong Party necessary. It is true that he did form a large Party after assuming power, but its ideological underpinnings were questionable.

The Arab East could not succeed in winning its independence from imperialism until the masses of the Arabian Peninsula reached the stage of revolution. However, a quick look at the artificial statelets created by imperialism over the last century should be sufficient to show how far away such a revolution is. The artificial borders drawn by the imperialists following WWI dividing the Arab East were completely alien to the way of life Arabs had enjoyed for millennia. The borders which divided tribes and created friction over ownership of resources which the Arabs never knew were enough to ensure that these divided statelets would depend on imperialist protection for their survival for a long time to come. If the nation-state was meant to be brought to the area then all the Arab East ought to have become one state, as the people form one nation according to the definition adopted and practiced in Europe in the nation-state era.

The Arabian Peninsula has a unique significance for all Muslims in general and the Arabs in particular. Most Arabs, truly or artificially, would be

able to trace their ancestry to Arabia. But the more important element is the spiritual and religious birthplace of Islam. Muslims, generally, believe the dictum in the Holy Qur'an that the first place of worship on Earth was created in Mecca. It is for this reason that Arabia had not been invaded or occupied for centuries until the imperialists came. It is not difficult to see how the control of Arabia means control of the hearts and minds of Arabs and Muslims alike. This fact was realized by the British and French imperialists some two centuries ago. When imperialism discovered that it could not occupy Arabia directly, it arranged for the Wahhab-Saud alliance to rule Arabia under its protection. This reality is as valid today as it was two hundred years ago. Whoever controls Arabia controls the Arab East. No revolution will succeed in the Arab East until there is revolution in the birthplace of Arabism and Islam—Arabia.

Saddam Hussein, whose nationalist convictions I never doubted, displayed his limitation in strategic thinking in at least three manifestations. Firstly, he thought the revolution in Iraq could succeed while Arabia was in the pocket of imperialism. Secondly, he thought that protecting Arabia against the Iranian Revolution was serving Arab Nationalism when in fact it was consolidating the hold of imperialism over it. This was clearly demonstrated when, five days after he entered Kuwait, Fahd of Arabia informed the Americans, to their great surprise, that he was puzzled as to why it took them so long to send their troops to Arabia. Thirdly, and more importantly in my view, Saddam Hussein thought he could build a strong state, with a strong economy, a strong industrial base, and strong social fabric, while attempting to arm Iraq and advocate its revolutionary mission to unite the Arab World and fight Zionism. I have no idea why he thought Zionism was going to sit idly by while he was advancing towards its destruction.

What options did the Ba'ath have in the 1960s? In my humble opinion they had three. The first, which I prefer, would have been not to assume power in Iraq but to remain the Party of the masses, ensuring that any government in Baghdad did not exceed the acceptable compromises with imperialism until the right revolutionary state was reached to take over. The second less favorable and probably more difficult option would have been to have an Iraq modeled on a closed totalitarian state such as North Korea, until such time that it became capable of asserting its power. The third option was to take a soft approach—acquiescing at times and rebelling at others, but always knowing when not to resist to the stage of invoking imperialist wrath while at the same time not having enough Arab sympathy. That, after all, is what Hafidh Al-Asad of Syria and Mu'ammar Qaddafi of Libya have done over the last four decades. It may have taken a long time but, probably, would have enabled the Ba'ath to build a strong industrial base, a strong economy and a solid scientific infrastructure for future development.

ENDNOTES

1 The Sykes-Picot agreement was a secret understanding concluded in May 1916, during World War I, between Great Britain and France, with the assent of Russia, for the dismemberment of the Ottoman Empire. The agreement led to the division of Turkish-held Syria, Iraq, Lebanon, and Palestine into various French and British-administered areas. The agreement took its name from its negotiators, Sir Mark Sykes of Britain and Georges Picot of France. Some historians have pointed out that the agreement conflicted with pledges already given by the British to the Hashimite leader, Hussein ibn Ali, Sharif of Mecca, who was about to lead an Arab revolt in the Hejaz against the Ottoman rulers on the understanding that the Arabs would eventually receive a much more important share of the territory won. BBC News- Key Documents <http://news.bbc.co.uk/1/hi/in_depth/middle_east/2001/israel_and_the_ palestinians/key_documents/1681362.stm>

2 Abhorrent because it means a Sign of Allah. It is an affront to Islam to call a man with such a title. The Qur'an refers to Allah's creation such as the heavens, Earth, the Sun, the Moon etc as His Signs.

3 Robert Fisk, "He takes his secrets to the grave. Our complicity dies with him," *The Independent*, December 31, 2006.

4 Sir Percy Cox was the British High Commissioner in Baghdad after World War I who in 1922 drew the lines in the sand establishing for the first time national borders between Jordan, .Iraq, Kuwait, and Saudi Arabia. And in each of these new states the British helped set up and consolidate ruling monarchies through which British banks, commercial firms, and petroleum companies could obtain monopolies. Kuwait, however, had for centuries belonged to the Basrah province of the Ottoman Empire. Iraq and the Iraqis never recognized Sir Percy's borders. He had drawn those lines, as historians have confirmed, in order deliberately to deprive Iraq of a viable seaport on the Persian Gulf. See Philip Agee, "Producing the Proper Crisis", <http://www.serendipity.li/cia/agee_1.html>

5 Peterson, Scott, 'In war, some facts less factual', *Christian Science Monitor*, September 6, 2002 <http://www.csmonitor.com/2002/0906/p01s02-wosc.html>. See also Urbina, Ian, 'This War Brought to You by Rendon Group', *Asia Times*, November 14, 2002, <http://www.gvnews.net/html/Shadow/alert3553.html>

6 See, inter alia, GlobalSecurity.org, <http://www.globalsecurity.org/military/world/iraq/army.htm>

PRE-PLANNING FOR REGIME CHANGE

US Imperialism and Zionism

US imperialism shares many of the characteristics of empire-building known to mankind over the centuries. However, there are features peculiar to it, of which the most prominent are the speed of its rise and the speed of its demise. The reason for the speed of its rise may be that its earliest settlers were colonialist Europeans whose very existence on the land was the result of European imperialism. Thus US imperialism is nothing but an extension of the original European imperialism that created it. Some forty years before the end of the bloody civil war which created the US as we know it today, the Monroe Doctrine had already asserted the imperialist credentials of the new State. The beginning of US imperialism was stated in the Monroe Doctrine of December, 1832 which affirmed that no European power would be allowed to interfere with the Americas, thereby claiming the right of the US alone to function there and eventually dominate these territories which were external to it. Needless to say, this doctrine was extended by action, if not by declarations, to other continents after WWII, until eventually in 1980, the Carter Doctrine would be applied to the Middle East. To appreciate the depth of imperialism so early in the history of the US in line with the Monroe Doctrine, it suffices to consider what happened during the tenure of Woodrow Wilson, the so-called liberal US President among whose principles were decolonization and self-determination. During his administration the US intervened particularly in Mexico, Cuba and Panama; maintained troops throughout Nicaragua and occupied Haiti in 1915, which occupation lasted until 1934.

While the two main colonialist powers of the WWI, Britain and France, were bandaging their wounds, the US was building the military and economic machinery required of an imperialist power. In the Suez fiasco the Americans signaled to their brethren in mainland Europe that they had become the main imperialist players. The creation of the State of Israel at the time of the ascendancy of US hegemonic ambitions was not accidental.

In order to understand the depth of the roots Zionism had already planted in the nascent imperial US, we need to remember that the liberal

President Woodrow Wilson, who advocated the right of self-determination and decolonization post WWI, strongly supported the creation of a Jewish state in Palestine. He never explained how he justified giving the whole country to four percent of its inhabitants in the name of self-determination! These sentiments were present at the highest levels in the US long before the Nazi persecution of the Jews in Europe was used to serve as the pretext for implanting a Jewish state in the Middle East.

The argument of those who say that the US was pursuing its own self-interest in the Middle East is flawed because if so, then it ought to have sided with the Arabs in their claim to self-determination in Palestine post WWI. The reason for such a natural conclusion could be seen from the following:

The Arab world was and still is predominantly religious. This explains the reason for the failure of communism to penetrate it. All it took for Muslim leaders and their religious stooges to bring their peoples to the side of the West was to point out that the communists were heathens while the Europeans were 'people of the book', classified as acceptable in Islam. If the US was out to contain communism in the region, then its natural ally would have been the Arabs who were more amenable to opposing communism than the Zionists, who had set up the first communist party in the region in the State of Israel.

As the Middle East was known to have the richest reserves of oil in the world, it would have made economic and political sense for the US to befriend it rather than target it. Two examples of the US refusing genuine Arab attempts at coming to an understanding may be found in its treatment of Nasir and Saddam. Nasir would not have gone to the Soviets for assistance and weapons, had not the Zionists in the US refused to respond to his request for assistance to build the Aswan Dam and to arm Egypt. Saddam was genuinely keen on reaching an understanding with the Americans to honor Arabs' aspirations in return for guarantees to protect US interests.

Zionism understood very early that the nation-state concept introduced by the UK/France post WWI was not in its interests. While it is routinely argued that Zionism/Israel is based on the European nation-state concept of the state embodying the nation (a single ethnic group), in actuality there is no Jewish ethnic group. There is no such thing as a Jewish race according to all reliable anthropological studies. What is the ethnic relationship between Ethiopian Jews, Khazar-descended Russian Jews (who converted to Judaism in the 9th century)[1], and Ashkenazi Jews? Israel is not a nation-state based on a single ethnic group. It is a state based on a single religion. Thus we had the Anglo-Saxon orientalists, most of whom are either Zionist or Zionist sympathizers, tell us repeatedly the composition of each state in the Middle East in terms of ethnicity, religions and sects. The writings were not intended to enlighten us but rather to insinuate that they would have difficulty in coexisting in these nation states. It is bewildering to realize

that many of these writings were done in the US where the living example of peaceful coexistence of all religions and sects can be seen by all.

In order for Zionism to survive it was necessary to prove the futility of the nation state in the Middle East. Cleverly it embarked on establishing this in stages. In the post WWI where its influence was not yet dominant it managed to divide Greater Syria into Syria, Lebanon, East Jordan and mandated Palestine. Later it created the ghostly statelets on the Gulf when logic and reality ought to have included them as part of Arabia, which was and still is the greatest ally of Zionism in the Middle East. However, the justification of Zionist ideology was superior even to that realization.

Zionism had realized that in order for it to succeed, it needed to have full hegemony over the Middle East. However, it could not do that when every state is based on the concept of nation state while it is based on an elitist religious state, the presence of a Palestinian remnant minority notwithstanding. The obvious way to acquire legitimacy, which had eluded Zionism for too long, was to transform the whole of the Middle East into units based on religious, or more specifically, sectarian bases (since the notion of a Middle East based on Islam per se, foreshadowing the return of the Caliphate and the empowerment that this might provide to the Muslim peoples within its embrace, would of course have been counter-productive to Zionist purposes). Balkanizing these states into sectarian statelets would serve to reduce their size, facilitate their mutual antagonism, and thereby disempower them.

Towards that end we have had the Lebanese civil war, the destruction of Iraq in 1991, and above all the invasion and destruction of Iraq in 2003. While government (and correspondingly, media) figures today display alarm at the possibility of the disintegration of Iraq into several states, it is precisely what the Zionists planned, when they executed the invasion of Iraq.

If Zionism can appear to have created a political entity in the Middle East based on its religious identity among such other entities as Shi'a, Sunni, Alawi, Druze, Maronite, Orthodox, Kurdish, Assyrians etc, then it can claim equal legitimacy which it could not have claimed otherwise. Once that objective is achieved, the Zionist State will not only be one among other such states but it would be the only nuclear power. All other Middle East statelets would aspire to please and ask for its protection but it will dominate and subjugate all others. In short Zionism would prevail. In my mind that is at the heart of what has happened to Iraq and in that perspective the Middle East political history should be considered.

In order to understand why the Iraqi president was put on trial, we need to look at the invasion and the occupation that led to it, and bear in mind why indeed (i.e. in whose interests) that should have occurred.

The Iraq Liberation Act

Enacted in 1998 by the 105th US Congress, *The Iraqi Liberation Act* makes the US the only state in history which legalized in advance its criminal intentions towards the government of another sovereign state.

Our starting point for pre-invasion preparation is neither conjecture nor speculation. It is not based on interpretation of statements made by one irresponsible leader or another. It is based on documentary evidence as disclosed in the US under the Freedom of Information Act. Before we look at these documents we need to consider one piece of legislation. On 31st October 1998 the US President signed into law, *The Iraqi Liberation Act*, which was published by the 105th Congress as Public Law 105-338. This law makes the US the only state in history which legalized such criminality in advance. The Act's main objective is stated as follows:

> Sec. 3. Sense Of The Congress Regarding United States Policy Toward Iraq.
> It should be the policy of the United States to support efforts to remove the regime headed by Saddam Hussein from power in Iraq and to promote the emergence of a democratic government to replace that regime.[2]

One need not be an expert in law to realize that the purpose of the Act is regime change. The Act proceeds to lay out the procedure to be followed to achieve that objective. It is also evident that when the policies set out in the Act failed to change the regime by covert operations, the US decided to carry out the outrageous alternative, and invade Iraq. The Act does not cite WMD as a cause for the campaign for changing the Iraqi regime—the US later used WMD as an excuse for the invasion. In effect the decision to remove Saddam Hussein was taken irrespective of the story fabricated by the US and the UK about the alleged danger to both of them of Iraq's mythical WMD.

The heart of the legislation is section 4 which reads:

> Sec. 4. Assistance To Support A Transition To Democracy In Iraq.
>
> (a) Authority To Provide Assistance- The President may provide to the Iraqi democratic opposition organizations designated in accordance with section 5, the following assistance:
>
> (1) Broadcasting Assistance

(A) Grant assistance to such organizations for radio and television broadcasting by such organizations to Iraq.

(B) There is authorized to be appropriated to the United States Information Agency $2,000,000 for fiscal year 1999 to carry out this paragraph.

(2) Military Assistance

(A) The President is authorized to direct the drawdown of defense articles from the stocks of the Department of Defense, defense services of the Department of Defense, and military education and training for such organizations.

(B) The aggregate value (as defined in section 644(m) of the Foreign Assistance Act of 1961) of assistance provided under this paragraph may not exceed $97,000,000.

Both section 2 (see below) and section 4 of the Act are in clear breach of international law. They constitute a declaration and a plan for the use of force against a sovereign member of the UN. The threat of use of force is prohibited by Article 2(4) of the UN Charter:

All Members shall refrain in their international relations from the threat of use of force against the territorial or political independence of any state, or in any other manner inconsistent with the Purposes of the United Nations.

This is not surprising behavior for the US, which has flouted international law for the last fifty years from Guatemala to Iraq, but it is surprising to witness the 'enlightened' intelligentsia and publics in Europe electing people like Tony Blair and Berlusconi, who aver that the US mission is about the rule of law and civilized international conduct.

For those of us dealing with English law, the Iraq Liberation Law 1998 reads like a piece of comic literature. No legislator should pull material from the media or from any hat and put it into law. Section 2 of the Act lists the findings of Congress that led to the legislation. Every paragraph of section 2 is more bizarre than the previous one.

Sec. 2. Findings.

The Congress makes the following findings:

(1) On September 22, 1980, Iraq invaded Iran, starting an 8 year war in which Iraq employed chemical weapons against Iranian troops and ballistic missiles against Iranian cities.

(2) In February 1988, Iraq forcibly relocated Kurdish civilians from their home villages in the Anfal campaign, killing an estimated 50,000 to 180,000 Kurds.

Anyone who reads section 2(1) without having witnessed what happened in the 1980s would assume that the US was not supporting Iraq in its war against Iran, if it had not, in fact, instigated it through Saudi Arabia.

In section 2(2) Congress falls into two troughs of illusions in its sinusoidal love-hate relationship with the Ba'ath regime in Iraq. Firstly it omits to note that in February 1988 Iraq was still at war with Iran and the Iranian army was active in North Iraq with the help and cooperation of the Kurdish fighters loyal to US allies, Talabani and Barazani. Merely by omitting this fact, the scale of operation and death is taken out of context, which is unacceptable in a newspaper article, let alone in an Article of legislation. Secondly by asserting the number of casualties, Congress would be establishing a fact which it had no way of having been able to assess. However, should Congress have had the capacity to establish the number of civilian deaths, then why did it wait a decade to decide action was necessary rather than addressing the matter when it actually occurred? Furthermore, such assertions in legislation serve to give credence to those in Iraq who have called for the execution of those accused of the Anfal campaign before an appropriate (judicial) investigation of same had taken place, and omit to mention that it occurred under circumstances of war. (Indeed, when the president of Iraq was ultimately brought to trial, the US ensured that this was *not* the issue over which he would be tried.) In any event, are we to assume that if Congress, which is the high legislative court in the US, is convinced of the crime to the extent that it includes it in its legislation, then there is no need for further proof? Needless to say, the rest of the findings of Congress were in the same vein as newspaper reports or gossip in Amman cafes.

The Future of Iraq Project (FIP)

It may be argued by some that the Iraq Liberation Act is not a declaration of war but rather a statement of intent in which the US demonstrated its willingness to assist the oppressed people of Iraq in

achieving democracy, American style. Such an argument would have been more difficult to rebut had it not been for the release of new documents under the US Freedom of Information Act, which is a more serious piece of legislation than that produced, under public pressure, by Tony Blair's Labour Government.

The US National Security Archives Office has posted some of the declassified documents released by the State Department from the Future of Iraq Project.[3] On the background to the project it says:

> Less than one month after the September 11 attacks, the State Department in October 2001 began planning the post-Saddam Hussein transition in Iraq. Under the direction of former State official Thomas S. Warrick, the Department organized over 200 Iraqi engineers, lawyers, businesspeople, doctors and other experts into 17 Working Groups to strategize on topics including the following: public health and humanitarian needs, transparency and anti-corruption, oil and energy, defense policy and institutions, transitional justice, democratic principles and procedures, local government, civil society capacity building, education, free media, water, agriculture and environment and economy and infrastructure.
>
> In total, thirty-three meetings were held, primarily in Washington, from July 2002 through early April 2003. As part of the internal bureaucratic battle for control over Iraq policy within the Bush administration, the Department of Defense's Office of Reconstruction and Humanitarian Assistance (ORHA), itself replaced by the Coalition Provisional Authority (CPA) in May 2003, would ultimately assume responsibility for post-war planning in accordance with National Security Presidential Directive 24 signed on January 20, 2003.

As everybody who is remotely knowledgeable of Iraq knows, Iraq during the Ba'ath rule was the last place in the Middle East that would give shelter to Al-Qaeda members or support their ideals. In fact the Ba'ath and Al-Qaeda represent opposing poles of ideology. The Ba'ath is based on secular, nationalist ideals, while Al-Qaeda is based on a fundamentalist Sunni Islamic dogma. There is no co-existence between them. It was Osama Bin Laden who in 1990 first requested permission from Saudi Arabia to allow his followers to fight the infidel army of Saddam Hussein, which invaded Muslim Kuwait. The decision to oust Saddam Hussein in response to the September 11 attacks, made public only a month after these attacks,

supports the conspiracy theory that the attacks themselves were instigated by elements of the US administration to rally the rest of the establishment to back the invasion of Iraq and put into action a US ground campaign to oust Saddam Hussein from power, a course called for in 1998 in an open letter to President Clinton by the Zionist/neo-conservative Project for a New American Century.

The Future of Iraq Project shows that the US was planning to reshape Iraq completely after its occupation, despite the fact that this had nothing to do with its *casus belli*, the WMDs or purported presence of Al-Qaeda.

Although this book is not about the history of US imperialism in the Middle East, one cannot escape the need to look at the evidence available in order to understand the roots of the calamity that has befallen Iraq since the 2003 invasion. The details of the preparation undertaken in the Future of Iraq Project show that the US was planning to reshape Iraq completely after its occupation, despite the fact that this had nothing to do with its *casus belli*, the WMDs or purported presence of Al-Qaeda. Despite the effort that went into the project, some parts of its reports are simplistic, some are naïve and some are based on misconceptions or pure lies. Without going into much detail, I would like to cite one instance of deliberate deception. I take this example from the Education Working Group Report, one of the 17 Working Groups referred to above.

> It must be recognized that before the advent of the Ba'athist regime of Saddam Hussein, Iraq had what is generally regarded as a high-quality education system at all levels. At the time of the Kingdom, the Iraqi education system was modelled on the British system of that time…Now all that has been undermined by the Ba'athist approach to education.[4]

Anybody who lived in Iraq or had any knowledge of Iraq would find this bizarre statement laughable. It is erroneous and purposely misleading. The British did not at any time initiate any educational system in Iraq nor did they establish a single college or high school. The Iraqi educational system was based on the French model which the British are currently considering adapting. Subsequently, the Ba'ath regime brought about an educational revolution in Iraq, making Iraq the only country in the developing world where illiteracy was eradicated. It offered good, free education from preparatory school to doctorate. During twenty years of Ba'ath rule, more scholarships were awarded to Iraqis to study abroad than in the whole of Middle East put together. I, like thousands of others, studied for a PhD on a

scholarship paid for by the Iraqi Government, even while not being a Ba'athist. Many of those scholarship students switched to the other side and joined the political opposition to the regime, and some were later to become members of the US- appointed Government.

When the Ba'athists assumed power there was only one university in Iraq, but when Iraq was invaded in 2003 there were more than twenty universities in Iraq, fully financed and run by the government.

Material like that cited above shows the shallowness of the knowledge of the alleged US experts on Iraq (but then, one recalls the authority acceded to a British intelligence document which later turned out to have been prepared by a doctoral candidate in the United States, many years before). On the other hand, it may have been a deliberate attempt at misleading people into accepting that action was needed to rescue Iraq from the dark ages. Or it is equally possible that these so-called experts were fed false information by dissident Iraqis who had scores to settle with the Ba'ath regime and the US willingly accepted such information even if it did not believe it, possibly with an intent to deceive the public. This is akin to the anecdote that the source of the US information on Iraq's chemical weapons was an alcoholic, sitting in a café in Amman, who assured the US that he knew there were mobile chemical trucks used by the regime for production of chemical weapons. Although no one with even a basic knowledge of chemistry ought to have believed it, we are told that the US experts somehow did.

Whatever the real reason for these false reports about Iraq, they all indicate why, after so many Working Groups and so much money spent and so many experts and advisors consulted, we have a disaster in Iraq today.

The released reports of the Future of Iraq Project (FIP) will help to shed some light, not only on the reason for the calamity that has been visited on Iraq since the invasion, but on the thinking and planning on the extent of the changes that would be instituted in Iraq that started immediately after the 9/11 attacks and prior to administration willingness to admit that its intent was regime change (let alone systemic overhaul). Here are some noteworthy points:

1. The activity of the FIP started in earnest when, in March 2002, the State Department informed Congress about earmarking $5 million to support the FIP.

2. Between 9 and 10 April 2002 the first meeting of the FIP took place in Washington, with a few Iraqi dissidents attending. Five Working Groups were set up, dealing with post-Saddam Iraq's needs in the fields of Public Health and Humanitarian Needs, Water, Agriculture and Environment, Public Finance and Accounts, Transitional Justice and Public Outreach.

3. The provisional draft, based on the April 9-10 planning group meeting of the Defense Institutions and Policy Group states the following:

> The goal is an armed force that can defend Iraq but not be a threat to its neighbors. Using both former military officers and civilian representatives of the political and non-political opposition, to develop plans for restructuring Iraqi forces into playing a depoliticized, positive and unifying role to share in rebuilding Iraqi society......*To assess how Iraq can enter into alliances to enhance its security without threatening the security of others.* [My emphasis]

It is not surprising that such a plan, which enabled Israel to be rid of a full Arab army without firing one single bullet, was put into force a year later. Thus, Bremer's decision to disband Iraq's army (a decision achieved in conference with top Bush administration neo-conservatives Douglas Feith and Paul Wolfowitz, and subsequently erroneously viewed as "a mistake" by many commentators who saw the act in terms of US interests rather than those of Israel),[5] as well as all security and intelligence, created one of the biggest voids in the security of a state since WWII. The chaos that followed and the lawlessness that resulted, led to militias being formed and armed under American and British supervision. It is not surprising that there are observers who insist that, because such an outcome was clearly envisaged if the army and the security forces were disbanded, then such an outcome was desired and planned for by the perpetrators from the outset. Until today I have not read or heard one argument to refute such a theory. Few, however, have acknowledged this in reference to its most obvious beneficiary, Israel.

4. The controllers of the FIP had to work out a way in which people would be paid for their work without it being seen as it really was—buying people's allegiance to the plans. It is accepted that many of those Iraqis taking part in the plan might have had a grudge against, or battle with, the Ba'ath related to its stifling of political freedoms and the severity of the measures it undertook to do so. However, the power of money in luring people into a plan could not be underestimated, nor was it to be foregone. Thus, an undated memo by the Bureau of Near East Affairs/Near Gulf Affairs, states:

> We consider it essential to avoid the perception that participants are receiving generous payments from the USG [US Government], which might have negative consequences both for the participants and for the interests of the US government in post-Saddam Iraq.[6]

Despite such an attempt at cover-up it is unavoidable that the truth of the scale of money allocated to the Project could clearly be seen from some leaked statements. Thus two released documents show the sum of $1,533,900 for setting up five initial Working Groups and for convening a "mini-conference" in Europe. Each of the 5 Working Groups was to receive £231,900 for 3 months' work, leading to the mini-conference. This is an indication of how lucrative the invitation was to some Iraqis to join any of these Working Groups, The State Department admitted they had an overwhelming response to their call for expert Iraqis.

5. There are no released documents to show what criteria were used to select the Iraqi participants in the Working Groups. There are no records of the full names, backgrounds and details of those participants. However, one document lists some 88 names in twelve working groups. Only a handful of these have become known over the succeeding years, while the majority are unknown people who become more suspect when no backgrounds or credentials are provided for any of them. Out of the total of 88 names, sixteen gave telephone numbers in the UK, seven others in Europe and the rest in the US. Almost all of them hold a US or a European passport with some of them having spent over thirty years outside Iraq. It is possible that exile had been forced on some but not on all of them. However, the mere fact of their long absence raised two objections to their ability to play a significant role in Iraq. Firstly, they would have lost touch with Iraqi society and would not be able to judge it as it had become rather than as it was. Secondly, it is inevitable that living for 30 years in any society would create some allegiance of the residents towards their host country which might prejudice their judgment, however sincere they may be, when there is a conflict of interest between the US and Iraq.

6. The integrity of some of those known persons is questionable. Without having to balance the argument between freedom of opinion and defamation, I will cite one example. Aiham As-Samarrai' headed two Working Groups, The Democratic Principles and Producers, and The Economy and Infrastructure working groups. He later joined the infamous government headed by former CIA asset, Ayad Allawi, which, on top of its rampant corruption, presided over the genocide committed in Fallujah and Najaf. As-Samarrai' was later charged with several corruption suits by the Transparency Commission before an Iraqi Criminal Court, both of which were created and selected by the US. As-Samarrai' was found guilty on one count and sentenced to two years in prison. However, the US authority promised to detain him in the Green Zone pending the other charges. Mysteriously, he surfaced in Amman, Jordan, and then in the UEA, claiming his innocence, and accusing the US-installed criminal court of failure.

It is not difficult to see how cynical many Iraqis are about the claims of George Bush and Tony Blair that the mission was to install democracy and human rights in Iraq.

7. It comes as no surprise that the released documents show the involvement of some academic institutes and think tanks like the Brookings Institute. These academic departments and think tanks have always been tools of imperialism, whose duty is to give credibility to atrocities by showing, by virtue of their being civil society organizations rather than in government, that there is freedom of expression and that their views are somehow untainted by state interests. I was surprised and dismayed, however, to note the involvement of CARE USA. CARE advertises itself as an international charity, expecting respect and funding from concerned people. Why would such a charity allow itself to become involved in any way with a clandestine campaign setting out to invade a sovereign state—a charity whose remit isolates it from a political stance. The corruption of CARE USA may have been the cause of the attack on CARE in IRAQ which led to the unfortunate death of its Iraq branch director, Margaret Hasan.

On the other hand, it is not surprising for Amnesty International and Human Rights Watch to be in the imperialist pocket insofar as they were created by people who neither view nor address issues in terms of imperialism, even though their mission is political in nature. While it might be argued that consultation with such organizations reflected a State's desire to give a veneer of respectability to its intended operations in Iraq, the organizations concerned should have refused to participate, on these very grounds: that an attack on Iraq had no basis and was an illegal war of aggression. That Amnesty International and Human Rights Watch were later to conclude that the trial of Saddam Hussein was a farce may owe much to the fact that had they declared otherwise, in view of the ludicrous events that transpired, their reputation would be shot even in the West.

8. Another released document reveals that the Democratic Principles Working Group met on 2-5 September 2002 with thirty Iraqi participants, whose identity is still a secret today. After expressing their confidence in the forecasted success of the democratic experiment in Iraq and their pride in its being different from the Afghani model, they still doubted they could achieve democracy speedily, and felt the need to include the proviso that: "the USG needs to prepare for a stay of five to ten years."

9. One other important document released from the FIP archives gives the objective and desired end-state that would be expected to be brought into being as a result of the regime change. The three options for the administration of Iraq are given as:

(i) Transitional Civil Authority, run and staffed through the UN,

(ii) Transitional Civil Authority authorized by UNSC resolution but funded, staffed and jump-started by a coalition of the willing led by the US,

(iii) US- or Coalition-led military government.

It is obvious from such a document that the invasion was meant to lead to direct rule by the US in accordance with the end-state, as outlined in that document.

10. To further reveal how shallow was and still is the understanding of Iraq and its complex society by the planners in Washington and their highly expensive think-tanks, a quick reference ought to be made to the section on names that were considered for the so-called Sovereignty Council for post-Saddam Iraq. Among the three names suggested were the following, plus comments:

Best Candidates

Adnan Pachachi, Sunni, former foreign minister, widely respected older statesman…

Bahr Aluloom is most respected Iraqi Shi'a cleric living outside of Iraq….

There was a proviso to the suggestion—namely that the selection must be "someone agreeable to both Barzani and Talabani".

Neither of the two octogenarians is remotely as described in the document. Four years after being propped up by the US and appointed to the Governing Council after the invasion, both have gone into oblivion as a testimony to US incompetence in making the simplest of evaluations. The third is Sayyid Abdul Majeed Al-Khoe'e, a son of the religious cleric who preceded Sistani in Najaf, who was later assassinated in Najaf following his return, post invasion.

11. On 20 January 2003, George Bush issued National Security Presidential Directive 24 (NSPD-24), titled *Post-War Iraq Reconstruction*, setting up within the Department of Defense, the Office of Reconstruction

and Humanitarian Assistance (ORHA) as the occupation authority that was later to be replaced by the CPA. It is fascinating how audacious the US administration can be in using rosy language for its oppressive tools of destruction. Ask any Iraqi, four years after ORHA and its offshoot landed in Iraq, how much reconstruction and humanitarian assistance he or the country received and you would get a negative response. To add insult to injury, Lt. General Jay Garner was chosen to head ORHA. Garner, according to Michael Young, "famously signed onto an October 12, 2000 statement by the arch-conservative, Jewish Institute for National Security Affairs, which praised the Israeli army for having exercised 'remarkable restraint in the face of lethal violence orchestrated by the leadership of a Palestinian Authority'". Young also informs us that Garner was the President of California-based defense contractor SY Technology, which worked on the US-Israeli Arrow missile defense system. The same company happened coincidently to be working on missile systems the US would use against Iraq.[7]

The released documents of the Future of Iraq Project show conclusively that the invasion of Iraq was planned completely irrespective of the alleged possession by Iraq of WMD.

There are many statements and actions that would supplement the above evidence showing that the invasion and destruction of Iraq was planned well ahead of any finding of failure by Iraq to comply with UN Resolutions. I will not attempt to analyze them because that is not the purpose of this book. However, a short reference is made to some spectacular statements and one event.

Rumsfeld's Statement after the September 11 Attacks

One of the architects of the invasion and occupation of Iraq is Donald Rumsfeld, the former US Secretary of Defense who presided over the war crimes and destruction in Iraq and should face an international tribunal if there is any justice left in this world.

A few hours after the 2003 attack, Rumsfeld held several meetings within his Department. Contemporaneous notes of the meeting, which were taken by Stephen Cambone and leaked to CBS News, were later declassified in February 2006 in response to a request by a law student and blogger, Thad Anderson, under the US Freedom of Information Act. This is how *'Competitive Research'* presented the notes:

> 12:05 p.m. September 11, 2001: Rumsfeld Finds Evidence
> of Al-Qaeda Role Not Good Enough
> CIA Director Tenet tells Defense Secretary Rumsfeld about
> an intercepted phone call from earlier in the day at 9:53
> a.m. An al-Qaeda operative talked of a fourth target just

before Flight 93 crashed. Rumsfeld's assistant Stephen Cambone dictates Rumsfeld's thoughts at the time, and the notes taken will later be leaked to CBS News. According to CBS, "Rumsfeld felt it was 'vague,' that it 'might not mean something,' and that there was 'no good basis for hanging hat.' In other words, the evidence was not clear-cut enough to justify military action against bin Laden." [CBS News, 9/4/2002] A couple of hours later, Rumsfeld will use this information to begin arguing that Iraq should be attacked, despite the lack of verified ties between al-Qaeda and Iraq (see (2:40 p.m.) September 11, 2001).

(2:40 p.m.) September 11, 2001: Rumsfeld Wants to Blame Iraq

Defense Secretary Rumsfeld aide Stephen Cambone is taking notes on behalf of Rumsfeld in the National Military Command Centre. These notes will be leaked to the media nearly a year later. According to the notes, although Rumsfeld has already been given information indicating the 9/11 attacks were done by al-Qaeda (see 12:05 p.m. September 11, 2001) and he has been given no evidence so far indicating any Iraqi involvement, he is more interested in blaming the attacks on Iraq. According to his aide's notes, Rumsfeld wants the "best info fast. Judge whether good enough hit S.H. [Saddam Hussein] at same time. Not only UBL [Osama bin Laden]. ... Need to move swiftly. ... Go massive. Sweep it all up. Things related and not." [8]

The Attack on a Restaurant in Baghdad

On 7 April 2003, over two weeks after the massive attack on Iraq, at around 15:00 local time, an air strike was carried out on Mansour, a residential area of Baghdad. The intended target was the As-Sa'a restaurant on 14 Ramadhan Street where it was alleged that Saddam Hussein was holding a meeting. A single B1 bomber dropped four allegedly precision-guided 2,000-pound bombs.

I visited Iraq three months after the attack. The restaurant was unscathed as I used it at least twice. So much for the precision-guided bombs and so much for the well-informed media, which have since told us repeatedly that the restaurant was destroyed. The bombs fell on two houses behind the restaurant, leveling both and killing a total of seventeen innocent people. Not a word has been heard about these innocent people nor has there been any attempt at paying those who survived any damages.

The attempt on Saddam Hussein's life raises several questions. As the US and UK were almost in full control of Iraq by 7 April, the attack on Saddam's life must be seen for what it was: an assassination attempt. At that early date, there was not even the pretext that the US faced an insurrection, mounted by forces under his direction. Civilized states that purport to live by the rule of the law should not perpetrate extra-judicial assassinations. A killing of any person without due process of law is murder and states that claim to be acting to uphold human rights and civilized values should not commit murder.

Needless to say, the attempt on Saddam Hussein's life on 7th April proves that the invaders, who wanted him dead on that day, would want him dead later. This confirms that the precise purpose of the invasion was to change the regime and eliminate its symbols, to say nothing of overhauling the entire state. Towards that end the US blocked the UN certification in 1997 that Iraq was free of WMD. Albright stated the US plan clearly while admitting that Iraq was free of WMD:

> On March 26, 1997, Albright gave a speech on Iraq at Georgetown University in Washington. She admitted that Iraqi WMDs had been largely destroyed: Iraq's military threat to its neighbors is greatly diminished. Most of its missiles have been destroyed. Its biological and chemical warfare production facilities have been dismantled. Nuclear materials have been removed.
>
> Albright insisted, however, that sanctions should continue despite Iraqi disarmament: We do not agree with the nations who argue that if Iraq complies with its obligations concerning weapons of mass destruction, sanctions should be lifted. She said that Iraq had to prove its peaceful intentions, but that Saddam Hussein's intentions will never be peaceful, adding that a change in Iraq's government could lead to a change in US policy. In short, regime change in Iraq was official US policy as far back as 1997 under President Bill Clinton.[9]

Regime change in Iraq was official US policy as far back as 1997 under President Bill Clinton.

The Downing Street Memo

David Manning, Tony Blair's Foreign Policy Advisor, wrote a memo on 14 March 2002, following his visit to the US and his meeting with Rice. The official transcription reads:

SECRET - STRICTLY PERSONAL
FROM: DAVID MANNING
DATE: 14 MARCH 2002
CC: JONATHAN POWELL
PRIME MINISTER

YOUR TRIP TO THE US

I had dinner with Condi on Tuesday; and talks and lunch with her an NSC team on Wednesday (to which Christopher Meyer also came). These were good exchanges, and particularly frank when we were one-on-one at dinner. I attach the records in case you want to glance.

IRAQ

We spent a long time at dinner on IRAQ. It is clear that Bush is grateful for your support and has registered that you are getting flak. I said that you would not budge in your support for regime change but you had to manage a press, a Parliament and a public opinion that was very different than anything in the States. And you would not budge either in your insistence that, if we pursued regime change, it must be very carefully done and produce the right result. Failure was not an option.

Condi's enthusiasm for regime change is undimmed. But there were some signs, since we last spoke, of greater awareness of the practical difficulties and political risks. (See the attached piece by Seymour Hersh which Christopher Meyer says gives a pretty accurate picture of the uncertain state of the debate in Washington.)

From what she said, Bush has yet to find the answers to the big questions:

- how to persuade international opinion that military action against Iraq is necessary and justified;
- what value to put on the exiled Iraqi opposition;
- how to coordinate a US/allied military campaign with internal opposition (assuming there is any);
- what happens on the morning after?

Bush will want to pick your brains. He will also want to hear whether he can expect coalition support. I told Condi that we realiised that the Administration could go it alone if it chose. But if it wanted company, it would have to take account of the concerns of its potential coalition partners. In particular:

- the Un [sic] dimension. The issue of the weapons inspectors must be handled in a way that would persuade European and wider opinion that the US was conscious of the international framework, and the insistence of many countries on the need for a legal base. Renwed refused [sic] by Saddam to accept unfettered inspections would be a powerful argument'

- the paramount importance of tackling Israel/Palestine. Unless we did, we could find ourselves bombing Iraq and losing the Gulf.[10]

It should be emphasized that the trip and memo were made in early 2002, which again shows how early the plans to invade and occupy were made. The argument seems to be on how to find the best camouflage to sell regime change to the public.

Blair's Statement to Parliament

On 24 March 2003, Tony Blair finally declared the real intention of the invasion to be the removal of Saddam Hussein:

We are now just four days into this conflict. It is worth restating our central objectives. They are to remove Saddam Hussein from power and ensure Iraq is disarmed of all chemical, biological and nuclear weapons programmes.[11]

ENDNOTES

[1] See Kevin Brook, "The Khazars" <http://www.wzo.org.il/en/resources/view.asp?id=140.>

[2] Iraq Liberation Act of 1998 (Enrolled as Agreed to or Passed by Both House and Senate), H.R.4655, One Hundred Fifth Congress of the United States of America, The Library of Congress. <http://thomas.loc.gov/cgi-bin/query/z?c105:H.R.4655.ENR:>

[3] New State Department Releases on the Future of Iraq Project, The National Security Archives, National Security Archive Electronic Briefing Book No. 198, posted 1 September 2006. <http://www.gwu.edu/~nsarchiv/NSAEBB/NSAEBB198/index.htm>

[4] Education Working Group Report, Future of Iraq Project, US Department of State, December 2002, p. 3. <http://www.gwu.edu/~nsarchiv/NSAEBB/NSAEBB198/FOI%20Education.pdf>

[5] Peter Slevin, "Wrong Turn at a Postwar Crossroads? Decision to Disband Iraqi Army Cost U.S. Time and Credibility", *Washington Post,* November 20, 2003.

[6] FIP Document No. 20020001, Department of State, Bureau of Near East, Released on 16 March 2006 <http://www.gwu.edu/~nsarchiv/NSAEBB/NSAEBB198/20020001.pdf> Retrieved on 24 March 2008

[7] Young, M., Iraqi New Rulers, Handicapping the Postwar Administrators, Reasononline, 19 March 2003.<http://www.reason.com/news/show/32667.html>

[8] Stephen A. Cambone, Center for Cooperative Research, History Commons. <http://www.cooperativeresearch.org/entity.jsp?entity=stephen_a._cambone>

[9] Lantier, A., Former US Official: US blocked UN Certification that Iraq had no WMDs in 1990s, 18 October 2007, World Socialist Web Site. <http://www.wsws.org/articles/2007/oct2007/ekeu-o18.shtml>

[10] Text of the David Manning Memo - March 14, 2002 memo from David Manning (UK Foreign Policy Advisor) to Tony Blair recounting Manning's meetings with his US counterpart Condoleeza Rice (National Security Advisor), and advising Blair for his upcoming visit to Bush's Crawford ranch. <http://downingstreetmemo.com/manningtext.html> Retrieved on 24 March 2008.

[11] Prime Minister Statement to Parliament, 24 March 2003 <http://www.pm.gov.uk/output/Page3337.asp

EUROCENTRISM, INTERNATIONAL LAW AND THE INVASION OF 2003

The Ramifications of Eurocentrism

Several centuries of European colonialism have led to the development of certain cultural propensities that have become so ingrained in people's minds that they are very rarely discussed. People have come to accept that there are different meanings to the words *'wrong'*, *'offence'* and *'crime'* when they are committed in our neighborhood from when they are committed by us, overseas. To illustrate:

- It is *'murder'* to kill a civilian in East London, for example, but it is called *'collateral damage'* when such a civilian is killed by European forces in Fallujah. Collateral damage is the vulgar term used to trivialize murder. Accepting collateral damage as "unavoidable" albeit "regrettable", despite the fact that we have never been given any justification to accept it at all, led not to discussing whether or not it is murder to kill civilians but rather to whether or not *the scale* of collateral damage should be tolerated—bearing in mind that it is usually the perpetrator who is allowed to determine that scale.

- It is unacceptable to blockade and starve your neighbors by denying them the basic needs of life because the right to life is sacred. But we are easily willing to live with the reality that a full nation of millions of people may be blockaded indefinitely causing hundreds of thousands of unnecessary child deaths and suffering on the ground that it enforces peace!

- No one in any society would dispute the right of the individual to

self-defense. However, we feel content with depriving a whole nation of that right by forcefully disarming it alone, while others around it are arming themselves menacingly.

Many people with good intentions talk about the need to put an end to wars and destruction. But few address the capacity for double-think of the culture. It is my view that unless this Eurocentrism changes, there will be no change in its propensity to wage war and wreak havoc and destruction. Unless people come to accept that an offence is the same whether committed nationally or internationally, there will be no end to war. It is only when ordinary people come to believe that the killing of children through blockades and/or maiming through cluster bombs and burning young children by phosphorous bombs in Fallujah and Lebanon is just as murderous as killing children in a park in London that we will have some hope of forcing an end to wars. This is the campaign that needs to be launched by the peace movement—a campaign of educating the public to appreciate this reality of the equality of life irrespective of whether it is inside their country or outside it, especially so today when globalization drives the world to interact as if it were a big village.

I believe that this entrenched belief in or acceptance of selective or hypocritical values has contributed to the failures in international relations and to the expectation among hundreds of millions of people in the formerly colonized developing states of duplicity of standards from Europe.

International Law: A Failed European Project

In any state, people accept that there is a body which has legislative power and the legislation promulgated by it has universal application, at least within its jurisdiction; these laws are enforceable and the consequences of their application can be appealed or reviewed. But laws do not grow in a vacuum. They are the product of political, ideological, philosophical, religious and cultural movements within a society. Most of the above features of national law could not be traced on the international level. The question that follows from this is whether there is such a regime as international law that ordinary people can identify with, or are the rules we are expected to uphold simply moral values that have developed in Europe over the last two centuries?

A widely accepted notion among European jurists is that international law derives its genesis from the Peace of Westphalia in 1648 which ushered in the nation-state system and the notion of state sovereignty. Whatever the truth or otherwise of this conviction, it remains true to say that the principles of international law today are primarily a product of European thinking and events, and of its historical, political and ideological movements. In other words, international law today is European-generated law. The fact that it is

accepted by the rest of the world—to the extent that it is—is only as true as the extent to which European power still holds. The United States, in the past decades, has resolutely ignored it at every turn.

I believe that international law, and I use the term loosely, could only be legally and morally acceptable if there are agreements between the states on what it should include.

When the UN Charter was drafted in 1945, there were fewer than fifty independent states falling within, or under the influence of, either of the two camps—the capitalists or the communists. However, sixty years later, these facts have changed. There are over 192 independent member states in the UN, one non-member state, the Holy See, with Palestine not counted as a non-member but rather as an entity, and the divide between capitalism and communism has gone. Thus the system that may have worked through both sides ensuring that certain lines were not crossed no longer functions. In short, the whole international atmosphere that gave rise to the UN has changed. If it was an unfair system in 1945, it became dysfunctional in 2003.

One need not be a lawyer to understand that any agreement must be freely negotiated and entered into by all parties in order for it to have any value or effect. However, more than three quarters of the subscribers to the UN Charter have never had the opportunity even to re-negotiate its terms. The reform of the UN to reflect today's realities has proved impossible to achieve.

The problems with the UN do not stop simply at the origins of the Charter. The main problem is caused by the setting up and functioning of the Security Council. The injustice resulting from the setting up of the Security Council includes several features, which highlight its Eurocentrism. Here are a few of the many problems with the UN insofar as it relates to law.

1. The war victors usurped the authority of the UN by creating the Security Council and according themselves a veto power. The UN as a forum of the world states thus became a prisoner of the will of the imperialist war victors. The Security Council has increasingly assumed the role of a supreme court, adopting resolutions outside its legitimate purview, making its resolutions more powerful than the rulings of any court.

2. The war victors ensured that their authority would never be fettered and their decisions would never be subject to legal scrutiny. When the International Court of Justice (ICJ) was created, it was given no powers beyond an advisory role, which the court itself acknowledged was not intended to endow it with the capacity to create a precedent binding on the member states.

3. Although it would have been expected that UN General Assembly Resolutions, being the consensus among the contracting world states, should become a source of international law, the ICJ implicitly rejected the principle and accepted these Resolutions simply as evidence of judicial opinion.[1]

4. Further usurpation by the war victors came in Article 103 of the UN Charter which reads:

> In the event of a conflict between the obligations of the Members of the UN under the present Charter and their obligations under any other international agreement, their obligations under the present Charter shall prevail.

In short this means that the Security Council can negate any agreement entered into by any number of states irrespective of whether or not the Security Council members taking part in the Resolution are subscribers to that agreement.

5. The drafting of the UN Charter made it possible for the Security Council to assume any role it chooses. Thus it is at times a legislative body, despite the fact that Article 38 of the ICJ Statute did not specify it as a source of international law. However, more importantly, in my opinion, is the Security Council's function as a court of law when it rules that some acts are unlawful or criminal, and passes and enforces punitive measures.

6. The Security Council must thus be the only court of law in the world whose members are not judges but rather diplomats or politicians, despite the fact that it makes the most serious judgments that affect the lives of millions of people in the world.

7. The decisions of the Security Council, contrary to those of legislative and judicial bodies functioning within any known political system, are not subject to review or repeal by a higher authority. While the ICJ can offer the Security Council its "advice", it cannot force the Security Council to alter same. Further, when the Security Council is apprised of a matter, this very fact freezes out deliberations on that issue by other bodies.

8. The Security Council can choose to reach decisions against member states without allowing the state concerned to address it. Normatively, it would be a denial of justice if any accused were to be denied the

right to address a body which was effectively empowered to render judgments on him or the right to be present when it was deliberating on the case. Iraq, for example, was denied the right to address the Council on several occasions during the 1990s.

9. The Security Council is the only organ that is allowed to follow procedures contrary to the Charter which created it. Thus despite the stipulated requirement in the UN Charter for the affirmative vote of all the permanent members and four of the non-permanent members for a Resolution to pass, the Council has decided that an abstention amounts to an affirmative vote! The Advisory Opinion of the ICJ of 12 June 1971 states that "for a long period the voluntary abstention of a permanent member has consistently been interpreted as not constituting a bar to the adoption of resolutions by the Security Council". This does not, in my mind, show anything but the fact that the Security Council has consistently breached Article 27 of the Charter.

In 1922 the League of Nations set up a Commission of Jurists to draft the Constitution of the Permanent Court of International Justice (PCIJ). The Statute of the PCIJ included an Article on what came to be known as the 'sources of international law'. This Article was later incorporated in Article 38 of the Statue of the International Court of Justice created in accordance with Article 92 of the UN Charter. It is important to note that the Statute of the ICJ has not been amended since its adoption. Article 38 reads as:

> 1. The Court, whose function is to decide in accordance with international law such disputes as are submitted to it, shall apply:
>
> a. international conventions, whether general or particular, establishing rules expressly recognized by the contesting states;
>
> b. international custom, as evidence of a general practice accepted as law;
>
> c. the general principles of law recognized by civilized nations;
>
> d. subject to the provisions of Article 59, judicial decisions and the teachings of the most highly qualified publicists of the various nations, as subsidiary means for the determination of rules of law.

In short, what the Article says is that the European jurists concluded

that what has been practiced by Europe over the centuries, which includes European custom and the principles recognized by the civilized European nations, will form the principles applicable to any case. If no such practice is traced, then they will look at judgments in European courts or in the writings of academics. There may be good grounds to accept this approach for Europe. But the question not answered yet would be: why should the rest of the world accept this as necessarily equally applicable to it?

There is no objective definition of what is a 'civilized nation'. When the Europeans invaded the four continents, they argued that they had a mission to civilize the barbarians of these continents. But did their own behavior of aggressive wars of conquest, the expropriation of land, and the slaughter of the original inhabitants, exemplify civilized practice? The question that was never asked by Europeans was whether or not those so-called barbarians believed themselves to be—and were, in fact—civilized, although they were never well armed. When Baghdad was destroyed by the army of illiterate moguls in 1258, it was basking in its cultural glory. Very little has changed during the last three centuries regarding the dealings of Europe with the rest of the world. The invasions of the eighteenth and nineteenth centuries were little different from the invasion of Iraq in 2003. The problem that faces a student of international law is whether or not these European practices carried out by European nations over the last two centuries form a cogent source and civilized basis for the development of a truly universal international law.

Would their actual practice of aggression and invasion explain why Europe resisted the adoption of the UN General Assembly's definition of aggression into the Statute of the International Court of Justice? Why should the writing of an American academic, who grew up if not glorifying then at least acquiescing in the violent bloody history of the US, be a source of international law and not the writing of a Muslim jurist? These are some of the questions that ordinary people outside Europe raise regarding the specification of the sources of international law in Article 38 of the ICJ.

Consideration of customary international law is important regarding the invasion of Iraq and the trial of its political leadership and its ruling Ba'ath ideology—not because the law that evolved as a result of the dealings of Europe with the rest of the world has been adhered to by European states themselves, or because of any intrinsic merit in this law which (however much their consultation and input might be argued) has not evolved naturally from the lives and customs of the rest of the world's peoples—but rather because the US/UK legal advisors who set up the Iraqi Special Tribunal have told their appointed Iraqi agents to argue that customary international law has automatic application in Iraq. I will show later the hypocrisy of the US/ UK in this regard, as neither state accepts that customary international law has automatic application within its own jurisdiction. In my opinion this

amounts to 'judicial imperialism' where the kind of rules that are applied in our colonies are not applied domestically. This is consistent with the re-imposition of economic imperialism, in the form of privatizing Iraq's oil thirty years after it had been nationalized, and cultural imperialism whereby Iraq was for more than a decade denied teaching material for schools and universities and not a single Iraqi was admitted to a European University. And it is consistent with military imperialism which saw Iraq brutally occupied and its army with an eighty-year tradition simply sacked, with all its military hardware dismantled and sold as scrap metal in Jordan by parties unknown.

There are two problems with the principle of customary law. There is a consensus among European jurists that customary law need not be the practice of a majority of States and that it binds all States, even those which took no part in its development through practice. I do not believe that this anomaly has been sufficiently addressed by European jurists. Thus 'in the case of Legality of the Threat of Use on Nuclear Weapons, the Court (ICJ) accepted that the opposition of the handful of nuclear States to any customary rule prohibiting such weapons blocked the creation of such a rule, even though it was favored by a substantial majority of the States of the World'.[2]

When Ayatollah Khomeini complained that international law does not apply to Muslims by virtue of the fact that Muslims neither contributed to its development nor were consulted on it, he was not expressing mere revolutionary rhetoric, but a deep concern among Muslims regarding the principles of international law as expressed by the Europeans. If this observation was pertinent in the 1980s it is more so today. Since the demise of Communism the only demon left for imperialism—and there must always be at least one—is Islam. Europe is fighting Islam in Iraq and Afghanistan and threatening to fight in at least four other Muslim states: Iran, Syria, Sudan and Lebanon.

Many Muslim States have existed on this planet since the beginning of the seventh century, two of which formed massive empires extending from Spain to China. Can it be other than a racist insult to assume that so many principles of customary law have developed in the two hundred years of the Europeans' occupation of the Americas and the rest of their colonial empires, and none from the 13 centuries of Islamic jurisprudence? But unfortunately that is the position of customary international law today.

In the diversified world we live in, there is no one single customary law. There is customary European Law, but it must be accepted that there are other customary laws that have developed independently alongside the European law as in the case of Customary Islamic Law which is peculiar to Islamic Shari'a. This means that there are principles in this law which differ fundamentally from customary European Law and which should be taken into consideration when dealing with Islamic States. Simply put, any attempt at imposing European principles that are in conflict with Islamic Shari'a will

be forcefully resisted in the Muslim world. This fact will not disappear with time. In fact the more Europe pretends to bypass this fact by attempting to impose its laws on the Muslim World, the stronger the adherence to Shari'a becomes. We acknowledge through our criminalizing and decriminalizing of actions that there are no 'right laws' and 'wrong laws' and thus ought to accept the existence of other customary Laws and attempt to accommodate their principles in international law.

Islamic Shari'a, according to Muslims, is the fundamental law ordained by Allah, not only in Qur'an and the sayings and practice (Sunna) of the Prophet Muhammad (PBUH) but also in what has been revealed to all the prophets from Adam to Muhammad. Appreciating the differences between customary Islamic and customary European laws may assist at least in understating the conflict of today. The principles in Islamic Shari'a are so entrenched in the minds of some billion people of the world today that no international arrangement affecting Muslims should attempt to override them. I will select a few examples to illustrate these differences.

Supremacy in Legislation

European political and legal systems accept that elected bodies are entitled to legislate on behalf of those who elected them. This authority to legislate including the drafting of a Constitution is limitless and supreme. There is no such authority in Islam. Supremacy belongs to Allah. Man is not entitled to allow what Allah has forbidden. If Allah criminalized usury then no legislative body in a Muslim State can allow it and be truthful to Islam. Equally when Allah allowed polygamy no legislation in a Muslim State should criminalize it. These are, by no means, the only two examples to illustrate this problem.

Arming the Nation

In Islam, as with Judaism and Christianity, the rift between good and evil took place when the devil rebelled. He was given leave to tempt humanity. This leave is perpetual and would only terminate by His divine will. In order to be able to resist that evil the Muslim *Umma* (nation) is under divine command to arm itself. The right to arms is not an option but an integral part of maintaining the faith. I must emphasize here that, contrary to some claims, the purpose of arms in Islam is for defense and not for spreading the word of Allah. There is no sanction to military action for missionary purposes in Islam; in fact the contrary is the truth: there is to be no compulsion to convert. It follows that Islamic Shari'a does not allow any interference in the right of a Muslim State to arm itself, because that would breach Allah's ordainment.

At the heart of the destruction of Iraq over a period of twelve years is the European claim to have the right to disarm it. In addition to the fact that

the right of a state to arm itself has been held to be non-negotiable in customary European law, a Muslim jurist would naturally have a dim view of the European claim. The argument that Iraq was being disarmed because it was a belligerent state is laughable and hypocritical. The most belligerent states in the last two centuries were European. In the most recent history, WWII gives us the true picture of

At the heart of the destruction of Iraq over the past twelve years is the European claim to have the right to disarm it—a form of juridical imperialism

European belligerence when European states committed the greatest genocides on each other without any Muslim intervention. Yet even as they protested the right of states in the Middle East to have WMD, these same European states (including the US and Israel in my definition of Europe) found it quite legal to store and further develop these arms themselves without any limitation on acquiring any system of weaponry they might choose to have, no matter how noxious. Equally perplexing for the Muslim jurist is that Israel is rewarded with new weapons and financial backing following its invasion of Lebanon while Iraq is decimated following its invasion of Kuwait. We are again witnessing judicial imperialism in which some are punished for committing certain acts while others are rewarded and absolved of any liability when they commit the same acts.

The Muslim jurist would go further and point out that it was precisely to prevent such an outcome as the sacking of Iraq in 2003 that Islamic Shari'a ordained the Muslim *Umma* to be armed to defend itself. Had Iraq acquired the nuclear weapons which the US, UK and Israel have, then no power on earth would have dared to invade it. It would have saved itself from the calamity that has befallen it and saved the lives of at least a million innocent people who have died so far as a result of the invasion alone, let alone those who died as a result of the blockade.

It is a lesson for the future. If the US, Russia, UK, France and Israel (all Judeo-Christian States) have nuclear weapons, then why shouldn't Muslim Iran have them, if the argument for having them is that they provide the ultimate deterrent against invasion and aggression?

Invasion (Aggression) and "Humanitarian Intervention"

European states' practice of colonialism, starting from the capture of Ceuta by Portugal in 1415 up until the invasion and occupation of Iraq in 2003, had one thing in common—namely subjugation, domination and exploitation. European imperialism, the natural growth of colonialism, used different reasons to justify its missions of conquest and destruction, ranging from spreading the 'word of God' to civilizing the indigenous 'barbarian' populations. Thus when the excuse to invade Iraq in order to disarm it turned

out to be bogus from the outset, the invading imperialist immediately fell back on the new excuse for imperialism—humanitarian intervention.

This is how Koskenniemi, a typical European academic, expresses the reason for 'humanitarian intervention':

> surely formal sovereignty should not be a bar for humani-
> tarian intervention against a tyrannical regime; in oppressing
> its own population, the State undermines its sovereignty'.
> We honour 'sovereignty' as an expression of a people's
> self-rule. If instead of self-rule there is oppression, then it
> would seem nonsensical to allow formal sovereignty to
> constitute a bar to intervention in support of the people.[3]

It is clear that the learned academic has not made a legal argument for 'humanitarian intervention' but rather has assumed the high moral ground to decide that he can determine when tyranny takes place, in which situation to intervene and to do so without the hapless people having themselves called for it.

Alternatively, Professor Francis A. Boyle eloquently sums up the true meaning of humanitarian intervention[4] in saying:

> Under international law, 'humanitarian intervention' is a joke
> and a fraud that has been repeatedly manipulated and
> abused by a small number of very powerful countries in the
> North in order to justify wanton military aggression against
> and prolonged military occupation of weak countries of the
> South—and typically developed countries of the North
> against lesser developed countries in the South—for
> political, economic, strategic, and military reasons that have
> absolutely nothing at all to do with considerations of humanity
> and humanitarianism. History teaches that powerful states
> do not use military force for reasons of humanity.

Boyle cites three examples from customary law to support his conclusion that "No state has the right or standing under international law to launch an illegal military attack upon another UN member state in the name of humanitarian intervention":

> The first example is the ruling of the International Court of
> Justice in the Corfu Channel Case (*UK v Albania*, 1949), in
> which the Court repudiated the argument of the UK
> Government relying on its right to intervention, protection
> and self-help and concluded that the UK violated Albanian

sovereignty even though the Albanian Government had failed to carry out its duties. The Court's reason for reaching that judgment was that 'respect for territorial sovereignty is an essential foundation of international relations.

Professor Boyle also quoted from the 1970 Declaration on Principles of International Law Concerning Friendly Relations and Cooperation among States in Accordance with the Charter of the UN, which reads:

> No State or group of States has the right to intervene, directly or indirectly, for any reason whatever, in the internal or external affairs of any other State. Consequently, armed intervention and all other forms of interference or attempted threats against the personality of the State or against its political, economic and cultural elements, are in violation of international law.

It is clear from the above Resolution adopted by the UN General Assembly that the majority of member States of the World do not entertain the imperialist view of the right to intervene.

The third example cited by Professor Francis Boyle is the ruling of the ICJ in the case of *Nicaragua v US*, 1986. In this historic judgment the Court not only condemned US actions against Nicaragua but by analogy its policies of intervention throughout the twentieth century. In paragraph 268 of the judgment, the ICJ said:

> In any event, while the US might form its own appraisal of the situation as to respect human rights in Nicaragua, the use of force could not be the appropriate method to monitor or ensure such respect...The Court concludes that the argument derived from the preservation of human right in Nicaragua cannot afford a legal justification for the conduct of the US.

The highlights Professor Boyle presented above suffice for the argument that humanitarian intervention has no basis in customary European Law. I shall now turn to the position of customary Islamic Law on intervention. The presence of a non-Islamic army on Muslim land is prohibited under Islamic Shari'a. The Qur'anic verses and the Prophet's sayings in support of this principle are too numerous to raise any doubt about its existence. The presence of a Muslim army in any Muslim state is admissible in accordance with Shari'a because Islamic Law recognizes only a Muslim

Humanitarian intervention has no basis in customary European Law.

Umma (nation) and no other form of nation. It follows that customary Islamic Law which developed under the Shari'a may contemplate intervention provided it is done by Muslim armies with a view to self-defense, the need for which might be presupposed by any existence of non-Muslim armies on Muslim territories. In fact, the presence of non-Muslim armies on Muslim land is prohibited whatever the need is, including assisting in self defense. Intervention even if carried out by the Security Council using military units from different non-Muslim states would be in violation of Islamic Shari'a and consequently its offspring, customary Islamic law.

The world we live in does not have one customary law: it may have customary European Law, customary Islamic Law, customary Chinese Law and others. Acknowledging this fact forces us to accept that in order for a principle to become customary International Law it should accommodate different customary rules in the main cultures in the world and not simply in Europe. Anything short of this practice would amount to 'judicial imperialism' that would be resisted and lead to even more problems than those the law set out to resolve.

Which Law, Then?

In my opinion, the only international legal system capable of functioning justly and fairly is one based on consensus among the majority of nations. It is this belief that makes me accept only paragraph (a) of Article 38 of the Statute of the ICJ—international conventions, whether general or particular, establishing rules expressly recognized by the consenting states— as a possible source of international law. In order to achieve that consensus the so-called customary principles ought to be incorporated into agreed treaties to become effective legal principles. I see two legitimate sources of international law, namely treaties and UN General Assembly Resolutions.

Apart from Treaties and Conventions, which themselves are unenforceable against the powerful European States, neither of the other sources of law enumerated in Article 38 of the ICJ Statue customary [European] Law—the principles of law as recognized by "civilized nations", nor the writings of [European] academics—constitute international law in my opinion because they all serve as tools of European imperialist oppression as developed over the last four centuries.

However, despite this, I intend to proceed in this book to show that the whole process is still criminally manipulated and executed, even on the basis of the so-called 'International Law' under which the Occupiers claim to have acted.

Misconceptions

The control of the Security Council by the permanent members has

consolidated a widely spread misconception about its authority, namely that the Security Council can pass any Resolution it wants. In a world system ruled by law, nobody is above the law. Even supreme bodies, like Parliament in the UK, operate under the rule of law which it created until it repeals it. The Security Council must be subject to two organs. Firstly, it must operate in matters of both law and procedure in accordance with the rule that created it—the UN Charter. More importantly, in my opinion, it must operate within the peremptory norms of customary international law, whose existence it acknowledges—rules like the absolute prohibition of genocide, slavery, murder, etc.

This misconceived view of the Security Council's authority has not arisen without any cause. It has spread because the Security Council, especially during the last twenty years, has indeed acted as if it were above the law and has breached customary principles of international law. That reality should not change the principle that the Security Council should not act outside the rules of the UN Charter or peremptory norms of international law. Previous breaches are no excuse for their continuation.

The International Criminal Court Jurisdiction

After decades of negotiation many jurists were happy to hear of the conclusion of the Statute of Rome creating the International Criminal Court (ICC) and its coming into force on 1 July 2002. However, that joy was short lived. One look at the Statute of the ICC reveals the ultimate control of the Court by the Security Council. Article 16 reads as follows.

> Article 16
> Deferral of investigation or prosecution
> No investigation or prosecution may be commenced or proceeded with under this Statute for a period of 12 months after the Security Council, in a resolution adopted under Chapter VII of the Charter of the United Nations, has requested the Court to that effect; that request may be renewed by the Council under the same conditions.

The above Article reveals two sad facts for justice. One is that the judicial process, which we constantly argue should be independent from political interference, is subject to the ultimate control of the Security Council without it even having to give reasons. Secondly and more bizarrely, it allows a state (the U.S.), which is not a party to the treaty of the ICC and thus does not recognize the Court, to be able to suspend its process and effectively veto its validity.

The ICC has no meaning to the world while Article 16 exists. It makes the ICC a judicial tool of imperialism whereby people in the developing

world are likely to face its jurisdiction while Americans and Europeans are likely to be guaranteed immunity. How countries in the developing world agreed to include such an Article is a mystery to me, unless they had no say in the matter or were coerced.

Resolution 1483

I shall provide evidence in Chapter 4 showing how Resolution 1483 was drafted by the US/UK, which was then rubber stamped by the Council. The Resolution was adopted on 22 May 2003, some two months after the beginning of the invasion of Iraq which the Security Council had refused to sanction. One article of that Resolution is of particular relevance to this exposition.

> 3. Appeals to Member States to deny safe haven to those members of the previous Iraqi regime who are alleged to be responsible for crimes and atrocities and to support actions to bring them to justice

I can understand the intention of the US/UK drafters who inserted this Article among others to vindicate their aggression against Iraq by declaring that the Security Council has ruled that there were people in the regime who were guilty of crimes and atrocities and that they only acted nobly to remove them. But why would the other members of the Security Council allow such an Article to be included in the Resolution? It makes no sense to pretend that the Security Council did not approve of the invasion of Iraq if, once the invasion took place, the Council then acquiesced to the invaders/occupiers doing what they allegedly set out to do from the outset, and now granting them authority to do so.

The inclusion of Article 3 is at best irresponsible and at worst an unlawful act by the Security Council. This is one of those incidences of the Security Council writing the law as it pleases, even if contradictory to its own earlier decisions. The problems with Article 3 above are numerous and frightening as a precedent. The Article refers to '*members of the previous Iraqi regime*' implicitly as having been legitimately arrested, when their detention by the invaders was a clear breach of international law. The Article refers to them being '*alleged to be responsible for crimes and atrocities*' but clearly left it open as to who was entitled to make the allegations and which law defined the alleged crimes and atrocities.

The Article goes on to call on member states '*to support actions to bring them to justice*'. In so saying, the Security Council left it open to anyone to claim that he was acting on the Security Council instructions to bring former members of government of a sovereign state now under belligerent

occupation as a result of an illegal war of aggression to justice—as Paul Bremer, the US proconsul of Iraq, believed he had the legal authority to do when he later promulgated Order 48. The judicial mess created by the Security Council in accepting Article 3 as drafted by the US/UK is an example of writing the law without any consideration of the consequences or with appreciating the consequences but being indifferent to them.

The proper procedure for the Security Council to follow in order to take control of such a situation would have been to create a judicial body to consider the allegation, name the people and set up the proper court and indict as called for. No responsible international body should make such a loose, irresponsible judicial statement about "alleged" crimes committed by members of a legitimate Government of a sovereign state that is a founding member of the United Nations and then leave the interpretation of such semi-judicial statements to those who themselves appear to have transgressed the UN's rules against aggression and thus need to justify the legality of their actions, or otherwise accept that they were breaking international law.

The Genocidal Sanctions Contravened the Genocide Convention

The most serious breach of international law committed by the Security Council was the imposition and maintenance of twelve years of total blockade against Iraq—irrespective of the rights or wrongs of the incursion into Kuwait, which could not have been worse, since it led to less than one tenth of the losses, than the incursion of Israel into Lebanon. The imposition of total blockade upon the entire population—men, women and children—of Iraq with a view to forcing them to oust the regime was an act of genocide imposed by the US/UK and upheld by the Security Council.

Here is the definition of genocide as per the Genocide Convention 1948 that has been ratified by almost all states and has since 2002 been incorporated into the Statute of the ICC. Genocide is defined in Article 6 of the ICC Statute as:

> For the purpose of this Statute, "genocide" means any of the following acts committed with intent to destroy, in whole or in part, a national, ethnical, racial or religious group, as such:
> (a) Killing members of the group;
> (b) Causing serious bodily or mental harm to members of the group;
> (c) Deliberately inflicting on the group conditions of life calculated to bring about its physical destruction in whole or in part
>
> Anyone who looks at Iraq in 1990 and Iraq in 2003 after twelve years

of total blockade can only conclude that the imposition of the total blockade caused genocide as defined, and was likely to have been intended to cause it.

The Security Council, in voting to continue the total blockade, breached one of the peremptory norms of international law, the crime of genocide. Nobody really knows how many Iraqis perished during the blockade but UNICEF itself attributed the deaths of 500,000 Iraqi children to this cause.

The dangerous precedent of imposing genocide on Iraq by the Security Council should not be allowed to be repeated: even those of good intentions who believe that economic sanctions afford a "kinder, gentler" recourse than force of arms must be brought to their senses. If the catastrophe that befell Iraq since 1991 until today has not taught us any lesson then the new century brings a bleak prospect for peace, security and prosperity.

It is my view that the Government of Iraq missed an opportunity by failing to challenge the decision of the Security Council to maintain a total blockade by asking the International Court of Justice (ICJ) to give an Advisory Opinion on it. I believe that it would have been difficult for the ICJ to find the imposition of a total blockade on Iraq anything but unlawful and contrary to international law, if not because it was genocide then because it was a form of collective punishment, in its indiscriminate nature of killing and destruction. Although the Opinion of the ICJ is not enforceable and carries no sanction, it remains a powerful legal tool. The Opinion of the ICJ in the case of the mining of Nicaragua by the US has been regularly cited by jurists all over the world. Any Opinion by the ICJ on the imposition of the blockade on Iraq could have assisted many wavering states in refusing to carry on supporting the act by citing the Opinion of the Court as an excuse in the face of US intimidation and coercion. Sadly that opportunity was missed by the Government of Iraq to the detriment not only of Iraq but of the rest of the world as the precedent was not challenged and given impetus to be condemned and stopped.

The Crime of Aggression

An acceptable dictionary definition of aggression may be:

the use of armed force by a state against the sovereignty, territorial integrity or political independence of another state

No sensible person would have any difficulty understanding such a definition. Thus when the UN General Assembly decided to adopt a legal and moral definition it came up with Resolution 3314 on 14 December 1974,[5] after its Special Committee on the Question of Defining Aggression submitted its report.

Aggression is the use of armed force by a State against the

sovereignty, territorial integrity or political independence of
another State, or in any other manner inconsistent with the
Charter of the United Nations, as set out in this Definition.

The Resolution goes on to elaborate on what amounts to aggression
regardless of whether there has been a declaration of war and includes
under aggression: blockades, bombardment of territory of another state,
allowing territory to be used for attack on another, etc. All such acts which
the US/UK mounted in the years from 1991 to 2003 should be viewed as
acts of aggression according to the UN, whose Resolutions the US/UK
governments continuously assert they are upholding.

However, despite showing that a sensible person would find it easy
to accept what aggression is and despite having had the UN agree on such
a definition, we are faced with the alarming discovery that after decades of
negotiation, the international community failed to agree on a definition for
the crime of aggression when drafting the Statute of Rome setting up the
International Criminal Court. Thus Article 5(2) of the Statute of Rome reads:

2. The Court shall exercise jurisdiction over the crime of
aggression once a provision is adopted in accordance with
articles 121 and 123 defining the crime and setting out the
conditions under which the Court shall exercise jurisdiction
with respect to this crime. Such a provision shall be
consistent with the relevant provisions of the Charter of the
United Nations.

It goes on to define the crimes of genocide, crimes against humanity and
war crimes but keeps quiet about the crime of aggression. But as the definition
of the other crimes which the Statute adopted
are all derived from conventions, resolutions of
international bodies and principles of customary
international law, why was it difficult to agree on
a definition for aggression following the same
path?

Why has the new International Criminal Court failed to achieve a definition for the crime of aggression when the definition of other crimes have all been derived from previous instruments?

It does not require great intelligence to
realize that the developing world has no problem
with adopting a definition for aggression identical
to that adopted by Resolution 3314 of the UN.
However, it does put the European imperialists in difficulty. The adoption of
such a definition would for the first time permit an international judicial
institution to criminalize and indict individuals for the commission of acts
which these powers have been conducting over four centuries in every corner

of the world and which they intend to carry on doing, albeit not under the pretence of 'civilizing the savages' but under other pretexts yet to come now that the one on upholding 'human rights' is wearing thin.

Exhibiting the arrogance and vulgarity that it has displayed recurrently and increasingly, the US came out and declared its total rejection of the ICC. It is the other older European imperialist powers, which were referred to by Rumsfeld as 'Old Europe', who have had to balance their pretence of upholding international principles (and hopefully restraining the US) while at the same time securing themselves against being criminalized, even in theory, for the acts of interventions, invasions and occupations they might intend to carry out in future. Serbia, Afghanistan and Iraq are only three samples of their perpetual campaign.

The crime of aggression creates another problem for these powers. It differs from the other three crimes in two ways which makes it more problematic for the imperialists. Firstly, while the other three crimes (war crimes, crimes against humanity and genocide) can only be committed by individuals for the purpose of indictment and criminal proceedings, the crime of aggression is necessarily committed by a state which would make the whole state subject to criminal proceedings. Secondly, the burden of proof is lighter in the case of aggression than in the other three crimes. It would be easier to prove that a state has committed aggression in accordance with Resolution 3314, simply by showing an intent and an attack, than to prove that a war crime was committed which would require details of evidence subject to the principles of admissibility of evidence.

To illustrate this further: it would be easier to see that had the UN definition of aggression been incorporated into the Statute of Rome, then the US/UK invasion of Iraq in 2003 would have been labeled as a 'crime of aggression' by the ICC without much difficulty. Moreover, the Judicial Committee of the House of Lords would have had difficulty denying activists such as Margaret Jones and her colleagues their defense of seeking to prevent a crime of aggression taking place against Iraq by disabling bombers.[6] However, as this has not been incorporated into the Statute of Rome it has become more difficult to argue successfully that there is enough evidence of war crimes and crimes against humanity having been committed in Iraq in the last four years, as many of us who have tried have come to discover— even though a sufficiency of evidence surely exists. This has been especially compromised by the office of the Attorney General in the UK being run by a political appointee of the Prime Minister, who may himself be implicated, along with his boss, in any crime that is committed by the British forces in Iraq, and the same kind of barrier would exist to a similar effort in the US.

For sixty years we have been reminded of the noble principles of international law that were born out of the Nuremberg Tribunal which came to be known as the '*Nuremberg Principles*'. These included war crimes,

crimes against humanity and crimes against peace, the latter defined as:

(i) Planning, preparation, initiation or waging of a war of aggression or a war in violation of international treaties, agreements or assurances;

(ii) Participation in a common plan or conspiracy for the accomplishment of any of the acts mentioned under (i).

During the trial the American prosecutor, Robert H. Jackson, stated:

To initiate a war of aggression, therefore, is not only an international crime; it is the supreme international crime differing only from other war crimes in that it contains within itself the accumulated evil of the whole.[7]

The question that any student of law would put to his tutor, would be to explain the reason for not applying such noble principles to the US and UK over Iraq. More significant, perhaps, would be to explain the reason for the general silence of the jurists in the Anglo-Saxon world, which almost amounts to an acquiescence in the crimes.

The US General View of International Law

The US disrespect for international law and its repeated breach of it, especially since WWII, makes it difficult to refute claims by some in the developing world, like Khomeini, that such a law, which is only used at the convenience of the West, is not worthy of respect.

The refusal of the US to ratify the ICC Treaty is one example of many, although it may be the most significant. That is so because the US not only refused to ratify the ICC Treaty but embarked on a campaign to encourage other states not to sign up to the Treaty, and on failing to succeed in that campaign, it pressured states into entering into bilateral agreements not to apply the ICC law to US citizens, and there, it achieved the acquiescence of over 100 states. By doing this, the US was breaching international law, not simply by not abiding by it but by encouraging other states to break it through these bilateral agreements.

Towards that end, the US passed the American Service-members' Protection Act of 2002 (ASPA) which, "prohibits the United States from providing military aid to countries that have ratified the Rome Statute of the International Criminal Court (ICC)." The ASPA effectively limits US cooperation with the International Criminal Court, restricts US participation in UN peacekeeping, prohibits military assistance to most countries that ratify the ICC's Rome Statute, and authorizes the President to use 'all means necessary and appropriate' to free any US or allied personnel held by or on behalf of the

ICC—a provision that has led European leaders to call it "The Hague Invasion Act."

> Despite the provision banning military aid to ICC countries, the ASPA does provide exemptions if the President waives the requirement for national security reasons or because countries have concluded a bilateral immunity agreement (BIA) with the US. In addition, certain U.S. allies are specifically exempted under the ASPA, including all NATO countries, Argentina, Australia, Bahrain, Egypt, Israel, Japan, Jordan, Kuwait, Morocco, New Zealand, Pakistan, Philippines, the Republic of Korea, Taiwan, and Thailand.[8]

If they wished to assume the moral high ground, European countries could set an example for the rest of the world by applying principles of international law, which were mainly developed by the Europeans, to themselves before expecting others to follow suit. They cannot thus on one hand acknowledge that the US is in breach of international law and at the same time appear very willing to go along with the US in any military venture, whether under NATO or otherwise, knowing and accepting that the US is likely to breach the obligations under international law which those Europeans have signed up to. This problem is especially acute for the UK since invading Iraq was done while the US was clearly not abiding by the relevant treaties and declared its intentions accordingly. An accomplice to a crime is just as guilty as the principal.

George Bush has repeatedly said that he would pursue what is in the US interest irrespective of what the rest of the world thinks or believes. Towards that end he appointed John Bolton, one of the strongest enemies of the UN, to be the US representative there. Alberto Gonzales, the former US Attorney General, is reported to have said that the Geneva Conventions have become irrelevant in the modern world. It is akin to saying that the laws on pornography have become irrelevant because the internet is spreading it. Some may say these are anecdotes and should not be taken seriously, they are for public consumption. But if they are supported by the US refusal to ratify the relevant conventions they do represent the policies of the US.

In addition to the refusal to abide by the ICC Treaty which many states have ratified, the US has failed to ratify at least two conventions relevant to the invasion and occupation of Iraq. These are the Convention on the Rights of the Child, and the Protocol Additional to the Geneva Conventions of 12 August 1949, and Relating to the Protection of Victims of International Armed Conflicts, (Protocol I). The importance of both arises from the fact that they affect the treatment of children specifically and civilians in general at the time of international conflict during the invasion and the occupation.

The refusal of the US to ratify either and adhere to their obligations clearly indicates that the US has every intention of breaching the rights of civilians and children in Iraq.

The Security Council and the Charter

The UN Charter empowers the Security Council in Article 42, when measures taken under Article 41 fail, to use military force but only 'to restore international peace and security'. The Charter, rightly in my view, ensured that any military action must be defined so that states would not feel free to take unilateral military measures and claimed them to be within the guidance of the Charter. The Charter stated two possible routes for military action. The inherent right of individual or collective self-defense if an armed attack occurs against a Member of the UN is guaranteed under Article 51. However, even that right is extinguished once the Security Council seizes of the matter and takes the necessary measures to maintain international peace and security.

The normal method of military action necessitated by the failure of measures taken under Article 41 is to be taken by the Security Council acting in accordance with Articles 43-49.[9]

These Articles lay down a clear procedure for action which leaves no doubt as to the prohibition of any state taking military action if not acting in self-defense against an attack. The main element is that all military actions taken by the Security Council should be under the direction of the Military Staff Committee (MSC), which was set up to consist of the Chiefs of Staff of the permanent members of the Security Council or their representatives (Article 47). It is my opinion that rules of action should be binding and a breach of them render the action unlawful. The reason for setting up the MSC is obvious. The failure of any military action to be under the control and direction of the MSC is a breach of the Charter and thus an unlawful act, irrespective of how noble it may be.

Although it is known that the invasion of 2003 was not carried out with Security Council authority, the attack and destruction of Iraq in 1991 too was not carried out under the supervision of the MSC. The Security Council had the time to organize the action under the direction of the MSC, but it is clear that the US/UK were not going to allow that because their agenda was not to drive Iraq from Kuwait but to cripple Iraq. I would suggest that the supervision of the MSC would not have allowed such a massive assault on the infrastructure of Iraq, but rather be restricted to driving the Iraqi army out of Kuwait.

The Illegality of the 2003 Invasion

On the eve of the invasion of Iraq the following facts were inescapable and unavoidable:

1. No state had claimed to be attacked by Iraq or under threat from Iraq in order to invoke the right of self-defense under Article 51 of the Charter.

2. The Security Council had authorized its inspectors to carry out their mandate searching for alleged WMD and those inspectors asked for a further period to enable them to complete their task.

3. The Security Council had not taken any measure for military action as allowed under Article 42 of the Charter.

4. The MSC was not activated or involved in preparation of any military action against Iraq as required by Article 47 of the Charter.

5. The Security Council was seized of the matter as per Article 5 of its Resolution 1454 of 30 December 2002. When the Security Council is seized of a matter even the right of self-defense is suspended. There was no legal entitlement for *any* action to occur, since the SC seizure had "frozen" the matter until it reached a further decision.

6. The Future for Iraq Project, as outlined in Chapter 2, was in an advanced stage preparing for various policies to be implemented following the overthrow of the legitimate Government of the Sovereign State of Iraq.

It is evident from these facts that the invasion of Iraq was contemplated and then carried out irrespective of international law insofar as the Security Council was already seized of the matter and Iraq was not attacking any state, not least of all those who invaded it in 2003.

The fact that the plan to restructure Iraq after the overthrow of its legitimate Government, which had as much legitimacy under international law as that of the US or the UK or a broad range of other states in the UN, was put in operation in November 2001, makes any claim that the invasion of Iraq in 2003 was to destroy WMD sound very hollow.

Although it is clear that no military action is admissible under international law unless it is under direct control of the Security Council, there are some who still had the audacity to argue that the US/UK were acting in accordance with international law. Thus the Attorney General of the UK, when ordered by the Prime Minister to find a legal justification to offer to his hesitant generals, contrived such a view. This was given in a response to a question in the British Parliament on 17 March 2003 after he had held the view on 7 March 2003 that such action would be a breach of international law. The main element of the letter of the Attorney General is:

2. In Resolution 687, which set out the ceasefire conditions after Operation Desert Storm, the Security Council imposed continuing obligations on Iraq to eliminate its weapons of mass destruction in order to restore international peace and security in the area. Resolution 687 suspended but did not terminate the authority to use force under Resolution 678.

3. A material breach of Resolution 687 revives the authority to use force under Resolution 678.[10]

The flaw in this argument is apparent in the failure to grasp the meaning of the Security Council Resolution and the authority of the Security Council. The first problem which the Attorney General failed to grasp is that the Security Council Resolutions are not statutes which a court could resort to and apply at any time until the statute is amended or repealed. They, that is the Resolutions, are decisions made for a specific situation or need and apply to that specific matter until superseded by another Resolution. Thus when Resolution 678, according to him, authorized the use of force, it was in order to oust the Iraqi army from Kuwait and not for any other purpose. Once that was achieved then the legitimacy of the use of force ended with the ceasefire. If that is not the proper legal interpretation then the Attorney General seems to be suggesting that the Security Council Resolution was open to any state to interpret as enabling it to use force should it conclude that Iraq was still failing to carry out some other obligations apart from departing from Kuwait. That, in my view, would be contrary to legally established justice and procedure, and an invitation to chaos in international relations.

The Attorney General goes on to state that Resolution 687 suspended but did not terminate the authority to use force. Assuming that such an argument is accepted, it still leaves a need for specific authority to resume the use of force by the same authority which suspended it and not by any Member State.

This brings me to the next problem with the Attorney General's apparent misunderstanding of the role of the Security Council. Once the Security Council seizes of a matter, no Member State has the right to act on its own. Iraq was a matter seized of by the Security Council as stated in every Resolution up to 1441 and 1454 prior to the invasion. It is inconceivable that the law advisor to the British Government advised his Prime Minister to act while the Security Council was seized of the matter and had not decided to take any military action. It is understandable for such political rhetoric to be made by a political figure like George Bush but not by the legal advisor to the British Government. The Attorney General knew all along that in order to

initiate military action, the Security Council had to undertake it in accordance with the Charter; he knew that such a Resolution was being sought according to his Prime Minister, and that the Security Council was not willing to authorize any use of force. That was the opinion he had held only two weeks before his 17 March 2003 letter. As all the material in the letter of 17 March 2003 was known when the Attorney General drafted his opinion of 7 March, why did he not reach the same conclusion then and only managed that three days before the invasion?

Knowing that authority was needed to act, knowing that such authority was not going to be granted, and still proceeding to act without it, amounts to an unlawful act.

Could the Security Council Have Given Authority to Attack Iraq?

A good deal has been said and written about whether or not a '*second Resolution*' of the Security Council was needed to authorize military action against Iraq. I hold a different orientation to the issue, which I shall attempt here to explain.

The United Nations was set up, as the preamble to the Charter states, "*to save succeeding generations from the scourge of war*". It is inconceivable that such an organization should be involved in declaring wars. The UN is expected, and the Charter confirms it, to take all measures necessary to stop wars and maintain peace and security. It may be necessary sometimes to take military action to maintain peace such as in putting an end to an aggression against a Member State, but these measures are only to be taken after exhausting all other means. I would emphasize the importance of this awareness because it seems to have fallen prey to the media hype regarding whether or not a second Resolution was required. The simple fact is that the Security Council could not have ordered a military action against Iraq in 2003 without committing a crime itself, since Iraq had not committed nor been proved to have committed any breach of international peace or security. An attack on Iraq in 2003 would have been a breach of Article 2(4) of the Charter.

The Security Council could not have ordered a military action against Iraq in 2003 without committing a crime itself, since Iraq had not committed nor been proved to have committed any breach of international peace or security. An attack on Iraq in 2003 would have been a breach of Article 2(4) of the UN Charter.

If even the threat of force against the territorial integrity or political independence of Iraq by any state amounted to a breach of the Charter, then how was the Security Council expected to authorize such a threat without itself breaching what it was set up to uphold? The invasion of Iraq was

clearly going to be an assault against the territorial integrity and independence of Iraq and the Security Council was not empowered to authorize it, and if it did, it would have acted *ultra vires*. I should reiterate my earlier assertion that the Security Council is not above the law, i.e. neither above the Charter that created it nor the principles of customary international law.

The Security Council in accordance with Articles 42-47, could have authorized some military action under the supervision of its Military Staff Committee and not the US/UK command, which would have had to have a specific remit. However, such a decision would only have been possible once the Security Council had reached the conclusion that Iraq was a threat to international peace and security and not for any other excuse. Debate on the invasion has been continuously diverted into whether or not Iraq complied with the previous UN Resolution. This is insufficient grounds for military action under the Charter. It must be established that such a failure to comply with the UN Resolution did in fact threaten international peace and security, which would require demonstration of both the possibility and intent of imminent use.

The Security Council did not believe in March 2003 that Iraq was a threat to peace and security and that is the reason why both the US and UK did not revert to it for an authorization—because they both knew that they had no convincing argument. Both the US and the UK would have needed more than the ludicrous and embarrassing presentation of Secretary Colin Powell about hydrogen generating vans as '*mobile chemical weapons factories*' and PM Tony Blair's fabrication about Iraq's ability to launch chemical missiles within 45 minutes to reach British bases or tourists in Cyprus.

On the eve of the invasion of Iraq in March 2003, the Security Council could not have authorized military action against Iraq even if it wanted to. Had it passed such a Resolution it would have been in breach of the Charter and the people of Iraq would have been entitled to seek redress from all the members of the Council who took such a decision which has led to the eventual destruction of their country, and the killing of over a million people and the creation of four million refugees in its first four years.

The attack of '*shock and awe*', as declared by the US/UK on Iraq in March 2003, was based on the use of overwhelming decisive force, and as such was a crime under the laws of war. It is a crime to use indiscriminate and disproportionate measures. The principle that makes it unlawful to use such measures has so long been established under customary international law that the ICJ reiterated it in its judgment on the illegality of the threat of use of nuclear weapons.[11] In addition to their declaration of intended use of overwhelming force, the US/UK made it clear that they would use nuclear weapons should a need arise—needless to say, such a statement is unlawful as held by the ICJ.

The '*shock and awe*' was not simply a rhetorical device; it had already been put into practice. On the eve of the March 2003 invasion, Iraq

had been through over twelve years of total blockade. The blockade ensured that no weapons were exported to it by any country. Iraq did not own much of a military industry; by that time all the weapons which were not destroyed in the 1991 attack or by UNSCOM shortly afterwards, had either become obsolete or unusable. Put simply, Iraq in March 2003 had no army that could stand in any battle or be a threat to anybody. The need for the massive use of force was not justified even on any tactical basis. The plan was clear from the moment the bombs started falling on Iraq. At minimum, it was to terrorize the population into submission, secure Baghdad and overthrow the regime. In order to do so the US/UK forces attempted to avoid engaging Iraqi forces as much as possible while pinning down these forces from air and through cruise missiles.

Saifuddin Fulayih Hasan Taha ar-Rawi, Chief of Staff of the Republican Army in 2003, was interviewed by Al-Jazeera TV on the fourth anniversary of the invasion. He talked about the battle at Baghdad Airport which ended the first stage of '*shock and awe*'. The scale and ferocity of that battle as told by ar-Rawi sums up what shock and awe meant and what the Iraqis endured. He is reported to have said that "the enemy used neutron and phosphorus weapons against Baghdad airport... there were bodies burnt to their bones. The bombs annihilated soldiers but left the buildings and infrastructure at the airport intact".[12] He went on to say that 2000 soldiers of the elite Republican Guards fought gallantly and were annihilated. In addition to using Neutron bombs, he claimed that the US used 9-ton bombs and some other bombs that disabled soldiers in the Airport battle. It is not difficult to conclude how an ill-armed army, hearing of an enemy using unheard-of weaponry capable of disintegrating humans, loses the will to fight with its obsolete weaponry. It was no longer about the will to fight but rather a situation in which '*shock and awe*' put one side a light year ahead in weaponry.

The aftermath of the occupation of Baghdad, which signified the surrender of the rest of Iraq, was unforgivable. An occupying force is responsible for the security and protection of people and property in occupied territory. Yet the US soldiers were watching the looting and burning of all ministries and industries with glee. The US argued that it did not have enough men to prevent the looting and arson. That is an unconvincing answer. A curfew immediately after the taking of Baghdad would have prevented the chaos that followed. It is not uncommon after major military operations for the armed forces to impose curfews. It is equally expected that the masses of the people would genuinely heed the advice and stay indoors. Such measures were taken quite successfully at election days and several other occasions during the occupation.

It was not missed by many Iraqis that the US/UK forces managed successfully to prevent the looting of the Ministry of Oil by placing only a handful of soldiers at its entrance which was sufficient to deter any attack on

it. Why didn't the occupiers provide so many handfuls of soldiers to Baghdad Museum and to each of the twenty or so ministries in Baghdad? The failure of the US/UK forces to prevent the looting and arson in Iraq following the occupation was either intended from the outset or they were indifferent to its occurrence. In both cases the occupier would be guilty of failing to carry out its responsibilities as an occupier.

The occupation of Iraq requires a separate consideration.

ENDNOTES

[1] Thirlway, H. , 'The Sources of International Law', *International Law*, ed. Malcolm D. Evans, OUP, 2003, p. 127.

[2] Thirlway, op. cit., p. 130.

[3] Koskenniemi, M., What is International Law For? The Sources of International Law, *International Law*, ed. Malcolm D. Evans, OUP, 2003, p. 97.

[4] See Francis A. Boyle, *Destroying World Order: US Imperialism in the Middle East Before and After September 11th*, Clarity Press, Inc., Atlanta, pp. 106-117.

[5] Definition of Aggression, UN Resolution 3314, 2319th Plenary Meeting, 29th Session, 14 December 1974. <http://daccessdds.un.org/doc/RESOLUTION/GEN/NR0/739/16/IMG/NR073916.pdf?OpenElement>

[6] *R v Jones* (Appellant) (On Appeal from the Court of Appeal (Criminal Division)), [2006] UKHL, 16, 29 March 2006. <http://www.publications.parliament.uk/pa/ld200506/ldjudgmt/jd060329/jones-1.htm>

[7] Crimes against peace, Principle IV(a), Principles of International Law Recognized in the Charter of the Nüremberg Tribunal and in the Judgment of the Tribunal, 1950, International Humanitarian Law:Treaties & Documents. <http://www.icrc.org/ihl.nsf/FULL/390?OpenDocument>

[8] American Servicemember's Protection Act, ASPA, Citizens for Global Solutions,<http://www.globalsolutions.org/issues/bia_resource_center/ASPA>

[9] UN Charter of the United Nations, UN, NY10017, Chapter VII.

[10] Iraq: Legality of Armed Force, Attorney General's Written Answer 17 March 2003, <http://www.publications.parliament.uk/pa/ld200203/ldhansrd/vo030317/text/30317w01.htm>

[11] International Court of Justice, Reports of Judgments, Advisory Opinions and Orders, Legality of the threat or use of nuclear weapons, Advisory Opinion of 8 July 1996 <http://www.icj-cij.org/docket/files/95/7495.pdf>

[12] US Accused of Using Neutron Bombs, AlJazeera.net/English, April 9, 2007, <http://english.aljazeera.net/NR/exeres/BA8304F2-89FE-49DC-8FB0-2212FE7889F7.htm>

CHAPTER 4

THE OCCUPATION OF IRAQ DURING BREMER'S RULE

This chapter addresses the outcome of the occupation during Bremer's absolute rule of Iraq, which laid down the bases on which the 'New Iraq' was designed in Washington and how Iraq is in the process of being systemically overhauled. This restriction of consideration is brought about by the time period germane to the subject of this book. It does not mean an acknowledgment on my part that the occupation ended in June 2004 as claimed by the US/UK authorities and their men in Iraq. It is not important that any organization, even the Security Council, can describe an occupation as anything else, as already defined under international law. Occupation by definition is an invasion plus taking possession of enemy country even if that were temporary. International law accepts that occupation ends in one of two ways—either the occupant withdraws or is driven out. As neither has happened and as the Prime Minister of the shadowy government in Baghdad has declared that he has no authority to move a company of police around the country, then Iraq is under occupation, irrespective of what the occupiers and the Security Council, which they largely control, would like us to believe. I am not alone in believing Iraq to be still occupied. On 28 February 2007 a bill was introduced in the House of the Representatives of the US Congress under number HR 1234 seeking *"To end the United States occupation of Iraq immediately."*

On 28 March 2003, a week after the beginning of the invasion and while missiles were showering Iraq and US/UK tanks were speeding across the desert, the Security Council passed Resolution 1472. Anyone who reads the Resolution would not be able to conclude that a member state of the United Nations is being invaded. It sounds like a caring Resolution dealing with a humanitarian crisis. If students of law are asked to point out an instance of futility and incompetence in the history of the UN, they need not go beyond pointing to Resolution 1472. The least that would have been expected of the Security Council on 28 March 2003 was a call for an immediate cessation of all military activities in Iraq. The proper measure ought to have been a

condemnation, followed by an undertaking by the UN for the restoration of the sovereign state of Iraq, and for full reparation to be made by the aggressors, in accordance with the principles of international law. The last clause in Resolution 1472 states that the Security Council "Decides to remain seized of the matter". What the Council failed to specify was: which matter was it to remain seized of?

Apart from the single clause in Resolution 1476 of 24 April 2003 affecting the validity of one clause in Resolution 1472, the Security Council remained silent on Iraq until 22 May 2003 when Iraq was fully occupied and the machinery of the state had been fully dismantled. This was the first time since the creation of the United Nations that one of its founding members had been occupied and dismantled, yet the United Nations did not even manage to condemn the act. The reason for this failure is simple: the same powers that control the United Nations through control of the Security Council were carrying out the aggression. They managed through that control to prevent any action being taken until they decided that a new Resolution was needed to support their plans and indeed, to provide the veneer of legality. To make matters clear, even to a novice in politics, such a Resolution was only passed after the US/UK circulated their letter of 8 May 2003.

Letter from UK/US to the Security Council On Their Intentions in Occupying Iraq

After the spectacle of President George Bush appearing on the *USS Abraham Lincoln* on 1 May 2003 to declare that the "Coalition of the Willing" had won the war, the UK and the US Governments circulated a letter on 8 May 2003 to members of the Security Council in which they set out their intentions.[1] The letter set out the purpose of the invasion but like a typical colonial document it is littered with misleading statements and lies. I shall first attend to the lies before looking at the declared intention of the invasion, which itself is partly fiction.

1. The first misleading statement comes in the first sentence of the letter which says: "The US, the UK and Coalition partners continue to act together to ensure the complete disarmament of Iraq of weapons of mass destruction.." This sentence clearly implies that the invasion was done with authority of the UN in order to disarm Iraq, which is clearly not the case.

2. In the first paragraph the letter says: "The States participating in the Coalition will strictly abide by their obligations under international law". That was never intended as it was clear from the Future of Iraq Project (see chapter 2) that the occupation was planned to breach

international law through changing the political, economic and social structure of Iraq—a change which is totally prohibited under international law.

3. The first paragraph goes on to state: "We will act to ensure that Iraq's oil is protected and used for the benefit of the Iraqi people". This sentence is almost comical. Not even the imperialist oil companies make a secret of their designs on Iraq. Following the 1958 military coup that ousted the monarchy, the imperialist oil companies lost 96 percent of the land of Iraq. In 1972 all Iraqi oil was nationalized and the people of Iraq managed their oil alone for their own benefit. The fact that all health and education became free and all utilities were almost free is a manifestation of the benefit that nationalization of oil has brought to the people of Iraq and thus of the social responsibility of Saddam Hussein's regime. The new Iraqi oil law which the present puppet government of Iraq is being pressed to sign would institute new "production-sharing agreements" under which foreign companies would now pay to Iraq a profit margin of a miniscule twelve percent on its own resource.[2]

4. In the second paragraph of the letter, the US/UK informed the Security Council that in order to meet the above objectives, they "have created the Coalition Provisional Authority (CPA), which includes the Office of Reconstruction and Humanitarian Assistance (ORHA)". A reader who has no prior knowledge would be led to believe that ORHA was created as part of the CPA, but that is not true. ORHA had already been created on an order by George Bush on 20 January 2003,[3] long before the invasion and the creation of the CPA. In fact the CPA was created to replace ORHA.[4] When Jay Garner was ruling Iraq, the administration was still the ORHA, established on 20 January. However, when Bremer became the viceroy, he set up the CPA.

5. In the penultimate paragraph the letter says: "Our goal is to transfer responsibility for administration to representative authorities as early as possible". This is a misleading statement however it is interpreted. All documents and reports that have been discovered since the invasion indicate that the intention of the occupiers has always been to stay in Iraq for the foreseeable future and in any case for no less than ten years. It would be misleading to talk about leaving as early as possible when the occupier had planned to stay in Iraq for a period comparable to its stay in Germany, South Korea or Japan, and when the world's largest embassy was still in construction, with fourteen "permanent" bases constructed.

The purpose of the invasion is more accurately outlined in the third and fourth paragraphs of the letter. In the third long paragraph the letter goes on to detail the measures to be taken to disarm Iraq and ensure it will not have the future potential of developing any such weapons. When one reads the paragraph, one begins to think that the invaders have lied so much about Iraq's weapons of mass destruction that they have come to believe their lies. On the eve of the invasion every significant body in the US/UK intelligence, the military and the scientific community—to say nothing of ordinary members of the public who protested in their millions all around the world—knew that Iraq did not have these weapons. The UN inspectors found no trace leading to their existence and were nearly completing their inspection. The irony of this statement is that it purports to detail a noble act by members of the UN, who themselves are not simply the biggest producers of weapons of mass destruction, and have the largest arsenals of them, but have in fact used them in the past.

The fourth paragraph admits to the more likely purpose of the invasion and occupation, namely to change the regime in Iraq. If the purpose of the invasion had been to disarm Iraq, then the noble member states of the US and the UK would have simply ensured either that Iraq was disarmed or verified that it had no such weapons, and withdrawn their forces to leave the sovereign state of Iraq to function as it had done. Sanctions could have been lifted and Iraq allowed it to exist like every other member state of the UN.

US/UK Crafting of SC Resolution 1483

It was on the basis of the US/UK letter of May 8, 2003 and its undertaking by the occupying powers that the Security Council passed Resolution 1483 of 22 May 2003[5] as the legal hook on which the occupation of Iraq was to hang its legitimacy. It should be stressed that the Security Council avoided any reference to the illegality of the invasion. It dealt only with occupied Iraq as a *'fact on the ground'* and called for principles of international law for occupied territories to be applied. By this measure both sides of the argument—the invaders claiming lawful action and those opposed, while failing to proclaim it in public, at least holding to their recognition that the invasion was unlawful—managed not to concede anything. Nonetheless, the UN Security Council thereby set aside its role as independent arbitrator and became complicit in the felony to occupy and pillage a sovereign state. Resolution 1483 reveals the identity of its drafter from its fourth paragraph. It states:

> Welcoming the first steps of the Iraqi people in this regard, and noting in this connection the 15 April 2003 Nasiriyah statement..

What was the Nasiriyah statement and who knew about it so that it could be included in a Security Council Resolution? Ahmad Al-Chalabi was transported by US planes with his guards to Nasiriayh in southern Iraq where he held a small meeting of his group and made a speech and a declaration. Ahmad Al-Chalabi, contrary to what the media has made of him, was not a political activist at any time in his life. He knows nothing about Iraq, having lived away from it for 45 years. He had no connections in Iraq, no political party, no popular base, no popular appeal and all his supporters came with him from abroad. It raises questions as to why the Security Council assumed that such a man had any political future in Iraq or that he appealed to any Iraqis, so that it welcomed his statement? The only people who considered him to be so vital and turned out to be so plainly wrong have been the hawks in the Pentagon, who derived through Chalabi and the Iraqi National Congress a major portion of the information on which U.S. Intelligence based its condemnation of Saddam Hussein, including reports of weapons of mass destruction and alleged ties to Al-Qaeda. The Security Council must have relied on these convictions to include such a reference in such a historic resolution. There are three features in the Resolution relevant to this matter, which require further consideration.

The first comes in the preamble of the Resolution where the Security Council took notice of the letter of 8 May 2003 and recognized "the specific authorities, responsibilities, and obligations under applicable international law of these states as occupying powers under unified command as 'the Authority'". In doing so the Security Council accepted the undertaking of the occupying powers of the US/UK Coalition and bound them by it.

The second element which is a further confirmation of the above binding responsibility came in clause 5 of the Resolution:

> ...Calls upon all concerned to comply fully with their obligations under international law including in particular the Geneva Conventions of 1949 and the Hague Regulations of 1907.

The third element relevant to our analysis came in clause 12 of the Resolution dealing with the setting up of the Development Fund for Iraq (DFI) meant to handle Iraq's assets and revenue from the sale of oil, which was to be monitored by the International Advisory and Monitoring Board whose members included qualified representatives of the Secretary-General, of the Managing Director of the IMF, of the Director-General of the Arab Fund for Social and Economic Development, and of the President of the World Bank.

The reference in paragraph 12 of the Resolution to the setting up of the DFI gives the impression that such a body was created legally. This is very disturbing because the DFI was created by the US to control Iraq's

money, that already existed in the form of frozen assets and the new money arising from the sale of oil. It is very rare for the Security Council to acquiesce in one state assuming control over the assets of another. This led to the unlawful unfreezing and transfer of Iraq's money to the Fund which resulted in Bremer's being able to squander some $9 billions of Iraq's money in one year.

The Security Council acquiescence led to the unlawful unfreezing and transfer of Iraq's money to the US, resulting in the loss of $9 billion of Iraq's money in one year.

Obligations of Occupiers under International Law

Although the Security Council Resolution speaks of international law in general and the Geneva Conventions and the Hague Regulations in particular, we will restrict our consideration to the adherence of the occupying powers to the particular treaties of Geneva and the Hague.

The Hague Regulations

The Hague Regulations of 1907 comprised the Regulation Concerning the Laws and Customs of War on Land annexed to Convention (IV) Respecting the Laws and Customs of War on Land which was signed on 18 October 1907 and entered into force on 26 January 1910. The following Articles of the Hague Regulations will be referred to when considering the breaches of international law during the occupation of Iraq.

Art. 4. Prisoners of war are in the power of the hostile Government, but not of the individuals or corps who capture them.

Art. 8. Prisoners of war shall be subject to the laws, regulations, and orders in force in the army of the State in whose power they are.

Art. 42. Territory is considered occupied when it is actually placed under the authority of the hostile army.

Art. 43. The authority of the legitimate power having in fact passed into the hands of the occupant, the latter shall take all the measures in his power to restore, and ensure, as far as possible, public order and safety, while respecting, unless absolutely prevented, the laws in force in the country.

The Geneva Conventions

There are four such Conventions that had replaced earlier Conventions.

The First Convention is for the Amelioration of the Condition of the Wounded and Sick in Armed Forces in the Field. The Second Convention is for the Amelioration of the Condition of Wounded, Sick and Shipwrecked Members of Armed Forces at Sea. The Third Convention deals with the Treatment of Prisoners of War. The Fourth Convention deals with the Protection of Civilian Persons in Time of War. We are interested here in the Third and Fourth Conventions, with the relevant articles as follows:

The Third Convention

Article 4
A. Prisoners of war, in the sense of the present Convention, are persons belonging to one of the following categories, who have fallen into the power of the enemy:

1. Members of the armed forces of a Party to the conflict as well as members of militias or volunteer corps forming part of such armed forces.

Article 82
A prisoner of war shall be subject to the laws, regulations and orders in force in the armed forces of the Detaining Power; the Detaining Power shall be justified in taking judicial or disciplinary measures in respect of any offence committed by a prisoner of war against such laws, regulations or orders. However, no proceedings or punishments contrary to the provisions of this Chapter shall be allowed.

If any law, regulation or order of the Detaining Power shall declare acts committed by a prisoner of war to be punishable, whereas the same acts would not be punishable if committed by a member of the forces of the Detaining Power, such acts shall entail disciplinary punishments only.

Article 118
Prisoners of war shall be released and repatriated without delay after the cessation of active hostilities.

The Fourth Convention

Article 54
The Occupying Power may not alter the status of public

officials or judges in the occupied territories or in any way apply sanctions to or take any measures of coercion or discrimination against them, should they abstain from fulfilling their functions for reasons of conscience.

This prohibition does not prejudice the application of the second paragraph of Article 51. It does not affect the right of the Occupying Power to remove public officials from their posts.

Article 64
The penal laws of the occupied territory shall remain in force, with the exception that they may be repealed or suspended by the Occupying Power in cases where they constitute a threat to its security or an obstacle to the application of the present Convention. Subject to the latter consideration and to the necessity for ensuring the effective administration of justice, the tribunals of the occupied territory shall continue to function in respect of all offences covered by the said laws.

The Occupying Power may, however, subject the population of the occupied territory to provisions which are essential to enable the Occupying Power to fulfill its obligations under the present Convention, to maintain the orderly government of the territory, and to ensure the security of the Occupying Power, of the members and property of the occupying forces or administration, and likewise of the establishments and lines of communication used by them.

Article 70
Protected persons shall not be arrested, prosecuted or convicted by the Occupying Power for acts committed or for opinions expressed before the occupation, or during a temporary interruption thereof, with the exception of breaches of the laws and customs of war.

Article 147
Grave breaches to which the preceding Article relates shall be those involving any of the following acts, if committed against persons or property protected by the present Convention: wilful killing, torture or inhuman treatment, including biological experiments, wilfully causing great

suffering or serious injury to body or health, unlawful deportation or transfer or unlawful confinement of a protected person, compelling a protected person to serve in the forces of a hostile Power, or willfully depriving a protected person of the rights of fair and regular trial prescribed in the present Convention, taking of hostages and extensive destruction and appropriation of property, not justified by military necessity and carried out unlawfully and wantonly.

Security Council Resolutions Post Invasion

The Security Council has passed several resolutions on Iraq since the invasion and occupation and many more in the period 1990-2003. Some of these resolutions bring into question the legality of the Security Council's action. But this is not the place for such an argument. What matters for this book are the resolutions that had been used during the occupation of Iraq which are relevant to the trial of Saddam Hussein. While in the narrow sense this would mean looking at one Order only which was passed by Bremer, that would only portray part of the picture. The trial of Saddam Hussein has to be seen within its broader context—the pursuit of regime change in Iraq as a starting point for US domination of Iraq in line with its further gradual domination of the Middle East. This would necessitate a look at other measures taken by Bremer in Iraq during his year of absolute rule. The only two other Security Council Resolutions, in addition to 1483, on which Paul Bremer relied in his legislation for Iraq are Resolutions 1511 and 1546.

Resolution 1511 (October 16, 2003)

There are many issues raised by Resolution 1511[6] that require careful consideration. However, I will consider only three of them. In clause 1 of the Resolution, the Security Council reaffirms a principle of international law, the importance of which will be revealed when we consider the legislations made by Bremer. It reads:

1. Reaffirms the sovereignty and territorial integrity of Iraq, and underscores, in that context, the temporary nature of the exercise by the Coalition Provisional Authority (Authority) of the specific responsibilities, authorities, and obligations under applicable international law recognized and set forth

in resolution 1483 (2003), which will cease when an internationally recognized, representative government established by the people of Iraq is sworn in and assumes the responsibilities of the Authority, inter alia through steps envisaged in paragraphs 4 through 7 and 10 below.

The significant phrase is '*the temporary nature of the exercise of responsibilities, authorities and obligations*'. Here, the Security Council is reiterating a fundamental principle of international law intended to prevent an occupier changing the nature or structure of the occupied territory for obvious reasons. The confirmation of the principle in this Resolution plainly means that the CPA/Bremer had no legal authority to take any measure that in effect would have led to permanent changes in Iraq. I shall show later that almost all of the legislation made by CPA/Bremer in the year of absolute power was designed to be permanent and thus clearly in breach of Resolution 1511.

The CPA/Bremer had no legal authority to take any measure that in effect would have led to permanent changes in Iraq.

In clause 3, the Security Council, in its pursuit of that elusive balance of acquiescing in the occupation but attempting to appear to give the Iraqis some say in their destiny, states that it:

Supports the Governing Council's efforts to mobilize the people of Iraq, including by the appointment of a cabinet of ministers and a preparatory constitutional committee to lead a process in which the Iraqi people will progressively take control of their own affairs.

The above clause gives the impression that the Governing Council of Iraq, which was appointed by Bremer, has had any real power other than on paper. However, the reality was far from that. Relying on the legislation made by Bremer it appears that the Governing Council was dissolved on 1 June 2004 as stipulated in Regulation No. 9 of 9 June 2004. The appointment of cabinet ministers to which the Security Council Resolution referred was made by Regulation No. 10 of 9 June 2004. Thus, when the ministers were appointed, the Governing Council no longer existed and could not have appointed them.

As further evidence of the lack of any power or authority at the disposal of the Governing Council, note that Bremer had already issued Memorandum No. 9 on 25 February 2004, two thirds through the life of the Governing Council, in which he took away the Council's simple authority of appointing Deputy Ministers, which the Council assumed it had had, and replaced it with the following:

>The Administrator [Bremer] shall have the exclusive authority
>to appoint Deputy Ministers.

Although Bremer did not bother to give any reasons, as with all his legislation, even for this change of *his own rules*, it suffices to show that the Security Council could not have been further from reality in suggesting that the Governing Council was mobilizing the people of Iraq.(clause 3 of Resolution 1511.)

In clause 23 the Resolution calls for the establishment of an International Advisory and Monitoring Board (IAMB), which ought to have been set up in accordance with Resolution 1483 of 22 May 2003, to monitor the spending of Iraq's assets by the CPA. The Council did not express its concern at the failure of the US/UK to set up IAMB whose membership was defined in Resolution 1483 despite the fact that five months had lapsed and Iraq's assets were being squandered by the CPA, as was later revealed.

Resolution 1546 (June 8, 2004)

This Resolution[7] is not less problematic than the entire train of Security Council Resolutions on Iraq since 1991. There are three points worthy of note in the Resolution.[8]

1. Clause 1 endorses the formation of the interim government of Iraq which the Council expected would assume responsibility and authority 'while refraining from taking any actions affecting Iraq's destiny beyond the limited period until an elected Transitional Government of Iraq assumes office as envisaged in paragraph 4 below'. This, in my opinion, goes to support the argument that the CPA should not have taken any measure with a permanent affect in Iraq. If an interim Iraqi Government is not entitled to take any such measure with a permanent effect then it stands to reason that no foreign authority should be able to do so.

2. The Council seems to have come up with a new definition of sovereignty. It seems to suggest that a state may be occupied but the government of that state can still claim it is exercising sovereignty. Changing the definition of sovereignty is not the prerogative of the Council because it goes against the understandings established over centuries. Occupation is a negation of sovereignty. The reference to the interim government of Iraq as being sovereign [9] is a contradiction in terminology, let alone in law. Acting under the same delusion, the Council went on to accept that the appointed Prime Minister of Iraq had the authority to enter into an agreement with the occupiers and

to request them to stay in Iraq. What the Council has missed is what many Iraqis have argued since, namely that it was the occupier who appointed the interim Prime Minister, who in turn asked the occupier to stay. How is it possible to refute the argument that the condition of appointing X as PM is that X would ask those who appointed him to stay and protect him? That is a long way from sovereignty. It is a trick relying on the gullibility of the international community.

It was the occupier who appointed the interim Prime Minister, who in turn asked the occupier to stay. Iraq remained occupied, whatever name the US and the Security Council gave to the occupying force.

Iraq remained occupied, whatever name the US and the Security Council gave to the occupying force. Calling it the multinational force as the Council has done in Resolution 1546 does not make it any less of an occupying power. Iraq remains occupied so long as it is put under the authority of foreign armies. This fact has long been accepted and incorporated in Article 42 of the Hague Regulations 1907: "Territory is considered occupied when it is actually placed under the authority of the hostile army."

3. In clause 17 the Resolution condemns all acts of terrorism in Iraq, citing several of its previous Resolutions. There is nothing wrong with condemning terrorism but there is a problem when terrorism is defined as the US wishes, and as the Security Council subsequently agrees, to be only acts of individuals. The Security Council must accept that terrorist acts are equally likely, if not more likely, to be committed by states. Resolution 1546 was adopted on 8 June 2004, almost two months to the day after the massive attacks by the US on the town of Fallujah in west Iraq. The attack led to complete residential areas being leveled to the ground and hundreds, if not thousands, of civilians killed and buried in mass graves. I lost relatives, children among them, and have photos of the leveled districts which I took after I visited the town. If there ever were an act of terror committed in Iraq at any time in the last century it was the attack on Fallujah in April 2004. Yet the Security Council thought it was fit to condemn individual terrorist attacks and avoided any reference to US actions in Fallujah. No life is more precious than another, and a crime is not less so for having been committed by a state. The names of the very few who were mentioned in some Security Council Resolutions as having been killed in Iraq accords them a greater humanity than the anonymous women and children murdered by US attacks in Fallujah in April 2004.

The Arrival of Paul Bremer

It is now obvious that when the US/UK decided to invade, they either thought that with a magic wand everything would fall into order soon after the invasion or they didn't care whichever way it went. I hate to make a judgment as to which one it was. But whatever the intention, the outcome would have been the same, simply because there was no plan on what to do after Iraq was occupied, the State Department's Future of Iraq Project, notwithstanding.

Anyone who looks at the chaos of the administration that followed the fall of Baghdad cannot but feel that the US/UK could not have been so ignorant of what occupation of a country like Iraq entailed. Thus they allowed the mob to loot and burn down every ministry, except the ministry of oil, while they stood idle and watched. It could have been easily prevented with a curfew similar to one of those they have imposed intermittently since. Jay Garner arrived in Baghdad 12 days after it was taken over by US troops. Garner held a meeting in the Presidential Palace on 28 April 2003 with some of the Iraqi exiles who were brought back on the back of the US tanks. The intention was to discuss what to do next, as nobody seemed to know. What Garner did not tell his gathering was that the night before the meeting he had been told by Rumsfeld that he was being replaced by Bremer and ORHA by the CPA.

Paul Bremer was a protégé of Henry Kissinger. His appointment as a supreme ruler of Iraq with absolute power and full authority afforded the Zionists a golden opportunity to implement their plan for Iraq which no war instigated by or directly involving Israel could have secured.

It has already been shown in Chapter 2 that the invasion and occupation of Iraq was planned a long time before the whole fabricated fuss about WMD was used as a pretext for invasion. Anecdotal evidence during the year of Bremer's rule supports the contention that the purpose has always been to occupy Iraq with the incredible dream of setting up an American model in the Middle East:

- On the plans for Iraq's economy Bremer is reported to have declared, following his arrival in Iraq that: "It's going to be a very wrenching, painful process, as it was in Eastern Europe after the fall of the Berlin Wall". "If we don't get their economy right, no matter how fancy our political transformation, it won't work".[10]

- On the political objective it is reported that he wanted his arrival in Iraq to be "marked by clear, public and decisive steps to reassure Iraqis that we are determined to eradicate Saddamism".[11] Eradicating Saddamism or Ba'athisim had nothing to do with the declared

objective of the war being the disarming of Iraq; it is about eradicating a nationalist ideology which in its foundation was anathema to US imperialist objectives.

- In order to show how far up the hierarchy the plans for transforming Iraq were, we look at one declared intention by one of George Bush's men sent to Baghdad. Thomas Foley, an investment banker who was with George Bush at Harvard Business School was appointed to manage Iraq's private-sector development. A week after arriving he told a contractor that he intended to privatize all of Iraq's state-owned enterprises within 30 days. When he was told that international law prohibits occupiers dispensing with assets in occupied territories, he responded: "I don't give a shit about international law. I made a commitment to the president that I'd privatize Iraq's businesses".[12]

The CPA Institutes Systemic Change in Iraq

As viceroy of Iraq during the thirteen months as an Administrator of the Coalition Provisional Authority (CPA), Paul Bremer promulgated 12 Regulations, 100 Orders and 16 Memoranda. Regulations were the instruments defining the institutions and authorities of the CPA. Orders were binding instructions issued by the CPA and Memoranda were interpretations of the Regulations and Orders. Bremer gave himself the right to issue Public Notices which had the effect of legislation for all practical purposes. Thus the occupying power whose authority, according to international law, was restricted to securing peace and order for the occupied territories and the security of its personnel, ended up promulgating more legislation in almost every field of life—from the formation of Judicial Council to traffic signs—than had the Government of Iraq in the previous year. I shall attend later to the main legislation during the overt occupation period. However, I would like to highlight the main purpose of the legislations as stated in the preamble of some of the 100 Orders.

The preamble to Order No. 39 on Tax Strategy for 2003 states that it is:

> determined to create conditions suited to the economic reconstruction of Iraq.

The preamble to Order 56 on Central Bank Law states that it is:

> determined to stabilize domestic prices and to foster an economic climate conducive to the establishment of a stable and competitive market economy.

The preamble to Order 64 Amending the Company Law of 1997 states that it is being made:

> for the development of Iraq and its transition from a non-transparent centrally planned economy to a free market economy characterized by sustainable economic growth through the establishment of a dynamic private sector, and the need to enact institutional and legal reforms to give it effect.

Before addressing some of the main features of the legislation by Bremer, we need to address two fundamental issues relevant to the legislation as a whole. Unless these two concerns are addressed properly the argument about the legislation becomes pointless. The first issue relates to the Constitution of Iraq and the second to the creation and authority of the CPA.

The Iraqi Constitution of 1970

The fundamental principle under international law that has since been incorporated in Article 43 of the Hague Regulation as cited above, is that *no change in the laws of the occupied land should be a consequence of the occupation*. It is also a principle of law that the legitimacy of legislation is derived from a higher authority. In any state, such authority is enshrined in the constitution, be that written or unwritten as in the rare case of the UK. On the eve of the invasion and occupation of Iraq, the constitution in force was the Iraqi Constitution 1970 which was promulgated by Revolutionary Command Council Order No. 792 on 16 July 1970.

The Hague Regulations: No change in the laws of the occupied land should be a consequence of the occupation.

A Constitution remains in force until repealed or replaced by a new document promulgated by a legitimate authority. Nothing in the invasion, occupation or even the timid Security Council Resolutions changes this fact.

It can undoubtedly be argued that the Iraqi people were entitled to adopt a new Constitution. I have no problem with that, but I do refuse to accept that a Constitution could be adopted under occupation irrespective of how free the process is. There have been few precedents since WWII in which a state was fully occupied and given a new Constitution while still under occupation.

However, even if it were to be accepted as legitimate that the Iraqi people were entitled to adopt a new Constitution even under occupation, the fact remains that such a Constitution was only adopted at the end of 2005.

This means that up until December 2005 the only Constitution in force in Iraq was still the Iraqi Constitution 1970. This brings into question the legitimacy of any legislation promulgated by the CPA, which conflicted with the 1970 Iraqi Constitution. Could Iraq truly be regarded as a legislative "clean slate" on which the CPA could write at will?[13]

The burden to justify the legitimacy of setting up the Iraqi Special Tribunal (IST) is on those who claim that the legislation setting up the IST was done in accordance with the rule of law.

Regulation No. 1

On 16 May 2003, Paul Bremer promulgated his first legislation in Iraq in the form of Regulation 1.[14] The importance of Regulation 1 is visible from its inception, reflected in the range of powers asserted in its text:

1. In the preamble to regulation 1 Paul Bremer, the administrator of the Coalition Provisional Authority (CPA) states:

 > Pursuant to my authority as Administrator of the CPA, relevant UN Security Council resolutions, including Resolution 1483 (2003), and the laws and usages of war, I hereby promulgate the following.

 But Security Council Resolution 1483 was only adopted on 22 May 2003—six days after Bremer promulgated his Regulation basing his authority upon it. It was therefore unlawful. A further question, surely, must be: how did Bremer know that Resolution 1483 was going to be adopted; how did he know what the terms were and more importantly how did he conclude that the Council was not going to modify the US draft in those SIX days. The only explanation seems to be the commonly held view, not just in the Arab World but also in large parts of the developing world in Asia, Africa and South America, that the Security Council has become a tool of US policy in which Resolutions are drafted by the Americans and approved by the Council—a situation which renders the Security Council irrelevant to any true process of law or justice in the perception of the developing world.

 Security Council Resolution 1483 was adopted on 22 May 2003—six days *after* Bremer promulgated his Regulation basing his authority upon it.

2. Assuming that by some legal trickery a way is found for Bremer to justify his reliance on an authority that did not yet exist, we proceed

to look at the Regulation and consider Section 1 paragraph 2 which reads:

> The CPA is vested with all executive, legislative and judicial authority necessary to achieve its objectives, to be exercised under relevant UN Security Council resolutions, including Resolution 1483(2003), and the laws and usages of war. This authority shall be exercised by the CPA Administrator.

Paul Bremer, who signed the Regulation, gave himself absolute power in Iraq which no dictator in the history of Iraq has ever dared to claim. Not even Saddam Hussein, from whom the US/UK purport to have liberated Iraq, ever claimed to exercise executive, legislative and judicial authority. But the disturbing fact in this assumption of absolute power is that, contrary to what Bremer claimed, it is a breach of international law. It is inconceivable for international law to grant an occupying power any legislative or judicial authority, albeit some temporary executive authority is conceded. If anything, international law makes it very clear that an occupying power does not have the right to legislate to change the judiciary system in the occupied territories, let alone all the other systemic changes Bremer went on to institute.

Paul Bremer gave himself absolute power in Iraq, which no dictator in the history of Iraq has ever dared to claim.

Article 43 of the Hague Regulation 1907, which was specifically stated in Resolution 1483 as binding on the occupying power, as cited above, calls on the occupier to respect, unless absolutely necessary, the laws in force in the country. That stipulation seems to negate what Bremer meant in Regulation 1 and went on to expand upon.

3. In confirming his intention to legislate for Iraq Bremer goes on in Section 3 paragraph 1 after defining Regulations, Orders and Memoranda, to state that:

> Regulations and Orders issued by the Administrator shall take precedence over all other laws and publications to the extent such other laws and publications are inconsistent.

4. This colonialist arrogance reaches its zenith in Section 3 paragraph 2 when Bremer refers to the language used, stating:

The Regulation or Order shall enter into force as specified therein, shall be promulgated in the relevant languages and shall be disseminated as widely as possible. In the case of divergence, the English text shall prevail.

This colonialist is not simply telling Iraqis *'I am supreme in your land'* but that *'my language is supreme and it would be your misfortune not to understand legislation made for you but in an alien tongue'*. We, the people of Iraq, are grateful to Allah that the Code of Hammurabi was not written in Latin!

Regulations, Orders and Memoranda

Regulations, Orders and Memoranda were promulgated by Paul Bremer with the declared intention of changing Iraq into a market economy. They also effectively set out to convert a semi-socialist, secular state in the Muslim world into a divided society, geared to pumping oil and consuming Western goods in the service of American capitalism. This capitalist model is detached from and contrary to Iraq's Islamic roots. It aspires to impose fictitious ideals that accord with neither the values nor the identity of the Iraqi people.

Bremer set out to convert a semi-socialist, secular state in the Muslim world into a divided society, geared to pumping oil and consuming Western goods in the service of American capitalism.

It is instructive to divide these legislations into different categories. The division may not be ideal and some may fall within more than one division. However, the divisions assist in showing how the legislation has been manipulated to transform Iraq into that intended model, which is only an unrealistic figment of the imagination of some American minds. A full analysis of all the legislation would divert from the theme of this task and ought to be considered separately. However, I do believe some overview of these legislations would put the Trial within the right context.

Economic Legislation

In twelve months four Regulations and over twenty Orders, promulgated with the clear intention, repeated in the preamble of all of them and stated plainly in the preamble of Order 64, to be:

for the development of Iraq and its transition from a non-transparent centrally planned economy to a free market

economy characterized by sustainable economic growth through the establishment of a dynamic private sector, and the need to enact institutional and legal reforms to give it effect.

It is vital to point out here that in all the economic regulations and orders, Bremer relied on Resolution 1483 as his authority to legislate. As we have seen above, the Resolution bound the occupying powers to international law and especially The Hague Regulation and the Geneva Conventions. This international law does not enable the occupier to change the law of the occupied territory but demands that it respect the law of that territory. In short, Bremer was in breach of the law from which he claimed to have derived his authority.

Regulation 2, on 10 June 2003, incorporated the Development Fund for Iraq (DFI) into Iraqi law. As we have already shown, this Fund was created by the US to act as the Iraq Central Bank, laying claim to Iraq's frozen assets, already in the hands of the US and its allies' banks, and to future revenue from the sale of Iraq's oil. The DFI, which was run by the US, is the successor to the Oil for Food Program, which was run by the UN. In fact over $8 billion in the Oil for Food Program was transferred into the DFI by the UN Security Council.[15] This illustrates once again how the Security Council has become a tool of US policies. Why else would it transfer Iraq's assets in its custody to the occupying power? It looked like a reward for the invasion and occupation.

Despite the Security Council having demanded in Resolution 1483 of 22 May 2003 that the Fund be monitored by the IAMB, no such Board was set up, as the Security Council acknowledged in its Resolution 1511 of 16 October 2003. Having found it proper to hand over Iraq's assets to a body consisting of unknown people, the Security Council did not even criticize the failure to have the functioning of the Fund monitored. In order to see what happened to Iraq's assets and oil revenues during Bremer's rule, we will consider only the report of Representative Henry Waxman to US Congress.

> The documents from the Federal Reserve indicate that the United States shipped nearly $12 billion in U.S. currency to Iraq between May 2003 and June 2004, an international currency transfer of unprecedented scale. The cash was drawn from accounts containing revenues from sales of Iraqi oil and frozen and seized assets of the former regime.
>
> Nearly half of the currency shipped into Iraq under U.S. direction—more than $5 billion—flowed into the country in the final six weeks before control of Iraqi funds was returned to the interim Iraqi government on June 28, 2004.

In the week before the transition, CPA officials ordered the urgent delivery of more than $4 billion in U.S. currency from the Federal Reserve, including one shipment of $2.4 billion— the largest shipment of cash in the bank's history.[16]

Despite all these sums of money having been transferred to Iraq, Bremer left Iraq in June 2004 without having executed one single project .

Regulation 3 set up, on 18 June 2003, the Program Review Board to recommend expenditures of resources from DFI in a manner that meets the interests of the people of Iraq. The Board was further entrusted with reviewing all identified requirements for the resources; prioritizing these requirements and integrating these requirements into a funding plan that would forecast available resources; recommending allocation of these

Despite nearly $12 billion sent to the Development Fund for Iraq, Bremer left without having executed one single project. 22 Anglo-Saxons and 3 Iraqis sat on the Board recommending expenditures to address Iraqi needs.

resources; and setting forth the justification for the proposed expenditure. Such responsibilities required a deep knowledge of Iraq and its needs. However, when Bremer set up the Board he appointed to it twenty-five members—22 Anglo-Saxons (Americans, British and Australians) and three Iraqis, one from the Iraqi Ministry of Finance and two from the Iraq Ministry of Planning.

Although the Board recommended the awarding of some 800 contracts in less than a year, its functioning has been reported to have been conducted as follows:

- "None of the minutes is complete. Many are missing."
- In some cases the minutes did not include an attendance list. When an attendance list was present, the roles and titles of the attendees were not always provided.
- Only rarely did the minutes record whether the attendees had reviewed and approved the minutes of the previous meeting, or the date of the next meeting.
- The minutes seldom recorded the wording of motions, who seconded them, who voted for them or against them, or even the vote tally.
- In some cases where an attendance list was part of the minutes, decisions were made when the board did not have quorum.
- KPMG, the international auditors of the Development Fund for Iraq, notes that of the minutes of the 43 Program Review Board meetings it was able to review, all from 2003, just two were attended by the Iraqi members.[17]

In view of these facts it would be difficult to argue that those 22 Anglo-Saxons, who had no knowledge or understanding of Iraq, would have been able to act in the interests of the people of Iraq as Bremer claimed, even if we assumed that they all had had good intentions. The Orders asserted a wide-ranging legal authority:

Trade Liberalization Policy (Order 12 of 7 June 2003) suspended all tariffs, customs duties, import taxes, licensing fees and similar surcharge for goods (except foodstuffs and some manufactured goods such as cars) entering or leaving Iraq and all other restrictions on such goods until the end of 2003. In doing so Bremer relied on Resolution 1483 but he in fact acted contrary to that resolution.

Trade Liberalization Policy 2004 (Order 54 of 24 January 2004) consolidated the suspension introduced in Order 12 towards 'developing policies that will foster international trade and a free market economy in Iraq'.

Reconstruction Levy (Order 38 of 19 September 2003) introduced a new tax on all goods to pay for the reconstruction of Iraq. In addition to the breach of international law and the fact that Bremer has already relieved Iraqis from taxation—under Order 12, this seemed to add insult to injury. After twelve years of genocidal blockade and two devastating wars, the least that the US should do is to rebuild Iraq and not ask impoverished Iraqis to pay for the construction of the devastation caused by the US/UK.

Tax Strategy for 2003 (Order 37 of 19 September 2003) suspended some income tax and real property rent tax and exempted the CPA and its contractors from the taxes specified in the order which had not been suspended.

Tax Strategy for 2004 (Order 49 of 19 February 2004) extended the principles incorporated in Order 37 for the same objectives.
Order 84 of 30 April 2004 amended orders 37 and 49 on tax strategy. It is clear that Bremer wanted to ensure that by the time he left Iraq, a new tax system would be in place which was very different from the system that had prevailed in Iraq for over fifty years and which he had no authority, under international law, to change.

Foreign Investment (Order 39 of 19 September 2003) opened Iraq to foreign investment, Bremer claimed, to help develop Iraq's infrastructure, foster the growth of Iraqi business, create jobs and raise capital. The

need for the legislation, according to Bremer, was 'the problems arising from Iraq's legal framework regulating commercial activity and the way in which it was implemented by the former regime'. Thus Bremer was aware that the legal framework that existed in Iraq did not allow him to open Iraq to foreign investment, but he still went ahead and changed it, contrary to international law. This is a typical case of capitalist manipulation which has been so widespread that, I believe, they have come to accept the fallacy that only free market and foreign ownership leads to a vibrant economy and prosperity. Indeed, this fallacy had already been exposed in Iraq. Prior to the imposition of the genocidal blockade Iraq had managed, without foreign investment, to generate a vibrant

Prior to its systemic reinvention, Iraq had achieved full employment—which no capitalist state could claim nor indeed aspires to achieve.

economy which led to the need to import men from Egypt (nearly four million of them), Morocco, and India in order to fill the vacancies for which there were no Iraqis. In short, Iraq achieved full employment— which no capitalist state could claim nor indeed aspires to achieve.

Bank Law (Order 40 of 19 September 2003) is one of the longest orders promulgated by Bremer. Running to 68 pages, it established what it claimed to be a safe, sound, competitive and accessible banking system for the purposes of providing a foundation for economic growth and the development of a stable Iraqi economy. The order laid down the foundation for a new banking system intended to transform Iraq 'from a non-transparent, centrally planned economy to a market economy'. In order to do this he acknowledged the 'problems arising from Iraq's legal framework regulating banking activities and the way in which it was implemented by the former regime.' It is obvious that despite Bremer claiming to rely on Resolution 1483, he was acting in clear violation of that resolution and international law.

Consolidation of State-Owned Enterprises (Order 76 of 24 May 2004) claimed to consolidate four state-owned banks into ministries because Bremer was 'determined to encourage more efficient Iraqi governance by consolidating government functions carried out by certain state-owned enterprises into government agencies'. However, a closer look at the enterprises listed in the Order reveals a different intent. Among the enterprises to be merged were:

> The Real Estate Bank
> The Industrial Bank
> The Agricultural Bank

These were not banks that were created during the Ba'ath rule. Some dated back to decades before the Ba'ath assumed power in Iraq. Thus their elimination could not be argued as removing Ba'ath Party products. Rather, it was designed to change the way the people of Iraq have come to understand and accept the role of the state. These banks had been set up to provide loans, in their respective fields, at a low interest, amounting to almost interest-free loans, which helped Iraqis for decades to build homes and businesses. There are tens or even hundreds of thousands of Iraqis today who would not have had an opportunity to own their homes had it not been for the Real Estate Bank. By eliminating these banks, Bremer ensured that in the new Iraq, a free market means that people would never enjoy such wonderful windfalls from a rich oil producing state. It may be argued that Bremer introduced this change, among other changes, because he knew from the outset that new Iraq would not own or control its oil revenue, which was to be transferred via a 'free market' to American oil companies.

In **Banking Law of 2004** (Order 94 of 6 June 2004) Bremer ensured that a new revised bank law, which at 70 pages was the longest piece of legislation since the occupation, was in place before he left Iraq. He left behind a new law that would open Iraq to multinational sharks operating under the guise of a free market.

Central Bank Law (Order 56 of 1 March 2004) set up a new Central Bank relying on Resolution 1483. In addition to the fact that no such authority was granted under that Security Council Resolution, there is no indication as to the reason for creating a new Central Bank in Iraq beyond the desire of Bremer to have created an oasis for capitalism in the Middle East, bringing it into line with the free market central bank model which, contrary to democratic rhetoric, places this supreme instrument for managing the domestic economy in private hands beyond government control.

Amendment to the Company Law (Order 64 of 29 February 2004) relied on Resolution 1483 to amend Iraqi Company Law No. 21 of 1997. The Order makes its purpose clear in stating that: 'some of the rules concerning company formation and investment under the prior regime no longer serve a relevant social or economic purpose, and that such rules hinder economic growth'. The purpose is thus to transform the social and economic system in Iraq in accordance with the wishes of the US, which is a violation of international law because the occupier has no authority to impose his will or system on the occupied territory.

Amendment to the Trade Marks and Descriptions Law (Order 81), **Patent, Industrial design, Undisclosed Information, Integrated Circuit and Plane Variety Law** (Order 82 of 26 April 2004) and **Amendment to the Copyright Law** (Order 83 of 29 April 2004), all set out to transform Iraq's laws in accordance with US designs. It would be impossible for anyone to argue that the security and peace of Iraq required the amendments of copyright laws. However, a careful consideration reveals the sinister US attempt at radically transforming Iraq's economy in its direct effect on farmers and future of agriculture in Iraq.

> For generations, small farmers in Iraq operated in an essentially unregulated, informal seed supply system. Farm-saved seed and the free innovation with and exchange of planting materials among farming communities has long been the basis of agricultural practice. This is now history. The CPA has made it illegal for Iraqi farmers to re-use seeds harvested from new varieties registered under the law. Iraqis may continue to use and save from their traditional seed stocks or what's left of them after the years of war and drought, but that is not the agenda for reconstruction embedded in the ruling. The purpose of the law is to facilitate the establishment of a new seed market in Iraq, where transnational corporations can sell their seeds—genetically modified or not, which farmers would have to purchase afresh every single cropping season. …While political sovereignty remains an illusion, food sovereignty for the Iraqi people has already been made near impossible by these new regulations. Iraq's freedom and sovereignty will remain questionable for as long as Iraqis do not have control over what they sow, grow, reap and eat.[18]

Financial Management Law and Public Debt Law (Order 95 of 2 June 2004) is a very serious order promulgated in the last month of Bremer's rule. It is in fact two laws in one order. The first law established a framework for the conduct of fiscal and budgetary policy by setting a structured process for the formulation of the federal budget. The political message here is that the decision has already been made by the US to transform Iraq from a unitary state into a federal state, thus the *federal* budget. There have been some reports of politicians in the US and

This demonstrates that the decision has already been made by the US to transform Iraq from a unitary state into a federal state, thus the *federal* budget.

the UK sounding alarm at the possibility of disintegration of Iraq. But when a small unitary state is divided into a federation by an occupying power, is it unreasonable to expect that the next likely outcome might be separation into small statelets? Indeed, is it unreasonable to ponder whether the US and its Zionist cohorts might seek to dismember Iraq to permanently remove its possibility to resist their depradations?

The second law relates to instructions to the Ministry of Finance to issue and pay debt securities guaranteed by the Government. The introduction of the capitalist concept of public debt is alien to Iraq, not just the Iraq of the Ba'ath but Iraq of the previous 80 years.

I believe that the above legislation affecting the structure of the economy of Iraq, which the US ensured was incorporated into a new Iraqi constitution, was done in violation of international law because it deliberately set out to change the whole system in an occupied territory. Whether or not the changes it instituted were adopted freely in later legislation is immaterial to the argument for its illegality. Its purpose has always been what the Future of Iraq Project, created in November 2001, set out to achieve: namely occupying Iraq and restructuring it as model of US globalization ambitions.

The principle under international law on changing the economy of the occupied territory is summed up by Stone as follows:

> Most Western writers would argue that the occupant could not transform a liberal economy into a communist one; and Soviet writers would no doubt be concerned about the reverse transformation.[19]

Legal and Judicial Legislation

If the change of the economic system by an occupying power is serious, any change in the judicial and legal systems is more serious to the extent that international law has specifically called for the law of occupied territories to be respected by the occupier (Article 43 of The Hague Regulations 1907). It also prohibits the removal of judges (Article 54 of the Fourth Geneva Convention). The changes in the legal system and judiciary that were introduced by Bremer were not just tinkering on the fringes but a major reshaping and staffing of them. All this was in violation of international law.

Regulation 1 of 16 May 2003 has already been attended to above and the argument is not repeated.

Dissolution of Entities (Order 2 of 23 May 2003) goes beyond anything allowed under international law. By dissolving all the military organizations in Iraq, the invaders again clearly proved from the first week of the invasion that the claim about WMD had little to do with the real intentions of the war. The security vacuum created by the dissolution of the Iraqi military could only have been filled with a semi-permanent presence of the occupying power. In other words the occupier intended from the outset to stay in Iraq if not indefinitely then for a very long period.

But the most disastrous outcome of the dissolution of the army has been the elimination of the most cohesive element in Iraqi society. The Iraqi army predated the Ba'ath ascension by some five decades. It was a professional army and represented Iraq in all its religions, sects, ethnicities. In short it was the only entity that could legitimately claim to defend all Iraq's disparate communities equanimiously. While it might be argued, and more particularly, believed by English readers, that Saddam Hussein used the army to hold Iraq together and put down the Kurds and the Shi'a, in point of fact the Iraqi army was used against the Kurds for longer periods during the rule of Qasim and Arif to put an end to an insurrection that was supported and financed by oil companies and Iran under the Shah. It was Saddam Hussein who put an end to the insurrection, first by the autonomy law and then by striking a deal with the Shah, until it was aroused by the Iranians during the Iraq-Iran war. As for the use of the army against the Shi'a, the only time it was so used was during the insurrection in the 1991 war, prompted by promises of George Bush, Sr. to come to the Shi'as aid. Without defending the excesses of that action, I would submit that any state would have suppressed foreign-instigated rebellion in those circumstances. But the blame does not lie with the army. The intelligence services in Iraq were the oppressive tool and not the Iraqi army which was a professional army that was demonized in order to legitimize its abolition for the sake of Israel. Since its creation in the 1920s it has acted as the last refuge and savior of Iraq in any dispute, as it always managed to rescue the nation, protect it and ensure its safety. By dissolving it, the US ensured the beginning of the disintegration of Iraq.

It has been reported that it was dissolved because it was the *Ba'ath* army. But such an assertion raises more questions than it answers. If the army and the intelligence were both staffed with Ba'athists, then the Ba'ath Party had a de facto legitimacy. The Party would be representative of the people of Iraq if only part of it made the million members of the armed and intelligence services. The US/UK could not have it both ways, on one hand claiming the

Ba'ath did not represent Iraq and on the other claiming that the million men in the army and intelligence services were all Ba'athists—who had to be purged because they resisted invasion and occupation. Or was the outcome envisaged from the outset and the purge carried out because that is precisely what the imperialist Zionists had planned for Iraq?[20]

The more pertinent question here is: what army is challenged on its politics? No one knows whether or not any army—including that of the US or the UK—is stuffed with rightwing extremists. The normative presumption is that armies are not a political group but rather are politically neutral and under the direction of governments. The Iraqi Army, whose members held a range of beliefs and political opinions, was answerable to the Iraqi Government and was prepared to defend its nation to the best of its ability as every army is expected to do.

Penal Code (Order 7 of 9 June 2003) is another breach of obligations under international law. Article 64 of the Fourth Geneva Convention, as cited above, stipulates that the penal laws of the occupied territory should remain in force. The only exception to that is when it constitutes a threat to the security of the occupying power or an obstacle to the application of the Convention.

- Section 1 of Order 7 orders judges, police and prosecutors to function according to Bremer's Regulation 1 whereas Article 64 requires them to function in accordance with the existing penal code of Iraq.

- Section 2 of Order 7 repeals the 26 amendments that were made to the Penal Code between 1969 and 2003. As no reason was given for the repeal and considering that the Penal Code which Bremer upheld was promulgated by the Ba'ath Government on 19 July 1969, the repeal is unlawful and in breach of international law.

- In **Memorandum 3** which was promulgated in 2003 but revised in its final form on 27 June 2004, just before the presumed handing over of authority to the appointed interim government, Bremer claimed to adhere to the Fourth Geneva Convention in the application of criminal law in Iraq to ordinary criminals and '*security detainees*' as he called them. The timing of the revised version is significant because it meant that all detainees from that date have been subject to the terms of the Memorandum.

The language of the Memorandum echoes the Regulations and Orders, either displaying total arrogance and indifference or an intention to mislead.

- In section 6 paragraph 1 of the Memo, Bremer stated that detaining people was carried out in accordance with the mandate set out in Security Council Resolution No. 1546. Anyone who reads the Resolution would find it difficult to conclude that there is such a mandate in it. It is, at best, a tenuous and dubious interpretation of the exceptional allowance to change the Penal Code cited above.

- The same paragraph refers to the right of the detainee to have his case reviewed after 72 hours of detention. Although the review is assumed to be carried out by his captors—the US army—it is a travesty to read that detainees are to receive a review after hours of detention when people have been in detention for four years without having even been charged with an offence.

The problem with the Memo is deeper than just breaching a Security Council resolution. It relates to whether or not the US accepted that by the end of June 2004 Iraq was still under occupation. While the Security Council was hailing the end of occupation, in theory at least, Memo 3 demonstrates that Bremer was still relying on his authority as an Occupying Power and treating Iraq as occupied land, invoking the Fourth Geneva Convention by using the exact language of the Fourth Convention.[21]

The other serious flaw with the authority promulgated in Memo 3 is that the Occupying Power has authority to detain people involved in activity against it, threatening its personnel and not to detain people who may have committed a crime prior to the occupation. Article 70 of the Fourth Geneva Convention on which Bremer claims to rely in Memo 3, states: 'Protected persons shall not be arrested, prosecuted or convicted by the Occupying Power for acts committed or for opinions expressed before the occupation'. Memo 3 refers to people placed in internment after 30 June 2004, but does not address the legal grounds for arresting or detaining people prior to June 2004 because it clearly cannot square the action with the prohibition in Article 70.

The Central Criminal Court of Iraq (Order 13, which was promulgated in 2003 but was revised in its final form on 22 April

2004), created the Central Criminal Court of Iraq. Baghdad had then two criminal courts on each side of the river. The creation of a new court is inadmissible unless it is set up by the occupying power to try crimes committed against it. However, the real purpose of creating the Court seems to be to facilitate the selection of judges on political grounds, to determine the legal climate of the future Iraq. Having claimed that Saddam Hussein "stacked the courts" by appointing people who were Ba'athist or affiliated to the Party, Bremer proceeded to do likewise. Section 5 of the Order stipulated the conditions for appointing judges. Among them, prospective judges must:

> Have a background of either opposition to the Ba'ath Party, non-membership of the Ba'ath Party or member-ship that does not fall within the leadership tiers described in CPA/ORD/16 May 2003/01 and entailed no involvement in Ba'ath Party activity.

Establishment of the Judicial Review Committee (Order 15 of 23 June 2003) set out its powers and functions in section 4 as follows:

> The committee shall investigate and gather information on the suitability of Judges and Prosecutors to hold office. It shall have the power to remove judges and prosecutors from office, confirm their continued holding of office, appoint replacements for judges and prosecutors removed from office…."

When I visited Iraq in June 2003, I was given a list of over fifty practicing Iraqi judges who had been summarily dismissed by the US personnel in charge of the judiciary in Iraq without any hearing and without any appeal. In Order 15 Bremer set out to do precisely what Article 54 of the Fourth Geneva Convention held he is not allowed to do.

Status of the Coalition Provisional Authority, MNF (Order 17, promulgated early after the occupation but revised in its final version on 27 June 2004) granted immunity from Iraqi legal process to the CPA, the so-called multinational force, foreign liaison personnel, international consultants and private security companies. First and foremost this breaches Article 6 of Iraqi Penal Code No. 111 of 1969 which assumes jurisdiction over all crimes committed in Iraq.

It may be argued that international law allows the occupier to protect its personnel who are themselves subject to their respective

military laws—although very little has resulted from such laws, as US and UK soldiers have received little or no punishment after committing murder and other atrocities in Iraq. However, it is difficult to make the same argument for personnel in the other categories who have also been granted immunity. Why should Private Security Companies (PSCs) enjoy any right to operate outside the law—as indeed they do? There are over 180,000 armed men employed by these PSCs who operate outside the law while carrying out semi-military activities.[22] They are neither answerable to the laws in their respective countries; nor to military laws of the occupying powers nor to Iraqi law.

Before his departure Bremer issued, on 26 June 2004, Memorandum No. 17 for the Registration Requirements for Private Security Companies in which he outlined the rules for use of force by PSCs and the code of conduct that the PSCs must follow. The only penalty for failure by the PSCs to follow the code would have been the forfeiture of the $25,000 bond which the PSC deposited on registration.

Neither Order 17 nor Memorandum 17 specified any process for adjudication when a crime is committed by a member of a PSC. This must be the first time since The Hague Conventions in which an army of over 100,000 was licensed to kill without being answerable to any authority or be subject to any law!

Modification of Penal Code and Criminal Proceedings Law (Order 31 of 10 September 2003) set out to amend the Penal Code in order to impose harsher sentences and to deny bail for certain offences. This seems to contradict the charge against the old regime of imposing harsh sentences in some amendments to the Penal Code.

Re-Establishment of the Council of Judges (Order 35 of 13 September 2003) created a Council of Justice to replace the existing Council of Justice and suspended all provisions in all laws, specifically those in the Law of Judicial Organization and Law of Public Prosecution of 1979 that conflicted with it. It is clear that such a change by the occupier to the judicial system of the occupied territory is prohibited. It is on the other hand worth pointing out that this change was decided long before the invasion, as indicated by its inclusion in the report of Transitional Justice Group, which was part of the Future of Iraq Project. (See Chapters 2 and 5)

Military and Security Legislation

The orders promulgated by Bremer went beyond anything seen in

any invasion since WWII. They were not simply restricted to dissolution of the Iraqi army but went on to eliminate an entire military industry and sabotage the concept of retaining a national army, effectively forcing Iraq to resort to unreliable alliances to protect it in the future.

In addition to Order 2 of 23 May 2003 and after having dismantled the structure that has existed since the 1920s, Bremer set out to reshape Iraq's military structure by the following orders:

> Order 22 of 7 August 2003 for the Creation of a New Iraqi Army,
> Order 23 of 7 August 2003 for the Creation of a Code of Military Discipline for the New Iraqi Army,
> Order of 24 August 2003 for the Creation of Department of Border Enforcement,
> Order 27 of 4 September 2003 for the Establishment of the Facilities Protecting Service,
> Order 28 of 3 September 2003 for the Establishment of the Iraqi Civil Defence Corps,
> Order 42 of 19 September 2003 for the Creation of the Defense Support Agency.

The analysis of these orders is beyond the scope of this work. However, there are two unavoidable observations.

1. When the Iraqi army was dissolved on the ground that it was a Ba'athist army, nearly one million military men were made redundant. Considering that in any nation not all able men are likely to join the army and considering that Iraq's population numbered around 25 millions, a significant number of people were eliminated from recruitment to any new army even if they desired to volunteer. The only likely recruits would have been inexperienced men who were most likely to have come from among the militias, which Bremer acknowledged later as having fought against the Ba'ath. It is quite surprising to hear politicians in the UK and US sounding alarm in 2006 at discovering that Iraq's military has been infiltrated by the militias. If you put members of the militias in charge of the recruitment for the army then you should expect them to recruit their own men.

2. The sinister element in the whole campaign to invade and occupy Iraq is partly revealed in Section 2 of Order 22 which reads:

 > The Iraqi Military Law Code Number 13 of 1940, the Iraqi Military Procedures Code Number 44 of 1941, the Code of Legal Notification of Military Personnel Number

106 of 1960, Punishment of Military Deserters law
Number 28 of 1972 and the Penal Code of the Popular
Army Number 32 of 1984 are hereby suspended.

The Military Laws which Bremer suspended were mainly developed before the Ba'athists came to power in 1968. This makes the argument that the cause for the invasion, having been WMD or even the removal of the Ba'ath, unsustainable. When the invasion dismantles the institutions of the state that existed before the Ba'ath came to power, then it can be assumed that the attack on Iraq goes far beyond any declared intentions, even those relating to the removal of the existing regime.

The Iraqi Military Law and Procedures Codes were products of the military culture in Iraq that had developed over hundreds of years and date back to service in the Ottoman Empire well before the Ba'ath was formed. As Section 2 of Order 22 makes evident, the main military legislations were promulgated before the Ba'ath assumed power, which demonstrate that, contrary to the propaganda, the Ba'athists did very little to tamper with these laws to suit their plans.

This issue of the true purpose and intended extent of the assault on Iraq and indeed on the region requires a separate analysis beyond the purpose of this book.

Regulation of Armed Forces and Militias within Iraq (Order 91 of 2 June 2004) supports the above contention about the inevitable domination of the army and security by members of the militias. The Order acknowledged 'that those who fought against the Ba'athist regime in resistance forces should receive recognition and benefits as military veterans for their service to their people' and considered that 'the Iraqi Armed Forces and other Iraqi security forces are in need of trained and experienced professionals'. It went on to detail how to reintegrate members of these militias into Iraq's armed forces. The integration of militias into government would seem to pose no problem when the US/UK support it, but is insurmountable in situations such as that of Hizbullah (which actually has democratically elected members in the Lebanese government), which they still persist in defining as "terrorists".

Realignment of Military Industrial Companies (Order 75 of 15 April 2004). Bremer dismantled the entire military industry of Iraq that had dated back to decades before the Ba'ath assumed power. Bremer did so despite having found that Iraq had no WMD which was the declared reason for the invasion. Needless to say, Bremer decided that, contrary to principles of international law, Iraq did not

need or have the right even to arm itself or defend itself or, if it did, then it should rely on the US/UK and their allies for armament.

Despite having found no WMD, Bremer dismantled the entire military industry of Iraq that had dated back to decades before the Ba'ath assumed power.

The picture would not be complete without considering **Memorandum No. 8** issued on 25 January 2004. Those who traveled to Iraq by road during 2004 and 2005, as I did, could not have missed the convoys of trucks carrying scrap metal to Jordan. Iraq has neither been a producer of metal nor had the industrial base to have some as a by-product. In Memorandum 8 Bremer informed us that prior to 1 February 2004 there would have been no need to acquire a license to export scrap metal from Iraq but he failed to inform us what the source of this massive export was. The only possible source seems to be Iraq's existing military hardware and military industry equipment and stocks of metal. Machinery, tanks, military vehicles and pieces of artillery—thousands of them—were cut and exported out of Iraq as scrap metal, depriving Iraq of the military hardware it needed like every other state. Who had the right to export them, so that he needed to apply for a license? Who indeed exported them? Who received the revenue of what was after all the property of the people of Iraq? These are questions that will not receive better answers than the question of where the $8 billion missing from the coffers of the CPA went—while being held on behalf of and for the benefit of the people of Iraq, as Paul Bremer and Jeremy Greenstock kept telling us.

Political Legislation

This is the most serious category of legislation which reveals the real purpose of the invasion and partly explains what has happened since. The basis of the political legislation is de-Ba'athification, which reflects the US/UK decision to eradicate the nationalist Ba'ath ideology from Iraq. I have already briefly addressed the history of the Ba'ath in Iraq in Chapter 1. I will now consider the scope of de-Ba'athification legislation and its status within international law.

De-Ba'athification of Iraq Society (Order 1 of 16 May 200) started with a fallacy:

> Pursuant to my authority as Administrator of the CPA, relevant UN Security Council resolutions, and the laws

and usages of war.

The truth of the matter is that Bremer was not acting pursuant to any UN resolution on the invasion and occupation of Iraq because the first such resolution was only made on 22 May 2003—after and not before Bremer assumed such authority. His assertion is thus misleading to say the least. It stated, inter alia:

- On April 16, 2003 the CPA disestablishes the Ba'ath Party of Iraq.[23]

- Senior Party members are hereby removed from their positions and banned from future employment in the public sector.[24]

- Individuals at the top three layers of management shall be interviewed for possible affiliation with the Ba'ath Party. If anyone is detained he will be removed from his employment if he is an ordinary member of the Ba'ath Party.[25]

- Rewards for any information leading to the capture of senior members of the Ba'ath Party would be granted.[26]

Establishment of the Iraqi De-Ba'athification Council (Order 5 of 25 May 2003) created a council serving at the discretion of the Administrator (Bremer) to investigate the Party and identify the whereabouts of its members and officials. This Council, which has been operating as a High Court against which there is no appeal, has functioned as a dictatorial body with incredible power. It has been intimidating, threatening and destroying lives since its creation. All it takes for it to shut people up is to threaten them with the possibility of being investigated. This was used more than once in the case of the IHT as shown in Chapter 5.

In order to implement Orders 1 and 5 Bremer issued Memorandum No. 1 in which the commander of the Coalition Forces was required to provide military investigative resources sufficient to receive and compile information concerning Ba'ath Party affiliations of employees at all ministries. The Memo gives the De-Ba'athification Council a major role in advising the CPA on de-Ba'athification policies and procedures. The Memo envisaged the Council assuming full responsibility for the process. This means that a few anti-Ba'ath individuals were eventually entrusted by the occupying power to decide who should and should not be employed. In Iraq, with little business opportunities, that decision amounted to controlling the right to life.

Disqualification from Public Office (Order 62 of 26 February 2004) stated that if the De-Ba'athification Council (created by Order 5) determined that an individual was a senior member of the Ba'ath Party then the Administrator of the CPA (Bremer) may disqualify him from participating in an election as a candidate for, accepting a nomination to, or holding, public office, at any level.

De-Ba'athification Is a Crime Against Humanity

The above Orders show that the US/UK intention was to disestablish the Ba'ath Party, an active party in Arab politics for sixty years. All senior members of the party were removed from employment and arrested. Any ordinary member was removed from employment once detained for investigation. All members of the armed forces and intelligence agency were dismissed. In short, a campaign of persecution was promulgated against hundreds of thousands of Iraqis for no crime but for belonging to or believing in the nationalist ideology of the Ba'ath Party, which prior to the invasion had been socially normative—as indicted by the sheer numbers of the membership. Further, there were no pernicious elements in that loosely nationalist ideology which might have provided grounds for its eradication—but many which sought to protect and affirm the Iraqi national identity.

The CPA action is precisely what international law had set out to prevent. No group of people should be persecuted on the grounds of their political beliefs. Such persecution would be a crime against humanity—the very charge for which Saddam Hussein was to be tried. The International Criminal Court that came into force on 1 July 2002 defines Crimes against Humanity as follows:

> Article 7
> Crimes against humanity
> 1. For the purpose of this Statute, "crime against humanity" means any of the following acts when committed as part of a widespread or systematic attack directed against any civilian population, with knowledge of the attack:
>
> ...(h) *Persecution against any identifiable group or collectivity on political,* [my emphasis] racial, national, ethnic, cultural, religious, gender as defined in paragraph 3, or other grounds that are universally recognized as impermissible under international law, in connection with any act referred to in this paragraph or any crime within the jurisdiction of the Court;

It seems that the act of de-Ba'athification was not simply inadmissible under international law but had even been specifically criminalized before 16 May 2003 when Bremer chose to disestablish the Party and arrest its members and remove them from their employment.

De-Ba'athification was not only inadmissible under international law but had even been specifically criminalized by the new International Criminal Court.

The US/UK governments first told us that they went into Iraq to disarm the regime of WMD but when that was exposed as a fictitious claim, they changed their argument to removing a regime which they only subsequently decided to charge with crimes against humanity. Now they have ended up themselves committing the same crime as that for which they were claiming to be punishing others and without having any democratic mandate from either their own or the occupied country to do so.

While news reports indicate that the US has been trying to get a rapprochement with former Ba'athist elements in an effort to find some element of Iraqi society with which it might ally, at this writing there have been only a few indirect contacts with some Ba'athists, who themselves have not yet recovered from the blow—but it is likely to be to no avail. The gap is too big. The US wants their help to bail them out of the mess, but the Ba'athists expect a restoration of their power, albeit with Islamic movements incorporated.

The CPA Sets Up Iraq's Transitional Administrative Law (TAL)

The Transitional Administrative Law (TAL) was in fact Iraq's interim constitution. Order 92 of 31 May 2004 setting up the 'Independent Electoral Commission of Iraq' notes 'that the Law of Administration for the State of Iraq for the Transitional Period (the 'TAL') provided for the Iraqi people to choose their government through genuine and credible elections to be held no later than 31 January 2005'.

Paradoxically, the problem with the TAL is not simply that the CPA had no authority to promulgate a constitution for occupied Iraq, but that it was never promulgated. The following facts may go towards explaining this statement.

1. On 16 May 2003, Bremer promulgated Regulation 1 assuming full executive, legislative and judicial authority of Iraq and declared the laws of Iraq will remain in force unless suspended, repealed or superseded by legislation passed by the CPA in the form of Regulations, Orders, or Memoranda.

2. The Iraqi Constitution 1970 remained in force as it was not affected in accordance with Regulation 1.

3. No Regulation, Order or Memorandum between 16 May 2003 and 31 May 2004 promulgated a document titled TAL or the Law of Administration for the State of Iraq.

4. The appearance of the TAL on the CPA website (http://www.cpa-iraq.org/government/TAL.html) does not bestow legitimacy on it so long as there was no reference to the authority under which it was promulgated or indeed as to who promulgated it.

5. The Governing Council of Iraq which was created by Regulation 6 on 13 July 2003 was not given any legislative power yet was acknowledged in the preamble of the TAL to have 'certain authorities and responsibilities'. Some authorities were granted by the CPA to the Governing Council over the eleven months of its life. However, the Council's authority was so limited in scope that even when it appointed Deputy Ministers, Bremer stepped in and removed that function from the Governing Council and retaining it exclusively for himself. To demean the Governing Council, this measure was issued in Memorandum 9 and not even in an Order. It is safe to conclude, lest anyone attempts to argue, that the Governing Council, which could not appoint Deputy Ministers, could not seriously have assumed the authority to promulgate a constitution.

It follows that TAL, the interim Iraqi constitution, was never enacted and thus its publication is another constitutional muddle added to that already created by Bremer's legislation. What happened to all the measures that were purported to be based on TAL—**The Electoral Law** (Order 96), and **Political Parties and Entities Law (**Order 97 of 7 June 2004) through which Bremer tried to lay down the political future for Iraq—is left for constitutional lawyers to figure out.

The Arrest and Detention of Saddam Hussein

On 13/14 December 2003, the US announced the arrest of Saddam Hussein, the President of the Republic of Iraq and declared him a Prisoner of War. However, there are several problems with his arrest and detention.

As an acting head of a state, he enjoyed full immunity under Article 40 of The Iraqi Constitution 1970. The immunity of serving heads of state is an international norm, which is acknowledged under many jurisdictions. The British House of Lords held, in the case of Pinochet, that a Head of State enjoys

immunity while serving (even though it was to rule that, as a former head of state, Pinochet did not enjoy immunity). However, a head of state does not lose his authority by being removed at the hands of an occupying power.

Assuming, for the sake of argument, that the above assertion of his immunity were to be rebutted, then the legal status of his arrest would have to be considered anew. He then could be arrested either as a POW, in accordance with the Hague Regulation and the Third Geneva Convention, or as a civilian internee in accordance with the Fourth Geneva Convention.

POW Status

A person would be classified as a POW if he belonged to one of the categories in Article 4 of the Third Convention cited above. It is suggested here that Saddam Hussein would not have qualified under any of these categories. To suggest that he was a member of the armed forces simply because he was commander-in-chief is no different to saying that George Bush is a military man. In fact the status of a potential POW was assessed by the House of Lords in London to be only applicable if the military person was in uniform. If he is arrested out of uniform he would not be classified as a POW even if he was involved in conflict.[27]

Further, Saddam Hussein was not arrested at a time of conflict. The US had officially declared a cessation of hostilities on May 1, 2003 while Saddam Hussein was arrested on 13 December 2003, more than 7 months afterward. POWs are only taken during conflict.

Article 118 of the Third Geneva Convention requires that POWs should be released without delay after the cessation of hostilities. It stands to reason that no one should be arrested as a POW after that time.

However, even if Saddam Hussein were a POW, then it can be rightfully argued that the US/UK occupiers failed to grant him the rights and treatment he was entitled to as a POW. Article 82 of the Third Convention stipulates that a POW should be subject to the laws, regulations and orders in force in the armed forces of the detaining power. Without going into details I suggest that no one would seriously maintain that Saddam Hussein, while in detention in the hands of the US/UK occupiers, enjoyed the protection of the laws of the armed forces in the US/UK.

These principles of international law were not arbitrarily adopted but were the result of centuries of conflict. It is not open to the US/UK to disregard all these principles as they choose, cherry-picking international law while demanding that others should fully abide by the principles of international law.

Civilian Status under Occupation

If no argument can be successfully sustained for Saddam Hussein's

detention as a POW, then he becomes a civilian internee subject to the Fourth Geneva Convention cited above. Any reference to the Geneva Conventions—whether by the Security Council Resolutions or the argumentation herein—implicitly includes the Protocols, [28] which supplement the Conventions by granting more protection to civilians caught in armed conflict.

If it were to be argued that the US has not yet ratified Protocol I and thus is not bound by it—or indeed if it were to be argued, as was the case with US Attorney-General Alberto Gonzales, that the Geneva Conventions had become irrelevant—it remains the case that Protocol I's adoption as international law would make it binding on the US through the Resolutions of the Security Council. If Security Council Resolutions were to rely on whether or not a certain state has ratified a specific treaty, its resolutions would have no meaning. A state cannot operate internationally and rely on international law and the UN, but still be able to excuse itself from being bound by whatever it chooses to reject. This is an unsustainable argument.

The UK, on the other hand, has ratified Protocol I and incorporated into domestic law in the Geneva Conventions (Amendment) Act 1995 making the UK obliged to ensure the application of the stipulation of Protocol I in Iraq even if the US decided not to.

Any breach of Protocol I is triable before a criminal court in London under the British Parliament's own Geneva Conventions Act. Article 1(1) of the Geneva Conventions Act as amended reads:

> (1) Any person, whatever his nationality, who, whether in or outside the United Kingdom, commits or aids, abets or procures the commission by any other person of a grave breach of any of the scheduled conventions or the first protocol shall be guilty of an offence.
>
> > (1A) a grave breach of the first protocol is anything referred to as a grave breach of the protocol in paragraph 4 of Article 11, or paragraph 2,3, or 4 of Article 85 of the protocol.

In the last four years every attempt by applicants to initiate action before a criminal court in England and Wales against US personnel—and there have been many of them—has been blocked by the Attorney General in his constitutional role, making a mockery of the UK obligations under the Geneva Conventions.

Breaches of Protocol I

To review the protections of Protocol 1 and the obligations it imposes

upon occupying powers, let us refer to how this was understood and reflected in the British Parliament's Geneva Conventions Act 1957 as amended.

We shall look at these paragraphs in full as they are important not simply in their application to the case of Saddam Hussein but in their general application to the people of Iraq who have been terrorized by an aggressive occupying regime that broke every principle of international law and had the audacity to show alarm at a few pictures of torture and inhumane treatment in Abu Ghraib, which is, as all Iraqis know, only the tip of the iceberg.

Article 11. Protection of persons

1. The physical or mental health and integrity of persons who are in the power of the adverse Party or who are interned, detained or otherwise deprived of liberty as a result of a situation referred to in Article I shall not be endangered by any unjustified act or omission......

3. Any willful act or omission which seriously endangers the physical or mental health or integrity of any person who is in the power of a Party other than the one on which he depends

Article 85. Repression of breaches of this Protocol

1. The provisions of the Conventions relating to the repression of breaches and grave breaches, supplemented by this Section, shall apply to the repression of breaches and grave breaches of this Protocol.

2. Acts described as grave breaches in the Conventions are grave breaches of this Protocol if committed against persons in the power of an adverse Party protected by Articles 44, 45 and 73 of this Protocol, or against the wounded, sick and shipwrecked of the adverse Party who are protected by this Protocol, or against those medical or religious personnel, medical units or medical transports which are under the control of the adverse Party and are protected by this Protocol.

3. In addition to the grave breaches defined in Article 11, the following acts shall be regarded as grave breaches of this Protocol, when committed willfully, in violation of the

relevant provisions of this Protocol, and causing death or serious injury to body or health:

(a) Making the civilian population or individual civilians the object of attack;

(b) Launching an indiscriminate attack affecting the civilian population or civilian objects in the knowledge that such attack will cause excessive loss of life, injury to civilians or damage to civilian objects, as defined in Article 57, paragraph 2 (a) (iii);

(c) Launching an attack against works or installations containing dangerous forces in the knowledge that such attack will cause excessive loss of life, injury to civilians or damage to civilian objects, as defined in Article 57, paragraph 2 (a) (iii);

(d) Making non-defended localities and demilitarized zones the object of attack;

(e) Making a person the object of attack in the knowledge that he is hors de combat;

(f) The perfidious use, in violation of Article 37, of the distinctive emblem of the red cross, red crescent or red lion and sun or of other protective signs recognized by the Conventions or this Protocol.

4. In addition to the grave breaches defined in the preceding paragraphs and in the Conventions, the following shall be regarded as grave breaches of this Protocol, when committed wilfully and in violation of the Conventions of the Protocol:

(a) The transfer by the Occupying Power of parts of its own civilian population into the territory it occupies, or the deportation or transfer of all or parts of the population of the occupied territory within or outside this territory, in violation of Article 49 of the Fourth Convention;

(b) Unjustifiable delay in the repatriation of prisoners of war or civilians;

(c) Practices of apartheid and other inhuman and degrading practices involving outrages upon personal dignity, based on racial discrimination;

(d) Making the clearly-recognized historic monuments, works of art or places of worship which constitute the cultural or spiritual heritage of peoples

and to which special protection has been given by special arrangement, for example, within the framework of a competent international organization, the object of attack, causing as a result extensive destruction thereof, where there is no evidence of the violation by the adverse Party of Article 53, sub-paragraph (b), and when such historic monuments, works of art and places of worship are not located in the immediate proximity of military objectives:

(e) Depriving a person protected by the Conventions or referred to in paragraph 2 of this Article of the rights of fair and regular trial.

The most significant element introduced by Protocol I is that the old principle of weighing civilian losses against the military advantage was scrapped. Attacking civilian targets became prohibited irrespective of whatever military advantage that may result from that.

Most of the above breaches have been committed at some stage in the last four years of occupation of Iraq. In April 2004 while Iraq was still officially under occupation, the occupying power mounted a massive attack on the town of Fallujah, some 40 km west of Baghdad, purportedly to rid the town of its insurgency. I was on a visit to Iraq and I was very concerned about it and kept track of it because of an added interest of having had members of my extended family resident in the town. The attack on civilian districts

White phosphorous, which stuck to bodies and burnt people alive, was widely used in indiscriminate attacks on civilian populations in Fallujah.

was indiscriminate. Helicopters, F16 fighters, artillery and tanks were used. White phosphorous, which stuck to bodies and burnt people alive, was widely used. Nobody knows even today how many thousands were killed or injured.

Needless to say, the so-called government of Iraq has no interest in embarrassing its masters in London and Washington with such matters. The International Red Cross told me that they have an agreement with the US not to discuss these matters in public.[29] Most of the civilian districts were leveled. When I visited the town later, I recorded that on video. I personally lost six members of my extended family ranging in age between 60 and 2. None of them was near any military action. When we submitted death certificates and witness statements to initiate action under the British Geneva Conventions Act, we were denied consent by the Attorney General, who was given the ultimate veto under British democracy. I leave to the judgment of the reader to choose from the above breaches, those which would apply to the action of the US/UK occupiers in Fallujah.

The occupying power committed a grave breach against Saddam Hussein when it held him for several years causing him physical and mental harm and endangering his integrity as a head of state contrary to Article 11(4) of Protocol 1. This includes demeaning images of the former Iraqi head of state that were broadcast incessantly through the media, taken soon after his capture, and clearly while having been mentally disabled.

Saddam Hussein was the main target of military attack (assassination) on more than one occasion during the invasion. These acts are a serious breach of Protocol I, being contrary to Article 85(3) (a) prohibiting the making of 'individual civilians the object of attack'.

ENDNOTES

[1] Letter from the Permanent Representatives of the UK and the US to the UN, S/2003/538, May 8, 2003, see Appendix I.

[2] See "Prominent Iraqis criticize oil law", Al Jazeera, <http://english.aljazeera.net/NR/exeres/AD19F8CA-E314-4901-8DDE-450A31ED2255.htm?FRAMELESS=true&NRNODEGUID=%7bAD19F8CA-E314-4901-8DDE-450A31ED2255%7d>

[3] Statement by Douglas J. Feith, Under Secretary of Defense for Policy, Senate Committee on Foreign Relations, February 11, 2003, The Office of Reconstruction and Humanitarian Assistance (ORHA). <http://www.sourcewatch.org/index.php?title=Office_of_Reconstruction_and_Humanitarian_Assistance>

[4] Chandrasekaran, R., *Imperial Life in the Emerald City*, Alfred A. Knopf, New York, 2006, p. 55.

[5] Security Council Resolution No. 1483 adopted on its 4761st meeting on 22 May 2003.

[6] Security Council Resolution No. 1511 adopted on its 4844th meeting on 16 October 2003

[7] Security Council Resolution No. 1546 adopted on its 4987th meeting on 8 June 2004. The Resolution referred to a report, submitted by the US to the Council on 16 April 2004, on the efforts and progress made by the multinational (occupation) force in Iraq.

[8] The Resolution referred in its preamble to the dissolution of the Governing Council. However the Resolution was adopted by the Council on 8 June 2004 and the Governing Council was only officially dissolved in CPA Regulation No. 9 dated 9 June 2004. Although it would be argued that the dissolution was decided before the drafting of the Regulation, it remains true that legislation has effect from the date of promulgation and not from other assumed or perceived dates. While the preamble to the Resolution goes on to refer to the report submitted by the US to the Council on 16 April 2004, on the efforts and progress made by the multinational (occupation) force in Iraq, it omits is any information on the availability of that report whether in the form of a document number in the archive of the UN or any other facility that would enable its tracing.

[9] The actual reference is found in Articles 2(B)(1) which refers to Sovereign Iraqi Interim Government, and 59(A) & (C) both refer to Iraqi status as a sovereign state.

[10] Chandrasekaran, op.cit., pp. 61-62.

[11] Ibid, p.70.

[12] Ibid, p. 126.

[13] The validity of the 1970 Constitution until December 2005 means that the arrest, detention, investigation and indictment of Saddam Hussein and his comrades was done in breach of the valid Constitution at the time of their arrests.

[14] Coalition Provisional Authority, Regulation Number 1, CPA/REG/16 May 2003.

15 Statement of Representative Henry Waxman, Committee on Government Reform, Congress of the US, June 21, 2005.

16 US Mismanagement of Iraqi Funds Prepared for Rep. Henry A. Waxman, United States House of Representatives Committee on Government Reform — Minority Staff Special Investigations Division, June 2005, <http://www.democrats.reform.house.gov>

17 Coalition Provisional Authority Program Review Board, <http://en.wikipedia.org/wiki/Coalition_Provisional_Authority_Program_Review_Board>

18 "Iraq's new patent law: A declaration of war against farmers", Grain, <http://www.grain.org/articles/?id=6>

19 Stone, Julius, *Legal Controls of International Conflict*, Stevens & Sons Ltd. London 1959, pp. 698-699.

20 See Chapter 2, endnote 4.

21 Section 6, paragraph 1 of the Memo states: "Any person who is detained by a national contingent of MNF (multi-national forces) *for imperative reasons of security* ... [my emphasis]. Equally Article 78 of the Fourth Geneva Convention states: "If the Occupying Power considers it necessary, for imperative reasons of security, to take safety measures concerning protected persons..."

22 'A Very Private War', *The Guardian*, August 1, 2007, <http://www.guardian.co.uk/g2/story/0,,2138878,00.html>

23 Section 1, paragraph 1.

24 Section 1, paragraph 2.

25 Section 1, paragraph 3.

26 Section 1, paragraph 5.

27 *Osman Bin Haji Mohamed Ali v Public Prosecutor* [1969] 1 AC 430, [1968] 3 All ER 488, PC.

28 Protocol Additional to the Geneva Conventions of 12 August 1949 and Relating to the Protection of Victims of International Armed Conflicts (Protocol I), 8 June 1977. <http://www.icrc.org/ihl.nsf/7c4d08d9b287a42141256739003e636b/f6c8b9fee14a77fdc125641e0052b079>

29 Meeting with the head of the ICRC mission in Baghdad recorded on video, June 2003.

THE CREATION OF THE IRAQI SPECIAL TRIBUNAL

I have shown in the previous chapters how the invasion and occupation of Iraq was carried out as a clear act of aggression, contrary to principles of law under both customary international law and treaties. The invasion and occupation of Iraq has created a very dangerous precedent which seeks to make "regime change" admissible even though it contravenes the fundamental principle of sovereign independence for all states enshrined in the UN Charter (Art 2(4)).

The invasion and occupation of Iraq has created a very dangerous precedent which seeks to make "regime change" admissible even though it contravenes the fundamental principle of sovereign independence for all states enshrined in the UN Charter (Art 2(4)).

This alarming feature of the beginning of the 21st century shows European colonialism is not simply being reintroduced in a different guise. It is opening the floodgate for any state, when disapproving of another, to send its armies marching in, occupying and either directly colonizing or installing a puppet regime on the basis that this was done in the pursuit of '*terrorism*' or in order to uphold human rights. The marching of the Ethiopian army into Somalia in January 2007, which was met with little international concern, emphasizes how this dangerous precedent may go on to impact the 21st century.

I have also shown how the occupation of Iraq, through the legislation passed by the CPA, consolidated the belief that regime change and the re-institutionalization of Iraq were the main objectives of the invasion. During the first year of occupation, the CPA promulgated 100 Orders, 12 Regulations and 16 memoranda. The main purpose of these different legislations has been the alteration of the political, legal, economic and social structure in Iraq to fit the model US imperialism wants to impose on the Middle East. It has been shown that such an attempt at transforming Arab Islamic Iraq into a shadowy European state under Judeo-Christian domination is contrary to international law, as stated in the Security Council Resolution which granted

the authority to govern occupied Iraq, and to the articles of treaties entered into by both the occupying and occupied states.

The US/UK Seek a Trial Venue

The US/UK occupiers were aware, long before the invasion, that the time would come when they would have to vindicate their genocide in Iraq as soon as it became apparent they could not substantiate the argument for removing WMD, which they knew no one was going to find. The back-up vindication would be to argue that they had done a noble job of rescuing a nation from its own indigenous dictator, redefining '*liberation*' to mean from '*one's own government*', and indicting the whole political genus of a nation in the name of protecting the human rights of its population. Today it is clearly evident what a consolation that has been to the people of Iraq.

In order to achieve this vindication, the US/UK had to try to convict both the political system and the cadre that existed in Iraq in order to legitimize the systemic reorientation of Iraq to their benefit that they intended to impose. To do this, they had to consider three potential routes:

1. The first route was to try the regime under existing Iraqi law, which the occupying power ought to have upheld under the international law which granted them the authority to govern Iraq. However, there were several problems with putting such a case before an Iraqi court.

 a. The constitutional immunity granted to the President and members of the Revolutionary Command Council under Article 40 of the Iraqi Constitution 1970.[1]

 b. The crimes of genocide, war crimes and crimes against humanity were not recognized under Iraqi law, except perhaps when applied to war and its consequences, and retroactive legislation was inadmissible under Iraqi law.

2. The second route available to the occupiers was to try the regime under their own domestic laws for breaches of the Geneva Conventions. Such a route is available for example in the UK under the Geneva Conventions Act 1957 as amended, as discussed in the previous chapter. Under this Act anybody who breaches the Geneva Conventions, wherever he is and whatever his nationality is, may be indicted before a criminal court in England and tried as if the crime were committed in England. However, that option would have been a nightmare for the judicial authorities in England. Apart from the security problems, the simple possibility of granting President Saddam

Hussein the protection of the judicial system of the Old Bailey would be painful for the warmongers of Downing Street. But more importantly, the occupying powers were aware of the difficulty of a jury finding a President of a Republic guilty for managing the affairs of his own country. In any case, his Counsel would have been able to show any reasonable jury in England that no evidence in the documents submitted could be found to convict the President. This option had a further liability related to the impossibility of imposing the death penalty in the UK, to say nothing of the fact that it would be an instance of the exercise of "universal jurisdiction" for crimes against humanity, etc., a practice which has been an anathema to imperial powers seeking to prevent or curtail legal avenues whereby they might be brought to justice.

Against a UK trial: the likelihood of a reasonable and proper conduct of the trial, the impossibility of a death sentence, and the exercise of the feared concept of "universal jurisdiction".

3. The third route is that of trial before an international tribunal. It is relevant that when the US decided to embark on regime change in Iraq, as was shown in Chapter 2, it passed the Iraq Liberation Act 1998. Section 6 of the Act reads in part:

> ...the Congress urges the President to call upon the United Nations to establish an international criminal tribunal for the purpose of indicting, prosecuting, and imprisoning Saddam Hussein and other Iraqi officials who are responsible for crimes against humanity, genocide, and other criminal violations of international law. [2]

It is clear that at the early stages of preparation in 1998, all that the US administration thought was internationally possible was an international tribunal. However, it seems that the international will was to become much more subdued in the following four years than the administration had envisaged, due to the "fortuitous" events of September 11, 2001.

Furthermore, both US and UK occupying powers ruled against an international tribunal, despite the argument they had put over a long period—that Iraq lacked the capacity to conduct its own trials of such magnitude as war crimes, crimes against humanity and genocide—and despite the fact that by de-Ba'athification, most of Iraq's judiciary had been unlawfully dismissed which would have

made an international tribunal the only logical conclusion. The reasons for such a decision may be centered around two fears which prevented the US and UK pursuing it. These were:

a. Both the US and UK realized the problems related to seeking a UN resolution to set up such a tribunal. Again, the Security Council had not been willing to grant the perpetrators of the invasion a mandate to do so. Had they gone back to seek an authority to set up a special tribunal for the President of Iraq, the Council in turn would have had a problem. If the Council decided to grant it, then it would be sanctioning the invasion and occupation which it chose not to do in the first place. However, if the Council were to refuse to grant such a demand, it would have created a new problem of what to do with the President and his men who were being held by the occupiers. It was partly to avoid these possibilities that no attempt was made to secure a special tribunal.

b. More importantly, such a tribunal would have been outside their control. The selection of judges and prosecutors, the access of defense counsel, the burden of proof, the standard of proof and the conduct of the trial would have been difficult for the US to control and manipulate fully as it did with the Iraqi Special Tribunal (IST). The editing of material being beamed from the trial would have been difficult to control, as has been the case in Baghdad. The termination of any proceedings and the timing of any decision would have been subject to principles of justice rather than of political calculations. Most disturbing for the US

An international tribunal would have been outside US/UK direct control and risked embarrassing revelations concerning the role of the US in the Iraqi assault on both Kuwait and Iran.

would have been any revelation, during the trial, of its role in the Iraq-Iran war and the events that led to the incursion and war over Kuwait. In an international tribunal these matters would have become public should the defendants have decided to use it in their defense or relied upon it in justifying any act. I will show later how the US managed to control all this through its control over the Special Iraqi Tribunal.

The US/UK decided, after considering all the above options, that the best alternative was to proceed, contrary to principles of law, to create an Iraqi Special Tribunal (IST). In this chapter I shall attend to the specific

breach of law in creating the IST, which should be added to the general breaches expanded upon in the previous chapters.

The Future of Iraq Project and the Transitional Justice Report

It was shown in Chapter 2 how the final decision to invade Iraq was made immediately after the 11 September attacks. The Future of Iraq Project (FIP) was set up in November 2001 with the objective of preparing plans for a post-Saddam Iraq. Among the 17 Working Groups set up by the US, one was called the Transitional Justice Working Group. In its report on the group, the International Center for Transitional Justice stated the following.

> Prior to the US-led invasion, a working group of State Department officials and Iraqi exiles had discussed a series of possible transitional justice initiatives. Although the working group suggested a variety of possible forms for a tribunal, from the outset US officials emphasized a preference for domestic Iraqi process, announcing even before the fall of Baghdad that they intended to institute an Iraqi-led process.[3]

Although the US wanted the process to appear as Iraqi-led, the whole process was US controlled. One of the many of think tanks working for the promotion of US imperialism calling itself the US Institute of Peace gives us some insight into this reality.

> Under the auspices of the US State Department–supported Future of Iraq Project, a working group on transitional justice has been consulting since July 2002 with the Iraqi Jurist's Association on a range of options pertaining to post-war justice in Iraq.[4]

A further careful consideration of the report of the Transitional Justice Working Group (TJWG), however, yields some serious issues worthy of note as they indicate how early the decision was made to reshape Iraq's judicial system and laws.[5] The report claims that "in order to achieve civil society in a future post-Saddam Iraq, it must be founded on the principle of respect for the rule of law".[6] However, from the outset the whole project and report is based on a breach of a fundamental principle of law that has been established under customary international law and encoded in conventions and treaties which state categorically that an occupying power should not change the laws of the occupied territories. I will look at the parts of the report relevant to the tribunal because any detailed analysis of the whole

report will distract from the focus of this book.

The first stage of reforming Iraq's legal system is through setting up a Judicial Council of nine retired judges (which was later created under Order 35 promulgated by Bremer on 13 September 2003) whose job it would be to vet practicing judges in Iraq and retire those with questionable political background. appoint investigating judges to investigate crimes committed by officials of Saddam's regime, and assume constitutional and legal duties during the transitional period.[7] Thus with the stroke of a pen, a few ill-informed legal advisors in the State Department relying on advice from a few unknown Iraqis in exile were able to abolish Iraq's judiciary of 80 years' history and replace it with people who may have all the good intentions in the world but, even according to the drafters, may lack the necessary competence.

Wth the stroke of a pen, a few ill-informed legal advisors in the State Department relying on advice from a few unknown Iraqis in exile were able to abolish Iraq's judiciary of 80 years' history.

It is evident from the beginning of planning that they foresaw the challenge of immunity that would inevitably be raised. The report addressed that as follows.

> Under Iraqi law, immunity does not pardon or annul a crime.
> It merely suspends legal proceedings for specific reasons.

There is no such principle under Iraqi law and indeed because no such principle could be entertained under any law, one might have assumed this to be a superfluous sentence. However, the drafters went on to develop an argument based on it: "Lifting this immunity implies that the special reason for the restriction is removed and things are back to normal. In other words, the person enjoying immunity shall be subject to legal proceedings like any other person". "Things are back to normal" is a singularly imprecise circumlocution for: when the country has been invaded, and the head of state has been deposed by military force. Anyone reading this last sentence would assume that the logical deduction would entail that when immunity existed then the person enjoying it would have been protected, but from the time it is removed he is no longer protected. The "special restriction" is in fact not some provision within the Iraqi law, but the law itself:

> The 1970 interim constitution grants this immunity to the President, RCC members, ministers and Ba'ath Party regional leadership members. Abolishing this constitution by the competent authority after regime change will automatically lift this immunity and restore normality.[8]

This must be the most bizarre statement I have come across in my 17 years of reading law. But then how else could they argue the case to put Saddam Hussein on trial when the rule of law which they wanted to use to convict him in fact granted him immunity? It has been shown in Chapter 4 that the 1970 Constitution was never abolished.

No sooner had the drafters of the report finished projecting retroactive legislation in approving the negation of immunity, than they condemned the Ba'ath Government for having breached this fundamental principle of law by stating:

> Criminal laws cannot be retroactively applied [9]

At a later stage in the report when referring to reform of the Penal Code, the report cites among the main criticism of the Ba'ath rule as having:

> Violated the principle of the non-retroactiveness of the Penal Code. The Iraqi Constitution and Penal Code stipulate this principle, which is consistent with what is stipulated in international law. However, the regime has issued decrees to retroactively impose the death penalty for acts, e. g. the well-known decree to impose the death penalty on members of the Da'wah Party retroactively to 1980.[10]

In their attempt to condemn the Iraqi Government, whether right or wrong, the drafters of the report were forced to first credit the Iraqi Penal Code in order to then discredit it.

> The general consensus of the commentators is that the original Iraqi Penal Code and Criminal Procedure Code were drafted by a distinguished group of jurists, legal experts and judges. However, successive amendments were introduced by Saddam's regime, which violate basic human rights and social norms. The main purpose of these amendments was to ensure the survival of the regime.

The following comments on the above paragraph may suffice to avoid a detailed analysis of the rest of the report.

1. The drafters of the report, in their haste to condemn, overlooked the fact that both laws cited in that paragraph were drafted during the Ba'ath Government. So if the Ba'ath regime chose distinguished jurists, judges and legal experts to draft the criminal law, then the regime should get credit for it.

2. A despotic regime does not need to pass a law and then go through the legal process of amending it to suit its interests. It would either suspend the law; repeal it, and replace it with one that fits with its interests or, better still, rule by dictate.

3. The report on this matter, like almost all other issues covered, fails to provide any examples to support any statement, judgment or condemnation. It denies readers the right to make an educated assessment and forces them to rely on the TJWG's assertions.

4. Looking at the amendments made to Criminal Procedure Code 1971, we find that there were 12 amendments between its promulgation until 1995. An investigation of these amendments leads to one conclusion, namely that none of them was politically motivated *because they were all procedural and natural* in any legislation. The drafters are invited, even today, to cite one example of an amendment that was made to maintain the 'survival of the regime'.

When the report makes its recommendation for the reform of the judiciary it starts with:

"1. Abolishing all special courts….."

Yet the first court to be created after the invasion was the Iraqi Special Tribunal.

The CPA's Crimes Against Humanity Investigations Unit

As soon as the Coalition Provisional Authority (CPA) was created, it set up the Crimes Against Humanity Investigations Unit (CAHIU). As all these activities are shrouded in secrecy we know very little about the constitution of units and committees set up by the occupying powers. They would always use security considerations as reasons for secrecy. Thus we end up not any wiser as to the real competence and extent of activities carried out. It has been reported that CAHIU was "charged with *supporting* [italics added] the Tribunal's investigation and operational endeavors"[11] However, it is difficult to see how that could have been an accurate description of the role it played, when the Tribunal itself was only set up some seven months later in December 2003.

CAHIU was headed by Tom Parker, who served for six months in 2003-04 as the United Kingdom's Special Adviser on Transitional Justice to the Coalition Provisional Authority (CPA) in Baghdad.[12]

This gives an indication of how early the UK became involved in the

setting up of the Tribunal and the training of its staff. One should not lose sight of the fact that the occupation was a joint venture between the US and the UK; that both sought leave of the Security Council to rule Iraq as occupying powers; that they were granted this authority jointly and that they shared every decision, with Jeremy Greenstock deputizing for Bremer. In short, the legal responsibility and all liabilities that followed from the invasion and occupation is shared by both parties irrespective of who was the principal and who was the accomplice. The fact that all these activities and preparations were carried out in secrecy by the US & UK gives weight to the argument that the trial of Iraq's Government was the plan of the occupiers, which they executed. This, in plain language, is victors' justice executed by proxy.

Sometime in September 2003, Ahmad Al-Chalabi, while presiding over the Governing Council which was appointed by Bremer, claimed to have appointed his nephew, Salim Al-Chalabi, to head a committee of four others to prepare a statute of the Tribunal. Ahmad Al-Chalabi, who has lived outside Iraq in voluntary exile since the July 1958 army coup which ousted the monarchy and affected his family's fortune and interest in Iraq, and who has never been involved in Iraqi politics, suddenly was hailed as the potential future ruler of Iraq. Salim Al-Chalabi, who was educated and lived most of his life outside Iraq, became the head of the administration of the Tribunal only to be forced out in August 2004 when an Iraqi warrant was issued for his arrest, naming him as a suspect in the June 2004 murder of Iraq's former director general of the finance ministry.[13] He was a graduate in economics with a degree in law, but there is some doubt about his expertise in Iraqi law or international criminal or humanitarian law.

The committee headed by Salim Al-Chalabi consisted of:

- Dara Noor Ad-Deen, a judge from Baghdad who was sentenced for three years and released after serving 8 months.
- Wa'el Abdul Lateef, a judge from Basrah who was jailed for one year by the Ba'ath Government.
- Ahmad Al-Barrak, a lawyer from Babylon.
- Naseer Al-Chaderchi, a lawyer from Baghdad.

Although the four members would be able to claim some degree of knowledge higher than that of their leader when it came to law in general and Iraqi law and society in particular, they were not suitable to act in preparing the Tribunal, on the basis of impartiality or conflict of interest. They all had political affiliations opposite to that of the Ba'ath. Two of them, at least, had been sentenced by the Ba'ath regime, and more importantly, all were members of the Governing Council (GC) appointed by Bremer to rule Iraq (See Chapter 4). All members of the GC were chosen for their known opposition to the Ba'ath ideology. It would be a clear breach of natural justice

for them to claim to be passing objective judgment against their enemy.

Although all these activities and the bragging of Salim about his selecting the staff of the Tribunal were in reality only cosmetic because the preparation for the tribunal was being carried out exclusively by the US/UK, they displayed, nevertheless, the intention of the occupiers to replace the Ba'ath with its enemies, irrespective of whomever they may be.

The occupiers lived to regret having adopted such a strategy.

In its quarterly report to Congress, the White House informs it of the setting up of the Iraqi Special Tribunal to try war crimes and crimes against humanity.[14] It concludes the information with the following statement:

> Currently, Iraq lacks the professional and technical investigative and judicial expertise to do this on its own, and therefore needs Coalition assistance.

Anybody hearing or reading official opinions or comments made by officials in the US or the UK on the trial of members of the Iraqi Government which were widely projected through the media could not have missed the mantra of its being a court set up by the Iraqis in accordance with Iraqi law to try people who have committed crimes against them. Yet the above statement of the White House clearly avers that in January 2004, and after the setting up of the IST, the Iraqis had no idea what *'war crimes'* or *'crimes against humanity'* were; had no professional expertise to investigate; and had no judicial expertise to try those crimes—as purportedly they were clamoring to do. In short Salim's team had nothing to do with the tribunal or the trial. This, in a nutshell, is the truth of it.

The CPA Sets Up the Iraqi Special Tribunal

On 10th December 2003, Bremer, in his capacity as the head of the CPA and ruler of Iraq, promulgated Order 48, authorizing the Iraqi Governing Council to set up the Iraqi Special Tribunal (IST).[15] But as we shall document, Bremer was not legally empowered to confer such an authority on the Iraqi Governing Council (nor was the Iraqi Governing Council viewed as legally empowered by the Security Council to exercise it.), nor did Bremer ever intend to actually confer this authority, nor indeed, did he do so. The IST was US micro-managed and controlled from start to finish.

It is important here to reiterate what has been analyzed in previous chapters regarding the illegality of the legislation promulgated by the CPA in Iraq in other regards. I have shown that the CPA acted in breach of fundamental principles of law as established by customary international law and conventions and treaties over the last century regarding occupied territory. The CPA's breaches were separate from the illegality or otherwise of the

invasion itself, which was also illegal.

In short I have demonstrated that the CPA breached the following principles of the Third Geneva Convention 1949 (TGC), Fourth Geneva Convention, 1949 (FGC), and The Hague Regulations 1907 (HR):

- The prohibition against changing judges (FGC, Art. 54),
- The requirement that the Penal Laws of occupied territory shall remain in force (FGC, Art. 64),
- No Penal provisions can be retroactive (FGC, Art. 65),
- Applicable laws must be those in force prior to offence (FGC, Art. 67),
- No proceedings for acts committed prior to occupation (FGC, Art. 70),
- All POWs shall be released after cessation of hostilities (TGC, Art. 118)
- Prohibition of changing the legal system (HR, Art. 43)

L. Paul Bremer III, then-ruler of Iraq, starts Order 48 by stating that his actions are "consistent with relevant UNSC resolutions, including Resolution 1483 (2003), Resolution 1500 (2003), and resolution 1511 (2003)". We dispatched claims related to 1483 in chapter 3. The Security Council in Resolution 1483 specifically grants the request of the US and the UK to govern Iraq as occupying powers when acting under Chapter VII of the Charter and:

> calls upon all concerned to comply fully with their obligations under international law including in particular the Geneva Conventions of 1949 and the Hague Regulations of 1907:

By recalling what the Geneva Conventions and The Hague Regulations stipulate, it becomes clear, even to the lay non-legal observer, that Bremer was acting in breach of Resolution 1483 and not under its authority. International Law prohibits changing the Penal Code but Bremer chose to create new crimes unknown under the prevailing Penal Code of Iraq. International Law prohibits creating new domestic courts but Bremer created not just a new court but a special court with specific mandate for specific crimes that allegedly took place in a specific era, needless to say all contrary to principles of law as we shall see later.

Resolution 1500, which consists of three short paragraphs, does not simply deny Bremer the authority he claimed but also negates his assertion in Section 1 (1) of the Order that:

> The Governing Council is hereby authorized to establish an Iraqi Special Tribunal....

Insofar as Resolution 1500 welcomes the establishment of the Governing Council "as an important step towards the formation by the people of Iraq of an internationally recognized representative government that will exercise the sovereignty of Iraq", it clearly determines that Iraq was still viewed as occupied territory, which means that Bremer was the occupier and thus any attempt at ceding authority to an Iraqi body which itself was viewed by the Security Council as only temporary would doom any effort to make the setting up of the IST look like an act of a sovereign state. The Security Council determined that the Governing Council was not sovereign but a step towards achieving sovereignty.

Resolution 1511, referred to in Order 48, in fact emphasizes further the occupation of Iraq and the temporary nature of that occupation which ought to have reminded Bremer of the limits of his legislative authority. The Resolution states in paragraph 1:

> … and underscores, in that context, the temporary nature of the exercise by the Coalition Provisional Authority (Authority) of the specific responsibilities, authorities, and obligations under applicable international law recognized and set forth in resolution 1483 (2003)…

It is difficult to see how Bremer could have concluded from the above decision of the Security Council that he had the legislative authority under international law to set up the IST as stated in the preamble to Order 48. Perhaps he thought it sufficient to cite Security Council resolutions, and that no one would in fact read them?

How could Bremer have concluded that the Security Council had given him the legislative authority under international law to set up the IST?

A further attempt at giving the impression that the IST was an Iraqi wish and design is given in the preamble which states:

> Acknowledging that the GC, reflecting the general concerns and interests of the Iraqi people, has expressed a desire to establish a Special Tribunal to try members of the Ba'ath regime accused of atrocities and war crimes.

Apart from the fact that most of members of the GC had arrived in Iraq with the invasion and thus had no idea what the wishes of the Iraqi people were, the preamble attempted to convey the message that the creation of the IST was a decision made by the Iraqis following the invasion and not the decision of the perpetrators of the invasion way back in April 2002 when they set up the Transitional Justice Working Group in the Future of Iraq Project. (See Chapter 2)

In furtherance of the previous attempts to base the promulgation of Order 48 on Security Council resolutions, the preamble states:

> Noting the call in UN SC Resolution 1483 for accountability for the crimes and atrocities committed by the previous Iraqi regime...

This clause seems, in my opinion, to portray Bremer as one who believes that he can rewrite Security Council resolutions and international law as he pleases and in the intimidated international atmosphere of the time, he seemed to have got away with it. How else would anybody argue that, in order to ensure that crimes are accounted for, it is admissible to breach all principles of law. Firstly, the Security Council, as was shown in Chapter 3, should not and could not breach international law because if it did its decision would be null and void. Secondly, if the Council wanted to ensure that international crimes are accounted for, then it is bound by duty to set up the mechanism to do that, which means that no one else has the jurisdiction to try international crimes except an internationally approved body which Bremer at no time represented. It should be stressed here that since the setting up of the ICC the authority of the Security Council to set up special tribunals ought to have been curtailed, but instead it is proceeding apace in so doing, most recently with its Resolution 1757 to establish a Special Tribunal for Lebanon to try those accused of assassinating former Lebanese Prime Minister Rafik Hariri.

Bremer seemed to believe that he could rewrite Security Council resolutions and international law as he pleased.

Despite appearing in section 1 of the Order to delegate authority to the Governing Council, Bremer soon declares his superior authority by stating in section 1(6):

> The Administrator [Bremer] reserves the authority to alter the statute creating the Iraqi Special Tribunal, or any elements of crimes or rules of procedure developed for the Tribunal, if required in the interests of security.

Furthermore, in section 2 of the Order, when stating the terms of conditions of the delegated authority, Bremer states in the case of any conflict arising:

> between any promulgation by the Governing Council or any ruling of judgment by the Tribunal and any promulgation of the CPA, the promulgation of the CPA shall prevail.

I suggest that the above sentence says it all. Accordingly, the following observations can be safely made:

1. The Administrator [Bremer] had absolute power over the Governing Council and any attempt, even in pretence, that it could exercise sovereignty is quashed.

2. The Administrator snubbed the Security Council which attempted in Resolutions 1500 and 1511, as noted above, to give some authority to the Governing Council as a step towards sovereignty.

3. The Administrator went beyond anything the Ba'ath regime had done when stipulating that his rulings would annul any "*ruling or judgment by the Tribunal*".

4. We have been continuously bombarded with allegations of the Ba'ath regime having tampered with justice, amended laws and subjected the judiciary to their dictate, only to be told by Bremer that he could go further and legitimize his own meddling by putting it into law.

Selection of the Tribunal's Staff

I have already attended in Chapter 4 to the intellectual massacre of Iraq's intelligentsia as a result of occupation and de-Ba'athification. I shall repeat here that among the names I was given in July 2003 were some 50 judges who were fired on orders from the US official in charge of the Ministry of Justice. If we accept that most of those judges were practicing judges in Baghdad and that more were removed in the months since July 2003, then we can imagine the extent to which the practicing judiciary was depleted. So when the time came to appoint judges for the Tribunal, there were very few competent judges available to choose from.

Insofar as Article 33 of the Statute of the IST reads:

> No officer, prosecutor, investigative judge, judge or other personnel of the Tribunal shall have been a member of the Ba'ath Party.

and having regard to the fact that, after 40 years of Ba'ath ideology dominating Iraqi politics and government to the extent that most Iraqi adults were born during the Ba'ath rule and many have known nothing else, it would not be unreasonable to expect that many people voluntarily joined the party and equally many joined it for survival to secure work or a better life. In brief, by 2003 there were very few people in any important employed or professional position who had not been in the Ba'ath party at some stage of their life.

However, Bremer decided that his selection for the Tribunal would

have to be made from among the smallest of communities living in North Iraq, or those living in exile, or some incompetent lawyers lurking around the courts in Baghdad. The drawback of this alternative remnant is that by restricting himself to North Iraq, Bremer could only access Kurdish judges which would have presented the appearance of a biased court. In fact, two of the judges who tried the Dujail case were Kurdish. There may be some competent Iraqi lawyers practicing in the US and the UK but I do not know of any Iraqi judge among them, and those who were trained to practice in these respective countries would have been trained in Common Law and thus be unsuitable for the Iraqi legal system. This does not mean that we conclude that an Iraqi practicing in the US/UK was selected for the Tribunal.

We even today have not been informed of the process, if any, whereby judges to the IST were selected, and who they were. Very few people have been privy to that information. After nearly one year of attending the court, the defense team was still not informed of the names of judges to be on the bench trying the case. The UK Foreign Office had the names but refused to divulge them, even under a Freedom of Information request. I suggest that this must be a rare incidence in history in which judges sat *incognito*.

However, Human Rights Watch (HRW) has been privileged in being one of the two US organizations, along with the International Center for Transitional Justice (ICTJ) to observe the trial and investigate the functioning of the court. HRW has gone further and carried out interviews with several judges and other members of the tribunals. I, like many others who have been denied such access, would have to rely on the reports of these organizations. It can be safely assumed that HRW knows the identity of the judges who have been interviewed and was able to verify their credentials, yet has chosen not to inform us so that we might make our judgments on the competence and background of those judges.

Nonetheless, some information has trickled through this secrecy, which may be summarized as follows.

1. "The judges who will begin trying Saddam Hussein tomorrow have been secretly trained in Britain in recent months, it emerged yesterday. The International Bar Association confirmed that it had helped to train the 20 Iraqi judges who make up the Special Tribunal, including the five sitting for Saddam's trial. Training was also held for 23 prosecutors", *The Times*, 18th October 2005.[16] This program of training of judges and prosecutors had naturally followed from the fact that they were all selected by the US and UK officials in the CPA, notwithstanding that Iraq has had an inquisitorial and not an adversarial system like that of England, and that the Tribunal was created to function within Iraqi law.

2. Three different bodies in England took part in the training program. They were (i) The International Forensic Centre of Excellence for the Investigation of Genocide (Inforce), an obscure organization set up in 2001 which seems to have chosen an acronym before fitting its name to it, (ii) the International Bar Association, a UK-based organization that has no legal basis under the laws of England, and (iii) an anonymous Consultant.[17]

 That the Iraqi judges needed this training attests to the likelihood that the selected parties had in fact been viewed as incompetent for the task.

3. There is no indication as to how these obscure organizations got involved in the functioning of the CPA. It would have been more sensible for the professional training to have been organized and supervised by any of the two respectable legal professional bodies in England, namely the Bar Council and the Law Society.

4. The training program took place between September 2004 and March 2005 and involved (a) Forensic training and internship, (b) Judicial training—mock tribunal, (c) Investigators training.

5. The British Government paid, as part of the program of the Department of International Development (DFID), the sum of £1,300,000 towards the cost of the six months program.[18] That sum of money was by no means the full cost of the training because, as will be shown later, some $128 million was also spent by the US on the training sessions in London.

6. However, despite the significant expenses incurred for training Iraqi judges, and despite the assertion of one of the barristers who helped in training the judges that "the judges are all very experienced and some have considerable experience as trial judges", and the assertion of the IBA that the "judges are knowledgeable and understand the imperative to make sure the trial is fair and that the defendants receive due process,"[19] Human Rights Watch has concluded that "the level of legal and practical expertise of the key Iraqi actors in the court— trial judges, administrators, prosecutors and defense lawyers—is not sufficient to fairly and effectively try crimes of this magnitude".[20] I suggest that if such is the conclusion of the HRW observer at the end of 2006, then it ought to have been obvious to those who trained them at the end of 2004, irrespective of any political pressure or financial inducements.

7. The disturbing question is why should an Iraqi Tribunal with allegedly Iraqi judges and operating under Iraqi law be trained by private contractors who have no knowledge of Iraqi law?

The most significant observation that stares one in the face once these facts are considered, is that the judges were selected very early in 2004 or a few months after the CPA promulgated the statute of the IST. This should be enough to refute all the claims that have been made by US & UK officials and their Iraqi parrots that the court was set up and selected by "the Iraqi Government", simply because in 2004 there was as yet no Iraqi Government, only an interim and effectively powerless Governing Council appointed by its occupiers. That was further proof of the IST being a symbol of victors' justice.

The Regime Crimes Liaison Office (RCLO)

The occupiers' domination and control of the whole trial is evidenced by the direct role of the US through the activity of the Regime Crimes Liaison Office (RCLO) which was set up in March 2004 by the US Department of Justice and funded by Congress. The fact sheet of the department of justice defines the RCLO as follows:

> The Department of Justice organized and now supports the RCLO, which was designated by the President as the lead U.S. government agency for support to the Iraqi High Tribunal (IHT). The IHT has jurisdiction to investigate charges of genocide, crimes against humanity, war crimes and violations of certain Iraqi laws, and has investigations underway against Saddam Hussein and other former Iraqi officials.
> The RCLO consists of approximately 140 personnel, including about 80 in Baghdad (investigative agents from the FBI, DEA, ATF, and USMS; prosecutors; military officers; and foreign nationals). [21]

When interviewed by Vanessa Blum for *Legal Times,* Greg Kehoe, the then-RCLO head, attempted to portray their role as purely supportive to the Iraqis:

> Basically, we are in a support role for the [Iraqi Special Tribunal]. We don't make decisions for them," Kehoe says. "We don't decide who, what, where, or how someone is going to be charged. Those decisions are up to the Iraqis, and we don't cross that line.[22]

However, Blum went on to advise us that by January 2005 the RCLO had already recruited "50 U.S. lawyers and investigators. The staff includes an additional 30 contractors from the Army Corps of Engineers and 25 *foreign nationals* from Iraq, Holland, Britain, and Australia." The number of people working for RCLO is as big as the staff of the IST itself, which seems to indicate more than the purely supportive role which Kehoe suggested. I shall show in the next chapters how the US Embassy controlled the procedure during the trial. However, one cannot leave this quote without commenting on how Blum included Iraqis among the 'foreign nationals'. That is not a misprint but a clear conscious or subconscious confirmation of the fact that all Americans consider the whole affair, especially the Tribunal, to be an American one and thus all others involved in it are '*foreigners*'.

The involvement of the RCLO during the pre-trial period was outlined in the Quarterly Update to Congress, as required by law, since Congress was financing that mission. In fact the RCLO controlled everything from refurbishing the courtroom, fitting it with equipment, providing special security, despite its being in the fortified Green Zone; **Far from having a purely supportive role as it claimed, the RCLO in fact controlled everything.** controlling the recording of the proceedings and its live transmission, thus maintaining a veto over what could and could not be disseminated.

Here are the main points in the Quarterly Updates:

January 2004 Update Report

It reported that $75 million were allocated to be spent as follows:

- $10 million to hire 5 operational teams of investigators,
- $27 million for accommodation and security of investigators,
- $8 million for evidence handling including a computerized tracking system,
- $4 million for capacity-building to train Iraqi investigators,
- $7 million to support the CPA Mass Grave Action Plan,
- $7 million for international investigators, prosecutors and jurists,
- $12 million for infrastructure and security of the IST. [23]

It may be debatable as to why it would be appropriate for a sovereign state, Iraq, to leave it to another state to pay the cost of investigating its alleged criminals—unless it is the latter who have the primary interest in the event. However, should this matter be settled by arguing that Iraq, having been devastated by two wars, a decade of crushing sanctions, and destruction of much of its public infrastructure, could not afford the expense of trying

those at fault, there still remains a striking feature in the above allocation. There is no part to be played by the Iraqi Governing Council which has just been appointed by the US/UK; no part for the Iraqi Ministry of Justice; no part for the Iraqi judiciary. In short the allocation of the money and its disbursement indicate that the setting up of the Tribunal, its planning, its investigation, its direction etc are wholly an American operation.

No part in this trial by the Iraqi people of a former dictator is to be played by the Iraqi Governing Council, the Iraqi Ministry of Justice, or the Iraqi judiciary.

April 2004 Update Report to Congress

This appears to be the first time in which the establishment of the RCLO was reported to Congress. On its reported activities, I choose the following:

- Five Deputy US Marshalls deployed to Baghdad on March 24, 2004 as the first wave of investigative advisors in the Regime Crimes Advisor Office, which will coordinate and provide assistance to the IST.

- The Regime Crimes Advisor Office and the Iraqi IST investigative staff will begin investigations of High Value Defendants.[24]

This report advises Congress that the RCLO (as it became known) was embarking on questioning the top men of the toppled Iraqi Government. However, the short declaration creates a dilemma for the US. Insofar as the IST was already set up and its staff selected prior to March 24, 2004, as I believe and the April 2004 Update seems to confirm, the US public mantra that the IST was an Iraqi court chosen by the Interim Iraqi Government— which in turn was only nominated by the US on July 13, 2004—was simply at minimum a chronological impossibility. This means that the investigation of the High Value Defendants was carried out by the US and its appointees (even if they were Iraqis) alone.

July 2004 Update Report to Congress[25]

The main points reported in July 2004, still prior to the July 13 appointment by the US of the Interim Iraq Government, were:

- "The RCLO has initiated investigations of High Value Detainees. The IST now employs 15 investigators, five investigative judges, three prosecutors and an administrator".

- "Iraqi IST investigators will receive professional training from members of the RCLO, DoD and private contractors."

This report confirms that the IST has not simply had its Statute drafted by the US, its judges selected by the US/UK and trained by institutions of their choice, but has its staff selected by the US, too. But more disturbing still is the statement that the US Department of Defense was involved in the training. Since when have ministries of war been competent to adjudicate in judicial matters, in order for them to be competent to train people in them, let alone in a foreign country?

October 2004 Update Report to Congress

The reported activity of the RCLO peaks in the October 2004 report. Among its main matters are:

- A document examination database and process were established at the Iraqi Survey Group (ISG) office in Qatar. This database and evidence processing has provided evidence which investigators in Iraq are using to question detainees, suspects and the accused.

- The RCLO continued investigations of high value detainees (HVDs). More than 30 HVDs have been interviewed. IST investigators have been involved in the investigative process. [26]

It is evident from the above reported matters to Congress, that the RCLO was conducting investigations of detainees without any legal authority. Questioning POWs should be done in accordance with principles laid down by international law but the remit and the actions of the RCLO fall outside that law. Note how the report referred to the IST being '*involved*' in the process, which is another attempt at giving the impression that the Iraqis were somehow involved in the interrogation.

The Iraq Survey Group, which was set up by the occupying powers and consisted of some 1,750 personnel from US, UK and Australia, the so-called Anglo-Saxon states, allegedly to search for WMD and thus vindicate the invasion, found nothing after a full year of search. However, it is reported that the ISG's work was relied upon by the RCLO.

The ISG's expertise with the HVDs was invaluable to the Regime Crimes Liaison Office and in its support of the Iraqi Special Tribunal. ... Document exploitation efforts supported the work of the Iraqi Special Tribunal through the Regime

Crimes Liaison Office (RCLO) and the US Department of Justice, who established cells in the Qatar and Baghdad locations to support the prosecution of regime officials.

January 2005 Update Report to Congress

The January Report introduces the Office of Transition Initiatives (OTI), which is a division of the US Agency for International Development (USAID), as a player in the IST along with RCLO. There seems to be an overlap between their two functions. The report advises Congress that RCLO was relying on resources of USAID and DoD. I wonder if it was a deliberate attempt at reducing the perception that the RCLO was dominant in the IST and was in the driving seat. Thus by introducing another organization appearing to share in the contribution, a slight dilution of that perception may result. We will see in the forthcoming updates further evidence of this postulation.

The RCLO was credited as having carried out the following:

* Trained 50 Iraqi Special Tribunal judges and prosecutors in London in October 2004

* Conducted the first set of preliminary investigative hearings for two of the top twelve High Value Detainees (HVDs), including Ali Hasan Al-Majid (Chemical Ali)[27]

while the OTI contribution to the IST is given as:

* One-third of 22 tons of documentary evidence for the IST processed

We are not any wiser as to the meaning of processing the tons of documentary evidence by the OTI. It is all the more puzzling since all the documents are in Arabic and it would have been far easier for the staff of the IST, or people hired by the Tribunal, to handle these documents rather than the OTI which had to rely on interpreters and translators all the time—unless the intention had always been to control every stage of the trial.

Most importantly, the report confirms that the RCLO has already questioned HVDs. Such questioning was undoubtedly unlawful as it breaches principles of law both Iraqi and international. However, the admissibility of any evidence from these investigations in the trial may never be known insofar as we were not told what documents the Tribunal had at its disposal and what documents it considered in its deliberations.

There are other reports confirming the interrogation of top Iraqi officials having taken place by agents other than the IST and even prior to its establishment. One such report, in May 2004, concerns over 8,000 people

being held by the US, including top Government officials.[28] Among those were over 100 HVDs including Saddam Hussein. The report goes on to tell us that:

> Interrogations are performed by military intelligence personnel and a small group of CIA officers.

October 2005 Update Report to Congress

There is only one reference in this report to the RCLO, while the rest concentrated on the logistical work of securing the Tribunal and gathering and securing of evidence.

> USAID/OTI will work with the RCLO to identify additional needs in order to provide continued support to the IST, FEF, and SEU. [29]

The above statement confirms what I stated previously, that the activities of RCLO have been merged with those of OTI so that it would be difficult to see who is doing what. This would lead to the possibility of the RCLO remaining in control of the whole process without being reported as such. Why else would it still be employing 140 personnel by August 2006?

January 2006 Update Report to Congress[30]

Note that it is not until this Report in 2006 that any reference is made to "the Iraqi High Tribunal" (IHT, previously referred to as the IST). However, there is no reference in the report to activity relating to legal procedures. The report is fully centered on logistical support for the Tribunal.

April 2006 Update Report to Congress

This report was compiled while the first trial was under way. Thus any ongoing involvement of the US agencies would be clearly an involvement in the Tribunal's process and not simply in preparing the ground for it. One matter of interest reported is the forthcoming termination of the activity of OTI in Iraq by June 2006, which meant that the RCLO was again the main body in charge of the Tribunal. Among the points in the report are:

- Completed investigation and analysis of mass grave site #4 (City of Nasiriyah); final report accepted by RCLO.

- Commenced implementation of final assistance activity providing for repatriation of key evidentiary documents to Iraq for use by the IHT in upcoming trials related to the Anfal Campaign [31]

The above two statements require some consideration as they impinge directly on the independence of the trials that were either under way or in preparation. The first clearly states that the result of investigation of a mass grave (not that we have as yet been advised of the findings in any mass grave) was submitted and accepted by the RCLO. It seems that that is as clear an admission as could ever be, that neither the IST nor the IHT has been involved in any of these investigations.

But more serious confirmation of the above submission comes in the second statement—that by April 2006 the US agencies were contemplating handing over documentary evidence to the Tribunal. Clearly then, none of that evidence was in the hands of the Tribunal by that date. But more significant is the fact that this evidence was not obtained by the Tribunal itself. The significance of this is seen in the light of the Iraqi legal system and the prevailing Criminal Procedure Code Law 23 of 1971, Article 213 (a) which states:

> The court reaches its verdict relying on the extent to which it is satisfied by the evidence presented during any stage of the inquiry or the hearing. This evidence includes admission, witness statements, written records of an interrogation, other official discoveries, reports of experts and technicians and other legally established evidence.

The above Article means that the court may rely heavily on documentary evidence gathered, compiled and submitted by RCLO. When taking other aspects of Iraqi criminal procedure into account, we are likely to have this documentary evidence determining the outcome of the trial before it starts. Who is to say to what extent the material that was eventually turned over had been vetted and screened to deny information necessary to the defense—or to prevent materials embarrassing to the occupiers from reaching other hands?

It is impossible to finish with the April 2006 Report without citing an example of the treatment of Iraqis by the US. This comes in the following two statements.

> Completed U.S. military troop housing spaces inside the IHT courthouse. Installed rest areas, rest rooms, dining areas and recreation spaces sufficient to support 100 personnel

engaged in cell block guard, medical, explosive ordnance disposal and command operations during trial sessions of high value criminals ($0.4 million).

Completed installation of courthouse Iraqi Police (IP) guard force living quarters. Installed 10 troop tents plus showers, rest rooms and minimal tent furnishings to house up to 110 personnel.

The US military men live in proper accommodation in the courthouse while the Iraqi military men have to live in tents outside it. That for me tells the whole story of the US occupation of Iraq.

Cherry-picking the Crimes: Why Dujail?

The Dujail events were chosen to speedily eliminate Saddam Hussein. There were several reasons for choosing Dujail:

- The attempted assassination of Saddam Hussein in Dujail had resulted in a clear Iraqi court case in which a certain number of Iraqis were tried followed by the execution of some (albeit no one to this day really knows how many).

- It was believed that the implication of Saddam Hussein would be easy to establish because every execution in Iraq had to be ratified by the President. There was little foreign involvement in the incident in Dujail which meant few secrets possibly involving the US, UK or others were likely to be unearthed.

- Had the case of Halabja, in which it was alleged that the Iraqi army used chemical weapons against Iraqi Kurds (in actuality, the Iranians and their Kurdish allies during the course of the Iraq-Iran war), been chosen for the trial of Saddam Hussein, there would have been a possibility of exposure of Rumsfeld, the same architect of 'shock and awe', as the American who in 1984 sold the Iraqis the chemicals that could have gone into producing chemical weapons. We need to be reminded here of how the imperialists choose to write history as they please. At the time of Halabja, when the US was on Iraq's side, the US army concluded that the chemicals must have been sprayed by the Iranians because Iraq did not possess such chemicals.

On the other hand, the choice of Dujail may objectively be seen as the weakest incident for which there might be any reason to indict Saddam Hussein. In order to explain the reason for this assertion we need to look at 1982 war events, the role of the Da'wah Party in Dujail in relation to the assassination attempt against Saddam Hussein, and the disclosures made during the trial for same.

Dujail may objectively be seen as the weakest incident for which there might be any reason to indict Saddam Hussein.

The Iraq-Iran War Events, 1982

Following the September 1980 Iraqi attack, many Iranian border towns fell to the advancing Iraqi army. However, the Iranian resistance soon proved to be greater than the Iraqis had expected from a depleted army. The Iranians managed to pin down the Iraqi advance while a new army was being trained and armed in the geographical depth of Iran. The Iranian counter offensive managed to turn the tide of the war. In May 1982 the liberation of Khorramshahr from the Iraqis was hailed by the Iranians as a great victory that cost the Iraqis dearly in men and material. On 13 July 1982 the Iranians crossed the international borders, threatening Basra, Iraq's second city and its main port with its richest oil deposit. It would have been inconceivable that at the time of these military reversals, anyone was going to trouble the President with information about the arrest, investigation, torture or exile of some people accused of his attempted assassination on July 8, then under investigation by the intelligence or security service. It was in order for such matters to be handed by the proper bodies that Saddam Hussein created the intelligence service and consolidated the security department. Such matters did not reach the President in normal times let alone during the course of battles in which the Iraqi army was faring badly.

The Dujail incident of 1982, in which a group of people belonging to a political party whose leadership was located in Iran and financed by the Iranians at the time of Iraq's war with that country, and the reaction of the Iraqi authorities to it, ought to be seen within the context of the reaction by other countries to events of equal magnitude or even more serious. For instance:

1. During WWII the US interned all Japanese and Americans of Japanese descent for the full duration of the war, not because they had committed any offence whatsoever, but for alleged protection of national security as they presented a risk.

2. On 10 July 2007 the Pakistani army stormed the Red Mosque in

Islamabad allegedly to eliminate some armed men. It was reported that the attack caused the death of several hundred (the true number may never be known) including boys and girls who were in the Mosque studying the Qur'an. This was presented to us as part of the war on terror. No questions were raised in the media as to the rectitude of the government response.

3. The UK House of Commons Foreign Affairs Committee published its yearly report in August 2007. The BBC reported the mild unavoidable criticism of Israel by the committee as follows:

> It called some of Israel's military actions in Lebanon during the war "indiscriminate and disproportionate". It particularly highlighted the attacks on United Nations observers and the dropping of more than 3.5 million cluster bombs (90% of the total) in the 72 hours after the UN Security Council passed the resolution which effectively ended the war.[32]

> I have not heard any media or government spokespeople calling for the indictment of Israel's Prime Minister for ordering 'indiscriminate and disproportionate' force which is a crime under customary International law or for the intended killing and maiming of thousands of children (the most obvious victims of cluster bombs) in the years to come.

4. A typical daily report from Iraq, four years after invasion and occupation, may read as:

> US-led forces killed 32 suspected militants in a raid on the Sadr City district of eastern Baghdad, the US military said today.
> The statement was issued after Iraqi police and witnesses in Sadr City said a bombardment by US helicopters and armored vehicles killed nine civilians, including two women, and wounded six others.
> Men and young boys wept over wooden coffins covered with blankets, while women shrouded in black accused the Americans of attacking civilians.[33]

These attacks were not against the Sunni triangle, which we have been told had been infested with Al-Qaeda. These attacks are against the impoverished Sadr City, inhabited by the hapless Shi'a whom our armies

ostensibly went to Iraq to save from the wrath of Saddam Hussein.

If Dujail was indeed a crime, then any of the above sample of hundreds and hundreds of crimes that have been committed on a daily basis over the last forty years of my observation of world affairs ought to be before a court. None of those will come before a court. But more importantly, the European conscience as represented by the media, the legal profession, the academics and the intelligentsia is quiet about them. Is it because we, including our allies, never commit any crime, or is it because the demon must always be on the other side?

Da'wah Party Involvement

The Da'wah Party, whose creation dates back to the post 1958 coup in Iraq, was initially supported by the Shah of Iran to subvert national plans in Iraq in furtherance of his grand ambitions for a revival of the Persian Empire. Although the Da'wah Party moved slightly to the left when it sided with the Islamic Revolution of Khomeini, it soon found itself back in the imperialist camp when it cooperated with the invaders of Iraq, and assumed power in Iraq under their auspices in 2005. In 1979 following the Khomeini victory the Da'wah had moved its operations headquarters to Tehran. In March 1980 the Iraqi Revolutionary Command Council banned the Da'wah Party, accusing it of being an agent of the enemy, and ordained that the death sentence would be imposed on any member of the Party. I believe that that measure earned the Da'wah more sympathy than it would otherwise have had.

In April 1980 the Da'wah carried out a failed assassination attempt on Tariq Aziz, the Iraqi deputy Prime Minister. In 1982 they carried out the failed assassination attempt on Saddam Hussein and in 1987 there was still another failed attempt on Saddam Hussein.

In order to put the Dujail assassination attempt in its proper context I would like to suggest the following hypothetical incident. Assume that in the summer of 1940 while the Battle for Britain was underway, some British men, who were members of a dissident British Party which was financed by Germany and whose headquarters was in Berlin, carried out a failed assassination attempt on Prime Minister Winston Churchill. What would the reaction of the British Government and people have been? It is precisely in that context that the aftermath of the Dujail assassination attempt should be considered. I dare say that at no time during the trial was the full context of the events raised properly by the defense or considered by the Tribunal in its judgment.

The full wartime context of the Dujail assassination was never raised properly by the defense or considered by the Tribunal in its judgment.

ENDNOTES

1 Article 40, Iraqi Provisional Constitution 1970, Order Number 792, Promulgated by The Revolutionay Command Council on 16 July 1970.

2 Iraq Liberation Act of 1998 (Enrolled as Agreed to or Passed by Both House and Senate), H.R.4655, One Hundred Fifth Congress of the United States of America, The Library of Congress, Section 6. <http://thomas.loc.gov/cgi-bin/query/z?c105:H.R.4655.ENR>

3 Briefing Paper, Creation and First Trials of the Supreme Iraqi Criminal Tribunal, International Center for Transitional Justice, October 2005, p. 5. (hereinafter referred to as 'ICTJ-1'). <http://www.ictj.org/images/content/1/2/123.pdf>

4 Establishing Justice and the Rule of Law in Iraq: A Blueprint for Action, US Institute of Justice, May 21, 2003. <http://www.usip.org/event/2003/0521_CIBiraqlaw.html>

5 Transitional Justice Working Group, The Future of Iraq Project, US Department of State, Document Number 200304121, March 2003. <http://www.gwu.edu/~nsarchiv/NSAEBB/NSAEBB198/FOI%20Transitional%20Justice.pdf>

6 Ibid, p. 4.

7 Ibid, p. 10.

8 Ibid, p. 12.

9 Ibid, p. 16.

10 Ibid, Appendix V, Annex A (Penal Code), pp. 124-125.

11 Ibid., p. 16.

12 ICTJ-1, p. 6. Cornell University, *International Law Journal* <http://organizations.lawschool.cornell.edu/ilj/milosevic_hussein.htm>

13 Terkel, A. Striking out with Salem, Center for American Progress, 12 August 2004. <http://www.americanprogress.org/issues/2004/08/b138764.html>

14 Office of Management and Budget, Reports to Congress, First Quarterly Report, January 6, 2004, p.43. <http://www.whitehouse.gov/omb/legislative/20040105-sec2207_main_report.pdf>

15 Coalition Provisional Authority, Order Number 48. CPA/ORD/9 Dec 2003/48.

16 Saddam trial judges were secretly trained in Britain, Timesonline, 18 October 2005. <http://www.timesonline.co.uk/tol/news/world/iraq/article579658.ece>

17 Development Assistance in Iraq: Interim Report , 7th Report of session 2004-05, International Development Committee, House of Commons, 5 April 2005, p. 66.

18 Id.

19 See endnote 16.

20 Judging Dujail, The First Trial before the Iraqi High Tribunal, Human Rights Watch, Vo. 18, No. 9(E), November 2006, p. 6. (hereinafter referred to as HRW-2) <http://hrw.org/reports/2006/iraq1106/iraq1106webwcover.pdf>

21 Attorney General Alberto R. Gonzales Travels to Baghdad, Department of Justice, Press Release, August 29, 2006. <http://www.usdoj.gov/opa/pr/2006/August/06_ag_575.html>

22 Blum, V., A Slow Search for Justice in Iraq, *Legal Times,* ICTJ, January 24, 2005. <http://www.lctj.org/en/news/coverage/article/360.html>

23 Executive Office of the President, Office of Management and Budget, First Quarterly Update to Congress, Section 2207, Part IV, January 6, 2004, pp. 43-44. <http://www.whitehouse.gov/omb/legislative/20040105-sec2207_main_report.pdf>

24 Executive Office of the President, Office of Management and Budget, Second Quarterly Update to Congress, Section 2207 April 5,2004, p. 35. <http://www.whitehouse.gov/omb/legislative/2207_report2.pdf>

25 Executive Office of the President, Office of Management and Budget, Third Quarterly Update to Congress, Section 2207, Appendix I, July 2, 2004, p. 24. <http://www.whitehouse.gov/omb/legislative/appdx_1_sectors_final.pdf>

26 US Department of State, Quarterly Update to Congress, Section 2207 Report on Iraq Relief and Reconstruction, Appendix I, October 2004, p. 28. <http://www.state.gov/documents/organization/36918.pdf>

[27] US Deaprtment of State, Quarterly Update to Congress, Section 2207 Report on Iraq Relief and Reconstruction, Appendix I, January 5, 2005, p. 41. <http://www.state.gov/documents/organization/40475.pdf>

[28] Gertz, B., 'Most prisoners in Iraq jails called 'threat to security', *The Washington Times* Nation-Politics, May 06, 2004. <http://www.washtimes.com/national/20040506-121952-7636r.htm>

[29] US Department of State, Quarterly Update to Congress, Section 2207 Report on Iraq Relief and Reconstruction, Appendix I, October 2005, p. 37. <http://www.state.gov/documents/organization/54802.pdf>

[30] US Department of State, Quarterly Update to Congress, Section 2207 Report on Iraq Relief and Reconstruction, Appendix I, January 2006. <http://www.state.gov/documents/organization/58811.pdf>

[31] US Department of State, Quarterly Update to Congress, Section 2207 Report on Iraq Relief and Reconstruction, Appendix I, April 2006, p. 33. <http://www.state.gov/documents/organization/64515.pdf>

[32] 'UK Damaged by Lebanon War Delay', BBC News, 21 August 2007, <http://news.bbc.co.uk/1/hi/uk_politics/6940331.stm>

[33] 'US Raid Kills 30 Iraqi Militants', BBC News, 8 August 2007, <http://news.bbc.co.uk/2/hi/middle_east/6936755.stm>

MAKING THE TRIBUNAL "IRAQI"

Establishing the Iraqi High Tribunal (IHT)

The Transitional Administrative Law (TAL) (see chapter 4 for the argument on its legal status) preserved and continued the Iraq Special Tribunal Statute in force and effect. However, in an attempt to refute the argument that the IST was a creation of the US/UK occupation, which would make the trial victors' justice pure and simple, the US devised a new ploy. The plan was to call the Tribunal by a new name and have its statute ratified by the Transitional National Assembly.

Article 26 of The Interim Constitution 2004, which was a repeat of TAL purportedly with Iraqi approval, upheld all the legislation promulgated by Bremer. However, further and in addition to Article 26, the Interim Constitution held in Article 28 that:

(a) The statute establishing the Iraqi Special Tribunal issued on 10 December 2003 is confirmed. That statute exclusively defines its jurisdiction and procedures, notwithstanding the provisions of this Law.

(b) No other court shall have jurisdiction to examine cases within the competence of the Iraqi Special Tribunal, except to the extent provided by its founding statute.

(c) The judges of the Iraqi Special Tribunal shall be appointed in accordance with the provisions of its founding statute.

This clearly emphasizes that the IST was the creation of the occupation to the extent that even when the authority had superficially been transferred to the Iraqis, it ensured that nothing should affect the process of vindication of the invasion, occupation and destruction of the nation of Iraq.

The US/UK officials in Washington, London and Baghdad foresaw the embarrassment the forthcoming trial of Iraqi officials was going to create

for them. In the months that followed the installation of the Transitional Government in Iraq, work was carried out on a new Statute that would dilute some of the features of the IST statute, alleging that to be in line with the thinking of the new Iraqi authority. This led to the birth of a new court called the Iraqi Supreme Criminal Court in Arabic, but calling itself the Iraqi High Tribunal (IHT) in English, which is the term I shall use to identify it.

Ever since, it has been repeatedly claimed that the trial of the Iraqi officials, including Saddam Hussein, has been carried out by an Iraqi Tribunal set up by an Iraqi authority and in accordance with Iraqi law. However, any review of the above facts would refute these claims.

Saddam Hussein's trial started on 19 October 2005. The IHT was created on 18 October 2005, i.e. one day before the trial started. It is obvious that the whole process of the setting up of the Tribunal, the selection and training of the judges and prosecutors, the gathering of evidence, reviewing of documents (reported to have been over two million), the interviewing of over 7000 witnesses,[1] and the interrogation of the accused, had all been done by the occupying powers, who legitimized their involvement by reference to their interaction with the Statute of the IST which had been created and applied by the Governing Council which had itself been appointed by the occupying powers. On the eve of the trial the prevailing law under which the trial took place was that made by Bremer. The attempt to portray the trial as having been held under the IHT Statute passed by an Iraqi authority is a fig leaf that fails to cover the naked control and manipulation of the process by the CPA. No legislation should seek to retrospectively bestow legitimacy on illegal processes and acts.

I have demonstrated that the Iraqi High Tribunal (IHT) was unlawful and because it was set up without legal authority it lacked jurisdiction over matters it claimed to have. However, even if one were to presume that a solid legal argument could be advanced to substantiate its legality, there would nonetheless remain the issue of whether the Statute and Rules of the IHT fit within the norms of law, whether Iraqi or international.

The Principle of Retroactivity

It is accepted that if an Iraqi legislative body is entitled to set up a tribunal then it should still be set up within the principle of law. The fundamental obstacle which the IST/IHT has to overcome is that of retroactivity. Retroactivity simply means criminalizing later that which, for whatever reason, was not criminal at the time of committing. The prohibition of retroactivity is not simply a legal principle but also a common sense one which ordinary people

accept and expect to be upheld. It would be impossible to argue that A should face trial at time X for an act he had committed at earlier time Y, when at time Y the act was not criminal—even though it has since been criminalized. Society would not be able to function with this kind of fear hanging over it.

The principle of prohibiting retroactivity is universal. Almost every jurisdiction has it in one form or another.

(i) International Criminal Court Statute (ICCS)

The Statute of the ICC, which has been universally accepted (except by the US and a few other states) as the law which defines international crimes and sets out the framework for trial of these crimes, enshrined the principle in Article (22).

> Article 22
> *Nullum crimen sine lege*
>
> A person shall not be criminally responsible under this statute unless the conduct in question constitutes at the time it takes place, a crime within the jurisdiction of the Court.

(ii) The European Court of Human Rights upheld the principle in the case of *Veeber v Estonia* (No. 2) Appl. No. 45771/99 at 31, 21 January 2003):

> according to the Court's case-law, Article 7 of the Convention is not confined to prohibiting the retrospective application of the criminal law to an accused's disadvantage; it also embodies, more generally, the principle that only the law can define a crime and prescribed penalty and the principle that the criminal law must not be extensively construed to an accused's detriment.

(iii) Iraqi Law

In domestic legislation, the Iraqi Penal Code 1969 states in section 2:

> (1) The occurrence and consequences of an offence are determined in accordance with the law in force at the time of its commission and the time of commission is determined by reference to the time at which the criminal act occurs and not by reference to the time when the consequence of the offence is realized:

(2) However, if one or more laws are enacted after an offence has been committed and before final judgment is given, then the law that is most favorable to the convicted person is applied.[2]

The Transitional Administration Law (TAL) which was created by the US/UK occupiers (see Chapter 3) holds itself to be the supreme law of the land in Iraq and goes on to state in Article 3 that:

Any legal provision that conflicts with this Law is null and void.

and then in Article 15 also upholds the prohibition on retroactivity, stating that:

(A) No civil law shall have retroactive effect unless the law so stipulates. There shall be neither a crime, nor punishment, except by law in effect at the time the crime is committed.

It is clear from the above that retroactivity is prohibited under both Iraqi and international law. It would thus follow that if the offences of which the Iraqi officials have been charged with were not criminal acts at the time they were committed, then the whole legal foundation of the Tribunal would collapse—however morally objectionable that may be.

The IHT Recognizes the Retroactivity Issue

The US/UK officials and legal advisers knew from the outset that it would have been almost impossible to put Saddam Hussein on trial elsewhere for reasons that were outlined in Chapter 5; the ICC has no jurisdiction; under English Law he would be entitled to immunity granted to Heads of State and prevented from facing execution; and the Security Council would not have agreed to establish a special international tribunal.

The only available avenue open to them in order to vindicate their invasion and destruction of Iraq was to ask the Iraqis to try him, convict him and execute him. By doing so it was left to the Iraqis to justify invoking retroactivity in the trial of top Iraqi officials. Thus Ra'id Juhi, the young inexperienced Iraqi chosen by Bremer to be the chief investigating judge in the most complex legal issues faced by any judicial authority in recent memory, says in the introduction to the IHT, the following:

Basically the criminal legislations do not cover the past. This principle is well-known in the criminal law. It is called

"the principle of retroactivity of laws". This is included in the Iraqi penal code no.111 of 1969, article no.2 paragraph 1. According to article no.1 of IHT statute the IHT is concerned with the crimes committed since July 17th, 1968 to May 1st, 2003. Statute no.1 of 2003 was issued in 2003 and statute no.10 was issued in 2005. Still those statutes did not violate the principle of retroactivity, as the crimes described in articles no.11-12-13-14 of the statute were valid in Iraq since the fifties of the last century and fully legal. For example, article no.11 of the statute concerning the crime of genocide, which is recognized internationally in international convention of 1948. Iraq ratified this convention on January 20th, 1959. Doing this meant that this convention is a part of the Iraqi laws, and Iraq is committed to its provisions, specially 1 & 2.

In regard to article 13 concerning the crimes of war which are grand violations to Geneva Convention of 1949, we find that Iraq has ratified this convention too. That was in February 12th, 1956. This means Iraq as a member in this convention is committed to follow the provisions in it as they became part of the Iraqi law, and the perpetrators must be punished.

Article no.12 concerned crimes against humanity; the legal source of these crimes is international customs, as there is no international convention which organizes its rules definitely. Still it is internationally agreed that the crimes described in article 12 of the IHT.? It is agreed that the international customs are so-called "international customs code".?

.......

Therefore, it is obvious that the IHT statute is never contradicting the principle of retroactivity as it contains originally criminal acts, described as being criminal in the international conventions ratified by Iraq since the fifties of the last century. Or they are described as being criminal in the statute no.7 1958. In other words, the IHT assembled those laws and rules in one statute.

It is vital to analyze the above statement because it reveals the chaos inside what came to be hailed in the US/UK as a legitimate court of law. But more importantly for me is that it shows little comprehension of the law of which the officials in that court were supposed to be in control.

Two errors expose a casual way of dealing with legislation and an ignorance of international law which the US/UK advisers have not even bothered to correct. The first is the reference to *'Statute No.1 issued in 2003'*, which seems to be repeating a statement whose origin is unknown and which has been repeated several times over the last two years. There is no such thing as Statute No. 1 of 2003. During 2003 there was no statute promulgated in Iraq. Bremer ruled Iraq by Regulations and Orders as he declared in Regulation Number 1 on 16 May 2003.

The second mistake in Juhi's opening statement to the IHT website relates to denying that crimes against humanity are included in any international convention. In fact, Article 12 of the IHT Statute which lists the Crimes against Humanity is almost identical[3] to Article 7 of the Statute of ICC, which is by definition an international convention. It seems that the US/UK advisers who drafted the IST/IHT Statute omitted to inform Juhi and his colleagues of the fact that all of Articles 11, 12 and 13 of the IHT Statute were in fact copied from the Statute of the ICC.

Addressing first the issue of retroactivity: the fact that this issue is raised by Juhi indicates that his advisers recognized that there might be a problem here, which would have to be successfully overcome. The problem is how to show that at the time of the Dujail incident, crimes against humanity existed under Iraqi Law as indictable offences. But knowing that they did not exist under Iraqi law in 1980s, Juhi and his advisers decided to get around the problem in this way: they recognize the validity of the prohibition against retroactivity—and then contend that the retroactivity prohibition is not problematic since Iraq had ratified the treaties in the 1950s.

However, Juhi and his advisers failed to show how it is possible to extend an international treaty dealing with treatment of people in occupied land at a time of war to the dealings of a state apparatus with its own population.

While Iraq may have ratified the Geneva Conventions, like many other nations, it did not pass any domestic implementing legislation, as demanded by the Conventions, making indictment for crimes under them accessible through domestic law.

Criminalizing actions could not be accomplished by extending a legal principle beyond its remit. It may sound reprehensible to argue that a state may commit actions internally which it accepted are illegal or even criminal internationally. But we are not conducting a moral argument. This is a legal issue being addressed in a court of law. A more detailed analysis will be presented in Chapter 9 dealing with the position of Iraqi jurisprudence regarding incorporating international treaties into Iraqi domestic law, but it suffices here to state that on Juhi's failure to establish the proof, the following may be concluded:

1. Iraqi law up until 2003 had no legislation which domestically criminalizes actions that may be classified as war crimes, crimes against humanity or genocide.

2. The first time these offences were criminalized was in Order 48 promulgated by Bremer as Administrator of the CPA in Iraq on 10 December 2003.

3. Any application of Order 48 or any law that was based on it would make the application retroactive.

4. The retroactive application of criminal legislation is prohibited under international and Iraqi law.

5. Order 48 claims to have been promulgated under international law and the IST Statute claims that Iraqi law applies.

6. In view of the above it follows that both Order 48 and the IST Statute are unlawful and their consequences are null and void.

Immunity of Heads of State

Another no less important legal principle is that of the immunity granted to an acting head of state. The rationale behind this principle is obvious. It is to enable heads of state to function without fear of being summoned before courts, which fear would inhibit their freedoms and curtail their capacity to function. The principle is old and universal.

I understand that today there are genuine calls to put an end to the principle of immunity intended to try to protect humanity from atrocities resulting from the unrestrained exercise of state power.[4] Such, indeed, will be a step forward for our world. But the issue should be handled with great care by those in the legal profession to ensure that it does not simply apply but is also enforced universally. Any failure in that respect would amount to its becoming an imperialist tool whereby it is applied to Saddam Hussein or possibly in future to Ahmadi Nejad while equally culpable people like Johnson, Bush, Blair, Howard and others are allowed to act without any such restraint.

Saddam Hussein, like many other heads of state, enjoyed similar immunity under the Iraqi Constitution. Section 40 of the Iraqi Constitution 1970 reads:

> The Chairman of the RCC, his deputy and members enjoy full immunity and no action could be taken against any of them without a prior permission from the Council.

It is difficult to see how any argument could be made to deny Saddam

Hussein and other members of the Revolutionary Command Council the immunity granted under the prevailing Iraqi Constitution, particularly if Iraqi law is to be regarded as still in force. There may be all sorts of moral arguments for changing laws and they are sometimes powerful and sometimes not. But what is the validity to saying a particular legislation is not existing, when it is, in fact, presently in force?

I have come across many arguments about the need to bring people to justice on the grounds that they have breached principles upheld under international law. I would have a different but a difficult argument to rebut such calls. But such a call would only be possible when such a trial is held under international law and by a fairly and correctly internationally-constituted tribunal.

Put another way: there could never have been any jurisdiction under Iraqi law to try the Head of the State in 2003. It follows that the IST/IHT even if it could be argued that it was properly and legally set up, has had no jurisdiction to try Saddam Hussein and members of the RCC because they have had full immunity under the constitution.

Developing the IST/IHT Statute and Rules

If I were to choose one word to describe the process of setting up the Tribunal and the following trial and outcome, I would say: chaos. The blame for that lies not only with the Iraqis alone, but equally with the Americans and the British who played a primary part in the setting up and in the trial procedures, as has been shown in previous chapters.

Chaos infested the drafting of the Rules of the Court. As Amnesty International reported in May 2005 under the heading of "Confusion in the Rules of Procedure and Evidence":

> At the time of writing, there were three versions of the Rules on the website. An official Arabic (which was drafted originally in Arabic) consisting of 90 rules and two English versions. One of the English versions, which consists of 90 rules, is very similar to the Arabic one, although it has some translation inconsistencies as will be detailed below. The other English version consists of 93 Rules and is different from the other versions [5]

To add to the chaos and confusion, on 18 October 2005 the Iraqi Official Gazette published a new set of Rules appended to the IHT Statute, which Statute stipulated in Article 16 that Tribunal should follow the rules of procedure provided in the Iraqi Criminal Procedure Code 23 of 1972. This is the version I will address herein.

It should be remembered here that by that time, the accused had

already been extensively interrogated by the US and investigated by the Chief Investigating Judge. No one knows which Rules were followed during these interrogations, if any.

Although the IHT Statute came into force on 18 October 2005, the whole Dujail Trial had started months before and was being processed under the IST Statute and whatever Rules the Inquisitors decided to use. The Trial that started on 19 October 2005 was not under the IHT Statute, but was based on the IST Statute that was created by the occupier and which differed very little from its successor. The promulgation of the IHT statute bestowed superficial legitimacy on the Tribunal since it simply duplicated the IST statute in attempting to protect US intentions while making the US creation look as if it were Iraqi.

To add more to the above confusion, it is worth noting that up until the time of this writing, the official website of the Tribunal in English—which is the only access the public has to it—actually provides, under the Heading of the IHT Statute, the Statute of the IST enacted under Order 48 and not that of IHT enacted on 18th October.

To Establish Special Courts—Or Not to Establish Special Courts

The IHT Statutes and Rules as translated by the ICTJ can be viewed at <http://www.ictj.org/static/MENA/Iraq/iraq.statute.engtrans.pdf>

In chapter 4, I addressed the legality of the occupation's Transition Administrative Law (TAL) and showed that it was not simply illegal because it violated basic principles of international law, but also illegal in that it never received any ratification by any authority and was not enacted in a Regulation or Order.

However, hypothetically accepting that it was lawful for the CPA to enact a new constitution in occupied Iraq, I am considering the Statute of the IST that was drafted under TAL.

In their pretended pro-democracy campaign, the US/UK drafted a civilized document on paper and called it TAL to serve as the constitution of Iraq until such time as the Iraqis were able to draft their own constitution. It is not possible to fault many of the principles included in TAL. However, no document is worth more than the paper it is written on if it does not implement what it purports to stand for. In Chapter Two of Fundamental Rights, TAL gives us, among the other principles it lists:

Article 15(I)
Civilians may not be tried before a military tribunal. *Special or exceptional courts may not be established.*[emphasis added]

However, no sooner has the TAL assured us that in modern democratic Iraq there will be no Special or Exceptional Courts, than it dismisses that principle in Article 48.

> (A) The statute establishing the Iraqi Special Tribunal issued on 10 December 2003 is confirmed. That statute exclusively defines its jurisdiction and procedures, notwith-standing the provisions of this Law.
> (B) No other court shall have jurisdiction to examine cases within the competence of the Iraqi Special Tribunal, except to the extent provided by its founding statute.
> (C) The judges of the Iraqi Special Tribunal shall be appointed in accordance with the provisions of its founding statute.

What good is a principle if, as soon as it is tested, it is negated? The TAL was issued to run for just over one year and it was unlikely that it was going to be tested very often. What then is the purpose of having a rule prohibiting special tribunals when one has just been established? Having a principle with exceptions is equivalent to not having it.

Furthermore, the IST could have only been created under existing Iraqi law as demanded by Article 64 of the Fourth Geneva Convention. The Iraqi Judicial Organization Law No. 160 of 1979 does not recognize the IST. The violation of this cannot be rectified by an Article in TAL that was promulgated after the IST was created. This principle is accepted as part of customary international law and appears in many conventions.

The IHT Statute: The IST Statute in Sheep's Clothing?

The Statute of the IHT, which was promulgated one day before the start of the trial, is a more punitive and prejudicial version (see for example the comparison of Article 27 below) of the Statute of the IST passed by the CPA even before Saddam Hussein had been captured. In reality the IST *was* the Tribunal because the whole process was carried out under it, especially the selection of the judges and the investigation. However, in a transparently phony attempt at bestowing some 'Iraqiness' on the Tribunal, the Statute of the IST was rewritten and given a new name. The differences between the two Statutes, as addressed below, reveal not only the extent of the US control of the process, but changes in the text, which are even more adverse to the accused, indicating the only "improvement" to it had reflected the desire for vengeance which some of the Iraqi puppets harbored.

Article 1: Jurisdiction
The Tribunal according to both the IHTS and ISTS has jurisdiction to

try Iraqis and non-Iraqis, who were resident in Iraq, for the crimes listed in the Act, committed in the period from 17 July 1968 to 1 May 2003. However, the IHTS deleted the section of the Article in ISTS which includes crimes committed *'in connection with Iraq's wars against the Islamic Republic of Iran and the State of Kuwait'*.

If we were to compare the jurisdiction in IHTS with the jurisdiction in the UK of the Geneva Conventions Act 1957 (as amended) for crimes committed contrary to the Geneva Conventions, (GCA), Article 1 of IHTS reads:

> The Tribunal shall have jurisdiction over every natural person, whether Iraqi or non-Iraqi resident of Iraq, accused of committing any of the crimes listed in Articles 11, 12, 13 and 14 of this law, committed during the period from 17 July 1968 to 1 May 2003, in the Republic of Iraq or elsewhere.

Section 1 of the UK Geneva Conventions Act 1957 (GCA) (as amended) reads:

> Any person, whatever his nationality, who, whether in or outside the United Kingdom, commits or aids, abets or procures the commission by any other person of a grave breach of any of the scheduled conventions or the first protocol shall be guilty of an offence.

The distinctions between the two legislations may be summarized as follows:

1. The IHTS is retroactive while the GCA covers crimes committed after promulgation.

2. The IHTS covers crimes committed over a limited political period while the GCA covers crimes committed from enactment until it is repealed.

3. The IHTS, even in its limited temporal jurisdiction, applies only to Iraq and resident of Iraq during the specified time period from 17 July 1968 to 1 May 2003, while the GCA applies to any body anywhere in the world who commits the crimes. It should be noted here that the GCA is in conformity with Article 146 of the Fourth Geneva Convention.

I would make the following observations on Article 1 of the IHTS, taking into consideration the above distinctions.

1. It has been argued by the proponents of the IST/IHT that the crimes in the Act became part of Iraqi law once the international conventions were ratified. If these crimes were to become part of Iraqi law, why should they be time-limited? Why would the IHTS not extend its temporal jurisdiction to the actual earlier times of ratification and from thence onward, particularly if it intends, as stated in Article 17(4) of the IHTS, that

 > The crimes stipulated in Articles 11, 12, 13 and 14 of this Law shall not be the subject of any statute of limitations.

2. By putting the temporal jurisdiction of the IHTS as from July 1968 to 2003, the IHTS has ruled that after 1 May 2005 no international crimes could be prosecuted in Iraq. Had the purpose of the legislation been, as has been claimed, to create a Tribunal to ensure that international crimes are properly prosecuted in Iraq, then there should have been no limitation on the temporal jurisdiction of the Tribunal set up for that purpose. The only conclusion one could draw from this reality is that the Tribunal has been set up to try a political genre—the Ba'ath Party—as a justification for the invasion, occupation and uprooting of the ideology behind that genre.

3. The IHTS has ruled non-Iraqis exempt from any liability for international crimes during and after the occupation, including any committed on Iraqi territory. As a principle of law this must be wrong because a crime is a crime irrespective of who commits it. The exemption which was granted by the US/UK occupiers in the ISTS and carried on to the IHTS is a confirmation of Order 17 promulgated by Bremer—all of which serve to protect the occupiers from liability for any criminal acts, including war crimes and crimes against humanity, in which they may have engaged. This exemption basically breaches the sovereignty of the state of Iraq. Any state that cannot extend its jurisdiction over its territory lacks in sovereignty. On 16 September 2007, according to BBC-1, personnel employed by the American security firm, Blackwater, fired indiscriminately at innocent civilians in a crowded square in west Baghdad, killing scores of people including women and children.[6] Following an outcry in Baghdad over the blatant crime, the Minister of the Interior, pretending that he had authority, declared that he was revoking the license of Blackwater, which he had not granted in the first place, only to be rebuked by the Supreme Judicial Council on the ground that he had no jurisdiction over the security firms. The Council's surprising intervention to

chastize the minister for lack of jurisdiction—even were it not compelled to do so by the occupying forces—would nonetheless attest to the lack of sovereignty of the Iraqi Government.

4. It may be argued that the military personnel of the US and UK in the occupation of Iraq are subject to their respective military law. However, there is no law to which any of the mercenaries operating in Iraq, under the guise of security men and numbering over 180,000 are subject. Any of these men can commit crimes with impunity in Iraq and have done so over the last four years. There have been numerous reports of members of security firms shooting at random and using Iraqi cars for target practice.[7] It suffices here to cite what the Iraqi Ministry of Interior had reported in the case of Blackwater. Associated Press reported the spokesman for the Ministry citing at least six incidents of personnel employed by Blackwater killing Iraq civilians, and concluded by saying: "These six cases will support the case against Blackwater, because they show that it has a criminal record".[8]

5. The exemptions in paragraphs 3 and 4 are both in breach of still-existing Iraqi Law which ought to be upheld and which has not been repealed even by the occupying power or the appointed or elected Iraqi Administrations. Article 6 of the Iraqi Penal Code Law No. 111 of 1969 reads:

> The jurisdiction of this Law extends to all crimes committed in Iraq. A crime is considered as having been committed in Iraq if any of the constituent acts of the crime or the outcome of the crime occurred in Iraq, or it was intended for the outcome to occur in Iraq. In all circumstances the jurisdiction of the Law covers everyone who takes part in a crime which wholly or partly occurred in Iraq even if his contribution was outside Iraq, irrespective of whether he was the principal or an accomplice.

It was shown earlier that the Law of the occupied land must be upheld by the occupying powers. It would thus follow that the restrictions of jurisdiction to Iraqis and the exemption of non-Iraqis from liability is contrary to Iraqi law and thus a breach of international law.

Article 4: Selection of Judges

Article 4 of the IHTS added two requirements that were missing in

the ISTS. Firstly, the IHTS requires that "prosecutors shall be persons of high moral character, honesty and integrity". Secondly, it required that both judges and prosecutors "shall have experience in the field of criminal law and meet conditions for appointment stipulated in the Judicial Organization Law (JOL) 160 of 1979 and the Public Prosecution Law (PPL) 159 of 1979".

These welcome additions were made to be in line with the assertion that the IHT functioned according to the prevailing laws of Iraq. However, the Article soon makes the one exception that renders that assertion redundant. It allowed Iraqi lawyers who were not judges to be appointed as judges in the Tribunal—all contrary to the JOL 1979. As we have established that most judges and lawyers were members of the Ba'ath Party and that Ba'athists were banned from taking part in the Tribunal, then it was more likely that many of those chosen as judges to the Tribunal were in fact lawyers and not judges. This conclusion leads to another, no less serious deduction, namely that it was unlikely that any of them has had any experience in the complex criminal matters that the Tribunal had to handle.

There are two other important matters introduced in Article 4.

1. It states that "the Presidency Council … may transfer judges and prosecutors from the Tribunal to the Supreme Judicial Council for any reason". It is impossible to explain this action except as a tool of intimidation, as such a dictatorial measure impinges directly on the independence of the Tribunal and gives the Government the final say in eliminating judges it does not approve of, as indeed happened later during the proceedings.

2. It confirms that "the judges, prosecutors and employees appointed in accordance with the law prior to this legislation shall be deemed legally approved as of the date of their appointment". It has been reported by ICTJ, one of the only two organizations allowed by the US to monitor the Trial, that "as of May 2005, the SICT's (IHT) total staff reportedly stood at some 250 personnel, including 48 judges and 16 prosecutors",[9] then the IHTS had effectively declared that its Article on the selection of judges and prosecutors was of little value or effect—as its drafters must have known—as all the judges and prosecutors had already been selected by Bremer and his US and UK advisers, as I have already established earlier.

The fine IHTS Article specifying criteria for the selection of judges and prosecutors was meaningless—as its drafters must have known—as all the judges and prosecutors had already been selected by Bremer.

The positive insertions of Article 4 should not distract our attention from the

missing elements expected under international standards. Two are worthy of note.

1. The Article is silent on any requirement that both genders be included in the Tribunal. In its silence on this issue the presumption is that in a male-dominated society, men will dominate the Tribunal, which is precisely what has happened, as the Tribunal is solely constituted of males. In contrast to that, we note that the ICC Statute endorses the introduction of this requirement in Article 36(8) (a), requiring "a fair representation of female and male judges".

 The Tribunal is also likely to have failed on paragraph (ii) by not including proper geographical representation, but in the absence of the names of judges, there is no way of ascertaining this.

2. The Article omits the requirement for judges to have legal expertise *in international law*. It would be contrary to the principles of justice to set up the first Tribunal to try people for international crimes committed contrary to international law and have people who have no knowledge of international law to adjudicate these offences. A knowledge of international law has now become important because, in the absence of such crimes in existing Iraqi law under which Saddam Hussein is to be tried, they have had to be put into Iraqi law by the IHTS, presumably with fingers crossed that the retroactivity issue would not be permitted to have its ugly head raised again by defense lawyers... The Statute of the ICC makes this requirement clear in Article 36(3) (b) (ii):

 > Every candidate for election to the Court Shall:

 > (ii) Have established competence in relevant areas of international law such as international humanitarian law and the law of human rights, and extensive experience in a professional legal capacity which is of relevance to the judicial work of the Court;

I doubt if any of the judges in the IHT meets this requirement.

Articles 5 and 6: Termination of Service

This Article gives three reasons for terminating the service of a judge or prosecutor. However, a most important stipulation has been omitted, namely that the judge would be removed if he failed to be impartial. The

requirement that judges should not be part of the Ba'ath party because of fear of impartiality when trying the Ba'ath ideology ought to have been balanced by a similar requirement that judge should not be members of any anti-Ba'ath party lest their impartiality is compromised. The right to impartial judges is a significant component of a right to a fair trial, explicitly proclaimed in Article Ten of the Universal Declaration of Human Rights, the Sixth Amendment of the US Constitution, and Article Six of the European Convention of Human Rights.

Article 14: Violations of Iraqi Law

This Article is of special interest as it sheds light on one aspect of the Tribunal. It is ironic that the US/UK intended to try top Iraqi Officials for crimes of stipulated Iraqi laws while at the same time refusing to accept the jurisdiction of the prevailing Iraqi law. It seems that the occupiers, decided, contrary to any principle of law, to pick and choose which laws suited their purpose to apply and to ignore those that did not.

The Article reads like political material coming out of a British tabloid, rather than the legal document it ought to be. It is phrased in such a way that it is open to any interpretation and arbitrary application. Its unprofessional status is emphasized by the fact that there are no elements of crime defined in the Statute. Two criticisms worthy of note are:

> Article 14(3):
> The abuse of position and the pursuit of policies that have almost led to the threat of war or use of the Iraqi armed forces against an Arab country, in accordance with Article 1 of Law 7 of 1958.

The reader need not be a legal expert to conclude that this is not a legal definition of an offence but a political statement that not only fails to identify what policies a sovereign state is not allowed to pursue or to *almost* have pursued but also presumes that a state official might be found guilty of policies that were *almost undertaken*, but in fact had not been.

> Article 14(4) reads:
> If the Tribunal finds that the special element of any of the crimes stipulated in Articles 11, 12 and 13 of this Law is missing, and establishes that the act involved constitutes a crime punishable under the Penal Code or any other penal law at the time of its commission, the Tribunal shall be competent to hear the case.

It was argued by the occupiers that the purpose of setting up the Tribunal was to try Iraqi Officials for crimes under international law, because "provisions relating to these crimes were never incorporated into Iraqi law".[10] If that were the case, it brings back the question of why the officials were not tried by a truly international criminal court—though indeed we already indicated why not in Chapter 5. It would have been normal to let the other offences, not falling under international criminal law, be tried in the normal criminal courts under prevailing Iraq Law as upheld by international law. The upshot of this is that once an official is brought before the Tribunal he could still be convicted of some other crime than those indicated in his official indictment. So if an international crime could not be leveled against him he would be convicted of any crime that existed under Iraqi law, if only to prove that he must have been guilty of some offence. Thus no accused would ever emerge "not guilty". This would enable the IHT not only to go on a fishing expedition for potential crimes, but to possibly include them in the trial at hand.

Article 14 of the IHTS is the proof—in the Statute of the trial itself—that this Tribunal was intended from the outset to be political.

Article 15: Individual Criminal Responsibility

Article 15 of the IHTS is identical to its predecessor, the ISTS, except for the insertion of one extra section which reads:

> Amnesty decrees issued prior to this Law coming into force do not apply to persons accused of committing any of the crimes stipulated in it.

This section is a breach of a fundamental principle of law, namely that amnesty once granted under an existing law could not and should not be taken away retrospectively, or selectively. There would be no value and meaning to the principle of law if an authority is allowed to flout such a principle.

However, the most serious breach of legal principles in this Article, identical to that in ISTS, and which to the author appears to be purposely hidden here, is section (3) which reads:

> The official position of any accused, whether as president of the State, chairman or member of the Revolutionary Command Council, prime minister or member of the cabinet, or a member of the leadership of the Ba'ath Party, shall not relieve such a person of criminal responsibility nor mitigate punishment. No person is entitled to any immunity with respect to any of the crimes stipulated in Articles 11, 12, 13 and 14.

I have already addressed the questions of retroactivity and immunity and established that Article 40 of the Iraqi Constitution 1970 grants immunity to the Chairman and members of the Revolutionary Command Council, being the supreme ruling body of the state. I suggest here that irrespective of whether the Tribunal was legal or illegal, the Statute that created it would still be subordinate to the Iraqi Constitution (1970) which was in force when the ISTS was enacted. This would make the attempt by the Statute to abrogate Article 40 of the Constitution null and void. It seems clear that until this contention is refuted in law, the whole Statute has no jurisdiction to try anyone covered by Article 40 of the Constitution, however noble the intent is and however balanced the Statute might be.

The author is suspicious of the fact that this fundamental principle of the jurisdiction of the Tribunal should be hidden in a section of one Article in the Statute when it ought to have been stipulated at the top of the legislation. However, as the US/UK drafters knew from the outset that they had no legal argument, they were left with no alternative but to hide it in the Statute, hoping it would not raise much opposition. I was informed by one of the prominent members of the English Bar who took part in the training of judges selected and trained by the US/UK for the Tribunal, that Judge Rizgar Muhammad Amin, who presided over the first stage of the Trial and then resigned, as will be discussed later, had great misgivings about his ability to try Saddam Hussein with Article 40 of the Constitution hanging over his head.

Article 17: Principles of Criminal Law

The Article in IHTS is similar to that in ISTS except in two matters. The IHTS added the Military Penal Code No 13 of 1940 and the Code of Military Procedure No. 44 of 1941 among the sources of criminal law. The second difference is that while the ISTS included the Iraqi Penal Code No. 111 of 1969 as it was on December 15, 1969, the IHTS included that Law as it was in 1985.

It is not possible to figure out the reasons for the difference between the two statutes or indeed why the IHTS accepts the Law as it was in 1985 and not as it was in 2005. The principle in international law is that the sovereign Law must be in force in its entirety until it is repealed by a competent authority. However, the stipulation in Article 17 of the IHTS does not repeal Law No. 111 but seems to choose to limit the application of part of it. That is a position that could not be supported in law. It goes to show further, the casual way in which these Statutes have dealt with fundamental principles of the application of the rule of law.

The reason for the ISTS to omit reference to the Military Penal Code and the Code of Military Procedure is that Order 22 dated 7 August 2003 suspended these Laws. When the IHTS was drafted, it seems that the fact

of suspension of these laws was overlooked. It is suggested that the supreme authority of the CPA could not be overruled by implication. Any restoration of the suspended laws had to be done with legislation. As these laws were not reinstated properly, Article 17 of the IHTS remains flawed.

There are no provisions in the IHTS as to which principle to follow when stipulations in it conflict with those in prevailing Iraqi law which this Article declares to uphold. We take as an example Article 15(4) of the Statute which does not absolve an accused from criminal responsibility when he 'acted pursuant to an order of the Government'. This stipulation is directly contrary to the stipulation in Article 39 of the Iraqi Penal Code Law No. 111 of 1969.

Article 18: Investigations and Indictment

The IHTS reproduces a similar version to that in ISTS, except for one deletion. The IHTS deleted section (c) which reads:

> If questioned by a Tribunal Investigative Judge, the suspect shall be entitled to be assisted by counsel of his or her own choice . . . The suspect is entitled to have non-Iraqi legal representation, so long as the principal lawyer of such a suspect is Iraqi.

This IHTS may have relied on the Iraqi Criminal Procedure Law (ICPL) which is also silent on the right of the accused to legal counsel. However, knowing that the investigation was completed under the ISTS (because the IHTS came into force one day before the trial started and after all the investigations were completed), and knowing that none of the accused had had any legal counsel during that stage of the investigation, whether by the US agencies or the Tribunal Investigative Judge, then the inclusion or deletion of section (c) with its noble principles inserted by the US/UK legal advisers in the newly constructed Iraqi legal system turned out not to be worth the paper they were put on.

Article 19: Rights of the Accused and Standard of Proof

Article 19 of the IHTS is equivalent to Article 20 of the ISTS and stipulates many proper rights for the accused. However, it fails to include a fundamental principle that has not existed in Iraqi law before and which we would have expected the occupiers, who advocated a restructured Iraqi legal system, to have inserted while restructuring it. The principle relates to requiring that the standard of proof be *'beyond reasonable doubt'*.

The ICC Statute Article 66 gives it as follows:

> In order to convict the accused, the Court must be convinced
> of the guilt of the accused beyond reasonable doubt.

It is imperative to have such a standard of proof in Iraqi trials for two reasons. Firstly, Iraq still has capital punishment and thus there is all the more reason to convict only on that standard lest people end up executed on a balance of probability. Secondly, Article 213 of ICPL No. 23 of 1971 states:

> The court makes its ruling in a case based on the satisfac-
> tion formulated by the evidence presented during any stage
> of the inquiry or the hearing. This evidence includes
> admission, witness statements, written records of interroga-
> tion, other official discoveries, reports of experts and
> technicians and other legally established evidence admitted
> by law.

The above Article leaves the Court to reach its judgment based on loose evidence, some of which would have been obtained with little protection of the accused during the interrogation stage. I am suggesting here that with these facts the US/UK ought to have raised the standard to that of *'beyond reasonable doubt'* to convince the doubters that they intended Iraq to have a reconstructed legal system in conformity with international principles.

Although paragraph 4(e) of the Article entitles the accused to examine prosecution witnesses, it seems that such right is fettered by Article 168(b) of ICPL No. 23 of 1971 which specifies that any examination is to be made through the court.

Article 25: Cassation

The IHTS, similar to the ISTS, gives three grounds for appeal for both the convicted and the prosecutor. These are:

1. If the verdict is made contrary to the law or if there is an error in interpreting it,
2. An error of procedure, or
3. An error of material fact which has occasioned a miscarriage of justice.

There is little to criticize in the above criteria except to say that it does not go as far as international standards would go. There are three shortcomings to this Article.

1. There is no reference and thus *no right to appeal* from other decisions than after the completion of trial and passing of judgment. It is acceptable universally that the accused should have the right to appeal decisions made by the Tribunal on substantive or procedural issues. For example, Article 82 of the ICC Statute gives the grounds for *'appeal against other decisions'* as: "(a) a decision with respect to jurisdiction or admissibility".

 As the creating of the IST/IHT has been in contention, it would have been only just and fair for the Statutes to allow an appeal from the refusal of the Tribunal to consider its legality or jurisdiction. Unfortunately that was missing and the accused never had the legal route to challenge the legality of the Tribunal which is the first of its kind in legal history, since WWII.

 The IHT Statute did not provide for any avenue of appeal to challenge the legality of the Tribunal, which was the first of its kind in legal history since World War II.

2. Article 25 does not allow for appeal on the grounds of failure in fairness and reliability. The necessity of such a possibility is so widely acknowledged in different jurisdictions that the ICC Statute included it in Article 81(iv) as "any other ground that affects the fairness or reliability of the proceedings or decisions."

3. The third shortcoming relates to the possibility of a higher appeal. It was shown earlier that the Appeal Chamber is part of the IHTS and it was also clearly shown that there is no restriction in the Statute on a trial judge being a member of the Appeal Chamber, which would mean the possibility of the same judge hearing an appeal from his own judgment. In view of these facts and the fact that 'New Iraq' under the newly reconstructed legal system has created a Federal Appeal Court, would it not have been ultimate justice to subject the judgments of the IHTS to appeal before the highest appeal court in the land, especially when dealing with such important allegations as these?

Article 27: Enforcement of Sentences

In the ISTS this Article reads as "Sentences shall be carried out by the legal system of Iraq in accordance with its laws."

However, the same Article in the IHTS displays the vindictive vengeful nature of the whole legislation. It is reproduced here in full because of its significance and its language.

First: Sentences shall be carried out in accordance with the law. Second: No authority, including the President of the Republic, may grant a pardon or reduce the penalties issued by this Tribunal. Penalties shall be enforceable within 30 days of the sentence or decision reaching finality.

This is a clear attempt at according supremacy to the role of superimposed constitutional legislation to fetter the supremacy of any existing constitution. That in fact, as we shall see later, is exactly what was claimed at the end of Trial. The right of the Head of State to grant pardon is universal and was enacted in the Iraqi Constitution drafted by the US/UK and accepted by referendum in Iraq in December 2005. However, the drafters of the IHTS chose to override that principle by attempting to deny the Head of State that right

It should be emphasized here that such a stipulation in the IHTS, even if signed by the Presidential Council, had no authority and was annulled by the Iraqi Constitution which was adopted later. I shall return to this matter later in the book.

However, what we must address here is the conflict between Articles 26 and 27. First the reader is reminded that we are dealing here with a trial characterized mainly, but not fully, by the following:

- All the pre-trial investigations were done by the occupying force and the investigative judge in camera without any legal assistance to the accused.
- The case has been adjudicated upon by anonymous judges.
- Most witnesses have given statements from behind curtains.
- No disclosure has been made to the defense team.
- The death sentence was available to the Tribunal.
- Iraq has become the most lawless state in the world.

Thus, where death sentence is passed on any accused and that sentence is enforced, then the time limit of 30 days makes a mockery of the right to gather evidence and seek a new trial as offered in Article 26.

Article 31: Immunity for Tribunal Staff

Contrary to universal norms, the defense and witnesses faced the possibility of civil action for things done or said inside the court. The Article in both ISTS and IHTS grants limited immunity to the judges, prosecutors, director and staff of the Tribunal but not to suspects' defense teams or the accused, or counsel for victims, or for victims themselves or witnesses. I know of no jurisdiction in which the defense or witnesses face

the possibility of civil action for things done or said inside the court.

Article 33: De-Ba'athification of theTribunal

Chapter 4 dealt with the de-Ba'athification legislation and the argument will not be repeated here. However, it is important to point out what Article 33 entails.

> No person belonging to the Ba'ath Party may be appointed as a Judge, Investigative Judge, Prosecutor, employee or any of the Tribunal's staff.

Although the de-Ba'athification legislation stipulated that people who were in specific positions of the Ba'ath leadership hierarchy were banned from employment, Article 33 extends that ban to any member of the Party, which would cover some two million people who were members of the Party at some stage.

General Failures of the Statute and Rules

These general failures with the Statute and the applicable Iraqi law ought to have been addressed in order for the trial to meet the minimum international standards and thus do justice to both the victims and the accused. It should be emphasized that an unfair trial does no justice to the victim.

The Issues of Criminal Intent and Knowledge of the Crime

Although the Iraqi Penal Code Law No. 111 of 1969 addresses the mental element of a crime in defining criminal intent in Article 33, it does not meet the international standard that has become accepted which requires that for a crime to be committed, concerns as to the perpetrator's intent and knowledge of the crime need to be met.

This is clearly presented in Article 30 of the Statute of ICC:

> Unless otherwise provided, a person shall be criminally responsible and liable for punishment for a crime within the jurisdiction of the Court only if the material elements are committed with intent and knowledge.

> For the purpose of this article, a person has intent where:

> In relation to conduct, that person means to engage in the conduct;

> In relation to consequence, that person means to cause
> that consequence or is aware that it will occur in the ordinary
> course of events,
>
> For the purpose of this article, "knowledge" means awareness
> that a circumstance exists or a consequence will occur in
> the ordinary course of events. "Know" and "knowingly" shall
> be construed accordingly.

The IHTS ought to have clearly defined the mental element according to the above principle.

The Elements of the Crime

The IHTS does not include any definition of the elements of crime. In view of the fact that the offences being tried by the Tribunal have never been part of Iraqi law, which means that even the most experienced judge has no precedents to rely upon, it became imperative that the elements be defined. By not defining them it is difficult to see what the Tribunal relied on in interpreting the definitions of crime.

Torture, Ill-Treatment and Evidence

There are no provisions in Iraqi law prohibiting torture as such, although ill-treatment is covered. Although the IHTS was supposed to incorporate international crimes into Iraqi law, it simply referred to the Iraqi Criminal Procedure Law (ICPL) No. 23 of 1971. Of specific relevance here is Article 218 of ICPL which reads:

> It is a condition of the acceptance of the confession that
> it is not given as a result of coercion, whether it be
> physical or moral, a promise or a threat. Nevertheless, if
> there is no causal link between the coercion and the
> confession or if the confession is corroborated by other
> evidence which convinces the court that it is true or which
> has led to uncovering a certain truth, then the court may
> accept it.

It is clear that the above Article would admit a confession obtained under torture and ought to have been rectified in the IHTS by specific provision. Equally relevant would have been the inclusion of provisions requiring the prosecutor to refuse to prosecute on the grounds of unlawfully obtained evidence. It is worth comparing the above principle with that in Article 69(7)

of the Statute of the ICC which reads:

> Evidence obtained by means of a violation of this Statute or internationally recognized human rights shall not be admissible if:
> (a) The violation casts substantial doubt on the reliability of the evidence.

Needless to say, such a blatant omission of an effective provision against torture from Iraqi law leads to speculation as to the reasons for it, both concerning the case at hand, and for the future.

The blatant omission of an effective provision against torture from Iraqi law leads to speculation as to the reasons for it, both concerning the case at hand, and for the future.

Investigation Stage

The Investigative Judge under indigenous Iraqi law has great power and discretion. Examples of these are:

- He may refuse to grant permission to the accused to attend the investigation and may refuse to let him question witnesses and may refuse to enable the accused to obtain copies of witness statements and documents obtained during the investigation. (Art. 57 ICPL)

- He may refuse to grant the accused permission to recall a witness to question or to hear other witnesses regarding other events, if he thought it would delay the proceedings, mislead justice or be impossible to grant. (Art. 63 ICPL)

- He may compel the accused to expose part of his body for examination, to give fingerprints, to glve samples of blood, hair and nails. (Art. 70 ICPL)

When the IHTS addressed the authority of the Investigative Judge it expanded his remit to his own choosing, stating in Article 8(6):

> An Investigative Judge may gather prosecution evidence from whatever source he deems appropriate and may communicate directly with all relevant parties.

The importance of the investigation stage is that during the trial, everything

that has been compiled in the investigation dossier constitutes evidence and the judge in the trial is entitled to treat witness statements in that dossier as if given in the trial. The IHTS, when it ought to have rectified this by providing clear guidelines on what the Investigative Judge could and could not do, chose to expand what was already the nearly unlimited authority of the Investigative Judge.

Elements of a Fair Trial

I suggest that most of the requirements for a fair trial[11] have not been met by the Statute and Rules drafted by the same people who claimed that they devastated Iraq in order to bring democracy, human rights and the rule of law. Some of the failures to meet these minimum requirements have been demonstrated in this chapter. The rest of the failures will be attended to in following chapters.

ENDNOTES

[1] Wiese, A., "Saddam trial first of expected dozen prosecutions", CTV Canada, September 30, 2005. <http://www.ctv.ca/servlet/ArticleNews/story/CTVNews/20050930/saddam_trial050930/20050930/>

[2] Bohlander, M., "Can the Iraqi Special Tribunal Sentence Saddam Hussein to Death?", *Journal of International Criminal Justice*, 3 (2005), 463-468, p. 465.

[3] Except for the deleting of the crimes of apartheid, forced pregnancy and enforced sterilization, and personal property.

[4] Robertson, G., *Crimes against Humanity*, Penguin Books, 2002.

[5] 'Iraqi Special Tribunal – Fair trials not guaranteed', Amnesty International, 13 May 2005, MDE 14/007/2005, p.38.

[6] 'US Contractor in Iraq Shootout', BBC News, 17 September 2007. <http://news.bbc.co.uk/1/hi/world/middle_east/6998458.stm>

[7] VIDEO: Mercenaries in Iraq Shooting Civilians, Global Research, September 19, 2007. <http://globalresearch.ca/index.php?context=va&aid=6820>

[8] 'Iraq Expands Blackwater Investigation', AP, 23 September 2007. <http://news.yahoo.com/s/ap/20070922/ap_on_re_mi_ea/iraq>

[9] Briefing Paper, Creation and First Trials of the Supreme Iraqi Criminal Tribunal, International Center for Transitional Justice, October 2005, p.11. <http://www.ictj.org/images/content/1/2/123.pdf>

[10] Ibid , p.12.

[11] As called for in Article (14) of the International Covenant on Civil and Political Rights (ICCPR), which will be addressed in greater length in Chapter 7. International Covenant on Civil and Political Rights, Office of the UN High Commissioner for Human Rights, December 1966. <http://www.ohchr.org/english/law/ccpr.htm>

CHAPTER 7

THE TRIAL[1]

The Offense

Here is the chain of events of the offense based on information purporting to have been gathered by the investigative Judge (but in reality gathered by the US agency, the RCLO) which was then to be established by the prosecution in court:

1. On 8 July 1982, the convoy of President Saddam Hussein was attacked on his way out of Dujail. It is claimed by the prosecution that no one was killed or injured.
2. People were rounded up, detained, interrogated and tortured.
3. On 14 October 1982 the Revolutionary Command Council issued an order authorizing the expropriation of land in Dujail for the purposes of an agricultural redevelopment and ordering compensation to be paid in accordance with the relevant law.
4. A dossier of some 361 pages was submitted to the President detailing the evidence against 148 individuals for their role in the assassination attempt.
5. On 27 May 1984 Saddam Hussein signed a decree, based on the above dossier, referring 148 individuals to the Revolutionary Court to be tried for their alleged involvement in the failed assassination attempt.
6. On 14 June 1984 the Revolutionary Court convicted the 148 individuals to death by hanging.
7. On 16 June 1984 President Saddam Hussein issued a decree ratifying the death sentence passed by the Revolutionary Court, which is a constitutional requirement for the sentence to become final.
8. Sometime in May 1985 the death sentences were implemented.

These events were put forward as the commission of a crime against humanity.

It must be noted here and cannot be emphasized strongly enough: the file of the original Dujail trial—some 361 pages of evidence gathered over

a period of nearly 18 months in relation to the attempted assassination of Saddam Hussein to be used as the evidentiary source for the trial of its perpetrators (see point 4 above)— was not put into evidence by the prosecutor though he clearly had it, having been able to specify its exact size. As a result, a vital source of information relative to the trial of Saddam Hussein himself was removed, not only from scrutiny by Saddam Hussein's defense team, but seemingly from the annals of history itself, or until such time as those materials which presently require concealment should cease to matter.

The dossier of the original trial— some 361 pages gathered over 18 months detailing the evidence against 148 individuals for their role in the assassination attempt— was not entered into evidence, and thereby kept not only from defense lawyers but seemingly from history, itself.

The Venue

In a clear attempt to add insult to injury, the Zionist invaders made another point in the choice of the venue for the trial. As the trial of Saddam Hussein was meant to be the political trial of the Ba'ath ideology that had dominated the Arab East for half a century, the choice of the venue was significant. Out of all the buildings in the massive complex of the Green Zone in Baghdad, it was not accidental that the headquarters of the Pan Arab National Leadership of the Ba'ath Party was chosen as venue for the trial of the Ba'ath.

In a personal communication, Khaleel Ad-Dulaimi described the inside of the trial building. The Tribunal was held in the fourth floor of the building while the accused were kept in cells on the ground floor. However, the whole show was controlled from the room opposite to the sitting judges, where the US military and officials were situated, flanked by their Iraqi agents. The television recording was carried out by the US RCLO which controlled what was allowed to be beamed some 20 minutes after its occurrence. No one attending the trial could have missed the fact that, out of sight of the camera which was clearly intended to convey a certain impression, the US presence was prevalent. They were everywhere, in every room, inside the court and outside it.

Sessions

The main events of the sessions will be given below.

19 October 2005 Session

The trial commenced on this day, presided over by the soft-spoken,

courteous Chief Judge Rizgar Muhammad Amin. Saddam Hussein was the last of the eight defendants to enter the courtroom carrying a copy of the Qur'an. The proceedings were transmitted half an hour after the actual event took place, which enabled the censor to operate and gave the RCLO a final say in what and what not to transmit. The quality of the sound was very poor and the English translation was even worse.

It was inevitable that the first encounter would pass without confrontation, and that Saddam Hussein would appear in command. Part of that exchange is given below.[2]

> **Judge**: Mr. Saddam, we ask you to write down your identity, your name, occupation and address and then we will allow you to talk. Now it is time to write down your identity.
> **Saddam**: I was not about to say much.
> **Judge**: We want your identity, your name, then we will listen to what you have. We are writing down the identities at this time. We will hear you when we need to listen to you.
> **Saddam**: First of all, who are you and what are you?
> **Judge**: The Iraqi criminal court.
> **Saddam**: All of you are Judges?
> **Judge**: We don't have time to get into details. You can write down what you like.
> **Saddam**: I have been here in this military building since 2:30, and then from 9:00 I have been wearing this suit. They have asked me to take it off and then put it on again many times.
> **Judge**: Who are you? What is your identity? Why don't you take a seat and let the others say their names and we will get back to you.
> **Saddam**: You know me. You are an Iraqi and you know who I am. And you know I don't get tired.
> **Judge**: These are formalities and we need to hear it from you.
> **Saddam**: They have prevented me from getting a pen and a paper because paper, it seems, is frightening these days. I don't hold any grudges against any of you. But upholding what is right and respecting the great Iraqi people who chose me, I won't answer to this court, with all due respect ... and I reserve my constitutional rights as the president of Iraq. You know me.
> **Judge:** These are the procedures. A Judge cannot rely on personal knowledge.
> **Saddam:** I don't recognize the group that gave you the

authority and assigned you. Aggression is illegitimate and what is built on illegitimacy is illegitimate.

The Judge read the defendants their rights and then read the charges. They were all charged with the same offences, namely murder, torture, forced expulsion and illegal imprisonment in relation to the trial of people in Dujail who had been sentenced by a local court following the assassination attempt on Saddam Hussein's life in 1982. Given the fact that the eight defendants ranged from the President of the Republic to a low-ranking party official in Dujail, it seems difficult to imagine how it was possible that they all could have committed the same offences. It should not escape the attention of an observer that putting Saddam Hussein on trial with a telephone exchange operator and charging them both with the same offence was intended to diminish recognition of his stature as a head of state.

Putting Saddam Hussein on trial with a telephone exchange operator and charging them both with the same offence was intended to diminish recognition of his stature as a head of state.

The Judge proceeded to ask each defendant for his plea. He started with the President, saying: "Mr. Saddam, go ahead. Are you guilty or innocent?

Saddam replied quietly: "I said what I said. I am not guilty".

The Chief Prosecutor, Ja'far Al-Musawi, began to outline the prosecution case.

It was expected that the trial would adjourn for several weeks to give both sides the opportunity to prepare their cases. Defense lawyer Ad-Dulaimi asked for the names of prosecution witnesses and for an adjournment of 90 days but no less than 45 days. The first request was not granted as no names of prosecution witnesses were disclosed. The court was adjourned until 28 November.

The defense team filed two petitions with the Tribunal. The first argued that the notice of evidence and witnesses was not provided to the defense in the timely manner stipulated in the Rules. The second petition called for the suspension of the proceedings due to insecurity. The defense did not receive a written or oral answer to either petition filed on 19 October.

This day was the first opportunity for Saddam Hussein, since his arrest on 13 December 2003, to meet the international lawyers retained by his family, in spite of their having made several written requests for a meeting.

28 November 2005 Session

On 20 October (one day after the start of the trial) defense lawyer Sa'doon Al-Janabi was abducted by men who identified themselves as officials

of the Ministry of Interior and murdered. On 8 November a second defense lawyer, Adil Muhammad Abbas Az-Zubaidi, was murdered and his colleague wounded. This session started with one minute of silence in memory of the two murdered defense lawyers.

Saddam Hussein was the last to enter the courtroom. When asked by Rizgar Amin to explain the reason for his being a few minutes late, the following exchange ensued.[3]

> **Saddam:** "They brought me here to the door in handcuffs. They cannot bring defendants in handcuffs. The Qur'an was in my hand and at the same time the handcuffs were on my hands. A defendant should be under the supervision of the court. … At the same time the elevator was out of order. I had to walk up four flights of stairs."
> **Judge**: "I will tell the police about this."
> **Saddam shouted back**: "You are the chief Judge. I don't want you to tell them, I want you to order them. They are in our country. You are the one who has the sovereignty. You are Iraqi and they are the foreigners and occupiers. They are the invaders. How can one defend himself if his pen is taken. Saddam Hussein's pen and papers were taken. I don't mean plain paper. There are papers downstairs about my case. My opinions, they are not here."

This was the first day for prosecution evidence. This included a video footage from Dujail dating to the day of assassination attempt in which Saddam Hussein is heard saying about a group of prisoners: "Separate them and investigate them".

Then came the video testimony of Waddhah Ismail Al-Sheikh, a high ranking director in Iraq's intelligence service, which the prosecution claimed to be a crucial testimony. Al-Sheikh, who has since died, is seen in the video while his statement was read in court by the Judge; he stated that more than 400 people from Dujail, including whole families, were rounded up and taken to Abu Ghraib prison. As the statement was read by the judge but we do not hear it spoken by the witness, it cannot be verified that what the judge read was what the witness really said. The only element in Mr. Al-Sheikh's testimony relevant to Saddam Hussein is that Saddam Hussein later decorated the officers who took part in the operation. The evidence was admitted despite the fact that the defense lawyers were not given an opportunity to cross-examine Mr. Al-Sheikh, despite the fact the authorities knew he was terminally ill and there had been no impediment to inviting defense counsel to be present at the taking of his statement or any time later. The London *Independent* commented on the evidence of 20 November saying:

"the evidence against the man the US and British want to portray as a tyrant equal to Hitler and Pol Pot, was somewhat desultory and probably would not have been allowed in a British court of law."[4]

"Evidence against the man the US and British want to portray as a tyrant equal to Hitler and Pol Pot ... probably would not have been allowed in a British court of law."

The hearing lasted for two hours and 45 minutes and was adjourned to 5 December.

On the same day Mr. Ramsey Clark, US counsel for Saddam Hussein, submitted to the Tribunal a request for security for the defense team following the death of two of them.

The defense team agreed to the Tribunal giving them three months to meet with their clients to enable them to prepare their cases because no such opportunity had been given since their detention. However, soon after, the US officials in the RCLO, which controls the Tribunal, instructed the Tribunal officials to renege on that and the decision was reversed.[5] This was another instance of US occupiers overturning the ruling of the Judge they put in, in order to frustrate the defense counsel and the judicial process.

HRW observers in the courtroom reported hearing one prominent parliamentarian saying: "this Kurdish Judge must go".[6]

5 December 2005 Session

The session started with a dispute when the Judge refused to allow Ramsey Clark and Najeeb An-Nu'aimi, acting for Saddam Hussein, to address the Tribunal. The Judge stated that only Khaleel Ad-Dulaimi, the defense counsel interposed by the US authorities, could address the Tribunal and that the defense should submit applications in writing. However, the Tribunal, which lacked a system to verify and track the deposition of documents, could neither confirm nor deny the claim by the defense lawyers that powers of attorney had already been filed with it. The refusal of the Judge resulted in a walk out by the defense team and a 90 minutes recess.

After the defense walked out, Saddam was heard saying: "You are imposing lawyers on us. They are imposed lawyers. The court is imposed by itself. We reject this. ... Long live Iraq; long live the Arab nation".

Barazan Ibrahim jumped up and shouted: "Why don't you just execute us and get rid of all this".

After the Tribunal reconvened the Judge reversed his decision and allowed both lawyers to address him. Clark addressed the Tribunal mainly on the security and safety of the lawyers, while An-Nu'aimi argued the illegality of the Tribunal.

Mr. Clark touched on the effect of the trial on the political situation in Iraq, saying: "Reconciliation is essential. This trial can either divide or heal. And unless it is seen as absolutely fair, and as absolutely fair in fact, it will irreconcilably divide the people of Iraq". At which point the Judge reminded him that he was to talk about the security guarantees for the defense lawyers. Mr. Clark responded that both sides were entitled to the same protection, but the measures offered to the defense were absurd.[7]

An-Nu'aimi addressed the question of the legitimacy of the Tribunal. He argued that the Tribunal was set up by the occupying powers and the statute, even after being ratified by the Iraqi authority, was no different from that issued by Paul Bremer, the US administrator of Iraq. The Tribunal, he concluded, was illegitimate.

The Tribunal gave no response to these submissions.

The first prosecution witness of the session was Ahmad Hasan Muhammad who stated that after the assassination attempt, the security forces arrested men of between fourteen and seventy years of age. He claimed to have been fifteen at the time of his arrest and to have been tortured in the Intelligence Headquarters in Baghdad before being removed to Abu Ghraib prison. He claimed that there was a mass arrest, and even babies were brought in with their families.

Saddam responded to the testimony of the witness saying: "If it's ever established that Saddam Hussein laid a hand on any Iraqi, then everything that witness said is correct."

The witness exchanged insults with Barazan, Saddam's half-brother.

The Judge intervened and ordered an end to it.

During the testimony the defense counsel objected that someone in the visitors' gallery was making threatening gestures. The Judge ordered his removal.

The second witness, Jawad Abdul-Aziz Jawad, claimed to have been ten years old when the assassination attempt took place and how troops used helicopters to attack the town. He claimed the regime killed three of his brothers, one before the assassination attempt and two after.

The defense performance was very poor. No real challenge was raised to the testimonies of witnesses, except for one question put by Ad-Dulaimi to the second witness questioning his ability to remember things when he was only ten years old. The witness responded that a three-year-old child remembers a lot. The question and the answer probably helped the prosecution more than the defendant.

There were times of heated exchanges between Saddam Hussein and the Judge. At one stage Saddam appeared threatening, telling the Judge: "When the revolution of the heroic Iraq arrives, you will be held to account."[8]

Judge Amin responded: "This insults the Tribunal. We are searching for the truth".

Saddam did not miss the opportunity to impose his authority again. He attempted to sound sympathetic to the position of the Judge. "This game must not continue, if you want Saddam Hussein's neck, you can have it! I have exercised my constitutional prerogative after I had been the target of an armed attack…. I am not afraid of execution. I realize there is pressure on you and I regret that I have to confront one of my sons. But I am not doing it for myself. I am doing it for Iraq. I am not defending myself. But I am defending you."

6 December 2005 Session

Three prosecution witnesses testified in this session. In order to preserve the anonymity of the witnesses, the testimony was given from behind a curtain and the voices were modulated. However, that did not work smoothly. The defense counsel complained that they could not understand what was being said because of the distortion in the voice. So the Judge ordered that the modulator be switched off, but then the audience could not hear. The Judge ordered an adjournment until the modulator was fixed.

Witness A was a woman who claimed to have been sixteen when she was arrested, abused and tortured. She accused Waddhah Al-Sheikh, whose evidence as prosecution witness was shown by video on 28 November, of interrogating and torturing her. She said: "I was forced to take off my clothes, and he raised my legs up and tied up my hands. He continued administering electric shocks and whipping me and telling me to speak" and that Al-Sheikh fired a gun at the wall to frighten her. She stated that after that, she was sent to Abu Ghraib and then sent to live near Samawah in southern Iraq. She was freed four years after arrest when she was twenty. When the Judge asked her who she wanted to accuse, she responded that she believed that Saddam Hussein was responsible for her detention and torture.

Witness B, a 74 year-old woman, told the Tribunal how her family had been arrested in 1981, one year before the Dujail assassination attempt. However, she could not link that arrest to the Dujail attempt of 1982. The Judge then decided that the voice quality was so poor that he had to switch off the modulator. That meant that the media and audience were unable to hear the rest of her testimony.

Witness C testified that he had been arrested with his parents and two baby sisters. They were kept for some days in the intelligence headquarters, then sent to Abu Ghraib for some days before being exiled to Samawah for three years. He claimed that he was tortured by an electric shock applied to his ears. He also claimed that his father, who was 65 and had heart problems, had died in prison.

Saddam Hussein interjected at this stage and complained at the condition he was being kept in. He complained that no one has questioned whether he had been tortured and went on to say:

I live in an iron cage covered by a tent under American democratic rule. You are supposed to come see my cage "Please, Mr. Judge, do not accept any insult to Iraq. It doesn't matter if he insults Saddam Hussein, because the Americans and the Zionists want to execute Saddam Hussein. What does the execution of Saddam Hussein matter? He has given himself to Iraq from the day he was at school and has been sentenced to death three times already. Saddam Hussein and his comrades are not afraid of execution."[9]

When the Judge adjourned the hearing to the next day, Saddam Hussein shouted: "I will not return. I will not come to an unjust court. Go to hell!"

7 December 2005 Session

The session started four hours late after Saddam Hussein failed to attend the hearing as he had threatened the day before. The rest of the defendants and the defense counsel were all present. The Judge stated that the Tribunal would brief Saddam Hussein on the proceedings taking place in his absence.

The defense counsel submitted to the Tribunal in open court a detailed, seven-page motion concerning security. The motion included a proposal for security arrangements that defense lawyers believed would adequately protect them to ensure their ability to fully participate in the trial.[10]

After the proceedings started, the Judge told the defense lawyers that "the court will meet the defense lawyers after today's hearing to discuss the security of the lawyers." I have been informed by defense lawyers that even the promise of the Court to pay for the cost of two armed guards for each lawyer was not honored. Thus when Al-Janabi was assassinated he had been completely vulnerable, with no personal guards.

In fairness to Judge Amin, HRW advises us that according to the correspondence seen by them, Judge Amin had referred the matter to the Tribunal President, who presides over the Appellate Chamber, but no response was forthcoming.

After the session convened, a male witness testified behind a beige curtain to conceal his identity. The witness, whose name was not publicly released, said he was arrested after the assassination attempt and taken to Ba'ath party headquarters, where he found people "screaming because of the beatings." The witness said Saddam's half brother and co-accused, Barazan Ibrahim, was present. He went on to say: "When my turn came, the investigator asked me my name and he turned to Barazan and asked

him 'what we shall do with him?' Barazan replied: 'Take him. He might be useful.' We were almost dead because of the beatings."

Under questioning by the Judge, however, the witness admitted that he had been blindfolded at the time and thought it was Ibrahim speaking because other prisoners told him so. The witness said he was taken to Baghdad "in a closed crowded van that had no windows." [11]

21 December 2005 Session

On 21 December 2005, Dr. Doebbler, armed with written power to act on behalf of Saddam Hussein, requested to see his client. Doebbler was told by Captain Phillip Lynch of the RCLO to wait for Judge Rizgar Amin, which he did. When the Judge arrived and Doebbler approached, he was assaulted by US Marshall Bartlett who threatened to remove him permanently.

A few minutes later, Captain Philip Lynch told Doebbler that the IHT had approved his request, but that the decision was reversed by Howard Davidson, a Canadian Judge who was acting as an advisor to the IST.[12]

On the security concerns the BBC reported the following:

> Ramsey Clark, a former US attorney general on Saddam Hussein's team, has not returned to Baghdad for this session because of security fears. Defense lawyer and former Qatari Justice Minister Najeeb An-Nu'aimi raised further concerns in court, complaining: "We were threatened at the airport and later put up in a house with no door to the lavatory."
>
> "We cannot continue with this case if there is deficiency in security," he told Judge Rizgar Amin.[13]

Saddam Hussein was subdued during this session in comparison to previous days.

The first witness of the day was Ali Hasan Muhammad Al-Haidari whose brother, the first witness, had claimed to have been fourteen at the time of the assassination attempt. He described how he and other residents of Dujail were taken to Baghdad and detained at the intelligence prison. He claimed that they were all tortured, saying: "I cannot express all that suffering and pain we faced in the 70 days inside".[14]

Saddam Hussein only interrupted the witness to ask for a break in the proceedings to allow him to pray. However, when the Judge refused his request, he turned his chair to the left and seemed to execute his prayer while sitting.

An exchange of insults took place between the witness and defendant Barazan Ibrahim.

Khamis Al-Ubeidi, a lawyer on Saddam's defense team, argued that the "witnesses have no legal value. Their testimonies are based on coaching and unjustified narrative." He said the defense team had security concerns that it wanted to tell the court about. "The court has to provide the lawyers and the defense witnesses with security," he said. "How can a lawyer work if he cannot move freely because of the security situation?" [15]

A second witness, who testified behind a curtain, said Saddam's half brother, Barazan Ibrahim At-Tikriti, was present when he was tortured in Baghdad. "During the interrogation they'd torture me, and Barazan was there eating grapes." "I was screaming. I'm an old man. He was there."

At-Tikriti became agitated after the testimony, shouting that he was a politician not a criminal. He raised a hand and said: "My hand is clean."[16]

Saddam Hussein then went on the offensive claiming that his US captors tortured him while in detention. He put it like this. "Yes I have been beaten, everywhere on my body. The marks are still there…. "I want to say here, yes, we have been beaten by the Americans and we have been tortured."

A second co-accused also said that he had been beaten by his US captors. However, Chief Prosecutor Ja'far Al-Musawi ridiculed the claim, arguing that Saddam Hussein was enjoying a nice cell with air-conditioning at a time when almost all of Baghdad was without electric power. He promised to investigate the claim and on finding it to be true would seek to transfer Saddam Hussein to the custody of the Iraqi authorities.[17] This seems to be a clear admission, contrary to other claims, that Saddam Hussein had never been in the custody of any Iraqi authorities.

22 January 2006

Three months after the commencement of the trial, a further several hundred pages of new evidence was disclosed to the defense counsel without any explanation for the failure to comply with the Tribunal's Rules.[18]

Before the session started, defense counsel was provided with a two-page letter without any supporting legal analysis, asserting the IHT competence to try the defendants and then denying the defense their right to make oral submissions on that matter. The Chief Judge simply said that the question had been decided but gave no reasoned decision.

The session was a closed-door hearing. It was claimed by lawyers for Saddam Hussein that Barazan Ibrahim revealed that the US officials had offered him a deal to set him free. According to Ad-Dulaimi, Barazan told the Tribunal that the Americans had offered him a senior political post in return for testifying against the President, which he had refused to do.

Ja'far Al-Musawi said that he could not talk about the closed-door hearing and stated that no such deal was offered to Barazan Ibrahim during that hearing.[19]

24 January 2006

While waiting for the hearing scheduled for the 24 January 2006, Ridha Hasan, a clerk of the Tribunal, returned to the defense counsel the submissions made on 21 December on the grounds that the Tribunal refused to rule on them. It was a scant improvement on their previous policy of silence, undertaken, perhaps, to keep the defense team from ceaselessly requesting? I know of no legal authority which allows a Tribunal to refuse to respond or rule on a properly submitted petition without giving reasons for such refusal.

The defense team was then locked in a room in the courthouse until 14:00 when they were told that the Tribunal was adjourning because witnesses had not shown up.[20]

However, it was widely reported that the adjournment was not because of the failure of witnesses to show up but rather due to the chaos resulting from the resignation under political pressure of Chief Judge Amin, the ousting of his replacement, Judge Hammashi, by the de-Ba'athification Commission whose legal authority itself was suspect, and the need to await the final political decision of the US and Iraqi officials, which was summed up by one Judge telling Associated Press: "Matters are not in our hands".[21]

29 January 2006 Session

Both Curtis Doebbler from the US and Salih Al-Armouti from Jordan were granted audience for the hearing after their documents were reviewed. They applied for transcripts of prior proceedings but received none.

This was the first session presided over by Judge Ra'ouf Rasheed Abdul-Rahman. He attempted from the outset to distinguish himself from his predecessor, stating that he would throw out anyone who broke the Tribunal's rules. However, the session degenerated into chaos. Barazan Ibrahim insulted the Tribunal and was dragged out of the courtroom. Al-Armouti was removed from the courtroom for yelling at the Judge. This was followed immediately by the walkout of the entire defense team in protest. The Judge immediately appointed new lawyers, and warned that any lawyer walking out would not be allowed back into the courtroom.

When Saddam Hussein objected to the appointment of lawyers by the Tribunal, he entered into a heated argument with the Judge and shouted "down with traitors, down with America" and left the courtroom, followed by two more defendants.

The trial started with only four defendants and none of the privately hired defense counsel.

Three prosecution witnesses—two women and a man—testified during this session concealed behind curtains. The three witnesses told similar stories about arrest and torture. The court-appointed defense lawyers forfeited the

opportunity to cross-examine any of the witnesses who testified on this day.[22]

1 February 2006 Session

On this day the defense again requested the disqualification of Judge Abdul-Rahman on the grounds of bias, citing his pre-trial statement that the President should be summarily executed.[23] Mr. Khaleel Ad-Dulaimi issued a statement in which he set out eleven conditions for the privately-hired defense to end their boycott of the proceedings, including moving the trial to a safe country which could offer better security.

The session was boycotted by five defendants and the entire privately-hired defense team in protest. They demanded the removal of Judge Abdul-Rahman on the grounds of bias against Saddam Hussein. The Judge convened the session with three defendants and the Defense Office court-appointed lawyers. He started with a half-hour closed session before opening it to the media.

The Chief Prosecutor asked the Judge to compel the defendants to attend but the Judge decided to proceed in their absence and to put the request to the panel of judges for their consideration. The Judge then advised the remaining three defendants that the lawyers appointed by the court would represent them during the absence of their chosen lawyers.

Several prosecution witnesses then told similar stories about arrest and torture. "One witness—a woman whose identity was withheld and who spoke from behind a beige curtain—testified that she had been arrested by Saddam's security forces and tortured in prison. She said she was stripped naked, hung by her feet and kicked repeatedly in the chest by Barazan Ibrahim, Saddam's intelligence chief at the time and the top co-accused in the trial."[24]

After nearly four hours of open court, the hearing was adjourned.

13 February 2006 Session

Saddam Hussein was forced to attend this day's session. He entered the courtroom dressed in a *dishdasha*—traditional Arab robe—with a black overcoat while Barazan Ibrahim was in a long-sleeved white underwear and bare-headed. As soon as Saddam Hussein reached the pen, a shouting match erupted between him and the Judge.

> **Saddam:** "Down with Bush. Long live the nation."
> **Saddam:** "Why have you brought us with force? Your authority gives you the right to try a defendant in absentia. Are you trying to overcome your own smallness?"
> **Judge Abdul-Rahman:** "The law will be implemented,"

Saddam: "Degradation and shame upon you, Ra'ouf,"
Later, he called the investigating Judges "homosexuals."[25]

The defense counsel were still absent, carrying on with their boycott demanding the removal of Judge Abdul-Rahman.

The prosecution put two of Saddam Hussein's officials on the stand and produced documents in an attempt to link the former President to the arrests, torture and execution that the prosecution was alleging.

The first official was Ahmad Hussein Al-Samarrai, the head of the Presidential Office from 1984-1991 and then from 1995 until the invasion. He informed the Tribunal that he had been forced to appear, was not fit to be a witness in the case, and that his honor would not allow him to be a witness against his leader.

When he was shown a document stating that the President had ratified the death sentences and asked if it was in his handwriting he responded that he could not remember anything.

The second witness, Hasan Al-Ubeidi, who was a director in the intelligence office, said that he was brought to the courtroom by force and argued with the prosecutor over his role.

It seems that the Tribunal then carefully used the absence of the defense counsel to read into the court record documents that would count as evidence and would be unlikely to be challenged by the Defense Office court-appointed lawyers. As HRW noted,

> The court read the statements of 23 prosecution witnesses into the court record, without making these witnesses available for questioning by the defense. Of those 23 witness statements, 13 were not in the dossier and were not subsequently disclosed to the defendants during the trial.[26]

In other words, 13 witness statements were never disclosed to the defense team as they ought to have been, beyond having been read in court. These obvious irregularities went unchallenged. None of the Defense Office court-appointed lawyers raised any objection to the reading into the record of testimony from witnesses whom they had neither seen nor questioned, nor did they request that the witnesses be summoned to be cross-examined.

None of the Defense Office court-appointed lawyers raised any objection to the reading into the record of testimony from witnesses whom they had neither seen nor questioned.

A second document disclosed by the prosecution in this day's session is worthy of note. The document, dated 1987, was a memo from inside the presidential office referring to two people who had been sentenced

to death by the Revolutionary Court in 1984 but had escaped execution, and suggested that those responsible for this mishap be investigated. A note written on the margin of the memo, allegedly by Saddam Hussein, approved that investigation but spared the two men the death sentence, saying that: "we cannot allow coincidence to be more compassionate than us".[27]

It is worth noting here that during the whole trial, no evidence was submitted by any party which could be claimed to exactly specify the number of people who were executed. Even today, we are not able to state how many people were executed in Dujail, and whether or not the number of 148 relates to those indicted but not necessarily to those executed. As the file of original Dujail trial was not put into evidence, we cannot establish who was tried and sentenced in absentia. Indeed, all the documentary record that that file would permit in relation to *all* the attendant events was made inaccessible, opening the door to the conflicting evidence of purported witnesses in the present day. The ratification of the death sentence did not mean that all those on the list were indeed executed. There was further evidence to support this possibility that not all those sentenced were executed when the prosecution acknowledged that four of those sentenced surfaced sometime later and were pardoned by the President. One of the defense witnesses told the Tribunal under oath that many of those sentenced were alive and gave the names of a few of them in writing to the judge.

14 February 2006 Session

The defense counsel were still boycotting when Saddam Hussein and his co-accused were brought into the courtroom.

At the start of the session Saddam Hussein told the Judge: "For three days, we have been holding a hunger strike protesting against your way of treating us—against you and your masters."[28]

(He was referring to three other defendants and himself being on a hunger strike.)

Barazan Ibrahim was allowed to address the Tribunal for nearly half an hour. He stated that after he had made only two visits to Dujail, the whole matter had been transferred to the General Security Services, a separate organization from his department and that neither he nor his department had had anything further to do with the case.

The Tribunal heard from three officials of the regime—Hamid Yousuf Hummadi, a former personal secretary to Saddam Hussein, a former governor, and an anonymous intelligence officer.

An important document was passed to Hamid Yousuf Hummadi, for him to verify the handwriting. Hummadi stated that it looked like the President's handwriting. The document, dated 21 July 1982, is a memo from Barazan Ibrahim to Saddam Hussein asking that the officers who carried out the

investigation be rewarded. The document carried the word 'agreed' with what looked like Saddam Hussein's signature.

19 February 2006

On this day, the defense counsel lodged with the court a petition drafted on 8 February that could not have been communicated earlier (due to the difficulty in gaining access to the Tribunal and security risks) which was supplemental to the petition of 1 February calling for the ousting of Judge Abdul-Rahman on the grounds of partiality. To this supplementary petition was attached an affidavit sworn by Ziayd An-Najdawi, a Jordanian lawyer, testifying that the Judge had stated his belief that Saddam Hussein ought to be summarily executed.[29]

26 February 2006

Following an email dated 20 February granting consent from Captain McCoy of the RCLO, the US body in control of the Tribunal, Mr. Ad-Dulaimi was able on this day to meet Saddam Hussein for the first time since 29 January, but with US soldiers listening in.

28 February 2006 Session

The defense team returned to court after a month-long boycott. However, as soon as Judge Abdul-Rahman refused to respond to their motion for his disqualification on the grounds of bias, two top lawyers (Khaleel Ad-Dulaimi and Khamis Al-Ubeidi) withdrew from court out of fear of prejudicing their client's rights.

The most direct evidence yet linking Saddam Hussein to the alleged offence at Dujail was submitted during this session by the prosecutor in the form of a Presidential Decree, dated 16 June 1984, ratifying the death sentence against the 148 who were tried by the Revolutionary Court in Dujail, presided over by the co-accused, Awwad Al-Bandar.

1 March 2006 Session

This was the last day of the prosecution's case.

Mr. Khamis Al-Ubeidi appeared for the defense team and made an application for a short adjournment but his application was rejected by the Tribunal.

The prosecution for the second day concentrated on disclosing documents relating to the involvement of the defendants. However, the documents of today's session related more to the lower-ranking defendants,

accusing them of informing on some of the residents of Dujail which had then led to their arrest and subsequent death. Saddam Hussein came to the rescue of these junior members of the Ba'ath party. He argued that apart from whether or not these documents were forgeries, it made no sense to accuse someone of complicity in a crime if he informed the authority about what he considered to have been a wrong committed by them. "To say that those people were sentenced to death because Abdullah wrote it or it was said that he wrote it, this is rubbish". Informants, which Abdullah is accused of being, could not be prosecuted under English law. In fact even their anonymity is guaranteed by law.

The Tribunal allowed, at such a late date in the prosecution case, evidence which had not previously been disclosed to the defense, again denying them the opportunity to challenge or scrutinize it. This is how HRW observers summed it up:

> During the prosecution's presentation of its documentary evidence on March 1, 2006, over 40 previously undisclosed documents were presented to the court, including the most important incriminating evidence against three of the "low-level" defendants: three letters addressed to former Minister of Interior Sa'doun Shakir naming suspected Da'wah Party members in Dujail in the aftermath of the 1982 assassination attempt, and allegedly written by 'Ali Dayih 'Ali, 'Abdullah Kadhim Ruwayid and Mizhir 'Abdullah Kadhim Ruwayid. Also presented on that day, but previously undisclosed to the defence, was a compact disc containing a recording of a conversation allegedly between Saddam Hussein and former Ba'ath Party Regional Command member Abdul-Ghafour, in which the latter refers approvingly to the destruction of orchards in Dujail. The date of the recording was not disclosed, nor its source or means of interception.[30]

Defending himself against the charge of having been an informant, Mizhir Ruwayid said: "The handwriting is not mine. The signature is not mine. I only finished elementary school and the document presented was written by someone with a bachelor's degree."

The prosecution called for the indictment of former Interior Minister Sa'doun Shakir which the Judge promised to consider before the next hearing.

At the end of the day Saddam Hussein attempted to take full responsibility for all that happened in Dujail and called on the Tribunal to set his co-accused free simply because they were following orders. The following are excerpts from his address, as reported by BBC News.[31]

Saddam Hussein: Your honor, you are looking for things and you have clarity in your hands, but you leave it and go looking for the unknown. What do I mean? For instance, the razing of Dujail's groves. I razed them. So why do you go after Taha Yaseen Ramadhan and Barazan Ibrahim?

You have no need to go after other people. I razed the land. I don't mean I rode a bulldozer and razed it, but I razed it. It was a resolution issued by the Revolutionary Command Council defining the pieces of land to be flattened for those who were convicted or those who would be convicted. And that was done. I signed the decree. If it was proved that they were convicted of the criminal assault on me, their groves would be flattened.

In any case, according to Iraqi state law, the government had the right to take over any land for the national interest, with a symbolic compensation. It is the state's right to appropriate and to compensate, and the necessary was carried out. Where is the crime? Where is the crime?

Why am I telling you I did it? Because I signed the decree. If I didn't want to sign it, I wouldn't have signed, because the attack happened against me, no one could force me to sign the decree. So why are you bringing this man, this farmer from Dujail? [referring to one of the co-accused]

And you've brought the head of the Revolutionary Court because he tried them. If I had wanted, I wouldn't have referred them to the Revolutionary Court. I did refer them to the Revolutionary Court. And they were tried according to the law, just as you are trying [us]. So Awwad [Bandar, former head of the court and a co-defendant] tried them according to the law, he had the right to try or to acquit according to the law and according to his own judgment.

If the chief figure makes things easy for you by saying he was the one responsible, then why are you going after these people, detaining them and searching for one who was responsible?

You mean, Saddam Hussein would say when he was leader, "I am responsible," then when things get tough he would say, "No, Abdullah was responsible"? [referring to Abdullah Kadhim Ruwayid, another co-defendant] No, Saddam Hussein would not do that, and you know that. He's not the type to do that. In the tough times Saddam Hussein carries people on his shoulders.

If putting a defendant on trial on charges of shooting at a head of state, whatever his name, is considered a crime, then you have the head of state in your hands. Why are you trying other people? They were not presidents, there was only one.

The head of state is here, so try him, and let the others go their way. If nothing in the law gives the right for the Revolutionary Command Council to decide to appropriate land and give its owners compensation, the head of the Revolutionary Command Council is here in your hands [for trial].

7 March 2006

The Tribunal wrote to the defense counsel limiting the number of lawyers to appeal for Saddam Hussein to five and barring both Curtis Doebbler, from the US, and Al-Armouti, from Jordan, both of whom had earlier been granted permission to appear for him after having been chosen by the defendant and provided with proper power of attorney. No explanation was given by the court for the decision

12 March 2006 Session

The session began with the defendant, Mizhir Abdullah Ruwayid, the low-ranking party official in Dujail, called for questioning. A copy of his statement had only been disclosed to his lawyer that morning. He denied any involvement in the rounding up of people in Dujail following the failed assassination attempt on Saddam Hussein. He stated that he was not in Dujail on the day of the attempt and said: "I swear by Allah that I have never hurt a human being".

His father Abdullah Ruwayid and another low-ranking party official Ali Dayih Ali, followed. They both denied any involvement in the aftermath of the assassination attempt.[32]

13 March 2006 Session

The first to be questioned in this session was Muhammad Azzawi Ali, another party official from Dujail. He denied any involvement in the rounding up of or the informing on people. When questioned by the Judge on detaining people, he responded: "I didn't detain anyone, not even a bug. I didn't write any report about people and if there is someone in Dujail who says this, bring him here and let him face me."[33] He denied having made the statement which the investigative judge claimed he had made.

The next was Awwad Al-Bandar, the Chief Judge of the Revolutionary

Court which tried the defendants in Dujail. He stated that he believed the accused in Dujail had been given a fair trial over two weeks. They had confessed to the attempted assassination of the President of the Republic and were convicted in accordance with the law. He went on to state the other element of the crime committed by the accused in Dujail—that they admitted to having acted on orders from Iran which Iraq was fighting at the time. This additional element of the crime was of no small moment, when viewed in context.

Treason, the additional element of the original Dujail crime, was a matter which no state would take lightly.

Were it to be proved, it would raise the issue of treasonous activity during wartime, a matter which no state would take lightly. (Awwad insisted throughout the trial that the accused confessed and demanded access to the original file of the Revolutionary Court trial to prove it. However, he was denied the file.)

During this session when Awwad Al-Bandar was making his statement as a defendant, the HRW observer noted that: "the presiding Judge adopted a hostile tone, frequently interrupting the defendant and ultimately refusing to allow him to finish his statement, although it was clearly related to the case against him."[34]

The last to be questioned in this session was Taha Yaseen Ramadhan. He denied any role in the execution and claimed the Tribunal was nothing more than a tool of US occupation. He claimed to have been tortured after his detention by the US forces in 2003.

15 March 2006 Session

When defense counsel returned to court on this day they requested the recall of witnesses whose statements had been read into the court record while they had been boycotting the proceedings, in order for them to be cross-examined. However, there was no response to the request.[35]

The defense counsel submitted a request of 17 points which included: equality of arms, written response for earlier submissions, timely notice and copies of all evidence and exculpating evidence in the possession of the prosecutor, timely notice of hearings, transcripts, private and confidential meetings with Saddam Hussein, adequate time and facilities to prepare defense. No ruling on this submission was ever made.[36]

During the taking of statements from the defendants, the Prosecutor again disclosed evidence for the first time, when he confronted Taha Yaseen Ramadhan with a document allegedly signed by him relating to the detention of certain individuals in Dujail. This document, despite having been displayed in court, was not disclosed to Ramadhan's lawyers.

Barazan Ibrahim, Saddam Hussein's half-brother and a former head of intelligence, was again questioned on his role in the rounding up and

execution. He stated that he only visited Dujail once immediately after the assassination attempt; that he had chided his men for making unnecessary arrests and had freed many of them. He went on to say that his involvement ended when the matter was transferred to the General Security Office which was a separate department not under his authority. He said that the signature on a memo asking for his officers to be rewarded for their role in the Dujail crackdown was a forgery. He did, however, argue that he believed that the men executed had received justice as they all took part in an attempt on the life of the President for the sake of Iran with which Iraq was then at war.

Barazan claimed that he had been mistreated by the US when arrested and derided their ignorance when they asked him questions on imaginary events, such as 'when did Osama bin Laden visit Iraq?'

The session became stormy when Saddam Hussein attempted to read his prepared text. The Judge kept interrupting him but he kept on. Saddam Hussein called on Iraqis to unite against the invaders and stop killing each other.

At one point, the Judge screamed, "Respect yourself!"

Saddam shouted back: "You respect yourself!"

"You are a defendant in a major criminal case, concerning the killing of innocents. You have to respond to this charge," Abdul-Rahman told him.

"What about those who are dying in Baghdad? Are they not innocents?" Saddam replied. "I am talking to the Iraqi people."[37]

The Judge closed the session to the public and Saddam Hussein went on to finish his statement.

But before the closing of the session to the public and after having chastized Saddam Hussein for using the trial as a political platform Saddam Hussein replied "I am the head of state".

The Judge responded: "You are being tried in a criminal case. Stop your political speech".

Saddam Hussein answered: "Had it not been for politics, I wouldn't be here".[38]

Ramsey Clark, his chief legal adviser, told CNN that during the closed session Hussein delivered a "powerful and effective" statement about the context of the time period in which the Dujail events took place. Clark said Hussein argued comprehensively about the necessity and legality of what the government had to do during that violent period—wracked by its war with Iran, infiltration from Iran, treason and desertions. The closed session lasted more than an hour and a half. Clark said the court has "threatened us with

prosecution if we release what he said."

"We don't even have a copy of it. I hope to get one. I'm going to do everything I can because I think it's important for the world to know what he said."[39]

The formal response of the former President of Iraq to his accusers, to the Iraqi people and to the world at large when on trial for his life for crimes against humanity, remains undisclosed.

To my knowledge, this text has never become available; what formal response the former President of Iraq made to his accusers, to the Iraqi people or to the world at large when on trial for his life for crimes against humanity, remains known but undisclosed. I believe that Saddam Hussein's other *defense* lawyers ought to have reported what he said and faced contempt proceedings. That much at least they owed him.

4 April 2006 Session

The defense counsel alleged during this session that the documents used by the prosecution and the Tribunal came from the Association of Free Prisoners, a political organization set up in Iraq following the occupation. They cited as evidence that the stamp of the organization appeared on many of the documents in the dossier. Judge Abdul-Rahman denied this claim but gave no explanation for the source of the documents.

5 April 2006 Session

Following the claim of the day before regarding the source of the dossier documents, the defense counsel asked the prosecutor for information about how the prosecution had obtained the documents in the dossier, *but the prosecution refused to answer.*

The Tribunal officials rejected the defense counsel's request that the authenticity of handwriting and signatures should be verified by an impartial independent expert and insisted, instead, that it be done by Ministry of Interior anonymous experts.

The defense counsel reported that during this session they repeated in writing their earlier requests to review some of the original documents with their client. The Tribunal granted this request but officials from the RCLO, the US body in control of the Tribunal, vetoed that and insisted that only defense counsel and not the client could view the documents.

The Judge admitted during this session that he had received at least six defense motions to which he has not had time to respond![40] Needless to say, the trial finished without any of the motions having been responded to.

This was the cross-examination session of Saddam Hussein who appeared on his own. He disputed the prosecution charge that he had ratified the death sentence on children as young as fourteen years old and dismissed the identity cards presented by the prosecution arguing that they could be forged in any market in Baghdad.[41]

He also challenged some of the content of the statement alleged to have been made by him before the investigative Judge during the March 15 session which had taken place behind closed doors, and claimed that things had been inserted into it.

Saddam Hussein demanded that an independent international body examine signatures to verify the authenticity of the death warrant which he seemed to be disputing. He also charged that the prosecution witnesses had been bribed and briefed on what to say.

In what seemed like a threat to the Judge he said: "Who could dare to give a verdict against the president who defended his country and stood up against those who fought with Iraq"?[42]

The only female lawyer in the defense team was thrown out of the courtroom because she yelled at the Judge when the Tribunal showed a new video without it having been previously disclosed to the defense. The Tribunal's admission of such practices turns the process into a trial by ambush.

6 April 2006 Session

Further new documents were introduced in this session concerning the age of some of those convicted by the Revolutionary Court. Although Awwad Al-Bandar was cross-examined on 13 March, he was recalled today for further examination in connection with the new evidence of the age of some of those executed. He repeated his earlier statement that he believed that the accused before his court had received a fair trial and denied the execution of minors.

"I am a Judge and my deep conscience does not allow to sentence someone under 20 to death", he told the court.[43]

As Awwad Al-Bandar had consistently requested the file of that trial, the Judge claimed in this session, not only that the court did not have it, but that Al-Bandar should have kept a copy for himself when he left the Revolutionary Court in 1989, and that any failure to find the file was Al-Bandar's responsibility.[44] There are two points worthy of note here. First, I know of no jurisdiction in the world in which a judge is expected personally to keep a copy of the case file. Second, and more importantly, the Judge was simply lying. The Tribunal has always had the file of the trial before the Revolutionary Court. This has been repeatedly reiterated throughout this book and can easily be seen through two facts: the inclusion of some selected pages from the file in the original dossier delivered on 25 September 2005 to the defense counsel, and the

reference by the prosecution to the exact number of pages in the original file as stated at the beginning of this chapter.

12 April 2006

The session was adjourned because the handwriting experts had failed to appear.

17 April 2006 Session

The prosecution produced reports from the Ministry of Interior experts authenticating the signature of Saddam Hussein on the death warrants and on the memo approving rewards for the intelligence officers who carried out the crackdown following the failed assassination attempt on his life.[45]

The defense lawyers objected to the report, claiming the experts were not independent, and called for the appointment of experts from any country apart from Iran. Saddam Hussein did not let this pass without adding 'and Israel'. The Judge adjourned the hearing until 19 April to give the experts more time to study the signatures.

19 April 2006 Session

The two main documents whose authentication was of paramount importance for the Tribunal were the death warrants signed on 16 June 1984 and the memo granting reward to the intelligence officers dated 10 October 1982, to which it was claimed that Saddam Hussein had annotated the word "Agreed" on the margin.

The Judge opened the trial stating that "The experts verified these documents and the signatures of Saddam Hussein were found to be authentic". [46]

The document of 16 June 1984 is the only document the prosecution has to link Saddam Hussein to the execution of the convicted perpetrators of the Dujail failed assassination attempt. It was included in the original dossier disclosed to the defense team on 25 September 2005. Although it was one of those semi-legible documents, the presumption must be that the experts have had a better copy than the one I received.

The experts also confirmed that the signatures of Barazan Ibrahim were also genuine. Although Saddam Hussein sat quietly through this, Barazan Ibrahim contested the conclusions of the experts, accusing them and the prosecution of bias. The defense counsel has consistently claimed that the documents were forgeries and called for the examination to be conducted by independent international experts.

When lawyers for the victims asked about a motion they had

submitted to the court, the court could find no record of it.[47] Tribunal chaos was again exposed, further supporting the claim that the court regularly could not find powers of attorney that defense lawyers claimed to have submitted, and that—preposterously, for a trial of this stature, on which so much money had been expended—the court lacked a system for verifying and tracking the receipt of documents.

24 April 2006 Session

Once again, the prosecution introduced new previously undisclosed evidence which the Tribunal admitted despite this occurring so late in the trial and despite the closing of the prosecution case on 1 March. It was a recording allegedly between Saddam Hussein and his co-defendant Taha Yaseen Ramadhan, in which they discussed the destruction of the palm groves in Dujail. Ramadhan is heard telling Saddam Hussein that the destruction of the palm groves was nearly complete and that the owners were being compensated. The second voice asking questions, allegedly that of Saddam Hussein, was not clear.[48] In any case no evidence was adduced in court to show which land was confiscated or whether any of the confiscated land had been owned by persons against whom the prosecution might claim the government was acting in reprisal. General accusations do not constitute an offence.

The Judge read a report from a team of five handwriting experts confirming the earlier report of the week before, that Saddam Hussein had personally signed the death warrants. However, neither the identity, nor the contents, nor the unanimity of the decision of the experts were made available to the defense team. If the truth had truly been sought, institutions, corporations, neutral government services, etc. could have made the attestations under their names, without the need to imperil specific experts by revelation of their identities. But what truth was being sought?

The HRW's report on the conclusion of the experts' examination raised another wrinkle—the authenticity of the documents themselves, despite their verified signatures:

> According to the summary of the reports read in court on April 19 and April 24, the panels were able to verify the signatures and handwriting on seven out of the 11 documents, but could not authenticate the documents because they were unable to assess the documents' age.[49]

15 May 2006 Session

It was not until this session, nearly seven months into the trial of

Saddam Hussein, that charges were at last formally made against the defendants. I know of no jurisdiction in which the accused and his counsel face prosecution witnesses without knowing in advance what are the charges they are supposed to refute. It also marked the beginning of the defense case. The Judge read out the indictment accusing Saddam Hussein of:

It was not until this session, nearly seven months into the trial of Saddam Hussein, that charges were at last formally made against the defendants.

- The illegal arrest of 399 people
- The torture of women and children
- The destruction of farmland
- The murder of nine people in the early days of the crackdown
- The murder of 148 people in the later phase of the crackdown[50]

When asked to plead, Saddam Hussein defiantly responded:

> Your honor, you gave a long report. That report can't be summed up by saying guilty or not… Your honor is now before Saddam Hussein, the President of Iraq," Saddam said. "I am the President of Iraq by the will of the Iraqis, and I remain President of Iraq up to this moment. I respect the will of the Iraqi people and I will defend it with honor in the face of the collaborators and in the face of America.
> I do not recognize the collaborators that they brought to appoint a court and put forward a law with retroactive effect against the head of state, who is protected by the constitution and the law.[51]

The Judge entered a '*not guilty*' plea on behalf of Saddam Hussein.

Then the Judge moved on to read the charges against each of the other seven co-defendants and asking for a plea. Some refused to plea and some pleaded not guilty.

After the charges were read and pleas entered, the defense began its case, starting with Ali Dayih Ali, the low-ranking party official from Dujail. Five defense witnesses appeared in this session, all talking from behind a curtain to protect their identity, before the hearing was adjourned.

Two incidents in this session reflected negatively on the Judge's competence and the Tribunal's impartiality. In the first the Judge refused to allow any of the other defendants to be present when a witness was giving evidence in defense of Ali Diayh Ali without giving any reasons for such conduct, even though the co-accused are entitled and have a right to hear

the evidence in the whole case. In the second the Judge refused to allow the defense lawyer to question his own witness!

The defense team has commented that the specific charges against Saddam Hussein were only made in this session, which was seven months into the trial and two and a half years after he was arrested.[52] HRW made the following observation on the indictment of 15 May:

> The charging documents read in court on May 15, 2006, were also not provided in a timely manner to the defendants. The court did not provide a written copy to private defense counsel on May 15, stating that printed copies were still being prepared. This was despite the fact that the court required the defense to commence their case on May 15, just subsequent to the reading of the charges. Private defense counsel repeated their requests for written copies every day for the next three trial sessions, to no avail, and a copy was only provided after one privately retained lawyer, who was considered more cooperative by the court, intervened informally with the trial chamber and repeated the request.[53]

16 May 2006 Session

Three defendants were brought into the courtroom for this session: Muhammad Azzawi Ali, Mizhir Abdullah Ruwayid and his father Abdullah. The first defense witness, Abdullah's son, spoke from behind a curtain. He said that his father was the tribe Sheikh who was loved for his generosity and fairness.

Mizhir, on the other hand, the witness said was a low-ranking Party member whose job was manning the Dujail telephone exchange and that he would never have been involved in arresting people.

The testimony of the first witness turned into a shouting match between the Judge and Saddam Hussein's defense lawyer when the Judge objected to the witness referring to him as Mr. President. The defense lawyer rejected that the Judge had any right to interfere in the choice of words by the witness as he was entitled to consider Saddam Hussein to be his President.

Another complaint raised by Saddam Hussein's lawyers was that he was not allowed into court to be able to respond to the evidence, which was a denial of justice.

17 May 2006 Session

All eight defendants appeared together in court for the first time

since charges were officially made against them. In what appeared like an acknowledgment of his error in having denied them the right to be in court during the previous sessions, the Judge stated: "To establish justice we prefer to bring in all the defendants today with their attorneys."[54] He had perhaps been advised by his US advisers of all the defendants' legal rights to hear all the evidence.

The session involved witnesses giving testimonies on behalf of the low-ranking party officials among the defendants. They all claimed these were good men with no responsibility for the crackdown that followed the failed assassination attempt on the President.

22 May 2006 Session

The Judge demonstrated further prejudicial behavior, this time in relation to defense counsel Bushra Al-Khaleel, a competent lawyer from a prominent Lebanese Shi'a family. She returned to Court for the first time since the Judge threw her out on April 5 and, rightly in my opinion, wanted to know why she had been thrown out in the first place. The following exchange ensued.

> "Please, I want to know what procedures have I broken," Bushra said.
> Abdul-Rahman snapped at her, "Sit down."
> "I would like to know what they are so that I do not repeat them," she said.
> "Sit down," the Judge shouted again, then yelled at the guards to take her away.
> Bushra pulled off her judicial robe in anger and threw it on the floor, then tried to push away guards who grabbed her hands, yelling, "Get away from me."
> As she was pulled out of the court, Saddam—sitting in the defendants' pen—objected.
> Abdul-Rahman told him to be silent.
> "I'm Saddam Hussein, President of Iraq. I am above you and above your father," Saddam shouted back.
> "You are a defendant now, not a president," the Judge barked."[55]

So for a second time the Judge had thrown the only female lawyer from the courtroom without any improper conduct on her part and without him giving any reason. The Egyptian member of the defense team objected to the expulsion of Bushra, indicating that it was meant to intimidate and frighten the defense team. This resulted in further shouting match with the Judge but the Egyptian was spared an expulsion.

The first defense witness of the session was Murshid Muhammad Jasim, a former employee of the Revolutionary Court, testifying for Awwad Al-Bandar. Mr. Jasim insisted that Mr. Bandar's court was "the most fair, the most just....[Mr. Bandar] is a quiet, polite, fair man".[56]

When asked by Mr. Bandar if defense lawyers were ever thrown out of court when trying to make an argument, Mr. Jasim responded: "No. Lawyers were always treated with respect in accordance with the law".

In response to questions from defense counsel, the witness stated the following:

- The Revolutionary Court, while he worked there, never made a Judgment in absentia. (This addressed the charges against Awwad that he tried people on paper, in absentia, and sentenced them to death.)
- Saddam Hussein used to punish anyone who interfered with the proper functioning of the court.
- Neither Saddam Hussein nor Barazan Ibrahim had ever contacted the court or recommended anything to it. They did not interfere with the conduct of the trial.[57]

Both Ibrahim and Ramadhan objected to the restrictions put by the Tribunal on the number of defense lawyers allowed in the courtroom on the ground of limited space and argued that some had traveled long distances from overseas to attend.

Two more defense witnesses were heard in this session and both testified on behalf of Barazan Ibrahim. The first was Sab'awi Ibrahim, who said he had come forward to testify for Saddam but was told he was appearing for Barazan. He testified that Barazan had told him that the only reason he went to Dujail, following the failed assassination attempt, was to check that the Presidential guard were not lax in their protection of the President.

The second witness for Barazan, a former general director of the anti-espionage branch of the intelligence service, testified from behind a curtain. He denied earlier prosecution evidence that the arrested families were held at the intelligence office in Dujail.

24 May 2006 Session

This session was interrupted repeatedly by shouting matches between the Judge on one side and Saddam Hussein and Barazan Ibrahim on the other. However, the most notable event of the session was the testimony of Tariq Aziz, the only Christian Deputy Prime Minister in the Muslim Middle East, who had been in detention for four years without having been charged with any crime. Despite all the rumors put out by the US

media about the likelihood of Tariq Aziz turning against Saddam Hussein, he appeared to be the same loyal Party leader he had always been, referring to Saddam as "my colleague and comrade for decades".

Tariq Aziz accused the Da'wah Party, whose leader and deputy leader have been Prime Ministers since the US/UK-led occupation, of having launched an assassination campaign against many members of the Government in the 1980s, including the President and himself. A hand grenade thrown at him had killed several civilians. "So put it [the Da'wah Party] on trial. Its leader was the Prime Minster and his deputy is the PM right now and they killed innocent Iraqis in the 1980s".[58]

On the failed assassination attempt on the President and the convictions that followed, Tariq Aziz indicated clearly the principles applicable then: "The president of the state in any country, if faced with an assassination attempt, should take procedures to punish those who conduct and help this operation.... According to the law, people who support this assassination can also be convicted."[59]

At some stage Saddam Hussein stood up and declared that he did not order Ibrahim or Ramadhan to carry out any action in Dujail. He went on to support the contention of the defense that the case had been handled by the security service and NOT the intelligence services headed then by Ibrahim, or the People's Army headed then by Ramadhan.

"This issue took its normal path," he said. "The security service is in charge of Iraqis inside Iraq while Mukhabarat was in charge of foreigners inside Iraq and Iraqis outside Iraq. I didn't order either Taha or Barazan in the Dujail issue."[60]

Saddam Hussein went on to say that his main worry was to avoid chaos following rumors of his death that might have spread in Dujail, so he decided to go back and show himself to the people of the town.

It seems that the Judge was determined to leave his mark for legal incompetence. For the second time he refused to allow the defense lawyers to question their witness, not realizing that the purpose of calling a witness is to question him. This is how HRW observers reported it:

> On May 24 the Judge refused to allow defense lawyers to direct any questions to defense witness Tariq Aziz, exclaiming that 'the defense team's aim is to insult the court,' although defense lawyers had not yet had a chance to pose any questions to Aziz before the Judge reached this view. After the lunch recess, the Judge reversed himself and permitted Aziz to be recalled for questioning, but with no explanation as to why he had disallowed questioning in the first place.[61]

Nor indeed, any explanation as to why he had changed his mind.

When questioned by the defense counsel about the compensation of residents of Dujail for confiscated land, Aziz said that most of the prosecution witnesses were liars and the Tribunal ought to have questioned them about the handsome compensation they received for the land which the state confiscated in accordance with the law.[62] The question arises as to why the issue should have depended on witness testimony for verification, when the truth of the matter could be proved by documentary record, as indeed it was, in the May 29 session. In any event, no one from the prosecution or their witnesses denied that compensation had been paid in accordance with the legal principles that predated the Ba'ath Party.

The other defense witness was Abd Hameed Mahmoud, the Director of Personal Security for Saddam Hussein. He gave an account of the assassination attempt and informed the Tribunal of the discovery of a radio set capable of long distance communication which indicated that Iran could have been involved in the assassination attempt. The conspirators identified the President's car for the attackers by slaughtering a sheep at the entrance to the town and marking the car with the blood from that sacrificial lamb.

The Tribunal heard the testimonies of three more defense witnesses.

29 May 2006 Session

This session was less turbulent than preceding ones. It was taken up mainly by defense witnesses testifying on behalf of Awwad Al-Bandar. One of them was a former Revolutionary Court lawyer, who testified from behind a curtain for security reasons, claiming that Al-Bandar was a fair and just Judge. "Mr. Bandar took the humanitarian aspect into consideration, and he was fair and made all judgments according to law".

The witness informed the Tribunal that from his experience in the Court, Mr. Al-Bandar, when in doubt about the age of the defendant, would send him to the proper authority to determine his age before proceeding with the case.

The second witness who was once a defendant before Mr. Al-Bandar in the Revolutionary Court and had been acquitted by him, said: "I didn't want a lawyer because I was innocent but the Judge gave me sufficient time to bring a defense lawyer to defend me.... I still remember he called me 'my son' and I was just a defendant".[63]

The fourth defense witness was Zemam Abdul-Razzaq, a former Party leader. He confirmed to the Tribunal that all those affected by confiscation had received proper compensation in accordance with the law.

Another witness, who had worked in the intelligence service and accompanied Barazan Ibrahim to Dujail on the day of the attempt, confirmed that when they got to Dujail he saw some 70-90 detainees, some of whom were released by Barazan later that day.

Mahmoud Dhiyab, a former Party official and minister, testified on behalf of Saddam Hussein. He stated that as an agricultural engineer he had been aware since 1974 of an agricultural development plan for Dujail and that the confiscation of land was simply part of that plan.[64]

The prosecution, while questioning a witness in this session, disclosed documents apparently issued by the 'compensation committee' formed to compensate Dujail residents whose land had been seized by the government. This according to HRW, indicated that the prosecution had not exercised due diligence in complying with its obligation under the IHT Rules to disclose exculpatory evidence.[65] Not only did the prosecution have a documentary record of payment for lands seized, as would have been the case in a normative confiscation—but the prosecution had gone on to charge Saddam Hussein in relation to this offense, despite possessing evidence which indicated no crime had been committed—perhaps in an effort to "bulk up" the charges to convey the impression of widespread abuse.

The prosecution had gone on to charge Saddam Hussein in relation to this offense, despite possessing evidence which indicated no crime had been committed—perhaps in an effort to "bulk up" the charges to convey the impression of widespread 'systemic' abuse.

30 May 2006 Session

The Tribunal heard dramatic testimony from a defense witness who stated that some two dozen of those allegedly executed in Dujail were still alive.

Around 23 of those who were mentioned among the 148 are still alive, and I know most of them," the witness, who claimed to live in Dujail, said from behind a curtain to protect his anonymity. "I've eaten with them, I've met them. ... I can take the chief prosecutor to Dujail and have lunch with them.

He gave Abdul-Rahman the names of six of those he claimed were still alive, but refused to give more, saying he feared reprisals from their tribes.[66] Of course the matter could have been proved, had the court really been interested in finding out the truth. The civil register in Dujail would have clearly shown every birth and death. Iraq had had good records until the invasion. It was yet another instance of a reliance on witness testimony, when an actual documentary record might, could and should have been obtained.

Another defense witness testified that some of those allegedly executed had in fact died in the Iran-Iraq war. He gave the Judge two names

and declared that he was concerned for the safety of his son if he were to disclose further information.[67] The chief prosecutor denied that the two names given by the witness were on the list of the case.

As the defense team produced witnesses who had no direct knowledge of the events in question, the Judge clearly indicated his impatience. He either did not recognize or simply would not permit the customary practice of calling character witnesses. In an attempt to limit the number of further witnesses allowed to the defense, the Judge said that defense lawyers had been presenting longer lists of witnesses on a daily basis since they opened the defense case earlier this month.[68]

This led to protests by Saddam Hussein and his defense team who demanded to be given equal opportunity to that given to the prosecution to present their case.

"The prosecution presented all his witnesses one by one. We have nothing here, just talk, but when even talk is forbidden then we enter an imbalance," Saddam Hussein said. "To attain balance we have to be given the same opportunity as the prosecution witnesses."

31 May 2006 Session

There was further drama in the court during this session. One of the defense witnesses, who spoke anonymously from behind a curtain, alleged that the Chief Prosecutor had tried to bribe him to give false testimony.

The defense played a DVD which showed one of the prosecution witnesses contradicting his statement in court. Ali Hasan Muhammad Al-Haidari had claimed that he was fourteen years old when the assassination attempt took place and that there had been no assassination attempt but celebratory shooting to mark the visit of the President. However, in the DVD shown by the defense, Al-Haidari appeared in 2004 to be addressing a ceremony in Dujail in which he described the attack on Saddam Hussein as an act of a "son of Dujail.. to kill the greatest tyrant in modern history".[69]

The Chief Prosecutor dismissed the witness's testimony alleging a bribe, on the ground that was baseless and called for the investigation of the witness. He dismissed the DVD as irrelevant because the statement on it had not been given in court under oath.

Muhammad Munib of the defense counsel argued that the foundation of the prosecution's case had collapsed. The testimony of one witness that some of those the prosecution claimed to have been victims were, in fact, alive would show that the documents of the prosecutor had been fabricated. The possible perjury of one of the witnesses required a review of all the prosecution witnesses.

Another defense witness stated that he was arrested by the security men after the failed assassination attempt, as a possible suspect but was

later acquitted. This second defense witness also claimed that a few of those allegedly executed were alive and gave the Tribunal a list of these names. When the chief prosecutor objected that the names were given to the witness by the defense counsel, the defense retorted by arguing that the witness was entitled to prepare his thoughts on paper in order for him to remember.[70]

Three defense witnesses were arrested after the end of this hearing on suspicion of perjury. The defense team claimed their witnesses were arrested, beaten, and held without access to their lawyers.

Three defense witnesses were arrested after the end of this hearing on suspicion of perjury and were interrogated by an investigative Judge. The defense team claimed their witnesses were arrested, beaten and held without access to their lawyers.

5 June 2006 Session

This was a brief session in which two more witnesses appeared for Ali Dayih Ali, the low-ranking party official, denying any involvement in the crackdown or informing in the Dujail attempt. The Judge said that he was not allowing any more witnesses for him.

The Judge then ordered the defense counsel to submit a final list of witnesses two days before the next session otherwise the Tribunal would not allow additional witnesses to be called. A defense lawyer read a list of names of people he claimed to be still alive, despite their names appearing among those allegedly executed. He gave their current residence and declared that some others had died in the Iran-Iraq war. According to the BBC: "The defense team read out a list of 15 names from the 148, at least 10 of whom, it said, were still alive." [71]

Following from this and recalling last week's testimony of another witness that some two dozen were still alive, one defense lawyer claimed the trial was null and void.[72]

Another defense counsel protested against the arrest of defense witnesses after the end of the last hearing. The Judge responded that they had been arrested and interrogated for four days on his orders.

There was a further encounter between the Judge and defendant Awwad Al-Bandar. The Judge seemed to have accepted the prosecution claim that proceedings in the Revolutionary Court under Al-Bandar had lasted one hour and rejected Al-Bandar's claim that it took 16 days. It is inconceivable that the Judge had not seen the original file of the Dujail Case before the Revolutionary Court which—as it transpired at the end of the trial—had been in the possession of the Tribunal, an inspection of which would have clearly dispelled that conviction. Even worse, is it possible to conjecture that while the file had been with the Tribunal, the Judge hadn't bothered to consult it—or indeed, that he himself was participating in and

permitting a further nondisclosure of what might be viewed as exculpatory material. An HRW observer made the following transcript of one such argument on 5 June:

> **Judge:** Asking for dossiers [of the Revolutionary Court's file, i.e. Dujail I] is the work of the defense but don't ask us to do it.
>
> **Al-Bandar:** The Americans have seized all the documents of the Iraqi government, and the court can ask them to bring it, but if [*sic*] you want to litigate me without knowing the truth.
>
> **Judge:** I don't do that, this is not a special court, I am not prosecuting you without fulfilling my conscience, I won't issue a sentence on 148 within one hour, I am not this type.[73]

12 June 2006 Session

The Judge read out allegations by the defense witnesses who had been arrested on 31 May and interrogated for four days that they had been bribed by defense lawyers. These witnesses were not brought into court and the defense lawyers were not provided with copies of these allegations nor the right to respond to them. Outside the courtroom the defense lawyers were threatened with arrest if they were to raise the matter in court the next day.[74]

Dr. Curtis Doebbler, the US attorney, complained to the Tribunal that the defense were at a serious disadvantage because of the disproportionately brief time given to them compared to that given to the prosecution. The chief prosecutor responded to Doebbler's submission—not the Judge. The Egyptian counsel in the defense team claimed that their witnesses were terrorized and were hesitant to come forward and testify. He cited, for example, that not one single witness had yet been heard on behalf of Taha Yaseen Ramadhan.[75]

A defense witness, a former companion of Ibrahim who testified from behind a curtain, stated that there was no mass arrest following the failed assassination attempt, that Ibrahim set free many of the detainees and denied any involvement of Ramadhan in the crackdown.

A second witness, who worked in the intelligence service, denied that families were detained in the intelligence headquarters, asserting that the office did not have detention rooms. Again, the actual facts were provable. It is common knowledge (and common sense) that when people are summoned to the intelligence office, they are questioned there and then detained in other centers and not in the building itself. The headquarters were too important to become a detention center.

There followed a shouting match between Ibrahim and the Judge, which resulted in his throwing Ibrahim out. As he was led out of the courtroom

Ibrahim was physically assaulted by the guards. However, when the Egyptian counsel objected to this assault taking place right there in the courtroom in plain sight, the Judge denied it had happened and asked defense counsel to submit a proper written complaint about the assault identifying the names of the guards who had assaulted Ibrahim!

When another defense counsel protested about the way in which witness counsel An-Nu'aimi, former Justice Minister of Qatar, was treated, the chief prosecutor explained that as the witnesses were being arrested Mr. An-Nu'aimi used his mobile phone to film the incident, which forced the guards to physically wrest his mobile from him.

When one statement allegedly made by one of the arrested witnesses, in which he was promised work in Syria if he testified for Saddam Hussein, was read in court, Mr. An-Nu'aimi objected that he could not comment because he was not present when the statement was made and the witness was not available for examination.

13 June 2006 Session

Another defense witness was called to testify. He was a member of Saddam Hussein's bodyguard. He stated that when Saddam Hussein first arrived in Dujail he entered a mosque and that when the sheep were slaughtered one woman dipped her hand in the blood and stained the President's car. The President then moved to another car. As they drove away from the town, the attack targeting the stained car came from the palm groves. The President, he said, insisted on returning to the town and had declared that the act could not have been carried out by people of Dujail because they were good people.[76] When questioned by defense counsel as to the command given by Saddam Hussein, he responded that the only command he gave was to cease firing, which he believed was intended to prevent innocent people being harmed.

In response to questioning by the prosecution the witness stated that he did not see anybody firing at the convoy. He said that he did not visit the town after the attack.

Another member of Saddam Hussein's personal protection unit was called in to testify. He stated that on the way out of the town, the convoy was attacked with heavy machine guns which hit the car carrying the President but he was unharmed because it was well armored. When asked by the defense about the orders given by Saddam Hussein following the attempted assassination, he responded that the only order he heard was to cease firing. No other order was given by Saddam Hussein to use force and he was not accompanied by any military aircraft.

When asked by the prosecution regarding the firing from the palm groves after the protection unit ceased firing, the witness confirmed that

firing continued even after the 'ceased fire' from the convoy, but he could not tell its direction. The protection unit consisted of 15-20 personnel and none of them was injured but he knew that some of the men in the accompanying platoon were hit.

After another witness, Sab'awi Ibrahim, began to testify, the Judge declared that the questioning by the defense was seditious and closed the hearing to the public.

Another witness who was a member of the intelligence service stated in his testimony that not one of the people of Dujail was detained in the intelligence office. In response to questioning by the prosecutor, he said that there were no military personnel in Dujail on the day of the attack and only a few of the People's Army on the following day.

A third witness who was one of Ibrahim's personal guards stated that no one was detained in the intelligence service office and they did not take part in the crackdown.

The prosecution then produced three further undisclosed documents allegedly signed by Taha Yaseen Ramadhan concerning land seizures in Dujail, and another compact disc recording of a conversation alleged to be between Taha Yaseen Ramadhan and Saddam Hussein.[77]

Ramadhan claimed that the compact disc had been fabricated for the simple reason that at the time the conversation was alleged to have taken place (sometime around 1982-1984) there were no compact discs. He requested that either the original tape be produced or an independent international expert examine the recording.

The Judge moved to close the defense case without giving any reasoned written decision and without any explanation, despite the fact that the defense wanted more time to call further witnesses. The defense team claimed that the Judge had earlier agreed to allow the defense to call more witnesses but as soon as he received a note from the RCLO, the US body in control of the Tribunal, he reversed his decision and closed the case.

When Doebbler, the US counsel, rose to object to the closing of the defense case, the Judge derided him saying: "We know his purpose. He comes here to hear his own voice and claim that he is an international lawyer".[78]

19 June 2006 Session

The Judge started the session by declaring it to be devoted to the prosecution's closing submission. He rejected the defense request to interject observations on the prosecution submission.

The chief prosecutor started his submission by declaring that the time limitation and immunity [sic] of some of the defendants would not bar their prosecution but presented no argument for taking this position on such a fundamental constitutional issue. He went on to state that even if the there

had been an assassination attempt, the reaction of the authorities was disproportionate insofar as several hundreds were rounded up on orders of Barazan Ibrahim, interrogated and tortured. He said that Taha Yaseen Ramadhan supervised the destruction of the palm groves. These acts were contrary to Article 12 of the IHT Statute. He accepted that some of those who were exiled to southern Iraq were later released on orders from Saddam Hussein.

The Chief Prosecutor then claimed that he had established, with the following evidence, the case against Saddam Hussein for having committed crimes against humanity contrary to Article 12 of the IHTS:

1. The recording shown in court of Saddam Hussein's speech to the people of Dujail in which he informed the people that the attackers had numbered no more than ten.
2. His statement of 12 June 2005 in which he stated that his convoy was attacked but none of his guards was hurt.
3. On returning to Baghdad, Saddam Hussein convened a meeting with the heads of security services with Taha Ramadhan chairing that meeting, to coordinate action in Dujail. No evidence for this was ever shown to defense or adduced in court.
4. Saddam Hussein ordered Barazan Ibrahim to mount the crackdown on Dujail. No evidence for this was ever shown to defense or adduced in court.
5. The Memo of the Presidential Office regarding the execution by mistake of four people.[79]
6. The Memo of the Department of Legal Affairs regarding the two who had escaped execution.
7. The Presidential decree of 1984 ratifying the execution.
8. The recording in which Saddam Hussein showed indifference to the deaths during interrogation.
9. His admission before the Tribunal that he was responsible for the whole affair. (See March 1, 2006 session)
10. His orders to compensate the people whose land had been confiscated.
11. His ultimate responsibility as the commander of the security services.

The Chief Prosecutor concluded that Saddam Hussein was responsible for the crimes committed in Dujail and called for the death sentence against him.[80]

10 July 2006 Session

This session was the beginning of the defense closing submissions.

However, Saddam Hussein, some of his co-defendants and the defense team failed to appear. A letter from Saddam Hussein made public at the beginning of the hearing gave the reasons for the boycott as:

> The tribunal is lacking in all procedures established by international and Iraqi law…For this reason, it seems there is a wish to condemn us for malicious American intentions, supported by collaborators in Iraq.[81]

He went on to make the political point behind his trial in saying:

> We did not become rulers of Iraq by American political or financial support…We were not brought to power by their warplanes and tanks, but by our will and the will of our great people.[82]

The Judge expressed his regret for the murder of defense lawyer Kahmis Al-Ubeidi on 21 June and acknowledged receiving requests from the defense team for more time to get more protection and prepare their defense following the disruption caused by the death of their colleague, which he had refused.

Only two of the eight defendants appeared today, Ali Dayih Ali and Muhammad Azzawi. When the prosecution asked the Judge to summon the other defendants, the Judge declined and said that to avoid chaos he was going to allow them to see it on closed circuit TV and listen to submissions in the presence of individual defendants.

The faces of the defense lawyers appearing today were masked in contrast to previous hearings.

The lawyer for Ali said that his client never assumed any official position in government; that the expert report of his signature was mistaken and even if he had informed on some people in Dujail, then that in itself would not amount to a crime.

When Ali addressed the court he asked a rhetorical question: "Who am I to be tried today as a senior official of the former regime? I was a simple employee and low-ranking Ba'ath Party member".[83]

Ali Dayih Ali was later found guilty of having committed the crime of murder as a crime against humanity contrary to Article 1(First)(A) of the IHT Statute and sentenced to fifteen years imprisonment!

11 July 2006 Session

When the Tribunal reconvened this day, Saddam Hussein and three of his co-defendants together with their defense team were absent, boycotting the trial since the murder of their colleague, Khamis Al-Ubeidi because of

the lack of adequate protection afforded to defense lawyers by the Court. The Tribunal heard submissions made on behalf of Abdullah Ruwayid. The defense lawyer claimed that they had not been given enough time for their defense although he was not criticizing the Tribunal's impartiality. He pleaded with the Tribunal that even if his client had informed on some people in Dujail, what mattered was if any of those informed about had been indeed affected by the information. As to the destruction of palm groves he argued that his client who was 90 years old played no role in it.[84]

On adjourning the hearing, the Judge decided that he would call on court appointed lawyers to make submissions on behalf of the defense team who had continued with their boycott and told the two lawyers present: "Tell your colleagues who are out of the country that if they do not show up next time, they will hurt the case of their clients".[85]

13 July 2006

The defense team applied for an injunction against William Wiley who was appointed by the RCLO, the US body controlling the Tribunal, to stop him contacting defense witnesses or any person connected with the defense. No decision was made on this application.

24 July 2006 Session

The hearing was resumed without Saddam Hussein who was in hospital after having been rushed there due to the effects of the hunger strike he had started on 7 July 2006. Barazan Ibrahim asked for time to enable him to find new counsel and rejected the lawyers appointed by the Tribunal. Ibrahim asked permission to leave the courtroom but his request was denied, at which point he declared that he was being kept against his will. He was ordered to sit and listen to the submission made on his behalf by the court-appointed counsel.

The court-appointed lawyer declared that he was there upon the request of the Tribunal and argued that he may not have precise information because he did not have transcripts of witnesses' statements. [86]

At some stage the Judge lost his temper and exposed his personal view of the defendant when he said to Ibrahim: "Enough blood. Your hands have been saturated with blood since your childhood".[87]

26 July 2006 Session

Saddam Hussein was presented in the courtroom against his will as he declared:

I was brought against my will directly from the hospital...
The Americans insisted that I come against my will. This is
not fair. ...Three days ago I was taken to hospital and
today I was brought here forcibly from the hospital. I was
fed intravenously... [88]

He went on to tell the Judge that he rejected the lawyer appointed
by the Tribunal and stated: "I refuse to appear before this Tribunal".

But the Judge responded by saying: "Your lawyers were informed of
the hearing and they chose not to come, despite the fact that they have
billions of dollars and sit in a neighboring country, where they incite violence."
The outburst revealed the judge's bias, and completely misrepresented the
resources of the defense, which relied on donations from individuals to
function.

The court-appointed lawyer then started delivering his argument. He
stated that there was no direct link between Saddam Hussein and the
crackdown in Dujail. The Judge asked the lawyer to slow down his delivery
to enable all parties to follow what was being said. As the lawyer was making
his submission Saddam Hussein interrupted him with his observations and
corrections.

Then Saddam Hussein put the following question to the Judge: "If
you were sitting somewhere else and not on the bench, would you have
considered what this man is saying as defense or prosecution?" [89] Saddam
Hussein was so exasperated with the court-appointed lawyer that he snapped:
"I challenge you to read this on your own. He probably didn't even write this.
The American agent, the spy probably wrote this for him."

When the lawyer asked the Tribunal to show mercy, Saddam Hussein
interrupted him saying that the only mercy he sought would be from Allah.

Finally, as he realized what the outcome would be, he called on the
Judge to sentence him to death by firing squad because he was a military
man and not by hanging as an ordinary criminal. They quickly moved into
politics with Saddam Hussein forcing the Judge to argue.

Saddam pointed his finger defiantly at him and added: "Not even
1,000 people like you can terrify me." Referring to the Americans, he added:
"The invaders only understand the language of the gun. I am in prison but the
knights outside will liberate the country."

On one point, Judge Abdul-Rahman and the defendant had a curious
coming together of views. When accused of inciting violence against Iraqis
Saddam responded: "I am inciting the killing of Americans and invaders, not
the killing of Iraqis. I am Saddam Hussein. I call on Iraqis to... work on
evicting the invaders."

The Judge asked if that were true, why were insurgents killing more
Iraqi civilians than American soldiers. "Why are they attacking Iraqis in coffee

shops and markets? Why don't they go detonate themselves among Americans?" the Judge asked.

Saddam retorted: "This case is not worth the urine of an Iraqi child." He said he had told his supporters "that if you see an American vehicle you should strike it" but the Judge switched off his microphones so that the rest of the sentence could not be heard.[90]

The above is a summary of the main events of the proceedings before the Tribunal compiled from the limited available sources—bearing in mind that the Tribunal denied the existence of a transcript of the trial.

An Appropriate Defense Obscured and Prevented

The defense neither fully boycotted the proceedings nor fully partook in them. As a result, the accused ended up effectively recognizing the unlawful Tribunal but failing to offer (when not being prevented from offering) any credible or coherent defense.

A major manifestation of the chaotic and unprofessional way in which the defense counsel conducted the case, is its failure to highlight the most significant factor in the Dujail incident, namely the Iranian complicity in an assassination attempt at a time when Iraq was at war with Iran.

This issue ought to have formed the core of the defense argument, the more so since supporting testimony was provided during the prosecution examinations:

- On 13 March 2006 Awwad Al-Bandar, the Chief Judge of the Revolutionary Court which tried the defendants in Dujail, stated that the defendants confessed to the attempted assassination of the President of the Republic and were convicted in accordance with the law. He went on to state the other element of the crime of treason being that they admitted to having acted on orders from Iran, which Iraq was fighting at the time. The issue of whether or not Iran was involved in the assassination attempt would have been made clearer to everybody had the file of the original Dujail trial been put into evidence. Yet, despite repeated requests, the Tribunal neither put it into evidence nor considered it in its judgment.

- On 15 March 2006 Barazan Ibrahim argued that he believed that the men executed had received justice as they all took part in an attempt on the life of the President for the sake of Iran with which Iraq was at war.

- On 15 March 2006 when Saddam Hussein was reading his statement, the transmission was terminated, whether on the Judge's order or

that of the US officials in control (see chapter 8). We have no record of what Saddam Hussein said regarding the Iranian involvement in the assassination attempt. [see 16 March session above]

- On 24 May 2006 defense witness Abd Hameed Mahmoud, the Director of Personal Security for Saddam Hussein, gave an account of the assassination attempt and informed the Tribunal of the discovery of a radio set capable of long distance communication which indicated that Iran could have been involved in the assassination attempt.

The case of the defendants brought before the Revolutionary Court in Dujail ought to have been considered in the light of the fact that the Court was addressing an act of treason by some Iraqis in the service of Iran, the enemy, at a time of war. Any state would have taken a very dim view of such an act of treason. I believe both the US and the UK have sentenced people to death for treason at time of war.[91]

Analysis of the Outcome

Investigating what are known as international crimes, such as war crimes, crimes against humanity, genocide and aggression, is very different from investigating ordinary common crimes because these international crimes are usually carried out by more than one person; they arise from a system and there is usually a complex web of subordinate roles involved. This is difficult for any jurisdiction to handle—let alone the unique circumstances then prevailing in Iraq, a country under occupation where there was no safety for anybody, where the politically-motivated occupiers controlled every aspect of the trial, and steered it post haste towards a pre-determined conclusion.

The difficulties in the case of Iraq were compounded for three main reasons:

1. In Iraq serious crimes that involved action by large numbers of people or by a conspiracy were always investigated, during the 35 years of the Ba'ath rule, by special agencies and tried by special tribunals which operated outside the normal judiciary. This led to a simple fact that the most experienced investigating Judge or magistrate in Iraq has had little experience of handling offences beyond common assault, burglary and other ordinary crimes. A few weeks training in London would not have been sufficient to rectify this shortcoming.

2. The IHT Statute excluded any person who had ever been affiliated to the Ba'ath party from taking part in the Tribunal. That led to the elimination of the most experienced Judges and prosecutors who

almost all had to affiliate to the Party at some stage during their professional lives.

3. Under international law the mental element (*mens rea*) is fundamental to establishing a crime. No such requirement exists under Iraqi criminal law. In addition the standard of proof is not even defined under Iraqi law. This means that in the inquisitorial system in Iraq a defendant could be found guilty purely on the conviction of the Judge that he had committed the act. The claim by those who set up the Special Tribunal in Iraq that it was fair and reasonable to try international crimes under existing Iraqi law is bogus. If indeed there was a genuine intent on creating such a fair Tribunal, then these fundamental matters ought to have been addressed in the Statute of the Special Tribunal. The outcome of such failure has not only been injustice to the defendants in granting them a fair and just trial, but equally injustice to the victims. When a trial is flawed no victim would be able to claim justice so long as the offender could rightfully claim he had not enjoyed a fair trial.

After a year of hearings that was characterized by disputes, boycotts, insults, political speeches, not simply by the defense but also by the prosecution and the bench, and breaches of almost any law of criminal procedure one could think of, the trial could not be claimed to have been the model of justice that its proponents claimed it was going to be. It was a sham.

The Failures of the Prosecution's Case

In his closing argument of 19 June 2006 (see above) the Chief Prosecutor claimed that he had established the case against Saddam Hussein of having committed crimes against humanity contrary to Article 12 of the IHTS. The prosecution's case may be reduced to three elements:

1. That the four senior defendants had colluded to convict and execute the culprits in Dujail. The four minor defendants aided and abetted by informing on them. The evidence adduced by the prosecution consisted of the trial before the Revolutionary Court, the death sentences, the Presidential decree ratifying the death sentences, the memos on the errors in executions, and Saddam Hussein's admission of responsibility.
2. That several families were forcefully exiled for some three years to southern Iraq before being allowed to return.
3. That land was confiscated from its lawful owners.

It must be pointed out that the witnesses' statements did not prove that Saddam Hussein ordered the torture of any of them. Even the Tribunal did not make such a conclusion as shall be seen in Chapter 9. Since no legal proof was to be adduced from these statements, the intent in introducing them was to deepen an inference of wrongdoing for political purposes.

The charge of confiscating land is the easiest to rebut. Evidence submitted by the prosecution itself, confirmed that the land had been expropriated with compensation in accordance with the relevant law then existing. It is difficult to see how this could have amounted to a criminal offence. There is hardly a state in the world which does not have some legislation that enables it to expropriate land for public use or for development. Whether or not the confiscation was a punishment and whether or not the suspects were compensated for the loss, the matter could hardly be included among those offenses which might come to be called a crime against humanity. The fact that the prosecution was aware that compensation had been paid made this purported crime suspect as one open to recrimination—made comprehensible only if one takes into account the circumstances of the trial itself—that it was conducted by an ad hoc criminal court of doubtful competence, under a new code of law, set up by foreign power with partisan political motives, which usurped to itself retrospective authority over the accepted judicial process ratified 25 years earlier by the sovereign government of the time, which was internationally recognized by all states and was a founding member of the UN.

But the prosecution failed to produce satisfactory evidence to establish the link between the President of the Republic and the activity of his subordinates. Collusion would have been established if it had been shown that Saddam Hussein intended and knew of the treatment (torture) of the detainees by intelligence services, by the People's Army and security services; and that he had the knowledge and intent that when the 148 were committed to court they would automatically be convicted and executed because the Revolutionary Court was nothing but a tool of the regime with no judicial independence. Even if President Saddam Hussein accepted responsibility and knew of the punishments the culprits were likely to and did incur, including death by hanging, it does not make him any more of a criminal than Governor George Bush signing the death warrants of criminals in Texas, some of whom have turned out to be innocent, or Attorney-General Janet Reno, for the events that led to the loss of innocent lives in Waco.

According to HRW the following were not satisfactorily substantiated:

• That Saddam Hussein knew and intended that referral to Revolutionary Court would result in sentence and execution,
• That Saddam Hussein and Awwad Al-Bandar colluded with each other,

- That Saddam Hussein had knowledge about how the Revolutionary Court functioned,
- That Saddam Hussein directly controlled the proceedings of the court,
- Any information on the structure and functioning of Revolutionary Court,
- The non-independence of court from will and policies of President,
- That Awwad Al-Bandar was guilty in participating in joint criminal enterprise,
- That Awwad Al-Bandar knowingly acted in furtherance of President's criminal plan,
- Any information on the structure and organization of Government institutions and security organizations,
- The command structure of the Popular Army and legal authority of Ramadhan over it,
- Membership, powers and organization of RCC, National Security Council (NSC) and Office of President, which would have shown if the report of the NSC about detention of 800 people from Dujail reached Saddam Hussein,
- The systematic use of torture in interrogation.[91]

It may be argued—as probably it was what the prosecutor and Judges if not members of the wider international public believed—that it was obvious that the nature of the regime meant that such oppressive conduct was prevalent in Iraq and could be presumed to have occurred. It would have been possible for the Tribunal to take judicial notice of these facts but evidence of same ought to have been submitted to it—but was not, due to efforts to strictly tailor the crime to the events. There is no procedure in a Tribunal which allows the admission of evidence in the form of "understood facts". Even a judicial notice has to be put to the court because the Judge sits in adjudication on the facts submitted to him and not on his knowledge or convictions.

There has been some enthusiasm over Saddam Hussein's rhetorical admission in court that he was responsible for the whole affair when he called on the Tribunal to set the others free and try him alone. However, caution is needed here because such an admission would not constitute evidence of a crime unless the documents decisively established the guilt. In the view of the ICTJ, the signature of Saddam Hussein on the decree ratifying the death sentences passed by the court "is not enough to constitute the requisite intent for crimes against humanity. What was required was evidence showing that the Revolutionary Court sentenced people to death without any trial, and that Saddam Hussein was aware of that."[92] No such evidence was submitted during the forty sessions of the trial.

HRW made the following observation on the failure of the Tribunal to establish the guilt:

> Overall, the case prepared by the investigative Judge in relation to the events in Dujail in 1982 suffered from important gaps in terms of the kinds of evidence necessary to prove intent, knowledge, and criminal responsibility on the part of the defendants. When preparing the case, it appears that neither the prosecution nor the investigative Judge paid sufficient attention to the requirements of what must be proved under international criminal law in order to establish specific, individual criminal responsibility of each defendant for the abuses that were committed against the people of Dujail.[93]

In my view, such failure proves two fundamental issues which I have already addressed: 1) the complete incompetence of the whole machinery of the Tribunal from Investigative Judge to its President, and 2) the fact that everyone employed by the Tribunal, including the appointed defense lawyers, believed that Saddam Hussein was guilty before the trial even began. Everything else flowed from this conviction, including the indifference to whether or not any evidence was adduced.

However, in the midst of reporting by HRW and others, a fundamental issue has been missed accidently or intentionally. It relates to the Crime Against Humanity as defined in Article 12 of the IHT Statute which is a reproduction of Article 7 of the Statute of the International Criminal Court. It is so vital for this point to be made that it would be a travesty of justice to report the matter without highlighting whether or not the Tribunal addressed it. We need to remind ourselves of what Article 12 of the Statute of the HIS says:

> First: For the purpose of this Law, 'crimes against humanity' means any of the following acts **when committed as part of a widespread or systematic attack directed against any civilian population**, with knowledge of the attack, [emphasis added].

It is clear that before the criminality of any act is considered it must be established that it was 'committed as part of a widespread or systematic attack'. If that is not established beyond reasonable doubt, then there are no grounds to consider the acts. There will always be crimes of willful killing, torture, deportation etc. but if not committed as part of 'a widespread or systematic act, then they will not be considered as crimes against humanity as defined under international law. Indeed they would be considered as

ordinary crimes triable under different domestic legislation. It is accepted by the ICC and subsequently adopted in the statute of the IHT that any of the acts defined in sub-articles A-J in Article 12 if committed as part of 'a widespread or systematic attack', would constitute a crime against humanity.

Could the Tribunal truly be regarded as having established that the acts it examined had occurred as part of a "widespread and systemic" attack against the people of Dujail—as a *crime against humanity*?

However, it should be asked whether, throughout the assessment of the trial of Saddam Hussein, any evidence had been adduced and the Tribunal successfully established that any of the acts with which the accused were charged had in fact been part of 'a widespread or systematic attack' directed against the people of Dujail. If it can be shown that no argument has been made for the offences as being part of widespread or systematic attack, then the whole trial would collapse. It is my opinion that the prosecution failed to show that the acts of which the accused were charged were anything other than, at most, an excessive measure to respond to an assassination attempt against the head of state instigated or supported by another state at a time of war. That, in my opinion, has nothing to do with a 'widespread or systematic attack against any civilian population'.

It should be of little surprise, then, that it can be established beyond doubt—as I shall proceed to do in the following chapter in case the reader is not already convinced—that Saddam Hussein did not enjoy a fair trial.

ENDNOTES

[1] We have been informed that the Tribunal does not have a transcript of the proceedings of the trial of Saddam Hussein. Although I do not believe that the RCLO, entrusted by the US Government to control the Tribunal, did not transcribe the whole trial, I have no way of establishing this. Accordingly, neither I nor any other member of the international community have any way of determining what went on in the proceedings beyond relying on the few reports, media coverage and the Tribunal's partial reporting on its website. It is by no means ideal but we have to deal with what is available. As a result, there may be some inaccuracies in reporting the events of a certain proceeding.

[2] 'You are an Iraqi. You know who I am', *The Guardian*, Thursday, October 20, 2005. <http://www.guardian.co.uk/international/story/0,,1596089,00.html>

[3] Sengupta, K., 'Saddam's trial delayed again after limp opening gambits', *The Independent*, 29 November 2005. <http://news.independent.co.uk/world/middle_east/article329996.ece>

[4] Ibid. It is difficult to see how a judge would allow such evidence to be put to the jury when the defence were denied the right to cross-examine and all because the prosecution failed to grant them such right.

[5] Clark, R., Doebbler, C., The Iraqi Special Tribunal: A corruption of Justice, 13 September 2006, [hereinafter referred to as C&D'], p. 60. <http://www.justiceonline.org/site/PageServer?pagename=IST> <http://hrw.org/reports/2006/iraq1106/iraq1106web.pdf>

6 Human Rights Watch-ICTJ trial observation notes, November 28, 2005. In a similar vein, Shi'a parliamentarian and Da'wah Party member Ali Al-Adeeb stated to the press, "The chief judge should be changed and replaced by someone who is strict and courageous." See Hamza Hendawi, "Saddam Lashes out at US as Trial Resumes," Associated Press, November 28, 2005. 'Judging Dujail, The First Trial before the IST', Human Rights Watch, Volume 18, No. 9 (E), November 2006.[hereinafter referred to as 'HRW-2'], p. 41. Footnote 151.

7 'Saddam says he's not afraid of execution in chaotic day in court', Court TV News, Dec. 5, 2005. <http://www.courttv.com/trials/saddam/120505_ap.html>

8 Cockburn, P. 'Witness chokes back tears as he tell court about Saddam's human grinder', *The Independent*, 6 December 2005. <http://news.independent.co.uk/world/middle_east/article331409.ece>

9 'Saddam vows he won't return to unjust court', Court TV News, 6 December 2005. <http://www.courttv.com/trials/saddam/120605_ap.html>

10 HRW-2, p. 22.

11 'Saddam Hussein's trial adjourned,' *The Independent*, 7 December 2005. <http://news.independent.co.uk/world/middle_east/article331705.ece>

12 C&D, p. 38.

13 'Saddam more calm as trial resumes', BBC News Wednesday 21 December 2005. <http://news.bbc.co.uk/1/hi/world/middle_east/4547702.stm>

14 'Witness: Saddam Hussein's regime killed, tortured people by ripping off their skin,' Court TV News, 21 December 2005.<http://www.courttv.com/trials/saddam/122105_ap.html>

15 'Saddam attends resumed trial after two-week break', *The Independent* 21 December 2005. <http://news.independent.co.uk/world/middle_east/article334540.ece>

16 Penketh, A.,'Saddam claims he was tortured in captivity,' *The Independent*, 22 December 2005. <http://news.independent.co.uk/world/middle_east/article334678.ece>

17 Mr. Al-Musawi did not advise us on who was going to investigate the actions of the US troops who have tortured detainees in Abu Ghraib and which Iraqi authority would take charge of Saddam Hussein, when all Iraqi officials depend on the US forces for their protection.

18 HRW-2, p. 48.

19 'Lawyers: Saddam's half brother says he rejected plea deal from US Officials', Court TV News, Dec. 27, 2005. <http://www.courttv.com/trials/saddam/122705_plea_ap.html>

20 C&D, p. 40.

21 'Saddam Hussein's trial delayed five days after judges opposed new appointment', Court TV News, January 24, 2005. <http://www.courttv.com/trials/saddam/012406_delay_ap.html> <http://www.courttv.com/trials/saddam/013006_protest_ap.html>

22 'Saddam Hussein escorted out of courtroom after shouting match', Court TV News, January 30, 2006. <http://www.courttv.com/trials/saddam/021306_ap.html>

23 C&D, p. 41.

24 'Saddam, four other defendants and defence team boycott new session of trial, Court TV News, February 1, 2006. <http://www.courttv.com/trials/saddam/020106_ap.html>

25 'Haggard Saddam forced into court', Court TV News, February 13, 2006.

26 HRW-2, p. 48.

27 This exposed the chaos that had prevailed both at the initial Revolutionary Court Trial of the Dujail men and that of Saddam Hussein. It seems that at no stage has it been established as to who was really killed, when and how. If some people of the 148 turned out to be alive, then the list signed by Saddam Hussein may not be a factual document of people who had indeed been executed.

28 'Saddam, co-defendants say they are on hunger strike in latest session of trial', Court TV News, February 14, 2006. <http://www.courttv.com/trials/saddam/021406_ap.html>

29 C&D, p. 41.

30 HRW-2, pp 49-50.

31 'Saddam responsibility claim quotes' BBC News, Wednesday, 1 March 2006. <http://news.bbc.co.uk/1/hi/world/middle_east/4764136.stm>

32 'Saddam's trial hears defendants', BBC News, Sunday 12 March 2006. <http://news.bbc.co.uk/1/hi/world/middle_east/4798208.stm>

33 'Saddam-era executions were fair', BBC News, Monday 13 March 2006. <http://news.bbc.co.uk/1/hi/world/middle_east/4800700.stm>

34 HRW-2, p.66.

35 HRW-2, p. 60.

36 C&D, p. 42.

37 'Judge reprimands Saddam Hussein for speech, then closes courtroom', Court TV News, March 15, 2006 as updated on April 28, 2006. <http://www.courttv.com/trials/saddam/031506_ap.html>

38 'Saddam denounces comedy court', BBC News, Wednesday 15 March 2006. <http://news.bbc.co.uk/1/hi/world/middle_east/4808050.stm>

39 In His First Testimony, Hussein Urges Iraqis to Fight, CNN.com, March 16, 2006. <http://edition.cnn.com/2006/WORLD/meast/03/15/saddam.trial/index.html>

40 C&D, p. 43.

41 Sengupta, K., 'Defiant Saddam accuses minister of running death squads in Iraq', *The Independent*, 6 April 2006. <http://news.independent.co.uk/world/middle_east/article356029.ece>

42 'Saddam Hussein dismisses evidence' BBC News, 5 April 2006. <http:news.bbc.co.uk/1/hi/world/middle_east/4878340.stm> This is clearly a reference to the famous Mraidi market in Sadr city known to forge anything from a birth certificate to a PhD.

43 'Saddam co-defendant defends actions', BBC News, 6 April 2006. <http://news.bbc.co.uk/1/hi/world/middle_east/4883966.stm>

44 HRW-2, p. 52.

45 C&D, p. 44.

46 'Saddam did sign death warrants', BBC News, 19 April, 2006. <http://news.bbc.co.uk/1/hi/world/middle_east/4921864.stm>

47 Human Rights Watch–ICTJ trial observation notes, April 19, 2006. HRW-2, p. 17.

48 'Trial hears Saddam Phone call', BBC News, 24 April, 2006. <http://news.bbc.co.uk/1/hi/world/middle_east/4937972.stm>

49 HRW-2, p. 56

50 'Defiant Saddam refused to plead', BBC News, 15 May 2006. <http://news.bbc.co.uk/1/hi/world/middle_east/4771479.stm>

51 'Saddam refuses to enter plea on charges of crimes against humanity in new trial session', Court TV News, May 15, 2006. <http://www.courttv.com/trials/saddam/051506_ap.html>

52 C&D, p. 65.

53 HRW-2, p. 54.

54 'Saddam trial hears defence case', BBC News, Wednesday, 17 May 2006. <http://news.bbc.co.uk/1/hi/world/middle_east/4988914.stm>

55 'Iraqi judge throws out female defence lawyer, shouts down Saddam', Court TV News, May 22, 2006. <http://www.courttv.com/trials/saddam/052206_ap.html>

56 'Lawyer thrown out of Saddam trial', BBC News, Monday 22 May 2006. <http://news.bbc.co.uk/1/hi/world/middle_east/5003944.stm>

57 Session 27, Dujail File, IHT web site. <http://www.iraq-iht.org/ar/26062006.html>

58 Cockburn, P.,'Saddam had right to kill villagers, says Tariq Aziz', *The Independent*, 25 May 2006. <http://news.independent.co.uk/world/middle_east/article571691.ece>

59 'Aziz testifies for Saddam defense', BBC News, Wednesday, 24 May 2006. <http://news.bbc.co.uk/1/hi/world/middle_east/5011164.stm>

60 'Former Iraqi minister Tariq Aziz testifies in the Saddam Hussein trial, Court TV News, May 24, 2006. <http://www.courttv.com/trials/saddam/052406_ap.html>

61 HRW-2, p. 66.

62 Session 28, Dujail File, IHT web site, <http://www.iraq-iht.org/ar/03112006.html>

63 'Saddam witnesses say Dujail fair', BBC News, Monday, 29 May 2006. <http://

64 news.bbc.co.uk/1/hi/world/middle_east/5026530.stm>

65 Session 29, Dujail File, IHT web site, <http://www.iraq-iht.org/ar/280112006.html>

66 HRW-2, p. 51

 'Defence in Saddam trial demands equal time, complaints of restrictions', Court TV
 News, May 30, 2006. <http://www.courttv.com/trials/saddam/053006_ap.html>

67 Session 30, Dujail File, IHT web site, <http://www.iraq-iht.org/ar/28062006.html>

68 'Witness: Saddam victims alive, BBC News, Tuesday, 30 May 2006. <http://
 news.bbc.co.uk/1/hi/world/middle_east/5029732.stm>

69 'Judge throws defendant out of courtroom after confrontation in Saddam Hussein
 trial', Court TV News, June 5, 2006.<http://www.courttv.com/trials/saddam/
 053106_ap.html>

70 Session 31, Dujail File, IHT Web site, <http://www.iraq-iht.org/ar/06062006.html>

71 'Saddam lawyers dispute execution', BBC News, Monday, 5 June 2006. <http://
 news.bbc.co.uk/1/hi/world/middle_east/5049330.stm>

72 Session 32, Dujail File, IHT web site, <http://www.iraq-iht.org/ar/05072006.html>

73 HRW-2, p. 65-66.

74 C&D, p. 60.

75 Session 33, Dujail File, IHT web site, <http://www.iraq-iht.org/ar/077052006.html>

76 Session 34, Dujail File, IHT web site, <http://www.iraq-iht.org/ar/10072006.html>

77 HRW-2, p. 49.

78 HRW-2, p. 67.

79 There is no way of reporting when this was disclosed in court since no one
 reported on it, and we do not have full transcript of the trial.

80 Session 35, Dujail File, IHT web site, <http://www.iraq-iht.org/ar/12072006.html>

81 'Saddam boycott malicious trial', BBC News, Monday, 10 July 2006. <http://
 news.bbc.co.uk/1/hi/world/middle_east/5163680.stm>

82 'Saddam Hussein boycotts trial, alleging bias and lack of security', Court TV
 News, July 10, 2006. <http://www.courttv.com/trials/saddam/071006_ap.html>

83 Session 36, Dujail File, IHT web site, <http://www.iraq-iht.org/ar/80082006.html>

84 Session 37, Dujail File, IHT web site, <http://www.iraq-iht.org/ar/90082006.html>
 <http://news.bbc.co.uk/1/hi/world/middle_east/5169406.stm>

85 'Boycott forces Saddam trial delay', BBC News, Tuesday, 11 July 2006.

86 Session 38, Dujail File, IHT Web Site, <http://www.iraq-iht.org/ar/10082006.html>

87 'Iraq trial resumes without Saddam' BBC News, Monday, 24 July 2006. <http://
 news.bbc.co.uk/1/hi/world/middle_east/5209018.stm>

88 'Saddam forced back to his trial'. BBC News, Wednesday 26 July 2006. <http://
 news.bbc.co.uk/1/hi/world/middle_east/5215866.stm>

89 Session 39, Dujail File, IHT Web site, <http://www.iraq-iht.org/ar/25082006.html>

90 Cockburn, P., 'Saddam: If I'm to be executed please make it by firing squad', *The
 Independent*, 27 July 2006. <http://news.independent.co.uk/world/middle_east/
 article1199355.ece>

91 In the case of the UK see for example the case of William Joyce and John Amery
 who were both convicted during WWII under the High Treason Act 1351 (as
 amended in 1945) and executed at Wandsworth Prison in London. <http://
 www.stephen-stratford.co.uk/treason.htm> In the US the following example may
 be cited: The cases centered around Operation Pastorius, a failed attack by Nazi
 Germany on the United States, staged in June, 1942. Eight Germans who lived in
 the United States, Ernest Burger, Herbert Haupt, George John Dasch, Edward
 Kerling, Richard Quirin, Heinrich Heinck, Hermann Neubauer and Werner Thiel,
 were recruited for the operation, masterminded by Admiral Canaris, the head of
 the German Abwehr, their Secret Service...Eventually all 8 were arrested and put
 on trial by a special military court —something like the military commission that
 Bush established—in Washington, DC. All 8 defendants were found guilty and
 sentenced to death. FDR commuted Dasch's sentence to 30 years and Burger's
 sentence to life. The other 6 defendants were executed on August 8, 1942, in the
 electric chair of the District of Columbia jail and buried in a potter's field in the
 Anacostia section of Washington, DC. This was the largest legal mass execution
 in United States history. <http://theunitedstatesconstitution.blogspot.com/2006/10/

world-war-ii-treason-cases-tokyo-rose.html>
92 HRW-2, pp. 82-83.
93 ICTJ, pp. 9-10.
94 HRW-2, p. 83.

CHAPTER 8

THE FAILURES OF THE TRIAL[1]

The following analysis of the proceedings of the Tribunal demonstrates the extent to which the whole process, from the setting up of the Tribunal by the occupying powers to the conclusion of the trial, has been illegal, executed contrary to Iraqi and international law. Here are the main features.

The Official Language of the Trial

It is natural to expect the language of any trial in Iraq to be Arabic. It was in Iraq that Arabic grammar and prosody was born; the first dictionary in any language was compiled in Arabic, and Arabic poetry reached its zenith in excellence and beauty. No other language can supplant that history and no other language takes precedence in Iraq. All other languages that exist in Iraq will be respected and supported but all should take second place to Arabic. Arabic in Iraq is like English in the British Isles where all other languages come second. The Arabs of Iraq constituted the largest part of the Semitic culture that gave birth to three different civilizations and gave many cities their Semitic old names like Ur in the south and Erbil in the north.

The people of Iraq have generally been proud of their linguistic heritage. This does not apply to the Arabs alone as this culture has become part of Islam and all Muslims have looked up to Iraq. Thus Mustafa Jawad, one of the greatest of Iraq's Arab linguists of the 20th century, was a Kurd by birth. Legislations, like other documents, were framed in proper classical Arabic. One superb example is the Iraqi Civil Code Law No. 40 of 1951, which stands out as a piece of distinguished legislation in classical Arabic. Such a piece of legislation represents the culture of its time when prominent jurists of the 1950's drafted it. It was so well drafted that in over 50 years it went through only minor amendments.

If we were to compare the quality of the language of the Iraqi Civil Code Law of 1951 with that of the Statute of the Iraqi High Tribunal (IHT) of 2005, we would have to sadly conclude that Iraq had gone back two hundred years to the dark days of Arabic under Ottoman Rule. I believe that no nation

can aspire to develop if it cannot master its language. When a nation allows its legislation to be written by people with poor command of its language, then this damages its self respect. How can a nation fool itself about protecting human rights when it cannot properly define what they mean in law?

The Statute of the IHT is so poorly drafted with so many errors and syntactical mistakes that if it were written by a high school student as a composition in Arabic, that student would fail that subject. The answer may lie in its having been a poor translation from an English original which gave it this flimsy appearance. If that was the case why did all these organizations, like Amnesty International, Human Rights Watch and the ICTJ, not object to the communications disaster? They had been crying over the lost opportunity of having international advisers and would have us invite those advisers. Yes there are many Iraqis and Arabs who understand English and are capable of translating conversational and media language. But it is different when it comes to law. The translation here cannot be acceptable if you only understand the gist of the argument. I would say that there are very few Arabs who would be able, for example, to translate legal terms without consulting a specialist dictionary. It must be precise. The result of a case may hinge on the interpretation of a sentence and that cannot be left to approximations.

The purpose of the above introduction has been to show that it is also disgraceful to the rule of law in any country to have someone sitting on the bench of a Tribunal who cannot communicate properly in the official national language. This was the case of Judge Ra'ouf Abdul-Rahman, who sat in the Dujail Trial after the resignation of Judge Rizgar Amin. It has been said that he is excused for being a Kurd. But imagine appointing someone to the High Court in London, and when he conducts proceedings in unintelligible English, we are told that he is entitled to that because he is either Welsh, Scottish or Cornish!

When I read a judgment of Lord Diplock (a prominent UK Law Lord of the 20th century) I do not simply enjoy his legal argument but equally his eloquence and masterly English. When I hear Judge Abdul-Rahman talk in court I cover my face in embarrassment. Why would a man who never qualified as a judge before, who comes from Halabja with a possible grudge, who does not know the official language of the Tribunal, be appointed as head judge in the most historic Trial in Iraq and end up discrediting Iraq's judicial history and the beautiful language of the Qur'an? Perhaps the answer lies in who appointed him.

US Control of All Aspects of the Trial

In Chapter 5 the setting up of the Regime Crimes Liaison Office (RCLO) was considered. It was shown how the function of the RCLO was

reported to Congress in the quarterly updates of the White House and the State Department . The role of the RCLO prior to the commencement of the trial was shown. I intend here to consider the sequence of interventions and decisions made by the RCLO which indicate its full and total control of the Tribunal.

Let us recall the following three facts relating to the existence of the RCLO.

1. The RCLO is alleged to have been created to support the Iraqis investigate and try their top leaders for crimes of genocide, war crimes and crimes against humanity at a time when the Americans acknowledge the Iraqis lacked the knowledge and competence to handle such investigations and trials. It is clear that the creation of the RCLO was intended under such realization to usurp the function of the IHT.

2. By August 2006, nearly a year after the commencement of Saddam Hussein's trial, the RCLO was employing over 140 personnel including investigative agents prosecutors, military officers and foreign nationals [2] from the FBI, Drug Enforcement Agency (DEA), Bureau of Alcohol, Tobacco and Firearms (ATF) and US Marshals Service (USMS). A body which intends simply to give support to a Tribunal would not be as big as the Tribunal itself and have greater competence unless it actually intends to substitute for it. The statement of the Department of Justice on the RCLO indicates that it was so much in control of the Tribunal that everyone from the US side related to the Tribunal was on RCLO staff, which ranged from the investigator to the military personnel.

3. The RCLO has had custody of the documents relating to the Tribunal and the cases it was supposed to try. These documents were among the 2 million or so documents removed by the US to Qatar after the occupation of Iraq. It will be shown below how the RCLO provided the IHT with documents for the trial. It should be noted here that both HRW and ICTJ have repeatedly criticized the IHT for not providing the defense counsel with exculpatory evidence. But considering that all the documents were in the custody of the RCLO which provided the Investigative Judge and Prosecutor with some of them, then was it not the responsibility of the RCLO to see to it that the relevant evidence was directed to the defense? Was it not a failure of the US authorities through the failure of the RCLO that would not have been tolerated in the Nuremberg Trial?

It may be possible to put up an argument that would explain that the above facts do not necessarily establish full control of the process by the RCLO. However, when we consider the continuous interventions, supervisions and running of the process, it would become impossible to rebut the above assertion. I neither intend to list all the incidences of such intervention and control by the RCLO, nor indeed do I claim to be privy to all such incidences. But I would like to list below some of these gathered from US Updates to Congress, from the three reports I cited earlier in this chapter, and from my personal knowledge that accumulated through my advice to some of the defense counsel.

1. In January 2004 it was reported to Congress that $75 million was allocated to the IST, but only $4 million was earmarked for capacity building to train Iraqi investigators.[3]

2. In April 2004 it was reported to Congress that five deputy US Marshalls were deployed to Iraq as the first wave to investigate Iraqi High Value Defendants (HVDs).[4]

3. In July 2004 it was reported that the RCLO initiated investigations of HVDs.[5]

4. In October 2004 it was reported to Congress that the RCLO had interviewed more than 30 Iraqi HVDs and had access to examine the millions of Iraq documents removed by the US to Qatar.[6]

5. In January 2005 it was reported to Congress that the RCLO had carried out *'preliminary investigative hearings'* for two of the top twelve Iraqi HVDs.[7]

6. On 17 August 2005 the RCLO in Baghdad sent an email to Saddam Hussein's lawyer, Khaleel Ad-Dulaimi.

7. On 18 August 2005 the US Embassy in Baghdad sent an email to Ad-Dulaimi relating to arranging a meeting with the Investigative Judge.

8. On 23 August 2005 the US Embassy in Baghdad sent an email to Ad-Dulaimi relating to the arrangement of visits to his client.

9. On 29 August 2005 the US Embassy in Baghdad sent an email to Ad-Dulaimi fixing a date for him to meet his client and inviting him to contact US Captain McCoy.

10. On 10 September 2005 the US Embassy in Baghdad sent an email to Ad-Dulaimi giving notice of an investigative session for Saddam Hussein.

11. In October 2005 a senior US adviser to the Tribunal said that 'the US will be involved in the trial *but from behind the scenes* (emphasis added), more like a puppet master role. In fact, the tribunal statute requires that both the judges and the prosecutors receive assistance from the US authorities'.[8]

12. On 28 November 2005 the Tribunal agreed to grant the defense three months to consult with their clients and prepare their defense, only to be overruled by RCLO officials at the Tribunal. [9]

13. On 21 December 2005 Curtis Doebbler, armed with a Power of Attorney signed by Saddam Hussein, was advised by US Captain Philip Lynch to approach the Judge and ask for audience.

14. On 21 December 2005 Curtis Doebbler was physically restrained by US Marshall Bartlett and threatened to be removed permanently from the courthouse.[10] Although Doebbler only referred to this incident in passing in his report, I believe it is more significant than it appears. The US Marshals Service, like the other Marshals dispatched to Iraq as cited in paragraph 2 above, was in fact enforcing US federal law which makes the Tribunal an instrument of the US judicial system.

15. On 21 December 2005 Captain Lynch advised Curtis Doebbler that his request for audience had been granted by the IHT but overruled by a Canadian, Howard Davidson, another appointee of the RCLO.

16. On 24 January 2006 defense lawyers waiting to attend the hearing were told by a US captain that the hearing was cancelled.[11]

17. On 20 February 2006 US Captain McCoy wrote to Ad-Dulaimi granting him permission to see his client on 26 February.[12]

18. On 16 March 2006 the BBC News reported that when Saddam Hussein was giving evidence in court on 15 March, an RCLO official was exposed to be in control of the transmission of the proceedings.

> At one point, journalists also heard in their head-
> phones one of the American officials telling a

> translator to stop conveying Saddam Hussein's words.[13]

19. On 4 April 2006 RCLO officials at the Tribunal prevented a lawyer from leaving to meet a potential witness, a meeting which had been already arranged, and of which the officials had prior knowledge.[14]

20. On 5 April 2006 RCLO officials at the Tribunal reversed the decision of the Tribunal, and were now refusing lawyers and clients the right to view original documents.[15]

21. In April 2006 it was reported to Congress that the RCLO was implementing the 'repatriation of key evidentiary documents to Iraq for use in the IHT in upcoming trials related to the Anfal Campaign'.[16]

22. In April 2006 it was confirmed that Mr. William Wiley, who had worked for the UN from mid-2005 to early 2006 had gone on to work for RCLO.

23. On 13 June 2006 the RCLO officials at the Tribunal instructed the Judge to terminate the defense right to call further witnesses after he had granted such permission.[17]

24. During 10-27 July 2006, William Wiley from the RCLO drafted the final statements to be read by the Defense Office lawyers. I hasten to add that William Wiley himself is not a lawyer.

In addition to the report to Congress and the direct interferences as listed above, there are other indicators pointing to the full control of the Tribunal by the US:

- The entire interior of the building was designed, refurbished and equipped by the US.
- The process of recording and transmission of the proceedings has been fully under US control.
- Access to the trial has been controlled by the US and people were not allowed in unless so authorized by the US authorities.
- The only observers who were allowed to monitor the trial were two US organizations—HRW and ICTJ—who were effectively the only people not serving the US government who were allowed to have access to the judges, prosecutors, and staff of the Tribunal.

I leave it to the reader's judgment to conclude, given the degree of the intervention cited above and given the secretive atmosphere surrounding the whole process, the real extent of US control of the Tribunal and the whole trial.

The role of the RCLO as the US body in control of the Tribunal was summed up by one of the Tribunal judges when interviewed by HRW. He simply said: "the RCLO functioned at times as the 'executive authority' of the IHT".[18]

Independence and Political Interference

The requirement that the judiciary be independent is so well established that it is basic to customary international law and has been incorporated in many conventions, domestic legislations and UN Resolutions.[19]

Although the IHTS attempted to respect the principle of independence of the judiciary as outlined above, it immediately created the possibility of interference in Article 4(4) which states:

> The Presidency Council, upon a recommendation from the Council of Ministers, may transfer judges and prosecutors from the Tribunal to the Supreme Judicial Council for any reason'.

It is not difficult to see the force of the above Article and its capacity to intimidate any judge or prosecutor who looked like he might be deviating from the officially expected line to tow.

The political interference started long before the trial commenced. This took the form of pre-judging the accused; distributing propaganda against the accused; calling for a speedy trial; declaring imminent conviction; expressing frustration at delay and so on. It is not difficult to see the reason for these machinations. The US/UK had a strategy for the Middle East which was based on occupying

Political interference started long before the trial commenced, coming not only from Iraqis but from outsiders, including President Bush, himself.

Iraq in order to surround Iran and complete the occupation of both sides of the Gulf, but the Iraqis who came with the US tanks had no legitimacy. Their sole aim was to argue for the elimination of the old regime.

The interventions in the trial came not only from Iraqis but extended to outsiders like President Bush himself. The ICTJ summed up the effect of these interventions in saying:

> Iraqi political leaders have continually made remarks and

exerted pressure, creating an atmosphere that is not conducive to the exercise of the presumption of innocence or to fair trial.[20]

The following are but a few samples of these clear interventions in the forthcoming judicial process.[21]

- On 16 August 2004 Reuters reported that Ayad Allawi told the Court to 'speed up Saddam's Trial'.

- On 31 May 2005 Associated Press reported Talabani as saying: 'Saddam likely to face trial soon'.

- On 24 June 2005 AFX News reported that 'Iraqi leader says judges wasting time on Saddam case'.

- On 5 October 2005 Radio Free Europe reported that President Jalal Talabani said that Saddam was guilty and should be executed twenty times.[22]

The interference in the judicial process became more pronounced and vocal and all the more oppressive to the Tribunal over time. Some examples of clear interference by Government officials and influential political figures which render the Tribunal as fully a tool of the executive are given below.

- On 6 September 2005 CNN reported before the trial even commenced that Jalal Talabani said that he 'had spoken to one of the Iraqi Special Tribunal judges involved in the investigation who had said that "he was able to take important confessions from Saddam Hussein and he has signed these confessions and there is a video and audio for these confessions"'.[23]

- On 8 September 2005 Iraq's Foreign Minister, Hoshyar Zebari, is reported to have said: 'the Ba'athist thugs in the country who still believe Saddam is coming back. I believe that if he had been tried before we would have better control of security now'.[24]

- On 28 November 2005, the Associated Press reported that 'the leader of the biggest Shi'te party, Abdul-Aziz Al-Hakim, accused the IST of weakness for not having sentenced Hussein to death already'.[25]

- In November 2005, Ali Ad-Dabbagh, the spokesman for the PM, is

reported to have commented that the 'judge [Rizgar Amin] is giving too much leeway to Saddam. He should respect the Iraqis and the victims' feelings'.[26]

- In January 2006, Ali Al-Adeeb, a prominent member of PM's Party said that 'the Chief Judge should be changed and replaced by someone who is strict and courageous'. Soon afterwards, and following the comments of Ali Ad-Dabbagh as above, Chief Judge Rizgar Amin tendered his resignation.[27] On Rizgar Amin's resignation HRW observes:

 Judges interviewed by Human Rights Watch stated that the resignation was principally caused by the severity and intensity of official criticism of his conduct of the trial. Judges observed that the attacks by government figures created an enormous sense of pressure upon them, and that there was in fact little understanding within the government about the IHT and its procedures.[28]

- Following the resignation of Chief Judge Amin, the 'ICTJ was told that members of the executive reportedly threatened to cut judicial allowances, following unfavorable media coverage of the IHT'.[29] It is not difficult to see the power of the executive threatening judges with their livelihood by exposing them to possible unemployment in turbulent Iraq with no security of work or personal safety.

- In January 2006, when Sa'eed Al-Hammashi was appointed Chief Judge to replace Rizgar Amin, Ali Faisal, the head of the de-Ba'athification Commission, forced his removal. Although the case against him had been dropped by November 2006, he has not been appointed to sit in any chamber of the Tribunal.

- On 8 January 2006 Adil Abdul-Mahdl, current Vice-President, was quoted as saying that Saddam "deserves to be put to death without trial... the continuing trial process is unnecessary and will only hurt the Iraqi people".[30]

- On 19 January 2006 President Bush was reported to have said that the trial was on track and that he was sure that Saddam would be executed at the end.[31]

I should add that had President Bush made such a public remark about any judicial process in the US, the accused would have had the case

against him thrown out because of its having been prejudiced by the remarks of the President. However, in light of the judicial imperialism into which Iraq has been plunged, not a single legal mind, and we are told the US is awash with them, made such an observation about their President meddling in a judicial process which he claims to be the affair of another sovereign state.

- On 6 July 2006 the *Arab Times* reported Iraqi PM Nuri Al-Maliki having said that 'the trial of the deposed Iraqi President Saddam Hussein would not take long and his execution for crimes against humanity would come soon after the court's verdict… if President Jalal Talabani refused to sign the death sentence, a presidential council would carry out the mission'.[32]

- The interference reached its zenith when Judge Abdullah Al-Amiri was removed on 9 September 2006 on orders of the PM. A few days earlier when the Judge was presiding over the Anfal case, he had made the following comments in response to Saddam Hussein:

 I will answer you: you are not a dictator. Not a dictator. You were not a dictator. The people or those who are around you, the official, make him a dictator, and that is not just you. This is the case all over the world.[33]

The interference by US and Iraqi politicians is a violation of the presumption of innocence which is so basic to fair trial and has even been incorporated in Article 19(2) of the IHTS, which states: "The accused shall be presumed innocent until proven guilty before the Tribunal in accordance with this law". The ICTJ summed up this blatant interference and intimidation by saying:

The ICTJ observed: "It is difficult to think of a more blatant attack on the independence of the judiciary."

 The political message is clear: if judges are seen as too lenient in their courtroom demeanor or judgment, they will be removed… It is difficult to think of a more blatant attack on the independence of the judiciary.[34]

Despite all the talk about watering down the effect of the de-Ba'athification campaign, it looked, if anything, like it was being strengthened. Thus, in October 2006, four trial judges, one of whom sitting in the on-going Anfal trial, were transferred to the Higher Judicial Council (which according to Article 4(4) of the IHTS could be done for any reason). The HRW advises us that: "According to one of the judges, those transferred were made to

understand that if they protested the transfer they would become subject to investigation by the NDBC."[35] We need to remind ourselves that once being investigated by the NDBC, the judge loses any opportunity of ever sitting as a trial judge as happened in the case of Judge Sa'eed Al-Hammashi. The transfer of these four judges is an even more blatant attack on the independence of the judiciary than that commented upon by the ICTJ.

Biased and Incompetent Judges

The Tribunal suffered from many defects that when viewed individually may appear tolerable but when combined are unforgivable. All the judges, except for the Chief Judge, who sat in different chambers, have had their identities kept secret. This meant that no names and no qualifications could be examined. The defense had no way of establishing who had been a judge prior to serving on the Tribunal, whether or not he has had any legal education, and so on. The anonymity is itself a violation of the

If it was not possible to hold the trial with the identity of the judges being made public, then the trial should not have been held in Iraq or an international tribunal ought to have been established.

principle of impartiality necessary for any fair trial as upheld by international law. The excuse of security or post-trial protection is not sufficient to justify this violation. If it was not possible to hold the trial with the identity of the judges being made public, then the trial should not have been held in Iraq or an international tribunal ought to have been established. If the only people who can vouch for the credentials of the appointed judges are the occupying power then there is no proof of impartiality having been established. Would not the secrecy, control and political motives as demonstrated throughout this book lead to a presumption of partiality?

It is hypocritical of the US to criticize states for certain practices, like overruling the courts, when at other times it finds it proper for itself to do precisely what it has criticized. Thus when anonymous judges were used in Columbia, the US State Department stated that: "human rights groups continued to charge that this system violated basic legal norms and procedural rights".[36]

When de-Ba'athification was enacted most competent serving judges were excluded from the Tribunal. This meant that the occupying power was left with few competent judges to choose from. Those people it chose were mainly opposed to the Ba'ath regime and supporters of the invasion and occupation. But that in itself is a *prima facie* breach of impartiality. Furthermore some of those people could themselves have been persecuted by the old regime. I would like to take two examples and demonstrate the difference. Both Judge Dara Noor Ed-Deen and Ra'ouf Abdul-Rahman were imprisoned

during the Ba'ath regime. When it came to appointment to the Tribunal Noor Ed-Deen declined because he felt he could not be impartial after having been imprisoned during the latter years of the Ba'ath rule. Abdul-Rahman, on the other hand, had no such compunctions in sitting as the Chief Judge in the Dujail case against Saddam Hussein, and went on to demonstrate that it was impossible to be impartial when you feel you had been a victim.

I would suggest that as it was Bremer and Feith/Wolfowitz who insisted on the wide scale of the de-Ba'athification (Chapter 4) and it was Bremer and his advisors who selected the judges from among the political opponents of the Ba'ath, then it must be concluded that the Tribunal was intended from the outset not to be impartial.

Because we do not know the identity of all of the judges we can only assess those whose identity has been revealed. It is not possible to generalize and argue that all the other judges are like the ones we are able to assess. But equally valid would be an argument that the opponents of the Tribunal would raise—that there is a greater likelihood than not that they were mostly partial. The burden is on the Tribunal to be transparent enough to show that it was impartial.

Ra'ouf Abdul-Rahman is one judge whose identity was revealed. However, because he was a lawyer who worked in Northern Iraq, there is little known about him in Baghdad. There is thus little solid evidence of his credentials except that which has leaked through some media reports. There is one sure fact about him, namely he was not trained as a judge under Iraqi law. Media reports about him indicate that he was born in Halabja; imprisoned during the 1970s for being a member of a Kurdish nationalist movement; tried in absentia and sentenced to life in prison; lost some family members in the 1988 attack on Halabja; and set up an organization to assist victims of the attack.[37] I suggest that all of this could make him a partisan judge.

The principle of impartiality, which has been incorporated in many international conventions such as Article 14 of the ICCPR, Article 6(1) of the ECHR and Article 19(4) of the IHTS, has been defined rather concisely in the forty-sixth session of the Human Rights Committee:

> The impartiality of the court and the publicity of proceedings are important aspects of the right to a fair trial within the meaning of article 14, paragraph 1. "Impartiality" of the court implies that judges must not harbour preconceptions about the matter put before them, and that they must not act in ways that promote the interests of one of the parties.[38]

Here are some utterances of the judges that demonstrate partiality:

- On 5 June 2006, Judge Abdul-Rahman said to defendant Al-Bandar,

the Chief Judge of the Revolutionary Court which tried the Dujail defendants in 1984: "This is not a special court. I am not prosecuting you without fulfilling my conscience. I won't issue sentence on 148 defendants within one hour. I am not this type". [39]

- In a film interview shown in France, one of the Tribunal judges soon to sit on the trial of Saddam Hussein said of him that he had "persecuted the Kurds; he killed them; wiped many of them out. He also used chemical weapons with the aim of committing genocide against this race, against this people, to eradicate them as a nation. He also went after the Shi'ites due to their religious beliefs".

- A second judge was reported in the same film as saying that Saddam Hussein is "one of the worst tyrants in history".

Such statements could not be argued as coming from impartial judges when impartiality is considered in the light of the above definition of the Human Rights Committee. It is more serious when we remind ourselves that the legal system under which the Tribunal was functioning is inquisitorial, where the judge is the arbiter of both facts and law. With such preconceived views harbored by the judges before or during the trial, there is very little hope of impartiality left.

Although Iraq has had a well established system of training judges through the Judicial Institute in which prominent academics and judges lectured, we are informed that all the judges and prosecutors needed to qualify for the task of the complex and most difficult and unprecedented trial in Iraq's history, was a few weeks of lecturing and relaxation in England and Holland. We are not informed of the specific legal professionals who took part in the training, as this remains an unreasonably guarded secret, beyond the fact that the International Bar Association, which is itself not a beacon of professional excellence despite what its name may indicate, organized the training. But even if the best legal professionals from the US and England were enlisted to train the Iraqis for the IST, there would have been a fundamental impediment to that training, namely that all the Americans and the British would have been versed in the adversarial system while Iraq and its IHT were intended to function within the inquisitorial system. However competent the British lawyer is in common law principles, he would not be competent to train lawyers in matters relating to civil law tribunals. In short the so-called training of the Iraqis was no more than a public relation exercise and a get-to-know-you opportunity.

In order to prove that this training was irrelevant it suffices to state that by the time the trial commenced, four of the original five judges for the case, who were trained in London, had been removed for one reason or

another—resignation, recusal, de-Ba'athification or illness. If the training was so fundamental, then the four new judges who were then appointed to replace them—but without such training—would have been incompetent. If the training made no difference, then the British taxpayer's money was wasted and ought to have been more wisely spent on a children's hospital in Basrah. Even more significantly, I have reason to believe that Ra'ouf Abdul-Rahman, the newly appointed Chief Judge of the Dujail case, was not even among those who were trained in London!

So much for the judges.

Then, what are we to make of the prosecutors' competence? I am not able to assess the credentials of any of them but I can only judge the Chief Prosecutor in the case from hearing him speak in court. Legal matters depend so much on clarity of expression and language that many a case fails or succeeds on interpretation of principles and statements. Thus if I had walked into the Old Bailey and heard a prosecutor addressing the court in pre-school English I would have been shocked that such a person held that position. This is not a small matter; it's a question of competence of the judges and prosecutors —one of the requirements for receiving a fair trial. How could a man who would fail his basic primary school Arabic exam be capable of submitting and arguing such complex international criminal issues whose Arabic terminology has not yet been absorbed into the Arabic language?

The incompetence did not stop at the judges, prosecutors and Defense Office but equally submerged the administration. HRW informed us that their interviews with court administration staff resulted in them complaining "that they received no training or instruction in administration procedures relevant to trials of this kind."[40] This added so much chaos to the existing incompetence. So much so that many judges declared that they could not tell what motions or documents had been received by the Tribunal. One need not be a legal expert to conclude that many an important document never reached the Chamber Judges or was not assessed in accordance with the law. This chaos was compounded by the indifference of the President of the Court to the complaints of the judges seeking to improve the administration of the court.[41]

The incompetence is best depicted by the Chief Judge as we did not have access to what the others were saying or doing. Here are some of the observations made by HRW, which together with ICTJ constituted the only two human rights organizations allowed to monitor the trial:[42]

- On 13 March 2006, the Judge frequently interrupted Al-Bandar, one of Saddam Hussein's co-defendants, when he was giving his statement and ultimately refused to allow him to finish it.

- On 15 May 2006, the Judge refused to allow the presence of defendants when one defense witness was making a statement.

- On 15 May 2006, the Judge refused to allow defense counsel to question his own witness, but later in the day, after being advised by the US advisers, allowed it.

- On 24 May 2006, the Judge refused to allow defense counsel to question defense witness Tariq Aziz, stating that 'the defense team's aim is to insult the court', despite the fact that no question had been put to Aziz as yet. However, after lunch, presumably on US intervention, he allowed the questioning to proceed.

- On 30 May 2006, having allowed the Prosecutor to introduce evidence at will, the Judge did not allow the defense to introduce a recently obtained video to refute one witness statement until the prosecution consented overnight.

- On 5 June 2006, the Judge insisted that Al-Bandar completed his Revolutionary Court trial in less than hour against the assertion of Al-Bandar that the trial took 16 days.

- On 12 June 2006, the Judge entered into a demeaning exchange of insults with one of the defendants, an act unbecoming of any judge.

- On 13 June 2006, the Judge derided one of Saddam Hussein's foreign lawyers stating that Dr. Curtis Doebbler has come 'to hear his own voice and claim that he is an international lawyer'.

- On 24 June 2006, the Judge said to one of the defendants that 'since you were a child, you were drowned in blood'.

- On 26 July 2006, the Judge said to Saddam Hussein in the absence of his defense counsel: 'Where are your lawyers? They incite violence, they took millions from Iraq and now they are outside Iraq. They are not lawyers, they incite violence'.

- On 27 July 2006, the Judge called Al-Bandar 'stupid' and ordered him to sit down.

- When some defendants claimed that the closing statements of the Defense Office were written by the RCLO's appointed foreign advisor, the Judge falsely denied it.[43]

HRW has attempted to cloak the improper conduct and unbecoming utterances by saying that:

> At the very least, these outbursts suggest that relations between the presiding judge and the defendants and their retained lawyers had become so poisoned that the judge had considerable difficulty detaching his own feelings towards some of them from the conduct of the case.[44]

These instances exemplify the spirit of the Tribunal as a whole. It was partial and incompetent. When a judge does not understand that a defendant has a fundamental right to question his witnesses, then he has no business sitting in judgment in any judicial matter. When a judge lies in court then those who appointed him are under a duty to remove him. As one of only two human rights NGOs engaged in surveillance of the trial's fairness, HRW should have indicated what would have been proper, normative procedure in such a situation, rather than making an observation which served to excuse the presiding judge.

A judge who finds he is becoming personally embroiled in the case—assuming he did not already hold preconceived views of the case—should either excuse himself or be removed in accordance with the law.

The Right to a Fair Trial

The requirement for a fair trial has been universally acknowledged and incorporated in many treaties. One such incorporation is in Article 14 of the International Covenant of Civil and Political Rights (ICCPR):

> Article 14:
> 1. All persons shall be equal before the courts and tribunals. In the determination of any criminal charge against him, or of his rights and obligations in a suit at law, everyone shall be entitled to a fair and public hearing by a competent, independent and impartial tribunal established by law. The press and the public may be excluded from all or part of a trial for reasons of morals, public order (*ordre public*) or national security in a democratic society, or when the interest of the private lives of the parties so requires, or to the extent strictly necessary in the opinion of the court in special circumstances where publicity would prejudice the interests of justice; but any judgment rendered in a criminal case or in a suit at law shall be made public except where the interest of juvenile persons otherwise requires or the proceedings concern matrimonial disputes or the guardianship of children.

2. Everyone charged with a criminal offence shall have the right to be presumed innocent until proved guilty according to law.

3. In the determination of any criminal charge against him, everyone shall be entitled to the following minimum guarantees, in full equality:

(a) To be informed promptly and in detail in a language which he understands of the nature and cause of the charge against him;

(b) To have adequate time and facilities for the preparation of his defense and to communicate with counsel of his own choosing;

(c) To be tried without undue delay;

(d) To be tried in his presence, and to defend himself in person or through legal assistance of his own choosing; to be informed, if he does not have legal assistance, of this right; and to have legal assistance assigned to him, in any case where the interests of justice so require, and without payment by him in any such case if he does not have sufficient means to pay for it;

(e) To examine, or have examined, the witnesses against him and to obtain the attendance and examination of witnesses on his behalf under the same conditions as witnesses against him;

(f) Not to be compelled to testify against himself or to confess guilt.

4. Everyone convicted of a crime shall have the right to his conviction and sentence being reviewed by a higher tribunal according to law.

5. When a person has by a final decision been convicted of a criminal offence and when subsequently his conviction has been reversed or he has been pardoned on the ground that a new or newly discovered fact shows conclusively that there has been a miscarriage of justice, the person who has suffered punishment as a result of such conviction shall be compensated according to law, unless it is proved that the non-disclosure of the unknown fact in time is wholly or partly attributable to him.

6. No one shall be liable to be tried or punished again for an offence for which he has already been finally convicted or acquitted in accordance with the law and penal procedure of each country.

We shall look at whether or not these requirements were satisfied in the process before the Tribunal. It has been demonstrated that the Tribunal was neither independent from the executive nor impartial. On the matter of presumption of innocence I have shown that both Iraqi and foreign officials have interfered with the independence of the Tribunal by claiming, before the commencement of the trial and during it, that the defendants were guilty. Moreover, some of the judges have declared such beliefs long before the trial commenced.

Minimum Guarantees of the Right to a Fair Trial

This section of the ICCPR Article requires the provision of certain guarantees to every accused with equality. These requirements were incorporated in Article 19(4) of the IHTS.

(a) *The Guarantee of being Promptly Informed and in Detail*

Saddam Hussein was arrested by the US on 13/14 December 2003. However, despite having been interrogated by several US investigative bodies, he was not informed of the nature and cause of the charge against him. There was no prompt information. On 1 July 2004, Saddam Hussein was summoned before a junior Investigative Judge whose only previous experience had been in investigating petty crimes. This was not an investigative session but rather a show for television. He was informed of vague allegations. During that session he refused to recognize the jurisdiction of the judge and asked for legal counsel which was not granted until some six months later.

Between April 2004 and January 2005 several reports to Congress referred to High Value Defendants, establishing that they were already defendants and not just accused, even though they had not been charged, and stating that several preliminary investigative hearings had been held by the RCLO. We are not informed under which authority these investigative hearings were carried out, and whether or not they formed any of the documents before the Tribunal and if so what basic law was breached in all this. But whatever the legal position of these activities, Saddam Hussein was neither informed of any charge nor had he had any legal counsel.

Although Saddam Hussein was summoned to trial on 19 October 2005, specific charges were first read to him on 15 May 2006, which is two and a half years after he was arrested, over six months into his trial and after the prosecution had concluded his case. It is impossible to see how a defendant could question witnesses against him and properly prepare challenges to the evidence in the absence of a clear indictment which specifically identified what offences he was supposed to have committed.

In the Dujail case, the only notice of charges against the defendant

was the referral decision from the Investigative Judge to the Tribunal. Although the defendants ranged from the President of the Republic to a minor local official in Dujail, nevertheless, the referral decision was identical for all eight, i.e. each and every one is supposed to have committed the same crime, which casts some doubt on the assertion considering the different role each ought to have played.

The referral decision states that each defendant is charged with:

[c]rimes against humanity against a number of citizens in the town of Dujail in Salahuddeen Governorate on July 8, 1982. This is in accordance with Clauses A, D, E and F of Paragraph 'First' of article 12 of the court law. It consists of:

A. Premeditated murder...

D. Removal of population or forcible removal of population.

E. Imprisonment or arbitrary deprivation of physical freedom contrary to the basic rules of international law.

F. Torture.[45]

Although the indictment read on 15 May 2006 was slightly longer it still did not address the main failure of the first charge, namely what every defendant is accused of having done.

A fundamental element of criminal law which the student of law has to grasp in the first week of his study is that for a crime to be committed there should be two elements occurring: one is the act (*actus reus*) and the second is the mental element (*mens rea*). Iraqi law generally does not put strong emphasis on establishing the mental element. This may not be such a disaster when the act is individual. However, in international offences the need to identify what each has done in the joint enterprise becomes more acute as some may give orders and some are allegedly aiding and abetting while others are subordinates. This makes the identification of each element of the crime of each defendant all the more difficult to identify but equally that much more important to do so.

Thus in the International Criminal Tribunal for Yugoslavia the Court held that when an accused is charged with having given orders to others to commit a crime, akin to the alleged charge against Saddam Hussein, then he ought to be given notice that the following facts would have to be proved against him:

(a) what command position he or she is alleged to have held;

(b) the identities of the subordinates over whom he or she exercised effective control and for whose acts he or she is alleged to be responsible;

(c) the conduct of the defendant that shows that he or she knew that a crime was being committed, or was about to be committed, by those identified subordinates; and

(d) the conduct of the defendant that shows that he or she failed to take the necessary and reasonable measures to prevent such acts or to punish the persons who committed them. (*Prosecutor v Blaskic*, ICTY, Case No. IT-95-14-A, Judgment (Appeal Chambers) July 29, 2004, para. 218)

It is clear that in neither the short nor the long indictments was Saddam Hussein given notice of the facts that were to be proved against him. It will be shown later that the prosecution did not even set out to show what criminal acts he was specifically supposed to have committed nor his possession of the required mental element to commit them. In short neither the indictment nor the proceedings established the guilt under the alleged charge simply because the charge was not identified.

(b) *Equality of Arms*

The guarantee to the accused to have adequate time and facilities for the preparation of his defense has become a wider right known as the '*Equality of Arms*' incorporated in many conventions and legislations, which is simply defined in the following judgment of the European Court of Human Rights.

The Court reiterates in this connection that according to the principle of equality of arms, as one of the features of the wider concept of a fair trial, each party must be afforded a reasonable opportunity to present his case in conditions that do not place him at a disadvantage vis-à-vis his opponent. (*Foucher v France* - 22209/93 [1997], ECHR 13 (18 March 1997)).

Has the Dujail trial safeguarded such a guarantee? The conclusion of the three reports on which this chapter relies seems to be summed up in what the ICTJ says:

The Dujail trial fundamentally breached the principle of equality of arms.[46]

I shall now consider the main requirements for equality of arms and see how far the process had secured them.

(i) Funding

Although the US/UK spent tens of millions of dollars preparing the case against Saddam Hussein and although it was reported that over $138 millions were spent on building and equipping the courthouse, living and working facilities for the staff in the Green Zone, no one really knows how much the whole process cost. No one can put a figure on the cost of sifting through two million documents in Qatar to pinpoint which should be presented in court and which should be withheld. No one knows the real cost of the teams of prosecutors, investigators and advisors hired by the US/UK from among their citizens and other countries.

While these unlimited financial resources were available to the prosecutors, the defense was impecunious. The money that Saddam Hussein had on him when he was arrested was confiscated. He did not have bank accounts outside Iraq. His team, including the foreign international lawyers, operated *pro bono*, which would have been a limitation by any standard. The Tribunal failed to provide any funds to assist the defense and even the money promised for the bodyguards of the defense counsel was never paid. This is undoubtedly a breach of a basic requirement of the equality of arms.

The defense was broke. Saddam Hussein did not have bank accounts outside Iraq. His team, including the foreign international lawyers, operated *pro bono*.

(ii) Disclosure in Accordance with Tribunal Rules

I am surprised to read HRW stating that the dossier was disclosed to the defense counsel on 10 August 2005, which would make it look as if it had been disclosed within the 45 days minimum time limit set by Rule 40 of the Rules.[47] I have a copy of a letter signed by the Chief Prosecutor and addressed to Mr. Ad-Dulaimi, Saddam Hussein's counsel, stating he had been advised by email on September 18th to appear before the chief prosecutor's office to receive the case documentation and further notifying him to appear on any day of September 25-27.

Ad-Dulaimi did manage to appear on 25 September 2005 and received the documents, which shows that the dossier was never disclosed within the 45 days minimum limit. This failure was one of the earliest objections raised by the defense team.

This dossier, which was supposed to be the prosecution evidence in the case, a copy of which was dispatched to me, revealed on inspection the following:

- The dossier consisted of over 900 pages.
- Over 40 percent of the pages were illegible and some of them were plain white papers.

- It consisted of three separate bundles each with a different pagination but with little substantive relations between them.
- It contained repetition of material among the three different bundles.
- There were tens of pages relating to matters of communications between the intelligence services and the Presidential Office that were not remotely related to the case.
- The complainants' complaints were almost all written in the same language as if they were drafted by the same person, all specifying nothing except having lost somebody in Dujail and accusing Saddam Hussein of the killing. While this might reflect use of a form letter to facilitate communications by people for whom drafting a letter would have been a task, it also raises the possibility that several copies of the same letter were made by the prosecutor and fictitious names were put on them.

In the view of the ICTJ, the dossier "contained many pieces of evidence of doubtful probative value.[48]

Such casual collation of the material indicated the complete indifference of those in charge of the trial as to the value of the evidence and made it impossible for the accused to understand what the case against him was.

While the prosecution had all the documents the RCLO thought were necessary for the case, the defense had to accept the case based on the prosecution producing documents suddenly, without prior disclosure, which amounted to trial by ambush. HRW reported the following examples of such conduct:

- On 13 February 2006, the court read into the record 23 witness statements, 13 of which were not in the evidence dossier and were never made available to the defense.
- On 1 March 2006, over 40 previously undisclosed documents were presented in court by the prosecutor.
- On 1 March 2006, a compact disc containing a recording of conversation between Saddam Hussein and one of the Party members was presented,
- Although the prosecution case was closed on 1 March 2006, the prosecution confronted defendant Taha Yaseen Ramadhan, while his statement was being taken, with a previously undisclosed document, which document has not since been disclosed to his defense.
- On 6 April 2006, the prosecution submitted further evidence relating to the age of some of those convicted in the original Dujail trial,

- On 24 April 2006, the prosecution presented another compact disc allegedly containing conversation between Saddam Hussein and Taha Yaseen Ramadhan.
- On 13 June 2006, which was the last day of the defense case, the prosecutor produced further three previously undisclosed documents and another compact disc. [49]

The Tribunal never questioned the introduction by the prosecutor of new evidence at will. However, when on 30 May 2006 the defense tried to introduce a recently acquired video which they claimed would refute one witness statement, the Tribunal refused to allow its introduction until the consent of the prosecutor was granted. It was not until the next day that the prosecution consented. It is clear that no equality was granted between the prosecution and defense.

At no time did the prosecutor or the Tribunal explain the failure to comply with the Rules regarding the disclosure of the evidence.

(iii) Non-Disclosure of exculpatory evidence

Following the invasion and occupation of Iraq, the occupying power seized all documents that were in the possession of the Iraqi Government on 9 April 2003. The defense counsel had no access to any document to support their case; it had to rely on the decisions of the RCLO concerning document access and endure its political partiality. Fundamental to a fair trial is a guarantee of equality of arms and fundamental to this equality is that the prosecutor should disclose to the defense any exculpatory evidence that goes to mitigate the guilt of the accused. This is so fundamental that an International Court has held it to be 'as important as the obligation to prosecute'.[50] The Statute of the ICC has incorporated it as a fundamental principle in Article 67:

> In addition to any other disclosure provided for in this Statute, the Prosecutor shall as soon as practicable, disclose to the defense evidence in the prosecutor's possession or control which he or she believes shows or tends to show the innocence of the accused, or to mitigate the guilt of the accused, or which may affect the credibility of prosecution evidence. In case of doubt as to the application of this paragraph, the Court shall decide.

The prosecutor and the Tribunal not only failed to voluntarily provide the defense counsel with such exculpatory evidence as stipulated in Article 67 of the Statute of the ICC, but declined to respond to several requests made by the defense for specific exculpatory evidence to be disclosed by

the prosecutor and the RCLO in control of the trial. Two instances:

1. The defense had always argued that the confiscation of land in Dujail had nothing to do with any punishment for the assassination attempt but was part of an agricultural redevelopment program with compensation paid to expropriated landowners. On 29 May 2006 and while questioning a defense witness, the prosecution showed the witness a document supporting that contention which had not been disclosed to the defense.

2. Despite the repeated request of defendant, Awwad Al-Bandar, for the file of the Revolutionary Court of the trial of 1984, no more than four pages were extracted and put in the dossier made available to the defense. It transpired later that all along the original file of some 361 pages had been in their possession, after having been located by the RCLO.

It must be stressed here that as the RCLO has been in control of the trial and of all the documents, the responsibility for these failures must be attributed to it. Had the RCLO intended that a full disclosure be made, it would have made the dossier available even if it meant the RCLO making it directly available to the defense. In any case how reasonable is it to believe that anyone in the prosecution department who owed their position to the RCLO had any independence to refuse to comply with the RCLO wishes?

(iv) Inequality in Providing Security

Judges, investigative judges and prosecutors were provided with around the clock security. They were all housed in secure living and working quarters within the Green Zone. Some of them have had their families provided with secure and protected residences outside Iraq.

The defense lawyers were not provided with any security outside the Green Zone. In fact despite repeated requests by defense counsel, the IHT has shown itself unwilling or unable to ensure their safety.[51] Some members of the defense team managed to get their families outside Iraq and sought to protect themselves by continuously moving around. However, not all were so lucky as to be able to afford to do so while working pro bono on the case. The result of this unfortunate state of affairs was the murder of three members of the defense counsel:[52]

* On 20 October 2005 (one day after beginning of trial) defense lawyer Sa'doon Al-Janabi was abducted by men who identified themselves as officials of the Ministry of Interior and killed. His murder was not investigated by the US or the interim Iraqi Government.

- On 8 November 2005 another defence lawyer Adil Muhammad Abbas Az-Zubaidi was killed and his colleague was seriously injured. This murder was never investigated either.

- On 21 June 2006 the third defense lawyer Khamis Al-Ubeidi was taken from his home by people claiming to be from the Ministry of Interior. He was later found murdered after having been tortured. The US **The defense lawyers received no protection. When three were killed, their murders were never investigated by the government.** official spokesperson falsely claimed that the Iraqi Government and the international community had offered protection but that Mr. Al-Ubeidi 'had refused this protection and refused these offers'. Needless to say, this murder has never been investigated either.

It was agreed early in the process between the RCLO and the defense counsel that the US would pay the cost of three guards for each defense lawyer. Some of them hired guards but when the US failed to honor its undertaking, they had to fire them simply because they could not pay their costs. In a meeting with the defense counsel in Amman on 7 May 2006, William Wiley, who was appointed by the RCLO as advisor to the Defense Office, admitted that the US had failed to honor the agreement to pay for the guards.[53] Al-Ubeidi was not guarded when he was abducted and murdered.

The ICTJ commented that "the killing of defense lawyers, in particular, gave rise to a perception that the IHT and RCLO had not taken sufficient steps to protect them from the outset of the Dujail trial." [54] On the consequences of the RCLO failure to provide security for the defense team, HRW made the following observation: "The ability of defense counsel to vigorously represent their clients without fear of reprisal or retaliation is essential for a fair trial".[55]

Finally I was informed that some of the defendants in the second case of the Anfal trial had been left without counsel because the defense lawyers have withdrawn from the case for fear of their safety.

(c) *Guarantee to be Tried Without Undue Delay*

The guarantee for a trial without undue delay is enacted in order to ensure that the prosecuting authorities do not unnecessarily prolong detention. The European Court of Human Rights developed a two-part test.

Firstly, it needs to be satisfied that the public interest outweighs the right to liberty. Once that limb of the test is satisfied the court proceeds to consider whether the proceedings have been prolonged by delays that could have been avoided. The Court has found that a detention for 14 days in police custody was a contravention of the European Convention (*Askoy v Turkey* (1996) 23 EHRR 553).

It may be argued that the case of Saddam Hussein could not be looked at in the same light as cases of individuals under the European Convention. However, it seems to me that the opposite argument should find more favor. Because of the anomaly of the case it ought to be looked at under the European Convention. Saddam Hussein's detention as a POW was contrary to international law because a POW could only be held during military action and he was arrested some eight months after the end of hostilities. As he was being held by the combined US/UK occupying authority, that would entitle him to be protected by the European Convention.

Saddam Hussein was captured in December 2003, and held for two years without charge and without trial in violation of the guarantee of trial without undue delay. He was being unlawfully held while the US/UK were setting up the mechanism and the case for his trial, i.e. framing the law to find him guilty retrospectively, scouring the range of possible offenses to see which might be pursued with the fewest unpleasant disclosures related to any historic interactions with the US/UK occupiers, themselves.

(d) *Guarantee of Right of Legal Council*

This universally acknowledged right was guaranteed in Article 19(4B) of the IHTS as follows:

> To have adequate time and facilities for the preparation of his defense and to communicate freely with counsel of his own choosing and to meet with him in private. The accused is entitled to have non-Iraqi legal representation so long as the principle lawyer of such accused is Iraqi.

But in actuality:

- The accused was not allowed to have counsel of his choosing.
- The accused never had a single private meeting with his counsel.
- The foreign lawyers' applications for audience remained unanswered which meant effectively they were rejected.
- The foreign lawyers who were allowed were either insulted, forcibly removed or prevented from attending.

In short, none of the guarantees of the right of legal counsel as incorporated into the IHTS were met.

Early in 2004 a few Iraqi lawyers submitted their names to the Iraqi Bar Association for approval to act as defense lawyers in the IST (the IHT did not yet exist). They were not chosen by any of the accused. Among those applying was Khaleel Ad-Dulaimi, a lawyer of negligible experience. His application was selected by the Iraqi Bar Association and approved by the US and Iraqi authorities. He was then appointed to represent Saddam Hussein. When Ad-Dulaimi met Saddam Hussein in December 2004 he was the first man not from the enemy camp whom Saddam had met since his arrest a year earlier. It must have been a unique experience for the man whom many Iraqis were not able to talk to, to be able to see one of his fellow citizens. The impact of that meeting must have been lasting and overwhelming. Indeed it turned out that Saddam Hussein never trusted anybody until he died the way he trusted Ad-Dulaimi. However, having good will and intent were no substitute for the experience and knowledge required in such a case. And it remains the case that Khaleel Ad-Dulaimi, although accepted later by Saddam Hussein to act for him, was not really chosen by him but appointed by the Tribunal—perhaps for those very reasons.

The entitlement of the defendant to seek special legal expertise is not just a right which should be guaranteed by the authority trying him but may even be an obligation of the state to secure the benefit of international lawyers. So held the European Court of Human Rights in the case of *McVicar v United Kingdom* (ECHR 46221/99 (2002)).[56] How much more so should this be the case in a trial which concerned a serving head of a sovereign state who had been captured by the occupiers of his country, whose trial was intended not only to establish the just cause and legal action of the invaders, but also serve as a historical precedent?

The Tribunal made no attempt to seek such international assistance for the accused, nor did it assist the accused in securing such defense. Thus when the family of Saddam Hussein attempted to secure proper advice from international lawyers, applications were made to the proper authorities to grant these lawyers permission to act, in accordance with Article 19(4B) of the IHTS. Many of those lawyers were chosen from the US and the UK because these were the main occupying states, the language of the ISTS was English, the RCLO in charge of the Tribunal was mainly American and the whole staff of the Tribunal was selected by the US/UK. However, when the RCLO discovered that their staff was no match for some of the international lawyers selected

When the RCLO discovered that their staff was no match for some of the international lawyers selected by the family of Saddam Hussein, they chose the tactic of non-response to cloak their refusal to allow them to appear.

by the family of Saddam Hussein, among whom were former US Attorney-General Ramsey Clark, Curtis Doebbler (US), Andre Chamy (France), Chang Matthias (Malaysia), Bushra Al-Khaleel (Lebanon), Ahmad Essiddeek (Tunisia) and Najeeb An-Nu'aimi (Qatar), they chose the tactic of non-response. They thought that this technique would enable them in future to respond that they had not refused to allow lawyers to appear. However, when an applicant cannot function without consent being granted, and the authority fails to respond to his application and there is no route of appeal against such failure, then silence amounts to refusal and transgression of the law.

Despite having been held since December 2003, the first time Saddam Hussein had an opportunity to meet an experienced lawyer was on 19 October 2005, after the trial commenced. This fact reveals two failures.

1. The accused had not had any legal counsel during any of the investigative sessions that took place before the trial. The right of the accused to legal counsel is so universal that it is difficult to see how a court would admit evidence secured when the accused was not in receipt of legal advice. It has been incorporated into the Statute of the ICC whereby Article 55(d) on the Rights of persons during investigation states: "To be questioned in the presence of counsel unless the person has voluntarily waived his or her right to counsel". The guarantee of counsel's presence during investigation is essential in the inquisitorial system because the investigation dossier constitutes the heart of the trial. Counsel is even more vital when a victor with military might is trying a victim without even civil rights.

2. The delay of legal advice must have been detrimental to the rights of the accused. The European Court of Human Rights held in *Ocalan v Turkey*, (ECHR 46221/99 at 131 (2005)) that:

 > to deny access to a lawyer for such a long period and in a situation where the rights of the defence might well be irretrievably prejudiced is detrimental to the rights of the defence to which the accused is entitled by virtue of Article 6.[57] (Article 6 of the European Convention relates to the Right of Fair Trial)

 > Considering that the period of delay in Ocalan's case, of a few weeks, was nowhere near two years as in the case of Saddam Hussein, it is not difficult to see how detrimental to his rights it was to deny him legal advice and how much it violated his guarantee for a fair trial, which the IHTS promised to deliver.

The other element of the guarantee of legal counsel is that of confidentiality and privacy. Every accused or defendant is entitled to have private consultation with his counsel and to receive and communicate matters in confidence that remain privileged until he decides to waive his privilege. Not once did Saddam Hussein have a private consultation with his counsel. In every meeting there would be US and possibly Iraqi personnel present. It would not be surprising if we were to hear in the future that every meeting between Saddam Hussein and his counsel was being taped. The violation of the right of the defendant to have his meetings confidential and in private reached its peak when on 3 April 2006 the papers of the defense team were searched and read by the Iraqi translators and RCLO officials before the lawyers were allowed to see Saddam Hussein.[58]

The Tribunal created a Defense Office in accordance with the Rules. However, since no member of the Defense Office lawyers had any knowledge or experience in international law, it seems that the RCLO had set up the Office only to make it look like the Tribunal was fulfilling its duties under the Statute.

By September 2005 there were only three lawyers in the Defense Office, none of whom had any experience or training in international criminal law. In November 2005 five more equally uninformed lawyers were added to the team. By December 2005 six of them resigned after their identity was revealed. As to the training and competence of this essential part of the Tribunal, HRW had this to say:

> When Human Rights Watch interviewed the Defense Office lawyers again in March 2006, they stated that they had not yet received further training, and that they did not have access to international criminal law judgments in Arabic.[59]

But even if they had been provided with these judgments, they were not going to become well-versed in international law overnight after reading a few judgments—assuming that any of them would have the stamina to read a judgment of few tens if not a hundred pages, considering that no Iraqi lawyer has ever come across an Iraqi judgment of more than ten pages.

In order to appreciate the meaning of such incompetence with respect to an effective fair trial, one needs to compare the Defense Office of the IHT with those of the Special Court for Sierra Leone and Bosnia's War Crime Tribunals.[60]

While the RCLO had spent tens of millions on the judges and prosecutors in the Tribunal, some expenditure on the Defense Office would have created an attempt towards equality of arms considering the disadvantage at which the private defense team was (particularly given the RCLO failure to accredit its foreign lawyers). The sad reality is that none of

this happened and the picture of the Defense Office is "one of disarray in terms of recruitment and training", [61] exemplified by the following:

- When the privately appointed lawyers for Ali Dayih Ali, one of the defendants in the Dujail case, withdrew from it because of intimidation or lack of funds, the court appointed two lawyers from the Defense Office to represent him. However, both lawyers simply failed to appear.[62]

- One member of the Defense Office appointed by the Tribunal to represent defendant Muhammad Azzawi neither met his client before the opening of the trial nor for a month after its commencement. He failed to appear in court on at least two occasions and never asked a single question during all the sessions observed by HRW between October 2005 and end of January 2006.[63]

- On their first day in court Defense Office lawyers did not ask a single question of any of the three prosecution witnesses.

- On 13 February 2006 the Tribunal allowed 23 witness statements to be read into the court record without notice to the defense and at a time when the privately-hired defense counsel were boycotting the trial. None of the appointed Defense Office lawyers raised an objection or asked any question at the time. "When asked by HRW why they did not object to the reading of the statements, a Defense Office lawyer responded that they did not wish to risk a reprimand from the judge".[64]

- Another Defense Office lawyer explained the fear of antagonizing the court when interviewed by HRW in October 2006. "The lawyer noted that the Defense Office lawyers were dependent on the court for their security, and were for that reason reluctant to do anything that might incur the hostility or ire of the court".[65] This clearly goes to show that the Defense Office lawyers knew well that the Tribunal was partial, having clearly shown itself to be against the defendants, and thus would not be happy with anyone appearing to be assisting them.

- Although the privately-hired defense counsel and the Defense Office were supposed to be on the same side assisting the defendants, there was little cooperation between the two sides to the detriment of the defendants. The defense counsel suspected the Defense Office of being a tool of the Tribunal, especially since some of its lawyers lived in the Green Zone, and the Defense Office did not want to be identified with people who were '*defending the indefensible*'. (So I

was told so by at least two defense lawyers.) The HRW in interviews with members of the Defense Office were told that they avoided dealing with private defense lawyers out of concern for their own security.[66]

- On 26 March 2006, defense lawyer Issam Gazzawi swore an affidavit in which he claimed that Mazin Abdul-Hameed Jabbar, one of the Defense Office lawyers, had stated that the "defendants in this case do not deserve being tried, and that they should be left in the streets for people to directly take their revenge on them. This is because the death penalty is a rather mild sentence when compared to the crimes they committed against the Iraqi people".[67] It is difficult to see why anyone with such personal opinion of a defendant should be appointed to defend him. It is not in the culture of the legal profession in Iraq to seek to defend a person's right to a fair trial on that abstract basis alone.

- HRW reported that the director of the Defense Office reiterated over several months that "the Defense Office did not, and would not, have a role in supporting or assisting the private defense lawyers". Other lawyers have informed HRW that "they preferred to keep their distance from the private defense lawyers out of concern for their own security".[68]

- In April 2006 the RCLO appointed William Wiley as the international advisor to the Defense Office despite his lack of legal training. That appointment seems to have sealed the argument for the defense counsel that the Defense Office was indeed a tool of the Tribunal, especially after Wiley contacted some defense witnesses without the permission of the defense counsel.

- Though himself not a lawyer, William Wiley wrote the closing statement for the Defense Office. HRW presented it like this:

> The statement was drafted in English, translated into Arabic, and provided to the Defense Office Lawyers to read aloud in court—indicating the underlying lack of capacity among the Defense Office lawyers themselves.[69]

I hasten to add that it indicated more than simple incompetence on the part of the Defense Office lawyers. It indicated the full control of the Tribunal by the RCLO to the extent that even the closing defense statement was written by someone appointed by the ultimate prosecutor, the US.

(e) *Guarantee of Right to Examine Witnesses*

The minimum requirement to guarantee the right of the defendant to examine witnesses was incorporated into Article 19(4E) of the IHTS in the following text:

> To have the right to call and examine defense and prosecution witnesses, and to present any evidence in his defense in accordance with the law.

The right of the defendant to examine prosecution witnesses is fundamental to a fair trial as it is impossible to argue that anyone could be found guilty purely on the bases of witness statements which he could not cross examine. I know of no jurisdiction which upholds such a belief.

This principle was not met during the Dujail case, where, inter alia:

1. No defense counsel was present at any of the investigative stage sessions and thus no prosecution witness was cross-examined on behalf of the defendant during investigation, which is the appropriate place and time for cross-examination of witnesses in the civil law system of law, i.e. the system used in France as opposed to the Common Law system of England.

2. In the dossier of evidence disclosed to the defense team at the end of September 2005, the names of all prosecution witnesses were deleted.

3. On 13 February some 23 new witness statements, and on 1 March a further six, were read into the court record. In total 29 new witness statements were read into the court record without any of these witnesses being cross-examined by the defense counsel.

4. Thirteen witness statements out of the above mentioned 23 were never disclosed to the defense lawyers—not before or even after having been read into the court record.[70]

5. When defense counsel returned to court on 15 March 2006 they requested recall of these new witnesses for cross-examination. The Tribunal, in its established conduct of silence as a procedural technique to thwarting defense efforts without written record of having done so, did not even bother to respond to counsel's application.

6. Prosecution witnesses, whose names were only disclosed to the

defense counsel one hour before appearing, testified from behind curtains, thereby preventing the defense counsel from watching their demeanor.

It is clear that the Tribunal breached the defendant's right to confront and examine witnesses against him. We are not able to find out what value was given to the statements read into the record. We are not any wiser as to whether or not these statements weighed heavily against the defendant in the judges' opinions which would make it all the more imperative that the defendant ought to have had the right to cross-examine the witnesses who made them.

However, Tribunal Rule 48 requires that names of prosecution witnesses be disclosed to the defense at least 45 days before the trial. It should come as no surprise in the atmosphere of trial by ambush to discover that witnesses' names were only disclosed one hour before the session in which they appeared. This meant that the defense could not carry out any investigation to verify the credibility of these witnesses. It was as good as if they had never been disclosed. No reason has ever been given for the failure to comply with the Tribunal Rules, whose enforcement should have been ensured by the Tribunal judges.

It is acceptable that the Tribunal should conceal the names of witnesses who fear for their safety from retaliation, but such protection must be balanced against the defendant's right to confront the witnesses and cross-examine them. When all the witnesses are anonymous then the rights of the defendant would be violated.[71] If a situation arises which requires that the identity of all the witnesses be concealed then the only conclusion that could be made is that the venue for the trial is the wrong one and for the trial to be fair, it ought to have taken place elsewhere. The security situation in Iraq had deteriorated to such an extent by October 2005 that it was obvious that no fair trial could be held in Baghdad due to the danger that this posed for all concerned. The staff of the Tribunal lost their freedom, most likely forever, because during the trial they had to be housed in the Green Zone and after the trial they would properly have to be moved and housed outside Iraq permanently. Defense Counsel were either murdered or were forced to flee Iraq, while witnesses had to have their identity concealed and only gave testimony in court from behind curtains.

There is still another reason for concern when witnesses are concealed in such a blanket way. It becomes very difficult to authenticate the identity of the witness. This is a serious matter considering that the problems it posed were not completely unprecedented. One such incident took place in the International Tribunal for Yugoslavia, when it was discovered that the notorious '*witness L*' was not the person he claimed to be.[72] HRW reported that as an "indication of lack of understanding of how to use positive

measures effectively". Five witnesses were permitted to testify on 13 and 14 February 2006 while concealed behind curtains, despite having had their names read out in court—which would give away who they were.[73] I would suggest another possible explanation for this seeming instance of incompetence. It may be that the persons testifying behind the curtain were not in fact the persons whose names were publicly disclosed, and had their faces been made visible, this might have been confirmed.

In the atmosphere of complete collapse of security, it was very difficult for the defense counsel to locate witnesses willing to appear on behalf of the defendants. Even if the defense counsel managed to locate such potential witnesses, it would have been very daring of any of them to come forward when no guarantee of safety was provided by the RCLO.

The inequality between the blanket anonymity granted to the prosecution witnesses and the exposure of the identity of one potential defense witness clearly demonstrates the inequality of arms. On 4 April 2006, and despite having given 24-hour notice as demanded by the RCLO in charge of the Tribunal, meetings with potential witnesses and senior UN personnel were cancelled. One of the witnesses to have been interviewed was killed shortly thereafter. It is very likely that the identity of that witness was leaked by the RCLO or members of the Tribunal staff. [74]

The intimidation of defense witnesses was clearly demonstrated on 12 June 2006 when the Judge read allegations against the defense counsel that they had bribed some defense witnesses. It transpired later that on 31 May 2006, three defense witnesses had been arrested, beaten and held without legal advice. None of the three witnesses were brought into court to be confronted about the allegation. The Tribunal did not provide the defense counsel with printed copies of the oral allegations read by the judge. The Judge also refused to allow the defense counsel to respond to the allegations.[75] It is not difficult to see that other potential witnesses hearing of these incidents would become more hesitant to come forward.

During the hearing of 13 June 2006, the Judge agreed to the request of the defense counsel to call more witnesses. However, after receiving a note from the RCLO officials, he reversed his decision and decided to close the case, stating that if the defense had not completed their case with 26 witnesses they would not be satisfied with 100 witnesses.

The above decision of Judge Abdul-Rahman should be compared to the opinion of the ICTY on giving proper consideration to the defense needs where it was held:

> [T]he authority to limit the length of time and number of witnesses allocated to the defense case ... [is] always subject to the general requirement that the rights of the accused pursuant to Article 21 of the Statute of the International

Tribunal be respected. Thus, in addition to the question whether, relative to the time allocated to the Prosecution, the time given to the Accused is reasonably proportional, a Trial Chamber must also consider whether the amount of time is objectively adequate to permit the Accused to set forth his case in a manner consistent with his rights.

Given that the prosecution had offered 58 witnesses and the Judge failed to give any consideration to whether the amount of time granted to the defense was objectively adequate, the Tribunal failed to meet the international standard expected to guarantee the defense needs.

Failures in Keeping Evidentiary Records

Rule 26 of the Rules of Procedure and Evidence of the Tribunal on the Preservation of Information and Evidence stipulates:

> First: The Investigative Judge, Public Prosecutor or Investigator shall send a copy of information and material evidence to the unit responsible for collecting evidence and information affiliated to the Tribunal. This unit shall preserve this material.

> Second: The Investigative Judge shall prepare an account of all the material gathered, including documents, books, papers, and other objects. He shall give a copy of this account to the individual from whom the material was seized. Material that is of no evidentiary value shall be inventoried and safeguarded until such time that it can be returned.

Although the defense counsel knew of no such unit, the ICTJ advises us that its observer mission to the Tribunal, from 27 February to 3 March 2005 "raised concerns that such a unit had, in fact, transparently ensured the origin and handling of the evidence in the Dujail trial." It is a polite way of saying that Rule 26, like many other Articles and Rules, has been brushed aside and the "chain of custody of documents could not be discerned".[76]

It is unbelievable that after having spent tens of millions of dollars on the Tribunal, the RCLO did not manage to set up one unit with one person, one scanner and one laptop so that all documents relating to the

Was it the intention of the RCLO from the outset to create this chaos to avoid any record of its miscarriage of justice being used to incriminate the perpetrators later?

case, whether issued by the court, submitted by the prosecution or by the

defense, would be scanned and saved. Yet that is the sad state of affairs under which this case was tried and concluded. One is almost tempted to suggest that it was the intention of the RCLO from the outset to create this chaos to avoid any record of its miscarriage of justice being used to incriminate the perpetrators later. As ought to have been obvious from the outset, the failure to set up a protocol for the proper handling of documentation led to total chaos expressed in, but not limited to, the following:

1. The dossier of partial evidence delivered to the defense team in late September 2005 was semi-illegible and with multiple repetitions.

2. There is no official list of documents submitted to, or issued by, the Tribunal.

3. Judges were not able to trace documents allegedly in the possession of the Tribunal.

4. Judges did not know what motions were filed by the defense counsel.

There is a more sinister element to this failure for which the occupying US/UK authority, through the conduct of the RCLO, are fully responsible.

It ought to have been known to the staff of the RCLO that the principles established in the Nuremberg trial have been hailed by the Anglo-Saxon judiciary as bases of new international law. Among such principles is the requirement to indicate where a document has come from, how it was obtained and whether or not it constituted partial or full extracts from larger files. The reason for such a requirement is obvious because the document may be taken out of context from a file which is otherwise favorable to the accused. This turned out to be precisely the case in this trial. Only three pages from the file of the Revolutionary Court trial of 1984 of the Dujail defendants were included in the dossier submitted as the prosecution evidence to the Tribunal. Despite repeated requests by Al-Bandar for the rest of the file to be disclosed, nothing was provided. It transpired later that the full file was in the possession of the RCLO. Awwad Al-Bandar was executed without having been given the opportunity to argue his defense in the light of the exculpatory evidence in that file.

The Nuremberg trial "went so far as to state that failure to produce the remainder of a document on the part of the prosecution would cause the court to infer that the evidence contained therein was unfavorable to the prosecution."[77]

Despite repeated requests by the defense counsel for the prosecution to identify the sources of these documents with some evidence in the form of a stamp of names of certain dubious political organizations

appearing on some of the documents, the prosecution refused and the Tribunal was partial when it denied the allegation of the defense, that these documents lacked credibility and were compiled by enemies of the Ba'ath regime, without giving its own explanation as to the source of the documents.

The failure to provide the sources of the documents is inseparable from the failure to establish the authenticity of these documents. The only time documents were verified was when handwriting experts were needed to verify if the signatures on some of the documents were identical to samples taken from some of the accused. On 5 April 2006 a meeting was convened between defense lawyers and the IHT during which the defense counsel requested that the authenticity of the documents and the signatures on them be established by independent and impartial experts, international experts, for example. The Tribunal rejected the request and insisted on asking for such verification to be carried out by unnamed experts from the Ministry of Interior which was generally accepted to have been under the full control of an anti-Ba'athist militia group.

On 19 and 24 April 2006 the prosecution produced reports from the Ministry of Interior experts stating that the signatures and handwritings on 7 out of the 11 documents and signatures presented by the prosecution were authentic. The defense counsel were not able to ascertain the identity of the experts, their competence, the method used or whether or not there was unanimity in reaching their opinion. None of the experts were summoned to court to be examined and the defense counsel were denied the right to have experts of their choice to examine the documents. That, in my opinion, amounts to a blatant breach of equality of arms and thus a violation of the fundamental principle required in a fair trial.

There are two other important failures in the handling of documents in general in addition to the other failures that have been covered in other areas. One is the failure of the Tribunal to include in the dossier the accused's own statement made to the Investigative Judge, which was only disclosed on the morning of his being questioned by the trial judge, making it impossible for his defense counsel to formulate an argument without these statements being available in advance and necessary to rely on the memory of the accused.

The second failure and by far the more serious is the denial by the Tribunal of the existence of a transcript of the trial. How can a trial even be conducted, let alone appealed, without a full transcript?. Although both ICTJ and HRW, who observed the trial, seem to accept that assertion without commenting on how astounding it is, I would be very surprised if the RCLO had not in fact

How can a trial even be conducted, let alone appealed, without a full transcript? How can this feature of the trial have received so little press comment?

recorded the whole trial and transcribed it later. It is just not the way the US authority, which is obsessed with details, does things. The RCLO had a monitoring unit observing the trial and filtering what could be released to the media. However, despite my doubt I have to accept the Tribunal's denial that such a transcript existed. The defense would have found it impossible to prepare an argument for appeal if they had not been able to access the transcripts of some 40 trial sessions, and more than 60 witnesses. That is another failure in maintaining equality of arms.

Failure to Provide Written Decisions

I have already referred earlier to the tactic employed by the Tribunal to frustrate the defense's opportunity to function properly by not responding to any application made by them. In their report Clark and Doebbler identified, among the main applications, the following submissions, stating that no written reasoned decision was made in relation to any of them.[78]

1 9 October 2005: A motion indicating that notice of evidence and witnesses was not provided to defense in a timely manner.
2 19 October 2005: A motion calling for proceedings to be suspended due to insecurity.
3 8 December 2005: A preliminary motion challenging the legality of the IST and its failure to ensure respect for human rights.
4 21 December 2005: A supplementary motion challenging the legality of the IST.
5 1 February 2006: A preliminary motion requesting the disqualification of Chief Judge Abdul-Rahman on grounds of bias.
6 20 February 2006: A supplementary motion requesting the disqualification of Chief Judge Abdul-Rahman on grounds of bias.
7 15 March 2006: a seventeen point request, including respect for some basic human rights for a fair trial.
8 13 June 2006: a request to prevent William Wiley who allegedly worked for the Tribunal from interfering with defense witnesses and from contact with defense lawyers whom he was threatening.

There was only one written decision by the court dated 19 February 2006, but not delivered to defense counsel until mid-March, which rejected the application to disqualify Judge Abdul-Rahman made on 1 February, claiming that it should have been made before 19 October 2005. This was an impossibility because Judge Abdul-Rahman only joined the IHT in February 2006. The decision contained no explanation as to how the defense were supposed to have challenged the impartiality of a Judge who was not on the IHT and not even known to them. More importantly the decision failed to

respond to any of the issues raised in the disqualification motion, including witnesses' allegations that the judge had said that Saddam Hussein was guilty and should be executed without trial.

On 22 January 2006 and just before the trial session started, the defense was provided with a two-page letter asserting the IHT competence to try the accused without making any legal argument to support the decision and denying the defense the right to make oral submission on the matter. The Chief Judge stated in the letter that the question of the Tribunal competence was decided by the Tribunal, itself.

HRW commented that the "the failure of the court to respond with reasoned written opinions "reinforces the impression that it was essentially indifferent or unaware of the fair trial principles".[79]

It is rather surprising that HRW, after spending months observing the trial, did not arrive at the only conclusion possible, namely that the Tribunal and all those who served in it had been chosen because they were convinced of the guilt of the accused which in turn made it easy to dispense with any procedural requirement which would have made no difference to the outcome.

In a further comment on the Tribunal's failure to respond, HRW states that:

> While some of the motions, such as the motion concerning the legality of the IHT, could be addressed in a final judgment…

It is difficult to understand how HRW could suggest that the fundamental objection regarding the jurisdiction of the Tribunal could be left to the final judgment. It stands to reason that before the Tribunal can proceed with the trial, it should establish that it has jurisdiction underpinned by the rule of law. Thus the first motion that had to be addressed would have been that which challenged the legality of the Tribunal. This ought to have been disposed of before any further proceedings.

It seems that the HRW belief that the challenge to the legality of the Tribunal could have been left to its own final judgment rests on its belief that Saddam Hussein ought to have been tried, which it had advocated for some time. However, HRW has failed to advise us under which rule of law Saddam Hussein could or should have been properly tried.

Equally I have not yet read one report by HRW calling for their indictment of George Bush and Tony Blair for crimes committed in Iraq contrary to the Statute of the ICC. From 1991 until today, three US Presidents and three UK Prime Ministers have committed aggression, genocide, war crimes and crimes against humanity against the people of Iraq on a scale history has not seen before, despite the fact that the people of Iraq have committed no crimes against the people of the US or the UK. Yet neither HRW nor any

similar organization that claims to represent the liberal-minded Europeans and to be out to uphold human rights, has even suggested the possibility of indicting any of these criminals.

It is a sad realization for people like me, who have come from the East and spent a good part of our lives among Europeans, that even the sincerely liberal-minded among our European hosts are so impregnated in imperialist culture that, consciously or unconsciously, they believe that the demon must always be on the other side. One day I approached an honest, decent, liberal-minded member of the House of Commons in London, seeking his support for my petition to indict Tony Blair for war crimes in Iraq. The gentle, soft-spoken MP responded that he could not get himself to sign a petition that would criminalize his leader!

ENDNOTES

[1] The material for this chapter is derived mainly from four sources—my personal knowledge and involvement, the report of Ramsey Clark and Curtis Doebbler, who were both involved in the defense of Saddam Hussein, the October 2005 and November 2006 reports of Human Rights Watch (HRW), and the International Center for Transitional Justice (ICTJ) which were the only two organizations allowed by the US authorities to monitor the trial, and have had unfettered access to the Tribunal judges, staff and records. I accept that, considering the nature of this trial and Tribunal, facts may be discovered in the future that may shed a different light on my analysis and observations. However, with the secrecy of the composition of the Tribunal and the complete blackout of any information on the proceedings beyond that which was allowed by the US controller to be transmitted, it is fair to rely on the above four sources. See Clark, R., Doebbler, C., 'The Iraqi Special Tribunal: A corruption of Justice', 13 September 2006. [hereinafter referred to as 'C&D'] <http://www.justiceonline.org/site/PageServer?pagename=IST>; Briefing Paper, 'The Former Iraqi Government on Trial', Human Rights Watch, October 16, 2005. [hereinafter referred to as 'HRW-1'] <http://www.globalpolicy.org/intljustice/tribunals/iraq/2005/1016hrw.pdf>; 'Judging Dujail, The First Trial before the IST', Human Rights Watch, Volume 18, No. 9 (E), November 2006.[hereinafter referred to as 'HRW-2'] <http://hrw.org/reports/2006/iraq1106/iraq1106web.pdf>; and Briefing Paper, 'Dujail: Trial and Error', International Center for Transitional Justice, November 2006. [hereinafter referred to as 'ICTJ'] <http://www.ictj.org/images/content/5/9/597.pdf>

[2] 'Attorney General Alberto R. Gonzales Travels to Baghdad', Department of Justice, Press Release, August 29, 2006. <http://www.usdoj.gov/opa/pr/2006/August/06_ag_575.html>

[3] Executive Office of the President, Office of Management and Budget, First Quarterly Update to Congress, Section 2207, Part IV, January 6, 2004, pp. 43-44. <http://www.whitehouse.gov/omb/legislative/20040105-sec2207_ main_ report.pdf>

[4] Executive Office of the President, Office of Management and Budget, Second Quarterly Update to Congress, Section 2207 April 5,2004, p. 35. <http://www.whitehouse.gov/omb/legislative/2207_report2.pdf>

[5] Executive Office of the President, Office of Management and Budget, Third Quarterly Update to Congress, Section 2207, Appendix I, July 2, 2004, p. 24.<http://www.whitehouse.gov/omb/legislative/appdx_1_sectors_final.pdf>

[6] US Deaprtment of State, Quarterly Update to Congress, Section 2207 Report on Iraq Relief and Reconstruction, Appendix I, October 2004, p. 28. <http://www.state.gov/documents/organization/36918.pdf>

[7] US Deaprtment of State, Quarterly Update to Congress, Section 2207 Report on Iraq Relief and Reconstruction, Appendix I, January 5, 2005, p. 41. <http://www.state.gov/documents/organization/40475.pdf>

[8] C&D, p. 59.

[9] C&D, p.60.

[10] C&D, p.38.

[11] C&D, p.40.

[12] C&D, p. 41.

[13] North, A., Chaos and Comedy at Saddam Trial, BBC News, 16 March 2006. <http://news.bbc.co.uk/1/hi/world/middle_east/4811236.stm>

[14] C&D, p. 77.

[15] C&D, p. 44.

[16] US Deaprtment of State, Quarterly Update to Congress, Section 2207 Report on Iraq Relief and Reconstruction, Appendix I, April 2006, p. 33. <http://www.state.gov/documents/organization/64515.pdf>

[17] C&D, p. 60.

[18] HRW-2, p. 84.

[19] On the principle of a fair trial within an independent court the European Convention on Human Rights states in Article 6(1): "In the determination of his civil rights and obligations or of any criminal charge against him, everyone is entitled to a fair and public hearing within a reasonable time by an independent and impartial tribunal established by law." The basic principles on the independence of the judiciary were incorporated in a resolution by the UN and adopted in 1985. (See Basic Principles on the Independence of the Judiciary, Seventh United Nations Congress on the Prevention of Crime and the Treatment of Offenders, Milan, 26 August to 6 September 1985, U.N. Doc. A/CONF.121/22/Rev.1 at 59 (1985), and endorsed by General Assembly resolutions 40/32 of 29 November 1985 and 40/146 of 13 December 1985. <http://www.unhchr.ch/html/menu3/b/h_comp50.htm> Article 1 of the resolution states: "The independence of the judiciary shall be guaranteed by the State and enshrined in the Constitution or the law of the country. It is the duty of all governmental and other institutions to respect and observe the independence of the judiciary."

[20] ICTJ, p.6.

[21] HRW-2, p.83.

[22] C&D, p. 57.

[23] Ibid.

[24] C&D, p. 58.

[25] C&D, p. 37.

[26] C&D, p. 58.

[27] C&D, p. 56.

[28] HRW-2, p.41.

[29] ICTJ, pp. 6-7.

[30] HRW-2, p.43.

[31] C&D, p. 57.

[32] Ibid.

[33] HRW-2, p.40.

[34] ICTJ, pp. 6-7.

[35] HRW-2, p. 39.

[36] C&D, p. 61.

[37] C&D, pp. 62-63.

[38] *Karttunen v. Finland*, Communication No. 387/1989, U.N. Doc. CCPR/C/46/D/387/1989 (1992) at para. 7.2. <http://www1.umn.edu/humanrts/undocs/html/dec387.htm>

[39] ICTJ, p. 8.

[40] HRW-2, p. 13.

[41] HRW-2, p. 14.

[42] HRW-2, pp. 66-68.

[43] HRW-2, p.85.

44 HRW-2, p. 69.

45 HRW-2, p. 46.

46 ICTJ, p. 12.

47 HRW-2, p. 20.

48 ICTJ, p. 10.

49 HRW-2, pp. 49-50.

50 *Blaskic* case, ICTY, Case No. IT-95-14-A, Judgment (Appeal Chambers) July 29, 2004, para. 264. <http://www.un.org/icty/blaskic/appeal/judgement/index.htm>

51 C&D, p. 33.

52 C&D, p. 49.

53 Ibid.

54 ICTJ, p. 8.

55 HRW-2, p. 20.

56 C&D, p. 67.

57 C&D, p. 70.

58 C&D, p. 37.

59 HRW-2, p. 31.

60 HRW-2, p. 29. The Defense Office of the Special Court for Sierra Leone maintains a list of qualified counsel to represent accused who cannot afford legal assistance; advocates with the court administration and judges to ensure that defense lawyers (both privately retained and court-funded) have the necessary resources to prepare a defense; hires defense investigators to inquire into factual issues relevant to an accused's defense; and participates in regular discussions with court management concerning the needs of defense counsel. Bosnia's War Crimes Chamber has a Criminal Defense Support Section (known by its Bosnian acronym OKO), headed by an experienced international defense lawyer, which forms part of the administrative and management structure of the War Crimes Chamber's Registry. As well as providing logistical and administrative support to all defense counsel, the OKO also engages in intensive training and capacity-building for Bosnian lawyers participating in trials before the War Crimes Chamber. The OKO manages the accreditation of lawyers seeking to appear before the War Crimes Chamber, in part to ensure that the lawyers have the necessary training and expertise. It also maintains five regionally-based teams that provide assistance to individual Bosnian lawyers defending persons indicted by the chamber. The assistance provided includes helping with the preparation and presentation of legal arguments, and the hiring of expert consultants if necessary.

61 HRW-2, p. 30.

62 ICTJ, p. 8.

63 HRW-2, p. 71.

64 HRW-2, p. 72.

65 Ibid.

66 HRW-2, p.32

67 C&D, p. 113.

68 HRW-2, p. 32.

69 Ibid.

70 HRW-2, p. 61.

71 See *P. S. v Germany* (App. 33900/96) Judgment of 20 December 2001.

72 Makara, P., The Protected Witness L, (*Prosecutor v Tadic*, ICTY Case No. IT-94-1) <http://www.srpska-mreza.com/WarCrime/Witness-L.html>

73 HRW-2, p. 63.

74 C&D, p. 44.

75 C&D, p. 46.

76 ICTJ, p. 10, footnote 38.

77 HRW-2, p. 56.

78 C&D, p. 33.

79 HRW-2, p. 64.

CHAPTER 9

JUDGMENT, SENTENCE, APPEAL AND EXECUTION

Sentence

On 5 November 2006, the IHT pronounced the conviction of seven of the eight accused. Saddam Hussein and two of his co-defendants were sentenced to death by hanging for having committed murder as a crime against humanity contrary to Article 12(1) (A) of the IHTS. He received several supernumerary prison sentences for other offences of crimes against humanity as indicted below.

The most bizarre thing about this trial is that sentence was pronounced before judgment. I know of no case in criminal history in which an accused was sentenced to death prior to the court arguing its judgment. It is not surprising to hear so many different explanations for the speed with which the sentence was passed. It may be said that the judgment was meant to follow and it did follow several weeks later, but the question remains: why couldn't the sentence have waited at least until after the reasoned judgment was delivered? It is difficult to refute the argument that the decision to speed up the process of sentencing, appeal and execution was made to coincide with certain political events in the US. The sentence pronounced on 5 November 2006 was not handed in writing to the defense team until days later, despite the fact that the deadline for appeal was considered to have dated from 5 November.

The most bizarre thing about this trial is that the accused were sentenced to death before the Court argued the reasons for it in its judgment.

The sentence of 5 November 2006 as posted on the Tribunal website reads as follows (my English translation):

The Iraqi High Tribunal Case No. 1/Cr.
First/ 2005
First Criminal Court Date: 5 November 2006
 13 Shawaal 1427

Sentence Order

The Iraqi High Tribunal convened on 5 November 2006 chaired by Judge Raouf Rasheed Abdul-Rahman and the following member judges - , - , - , - , [the names were left blank] and made the following order in the name of the people:

First:

1. A. Sentencing Saddam Hussein Al-Majeed, Barazan Ibrahim Al-Hasan and Awwad Hamad Al-Bandar to death by execution for committing murder as a crime against humanity contrary to Article 12 (1)(a) in conjunction with Article 15 (1), (2), (3), and (4) of the Law of the IHT Number 10 of 2005. The sentence has been determined in accordance with Section 406(1)(a) of the Iraqi Penal Code Law No. 111 of 1969 as amended by Article 24 of the Law of IHT Number 10 of 2005. This order has been taken unanimously.

. . .

Third:

In accordance with section 224 (d) of the Criminal Proceedings Law Number 23 of 1971 the convicted have been advised that the papers of the case would automatically be sent to the appeal chamber of the IHT to consider the sentence by way of appeal. They also have the right to appeal the order in front of the appeal chamber of the IHT within 30 days starting the following day to the pronouncement of the order on 5 November 2006.

Fourth:

A. The Tribunal has ordered the confiscation of all assets, both movables and immovables."

B. The claimants in this action are entitled to seek action in the civil courts for damages resulting from the crimes committed against them.

The Order outlined other sentences of imprisonment against all the accused, except Muhammad Azzawi Ali, who were all convicted of several

other crimes contrary to Article 12 of the IHT Law Number 10 of 2005 (see details below). The document referred to 'Judgment Order' when in fact it included nothing but sentence.

Secondly, *all* the convictions were for acts committed contrary to Article 12 of IHT Statute, i.e. crimes against humanity, even though the role of some of the defendants had been very minor (such as informing) and could not possibly have merited their being charged in relation to a crime against humanity, recognized as among the world's most heinous crime.

A few weeks later a detailed long judgment of nearly 300 pages was posted on the Tribunal website.[1] The unavoidable question is why this judgment had not been made available before sentence was pronounced.

Summary of the Tribunal's Sentences

The following sentences were passed against the convicted.

- For the crime of Willful Killing contrary to Article 12(First)(A) of the IHT Statute: Saddam Hussein, Barazan Ibrahim and Awwad Al-Bandar each sentenced to death; Taha Yaseen Ramadhan sentenced to life imprisonment; [the Appellate Chamber later ruled that it was lenient. This sentence was raised to death.] Abdullah Kadhim Ruwayid, Ali Dayih Ali and Mizher Abdullah Kadhim each sentenced to fifteen years imprisonment.

- For the crime of Deportation or Forcible Transfer of Population contrary to Article 12(First)(D) of the IHT Statute: Saddam Hussein, Barazan Ibrahim and Taha Yaseen Ramadhan, each sentenced to 10 years imprisonment.

- For the crime of Imprisonment or other severe deprivation of physical liberty as a crime against humanity contrary to Article 12(First)(E) of the IHT Statute: Saddam Hussein, Barazan Ibrahim, Taha Yaseen Ramadhan, Abdullah Kadhim Ruwayid, Mizher Abdullah Kadhim, and Ali Dayeh Ali, each sentenced to 15 years imprisonment.

- For the crime of Torture contrary to Article 12(First)(F) of the IHT Statute: Saddam Hussein and Barazan Ibrahim each sentenced to 10 years imprisonment; Taha Yaseen Ramadhan, Abdullah Kadhim Ruwayid, Mizher Abdullah Kadhim, and Ali Dayeh Ali, each sentenced to 7 years imprisonment.

- For the crime of Other Inhumane Acts contrary to Article 12(First)(J) of the IHT Statute: Saddam Hussein, Barazan Ibrahim and Taha

Yaseen Ramadhan each sentenced to 7 years imprisonment.

Observations on the Tribunal's Judgment

Questions of Authorship

The translation of parts of the judgment as they appear in this chapter are mine and based on the Arabic judgment as posted on the web site of the IHT. Iraq, like any other country, has its own judicial traditions and practices. Judicial practices acquired over the centuries have produced a style in judgments that is easily recognizable in Iraqi courts. The style and length of judgments are familiar to any practicing lawyer in Iraq. When the norm is that the length of any judgment does not exceed 50 pages and the text sums the issues up rather than analyzing them, then a deviation from that would raise questions. The posted judgment in Dujail deviated from the norm both in length and nature. Firstly, it consisted of 300 pages and secondly it is written in a language dissimilar to Iraqi legal precedents.

It would be difficult to argue that Iraqi judges had learnt a new judicial culture overnight because judicial culture is not so easily amenable to change. In any case even those judges who were trained in London for only a few weeks did not stay on the bench, as we have seen, so clearly this is not a reflection of any training input Iraqi legal professionals might have received. Furthermore the legal language is analytical, which is typical of Common Law procedures. It is difficult to resist the conclusion that the judgment was written in English by the US/UK legal advisors in the RCLO in exactly the same way the defense was written by the appointee of the RCLO and then translated into Arabic. This may even explain the delay between pronouncing sentence and issuing the Judgment. When it was decided to execute Saddam Hussein before the end of 2006, the judgment was not yet completed. Thus a speedy draft of the sentence was prepared and read in court while the US/UK advisors were completing the judgment.

Inaccurate and Misleading Statements

There are numerous inaccurate and misleading statements throughout the judgment. I will address some which are worthy of mentioning, not least because they display a lack of knowledge or an indifference to the truth. For the sake of brevity and to avoid any confusion I shall refer to the original trial of

those charged with the attempted assassination of Saddam Hussein as Dujail-1 and to the current trial of Saddam Hussein as Dujail-2.

- The case of Dujail-1 is referred to as so complex 'with so many arrested that arrest and execution covered many members of the armed forces who were fighting on the frontline then and had no knowledge of what had happened in Dujail'.[2] However, insofar as no evidence was adduced during the trial of Dujail-2 of the murder of members of the armed forces, then the Judgment should not refer to such matters as either factual or evidential. A similar insertion of new unexamined circumstances states:

> as the resultant victims of the calamity were 148 as stated in the judgment of the Revolutionary Court number 942/c/982 dated 14 June 1984 and ratified by Presidential decree number 778 dated 16 June 1984, in addition to the tens who died during detention frightened, terrified, hungry, sad and subjugated whether in the intelligence detention, in Abu Ghraib or in the desert camp (Liya) away from people's eyes for whose death no considera-tion was made.[3]

Apart from the emotive language improper for a judgment in a criminal case, the Judgment again refers to tens dead. One of two states is possible— either there were people who died in these alleged locations beyond those stated in the indictment, and if so their names ought to have been identified and added to the offence. Alternatively no such death took place and the judgment should not have made any such reference to them. If in fact they occurred, why were they not included at the appropriate time? Were they only inserted later, perhaps out of a perceived need to intensify the sense of wrongdoing necessary to the charge of "crimes against humanity"? This is a substantive issue that goes to the heart of the process.

- Because the defense lawyers have referred to Saddam Hussein as the President, all petitions and applications with such reference were not responded to. The Tribunal concluded on page 12 that:

> as Saddam Hussein has no position in front of this court but that of being the accused, the Court has decided not to make any judgment on any petition submitted with that title or that description [of President] and not even to refer to these petitions in the judgment because they were not proper.[4]

It would be a breach of basic justice for an accused to lose his historic rights simply because the Court did not approve of the way he was addressed by his defense team. Why should the title, or the way the accused was being addressed, have any bearing on the legal process or the rights of the accused as secured by the rule of law?

- The Tribunal questioned that the assassination attempt was directed at the President.[5] It gave no argument or facts to substantiate this view, only expressed its opinion in a statement despite the fact that overwhelming evidence had been presented to the Tribunal that such an attempt had been directed at the President. However, in order for the Tribunal to have reached such a decision it would have to have further reviewed the file of Dujail-1 and should have included the evidence from that trial on which it based such conclusions. The defense lawyers had repeatedly requested the file of Dujail-1—a primary source of evidence for their case—to be disclosed to them but were denied that right despite it having been in the hands of the RCLO which handed it over to the Tribunal.

- The Tribunal referred to the number of lawyers murdered as three; two from the Defense Office team appointed by the Tribunal and one from the defense lawyers privately appointed by the accused. The truth of the matter is that three of the lawyers appointed by the accused were murdered and none from the Defense Office team as the Tribunal asserted.[6]

Crimes and the Tribunal's Jurisdiction

There are two fundamental issues which the Tribunal had to establish in order to reach its judgment:

1. That there was legal ground for the charge to be made against Saddam Hussein in the criminality of the alleged acts at the time of their commission, in the jurisdiction of the Tribunal to try him, and in the avoidance of his entitlement to immunity.

2. The role of Saddam Hussein in the alleged crimes.

If the Tribunal failed in establishing the first, then there is no need to pursue the second.

Analysis of Tribunal's Judgment on Jurisdiction and Crimes

The indictment and the sentence of Saddam Hussein rested on Article 12 of the Statute of the IHT which has been shown to be similar to

that of the IST which in turn has been shown to be derived from Article 7 of the Statute of Rome setting up the International Criminal Court. In order for the Tribunal to convict Saddam Hussein it had to begin by establishing that the crimes listed under Article 12 of the Statute of the IHT were also crimes under Iraqi Law at the time of commission, since the trial was conducted under Iraqi law. Any other argument would be academic especially if it ended up being a lecture on the development of international law.

The Tribunal asserted that it considered the charge in accordance with Article 12 of the IHTS.[7] In over thirty pages of muddled argument the Tribunal tried in vain to argue its conclusion that Article 12 of the IHT did indeed exist under Iraqi law at the time of the commission of the acts and that it had the jurisdiction to try the action. However, as I shall show below, the Tribunal, in repeated incoherent paragraphs, attempted to restate the principles of international law but failed to prove its conclusion—which it acknowledged had to be established before it was able to try the action.

1. The Tribunal refers to Article 17 of the Statute of the IHT[8] which referred to The Military Penal Code No. 13 of 1940 and the Code of Military Procedure No. 44 of 1941 as sources of principles of criminal law, overlooking the fact that these laws had been suspended by the CPA's Order 22 of 7 August 2003 and not reinstated.

 The Tribunal accepts later in the judgment that the Transitional Administrative Law (TAL) of 8 March 2004 formed the interim constitution of Iraq following the end of the authority of the CPA, and that the suspension of these laws (as reiterated in TAL article 26) remained in force. The failure of the Tribunal to address this muddle demonstrates the chaos of the imposed legislation and throws the whole assertion by the Tribunal that it was applying Iraqi law into serious doubt.

2. The Judgment gives the definition of 'attack' in Article 12 of the IHT Statute as exactly that defined in Article 7(2) of the Statute of the ICC: "Attack directed against any civilian population" means a course of conduct involving the multiple commission of acts referred to in paragraph 1 against any civilian population, pursuant to or in furtherance of a State or organizational policy to commit such attack".[9]

 There are three problems with the Tribunal's reliance on this definition in describing the activity of the Iraqi Government in 1982-84 in Dujail. These are:

a. The definition as made in the IHT Statute of 2005 could not apply to actions that took place in 1982. The only definition of the offence open to the Tribunal to use is that which existed then.

b. The International Criminal Court only agreed on this definition after decades of negotiation between the contracting parties which indicates that it was not a definition on which all parties agreed. To prove the difficulty of reaching consensus on the definitions of offences, we need to remember that the crime of aggression is still undefined in the Statute of the ICC.

c. Even if the same definition of 'attack' is assumed to have existed in 1982-84, it would still be difficult to see how the Tribunal applied it to the Dujail case, which concerned a government response via criminal process to an attempted assassination of the Head of State.

3. The Tribunal refers to the Security Council Resolutions in what appears to be a prelude to establishing its legitimacy and jurisdiction.[10] The earlier muddle carries on as the Tribunal makes the following errors:

a. It refers to Regulation Number 1 of the CPA dated 16 May 2003 as having been in accordance with Security Council Resolutions. However, had the Tribunal taken the effort to verify the facts and not rely on media reporting, it would have concluded that when Paul Bremer assumed authority over Iraq on 16 May 2003, no Security Council Resolution had been adopted granting such authority. It means that Bremer assumed total executive, legislative and judicial authority over Iraq irrespective of what the Security Council was going to decide later. That, in short, is what belligerent occupation is.

b. It refers to Security Council Resolution 1546 dated 8 June 2004 as one of the two Resolutions laying the grounds for the authority to establish the Authority of the new Iraqi administration which gave rise to the order creating the Tribunal. However, the Tribunal erred in fact. Order 48 of the CPA which created the Iraqi Special Tribunal to try Saddam Hussein and his Government was promulgated on 10 December 2003, some six months before the Security Council Resolution 1546 was adopted. In short the decision of the Occupier to try the legitimate Iraqi Government of 2003 had nothing to do with the authority of the expected Iraqi Government of late 2004, which itself was set up by the Occupier

irrespective of whatever the Security Council Resolutions said or did not say.

c. It refers to the adoption of TAL by the Governing Council. I have already shown that the Governing Council, which was created by Bremer in Regulation 6 on 13 July 2003, was not granted any legislative power. If anything it was denied any semblance of authority when Bremer refused to allow it to appoint deputy Ministers in Memorandum 9 dated 25 February 2004. I have demonstrated earlier that TAL has never been enacted because it was published without being promulgated by anybody with legal authority to do so, not even the CPA.

4. The Judgment concludes from the previous notices and assertions[11] that, as Article 131 of the Iraqi Constitution 2005, adopted by referendum, has stipulated that the Tribunal established by the occupier should continue, then the **Article 131 of the Iraqi Constitution 2005** submission of the **in effect recognized a criminal process** defense lawyer of **set up by the occupying forces in Iraq.** Awwad Al-Bandar on the lack of jurisdiction of the Tribunal was a defective defense, rejected and baseless in law. But the Tribunal did not address the fact that the whole process was carried out under the IST, which was set up by the occupier and not by any presumed Iraqi authority.

5. The Tribunal attempts to address the defense of immunity from prosecution granted in Section 40 of the Iraqi Constitution 1970 to the Chairman and members of the Revolutionary Command Council.[12] The Tribunal asserts its jurisdiction on the following two grounds:

a. The crimes committed by the accused were crimes against humanity for which there is no immunity.

b. Assuming there were such an immunity, the collapse of the regime enabled the current Iraqi authority to repeal that immunity and charge Saddam Hussein with these crimes.

However, if immunity was in force at the time of the alleged action, then its negation at a later date could not remove its efficacy at the time of the act without rendering the whole concept of immunity meaningless. Immunity is enshrined in almost all states in order to enable a head of state to act without fear of being subject to the

process of law while conducting his duties in good faith. It cannot be argued that such a right could be retrospectively denied.

It is not yet acceptable under international law that crimes against humanity render state-conferred immunity voidable.[13] If it were, for the sake of argument, then the first duty which the Tribunal had to dispose of was to show that crimes against humanity were triable offences under Iraqi law. But as the Tribunal had not done so, it could not have argued that immunity was not available simply because these were crimes against humanity under *international* law. If they wanted to apply international law they should have tried the case in the international court.

6. The Tribunal noted the views of the Secretary General of the UN on denying immunity for people committing crimes against humanity or war crimes.[14] By the same token, if the views of the Secretary-General on what was legal were to be regarded as establishing the law, then his opinion that the invasion of Iraq was illegal ought to have forced the Tribunal to conclude that its own creation on 10 December 2003 by the occupier as a result of the invasion was illegal.

7. The Tribunal argues that Article 15 of the IHTS negates the immunity granted to any member of the Revolutionary Command Council.[15] That seems to be a spurious argument. If the Statute which created the Tribunal is objectionable, then it cannot be used as a justification for rejecting the objection. The retroactivity problem arises here, too.

8. The Judgment attempts to establish that the offences against the accused existed under Iraqi law at the time of their commission. It accepts that the principles prohibiting the application of law retroactively found in the Statute of the ICC[16] are upheld by Iraqi constitutions, including that of 2005, and by Iraqi Penal Code Number 111 of 1969.[17] The Tribunal agrees that it would be serious if the retroactivity argument were to be established.[18] On the existence of these offences the judgment says:

> These actions constitute crimes in most states of the world if not all. The Statute of the Tribunal has not created crimes that were admissible acts at the time of commission of killing and torture and others of which the accused are charged.

However, it is not true that crimes against humanity are criminalized in most states, as many states had not nationally

recognized these crimes, (notably the USA) unless the Tribunal was trying to loosely define the offences contrary to Article 22(2) of the Statute of the ICC. And even so, the Tribunal failed to specify which *Iraqi* Law defined these crimes. There should be no presumption of the existence of law in defining crimes, as the Tribunal seems to imply.

The Judgment attempts unsuccessfully to argue that it is not possible in customary international law to define crimes in the same way as in domestic legislation. It is an attempt to avoid the restriction created by the accepted principle in Article 22(2) above. While attempting this, the Tribunal fell again into another muddle, stating:

> Despite this the truth is that up to a large extent and especially in the case of crimes against humanity the identification of acts as international crimes is done in the same fashion in which the empirical rules of international law are created, i.e. through international customs. In addition the identification of crimes in international law is not as precise as it is under domestic criminal legislations.[19]

However, crimes against humanity and the elements of these crimes are fully identified in Article 7 of the Statute of the ICC and the 48 pages expanding on the elements of crime in Articles 6-8 of genocide, crimes against humanity and war crimes.

9. After some convoluted argument, the Judgment concludes that because international criminal law is different from domestic criminal law and because there are no legislative bodies in international law, the principle of no crime without the action having been criminalized at the time of commission as per Article 22 of the Statute of the ICC will be applied according to the Tribunal "by ensuring that the act or omission was an international crime, not necessarily as stipulated in an international convention or treaty, because the origin of most of these crimes is international custom",[20] i.e. criminalizing it by ruling it to be criminal (!)

10. The Tribunal proceeds to assert that:

> The wide construction of the principles of illegality of crimes and punishment under international criminal law allows us to say that it is possible to accuse and punish

> anyone who commits international crimes even if not specified in a law or identified as international crimes in domestic legislation. It is sufficient of [sic] a state to sign an international treaty which criminalizes the act. This justification would be proper to apply for crimes of genocide and war crimes committed in Iraq. In addition to that the punishment for crimes against humanity finds its legal foundation in international custom which assumes an injunctive rule and which (customary law) applies in all world states without need of encoding in domestic laws.[21]

There are several problems with the above statement which the Tribunal assumes as a basis for its judgment.

- Firstly, it is not accepted in international law that a state's signature alone on a treaty creates automatic national application and effect.[22]

- Secondly, customary international law on the crimes under consideration has received very little application in domestic jurisdictions. The US does not recognize it nationally and in the UK it is now the law, as upheld by the House of Lords in (*R v Jones* (Appellate) [2006] UKHL 16), that customary international law has no effect unless Parliament legislates.

11. The Tribunal then seems to have lost track of the legal argument:

> Our Tribunal asserts here that most, if not all, acts or omissions that constitute crimes against humanity are crimes under Common Law whose guilt and punishment are stipulated in national criminal legislations in all states including Iraq. All that has happened is that they have been transferred from national sphere to international sphere.[23]

The above statement suffers from serious anomalies. First, it states that these crimes existed under Iraq law but fails to state where in Iraqi law they are defined, let alone providing evidence or citations indicating that they exist in 'all states'. Second, it asserts that international criminal law emerged from existing domestic legislations. If that were the case, then why did the countries of the world have to negotiate for decades to set up the ICC if a significant proportion of

them already had national legislations criminalizing crimes against humanity? Indeed, if Iraq already had criminalized these actions, then there would have been no need for the special tribunal and Articles 11-14 of its Statute.

The Tribunal states that these crimes existed under Iraq law but fails to state where in Iraqi law they are defined, let alone providing evidence or citations indicating that they exist in 'all states'.

12. No sooner had the Tribunal made the above assertion than it seems to contradict it, stating that:

> The Tribunal, despite being national, has jurisdiction to consider international crimes not because the Statute of the Tribunal, which is a national law, stipulated them but also because Iraq either has signed international treaties that covered international crimes, as in the case of war crimes in the Geneva Conventions of 1949 and their Protocols and the Genocide Convention of 1948, or because the principles of international criminal law apply, not only in Iraq but in all states, directly without a need of any stipulation in the domestic legislations of these states.[24]

The above statement refers to war crimes when the charge in the case concerns crimes against humanity. There is no analogy to be drawn in criminal matters. Furthermore, the war offences that were criminalized in the Statute of the ICC and later incorporated in the Statute of the Tribunal are not the same as those in the Geneva Convention which would make the reference unsatisfactory. The Tribunal seems to assume, wrongly, that Iraq had ratified the Protocols added to the Geneva Conventions.

13. The Tribunal seems again to contradict its assertion of the automatic application of crimes against humanity:

> The trials of the horrific crimes committed by Nazi leaders have created a strong and important impact in legal thinking and international criminal law that the Secretary General of the UN requested in October 1946 in his report to the General Assembly of the UN the imperative necessity to include with International Law the principles that were born out of the tribunals and

punishments of the German war criminals. The US submitted in November 1946 a Resolution to the UN asking the international organization to adopt the Nuremberg principles and frame them in a Code that defines the Crimes against Peace and against the security of humanity and punishes for them. The US proposal received unanimous support.[25]

Having noted that the Tribunal earlier asserted that principles of customary international law have automatic application in national courts and assume precedence over national legislations without a need for them to be promulgated nationally, and having noted that the Tribunal had asserted that the Nuremberg Principles have become part of customary international law, it seems that the Tribunal in the above statement indicates that there was still a need to incorporate these principles in treaties, conventions and resolutions in order for them to become part of international law. Indeed, if customary international law were to be regarded as having automatic application in all states (presumably in the US/UK as well?) then why bother to legislate further? There would be no need to negotiate and conform what had already existed. The simple fact that it took decades for the world's states to agree on the ICC Statute demonstrates that these principles were not easily accepted as having been binding on states, let alone individuals. In any case there would be no need for duplication in legislation.

It is not easy to see how the Tribunal expects the reader to reconcile these two opposing statements. Either customary international law has automatic effect nationally which requires no further national legislations or international treaties, or international treaties and national legislations are necessary to criminalize acts. Both positions cannot be right at the same time as the Tribunal has led us to accept in its judgment.

14. In its pursuit to prove its adherence to principles of international law the Tribunal at some stages of its judgment did more damage than good to its argument. Thus on page 47 it refers to the '*Convention on the Non-Applicability of Statutory Limitations to War Crimes and Crimes against Humanity*'. However this reference suffers from two negative aspects as far as the Tribunal argument is concerned.

- The Convention is clear in its stipulations in Article 1 and 2 that it applies to crimes committed between states and not crimes within a contracting state. Any attempt by the Tribunal to apply this to internal matters in Iraq is unsustainable.

- Iraq has not ratified or signed the Convention and thus could not be bound by it.

However much the Tribunal asserted it wanted to uphold international principles as it relates to the non-applicability of the statute of limitations, it was being set up and was operating under a Statute which sought to restrict its period of applicability,[26] and is therefore defective on these same principles.

If the Tribunal's Statute is to be the law whereby such crimes are automatically criminalized in Iraq by virtue of their being part of the customary international law, as the Tribunal has insisted all through the judgment, then there should be no limitations in jurisdiction in time or people or place.

15. The Judgment attempts to include the establishment of the Iraqi Special Tribunal as part of the historical chain of development in customary international law itself.[27] We hope, however, that this book has served the contrary purpose—to illustrate how this Tribunal and the entirety of circumstances surrounding it represent a pernicious and tragic avenue both for the development of international law and for human well being, and thereby to post a road sign warning humanity against its use as a precedent. We shall address what we feel to be the appropriate historic disposition of the Iraqi High Tribunal more extensively, in our conclusion, below.

16. In responding to the defense argument on retroactivity of criminalizing and punishing acts, the Tribunal stated.

> The defense [of retroactivity] is baseless. The criminalization of these acts existed before the issue of the law of the Tribunal in 2003; it existed under customary international law; it existed under the international treaties which Iraq had ratified; it existed under Baghdadi Penal Code and the Iraqi Penal Code Number 111 of 1969 and Military Penal Code Number 13 of 1940 and other punishing laws in Iraq. Thus it can be said that the Law of the Tribunal if it was not revealing the criminal nature of these actions as opposed to creating them, then it has transferred these crimes from the international sphere, where they existed, to the national sphere.[28]

There are several flaws and contradictions with this statement. These are:

a. The Tribunal referred to their existence under Iraqi Penal Code No. 111 of 1969 but failed to identify the sections in the Law where such criminalization is clearly specified. Imposing a death sentence could not be based on a vague reference to the existence of an undefined punishment for an undefined offence existing at an unspecified place somewhere in a specific law.

b. The last sentence in the above statement on page 52 is a complete reversal of the view that the Tribunal has stated earlier on page 44:

> Our Tribunal asserts here that most, if not all, acts or omissions that constitute crimes against humanity are crimes under Common Law whose guilt and punishment are stipulated in national criminal legislations in all states including Iraq. All that has happened is that they have been transferred from national sphere to international sphere.

However on page 52 it asserts that:

> Thus it can be said that the Law of the Tribunal if it was not revealing the criminal nature of these actions as opposed to creating them, then it has transferred these crimes from the international sphere, where they existed, to the national sphere.

These two contradicting statements tell the whole story of the muddle of the 300 pages of judgment.

Summary of the Tribunal's Judgment on Its Jurisdiction and Crimes

The above summary of the first 50 pages of the Judgment gives the Tribunal's opinion on the fundamental issues which need to be addressed before there is any purpose to proceed and apply the evidence to the actions. If there is no crime or no jurisdiction then there should be no trial.

The finding of the Tribunal on these issues may be summarized as follows.

1. There is no retroactivity under Iraqi criminal law as held in international law and incorporated in the Statute of the ICC.

2. The Statute of the Iraqi Special Tribunal (IST) promulgated by the

Occupier on 10 December 2003 to try the Ba'ath Government of Iraq for the period between July 1968 and May 2003 for crimes against humanity, war crimes, genocide, as defined in the Statute of the ICC which came into force on 1 July 2002, is legal and binding on Iraq's judiciary.

3. The Iraqi High Tribunal, which was the IST with a new name, and which came into being on 18 October 2005 derived its legitimacy from the Iraqi Interim Constitution (TAL) promulgated by the Occupier which stipulated that the constitution and actions of the IST be maintained and continued.

4. The crimes in the Statute of the IHT derived from the IST, namely genocide, war crimes and crimes against humanity, have always existed under the Iraqi Penal Code in one form or another.

5. The immunity granted to members of the Revolutionary Command Council in Section 40 of the Iraqi Constitution 1970 has no effect as the new authority in Iraq (which in this case was the Occupying Power) was entitled to remove it retrospectively.

6. All states of the world accept that customary international law applies in national courts without any need of domestic legislation.

7. States of the world have agreed to enter into treaties that prohibit and criminalize certain actions that were already prohibited under customary international law. However, it is not clear from the judgment what is the need for these treaties if these crimes were already part of customary international law and that law, according to the Tribunal's finding, had direct effect and application in national courts.

8. It is not clear whether the Tribunal has concluded that national laws gave rise to international laws or the principles were transferred from the international sphere to national spheres. Both contradictory statements were made by the Tribunal in different parts of the judgment.

9. The Tribunal had the jurisdiction to try the accused under the Statute of the IHT and all the arguments put forward by the defense were baseless in law.

I shall attend to the finding of the Tribunal on these fundamental issues as follows.

Summary Refutation of the Jurisdiction of the Tribunal

The Iraqi Special Tribunal (IST) was created by Order 48 promulgated by the CPA as an occupying authority on 10 December 2003. The Tribunal has failed in its judgment as shown above in proving that such an entity was legal under Iraqi or international law. It is improper for the Tribunal to state that the legitimate authority in Iraq can set up tribunals as it sees fit. The authority in Iraq in December 2003 was the occupying power which had very little authority under international law in terms of setting up trials and trying people in the occupied territories.[29]

In order to circumvent this failure to refute the defense submission, the Tribunal attempted but failed to successfully argue that it had legitimacy by virtue of the enactment of TAL on 8 March 2004 by the Governing Council appointed by Paul Bremer of the CPA.[30]

Whether or not the Tribunal lacked understanding what legislation is or was operating in the chaos of everything that prevailed during Bremer's rule of Iraq or *the Tribunal had not drafted the Judgment*[31] does not relieve the Tribunal of the requirement to produce correct and valid legal arguments.

The Tribunal concluded on page 34 of its judgment that: "the submission of Awwad Al-Bandar, lawyer, regarding the Tribunal and its legitimacy is flawed, rejected and has no basis in law".

However, in view of the above analysis, it is more likely that it is the Tribunal's conclusion on its jurisdiction which has no basis in law.

Immunity of a Head of State

The Iraqi Constitution 1970, like many other constitutions, had in Article 40 granted full immunity to the Head of the State from any proceeding without leave from the Revolutionary Command Council. The accepted principle in international law is that immunity exists while the Head of State is in office but ceases with the termination of official functions. After Pinochet was arrested in England in response to an extradition warrant issued in Spain, legal proceedings reached the House of Lords and the question of immunity of a head of state was considered by their Lordships. In order to show the complexity of this matter, I would like to cite some of the legal argument forwarded by Lord Hope.[32] His Lordship held the view that immunity would not be removed even if the act is criminal.

> The fact that acts done for the state have involved conduct which is criminal does not remove the immunity. Indeed the whole purpose of the residual immunity *ratione materiae* is to protect the former head of state against allegations of such conduct after he has left office. A head

of state needs to be free to promote his own state's interests during the entire period when he is in office without being subjected to the prospect of detention, arrest or embarrassment in the foreign legal system of the receiving state: see *United States v. Noriega*, p. 1519; *Lafontant v. Aristide* (1994) 844 F.Supp. 128, 132. The conduct does not have to be lawful to attract the immunity.

It may be said that it is not one of the functions of a head of state to commit acts which are criminal according to the laws and constitution of his own state or which customary international law regards as criminal. But I consider that this approach to the question is unsound in principle. The principle of immunity *ratione materiae* protects all acts which the head of state has performed in the exercise of the functions of government.

There are strong arguments in support of denying immunity to a head of a state when certain crimes are committed. However, such a measure has to be agreed upon by the world community and enshrined in new conventions. To that end, Lord Hope quoted with approval the view of Lord Slynn of Hadley:

So it is necessary to consider what is needed, in the absence of a general international convention defining or cutting down head of state immunity, to define or limit the former head of state immunity in particular cases. In my opinion it is necessary to find provision in an international convention to which the state asserting, and the state being asked to refuse, the immunity of a former head of state for an official act is a party; the convention must clearly define a crime against international law and require or empower a state to prevent or prosecute the crime, whether or not committed in its jurisdiction and whether or not committed by one of its nationals; it must make it clear that a national court has jurisdiction to try a crime alleged against a former head of state, or that having been a head of state is no defence and that expressly or impliedly the immunity is not to apply so as to bar proceedings against him. The convention must be given the force of law in the national courts of the state; in a dualist country like the United Kingdom that means by legislation, so that with the necessary procedures and machinery the crime may be prosecuted there in accordance with the procedures to be found in the convention.[33]

Although the above submission is not intended to cover this complex matter, it is meant to show the legal wisdom in the UK at least on this matter. Thus the legal brains in the House of Lords in London believe that immunity of a head of state can only be removed by international convention which is given domestic jurisdiction by national legislation and would take effect from the time of such legislation. In comparison it was unfair that Judge Ra'ouf Abdul-Rahman concluded that the immunity granted to Saddam Hussein by the Iraqi Constitution 1970 was removed retrospectively by Paul Bremer in 2003.

Were the Acts Criminal?

Following its dismissal of the defense submissions that it had no jurisdiction to try the President of the Iraqi Republic, the Tribunal then sought to prove that the acts with which he was charged were criminal at the time of their commission. It should be made clear that the argument will concentrate on the crimes against humanity as defined in Article 12 of the Statute of the IHT 2005 which is copied from the Statute of the IST 2003 which is itself copied from the Statute of the International Criminal Court 2002.

The Tribunal concluded that the crimes of which the accused Saddam Hussein was charged existed under Iraqi law, customary international law and treaty law. The charges laid against Saddam Hussein and his seven co-accused under Article 12 were crimes against humanity, which:

> means any of the following acts when committed as part of a widespread or systematic attack directed against any civilian population, with knowledge of the attack:
> A. Willful killing;
> B. Extermination;
> C. Deportation or forcible transfer of population;
> D. Imprisonment or other severe deprivation of physical liberty in violation of fundamental norms of international law;
> E. Torture[34]

(i) Crimes against Humanity under Iraqi Law

The Tribunal repeatedly asserted that crimes against humanity existed under Iraqi criminal law at the time of the commission of the alleged acts. Yet it failed to identify which Article in the Iraqi Penal Code Law Number 111 of 1969 supports its assertion, which must be established if such an assertion were to become an actual legal dictum rather than an emotional media report useful for political purposes.

The first important point to note, in so far as the application of Article

12 is concerned, is that it relates to offences committed within a '*widespread or systematic attack*' on civilians. It is vital, in my opinion, in order to understand the application of such a definition in Iraqi criminal law, to look back at the origins of the Iraqi Penal Code. When the Iraqi Penal Code Act was promulgated on 19 July 1969 it gave as the Reasons for its Enactment the following.

> The prevailing criminal law in Iraq today was issued by the British occupying forces in 21 November 1918 to enter into force from 1 December 1919. It was called the Baghdadi Penal Code because it was enacted in the [Ottoman] *Wilayet* of Baghdad but its jurisdiction was extended later to cover other parts of Iraq. When the first Iraqi constitution was adopted in 1925, Article 114 gave to all the orders, regulations and laws, including the Baghdadi Penal Code, issued by the commander of British forces in Iraq, the British High Commissioner and the Iraqi Government, the force of law until repealed or amended.

> The Baghdadi Penal Code was issued in English and the first Arabic translation was issued two years later in 1921... Litigants found themselves with three different versions of the Law—the English version, the first Arabic translation and the corrected Arabic version.

> In formulating the principles in this Act several factors were taken into account... Note was taken of practice and judgment of the Iraqi judiciary and of laws on punishment that had been implemented in Iraq over many years. Note was taken of criminal legislations in other states, especially Arab States because of the similarity of social structures and because of the principle of unifying Arab legislations...

There are striking parallels that could not be missed between what happened in 1919 and in 2003.

- Paul Bremer's legislations of 2003 were all promulgated in English just like the 1919 Baghdadi Penal Code. In order to save the Iraqi courts the agony of which version to rely upon, as happened in the period following 1919, Paul Bremer ordained that in the case of any difference, the English version should prevail.

- There are three different versions of the Rules of the IHT in 2005 just

as there were three different versions of the Baghdadi Penal Code after 1921.

- The Iraqi constitution adopted in 2005 incorporated, just like the 1925 constitution, the legislations passed by the occupying power. The 80 years of so-called national government in Iraq appear to have been nothing but a mirage.

The Iraqi constitution adopted in 2005 incorporated, just like the 1925 constitution, the legislations passed by the occupying power—as if the intervening 80 years of national government in Iraq were nothing but a mirage.

The fundamental fact about the process of development of the Penal Code in Iraq has been its application to domestic crimes and complete lack of even any reference to any crime defined in international law that is not in itself a possible national crime. Thus the definition of '*widespread or systematic attack*' on civilians would have no place in Iraqi Penal Code because the legislature during the last eighty years in Iraq could not have envisaged such a situation in which anyone would be able to mount such an attack on civilians without being a foreigner committing an act of war, which in itself could not have been legislated upon in Iraq. This brings into question the assertion of the Tribunal that the Crimes against Humanity under Article 12 of the Statute of the IHT were already part of the Iraqi Penal Code.

Even if we were to allow the imagination to roam beyond the legally acceptable and assume that a 'widespread or systematic attack' was a possibility in the mind of the Iraqi legislators, then the Tribunal ought to have shown which element of Article 12 existed under Iraq law. Part Three of the Penal Code Law Number 111 of 1969 deals with crimes against the person. Neither Extermination, nor Deportation nor Torture are to be found anywhere in Part Three of the Law. It follows that the Tribunal's conclusion that the crimes under paragraphs B, C and E were recognized under existing Iraqi law has no foundation in truth. That leaves two elements of the offences under Article 12 to be further considered as it relates to Iraqi law.

The closest Article in Iraqi Penal Code law to paragraph D defining '*imprisonment or other severe deprivation of physical liberty in violation of fundamental norms of international law*' is Article 421 which reads: "Shall be imprisoned anyone who arrested another, detained him or deprived him of his liberty in any form without an order from a specialized authority in other circumstances that laws and regulations allow".

It is clear that there was no provision under the Iraqi Penal Code to address any possible instances of criminality that might pertain to the proper state-authorized bodies arresting people, detaining them or depriving them of their liberty. Paragraph D of Article 12 of the Statute of the IHT, contrary to

the Tribunal's conclusion, had no foundation under Iraqi Penal Code that existed prior to May 2003.

The only recognized crime under the Iraqi Penal Code that can give rise to an argument is that in paragraph A under Article 12: Willful Killing. Under Article 406 of Penal Code Law a premeditated killing is punishable by death. The Tribunal, having failed to establish that the execution of those convicted for the attempted assassination of the President was unlawful, concluded nonetheless that the ratification of the executions by the President was willful killing. In order to substantiate the applicability of Article 12, the Tribunal should have but didn't refute the applicability of Article 39 of the Penal Code, which stipulates that:

Having failed to establish that the execution of those convicted for the attempted assassination of the President was unlawful, the Tribunal concluded nonetheless that the ratification of the executions by the President was "willful killing".

> There is no crime if the action was in fulfillment of a duty imposed by Law.

As the Iraqi Constitution 1970 demands that death sentences be ratified by the President, then doing so does not in itself constitute a crime. It is no more a crime than if a Governor of a State in the US ratified a death sentence on an accused whose conviction was discovered later to have been a mistake.

It is my opinion, based on the above analysis, that the Tribunal failed to establish that the offences with which Saddam Hussein was charged were offences recognized under the Iraqi Penal Code that was in force at the time of the commission of these executions.

(ii) Crimes against Humanity under Customary International Law

That there are crimes under customary international law is undisputed. However, disputes remain as to whether or not actions criminalized under international law have automatic effect in domestic law. The Tribunal treated this issue of paramount international legal importance with total disregard, stating repeatedly that customary international law is accepted by all states of the world as having automatic domestic application. The Tribunal seemed to accept it as a fact without providing instances, citations or documentation to this effect.

Customary international law as defined in Europe should not apply for the specific reason that it is used as a tool for invasions and subjugation. The only law that should apply is treaty law, which facilitates the democratic

participation of states in the determination of law. With the setting up of the ICC, however, any international crime is now *potentially* justiciable internationally before the ICC and domestically before the courts of the Contracting Party. There is no need to argue what is the position of an offence committed by an individual when his state does not ratify an international treaty, because that individual ought now to be indicted in any state that had ratified the ICC Statute and legislated to incorporate it domestically, as the UK has done, or before the ICC if no state would be able or willing to take that measure. That is the theory. This new development does not change the existing mechanisms through which some states have legislated to universally criminalize acts committed in breach of other international instruments such as the Geneva Conventions.[35]

The reality, however, is that the Security Council has the ability to intervene at any point, assume and subsequently bury any investigation, and as a fail-safe, the US as an instance, has entered into over 100 bilateral agreements with other states whereby the latter agree not to bring US citizens before the courts. And should states even attempt such an activity—the example of Belgium—whose courts attempted to try Tommy Franks before being subdued by the American threat of removing NATO headquarters from that country—should suffice. Thus any US official is unlikely to face any of these possibilities regarding crimes committed in Iraq.

Once again the issue remains: is this law only to be applied to weaker states, while the strongest enjoy impunity?

However, I do want to consider the position of customary international law in two countries—namely the US and the UK.

(a) The Status of Customary International Law in the US

There is no consensus among US academics and jurists as to the status of customary international law. Opinion on the extent to which customary international law is part of domestic law in the US varies from the school of thought which believes that it has direct application in courts, to the school of thought which holds that customary international law is not part of federal law.

A summary of these diverse schools of thought is given below.

> The most expansive theory justifying the incorporation of international law into domestic law holds that customary international law—at least in so far as it embodies fundamental norms such as those governing war crimes or torture—cannot be violated by the United States, even with the express authorization of Congress and the President acting in unison.

The more prevalent opinion of scholars, however, is that Congress has the power to override any norm of customary international law by enacting statutes. Under this view, customary international law is a default rule that can be overridden by congressional action. Within this camp, some advocates of international law believe that newly developed norms of international law nevertheless supersede prior inconsistent federal statutes until Congress overrules them. By this rationale, whenever a new norm of international law arises, that norm can be enforced by U.S. courts unless and until Congress chooses to override it. While there is widespread agreement that Congress can override customary international law, there are a variety of views on the question of whether the President is bound by it. One position holds that customary international law binds the President unless he is exercising constitutionally enumerated powers. Another holds that the President has no independent constitutional authority to violate customary international law and is thus always bound, unless authorized by Congress. A distinct minority of scholars believe that the President has no obligation to follow customary international law whatsoever. The dominant view also holds that customary international law, as determined by federal courts, can displace state law. Irrespective of Congress's or the President's authority over international law, it is argued that international law remains federal common law and thereby takes precedence over conflicting state law. Recently, some scholars have denied that customary international law has the status of federal law. Under this view, neither the political branches nor the states are bound to follow it.[36]

(b) The Status of Customary International Law in the UK

The status of customary international law in the UK is clearer than that in the US. The supremacy of Parliament makes it impossible for the courts to recognize any law that is not enacted by Parliament. The criminalization of offences would not be recognized in English courts even if created under customary international law until Parliament legislates accordingly. This principle has been repeated in the House of Lords judgments and summed up by Lord Bingham:

> I would accordingly accept that a crime recognized in customary international law may be assimilated into the domestic criminal law of this country. The appellants, however,

go further and contend that that result follows automatically. The authorities, as I read them, do not support that proposition. Lord Cockburn CJ rejected it in *R v Keyn* (1876) 2 Ex D 63, 203, when he said: 'Nor, in my opinion, would the clearest proof of unanimous assent on the part of other nations be sufficient to authorize the tribunals of this country to apply, without an Act of Parliament, what would practically amount to a new law. In so doing we should be unjustifiably usurping the province of the legislature. The assent of nations is doubtless sufficient to give the power of parliamentary legislation in a matter otherwise within the sphere of international law[37]

The above dictum of Lord Bingham illustrates that under English Law there is no direct domestic application in the UK of customary international law and any crime under that law which is not criminalized by an Act of Parliament would not be recognized as such by an English court.

The rationale behind the uncertainty in the US and the clear rejection in the UK in allowing principles under customary international law to have direct effect in domestic law is not difficult to understand.

There is a more fundamental reason why, in my opinion, the Tribunal was wrong in reaching such a conclusion and basing its judgment on it. The matter was treated in the Preface and the Introduction where I argued that Islamic Shari'a is more likely to be incompatible with some of the principles of European Customary Law.

(iii) Crimes against Humanity under Treaty Law

The third leg of the Tribunal's argument, namely that the offences existed under Treaty Law ratified by Iraq must now be addressed. Here we arrive at a very important juncture in our analysis. The question of the position of Treaty Law under Iraqi jurisprudence has been completely misunderstood and chaotically presented by the Tribunal. The reason, in my opinion, is the lack of legal competence of the Iraqis in charge of the Tribunal and the indifference of their US/UK advisers. The problem has its roots in the selection of the incompetent Iraqis who were enlisted in the Judicial Council of the Future of Iraq Project, (see Chapter 5). Had anyone bothered to research Iraqi jurisprudence it would have become apparent how misguided the Tribunal was in its conclusions. The starting point in this is the Iraqi Law enabling the ratification of the Geneva Convention, which reads as follows:

Law No. 24 of 1955

We, Faisal II, King of Iraq
Having regard to paragraph (1) of Article 26 of the Iraqi

Constitutional Law, and upon approval of Parliament, promulgate the following law:

Article 1 – His Majesty, the King, is entitled to take any necessary measure for the State of Iraq to join the Geneva Conventions for the protection of war victims entered into in Geneva on the 12th August 1949 and to sign it.

Article 2 – This Law becomes valid from the date of its publication in the official gazette.

Article 3 – Ministers of the State must implement this Law.

Promulgated in Baghdad on 4 of Rejeb 1374 [Hijra] falling on 26th February 1955.

Faisal and members of the Cabinet

The enactment of the above law establishes the following conclusions of which the Tribunal was oblivious:

1. The jurisdiction of Iraq is sovereign and no law or commitment can have any effect without a legislation approved by Parliament, Government and Ruler.

2. The Government of Iraq has no authority to enter into any international commitment without the legislature authorizing such measure.

3. It took a year between the granting of the authority in February 1955 and the ratification of the Conventions in February 1956.

4. The Iraqi Government made no provisions in Law 24 or in subsequent legislation for the criminalization of the breaches of the Geneva Conventions as required by Article 146 of the Fourth Convention.

It is clear that the Tribunal was unaware of the existence of Law 24 of 1955 when it repeatedly asserted in its judgment that it is beyond dispute that International Treaties have automatic application in domestic courts that require no national legislation.

The practice of Iraq has been in line with the practice in many other jurisdictions; for example neither the US nor the UK would accept the application of a properly entered into treaty in domestic courts until the Senate and Parliament respectively had legislated.[38]

The Tribunal referred more than once to Iraq having ratified the 1949 Geneva Conventions which criminalized the alleged actions, as the binding international treaty on it. However one look at the Geneva Conventions suffices to make one wonder how the Tribunal found any relevance of these Conventions to the alleged offences in the Dujail case.

One look at the Geneva Conventions suffices to make one wonder how the Tribunal found any relevance of these Conventions to the alleged offences in the Dujail case.

The Convention is called: "*Geneva Convention Relative to the Protection of Civilian Persons in Time of War*", which clearly identifies it as applicable to civilians caught in a war. Article 2 of the Convention covers the situations in which the Convention applies as:

- All cases of declared war or armed conflict between states party to the Convention;

- Partial or total occupation of a territory even if such occupation is met with armed resistance;

The Tribunal had not argued in its judgment how it concluded that the Geneva Conventions bound the actions of the Iraqi Government in the case of Dujail. It is clear that the people arrested and tried in Dujail charged with having been involved in an assassination attempt would not have qualified as civilians in time of war, but rather Iraqi citizens accused in a criminal act and thus the Geneva Convention could not apply to them. Had they been Iranian, then there could have been an argument for the application of the Geneva Convention. Nor could the Dujail incident be classified as an insurrection or an internal armed conflict, which also might have brought the Geneva Convention into play.

It is worth pointing out here that the Tribunal ought to have taken notice of Article 146 of the Third Geneva Convention when deliberating on its automatic applicability in Iraqi courts. Article 146 reads:

> The High Contracting Parties undertake to enact any legislation necessary to provide penal sanctions for persons committing or ordering to be committed, any of the grave breaches of the present Convention defined in the following Article.

If the Convention, as the Tribunal concluded, had automatic application in national courts then there would have been no need for the Convention to call on states, which are parties to it, to enact domestic legislation to give

effect to its provisions. The only conclusion to be drawn from Article 146 is that the international community party to the Convention held the view that the Convention did not have automatic domestic application, which refutes the conclusions of the Tribunal to that effect. Although we have concluded that the Geneva Convention could not have applied to the case of Dujail, even if it did apply it could not have been applied to anyone in Iraq so long as the Iraqi Government had not enacted any legislation in accordance with Article 146 to give effect to the Convention.

A further question that arises here is: does the Fourth Geneva Convention recognize crimes against humanity as defined in Article 12 of the IHT Statute

It is not open to the Tribunal to conclude that simply because both Article 12 of the IHT Statute and Article 147 of the Geneva Convention have willful killing among their elements, that they are identical and that thus the retroactivity issue has been resolved insofar as the IHT's Article 12 (albeit modeled after Article 7 of the ICC Statute of 2002, which would be conceded as inadmissible) has always existed in Iraqi law by virtue of Article 147.

The truth of the matter is that Article 147 refers to crimes committed at times of war and is intended to protect persons and civilians covered by the Convention. Article 12 of the IHT Statute, which is derived from Article 7 of the Statute of the International Criminal Court almost word by word, was enacted to try actions committed against a civilian population when committed as part of a systematic action, be that in war between states or within a state itself. It was clearly an attempt by the Tribunal to apply Article 7 of the Statute of the ICC as having been Article 147 of the Geneva Convention in order to avoid being rebutted in applying the ICC Statute retroactively, which the Tribunal has conceded was not admissible.

The Tribunal's Analysis of the Case against Saddam Hussein

The Tribunal's consideration starts with citing the charges of crimes against humanity as defined in Article 12 of the Statute of the IHT which is derived from the Statute of the ICC that came into force on 1 July 2002. I have already addressed above the position of the offences in Article 12 and shown that they did not form part of the prevailing Iraqi law at the time of their commission.

Summary of Prosecution Witnesses' Statements

The Tribunal addressed the prosecution witnesses' statements and testimonies against Saddam Hussein in only two pages of the 300-page judgment. The Tribunal's finding on this started with the following statement:

Most of the complainants whose statements have been taken during the investigation and trial and who have laid accusation against Saddam Hussein, never saw Saddam Hussein ordering the arrest, imprisonment, torture or killing any of the people of Dujail. In addition they never saw Saddam Hussein do any of these acts personally.

However, some of the complainants and witnesses testified that they heard and saw *others* [my emphasis] stating that Saddam Hussein ordered his subordinates to carry out these acts…"[39]

The Tribunal went on to consider briefly the statements of seven witnesses. None of these indicated that the accusation against Saddam Hussein arose from anything beyond having been the head of state and thus automatically responsible for the acts of the state organizations. The Tribunal concludes this section of its consideration by stating:

It seems from the preceding consideration that there were no eye witnesses testifying that Saddam Hussein committed these crimes by himself or even ordered that these crimes be committed. However, this does not mean that there was no other evidence or inferences of his responsibility for these crimes, considering the kinds of personal criminal responsibilities as defined in Article 15 of the Statute of the IHT…[40]

It is clear that the Tribunal admits that the evidence at best is hearsay, the admissibility of which every student of law is taught to challenge without having to go into its reliability. The Tribunal failed to address the reason for the failure of the investigators to trace any of the people who were the originators of these hearsay statements and subpoena them before the Tribunal to repeat their alleged statements.

The Tribunal, in my opinion, failed in this section of its consideration on two further counts. Firstly, it did not address the failure of the investigator to enable the accused or his counsel to cross-examine some of the statements considered by the Tribunal, which amounted to a denial of justice. Secondly, it relied on the personal criminal responsibility, as defined in Article 15, which is itself a matter in contention because it did not exist under Iraqi law prior to 2003, some twenty years after the alleged crimes were committed.[41]

Tribunal's Summary of Saddam Hussein's Statement

The Tribunal summed up the main points in the statement of Saddam

Hussein taken before the Investigative Judge on 12 June 2005[42] (which was done behind closed doors) and during the Trial. It is not clear from the judgment which statements occurred, when.

1. He accepted that if Barazan Ibrahim, his brother and co-accused, has testified that he had asked him to investigate the assassination attempt on his life, then he had done so.

2. He accepted that any statement attributed to Taha Yaseen Ramadhan, his co-accused, if said by him must be true.

3. He accepted that he ordered the release in 1986 of the people from Dujail who were exiled to southern Iraq but denied precise knowledge of who had ordered their detention and exile.

4. In responding to the reason for his failure to take measures against the people responsible for the death in detention of some people from Dujail, Saddam Hussein said that the lack of any scribble by him on the margin of any report did not mean that no action was taken against people who committed offences.

5. He denied, in response to a question, having ever ordered the killing of civilians, stating that he never did, and never will, order the killing of civilians.

6. He denied that there were any plans for any action regarding the arrest and detention of families, oppression of people and confiscation of land in Dujail.

7. In response to a question about his failure to secure legal protection for the people convicted by the Revolutionary Court, he said that there was nothing in the Constitution that required the President of the Republic to enquire as to proceedings and functioning of the Court before ratifying the death sentence passed by it.

8. In his statement in the trial on 15 March 2006, Saddam Hussein concentrated on the right of the President of the Republic to detain those who attempted to assassinate him; to investigate them; to commit them to trial and ratify the judgment of the Court, all in accordance with the Constitution. Regarding the destruction of the Palm groves he said that it was meant to ensure security for the people of Dujail, considering that the search revealed the existence of training fields for the Da'wah Party. He reasserted his immunity

under the Iraqi Constitution and rejected the legitimacy of the Tribunal.

9. The Judgment stated that on 5 April 2006 Saddam Hussein was given another opportunity to make a statement. On that date Saddam Hussein rejected the accuracy of the statement dated 12 June 2005 before the Investigative Judge and alleged that the prosecution witnesses' statements were fabrications. He repeated his rejection of any jurisdiction of the Tribunal to try him.

10. When asked if any military unit could move without an order from him, he responded that when a security incident required immediate action the units would act without orders, but the President is capable to put an end to any operation with one telephone call.

11. He cast doubt on some of the documents allegedly exchanged between the Presidential Office and the intelligence services. However, he said if Barazan Ibrahim said that he had honored a few intelligence officers for their services, then it must have been true and there was nothing shameful in it or that would amount to an offence.

12. In response to a question on his ratification of the death sentence of 148 people, he responded that the ratification was the duty of the head of state. But he said that he was not the judge and the matter had been handled by the Court.

13. When he was asked about the execution of four people by mistake who were declared as having died in detention as contrary to the law, he responded that they were considered as martyrs and the person responsible for the error was committed to trial and sentenced to two years imprisonment.

14. On the exile of 399 people of Dujail to southern Iraq, Saddam Hussein responded that when he learned of the case he was hurt and ordered their immediate release but denied having had knowledge of their exile at the time it happened. It ought to be pointed out here that the original indictment gave no figure for the number of people having been exiled. This further highlights the casual way the Tribunal has dealt with such serious factual and legal issues.

15. When asked about the failure to hand over the corpses of those executed to their families, he responded that he had no knowledge of the matter and was not a manager of a cemetery. When the Tribunal persisted with requesting answers to messages exchanged between

the Presidential Office and other Party or Government offices, he responded that if the intention were to ask about every exchange between any two directors or the head of the Presidential Office, they would need a convoy of trucks to carry the answers.

16. Saddam Hussein doubted the authenticity of identity cards of some of those sentenced to death by the Revolutionary Court as having been minors and stated that he believed these were forgeries.

Summary of Defense Witnesses' Statements

The Tribunal heard twenty-one defense witnesses for Saddam Hussein, which it concluded were either general or had no relation to the Dujail incidents, or were hearsay evidence of what others had related on the assassination attempt on the former President. Some eyewitnesses testified that many caches of arms were discovered in the Palm groves of Dujail following the attempt and that the attempt was all carefully prepared and planned.

When the Tribunal analyzed the defense witnesses' statements, it made a point of indicating that each of these witnesses was not an eye witness of the evidence he was giving. No such repeated observations were made when analyzing the prosecution witnesses' statements, though it was indicated in the summation.

Questions Specifically Relative to Saddam Hussein

The Tribunal attempted on page 101 to address the specific issues relevant to Saddam Hussein's role by asserting that it was concluded, when considering the evidence against Awwad Al-Bandar, the presiding judge of the Revolutionary Court, that all the conclusions reached there applied to all the accused, including Saddam Hussein. A statement such as this raises a fundamental question as to whether the Tribunal really appreciated what criminal proceedings mean and what laws regulate admissibility and application of evidence.

The Tribunal went on to put forward several questions which it considered important to address in order to identify the role of each of the accused. These were:

1. Was the event of 8 July 1982 an assassination attempt on the former President, Saddam Hussein, or was it an operation planned by the accused and his subordinate organizations to provide a pretext for persecuting the people of Dujail? If what happened was an assassination attempt, then what was the scale of that operation and was it planned?

2. What was the number of people who took part in the incident?

3. What was the approximate number of guns used in the incident?

4. Were any caches of guns found in the Palm groves of Dujail, and if so what were their types? If such weapons were indeed discovered, why were they not used in the incident?

5. Was Saddam Hussein or any of his aides or guards injured during the incident?

6. Did an attack on the people of Dujail take place; and if so, when, how and who took part in it, who gave the orders for such an attack, what weapons were used in it and for how long did the attack last?

7. Were any of the Dujail people arrested or detained in 1982? When, how many, on whose orders, by whom and what gender and age were those arrested or detained?

8. Were any of those arrested in Dujail subjected to torture at the intelligence services, the security services, Abu Ghraib prison, the desert camp, or at any other location?

9. What kind of torture was inflicted on the detainees, who ordered it and who executed it?

10. Were any of the people of Dujail killed in the areas of detention, who was killed and who ordered, aided, abetted or procured these killings?

11. Did any of the of the people of Dujail die in the areas of their detention due to bad treatment, shortage of food, lack of medical care, who died and who caused the deaths?

12. Were Palm groves in Dujail destroyed and land expropriated, and if so who ordered the act, who supervised it, who carried it out and who helped in it?

The reader who comes across the above questions would expect some detailed analysis to follow. However, no sooner had the Tribunal suggested these questions than it answered them by simply stating on page 102 that: "answering most of these questions has been done in a detailed fashion in the charge sheet against Saddam Hussein dated 15 May 2006".

It is inconceivable that the above questions could have been satisfactorily answered in one page of an indictment filled with names and dates explaining the sequence of events. The Tribunal seemed to create a tautology by stating the questions it needed to enquire into in order to establish criminal responsibility for offences allegedly committed in the indictment and then immediately relying on each statement in the charge sheet as *the answer* to these questions. It was as if the Tribunal had already concluded that since these questions were addressed in the charge sheet, then there was no need to go any further with the analysis and the whole trial was a waste of time since all the facts establishing the guilt were known all along.

The Tribunal seemed unable to appreciate what establishing criminal responsibility means. It cannot make a presumption of association in a joint act unless the continuous chain of responsibility showing the carrying out, ordering, aiding or abetting the act has been proved beyond reasonable doubt. The indication that the Tribunal had missed this fact is clearly demonstrated by the above questions which it raised as being specifically appropriate to answer in the case of Saddam Hussein.

I shall not attempt to respond to each and every question and argue whether or not it is relevant to the proof of complicity of Saddam Hussein in any of the alleged offences, particularly since the only evidence of any complicity put forward by the prosecution was his signature on one document, and the word "Agreed" scrawled in the margin of another. However to illustrate my observation related to a continuous chain of responsibility, I will address the question of the possible deaths of some of those detained and exiled to southern Iraq.

Let us assume for the sake of argument that Saddam Hussein ordered that these people be detained and exiled to a desert location in southern Iraq, despite the fact that no evidence was adduced during the trial to support this charge and he had persistently denied it. Suppose that it transpired that some of those detained there died because of lack of medical care or poor nutrition. None of these could establish criminal responsibility against Saddam Hussein unless it is established beyond reasonable doubt that he ordered that those detained be denied medical care and proper nutrition, and would reasonably have been expected to know that this would lead to their deaths. Any evidence short of that would not lead to criminal responsibility. The Tribunal seemed to have convinced itself of the layman argument which goes like this: If Saddam Hussein was the head of the regime, then he is automatically responsible for the death of anyone[43] in the hands of any of the State organizations. Such a statement may make sense in a chat in a coffee shop in Baghdad or Erbil but does not carry much weight in law.

The Tribunal's conclusion is also contradictory to this presumption. If Saddam Hussein was the tyrannical despot the Tribunal believes he was, then why did he have to bother with exiling people to a camp and ordering

their starvation when he could have ordered their execution and burial in one of the thousands of mass graves, of which we have been told he had littered Iraq, and finish with the matter? Indeed this leads to another more basic question: why did he wait for the trial, when he could have executed them immediately after the attempt if the whole episode was a plan prepared by the regime to terrorize the people of Dujail as the Tribunal seemed to have concluded.

If the Dujail episode was a plan prepared by the regime to terrorize the people of Dujail, why bother with a trial? Why not just attack Dujail from air and land, level a few residential districts, and claim this was to flush out terrorists—as the US/UK did in Fallujah?

He could have done what the US/UK did in Fallujah in April 2004; attacked Dujail from air and land, leveled a few residential districts and claimed he was flushing out terrorists from the Da'wah Party!

Evidence and Inferences Against Saddam Hussein

The Tribunal summed up the evidence and inferences against Saddam Hussein from what preceded in the Judgment as follows.

1. Saddam Hussein was, between 6 July 1982 and 16 January 1989, the President of the Republic, the Commander-in-Chief of the armed forces, and the Chairman of the Revolutionary Command Council holding both executive and legislative power, which enabled him to promulgate any law whenever he desired. The judicial authority was under the control of the Minister of Justice who was himself subordinate to the executive authority. The irony here is that the Tribunal, which accuses the regime of a despotic nature, itself derived its creation, constitution and legitimacy from the CPA whose head, the American, Paul Bremer, declared on 16 May 2003 that he alone held all the executive, legislative and judicial authority in Iraq and went on to promulgate over 100 laws in the span of 11 months, as he pleased!

2. The video recording shown in court, in which Saddam Hussein, while addressing the people of Dujail, stated that the assassination attempt was carried out by a few people not exceeding ten in number.

3. Saddam Hussein's statement before the Investigative Judge on 12 June 2005 that only a few bullets were fired at him and no one was hurt.

The Tribunal did not accept his later retraction of that

statement and relied on the ruling of the Court of Appeal that statements before an investigative judge are closer to the truth. This Tribunal did not accept that any caches of weapons were discovered in the Palm groves as some defense witnesses had testified.

The Tribunal concluded from all that was available to it that there had been an assassination attempt against the former President of the Republic, but that the attempt had been small and the culprits few in number. It concluded that the assassination attempt was not planned but rather a spontaneous act. This conclusion was based on Saddam Hussein's statement that no one knew of his visits in advance. The Tribunal concluded that Saddam Hussein and his regime had used the incident as an excuse to severely punish the people of Dujail, few of whom were (according to the Tribunal) loyal to the Ba'ath Party or Saddam Hussein.

The Tribunal offered no supporting evidence or arguments supporting the many notions put forward here: that Saddam Hussein had used his attempted assassination as an excuse to punish the people of Dujail, or that the people of Dujail were mostly disloyal—or known by the regime to be disloyal. The Tribunal has not offered any argument in the Judgment as to why the arrest of people involved in an assassination attempt on the head of state was the equivalent of a plan to persecute and punish the whole town of some 10,000 people. No evidence was submitted or acknowledged by the Tribunal to suggest that the arrests and detention of the people of Dujail would have taken place had the assassination attempt not taken place. In any case Saddam Hussein had just completed his visit to the town which he took pride in and to show his determination that he held nothing against the people of Dujail he turned back after the attempt to address the people and inform them that he was not concerned about the activities of the few in the town—an action which might well have been presumed to be reckless, if it were known that the population of Dujail were disloyal.

4. The orders issued by Saddam Hussein to the officials in the security organization directly answerable to him and the order to Taha Yaseen Ramadhan to head a Working group to properly plan how to handle the situation starting with the arrest of the people of Dujail, their detention and investigation. That is precisely what happened on the day of the attack and the following days and weeks.

5. The order issued by Saddam Hussein to the head of intelligence services, Barazan Ibrahim, to command the operations in Dujail.

6. The official documents that establish what Saddam Hussein knew and his orders regarding what was happening in Dujail about actions that constituted crimes against humanity. These are listed as:

 a. The report from Barazan Ibrahim to Saddam Hussein dated 13 July 1982 regarding the request for decoration of officers of the intelligence service for the distinguished effort in arresting and investigating the people of Dujail.

 b. Order of the Revolutionary Command Council (RCC) number 982 dated 31 July 1982 decorating these officers.

 c. Orders of the RCC number 1283 dated 14 October 1982 and 100 dated 23 January 1985 expropriating land in Dujail.

 d. Order [left undated by the Tribunal] committing 148 accused from Dujail to the Revolutionary Court and Presidential Decree number 778 dated 16 June 1984 ratifying the death sentences.

 e. Report submitted by the Committee headed by Hussein Kamil in 1987 regarding the Dujail case with comments by Saddam Hussein. To my knowledge, this Report was not even presented during the trial.

 f. Report submitted by the legal section of the Presidential Office dated 28 July 1987 regarding the execution by error of four people.

 g. Report submitted by the legal section of the Presidential Office dated 5 April 1987 regarding discovery that two of those convicted had escaped being executed.

 h. A recording which showed Saddam Hussein stating that he did not care much about how many people die during investigation. [Although that recording was made before Dujail and had no link to it, the Tribunal believed that it could infer from it the way Saddam Hussein used to think.]

 i. The order of Saddam Hussein to compensate the owners of the Palm groves that were destroyed.

 j. Satellite images of Dujail dated 25 September 1982 and 31 July 1983 showing the areas in which the Palm groves where destroyed.

k. The failure of Saddam Hussein to order any investigation or trial of those responsible for the arrest, detention, torture or killing of the old and the children, despite his knowledge of these acts having taken place.

l. The voice recording of conversation between Saddam Hussein and Taha Yaseen Ramadhan over the compensation for the destroyed Palm groves.

m. The voice recording of the speech of Saddam Hussein addressing the heads and dignitaries of the Juboor Tribe in which he referred to what had happened to the people of Dujail.

n. The statements of some of the witnesses and complainants referred to, previously. [sic].

o. The responsibility of Saddam Hussein as superior head, as he was between 8 July 1982 and 16 January 1989 the President of the Republic, the Commander-in-Chief of the armed forces and the head of the RCC.

The Tribunal goes on to conclude that from the exchange of letters with comments on their margins, it has been proved that Saddam Hussein ordered acts that constituted crimes against humanity and that consequently he was criminally liable for crimes committed by his subordinates in Dujail on 8 July 1982 and for what happened to the people concerned for years thereafter, up to 16 January 1989 as had been stated in the indictment of 15 May 2006.

Extent of Saddam Hussein's Responsibility

The Tribunal proceeded to analyze the extent of Saddam Hussein's responsibility in each of the offences under Article 12 relying on the evidence and inferences it had drawn. (I am using the numbering used in Article 12 of the IHTS to identify the offences.)

(A) Willful Killing

After reciting the events of the previous paragraphs, the Tribunal concluded this section of its analysis by stating:

> This Tribunal believes unwaveringly, without any reasonable
> doubt and as this being the only logical and reasonable

conclusion, that the accused Saddam Hussein made direct or indirect orders (through the accused Barazan Ibrahim and Taha Yaseen Ramadhan) to attack the town of Dujail following the failed assassination attempt by a few people. That attack was unnecessary and disproportionate to the limited attempt.[44]

No evidence of such order "to attack the town" was offered in the trial and both of the named accused had denied having been ordered to mount such an attack.

The Tribunal considered Saddam Hussein's responsibility for murder as having occurred through his ordering the trial and concluded that Saddam Hussein was a principal actor in murder when he ratified the death sentences passed by the Revolutionary Court.[45] But the Tribunal had failed to show why a sentence passed by a legally constituted court would amount to murder—and it misinterpreted the meaning of a principal in a crime. When it attempted to expand on the liability of the principal in an offence, it stated that "he who orders others to commit a crime is considered a principal because he undertakes a main role that may even be more important and dangerous than the principal in the crime".[46] In doing so the Tribunal asserts that transferring a person to trial before a legally constituted court is a crime. Such an assertion has no legal foundation.

(D) Deportation or Forcible Transfer of Population

The Tribunal considered the event of exiling some people from Dujail to Camp Liya in southern Iraq in 1983, and concluded that it had enough evidence to support the legal charge of "forcible transfer".

Although it had not been shown that Saddam Hussein had ordered the forcible transfer of those families, the Tribunal stated it believed that he learned of the act sometime around April 1983 and overlooked and did not stop it. The inaction of Saddam Hussein was, according to the Tribunal, "an expression of the undeclared agreement required in a joint criminal act, which represented the contribution of Saddam Hussein towards consolidating the criminal activity and objective of the Ba'ath Party and regime".[46]7

The Tribunal based its conclusion of belief on correspondences between the Intelligence Services and the Security Directorate relating to the exiled families, none of which were addressed or marked as copied to Saddam Hussein. It would be naïve to assume that the Head of State would know the details of every activity carried out by his intelligence and security services.

It would have been even more bizarre to reach that belief in the case of Iraq in 1983-1984. There are two reasons. Firstly, the Intelligence Service

under Barazan Ibrahim assumed so much power and authority that it enacted his command with impunity; ran every Ministry, especially the Foreign Office to the extent that its employees began to address Barazan Ibrahim as the 'President'. That was the main reason why, in 1983, Saddam Hussein fired Barazan Ibrahim and reshaped the services. The Intelligence Service never recovered its previous influence.

Secondly, during 1983-1984, Iraq was facing defeats in its war with Iran and Saddam Hussein was busy monitoring with anguish the daily battles and the gloomy prospects of a full defeat. It was left to Ahmad Hussein, the Chief of the Presidential Office, to deliver correspondences and reports to the President. It would have been unthinkable for a reasonable man, like Ahmad Hussein whom I know personally, to inform the President about the events of exiling some people within Iraq at a time when he felt that the President ought to worry about the future of the country. If anybody in the Presidential Office knew of the case of exiles in Camp Liya, it would have been Ahmad Hussein and he would not have bothered the President with it. That in my mind is the logical explanation of Saddam's ignorance of the affair. But as the Tribunal had failed to show otherwise, then its conclusions are conjecture and not based on fact and should not be the bases on which a judgment could be made. (See my treatment in Chapter 5 on Why Dujail)

(E) Imprisonment or other severe deprivation of physical liberty in violation of fundamental norms of international law

After reciting the events of arrests of many people following the assassination attempt on Saddam Hussein, the Tribunal concluded:

> None of the complainants of witnesses had testified that Saddam Hussein personally arrested anyone of the people of Dujail, nor that they heard Saddam Hussein ordering such arrests. But it is established that the accused Saddam Hussein ordered the accused Barazan Ibrahim and the accused Taha Yaseen Ramadhan to interrogate the people and supervise all measure necessary towards that end.[48]

The Tribunal went on to assert that the accused had implicitly admitted his knowledge of the imprisonment of the victims when he stated in Court on 21 December 2005 that any harm caused to witnesses who testified was wrong and contrary to the law. Such a statement does not, of course, prove any such knowledge at the time.

Having argued the above the Tribunal concluded that:

Because of the above the Tribunal is totally convinced that

the accused Saddam Hussein bears full criminal responsibility for the imprisonment, the severe deprivation of physical liberty of the people of Dujail as a crime against humanity.

I am baffled as to how the Tribunal arrived at such a finding but even more baffled at its inference that when a man states that subjecting people to deprivation is wrong and contrary to the law, then it can be concluded that he knew that it had happened, and that he approved of it.

(F) Torture

The Tribunal reviewed statements made by witnesses for the Court regarding the torture they had been subjected to and concluded that it was convinced that detainees were subjected to torture. However, the Tribunal observed that "none of the complainants said that Saddam Hussein himself tortured anybody or that they heard him ordering torture to occur. But, most of them said that Saddam Hussein was responsible because he was the President and, as the shepherd, was responsible for his flock".[49]

The Tribunal went on to argue that although it accepted that Saddam Hussein had ordered that Barazan Ibrahim supervise the investigation which did not include a clear order to torture them, this nevertheless implied torturing them.

In a second bizarre twist in support of its conviction of Saddam Hussein's knowledge of the torture of the detainees, the Tribunal cited his order to prosecute the intelligence officer, Hikmat Abdul-Wahhab, for having negligently caused the mistaken death of four victims from Dujail. Instead of using the evidence that Saddam Hussein had prosecuted a member of the intelligence service for causing the death of four people in his favor, it chose to assume it as evidence of his complicity through knowledge!

The Tribunal's conclusion on Saddam Hussein's responsibility for the treatment of prisoners while in the custody of the intelligence service is based neither on evidence nor can it rely on inferences of dubious merit. It is even more disturbing to find that the Tribunal seemed capable of putting forward evidence as supporting its findings of culpability when that evidence would appear to do the very opposite. It was as if the Tribunal felt it simply needed to state something—anything—in order to fill up the space, and nobody would ever give its reasons any intelligent review. Such instances lead to the appearance that Saddam Hussein would be found guilty whether he acted to stop a crime or did not.

It was as if the Tribunal felt it simply needed to state something—anything—in order to fill up the space, and nobody would ever give its reasons any intelligent review.

Conclusion on the Tribunal Judgment

In every consideration of elements of the offences under Article 12 with which Saddam Hussein was charged, the Tribunal concluded that there was no direct evidence that he committed any of them or ordered them to be committed. Yet nonetheless the Tribunal concluded that he was responsible for them.

The legal test that ought to have been applied is that which was accepted in the International Criminal Tribunal for Yugoslavia, which I would apply here despite my misgivings about that Tribunal.

(i) that he knew that a crime was being committed, or was about to be committed, by those identified subordinates; and

(ii) that his conduct shows that he failed to take the necessary and reasonable measures to prevent such acts or to punish the persons who committed them.[50]

The Tribunal failed to satisfy both requirements of that legal test and thus failed to establish that Saddam Hussein was criminally responsible for the acts with which he was charged.

The Appeal

Following the pronouncement of sentence on Saddam Hussein on 5 November 2006, the following sequence of events took place as communicated to me by defense lawyer, Wadood Fawzi.

On 22 November, i.e. some 17 days after pronouncement of sentence, the defense lawyers received the 296-page judgment. As the time limit for filing an appeal is 30 days after sentence pronouncement, the defense was left with only 11 days to analyze the Judgment and appeal from it.

On 3 December, the defense lawyers lodged their appeal and requested an extension to file an annex to the appeal in accordance with the Criminal Procedure Law. Such an annex was filed on 17 December.

On 27 December the defense lawyers received the decision of the Appellate Chamber of 26 December approving conviction and sentence.[51]

On 30 December 2006 Saddam Hussein was executed.

The striking fact about the above sequence of events is the speed with which everything was drawn to a close. The case was unique and historical as it is not every day that a Head of State is put on trial. The case was far from simple with many unprecedented questions for international law and Iraqi law. The evidence and testimonies were sketchy and largely hearsay. The accused were not given a fair hearing. Yet despite having taken

more than twelve months of proceeding, and despite a Judgment of 296 pages, the whole appeal and approval by the Appellate Chamber was completed in less than a month.

There is a striking and unprecedented feature in the Appellate Chamber's judgment. It starts with the following sentence:

> The Appellate Chamber of the Iraqi Criminal Tribunal consisting of its judges authorized to judge in the name of the people, met on the 5 Thi Al-Hijja, 1427 falling on 25 December 2006 and passed the following judgment.

However, there is no indication as to who the members were or how many judges considered the appeal. Whilst the IHT judgment at least had the signatures of five judges, albeit with concealed names, the Appellate Chamber did not even bother with this nicety. The only name and signature on the judgment is that of its Chair, Arif Abdul-Razzaq Shaheen.

The Appeal Judgment consisted of 18 pages, the first six of which cover the Judgment of the IHT against all the accused and summary of the appeals lodged from these judgments. It gave the following summary for the grounds of appeal on behalf of Saddam Hussein.

- The lack of jurisdiction of the IHT.
- The immunity of the President.
- The non-criminality (non-existence) of the offences under existing Iraqi law.
- Failure to apply the proper standard of proof of 'beyond reasonable doubt'.
- Termination of proceedings without hearing the accused's defense.
- The IHT Statute's contravention of Iraqi criminal law.
- Breach of basic principles of fair trial.
- Breach of justice in expelling members of defense team.
- Breach of Article 156 and Article 159(2) of the Iraqi Civil Proceedings Law Number 83 of 1969.

The Appellate Chamber decided to consolidate the appeals of all the defendants and consider them as one. The Appeal Judgment signed by the President of the IHT mirrors the incompetence of the Tribunal: the casual way in which the Appeal Judgment is written, the lack of a single piece of evidence being identified to support its Judgment, the misunderstanding of the principles of international law and the total indifference to the principles of justice that transcends all laws, international or domestic. These all demonstrate the incompetence of the IHT and a total failure of justice. This is demonstrated from the first paragraph of the Appeal Judgment on pages 6-7[52] which reads:

After having considered the judgment appealed from, it has been found that the evidence on which the Tribunal based its judgment in convicting the accused, Saddam Hussein, consisted of:

1. his being, at the time of the incidents from 8 July 1982 until 16 January 1989, the President of the Republic, the Commander of the Armed Forces and the President of the Revolutionary Command Council;
2. the fact that he held both executive and legislative authority;
3. the recording of him addressing the people of Dujail on the day of the incidents, saying that those who fired at him were two to three but no more than ten people;
4. his statements during the preliminary and judicial investigation;
5. the orders he gave to those in charge of security organizations;
6. the hundreds of official documents attached to the case file;
7. his order to compensate the people whose palm groves were destroyed.

The convicted is thus responsible for the systematic and widespread attack directed at the civilian population of Dujail and had knowledge of it. Consequently the intent of murder as a crime against humanity had materialized. The material element represented in the criminal conduct (the act of killing) and the criminal result of the death of the victims among the people of Dujail and the causal link with that conduct has all existed. Considering that crimes against humanity have been defined in law as those acts under Article 12 of Law Number 10 of 2005 when committed as part of a widespread and systematic attack directed against any group of civilian population with knowledge of that attack, then most of these crimes may take place as a result of act of a State or policy executed by actors who wield authority or others. But it is obvious that when such crimes are committed or are directed against civilians, then it is necessarily the result of a State policy which carry its acts through perpetrators who have authority or is the result of policy of actors who have no authority. As the convicted Saddam Hussein had authority by virtue of the fact that he

was the former President of the Republic and that he directed his crimes against the civilian population in order to kill, then the intent to kill existed and he consequently is responsible for it as a crime against humanity and thus all the defenses put forward by his agents are rejected.[53]

I leave it to the readers to judge for themselves the quality of such a legal argument, which in my opinion would be struck out of an essay written by a first year student of law. However, if we put issues of language aside and assume that the judge intended to say that, having admitted the above seven elements of evidence, then the Tribunal was right to convict. I shall briefly address the failures with such conclusion.

- Being the President of the Republic and holding executive and legislative authority is not evidence unless the causal link is shown to exist, and when it is shown that the test as suggested by the ICTY (see above) is satisfied. If that were not the proper legal position then the British Prime Minister would have been criminally liable for the massacre of Bloody Sunday in Northern Ireland [54] and the US President would have been criminally responsible for the burning of civilians by the FBI in Waco,[55] or the phosphorus bombing of people of Fallujah.

- The address by Saddam Hussein to the people of Dujail after the failed assassination attempt had been repeatedly relied on by the Tribunal and the Appellate Chamber. I find it difficult to understand the reference to it. When Saddam Hussein addressed the people of Dujail he was conveying a message which is expected of a Head of State in a time like that, namely that *'I do not hold you responsible for an act by a few among you'*. However, when the investigation later uncovered a plot instigated and financed[56] by Iran at a time Iraq was at war with Iran, then the arrest of a wider circle of people suddenly becomes 'justified' and would have modified what Saddam Hussein assumed immediately after the attempt. I am not able to understand how the Appellate Chamber used that statement as an element of evidence substantiating guilt.

- The Appellate Chamber failed to cite one example of what Saddam Hussein said during the investigation to support its claim that it served to incriminate him. It equally failed to cite one order he gave to his subordinates that amounted to guilt which was conducted outside his duty and responsibility, and which document linked him directly to the offences. When a court of the first instance is

challenged on its handling of evidence, it would not be sufficient for the appellate body to make a sweeping statement about its findings.

- It seems to me that both the argument of the Tribunal and the approval of the Appellate Chamber that Saddam Hussein's order to compensate some of the people of Dujail for their Palm groves amounted to admission of guilt, is ill conceived to say the least. If anything it ought to be construed in his favor. A leader bent on punishing his people would not go around paying them for the damage his action had caused.

The Appellate Chamber proceeded after the above conclusion to give its reasons which did not necessarily correspond to the appeal lodged on behalf of the accused:

1. The Appellate Chamber (AC) argued that the setting up of the Iraqi Special Tribunal (IST) in Order 48 issued by Paul Bremer, the head of the Coalition Provisional Authority (CPA) was done in accordance with Security Council Resolutions (1483, 1500 and 1511).[57] This is an error of fact. A quick look at these Resolutions, despite the fact that the Security Council acted *ultra vires*, would immediately reveal the opposite to the AC assertion. Security Council Resolution 1483, in fact, was not simply silent on this issue but sought to prohibit the CPA from setting up any special Tribunals or changing the Laws of Iraq. Neither Resolution 1500 nor 1511 lend any support to the assumptions made by the AC.

2. When addressing the defense of immunity granted to the President in Article 40 of the Iraqi Constitution 1970, the AC argument avoided any reference to Article 40 and put forward no argument to refute that defense. Instead it went on to argue that the concept of immunity had died after WWII, which notion was supported by the creation of the new international criminal tribunals, and that the Statute of the Tribunal enabled it to try the accused irrespective of his official position. The AC relied on Article 13 of the Third Geneva Convention in support of its argument. The defense of immunity of the Head of State is fundamental and both the Tribunal and the AC had to overcome it before establishing jurisdiction. It seems to me that the AC had failed, just like the Tribunal, in disposing of this burden. I shall briefly argue my reasons.

 a. The failure of the AC to argue the invalidity of Article 40 of the Iraqi Constitution 1970 renders the rest of the argument spurious.

There is no room in law to argue the morality of a principle in the presence of a clear legal principle supporting it.

b. It is not true that the principle of immunity for heads of state has died since WWII. The AC gave no evidence of that. In fact I have shown in this chapter how the legal opinion in the UK, expressed in the words of the learned Lord Hope, contradicts what the AC stated. The setting up of the Yugoslavia Tribunal is not evidence of a change in the principles of international law. Rather it was another instance of victors' justice, established with dubious legality and intended to justify the aggression of NATO.

c. Article 13 of the Geneva Convention 1949 is completely unrelated to the situation under review. Article 13 reads as:

> Prisoners of war must at all times be humanely treated. Any unlawful act or omission by the Detaining Power causing death or seriously endangering the health of a prisoner of war in its custody is prohibited, and will be regarded as a serious breach of the present convention.

I fail to see how the AC could expect to get away with this purposeful deception of inviting people to accept that its argument is supported by an international treaty such as the Geneva Convention.

3. The AC accepted that retroactivity is inadmissible under Iraqi Law. However, in order to establish jurisdiction to try offences committed contrary to Article 12 of the Statute of the IHT, the AC repeated the argument of the Tribunal that as these were criminalized under customary international law, then they have automatic application in Iraq. I have already addressed this contention above and need not repeat the argument as the AC added nothing new.

4. The defense had argued that the Tribunal ought to have adhered to Article 2 of the Criminal Penal Code Law Number 111 of 1969 which binds the court to pass the most favorable sentence available when one or more laws are enacted after the commission of an offence, and since the CPA had suspended the death sentence then the Tribunal was bound not to impose it. On page 7 of its judgment the AC stated that the setting up of the IST was a legitimate act carried out by the CPA in Order 48 of 10 December 2003 relying on the

authority of Security Council Resolution. However, on page 11 of the same judgment the AC stated that the CPA had no legislative authority in Iraq. I suggest that both arguments cannot be held, and dished up as needed. Either the AC believed that the CPA had legislative authority in Iraq which would have made it legal for it to promulgate both Order 48 setting up the IST and Order 7 suspending the death sentence, or that the CPA had no legislative authority and thus the setting up of the IST itself, and the activities it undertook that enabled the IHT trial were also unlawful.

5. All the remaining points of appeal were dismissed by the AC in one sentence on page 12 of its Judgment.

> As regards the other defenses, all the accused were given adequate guarantees that was sufficient to provide a just trial. He was immediately informed of the charge against him and its reasons. He was given enough time to prepare his defense and was given legal assistance from among those he chose. He was given ample opportunity to defend himself with the assistance of his legal advisers and given the opportunity to question his witnesses and cross-examine prosecution witnesses. He fully used his right to defend himself and was not forced to state what he did not want to state. The defenses raised on these issues are rejected too.

It was as if the AC had tired of the matter, and decided to shelve the whole lot in one swoop.

Is the Death Sentence Available under Iraqi Law?

The Tribunal and the AC argued repeatedly that the norms of customary international law have direct application in Iraq. If this is so, then with what legitimacy can it propose to apply the death penalty, which no longer holds international legitimacy?

It is true that the death sentence was an acceptable punishment in almost every state during the previous centuries. However, as the norms of customary international law develop with time, the world has come to adopt the new

As the Tribunal and the Appeal Court argued repeatedly that the norms of customary international law have direct application in Iraq, then how could they propose to apply the death penalty, which no longer holds international legitimacy?

norm of abolishing it as a punishment. Most states in the world today do not carry out death sentences either because the new norm has been accepted in practice or because new legislation has abolished it. Europe, where all the customary international laws have developed over the last centuries, has gone further and abolished the death sentence by legislation. And finally, this has received universal treaty recognition in the abolition of the death penalty by the Second Protocol to the International Covenant on Civil and Political Rights, ratified as General Assembly Resolution 44128 of 15 December 1989.

Furthermore, there is a principle in international law called *lex mitior*, which holds that if new laws or rules come into force between the alleged offences and the hearing of the allegations on them, then the sanctions that are '*more favorable*' to the accused must be applied. This principle has long been incorporated in Iraqi Penal Code Law Number 111 of 1969, Article 2. The principle has also been incorporated in Article 24(2) of the ICC Statute which amounts to its universal acceptance by almost all the principal states of the world.

I have shown in Chapter 4 that when Paul Bremer arrived in Iraq he set up the CPA and declared on 16 May 2003 in Regulation 1 full and absolute power in Iraq. On 9 June 2003 Paul Bremer promulgated Order 7 which suspended capital punishment.

Six months later on 12 December 2003, Paul Bremer promulgated Order 48 setting up the IST and gave it its Statute. The IST carried out the process until the eve of the trial of Saddam Hussein, when in an act of 'legal acrobatics' its name was changed into IHT to pretend that it was a creation of the an Iraqi authority and not that of the occupying power.

Since both the ISTS and its derivative, the IHTS, acknowledge that the Iraqi Penal Code Law Number 111 formed the general principles of criminal law in the trial and since the Tribunal, the AC and the Iraqi Governments since 2004 have all accepted that the legislations passed by the occupying powers form part of Iraq's new constitution and bind all authorities, it is difficult to understand the AC's refusal to allow Saddam Hussein to benefit from the *lex mitior* principle. The death penalty was not the only available penalty.

Saddam Hussein had to die in order for the invaders to justify the killing, the carnage and the continuous destruction of Iraq.

The Execution

After the long journey we approached the final chapter in this farcical show trial. I would like to state that Saddam Hussein had to die in order for the invaders to justify the killing, the carnage and the continuous destruction

of Iraq. However, even though they had all the means to stage the act properly, they still ended with a trail of inconsistencies, unprofessional practices, suppression of evidence, transgressions of law and even of UN Resolutions.

Saddam Hussein was accused by the invaders and their stooges of acting as he pleased and breaching the rule of law. The '*new democratic*' regime, which uses F16 fighters against its civilians, has promised to change the old practices and apply the rule of law.

Thus a new Iraqi constitution was promulgated and adopted by a referendum.

This 2005 constitution, like almost any other in the world, included an Article, 71(8), which requires that the Head of State ratify any death sentence passed by any court in Iraq.

But some transitional arrangements were required to please the opportunists among the Sunnis, Shi'a and Kurds. Among these was the need to have a Presidential Council rather than a President. This Presidential Council consists of a Kurdish head and one Arab Sunni and one Arab Shi'a as deputies.

The following Constitutional requirements resulted:

1. Death sentences pronounced by any authorized court in Iraq must be ratified by the President of the Republic.
2. The authority of the President of the Republic, including that of ratification of death sentences, is exercised by the Presidential Council.
3. The decisions of the Presidential Council must be unanimous.

Thus when the Appellate Chamber approved the death sentence on Saddam Hussein, it was naturally expected that such a sentence would have to be ratified by the Presidential Council to legitimize the execution. But that was more easily said than done. Neither Tariq Al-Hashimi, the Sunni Arab Deputy President nor Jalal Talabani, the Kurdish President, was willing to put his name to the death sentence. Al-Hashimi would have had difficulty in convincing his Sunni constituency that the execution of their symbol was justified on moral or legal grounds. Jalal Talabani, on the other hand, had always wanted to see Saddam Hussein removed forever, but he was too shrewd a politician to have his blood on his hands. Why have history record that an Arab Nationalist was executed by a Kurdish President? Knowing that Saddam Hussein was going to be executed one way or another, he attempted to appear as the humanitarian he never was and claimed that he objected to capital punishment as a matter of principle, notwithstanding that he had previously repeatedly informed the media that Saddam Hussein ought to be executed repeatedly!

It became clear that the Presidential Council was not going to ratify the

death sentence as required by the Constitution. Suddenly there arose a simple-minded argument which was even attributed to some anonymous members of the Tribunal. It was based on using Article 27 of the IHTS which reads:

> No authority, including the President of the Republic, may grant a pardon or reduce the penalties issued by this Tribunal. Penalties shall be enforceable within thirty days of the sentence of decision reaching finality.

Those who wanted to go for lynching argued that once the death sentence was approved by the Appellate Chamber then it should be executed within thirty days without any need for the Presidential ratification as required by the Constitution. It is alleged that in the end the Prime Minister signed it despite the fact that he had no authority to do so—but who cares?

It is not difficult to see how misconceived such an argument is. The Constitution is a supreme legal document and thus cannot be subordinated to any other domestic legal document, however important it may be. Thus Article 27 of the IHTS could not assume precedence over the Constitution without effectively abrogating it. Such an authority is not available to any legislation. If we were to assume that it was indeed intended in the IHTS to uphold Article 27, it is still true that such stipulation has since been repealed by the Constitution. There is no provision in the Constitution that allows the authority of the President to be fettered. As the Constitution requires Presidential ratification then no death sentence could be executed without that occurring, whatever any other legislation may or may not say.

Saddam Hussein was, according to his captors, a POW since his detention on 13/14 December 2003. He remained in the hands of the US/UK authority until his execution. Iraq has been occupied ever since 1 May 2003 when President Bush declared that the military operation had ended and the US/UK had prevailed. Although the sovereignty of Iraq was partially breached since 1991 by the imposition of the no-fly zones by the US/UK, it was totally breached when it was fully occupied by the US/UK forces. Iraq today remains occupied, whatever name is given to the foreign troops controlling its land, its borders, its air space, its economy and more importantly, the freedom of its citizens. This is occupation as defined under international law. If a learned legal mind in the UK or the US objects to this then he ought to advise us as to the position of the tens of thousands of Iraqis who have been held by the occupying force on Iraqi soil. And bear in mind the classification of the French who were detained in France by the Germans during WWII.

As a POW, as classified by the US/UK occupiers of Iraq, Saddam Hussein was their responsibility and was entitled to be protected by the Fourth Geneva Convention of 1949. Whether it was Nuri Al-Maliki and the

vengeful turbans around him, or the neocons led by Dick Cheney in Washington, who wanted the execution to be rushed through before the New Year, it remained a fact that Saddam Hussein's execution was an unlawful killing in which the US/UK were complicit.

Even if all the argument put forward in this book about the illegality of the Tribunal, the unlawful retroactive application of criminal law, the unfair trial etc., is not accepted, the death sentence could only have been proper had it been executed in accordance with the law as created by the US/UK and the new regime they set up in Iraq. It was the duty of the US/UK holding Saddam Hussein to ensure that he would not be handed over to the executioner until the death sentence was properly ratified in accordance with the procedures required by the Iraqi Constitution. Nuri Al-Maliki has no constitutional authority to ratify a death sentence. Only the Presidential Council does. The US/UK ought to have refused to hand over Saddam Hussein until the process was complied with fully in accordance with the law.

But how likely was that, since events were, however circuitously, proceeding at last to that destination that they had intended since the beginning?

To sum up I submit that Saddam Hussein's execution was an unlawful killing because not only was his trial a disgraceful exercise in twisting legislation, perverting the course of justice and jumping to prejudicial conclusions, but the sentence was carried out without proper legal authority and with the connivance of an illegal occupying entity. It was morally inconsistent because one of the effective powers behind the Iraqi government (the UK) has abandoned the death penalty and yet stood by while it was carried out. It destroyed trust in US/UK politicians because their coalition violently tore Iraq to pieces allegedly to remove a 'tyrannical regime' that was abusing human rights whilst committing far more serious breaches of human rights from a more distant tyrannical seat of power. This is without considering the lies which took the US/UK to war in the first place or the covert reasons which are likely to be about maintaining Israel as the regional superpower and paying for the destruction of Iraq by raiding its own oil resources.

The sudden termination of the Trial, which was followed by a sudden sentence passed without judgment on 5 November, with every indication that it would be followed by a swift execution of Saddam Hussein without even a proper appeal, coincided with the Congressional re-election in November 2006, and may have been intended to give President Bush an apparent victory for his Party acolytes. No doubt Tony Blair was also desperately searching for excuses to ward off critics of his catastrophic Iraq war which ultimately brought his early demise as Prime Minister in June 2007. Both leaders face calls for criminal prosecutions for their willful part, as they accused Saddam, in the deaths of hundreds of thousands of innocent Iraqi people and in the destruction of their country.

More significantly, the execution was deliberately timed to take place on December 30th, 2006, on the very day that Sunni Muslims not just in Iraq but worldwide were observing the religious holiday of *Eid-ul-Adha* (Feast of Sacrifice). Concurrently, both the media and official U.S. statements pointed to the Shiite Muslims (and the so-called "Shiite government") as being responsible for the execution—thereby seeking to enrage Sunni Muslims against Shi'a Muslims in Iraq and the Middle East.[56]

The execution was deliberately timed to take place on the very day that Sunni Muslims not just in Iraq but worldwide were observing the religious holiday of *Eid-ul-Adha*.

But the message the world reads may not be as its purveyors have intended. As former Malaysian Prime Minister Mahathir Muhammad put it:

> On the Holy day of Eid, the world watched in horror at the barbaric lynching of President Saddam Hussein of Iraq, allegedly for crimes against humanity. This public murder was sanctioned by the War Criminals, President Bush and Prime Minister Blair.
>
> The entire trial process was a mockery of justice, no less a Kangaroo Court. Defence counsels were brutally murdered, witnesses threatened and judges removed for being impartial and replaced by puppet judges. Yet, we are told that Iraq was invaded to promote democracy, freedom and justice. [58]

The Iraqi High Tribunal and the Evolution of International Law

The trial of Saddam Hussein was undoubtedly intended to be billed as the Trial of the Century and a celebration and justification of the use of American military power—before it descended into the chaos and contradictions that have labeled it, similar to the war on Iraq itself, a fiasco. Even as the Bush administration sought to establish the processes which set out Iraq's invasion and politico-institutional redesign as another historic benchmark in development of a purported right of humanitarian intervention in service to the law of American Empire, which in turn might come to be seen as having overtaken international law as then understood, if not practiced, by Europeans, things may be falling apart due to the resistance of the Iraqi people.

The Iraqi High Tribunal remained caught in the time warp. Still projecting for itself a historic role in the future evolution of international law, it elaborated its interpretation of what was at stake and its place in the purported historical chain of precedent-setting bodies as follows:

The Tribunal believes that international custom regarding crimes against humanity during time of peace has been consolidated later through the issue of law for the International Criminal Tribunal for Former Yugoslavia (ICTY) 1993, the law for the International Criminal Tribunal of Rwanda (ICTR) 1994, the Statute of the ICC 1998 and finally the Statute of the Iraqi Special Tribunal 2003 and the Statute of the IHT 2005.[59]

However, there is an absolute difference in the nature and the legal foundations of these Tribunals (which many regard, particularly the ICTY and ICTR, as improperly established)[60] compared to those of the Iraqi Special Tribunal. This may be summed up as follows:

1. The International Criminal Court differs so much in its principle from the Iraqi Special Tribunal [the IHT] that it would be ludicrous even to attempt to conclude that the IST is a derivative of the ICC. The fundamental principle of the ICC is that the crimes of genocide, war crimes and crimes against humanity could only be tried if committed after 2002 while the IST[IHT] has a retroactive jurisdiction to 1968 despite having been created in 2003. The ICC Statute makes it possible to try the current Government of Iraq but not that of 1968-2002, while under the IST Statute it is impossible to try the current Government of Iraq because there is a presumption that crimes against humanity could only have been committed in Iraq between 1968 and 2003.

2. The ICTY was created by Resolution 827 of the United Nations Security Council, which was passed on May 25, 1993, while the ICTR was created by Resolution 955 adopted on 8 November 1994. Thus both Tribunals were created by the Security Council exercising its role in accordance with International Law while the Iraqi Special Tribunal was created by Order 48 of 10 December 2003 promulgated by Paul Bremer the Administrator of the occupying power in Iraq contrary to Iraqi and international law.

3. Both the ICTY and the ICTR have international judges, prosecutors and advisors and were situated in remote areas to ensure independence, impartiality and fair trial to both the accused and the victims. The IST was created by the Occupier with anonymous judges selected on the principle of enmity to the old regime which they were trying and located in one the most insecure cities in the world where intimidation would be a danger for anybody taking part in the Tribunal as we have seen, at least three lawyers were assassinated.

4. Both the ICTY and the ICTR were created to try specific crimes committed during a specific conflict of a transnational nature. However, the IST was created to try internal offences. The IST was also likely to have been set up to try a political era in the history of Iraq— namely the Ba'ath rule in Iraq between 1968 and 2003. I hasten to add that the trial of a political era is itself a crime against humanity because it breaches Article 7(h) of the Statute of the ICC.

Conclusion

The trial of Saddam Hussein over his consent to the Judicial Execution of 148 people in 1984, who participated in an assassination attempt, was a spectacular example of an unlawful show trial. It lacked nearly every norm of legal process. The Tribunal was set up in December 2003 by an illegal invader who falsely claimed legitimacy under UN Resolutions which expressly forbade interference in the legal aspects of Iraqi life. The Iraqis invited onto the Tribunal were trained in the UK for the purpose. They were also selected from opposition groups, all of whom stood against Arab Nationalism. It thus had discriminatory undertones. Its name was changed when the Iraqi government took over but it still ignored Iraqi law when it suited.

The Trial was a miscarriage not only of justice but of what Europe claims to be democratic process and the rule of law. The Tribunal was set up by the occupying power contrary to principles of international law prohibiting interference in government of occupied people. Was this because the evidence was lacking? Or was it because the flawed procedure had to dismiss much of the defense's argument and come up with the grounds for indicting and beheading a former head of state in contravention of his immunity—a process which could not have been accomplished through even a biased procedure operating under international legal norms.

The sole contribution of the Tribunal to international law is that it sets a precedent for trying other heads of state who challenge US supremacy and are arbitrarily charged with committing genocide, war crimes and crimes against humanity. While Mr. Bush and Mr. Blair are most eminent candidates for such charges arising from their unlawful invasion, massacre and destruction of Iraq, their likely immunity invests the entire regimen with a bias that discredits it as a source of universal justice when law becomes a tool of power.

The criminal behavior of the United States, its foreign lobbyists and its partisans in this historic trial sets an ugly precedent for its pernicious intervention in other targeted states.

The criminal behavior of the United States, its foreign lobbyists and its partisans in this historic trial sets an ugly precedent for its pernicious intervention in other targeted states. This detailed examination reveals how the 'New World' is in fact being 'ordered'. Its methods present a terrifying prospect of ruthless dictatorship, loss of sovereignty, independence and removal of the human right to justice. It also reveals a level of US deception, hypocrisy and flagrant flouting of even its own laws to achieve political objectives, such as the demonizing of an entire political Party, the Ba'ath, and the deliberate dismantling of a legitimate state apparatus. This has enabled the subjugation of a nation. It has not been to prevent inhumanities by a local head of state, as the world was led to believe, because far worse atrocities have been committed by the occupiers of Iraq than by its native government.

It is therefore more likely to be part of a much wider plan to control the remaining global energy supplies. We know that Henry Kissinger launched a plan to subjugate the whole oil-producing region of the Middle East in 1975. Since well before '9-11', the neo-Con cabal in Washington planned to implicate the entire Muslim world in 'terrorism' as an excuse to invade and subjugate other factions and nations before they could rise to overthrow this creeping dictatorship. The Tribunal had to produce a 'guilty' verdict and had to hand down the most extreme sentence in order to prop up this New World Order and terrify anybody who might challenge it.

ENDNOTES

[1] Iraqi High Tribunal, Judgment Case November 1/C First/2005, Dujail Case, 5 November 2006. <http://www.iraq-iht.org/ar/doc/resco/part1.pdf>

[2] Id, p. 10.

[3] Id., p. 18-19.

[4] Id, p. 12.

[5] Id., p. 18-19.

[6] Id., p. 28.

[7] Id., p. 20.

[8] Id., p. 4-5.

[9] Id., p. 14.

[10] Id, pp. 30-34.

[11] Id., p. 34.

[12] Id, p. 35.

[13] This is evidenced by the fact that, with regard to the Statute of the ICC, "as of 23 August 2004, only 12 states had ratified the Agreement on Privileges and Immunities, although 62 states have signed it. Only three states are known to have included the Agreement on Privileges and Immunities in their draft implementing legislation (Ecuador, Ireland and Uganda). Amnesty International is not aware of any state that has so far implemented the Agreement in legislation". <http://web.amnesty.org/library/Index/ENGIOR400192004?open&of=ENG-385>

[14] See Judgment, supra, p. 35.

[15] Id., pp. 36-37.

[16] Articles 22, 23 and 24 of the Statute of the ICC, cited on page 39 of the Judgment,

supra.

17 Judgment, Supra, p. 39.

18 Id, p. 40.

19 Id, p. 42.

20 Id., p. 44.

21 Id., p. 44.

22 For my discussion of this issue, see Chapter 6.

23 Judgment, supra., p. 44.

24 Judgment, supra, p. 46.

25 Id., p. 47.

26 Article 1(Second) of the Statute of the IHT, inherited from the Statute of the IST set up by the CPA reads: "The Tribunal shall have jurisdiction over every natural person, whether Iraqi or non-Iraqi resident of Iraq, of committing any of the crimes listed in Articles 11, 12, 13 and 14 of this law, committed during the period from 17 July 1968 to 1 May 2003".

27 Judgment, supra, p. 48.

28 Judgment, supra, p. 52.

29 See Chapter 4 for the stipulation of the Hague Regulations and the Geneva Conventions regarding the obligations of the occupier.

30 Judgment, pp. 32-34.

31 See Chapter 4 regarding the argument on TAL

32 Judgment - *Regina v. Bartle and the Commissioner of Police for the Metropolis and Others* Ex Parte Pinochet, session 1998-1999, House Of Lords, 24 March 1999.

33 Id, citing the dictum of Lord Slynn of Hadley: [1998] 3 W.L.R. 1456, at p. 1475B-E.

34 Judgment, p. 24.

35 The UK for example has legislated to incorporate the ICC Statute in the ICCA Act 2002 which gave the UK courts jurisdiction to try individuals who commit acts contrary to the ICC Statute. The UK has a parallel active legislation in the Geneva Conventions Act 1957 as amended in 1995 which criminalize acts committed contrary to the Geneva Conventions and their Protocols. It is important to point out here that the scope of some crimes under the Geneva Conventions Act is wider than that under the ICC Act as in the case against civilians during military conflict.

36 McGinnis, John O., Somin, Ilya, Should International Law Be Part of Our Law? *Stanford Law Review*, Vol. 59, No. 5, March 2007, pp. 1175-1247. <http://papers.ssrn.com/sol3/papers.cfm?abstract_id=929174#PaperDownload>

37 See *R v Jones* (Appellate) [2006] UKHL 16) paragraph 23.

38 See Chapter 6.

39 Judgment, p 91.

40 Id, p. 93.

41 In order to establish the criminal contribution of Saddam Hussein the Tribunal relied on Article 15 of the Statute of the IHT. However, the Tribunal ends up in the same circular argument. It cannot, in my opinion, rely on the criminal liability in Article 15 unless it can show that such liability existed under Iraqi Law prior to the enactment of the Statute of the IHT, which has been restated in Article 15. The Tribunal attempted to argue that by citing Articles 47, 48, 49 and 53 of the Iraqi Penal Code No. 111 of 1969. However, none of these Articles is related to Article 15. The Tribunal states without proof that so long as both the general principle in the Iraqi Penal Code and the specific principle in the Statute of the IHT agree on the definition of criminal liability then the special law applies. It is clear in my opinion that the Tribunal had failed in showing that Article 15 reiterates principles that existed under Iraqi criminal law. In this case why should Article 15 apply without invoking retroactivity, which the Tribunal accepted should not be admitted in its proceedings?

42 Id. Judgment, pp. 93-98.

43 Private Communication from Wadood Fawzi dated 4 April 2007.

44 Judgment, p. 114.

45 Id., p. 117.

46 Id, p. 118.

47 Id, p. 128.

48 Id, p. 130.

49 Id, p. 135.

50 *Prosecutor v Blaskic,* ICTY, Case No. IT-95-14, Judgment (Appeal Chambers) July 29, 2004.

51 Iraqi High Tribunal, Appeal Judgment No. 29/T/2006, 26 December 2006. <http://www.iraq-iht.org/ar/doc/resco/part1.pdf>

52 Appellate Chamber Judgment, pp. 6-7. My translation from an awkward and cumbersome original.

53 Id.

54 'Bloody Sunday' refers to the events that took place in Derry on the afternoon of Sunday 30 January 1972. A Northern Ireland Civil Rights Association (NICRA) march had been organised to protest against the continuation of Internment without trial in Northern Ireland. Between ten and twenty thousand men, women and children took part in the march in a 'carnival atmosphere'. The march was prevented from entering the city centre by members of the British Army. The main body of the march then moved to 'Free Derry Corner' to attend a rally but some young men began throwing stones at soldiers in William Street. Soldiers of the Parachute Regiment, an elite regiment of the British Army, moved into the Bogside in an arrest operation. During the next 30 minutes these soldiers shot dead 13 men (and shot and injured a further 13 people) mainly by single shots to the head and trunk. <http://cain.ulst.ac.uk/events/bsunday/sum.htm>

55 Waco Siege, a fifty-one-day siege by federal agents of the Branch Davidian religious group's commune headquarters outside Waco, Texas, in early 1993. The siege, which began after a botched and bloody attempt on 28 February 1993 to arrest the group's leader, David Koresh, on a weapons charge, ended in the deaths of four federal agents and seventy-eight Branch Davidians. The stalemate ended when U.S. Attorney General Janet Reno ordered the use of force on April 19. Soon after federal agents moved, fire engulfed the compound, killing 72 [20 children among them], provoking controversy over the use of force in dealing with dissident sects. Although some surviving members of the sect were acquitted of manslaughter, they received harsh sentences when convicted on lesser charges. In August 1999, new documents surfaced indicating that the FBI had fired three flammable tear gas canisters during the raid on the compound. Following a ten-month investigation, Senator John C. Danforth released a report concluding that although federal agents had mishandled evidence, they had neither started the fire nor improperly employed force. US History Encyclopeadia, Answrs.com. <http://www.answers.com/topic/waco-siege>

56 Awwad stated in Court that such facts were established in the Dujail-1 and in the absence of any evidence in Dujail-2 to refute it, then it should stand)

57 Appeal Judgment, supra, p. 7.

58 Mahdi Darius Nazemroaya, "Saddam Hussein's Last Words: 'To the Hell that is Iraq'": What the Media Deliberately Concealed," GlobalResearch.ca, <http://www.globalresearch.ca/index.php?context=va&aid=4620>

59 Id.

60 Judgment, supra, p. 48.

CHRONOLOGY OF EVENTS IN IRAQ

JULY 1958-DECEMBER 2006

1958 Jul 14 A military coup led by General Abdul-Kareem Qasim and Col. Abdul-Salam Arif overthrows the monarchy, killing the royal family, declaring Iraq as a republic and appointing Qasim as prime minister.

1958 Jul 27 A short thirty-Articles provisional constitution is published setting out basic principles of the new Iraqi Republic with executive and legislative power in the hand of the Government headed by Qasim.

1958 Sep Qasim removed Arif from power and despatched him as ambassador to Germany as part of the rift between Qasim and Arif over the pan-Arabist view of the latter.

1958 30 Sep A Land Reform Law was promulgated which set out to limit land ownership intending to hand over land to landless peasants.

1958 4 Nov Arif returned to Baghdad and was arrested, charged with an attempted coup against Qasim.

1959 Feb Arif is convicted and sentenced for attempting a coup against the regime in October 1958. Members of the Ba'ath and Istiqlal parties in Qasim's Government resigned their posts.

1959 8-12 Mar The Mosul rebellion takes place. Following the Peace Partisans (the Iraqi Communist Party front organization) rally on 6 March in Mosul, fighting broke out and Col. Abdul-Wahhab As-Shawaaf, a member of Free Officers Committee, rebelled against Qasim in Mosul. As-Shawaaf was killed and many Free Officers were arrested and indicted for attempted Coup. Army was purged of Arab nationalist officers.

1959 14 Mar Iraq rejects Eisenhower's Doctrine for financial assistance and withdraws from all subsequent military cooperation with the US on the ground that it infringed Iraq's neutrality.

1959 24 Mar Qasim withdraws Iraq from Baghdad Pact (set up on 24 February 1955 with Britain, Turkey, Iran, Pakistan and Iraq as members and US as observer, allegedly to contain Soviet expansionism).

1959 30 Mar Last British soldier leaves Iraq. British military presence in Iraq was part of the 1930 Treaty between Britain and its appointed Government in Iraq following the WWI occupation and mandate.

1959 1 May Iraqi Communist Party musters some 500,000 on the streets of Baghdad calling for a role of the ICP in Qasim's Government. Qasim appears on the balcony of the Ministry of Defense, waves for the masses and goes inside.

1959 4 Jul Iraq withdraws from the Sterling zone, making Iraqi currency

independent for the first time since the creating of Iraq post WWI.

1959	14-16 Jul	Murder of over 50 Turkaman took place in Kirkuk at the hands of Kurds.
1959	19 Jul	Qasim blames the Iraqi Communist Party (ICP) for the chaos and calls them anarchists. Many ICP members, but none of their leaders, were arrested.
1959	20 Sep	Iraqi army officers, some of them from the original Free Officers Committee, were executed for their involvement in the Mosul rebellion of 8-12 March.
1959	7 Oct	A failed assassination attempt on Qasim carried out by Ba'ath Party under the direct supervision of its Secretary General, Fouad Ar-Rikabi. Qasim is injured and one of assassins is killed. Saddam Hussein was injured and fled to Syria. Some 78 Ba'athists were arrested and tried for the failed attempt. All were later forgiven and released after some time in jail.
1960	1 Jan	Qasim enacts The Law of Associations depriving the Iraqi Communist Party of a license to function while still managing to meet and socialize with its leaders.
1960	10-14 Sep	In a meeting in Baghdad, Arab oil states of Iraq, Saudi Arabia and Kuwait together with Iran and Venezuela set up the Organization of Petroleum Exporting Countries (OPEC).
1960	Nov	Qasim set up the Palestinian Liberation Regiment as part of his campaign to outmaneuver Nasir on Palestine.
1961	19 June	Britain announced its intention to grant the protectorate of Kuwait, carved out of Iraq post WWI, its independence.
1961	25 June	Qasim called for the return of Kuwait to the Iraqi homeland.
1961	July	UK sent troops to Kuwait to pre-empt any Iraqi action.
1961	Sep	Mustafa Al-Barazani, who returned to Iraq after having been pardoned by Qasim, started the new Kurdish rebellion that was to mark the beginning of many of Iraq's later ills.
1961	11 Dec	Qasim promulgated his greatest achievements in Law No. 80 of 1961 which took away some 96% of the land of Iraq from foreign oil companies which had not been yet exploited under the old agreements.
1963	8 Feb	A coup led by the Ba'ath Party and other Arab Nationalists overthrew Qasim; was opposed violently by the Iraq Communists which led to their bloody persecution; and returned Arif as President of the Republic. The Ba'athist Ahmad Hasan Al-Bakr became the PM and Ba'ath Party Secretary General became interior minister.
1964	11 Nov	Ba'ath Party national conference was invaded by army officers who arrested Secretary General Ali Salih As Sa'di, and some of his comrades and despatched them to Spain in what was an open coup within the Party staged by his opponents led by Hazim Jawad with tacit support from President Arif.
1963	18 Nov	Following the collapse of order inside the Ba'ath Party brought about

by the coup against Ali, President Arif mounted his own coup, ousting the Ba'ath completely from power including those who supported him against Ali.

1965	15 Sep	An attempted coup by officers of Nasserite affiliation was foiled by President Arif with many of the conspirators fleeing to Egypt.
1966	13 Apr	President Arif is killed in a mysterious helicopter crash on a visit to Basrah. His brother Abdul-Rahman Arif was chosen as a successor President.
1966	29 Jun	Iraqi PM Arif Abudl-Razzaq announced a ceasefire with Kurdish rebels in an attempt to put an end to some five years of fighting. The ceasefire was soon broken before the year was out.
1968	17 Jul	A bloodless coup mounted by Ba'athist and other conspirators ousting Abdul-Rahman Arif, appointing Ahmed Hasan AlBakr as President and conspirator Abdul-Razzak An-Naif as PM.
1968	30 Jul	The Ba'athists ousted their partners in the Coup and assumed power alone, signalling the rule of the Ba'ath for the next 35 years.
1968	Nov	Kurdish members in Iraqi Government resigned and rebellion resumed.
1969	Mar	Kurdish rebels mounted a successful attack on Kirkuk refinery.
1969	19 Apr	Iran unilaterally abrogated the 1937 Frontier Treaty which regulated the borders between the two countries.
1970	21 Jan	Iraq claimed to have uncovered a coup sponsored and backed by Iran.
1970	11 Mar	The March Proclamation was signed by the Iraqi Government and Kurdish rebel leader, Mustafa Al-Barazani, granting Kurdish autonomy in Kurdish majority areas in northern Iraq.
1971	1 Dec	Following British withdrawal from the Gulf, Iran occupies, with British support, the islands of Greater Tunb, Lesser Tunb and Abu Musa off the Arabian shores. Iraq asserted the Arab nature of these islands, broke off relations with Iran and the UK.
1972	26 Mar	A unique communiqué was issued following talks between Saddam Hussein of Iraq and President Al-Asad of Syria representing opposing factions of the Ba'ath.
1972	Apr	A 15-year Treaty of Friendship and Cooperation was signed between Iraq and the USSR.
1972	14 May	Iraqi Communists joined the Iraqi Government.
1972	1 Jun	Iraq nationalized the Iraqi Petroleum Company.
1973	30 Jun	Nadhim Igzaar, head of Iraq's Security Services, plot of an assassination attempt against Saddam Hussein and Ahmad Hasan Al-Bakr was uncovered which led to his execution and purge of the Party.
1973	11 Oct	Iraqi joined the war with Israel on the Syrian front and joined other Arab States in the oil embargo.

1974	11 Mar	Law Number 33 of 1974 for Autonomy in Iraqi Kurdistan was officially promulgated, giving force to the accord of 11 March 1970.
1974	13 Mar	Negotiations between the Iraqi Government and the Kurdish rebel Mustafa Al-Barazani collapsed following disagreement on size of Autonomous Region. Hostilities resumed with Kurdish rebels receiving backing from Iran and the US.
1975	6 Mar	The Algiers Accord was signed between Iraq and Iran following a meeting of OPEC. In it both sides accepted the delineation of their land boundaries in accordance with the Constantinople Protocol 1913 and to demarcate their river boundaries according to the thalweg (median river course) line.
1975	13 Jun	Iraq and Iran sign Treaty concerning the Frontier and Neighbourly relations between Iran and Iraq consolidating the Algiers Accord. Iranian and US support for the Kurdish Rebellion stopped and it was routed within weeks.
1977	5 Feb	The annual religious procession from Duwereej to Karbala on the 40th day following A'shura' turned into an anti-Ba'athist demonstration, which was attacked by security and police resulting in deaths, injuries and arrests.
1978	26 Oct	A meeting in Baghdad between President Al-Asad of Syria and Al-Bakr of Iraq resulted in some reconciliation with the setting up of the Charter of Joint National Action.
1979	16 Jul	Saddam Hussein replaced Ahmad Hasan Al-Bakr as President of Iraq and Secretary General of the Ba'ath Party.
1979	28 Jul	Saddam Hussein accused some of his comrades in the Party leadership of plotting against him with Syrian support. The purge, deaths and imprisonment that followed were the worst massacre the Ba'ath Party has ever had.
1980	1 Apr	Da'wa Party claimed responsibility for assassination attempt of Tariq Aziz, Iraq's Deputy Prime Minister in Mustansiriyya University.
1980	9 Apr	Iraq secretly executed one of the most prominent Shi'a clerics of the time. Muhammad Baqir AsSadr was executed along with his sister, Bint Al-Huda.
1980	4 Sep	Iraq claimed that Iran had bombarded Mandali and Khaneqeen.
1980	17 Sep	Iraqi abrogated the Algiers Accord and Baghdad Treaty of 1975.
1980	22 Sep	Iraqi troops crossed the border into Iran.
1980	23 Sep	Iran bombs Iraqi military and economic targets.
1981	7 Jun	Israel, using US bombers, attacked and destroyed Iraq's Osirak nuclear plant that was being built by the French.
1982	12 Apr	Iran launched a strong counter attack destroying Iraq's oil terminal at Faw and reducing Iraq's revenue. Iraq offered to withdraw from Iran in return for end of conflict but Iran demanded reparations.
1982	8 Jul	A failed assassination attempt on Saddam Hussein following his visit

		to the town of Dujail north of Baghdad, resulted in crackdown on the perpetrators and conspirators who, according to the Iraqi report, were members of the Da'wa Party collaborating with Iran.
1983	Jul	In demonstrating full cooperation between Kurdish rebels and Iran, an attack in July resulted in Iraq losing the garrison town of Hajj Omran to the joint Kurdish-Iranian forces.
1984	Feb	War of cities took place in which both Iraq and Iran attacked each other's cities.
1984	27 Mar	Iraq attacked Iranian oil terminal at Kharg Island using French Exocet missiles.
1984	12 Jun	UN-mediated ceasefire came into effect with monitors posted in Baghdad and Tehran.
1985	17 Mar	Iranian troops crossed into Iraq and cross the river Tigris closing the Baghdad-Basrah road.
1985	6 Apr	A new ceasefire was agreed following attacks by Iraq on Ahwaz and Bushair and by Iran on Baghdad.
1985	26 May	Iraq broke ceasefire.
1985	13 Sep	Iran received 508 US-made Tow missiles, as part of secret arms-for-hostages deal with US.
1986	17 Jan	A further 4000 Tow missiles authorized by Reagan on 17Jan 86, were supplied through Israel.
1986	11 Feb	Iran captures the Faw peninsula in southern Iraq and threatened Basrah.
1986	Oct	A pact between Iran and Kurdish rebels was created in which both sides agreed to fight on until the overthrow of the Ba'ath rule in Baghdad.
1987	17-25 Jan	Iraq resumes war of the cities.
1987	4 Mar	A joint attack by Iranian and Kurdish forces deep into Iraq came close to Rawanduz.
1987	26 Mar	The advance of Iranian-Kurdish forces led to the appointment of Ali Hasan Al-Majeed, Saddam Hussein's cousin, as commander of northern Iraq, who started the policy of evacuating a strip of land along the border in north Iraq.
1988	27 Feb	Iraq retaliated for attack on Baghdad by hitting Tehran for the first time.
1986	1 Mar	Iraq said it had fired 16 missiles into Tehran in the first long-range rocket attack on the Iranian capital since the Iran-Iraq war began.
1988	16 Mar	The town of Halabja is hit with chemical weapons during battles between Iraqi forces on one side and Iranian-Kurdish forces on the other.
1986	16-18 Apr	The newly-restructured Iraqi Army began a major operation named "Ramadhan Mubarak" aiming at clearing the Iranians out of the peninsula. The Iranians were expelled from the peninsula within 35 hours, with

much of their equipment captured intact.

1988	18 Apr	US blew up 2 Iranian oil rigs, destroyed an Iranian frigate and immobilized another in the Gulf.
1988	3 Jul	*USS Vincennes* shot down an Iranian Airbus passenger aircraft in the Gulf, killing 290.
1988	20 July	Iran accepted UN-brokered ceasefire.
1988	6 Aug	Iraq's president said his country would agree to a ceasefire with Iran, provided the Iranians promised to hold direct talks immediately after the truce took effect.
1988	7 Aug	Iranian Foreign Minister Ali Akbar Velayati signaled his government's acceptance of Iraq's modified peace proposal aimed at bringing about a ceasefire in the Persian Gulf.
1988	8 Aug	UN Secretary-General Javier Perez de Cuellar announced a cease-fire between Iran and Iraq. This became a Iraqi national holiday until it was abolished in 2003.
1988	20 Aug	Formal ceasefire between Iran and Iraq came into force with UNIIMOG entrusted with observing borders.
1988	25 Aug	Iran and Iraq began talks to end their 8-year war.
1989	27 Mar	On March 27, 1989 King Fahd of Saudi Arabia signed a non-aggression pact with Saddam, an agreement that received little publicity during the period when Saudi Arabia hosted the forces that were to launch the most devastating onslaught on Iraq in modern times. It is interesting to note that in Feb. 1989 Saddam offered a similar agreement to Kuwait. Kuwait did not respond.
1989	2 Aug	The Jordanian banking authorities took over Petra on the grounds that when all Jordanian banks were told to deposit 30% of their foreign exchange with the central bank, Petra had failed to come up with the money. Ahmad Al-Chalabi , founding head of Petra Bank, left the country two weeks later. In April, 1992, Chalabi was tried in his absence (along with 47 associates), found guilty, and sentenced to 22 years jail on 31 charges of embezzlement, theft, misuse of depositor funds and currency speculation. Ahmed Chalabi, who later formed the Iraqi National Congress, returned to Iraq as 'liberator' with the US invasion and was hailed to be the Pentagon-favored man to rule Iraq.
1989	Sep	A mysterious explosion at a military factory south of Baghdad led to arrest of a British nurse and an Iranian journalist working for a British newspaper on the ground of spying. The incident signalled the open demonizing of Saddam Hussein in the West.
1989	20 Nov	Summarized agreements reached at a meeting with CIA director William Webster at the CIA headquarters in Langley, Virginia, on Nov. 14 1989 were published. The document, which was unknown to Saddam at that time, showed collaboration between the Kuwaiti Security Department (KSD) and the US Central Intelligence Agency (CIA). Paragraph 5 of the memorandum stated: "We agreed with the American side that it was important to take advantage of the deteriorating economic situation in Iraq in order to put pressure on that country's government to delineate our common border."

1990	16 Feb	Arab Cooperation Council (Iraq, Egypt, Jordan, N. Yemen) was set up.
1990	15 Mar	Iraq executed Iranian journalist Farzad Bazoft, who was working for a London newspaper, after having convicted him for spying.

1990 22 Mar — Gerald Vincent Bull, the Canadian engineer who developed long range artillery, which included designing the Project Babylon "supergun" for the Iraqi government, was shot dead outside his home in Brussels, Belgium by Israeli agents. No one was ever caught or prosecuted for his murder.

1990 28 Mar — British customs officials announced they had foiled an attempt to supply Iraq with 40 American-made devices for triggering nuclear weapons.

1990 28 Mar — Iraqi President Saddam Hussein opened a two-day Arab League summit in Baghdad with a keynote address in which he said if Israel were to deploy nuclear or chemical weapons against Arabs, Iraq would respond with "weapons of mass destruction."

1990 30 Mar — The Iraqi president commented to participants at an Arab summit in Baghdad (28-30 March) that .. "for every US dollar drop in the price of a barrel of oil, the Iraqi loss amounted to $1 billion annually.. War is fought with soldiers and harm is done by explosions, killing and coup attempts, but it is done by economic means as well. I say to those who do not mean to wage war on Iraq, that this is in fact a kind of war against Iraq. Were it possible we would have endured.. But I say that we have reached a point where we can no longer withstand pressure."

1990 12 Apr — Saddam Hussein met with 5 US senators: Robert Dole, Alan Simpson, Howard Metzenbaum, James McClure and Frank Murkowski; the US ambassador was also present. The US senators criticized the American press in their attempts to propitiate Saddam, emphasizing that there was a difference between the attitudes of the US government and those of journalists.

Senator Howard Metzenbaum said: 'I am a Jew and a staunch supporter of Israel', paid Saddam a compliment: '... I have been sitting here listening to you for about an hour, and I am now aware that you are a strong and intelligent man and that you want peace.. if.. you were to focus on the value of the peace that we greatly need to achieve in the Middle East then there would not be a leader to compare with you in the Middle East..'

1990 21 May — A request by Iraq for $500 million loan guarantee from the US was suspended following an earlier decision by the US that further credit for American grain was not forthcoming. These were signs of growing US hostility towards Iraq.

1990 Jun — Kuwait and the UAE continued to produce oil as they wished, to the point that the price per barrel sank to $11. At this level, Iraqi revenues were such that they could scarcely service current expenses, much less repay foreign loans or fund the required national reconstruction.

1990 24 Jul — Iraq, accusing Kuwait of conspiring to harm its economy through oil overproduction, massed tens of thousands of troops and hundreds of tanks along the Iraqi-Kuwaiti border. US warships in Persian Gulf were placed on alert.

1990	25 Jul	The US ambassador to Iraq, April Glaspie, met with Iraqi President Saddam Hussein to discuss Iraq's economic dispute with Kuwait. Saddam told Ms Glaspie that Kuwait's borders were drawn in colonial days. Saddam had always been an anti-colonialist. "We studied history at school," the luckless Glaspie replies. "They taught us to say freedom or death. I think you know well that we... have our experience with the colonialists. We have no opinion on the Arab-Arab conflicts, like your border disagreement with Kuwait." Glaspie went on her summer leave never to return to Iraq. In a post-war press interview, as the writer Christopher Hitchens has pointed out, Glaspie gave the game away. "We never expected they would take all of Kuwait," she said.
1990	31 Jul	An Arab Conference was convened in Jedda. According to Jordan's King Hussein, there was a pre-conference, closed door meeting at which the Al-Saud and al-Sabah families agreed to Hussein's terms (in addition to forgiving the debt, they were each to give $10 billion toward the Iraqi war debt). That agreement was then to be "arrived at" in Jedda. But on July 30th, Sheikh Sabah Ahmad al-Jaber al-Sabah, the brother of the Emir, and foreign minister, was speaking to Jordanian diplomats. He ridiculed the Iraqi forces, and when the Jordanians rebuked him, he said, "If they don't like it, let them occupy our territory ... we are going to bring in the Americans."
1990	2 Aug	Iraqi troops crossed into Kuwait and controlled the country within 12 hours, discovering that the ruling family had fled the country.
1990	2 Aug	Security Council passed Resolution 660 condemning the attack and calling for Iraqi withdrawal.
1990	3 Aug	US announced the commitment of Naval forces to Gulf regions.
1990	4 Aug	The European Community imposed an embargo on imports of oil from Iraq and Kuwait to protest the Baghdad government's invasion of its oil-rich neighbor.
1990	6 Aug	King Fahd of Saudi Arabia, in a meeting with US defense secretary Richard Cheney, requested US help and agreed to unlimited US military presence in Arabia.
1990	6 Aug.	Security Council passed the unprecedented Resolution 661 installing the sanctions regime on Iraq, which prohibited all commodity imports from Iraq and exports to Iraq, except supplies intended strictly for medical purposes, and in humanitarian circumstances, foodstuffs. This sanctions regime lasted until the invasion of 2003.
1990	7 Aug	President Bush ordered U.S. troops and warplanes to Saudi Arabia to guard the oil-rich desert kingdom against a possible invasion by Iraq.
1990	8 Aug	Iraq announced the eternal merger of Kuwait with Iraq as the 19th province. US fighters started arriving in Arabia.
1990	9 Aug	The Security Council passed Resolution 662 declaring the annexation of Kuwait as invalid.
1990	11 Aug	Egyptian and Moroccan troops arrived in Saudi Arabia to join US forces in helping to protect the desert kingdom from possible Iraqi attack.
1990	12 Aug	Iraq offered to withdraw from Kuwait in exchange for Syrian

		withdrawal from Lebanon and Israeli withdrawn from territories occupied in 1967.
1990	15 Aug	In an attempt to gain support against the US-led coalition in the Persian Gulf, Iraqi President Saddam Hussein offered to make peace with longtime enemy Iran.
1990	18 Aug	A US frigate fired warning shots across the bow of an Iraqi oil tanker in the Gulf of Oman, apparently the first shots fired by the US in the Persian Gulf crisis.
1990	19 Aug	Iraqi President Saddam Hussein offered to free all foreigners detained in Iraq and Kuwait provided the United States promised to withdraw its forces from Saudi Arabia and guaranteed that the international economic embargo would be lifted.
1990	23 Aug	Iraq made another offer to withdraw from Kuwait if guranteed access to the Gulf and full control of its Rumallah oil fields.
1990	25 Aug	Security Council passed Resolution 665 strengthening the total embargo against Iraq.
1990	31 Aug	UN Secretary-General Javier Perez de Cuellar met twice with Iraqi Foreign Minister Tariq Aziz in Amman, Jordan, trying to negotiate a solution to the Persian Gulf crisis.
1990	5 Sep	Iraqi President Saddam Hussein urged Arabs to rise up in a Holy War against the West and former allies who had turned against him.
1990	5 Sep	In Moscow, Soviet President Mikhail S. Gorbachev met with Iraqi Foreign Minister Tariq Aziz.
1990	10 Sep	Iran agreed to resume full diplomatic ties with onetime enemy Iraq.
1990	13 Sep	The UN Security Council, at its 2939th meeting, adopted Resolution 666, regarding foodstuffs to be supplied to the civilian population in Iraq or Kuwait in order to relieve human suffering.
1990	15 Sep	France announced it would send 4,000 more soldiers to the Persian Gulf and expel Iraqi military attaches in Paris in response to Iraq's raids on French, Belgian and Canadian diplomatic compounds in Kuwait.
1990	17 Sep	Defense Secretary Dick Cheney sacked Air Force Chief of Staff General Mike Dugan for openly discussing contingency plans to launch massive air strikes against Baghdad and target Iraqi President Saddam Hussein personally.
1990	24 Sep	Security Council passed Resolution 669 imposing an air embargo on Iraq.
1990	3 Oct	Iraqi President Saddam Hussein made his first known visit to Kuwait following its recovery.
1990	17 Oct	In testimony before the Senate Foreign Relations Committee, Secretary of State James Baker said Iraqi President Saddam Hussein "must fail if peace is to succeed."
1990	8 Nov.	The US announced doubling its troop presence in the region to over 400,000.
1990	20 Nov	The Soviet Union again rebuffed President Bush's efforts to rally

		support for a UN Security Council resolution authorizing military force against Iraq.
1990	23 Nov	President Bush conferred separately with Egyptian President Hosni Mubarak in Cairo and Syrian President Hafidh Al-Asad in Geneva, seeking Arab support for his drive to expel Iraqi troops from Kuwait.
1990	29 Nov	Security Council passed Resolution 678 authorizing the use of all means necessary after 15 January 1991 to enforce previous UN Resolutions including that requiring Iraqi withdrawal from Kuwait.
1990	1 Dec	Iraq accepted a US offer to talk about resolving the Persian Gulf crisis.
1990	6 Dec	Iraq announced that it would release all its hostages, saying foreigners could begin leaving in two days.
1990	17 Dec	President Bush pledged "no negotiation for one inch" of Kuwaiti territory would take place as he repeated his demand for Iraq's complete withdrawal.
1991	9 Jan	A meeting was held in Geneva between US Secretary of State James Baker and Iraqi Foreign Minister Tariq Aziz which led to no resolution except the refusal of Aziz to receive an ultimatum letter from President Bush to President Saddam Hussein.
1991	12 Jan	US Congress authroized invading Iraq. The Senate voted 52-47 in favor.
1991	17 Jan	Operation Desert Storm invading Iraq started with massive air and missile attacks.
1991	18 Jan	Iraq retaliated with Scud missiles attack against Israel.
1991	25 Jan	Iraq Scud missiles hit US military barracks in AlKhobar.
1991	13 Feb	US attacked a civilian shelter in Amiriyah in Baghdad killing nearly 1000 civilians in what many Iraqis assumed was in retaliation for attacks on Israel. The shelters was one of several civilian shelters built by a Finnish company but its design and layout had been handed over to the US military.
1991	28 Feb	Ceasefire took effect at 8:00 am.
1991	3 Mar	Iraq accepted terms of ceasefire.
1991	3 Apr	Security Council passed Resolution 687 formally ending war established arms inspection body UNSCOM to which, together with the IAEA, the Iraqi government was obliged to grant unimpeded access to all sites and facilities in Iraq, in order to supervise disarmament of all Iraq's non-conventional weapons and ballistic missiles with a range of more than 150 km.
1991	Mar-Apr	Revolts in southern and northern Iraq led to killing of Government and Ba'ath Party members and destruction of property. Government crushed southern revolt by end of March and northern by early April.
1991	6 April	Saddam Hussein accepts US Resolution agreeing to destroy WMD and allowing UN inspectors to monitor disarmament.
1991	8 Apr	British PM John Major's proposal for 'Safe Havens' policy in northern

Iraq, approved by EU meeting in Luxembourg.

1991	10 Apr	The US orders Iraq to end all military activity in northern Iraq creating a de facto separate Kurdish state.
1991	Jun	The UK-US sets up in Iraq, without international authority, a "no-fly zone" north of the 36th parallel.
1991	Jul	US forces withdrew from northern Iraq in mid-July but remained in southern Turkey until October.
1991	Oct	President Bush informed Congress that the US was intensifying its covert operations in Iraq.
1992	26 Aug	Bush announces a 'no-fly zone' in Iraq below the 32nd parallel in Iraq.
1992	27 Dec	US shoot down an Iraqi MIG for 'violating' the southern no-fly zone created by the US in Iraq on 26 August.
1993	10-19 Jan	Following Iraq's challenge to no-fly zones by introducing surface-to-air missiles in them, US/UK bombing resulted in tens of Iraqis killed and forced the Iraqi Government to rescind measures.
1993	18 May	Martin Indyk, Special Assistant to the US President on Near Eastern & South Asian affairs, announced a policy of "Dual Containment" of Iran and Iraq.
1993	27Jun	US launched 23 Tomahawk missiles against Baghdad claiming Iraq was involved in an attempt to assassinate former President Bush on his visit to Kuwait (in mid-Apr).The attack killed many civilian Iraqis including the gifted Iraqi painter Leila Al-Attar.
1994	7 May	The rivalry between Kurdistan Democratic Party (KDP) and Patriotic Union of Kurdistan (PUK), coalition partners for 5 years, broke out into open conflict in northern Iraq. Fighting continued until Sept, and intermittently thereafter despite peace plan of Nov 94. Over 3000 killed by Jun 96, with PUK controlling half the territory but two-thirds of the population.
1994	29 May	President Saddam Hussein retained for himself the post of Prime Minister.
1994	10 Nov	Iraqi National Assembly officially acknowledges Kuwait's sovereignty; ratified by RCC in a decree signed by Saddam Hussein.
1995	14 Apr	Security Council adopted Resolution 986 providing an "oil-for-food" plan for Iraq, allowing Iraq to sell $1bn worth of oil every 90 days.
1995	7-8Aug	Two of Saddam Hussein's sons-in-law, Lt. Gen. Hussein Kamil (former director of Iraq's Military Industrialization Establishment, in charge of WMD program) and Saddam Kamil defected to Jordan with Saddam's daughters; Hussein Kamil takes crates of documents revealing past concealment of WMD capacities, and provides these to UNSCOM.
1995	20 Aug	Iraq responded by revealing a major store of documents that showed that Iraq had begun an unsuccessful crash program to develop a nuclear bomb.
1995	15 Oct	Saddam Hussein wins another referendum allowing him to remain

President for another seven years.

| 1996 | 23 Feb | Hussein and Saddam Kamil, having been shunned by Iraqi opposition groups, agreed to return to Iraq, where they were promptly assassinated by their cousins. |

1996 26 Jun Attempted coup in Iraq, organized by the Iraqi National Accord and coordinated in part by CIA operatives within UNSCOM, fails when 120 coup plotters are arrested (and largely executed) by the Iraqi regime.

1996 28 Jul The Iranians in support of Talabani's PUK made a 72-hour incursion into Kurdish "safe haven", focused on Mas'ud Al-Barazani's KDP camp at Koi Sanjaq.

1996 31 Aug Iraq, working with the KDP, occupies Irbil, 12 miles into the no-fly-zone, and destroys Western-backed opposition bases. The KDP takes over most of Iraqi Kurdistan. Saddam Hussein lifted internal economic embargo on the Kurdish region.

1996 2 Sep Iraqi forces withdrew from Kurdish region.

1996 2-4 Sep US retaliated by launching military strikes against Iraq and extending the southern no-fly zone to 33rd parallel, bringing it to the suburbs of Baghdad. There was little international backing for these illegal actions, except from UK.

1996 Dec During the GCC summit meeting the UAE criticized the continued isolation of Iraq.

1996 10 Dec Oil flows for the first time since 1990 from Iraq, through Turkish pipeline. SCR986 (14 Apr 95) had permitted exports under the oil-for-food program; this was accepted by Iraq on 22 May 96. In six months, $1bn of revenue generated will be spent on food & medicine for 18m Iraqis living under Baghdad rule; $260m goes to 3m people in Kurdish areas, only $17m permitted for essential infrastructure.

1997 29 Oct Iraq demands US members of UNSCOM leave Iraq.

1997 13 Nov All UNSCOM inspectors withdrawn, but allowed back later that month after Russian urging.

1998 13-22 Jan Iraq withdraws cooperation with UN inspectors, claiming too many members are American and British spying for their Governments; then denies UN inspectors access to presidential sites.

1998 27 Feb A *Memorandum of Understanding* between the UN and Iraq, brokered by UNSG Kofi Annan, narrowly averted building US airstrikes following Iraq's denial of access for UNSCOM to 'presidential & sovereign'. The Memo which was later approved by Security Council Resolution 1154 on 2 March, required that senior diplomats *must* accompany inspectors at 8 *defined* presidential sites.

1998 Sep UNSCOM Inspector Scott Ritter resigned claiming that the entire inspection program was unwarranted and that Iraq had no WMD.

1998 17 Sep The *Washington agreement* between Talabani's PUK and Barazani's KDP, announced at the US State Department, set up the Higher Coordination Committee to coordinate between the separate administrations in Irbil and Sulaymaniyya in Northern Iraq.

1998	31 Oct	President Clinton signs the Iraq Liberation Act, which authorized the president to provide assistance to Iraqi opposition organizations to act to overthrow the sovereign state of Iraq.
1998	31 Oct	In response to US enacting the Iraq Liberation Act, the Government of Iraq halted cooperation with UNSCOM.
1998	14 Nov	Under pressure from a US missile attack, Iraq agreed to cooperate with UNSCOM.
1998	15 Dec	UNSCOM executive chairman Richard Butler reported that Iraq had failed to fully cooperate and withdrew UNSCOM staff relying on US advice.
1998	16-19 Dec	Following the US advice to Butler to withdraw UNSCOM staff, the US & British carried out an extensive bombardment of Iraq in '**Operation Desert Fox**'.
1999	19 Feb	Iraq's most prominent Shi'a cleric, Ayatollah Sayyid Muhammad Sadiq as-Sadr (father of Muqtada as-Sadr) is assassinated in Najaf.
1999	17 Dec	Security Council Resolution 1284 created UNMOVIC to replace UNSCOM. The Resolution was considered adopted despite the fact that three permanent members of the Council, Russia, France and China, abstained and despite the fact that the UN Charter stipulates that for any resolution to be valid it must receive 'the affirmative vote of nine members including the concurring votes of the permanent members'.
1999	Jan-	Beginning in January, weekly, sometimes daily, bombings of Iraq targets on Iraqi soil carried out by US and British bombers. More than 100 air strikes take place during 1999 and continue regularly over the next four years culminating in the 2003 invasion.
2000	Aug	Baghdad airport opens for the first time since 1990.
2001	15 Feb	US and Britain bomb Iraq's air defense network.
2001	20 Sep	US and British jets bomb missile batteries in southern Iraq.
2002	29 Jan	President Bush, in his State of the Union address, identifies Iraq along with Iran and North Korea as an "axis of evil".
2002	28 Mar	Arab summit called for the lifting of sanctions on Iraq and opposes threats of aggression against it.
2002	Apr	Baghdad suspends oil exports to protest against Israeli incursions into Palestinian territories. Despite calls by Saddam no other Arab state follows suit. Exports resume after 30 days.
2002	Mar-May	Talks begin between UN Secretary-General Kofi Annan and Iraqi representatives on the return of weapons inspectors. Foreign Minister Naji Sabri provides a list of 19 questions to the Security Council, largely on whether the return of inspectors would end US threats of an invasion; the US mission to the UN blocks a reply to the non-technical questions.
2002	14 May	Security Council adopted Resolution 1409 implementing a new import

sanctions regime on Iraq in which only items on the annexed Goods Review List (GRL) were to be reviewed by the Sanctions Committee.

2002	2 Jun	President Bush publicly introduces the new defense doctrine of preemption in a speech at West Point.
2002	5-6 Jul	Talks resumed between Annan and Sabri.
2002	1 Aug	Iraqi Foreign Minister, Naji Sabri, invited UNMOVIC head Hans Blix to talks in Baghdad.
2002	5 Aug	Iraq's National Assembly speaker Sa'doon Hammadi also invited US Congress members to inspect Iraqi sites with their own experts to verify that Iraq had no WMD.
2002	7 Aug	Kofi Annan rejected Iraq's invitation to Hans Blix to talks in Baghdad.
2002	4 Sep	US defense officials confirmed plans to transport a brigade's worth of equipment—about 70 tanks and other tracked vehicles plus additional military cargo—to Kuwait from the United States aboard a commercial cargo vessel in late September.
2002	8 Sep	Al-Barazani (KDP) and Talabani (PUK) met for the first time in 2 years in Irbil to sign an agreement: commits both sides to a future democratic, federal Iraq, and to reestablish the Iraqi Kurdish National Assembly (which begins sitting in Irbil on 4 Oct, for the first time since 1994, ratifying the 1998 Washington agreement).
2002	12 Sep	In his speech to the UN President Bush calls for a multilateral action against Iraq to remove President Saddam Hussein. If not Bush contends, the US will have no choice but to act on its own against Iraq. The speech of President Bush was moved forward by almost two weeks so that President Bush could deliver a major address one day after he participated in the September 11 commemoration events.
2002	16 Sep	The United States acknowledged that it had recently asked the British Government for permission to build special shelters on the island of Diego Garcia so that US B-2 Spirits could operate from the airbase there. It takes 30 days to complete the construction of one shelter.
2002	16 Sep	In a letter to UNSG, Naji Sabri, Iraq's foreign minister, made an *unconditional offer* to allow UN weapons inspectors back into Iraq.
2002	24 Sep	Britain publishes dossier saying Iraq could produce a nuclear weapon within one or two years, if it obtains fissile material and other components from abroad.
2002	30 Sep	UN negotiators and an Iraqi delegation meet in Vienna for three days of talks to agree terms for resuming weapons inspections. But talks leave eight presidential compounds off-limits, and US rejects inspectors' return without a new Security Council resolution.
2002	2 Oct	Iraq's unconditional offer was rejected by the US, who introduced a new draft resolution to the UNSC, demanding a revised mandate for the inspectors and the authorization for the use of force if it sees Iraq as violating the resolution.
2002	10-11 Oct	Congress adopts a joint resolution authorizing use of force against Iraq. The Republican-controlled House voted 296 to 133 to allow the president to use the military "against the continuing threat" posed by

the Iraqi regime. The Democratic-run Senate followed at 1:15 a.m. 11 October with a vote of 77 to 23 for the measure.

2002 11 Oct The Pentagon issued orders to the Army's V Corps and I Marine Expeditionary Force to deploy headquarters staffs to Kuwait, in the first non-routine dispatch of conventional ground forces to the Persian Gulf region in anticipation of military action against Iraq.

2002 Mid-Oct Military vehicles and equipment — trucks, road graders, Humvees and bridging gear — were being shuttled aboard the T-AKR 288 Bellatrix, a Military Sealift Command vessel, set to leave soon for the Middle East. This was the first time since the Gulf War that the Pentagon had deployed a large sealift vessel with military equipment in San Diego for delivery to the Persian Gulf, as part of the deployment of the I Marine Expeditionary Force.

Two Military Sealift Command roll-on/roll-off ships — TAKR 300 Bob Hope and TAKR 301 Fisher— were activated and sent to pick up equipment for "a mechanized Army division based in Georgia". The equipment was being shipped to Kuwait and could arrive there by mid-November. Crews loaded 8,300 metric tons aboard the TAKR 300 Bob Hope. Another ship, the TAKR 301 Fisher, was loaded with 6,600 tons of equipment.

2002 16 Oct Iraq renews offer to UN weapons inspectors, after 'referendum' gives Saddam Hussein another seven-year term as president.

2002 8 Nov A slightly weaker version, threatening "serious consequences" if stringent demands are not met, was unanimously adopted as Security Council Resolution 1441. The UN Security Council Resolution 1441 contained no hidden triggers and no automaticity with respect to the use of force. If there is a further Iraqi breach reported to the Council by UNMOVIC, the IAEA, or a member state, the matter will return to the Council for discussions.

2002 13 Nov President Saddam sends a letter to the UN secretary-general, Kofi Annan, accepting Resolution 1441.

2002 Mid-Nov Two Military Sealift Command roll-on/roll-off ships that were activated and sent to pick up equipment for "a mechanized Army division based in Georgia" in mid-October arrived in Kuwait by mid-November.

2002 18 Nov United Nations weapons inspectors arrive in Baghdad to re-launch the search for WMD.

2002 22 Nov Vladimir Putin warns the US not to go it alone against Iraq, sounding a note of caution after an otherwise warm welcome to President Bush in Russia.

2002 27 Nov Weapons inspections recommenced with inspectors reporting Iraqi compliance. Thanked the Iraqis for their cooperation but did not comment on findings.

2002 3 Dec In a public relations coup for Iraq, government officials cooperate fully with UN weapons inspectors when a surprise search is sprung on one of Saddam Hussein's Baghdad palaces.

2002 7 Dec Iraq provides a 12,000 page report on its past and existing non-conventional weapons capacities, detailing the disposal of all its WMD as required by SCR1441, to the IAEA and UNMOVIC.

2002	8 Dec	Copies of the dossier are flown to the UN inspection agency in New York, the Security Council and the UN nuclear agency in Vienna for examination.
		General Amir al-Sadi, an adviser to President Saddam Hussein, admits that Iraq had come 'close' to developing a nuclear bomb but that program had long been abandoned.
2002	17 Dec	Just 10 days after the 12,000-page dossier was delivered, Colin Powell, the US secretary of state, indicated that the White House was going to reject the Iraqi weapons declaration, saying there were problems with the 12,000-page document.
2002	18 Dec	The foreign secretary, Jack Straw, indicates that the UK government believes Iraq has made a "material breach" of the UN resolution. Meanwhile the Ministry of Defence reveals that ships are being chartered to carry troops and heavy armor to the Gulf.
2002	20 Dec	The US declares at the UNSC, without any proof or support from UNMOVAC reports, that Iraq has committed a material breach of the Resolution.
2002	31 Dec	A UN inspection team member in Iraq admits to finding "zilch" evidence of weapons of mass destruction and says that the teams have been provided with little guidance from western intelligence agencies.
2003	9 Jan	Hans Blix says UN weapons inspectors have not found any "smoking guns" in their search for weapons of mass destruction in Iraq.
2003	11 Jan	A British naval task force leaves for the Gulf headed by the *HMS Ark Royal* aircraft carrier and carrying some 3,000 marines.
2003	12 Jan	The *USS Saipan*, the *USS Gunston Hall* and the *USS Ponce* depart from North Carolina carrying elements of the 2nd Marine Expeditionary Brigade. It will take roughly 3-4 weeks for the task force to transit to the Persian Gulf.
2003	12 Jan	The Turkish government gave US military planners permission to examine ports and airstrips to see what upgrades are needed for a war against Iraq. But Turkey delayed deciding whether to let US forces use those facilities until after a UN weapons inspectors report due 27 January 2003.
2003	15 Jan	Though the fastest route to their destinations would take the ships through the Suez Canal, the *USNS Pilalaau* (TAKR 304) and the *USNS Yano* (TAKR 297) were under orders to take a slower route around Africa's Cape of Good Hope. The voyage to the Gulf region was expected to take 21 to 25 days, suggesting they would arrive around 15 January 2003.
2003	28 Jan	In his state of union address, President Bush announces that he is ready to attack Iraq even without a UN mandate.
2003	29 Jan	The Russians insisted that the Security Council should meet on 29 January to consider the UNMOVIC report.
2003	Jan-Mar	Weapons inspections continue in Iraq, with reports from the UNMOVIC executive chairman Hans Blix (19 Dec 02, 9 Jan 03, 27 Jan 03, 14 Feb

03, 7 Mar 03) providing reports of increasing Iraqi cooperation, including permission for overflights by US U-2 surveillance flights (10Feb) and agreeing to the destruction of al-Samoud II missiles (27 Feb; begins on 1Mar).

| 2003 | 5 Feb | Colin Powell used satellite photographs, tapes of intercepted conversations and newly opened CIA files to make the United States case against Iraq at the Security Council in a determined attempt to win over international opinion. |

| 2003 | 6 Feb | The British defence secretary, Geoff Hoon, announced that around 100 aircraft and 7,000 RAF personnel were to be deployed in the build up for a possible war against Iraq. |

| 2003 | 7 Feb | The British PM office admitted that much of its dossier on Iraq, released a week earlier in an attempt to reinforce the case for war, was lifted from academic sources and compiled by mid-level officials in Alastair Campbell's Downing Street communications department. |

| 2003 | 8 Feb | Hans Blix and Muhammad El Baradei were given new documents by Iraq, and described key talks with Iraqi officials in Baghdad as 'very substantial'. |

| 2003 | 9 Feb | The US reacted furiously to a Franco-German peace initiative to triple the number of arms inspectors in Iraq and back them up with surveillance flights. The Bush administration saw it as a thinly-disguised attempt to derail the US timetable for war. |

| 2003 | 14 Feb | Hans Blix submitted his latest report on Iraqi compliance with resolution 1441 to the UN security council, surprising the members with a more upbeat assessment of the pace of Iraq's disarmament than had been expected. The report, which listed examples of Iraqi compliance with the inspectors, thus failing to provide any clear casus belli, threw into confusion British and American plans to draft a new resolution mandating military action. It severely embarrassed Colin Powell by questioning the US intelligence on Iraqi munitions that he presented to the Council earlier in the month. |

| 2003 | 15 Feb | Massive peace demonstrations take place around the world—from Tokyo to California. |

| 2003 | 22 Feb | Hans Blix orders Iraq to destroy its al-Samoud missiles by March 1. The UN inspectors have determined that the missiles have an illegal range limit. Iraq, under UN Resolutions, can have missiles that reach neighboring countries, but not ones capable of reaching Israel. Israel, on the other hand, has missiles of over 2000 km range. |

| 2003 | 24 Feb | US, UK and Spain introduced the text of a draft resolution to the Security Council, stating that Iraq has "failed to take the final opportunity afforded to it in Resolution 1441". However, the draft failed to secure enough support. |

| 2003 | 24 Feb | Russia, France and Germany put forward a counter-proposal to America and Britain's draft resolution: a step-by-step program for Iraqi disarmament. |

| 2003 | 28 Feb | Hans Blix's interim report to the UN is published, giving a mixed assessment of Iraqi cooperation with weapons inspectors, but hailing Saddam Hussein's commitment to comply with tomorrow's UN deadline |

for the destruction of Iraq's illegal Samoud II missiles.

2003 1 Mar Iraq began destroying Samoud II missiles and 360 rocket engines in accordance with request of UNMOVAC.

2003 1 Mar At the Arab summit in Sharm al-Shaykh, the UAE publicly propose Saddam Hussein going into exile, but the summit resolves that no Arab state should "participate" in an attack on Iraq without UN approval.

2003 1 Mar Turkey's parliament votes against allowing US troops to be stationed in Turkey, despite the offer by US of $26 bn in aid and loan guarantees.

2003 5 Mar The foreign ministers of France, Russia and Germany release a joint declaration stating that they will 'not allow' a resolution authorizing military action to pass the UN Security Council.

2003 7 Mar Blix appeared attempting to forestall war, calling for more time to verify Iraq's compliance.

2003 9 Mar UK-sponsored amendments, proposing a 17 Mar deadline for action was put forward.

2003 10 Mar Britain announced 'six key tests' for Iraq to comply with if it is to avoid war, including President Saddam making a TV address admitting having weapons of mass destruction. The idea galvanized some diplomatic support, but not enough to suggest the US/UK could win a second UN resolution, effectively authorizing an attack.

2003 10 Mar Attempts to get a second resolution fail when French president Jacques Chirac says he will veto it because the inspection process has not had enough time to disarm Iraq.

2003 16 Mar Sensing no majority support in the Security Council, the Azores summit of President Bush, and Prime Ministers Blair and Aznar (Spain) called for international support, with President Bush announcing a 24 hour deadline for UN support.

2003 16 Mar The IAEA and UNMOVIC were advised by the United States to withdraw their inspectors from Iraq. Such a withdrawal should be completed by March 18 depending on how long it takes for the United Nations to approve such a withdrawal.

2003 17 Mar The UK withdrew the draft resolution and UNS-G Kofi Annan withdrew UN personnel from Iraq and suspended the oil-for-food program.

2003 17 Mar The Attorney General in the UK, after having gave his legal opinion on the illegality of the war on 7 March, relied on the opinion of a certain professor and sneaked the new opinion into a one-page written answer in Parliament. Britain went to war relying for its legality on the opinion of one university professor.

2003 18 Mar President Bush gave Saddam Hussein 48 hours to leave Iraq.

2003 19 Mar The foreign ministers of Germany, France and Russia condemned the impending military action in strong terms, saying that the use of force against Iraq had not been approved by any UN resolution.

2003 20 Mar The invasion started at 5:30 Baghdad time with the US beginning its bombardment of Baghdad with the targeting of a building that Saddam

Hussein was thought to be in; movement of US, UK and Australian troops into Iraq after unexpected early resistance from Iraqi troops in Umm Qasr (21-25 Mar), Nasiriyah (24 Mar) and Najaf (25 Mar), and the first suicide bomb attack on US troops in Najaf (29 Mar).

2003	27 Mar	US forces advancing towards Baghdad are held up by fierce fighting in the city of Samawah against 1,500 Iraqi paramilitaries guarding a bridge across the Euphrates river, which they eventually capture.
2003	27 Mar	Paul Wolfowitz reveals that the government intends to finance the war by taking Iraqi oil assets: "There's a lot of money to pay for this. It doesn't have to be U.S. taxpayer money. We are dealing with a country that can really finance its own reconstruction, and relatively soon."
2003	1 Apr	The New Moon on 01 April would provide cover of darkness for American forces entering Baghdad. Using night-vision capabilities, this could be helpful in achieving surprise, with the attacker deriving additional advantages from the defender's inability to aim his fire effectively.
2003	2 Apr	Colin Powell declares, "I can assure you that we all want to end this as soon as possible, so we can get on with the task of allowing the Iraqi people to form a new government."
2003	3 Apr	US troops from the 3rd Infantry Division reach Saddam International Aiport, 10 miles from Baghdad's city centre, after heavy overnight bombardment. As many as 80 Iraqis, some of them civilians, are reported to have been killed at the village of Furat near the airport in what witnesses described as a rocket attack.
2003	3 Apr	The British Ministry of Defence admits to having used Israeli-made cluster shells around Basrah as well as cluster bombs dropped from RAF Harrier jets.
2003	7 Apr	Three houses in Baghdad's up-market al-Mansour area were destroyed with a loss of 17 civilians in what neighbors said was an allied missile attack. US officials said that they had intelligence President Saddam and his sons were meeting there and that attack was an assassination attempt.
2003	7 Apr	British forces take control of Basrah, Iraq's second-largest city.
2003	9 Apr	Baghdad fell to the invading US army after two days of fierce fighting at Baghdad airport where different non-conventional weapons were used, annihilating a few Presidential regiments. NO WMD WERE FOUND.
2003	18 Apr	Tens of thousands of Iraqis demonstrate against the US occupation of Iraq in central Baghdad.
		The head of the Iraqi National Congress, Ahmad Chalabi, who some in Washington want as a new Iraqi leader, makes his first public appearance in Baghdad.
2003	21 Apr	Retired gen. Jay Garner arrived in Baghdad to take charge of the Office of Reconstruction and Humanitarian Assistance (ORHA), established by President Bush to administer Iraq post-war.
2003	22 Apr	The UN chief weapons inspector, Hans Blix, condemned British and American handling of the hunt for any possible weapons of mass

destruction in Iraq.

2003	24 Apr	The UN secretary general, Kofi Annan, called on the US-led coalition to respect international law as the "occupying power" in Iraq, drawing immediate ire from US officials who resist the label "occupier".
2003	28 Apr	US troops fired on a group of Iraqi demonstrators near Baghdad, killing at least 13 people and wounding 75 others.
2003	30 Apr	US troops opened fire on Iraqi civilians for the second time as an angry crowd in Falluja protested over an earlier shooting.
2003	I May	President Bush declared an end to the Iraq war stating that the US had prevailed.
2003	3 May	The Bush administration moves to heal a damaging rift with London, following claims from a senior Washington official that Saddam Hussein may have got rid of most of his weapons of mass destruction before the war. Such claims are highly awkward for Tony Blair, who remains adamant that banned weapons will be found and prove the coalition was justified in going to war.
2003	7 May	Paul Bremer was appointed by President Bush to replace Jay Garner in ruling Iraq.
2003	8 May	US and UK applied to the Security Council for authority as occupying power to rule Iraq.
2003	9 May	US and UK laid out their blueprint for postwar Iraq in a draft resolution to the United Nations Security Council, naming themselves as "occupying powers" and giving them control of the country's oil revenues.
2003	12 May	The US-appointed ruler of Iraq, Paul Bremer, arrived to take up his post.
2003	15 May	UK Foreign secretary, Jack Straw, conceded that hard evidence of weapons of mass destruction might never be found in Iraq. He said that it was "not crucially important" to find them because the evidence of wrongdoing was overwhelming. That was the closest the UK Government came to admitting that its dossier on Iraq's WMD was fabricated.
2003	16 May	Paul Bremer promulgated first Regulation announcing that the Coalition Provisional Authority (CPA) of which he was the administrator is the ultimate authority in Iraq with himself assuming supreme legislative, executive and judicial authority in Iraq. Bremer relied in his Regulation on the authority of Security Council Resolution 1483 which was only adopted 6 days later on 22 May.
2003	16 May	Paul Bremer enacted Order Number 1 in which he ousted the whole political era of 35 years in the de-Ba'athification of Iraqi Society.
2003	22 May	Security Council Resolution 1483 acknowledged letter of US/UK of 8 May; recognized the US and UK as occupying powers; gave them control over Iraq's oil revenues; lifted sanctions, and bound them to operate within international law especially the Geneva Conventions 1949 and the Hague Regulations of 1907.
2003	23 May	Paul Bremer enacted Order Number 2 for the 'Dissolution of Entities' in which he dissolved among others the Iraqi Army, Intelligence Service

		and National Security effectively leaving Iraq without any organization to secure peace and order.
2003	30 May	In separate speeches, US secretary of state Colin Powell and British PM Tony Blair deny that intelligence about Iraq's WMD was distorted or exaggerated to justify an attack on Iraq.
2003	2 Jun	British PM was accused, by Clair Short, of having lied to the British Cabinet on Iraq and for having concluded a secret war pact with the US.
2003	6 Jun	Hans Blix hit out at the quality of intelligence given to him by the United States and Britain on Iraq's alleged chemical and biological weapons programs. "Only in three of those cases did we find anything at all, and in none of these cases was there any weapons of mass destruction, and that shook me a bit".
2003	10 Jun	Hans Blix, the UN chief weapons inspector, lashed out at the "bastards" in the Pentagon who smeared him and tried to undermine him throughout the three years he had held his high-profile post.
2003	Jun	At a "BBC Breakfast with Frost" interview, Paul Bremer boasts of the US military's strength: "[W]e dominate the scene and we will continue to impose law and order and impose our will on this country."
2003	4 Jul	A tape recording purportedly of Saddam Hussein is broadcast urging guerrilla fighters in Iraq to continue their resistance to the US-led occupation of the country.
2003	7 Jul	Bush administration concedes that evidence that Iraq was pursuing a nuclear weapons program by seeking to buy uranium from Africa, cited in January state of the union address and elsewhere, was unsubstantiated and should not have been included in the speech.
2003	8 Jul	British PM Tony Blair told a committee of MPs that his evidence for Iraq's attempts to secure uranium from Niger did not come from forged documents but "separate intelligence". Blair failed to inform his MPs that the source as usual was Israeli intelligence who had been good at feeding gullible European intelligence services anything it chose.
2003	11 Jul	The CIA director, George Tenet, apologized for not preventing George Bush from making use of the British-sourced uranium claims in his state of the union address.
2003	13 Jul	Paul Bremer, in Regulation Number 6, appointed the Iraqi Governing Council consisting of 25 men and women, most of whom have lived most of their lives outside Iraq, to assist him in ruling Iraq although the Council was given no authority.
2003	22 Jul	Uday and Qussay, sons of Saddam Hussein, were killed by US troops in the city of Mosul in northern Iraq.
2003	13 Aug	Paul Bremer, in Order Number 24, dissolves the Ministry of Atomic Energy.
2003	19 Aug	UN headquarters at the Canal Hotel in Baghdad is bombed; 24 are killed, including the head of the UN mission, Sergio Vieira de Mello.
2003	22 Aug	UN secretary general, Kofi Annan said that America and Britain will face a challenge to persuade the international community to send

troops to Iraq unless they agree to share power.

2003 29 Aug A large car bomb blast at the Imam Ali mosque in Najaf killed 80-125, including Muhammad Baqir al-Hakim of SCIRI.

2003 17 Sep George W. Bush admits no Saddam link to 9/11: "No, we've had no evidence that Saddam Hussein was involved with September the 11th."

2003 18 Sep The former UN chief weapons inspector, Hans Blix, accused the US/ Uk of spin over Iraq and said that he believed Iraq had destroyed most of its weapons of mass destruction 10 years ago.

2003 19 Sep In orders 37 and 38, Paul Bremer reshaped Iraq's tax strategy and introduced a reconstruction levy. In Order 39 he opens Iraq to foreign investment for the first time in over forty years.

2003 22 Sep After a second, smaller, explosion at a police checkpoint outside the compound, the UN pulls almost all of its foreign staff out of the country.

2003 2 Oct According to an interim report by David Kay, the lead investigator searching for WMD in Iraq, no WMDs have been found as yet.

2003 14 Oct Paul Bremer, in Order 43, issues new Iraqi banknotes.

2003 16 Oct Security Council adopted Resolution 1511.

2003 6 Nov Several US papers report that, in the weeks before its fall, Iraq's Ba'athist regime made a series of increasingly desperate peace offers to Washington, promising to hold elections and even allow US troops to search for banned weapons.

2003 14 Nov General John Abizaid, head of US Central Command, says number of insurgent fighters no more than 5,000.

2003 3 Dec It was reported that the US was planning to set up a paramilitary battalion in Iraq drawn from the five main political parties to help American troops fighting a fast-spreading insurgency. Those armed by the US became the insurgents and militia of later months.

2003 9 Dec In a directive issued by Paul Wolfowitz, the Pentagon excludes countries that opposed the Iraq invasion from bidding for reconstruction contracts and naming France, Germany, Canada, Mexico, China and Russia.

2003 10 Dec Paul Bremer, in Order 48, sets up the Iraqi Special Tribunal (IST) to try the Ba'ath regime for actions between July 1968 and May 2005 which were only criminalized under the Statute of the ICC which came into force in June 2002 and which has not been ratified by the US or Iraq.

2003 13 Dec Saddam Hussein was captured by US forces.

2004 15 Jan Tens of thousands of Shi'a hold a peaceful demonstration in Basrah in support of direct elections.

2004 19 Jan The United States asks the UN to intercede in the dispute over the elections process in Iraq. Shiite leader Ayatollah al-Sistani, at the center of the debate, has refused to meet with American officials

About 100,000 Shiites march in Baghdad and other cities in support of

		Ayatollah al-Sistani's demand for direct elections. It is the largest protest since the occupation of Iraq.
2004	28 Jan	David Kay, the former head of the US weapons inspection teams in Iraq, told senate committee "we were almost all wrong" in believing before the war that Saddam Hussein had chemical or biological arms. What Kay did not explain is how conceivable was it that all those sophisticated intelligence services could have been wrong and if so why should anybody rely on them. His report sets off a firestorm of allegations: did the U.S. receive bad intelligence, or did the Bush administration manipulate the intelligence to build the case for war, or both?
2004	12 Feb	The most powerful man in post-Saddam Iraq, Ayatollah Ali al-Sistani, held talks with senior UN envoy Lakhdar Brahimi at his home in Najaf.
2004	13 Feb	Following the talks with Iraq's leading Shi'a cleric, Ayatollah Ali al-Sistani, who favored immediate elections, the UN indicated its support in principle for early elections but conceded that they are unlikely to happen in the current climate.
2004	19 Feb	UN Secretary-General Kofi announces the results of its report about Iraqi elections, concluding that "elections cannot be held before the end of June, that the June 30 date for the handover of sovereignty must be respected, and that we need to find a mechanism to create the caretaker government and then prepare the elections sometime later in the future."
2004	7 Mar	Admiral Sir Michael Boyce, who led Britain's forces to war in Iraq, revealed how Britain was on the brink of a constitutional crisis after he demanded 'unequivocal... legal top cover' before agreeing to allow British troops to fight. Such legal cover was provided by the UK Attorney General relying on the advice of a typical sycophant professor of whom the UK had produced many over the centuries to justify its despicable history of conquest.
2004	8 Mar	The Transitional Administrative Law (the interim constitution) is signed in Baghdad by the IGC. The TAL specifies that an "interim government" (IIG) will be installed from 30 Jun until Jan 05, when elections will take place to create a "transitional government" and national assembly, to lead to a full constitution by Oct05. Has a federal arrangement which gives the opportunity to the 3 Kurdish-majority governorates to veto the constitution. THE IGC DID NOT STATE BY WHICH AUTHORITY IT PROMULGATED THE TAL.
2004	18 Mar	The incompetent retired General, Jay Garner, who was dismissed as Iraq's first occupation administrator after a month in the job, said that he fell out with the Bush circle because he wanted free elections.
2004	28 Mar	The US closed al-Hawza, a newspaper aligned with Muqtada as-Sadr.
2004	31 Mar	Four US contractors were attacked in Falluja and their bodies burned, dragged by cars and strung up from a bridge by a mob. Five US soldiers were also killed by a roadside bomb outside Falluja.
2004	4 Apr	Following the close of al-Hawza on 28 Mar and arrest of Mustafa Yaqubi, a senior aide of Muqtada as-Sadr, fighting breaks out from 4 Apr with US troops in Sadr City, Najaf, Nasiriyah, Basrah, Kut and Amara.

2004	4 Apr	In an apparent act of revenge for the killing of the US contractors in Falluja, the US surrounded the city in preparation to launch a large-scale invasion of the city .
2004	6-7 Apr	Coalition forces fought Shi'a gunmen and Sunni insurgents on several fronts, with British, Italian and US troops involved in battles that kill dozens of Iraqis and at least 15 coalition soldiers.

The coalition lost control of several areas as the Sunni and Shi'a uprisings spread from Kirkuk in the north, to Kut in the south.

2004	8 Apr	US attack from land and air on Falluja intensifies, leaving thousands killed and injured; many of the dead were buried in a football field.
2004	11 Apr	US orders a ceasefire in Falluja to give political discussions a chance to break the cycle of violence.
2004	13 Apr	The US gave up on its demand for the handover of the people who killed four American security guards and mutilated their bodies in Falluja, according to senior Iraqis.
2004	22 Apr	In a shift of policy, US announces that some Iraqi Baath Party officials who had been forced out of their jobs after the fall of Saddam Hussein will be allowed to resume their positions. *Over a million people lost their jobs*, including teachers and members of the military, depleting Iraq of skilled and experienced workers to rebuild the country.
2004	26 Apr	Aid agencies warn that the Geneva convention is being breached in Falluja, Iraq, amid serious concern about the safety of civilians in the city where at least 600 people have been killed by coalition forces.
2004	27 Apr	UN envoy Lakhdar Brahimi reports to the UN Security Council that by the end of May a transitional government to will be in place to run Iraq until elections are held in 2005. The Proposed government will include a president, two vice presidents, a prime minister, and a consultative conference made up of about 1,500 Iraqis—all appointed by the US. The government will have limited control over Iraq, and would not be authorized to enact new laws. All the necessary legislation has been done by Paul Bremer between May 2003 and June 2004.
2004	28 Apr	US warplanes pound residential areas in Falluja with 500 lb laser-guided bombs and marines battle with insurgents on the ground while commanders in Baghdad insist a ceasefire is holding. Many residential areas were levelled to the ground.
2004	29 Apr	US forces announce an end to their siege of Falluja, saying they will pull out immediately to allow a newly-created Iraqi security force to secure the city.
2004	29 Apr	A first series of photos were released showing torture and sexual abuse by US prison guards of Iraqi detainees at Abu Ghraib jail. The true scale of torture and rape has never been shown.
2004	4 Jun	The Pope subjected George Bush to a very public, relentlessly critical assessment of the US administration's performance in Iraq, attacking "deplorable" abuses of prisoners and calling for an international solution to the country's crisis.
2004	7 Jun	Security Council adopts Resolution 1546 recognizing the legitimacy of new arrangements but failed to mention TAL. [.....]

2004	7 Jun	Paul Bremer, in Order 96, sets out the Electoral Law for the election of the General Assembly in which election will be done by direct, universal and secret ballot in one single electoral constituency.
		In Order 97 Paul Bremer sets out the rules that govern the certification of political parties to take part in the election. No person or organization was to take part in the election unless certified as a political entity under the Order.
2004	9 Jun	Tony Blair and George Bush issue a joint call for greater NATO involvement in Iraq. France rejects the plan.
2004	9 Jun	Paul Bremer promulgates Regulation 9 dissolving the Governing Council which he created on 13 Jul 2003 as a rubber stamp authority with no authority or power.
2004	9 Jun	In regulation 10 Paul Bremer appointed the Interim Government of Iraq headed by Ayad Allawi, former Ba'athist turned into CIA agent, and 32 ministers, most of whom turned out to be corrupt thieves. In the typical casual attitude of Paul Bremer that had pervaded his rule in Iraq he listed the President and his two deputies in the same Regulation appointing the Government of Iraq. Paul Bremer was not able or was indifferent to the fact that the President of a Republic is not a member of its Government.
2004	16 Jun	The commission investigating the 9/11 attacks found "no credible evidence" of a link between Iraq and al-Qaida, contradicting President George Bush's assertion that such a connection justified the toppling of Saddam Hussein.
2004	17 Jun	In a poll conducted by the Coalition Provisional Authority in May, 92% of Iraqis saw the U.S. as "occupiers," 3% saw them as "peacekeepers," and only 2% Iraqis viewed them as "liberators."
2006	27 Jun	Paul Bremer amended Order 17 to grant full immunity for all those working with and for the occupying power in Iraq after 30 June 2004. In effect the Order put all foreign forces and the mercenaries operating under guise of security companies outside any law.
2004	28 Jun	Ayad Allawi was appointed by Paul Bremer, became the Prime Minister of the Interim Government whose members were appointed by Bremer
2004	9 Jul	A Senate Intelligence Committee report blamed the CIA for the Bush administration's apparently unfounded claims about Iraq's weapons of mass destruction. The report admonished the outgoing director, George Tenet, and CIA analysts who, one Republican senator claimed yesterday, made "wholesale mistakes" in the collection and processing of intelligence.
2004	14 Jul	The Butler report on pre-Iraq war British intelligence is released, and it echoes the American findings of the week before (though with a much milder tone) that pre-war intelligence exaggerated Saddam Hussein's threat. In particular, the British intelligence dossier asserting the widely suspect claim that Saddam Hussein could deploy weapons within 45 minutes was deemed highly misleading, and "led to suspicions that it had been included because of its eye-catching character."
2004	22 Jul	Australia releases the Flood report, whose assessment of pre-war

intelligence on Iraq finds the evidence supporting Iraq's possession of WMD "thin, ambiguous, and incomplete."

With the release of the Australian report, the three Anglo-Saxon states sought to clear themselves regarding the evil done in Iraq.

2004	15 Jul	Hans Blix, the head of the UN weapons inspectors in Iraq before the war, accuses Tony Blair of misleading the British people by failing to "think critically about the evidence at hand".
2004	22 Jul	The Pentagon acknowledges in a long-awaited report that abuse of Iraqi and Afghan prisoners by their US army guards occurred on a far greater scale than previously disclosed, with at least 94 confirmed cases of death in custody, sexual and physical assault, and other mistreatment.
2004	22 Jul	Congress votes overwhelmingly, 96-0 and 410-12, to continue funding the war in Iraq.
2004	6 Aug	A large US assault on Muqtada al-Sadr's forces in Najaf killed around 300.
2004	15 Aug	Peace talks collapsed between Iraqi officials and Muqtada al-Sadr as fighting between the radical cleric's Mahdi soldiers and US troops continued in the holy city of Najaf.
2004	19 Aug	Iraq's national conference, which was chosen by the US, finally elected the country's interim assembly, which would serve as a watchdog over the interim government until national elections held in January 2005.
2004	20 Aug	In a desperate attempt to show that he wielded power the US-appointed prime minister, Ayad Allawi, announced the first of several "final calls" for Muqtada al-Sadr to call off fighters holding Najaf's revered Imam Ali shrine or face an assault by US-backed Iraqi soldiers.
2004	24 Aug	The Pentagon-sponsored Schlesinger report's investigation into the Abu Ghraib scandal called the prisoner abuse acts of "brutality and purposeless sadism," rejected the idea that the abuse was simply the work of a few aberrant soldiers, and asserted that there were "fundamental failures throughout all levels of command, from the soldiers on the ground to Central Command and to the Pentagon."
2004	27 Aug	The bloody, three-week battle in Najaf between the US forces and the militia of militant cleric al-Sadr ends in August when Shiite cleric Grand Ayatollah Ali al-Sistani negotiates a settlement.
2004	15 Sep	The British Ministry of Defence admited for the first time that senior British officers were working closely with American commanders at Abu Ghraib, the Baghdad prison where Iraqi prisoners were systematically abused and humiliated.
2004	15 Sep	In a BBC interview, UN Secretary General Kofi Annan says the war against Iraq was illegal and violated the UN Charter. The US, UK, and Australia vigorously reject his conclusion.
2004	17 Sep	The comprehensive 15-month search for weapons of mass destruction in Iraq concluded that Iraq had no WMD.

2004 19 Sep US jets bomb a militants' checkpoint in Falluja as frustrated military commanders appear to be moving closer to an all-out offensive against the city. At least four people are killed in the attack, the latest in a series of near-daily bombing raids conducted by the US in Falluja in the past two weeks.

2004 21 Sep The UN secretary general, Kofi Annan, delivered a stern rebuke to nations that "shamelessly disregard" international law. Mr Annan, who last week branded the US-led war in Iraq "illegal", told the UN General Assembly that international law remained the cornerstone of global stability in a speech laced with many veiled—and at least one explicit—criticism of the US.

2004 22 Sep The confusion surrounding the decision over whether two "high-value" women prisoners being held in Iraq would be released underlines the limits of the interim government's authority. The apparent differences between the statements of Iraqi ministers and US officials raise renewed questions over the coherence of the new administration and the degree of independence it actually enjoys.

2004 I Oct US offensive in Samarra killed almost 100 people as army began pre-election pacification push.

2004 15 Oct US forces continue a wave of air and ground assaults on the rebel-held city of Falluja after local officials break off peace talks, saying US and Iraqi authorities are making impossible demands. This signalled the second destruction of the town in six months.

2004 16 Oct The British MoD announced that Black Watch soldiers would be redeployed in central Iraq during US assault on Falluja.

2004 19 Oct Margaret Hasan, British-Iraqi director of CARE International, is abducted in Baghdad. She is later presumed dead. CARE International was involved in the Future for Iraq Project set up by the US in October 2001 to prepare for the overthrow of Saddam Hussein and occupation of Iraq [...]

2004 29 Oct British medical journal *The Lancet* performs a study and estimates that 100,000 Iraqis have died as a result of the Iraq war.

2004 8 Nov The attacks on Falluja became a full-scale assault, when thousands of American troops supported by air, artillery and tanks fought their way into the most dangerous parts of Falluja to win back control of the Iraqi insurgent stronghold resulting in around 1,600 killed. The city has been severely damaged by artillery, air and tank bombardments, and most of the city's 300,000 residents have not returned.

2004 13 Nov The human cost of the battle of Falluja emerged as large numbers of wounded civilians were evacuated to hospitals in Baghdad.

2004 15 Nov US troops called in air strikes on the Iraqi city of Baquba, a city north east of Baghdad, as they fought gun battles in the street with crowds of insurgents.

2004 30 Nov The US-led war in Iraq created a healthcare disaster in a country where 20 years of war, mismanagement and sanctions had already left public health in a fragile state, according to Medact, a UK-based medical charity.

2004	27 Dec	Iraq's largest mainstream Sunni Muslim party pulled out of the election race, saying the violence plaguing areas north and west of Baghdad made a "free and fair vote" on January 30 impossible.
2005	7 Jan	US Lt. Gen. Thomas Metz acknowledges that large parts of nearly 25% of Iraq's provinces are not secure enough to hold elections.
2005	12 Jan	The White House announces that the search for weapons of mass destruction in Iraq, one of the main justifications for the war, is officially over. No such weapons were found.
2005	12 Jan	US investigators searching for Saddam Hussein's alleged weapons of mass destruction left Iraq and appealed to the Pentagon for the release of several Iraqi scientists still being questioned.
2005	14 Jan	A CIA thinktank says the chaos of Iraq is giving rise to a new brand of terrorists who will eventually replace al-Qaida as a global threat.
2005	30 Jan	Iraqis went to the polls to elect members for the national assembly from list of nominees based on sectarian or ethnic bases. There were no individual names to choose from as each party list was for the whole country. In short people were invited to choose on ethnic or sectarian identity.
		A coalition of Shiites, the United Iraq Alliance, received 48% of the vote, the Kurdish parties received 26% of the vote, and the Sunnis just 2%. The Sunni vote was so low because most Sunni leaders had called for a boycott.
2005	Jan	Poll shows 82% of Sunni Arabs and 69% of Shiites want a US withdrawal immediately, or after an elected government is in place. (Zogby)
2005	7 Feb	UN spokesman said that the head of the UN oil-for-food program in Iraq and a senior UN official who dealt with contracts for the program are suspended following an independent investigation that accused them of misconduct.
2005	13 Feb	Final results from the January 30 ballot have the Shi'a parties about 48% of votes cast.
2005	15 Mar	The prime minister of Italy, Silvio Berlusconi, announces he will begin withdrawing his country's troops from Iraq in September under pressure from public opinion.
2005	23 Mar	The Shi'a parties brokered a deal with Kurdish parties to end impasse over the formation of government.
2005	25 Mar	The UK government was challenged to publish the "entire paper trail" of the legal advice it received about the war against Iraq in light of the disclosure that the attorney general, Lord Goldsmith, believed it would be unlawful less than two weeks before the invasion.
2005	31 Mar	US spy agencies were "dead wrong" in "almost all" of their pre-war judgments about Iraq's weapons of mass destruction capability, a commission appointed by the US president said in final report today.
2005	15 Apr	Britain and America reacted angrily to accusations by the UN secretary general, Kofi Annan, that they were partly to blame for the oil-for-food scandal because for years they had overlooked the illegal trade in

Iraqi crude.

2005	18 Apr	As Iraqi President Talabani indicated that he would not sign a death warrant for Saddam Hussein, Iraq's new rulers were split over whether to execute Saddam Hussein if he is convicted of war crimes, with Talabani facing calls to resign if he refused to sign a death warrant.
2005	28 Apr	The full 13 pages of the attorney general's formerly confidential advice on the legality of the Iraq war was published. Prime Minister Tony Blair battled accusations that he misled parliament and the cabinet over its contents since Lord Goldsmith, the attorney general, spelled out to Mr Blair the dangers of Britain going to war without a second UN resolution, indicating its being a breach of international law.
2005	28 Apr	Iraq's leaders ended three months of political deadlock by approving the first government, although continued wrangling means several key positions remain unfilled. Ibrahim al-Ja'fari from the Da'wa party became PM.
2005	1 May	The leaked, top-secret "Downing Street Memo" of July 23, 2002, indicates that eight months before the Iraq war was launched, Blair and top British government officials acknowledged that "the case [for war] was thin," but that "Bush had made up his mind to take military action." The US wanted the war "justified by the conjunction of terrorism and WMD. But the intelligence and facts were being fixed around the policy." Memo receives enormous attention in the UK but not in the US.
2005	18 May	Fresh allegations about the abuse of Iraqis by British soldiers, including torture and sexual humiliation, were released amid calls for an independent inquiry and the description of a recent court martial as a "farce".
2005	22 May	As part of the deliberate tactic of misleading the public it was claimed that US military commanders are planning to pull back their troops from Iraq's towns and cities and redeploy them in four giant bases in a strategy they said was a prelude to eventual withdrawal. However, the US never had any intention of withdrawing from Iraq.
2005	30 May	The chief of police in Basrah admitted that he had lost control of three-quarters of his officers and that sectarian militias have infiltrated the force, using their posts to assassinate opponents.
2005	27 Jun	Britain has been involved in political negotiations with some Iraqi insurgents, Tony Blair revealed. He predicted the next year will be "decisive" in determining the country's future, and reaffirmed that British troops will stay "until the job is properly done".
2005	8 Jul	Italy's prime minister, Silvio Berlusconi, confirmed that his country will begin pulling troops out of Iraq within two months. Speaking at the G8 Gleneagles summit, Mr Berlusconi said the withdrawal of the first of Italy's 3,000 troops will start in September.
2005	11 Jul	According to a secret memo written by John Reid, the UK defense secretary, Britain and the US were privately planning to withdraw most of their forces from Iraq by early next year. Under the plans, Britain will cut the number of its troops from 8,500 to 3,000 by the middle of next year (2006).
2005	17 Jul	Chatham House, the independent thinktank on foreign affairs in the

UK, said that Britain's involvement in the wars in Iraq and Afghanistan contributed to the terrorist attacks in London.

2005	20 Jul	Trouble continued to plague the committee drafting Iraq's new constitution: Sunni members walked out, citing fears for their own safety; Kurdish leaders said they can live without a deal, and women's groups balked at a proposal to give a strong role to Islamic law.
2005	28 Jul	British intelligence service MI5 linked Iraq to extremists in the UK. On its website, it stated that Iraq was a "dominant issue" among extremists in Britain, contradicting ministers who have suggested that the London bombings of July 7 and July 21 had nothing to do with the Iraq invasion.
2005	22 Aug	Iraq's ruling coalition submitted a new constitution to parliament but delayed a vote for three days to try to win over Sunni Arabs who said it could lead to civil war. The constitution confirmed the division of Iraq on ethnic and sectarian bases.
2005	28 Aug	The ruling Shia and Kurdish coalition bulldozed over the objections of Sunni Arabs to finish a new constitution. Frantic efforts to reach a consensus collapsed when a blueprint for a new democratic state, that lacked the support of Sunni leaders, was submitted to parliament, triggering what promises to be a bitter referendum battle.
2005	29 Aug	Thousands of Iraqis took to the streets of Iraq to demonstrate against the country's draft constitution.
2005	7 Sep	A long-awaited report into the handling of the multimillion-pound Iraq oil-for-food program was published, accusing the UN of "corrosive corruption". The report blames Kofi Annan, the UN secretary general, for mismanagement.
2005	11 Sep	US infantry backed by aircraft and tanks encounter little resistance when they enter Tal Afar, in the north of the country, after a two-day indiscriminate offensive, and find hundreds of dead and wounded, although troops find entire districts abandoned by civilians in advance of the offensive.
2005	19 Sep	Further evidence of the sovereignty or lack of it in Iraq was demonstrated today. Clashes erupted between the British military in Basrah and Iraqi police after two SAS officers, disguised as Arabs and carrying weapons and suspicious equipment, were arrested by police carrying out their duties as instructed by their British masters. A British army tank blasted through the walls of Basrah's police station and freed them while another was pelted with petrol bombs and stones. Representatives of the radical cleric Muqtada as-Sadr described the British actions as "international terrorism".
2005	20 Sep	The governor of Basrah condemned the "barbaric aggression" of British forces used to free the SAS soldiers held at a police station.
2005	20 Sep	Iraqi authorities issued a warrant for the arrest of former defence minister Hazim Sha'lan in connection with the "disappearance" of more than $1bn from ministry coffers. Hazim Shallan was the defence minister in the government of Ayad Allawi, which was appointed by Paul Bremer to prepare Iraq for the democratic civilized future.
2005	22 Sep	George Bush insisted that US forces will not withdraw from Iraq "on my watch", while Iraq's prime minister, Ibrahim al-Jaafari, and the

British defence secretary, John Reid, made it clear that no timetable existed for the withdrawal of British troops.

2005 15 Oct Iraqi voters head to polls to vote on a constitution.

2005 19 Oct Saddam Hussein appeared in court for the first day of his trial over the killing of 142 who were tried for an assassination attempt on his life in 1982 and executed in 1984.

2005 20 Oct One day after the start of the trial lawyer Sa'doon Al-Janabi, a member fo Saddam Hussein's defense team, was abducted by men who identified themselves as officials of the Ministry of Interior and murdered.

2005 25 Oct Electoral commission reports that constitution has passed, with 79% of voters supporting it. But it failed by more than a two-thirds majority in two Sunni-dominated provinces and by less than a two-thirds majority in a third, making the victory a narrow one.

2005 30 Oct After persistent denial that the US had kept any records of Iraqi casualties, in the first conservative official US estimate of the Iraqi death toll to be published, the Pentagon calculated that at least 26,000 Iraqis had been killed or injured since the invasion in March 2003.

2005 30 Oct Italian prime minister Silvio Berlusconi, one of the US's closest allies in support of the Iraq war, told Italian television that he had tried to persuade the US government not to wage it. However, what Berlusconi failed to advise the viewers is why he joined the invasion.

2005 8 Nov A second member of Saddam Hussein's defense team, Adil Muhammad Abbas Az-Zubaidi, was murdered and his colleague wounded.

2005 13 Nov US troops found 170 prisoners locked inside an interior ministry bunker in Baghdad, many beaten and malnourished and some seemingly the victims of brutal torture.

2005 18 Nov House of Representatives voted 403-3 to continue the occupation.

2005 19 Nov US Marines massacre 24 civilians in Haditha, including several children shot to death execution-style. The massacre is covered up and only revealed in March of 2006 after an investigation by *TIME Magazine* and a human rights group.

2005 21 Nov For the first time, a group of Sunni, Shiite, and Kurdish leaders sign a statement that demands a specific time for the pullout of foreign troops.

2005 2 Dec The Pentagon acknowledges that it hired a U.S. public relations agency, the Lincoln Group, to translate into Arabic articles written by American soldiers. The agency then passed the stories on to advertising agencies that paid Iraqi news outlets to run them.

2005 5 Dec Today's session of Saddam Hussein's Tribunal started with a dispute when the Judge refused to allow Ramsey Clark and Najeeb Al-Nu'aimi, acting for Saddam Hussein, to address the Tribunal.

2005 15 Dec Iraqis turned out in numbers to vote for a four-year parliament, with initial figures suggesting a 70% turnout. The voters were asked to choose from national lists of anonymous people made up by parties based on purely ethnic or sectarian bases.

2005 19 Dec With 89% of election votes counted, the Shia-based United Iraqi Alliance led with a 58% share, followed by the Consensus Front, a coalition of Sunni religious and secular parties with 19%. Former US-appointed prime minister Ayad Allawi's party trailed in third place.

2005 21 Dec Saddam Hussein accused his US jailors of beating him "on every part of my body", in an outburst as his trial resumed following a 10-day recess.

2005 Jan Chief Judge Rizgar Muhammad Amin, having come under severe political pressure and criticism for the way he was handling the case against Saddam Hussein, had to resign. The second most senior judge, Sa'eed Hammashi, was appointed to replace him. However, the de-Ba'athification Commission, which was appointed by Paul Bremer, decided he was not fit because of his alleged affiliation to the Ba'ath and suspended not just his appointment but all his functions within the Tribunal. Finally a Kurdish lawyer, Ra'ouf Abdul-Rahman, who had always been politically opposed to the Ba'ath and who never qualified as a judge under Iraqi law, was appointed to head the Tribunal.

2006 20 Jan Preliminary election results are reported for the Dec. 15 parliamentary elections. The Shiite United Iraqi Alliance—an alliance of Shiite religious parties—captured 128 of the 275 parliamentary seats. It did not succeed in winning the two-thirds majority needed to rule without coalition partners, and will seek to form a coalition over the next weeks.

 Eleven other political groups won seats: an alliance of the two major Kurdish parties won 53 seats; the Iraqi Accordance Front (Sunni Arab), 44 seats; Iraqi Front for National Dialogue (Sunni Arab), 11 seats; Iraqi National List (secular), 25 seats; Islamic Part of Kurdistan, 5; Reconciliation and Liberation Bloc (Sunni Arab), 3; Risaliyoun (Shiite), 2, Turkomen Iraqi Front (ethnic Turks), 1; Iraqi Nation List (Sunni), 1; Yazidi minority religious sect, 1; Al-Rafidian List (Christian), 1.

2006 23 Jan Report by the Special Inspector General for Iraq Reconstruction finds evidence of fraud, that money for rebuilding was casually and insecurely stored, and contract work was improperly certified as complete

2006 15 Feb A US Senate report on progress in Iraq indicates that despite the US spending $16 billion on reconstruction, every major area of Iraq's infrastructure is below prewar levels. This includes electricity, drinkable water, heating oil production, crude oil production, and sewage service. The report also indicates that the number of insurgent attacks has increased: between March 2004 and Dec. 2005, they have grown by more that 200%.

2006 22 Feb A massive explosion seriously damaged the golden dome atop the Shi'as' most revered shrine in Iraq, the Hasan Askari Shrine, in Samarra. The bombings ignited ferocious sectarian attacks between Shiites and Sunnis. No one knows who the perpetrators of such an attack are, except to say that it was done by professionals.

2006 16 Mar The US military and Iraqi forces launch "Operation Swarmer" near Samarra, a massive attack against insurgents. It Is the largest air assault since the beginning of the war in 2003.

 Iraq's new parliament meets for the first time since its election in

December 2005. Leaders continue to struggle to form a government of national unity with little success.

2006 22 Apr Nuri al-Maliki of the Shi'a Daiwa party is approved as prime minister, ending four months of political stalemate.

2006 29 Apr The *Los Angeles Times* reports that Parsons, the US company awarded multibillion dollar contracts to rebuild Iraq's health and security infrastructure, will finish only 20 of 150 planned health clinics. It has spent $60 million of the budgeted $186 million for its own management and administration.

2006 30 Apr According to the April report of the Special Inspector General for Iraq Reconstruction (SIGIR), more than 75% of oil and gas restoration projects are incomplete, as well as 50% of electrical and 40% of water and sanitation projects. Yet the most of the $20 billion Congress has allocated for reconstruction has been spent. Incompetence and fraud have characterized numerous projects. Stuart Bowen, Jr., the Special Inspector General, is currently pursuing 72 investigations into corruption by firms involved in reconstruction.

2006 15 May After seven months and the completion of the prosecution case, today was the session in which charges were formally made against Saddam Hussein and his co-accused.

2005 13 Jun In today's session the Judge moved to close the defense case without giving any reasoned written decision and without any explanation, despite the fact that the defense wanted more time to call further witnesses. The defence team claimed that the Judge had earlier agreed to allow the defense to call more witnesses but as soon as he received a note from the RCLO, the US body in control of the Tribunal, he reversed his decision and closed the case.

2006 15 Jun The Congressional Committee on Government Reform's Minority reports that despite $50 billion in expenditures, oil and electricity production remain well below pre-war levels.

2006 21 Jun One of the main lawyers defending former Iraqi leader Saddam Hussein at his trial has been shot dead. Khamis al-Obeidi's body was found dumped in the capital, Baghdad, hours after he was abducted from his home. Defence lawyers have frequently complained that they have not been given enough protection, calling the trial's fairness into question. Two other defence lawyers were murdered last year in the early stages of the trial, which is set to end next month. Mr Obeidi was abducted from his home in Baghdad's northern Adhamiya district at about 7:00 local time by men wearing police uniforms. Police said Mr Obeidi's body was found with several bullet wounds near the Shia district of Sadr City. [BBC – 21 June 2006]

2006 Jul The supposedly sovereign Iraqi government takes steps to petition the United Nations to end the US military's immunity from Iraqi laws.

A Harris Interactive Poll finds 61% of people in the US believe "Invading and occupying Iraq has motivated more Islamic terrorists to attack Americans and the United States."

A *New York Times*/CBS News poll finds 71% of people in the US believe occupying Iraq for several more years would either make no difference in their security, or make them less safe.

2006	10 Jul	Today's session of the Tribunal was decided by the Judge to be the beginning of the defense closing submissions. However, Saddam Hussein, some of his co-defendants and the defense team failed to appeal as they were boycotting in protest at the murder of lawyer Khamis Al-Obaidi and the general denial of justice.
2006	10 Jul	The Government Accountability Office, an independent investigative branch of Congress, releases a report that maintains that the Bush administration's Iraq strategy is inadequate and was poorly planned.
2006	11 Jul	The U.S. Army announces that it is discontinuing its multibillion-dollar deal with military contractor Halliburton, which has provided service to the military in Iraq and elsewhwere. Government audits have uncovered more than $1 billion in questionable charges.
2006	18 Jul	The UN announces that during June, an average of more than 100 civilians were killed in Iraq each day. During the first six months of the year, civilian deaths increased by 77%, reflecting the serious spike in sectarian violence in the country.
2006	26 Jul	Against the continuous protests of Saddam Hussein to the defense and the lawyer delivering it, a lawyer appointed by the Tribunal started delivering his defense. The defense was written by William Wiley, a non-legally qualified person who was appointed by the RCLO to assist the court appointed lawyers, and was then translated into Arabic and delivered by the Iraqi lawyer appointed by the Court.
2006	27 Jul	The trial of Saddam Hussein, the former Iraqi president who faces charges of crimes against humanity, ends after nine months.
2006	28 Jul	Audit finds that the United States Agency for International Development used an accounting scheme to mask budget overruns on reconstruction projects in Iraq.
2006	15 Aug	According to Iraq's health ministry and the Baghdad morgue, a total of 3,438 civilians were killed in July, an increase of 9% over June.
2006	Aug	100,000 Iraqis march and protest in Baghdad against the US-backed Israeli war against Lebanon. Chants included "no, no to the occupiers" and "death to Israel, death to America."
2006	1 Sep	A Pentagon report finds that since the new Iraqi government was established in May, civilian and security forces casualties have increased by 51%.
2006	23 Sep	A classified National Intelligence Estimate—a consensus view of all 16 US intelligence agencies, signed off by Director of National Intelligence John D. Negroponte—is leaked to several newspapers. It concludes that "the Iraq war has made the overall terrorism problem worse."
2006	11 Oct	The Iraqi Parliament votes in favor of a law that would allow provinces to unite and form semi-independent regions. Sunnis in parliament, who oppose the move out of fear that Shiites and Kurds will control most of the country's oil, boycott the vote.
2006	Oct	The UN reports that 914,000 Iraqis have fled from their homes since the March 2003 invasion of Iraq.

2006	19 Oct	The US military acknowledges that its 12-week-old campaign to establish security in Baghdad, which has been wracked by sectarian death squads and insurgents, had been unsuccessful. Maj. Gen. William B. Caldwell IV conceded that the campaign "has not met our overall expectations of sustaining a reduction in the levels of violence."
2006	29 Oct	The US military acknowledges that its 12-week-old campaign to establish security in Baghdad, which has been wracked by sectarian death squads and insurgents, had been unsuccessful. Maj. Gen. William B. Caldwell IV conceded that the campaign "has not met our overall expectations of sustaining a reduction in the levels of violence."
2006	3 Nov	*The New York Times* reveals that a military authorization bill signed by President Bush in October includes a provision that will terminate the Office of the Special Inspector General for Iraq Reconstruction on Oct. 1, 2007. This federal oversight agency, headed by respected Republican lawyer Stuart Bowen, has been pursuing more than 82 investigations into corruption and waste in Iraq by corporations such as Halliburton, Bechtel, and Parsons.
2006	6 Nov	Saddam Hussein is sentenced to death in the case of Dujail.
2006	22 Nov	Today, i.e. some 17 days after pronouncement of sentence, the defense lawyers receives the 296-page judgment. As the time limit for filing an appeal is 30 days the defense was left with only 11 days to analyze the judgment and appeal from it
2006	22 Nov	Civilian deaths reach a record high in Iraq: some 3,700 Iraqi civilians died in October, the highest toll since the war began in 2003, according to the United Nations. Report also says that about 100,000 Iraqis flee each month to Jordan and Syria.
2006	3 Dec	The defense lawyers lodge their appeal and request an extension to file an annex to the appeal in accordance with the Criminal Procedure Law. Such an annex was filed on 17 December.
2006	6 Dec	A bipartisan report by the Iraq Study Group is released. Led by former secretary of state James Baker and former Democratic congressman Lee Hamilton, it concludes that "the situation in Iraq is grave and deteriorating" and "U.S. forces seem to be caught in a mission that has no foreseeable end." The report's 79 recommendations include reaching out diplomatically to Iran and Syria and having the U.S. military intensify its efforts to train Iraqi troops.
2006	Dec	A survey of 2,000 people by the Iraq Centre for Research and Strategic Studies finds that 95% of Iraqis believe security has deteriorated since the March 2003 invasion.
2006	27 Dec	The defense lawyers receive the decision of the Appellate Chamber of 26 December approving conviction and sentence.
2006	30 Dec	Saddam Hussein is hanged.

ENDNOTES:

[1] <http://middleeastreference.org.uk/index.html>
[2] Chronology of Events in the Middle East from 1908 to 1966

<http://middleeastreference.org.uk/Chronology.html>

3 Chronology of Events in the Middle East from 1967 to 1990
 <http://middleeastreference.org.uk/Chronology2.html>

4 Chronology of Events in the Middle East from 1991 to 2005
 <http://middleeastreference.org.uk/Chronology3.html>

5 BBC, Timeline: Iraq – A chronology of key events
 <http://news.bbc.co.uk/1/hi/world/middle_east/737483.stm>

6 The Iraq Crisis – Timeline, Chronology of Modern Iraqi History, MidEast Web.
 <http://www.mideastweb.org/iraqtimeline.htm>

7 Iraq Timeline, 1920s-1999, Infoplease.<http://www.infoplease.com/spot/
 iraqtimeline1.html>

8 Iraq Timeline, 2002, Infoplease. <http://www.infoplease.com/spot/
 iraqtimeline2.html>

9 Iraq Timeline, 2003, Infoplease. <http://www.infoplease.com/spot/
 iraqtimeline2.html#header_2003>

10 Iraq Timeline, 2004, Infoplease. <http://www.infoplease.com/spot/
 iraqtimeline3.html>

11 Iraq Timeline, 2005, Infoplease. <http://www.infoplease.com/spot/
 iraqtimeline4.html>

12 Iraq Timeline, 2006, Infoplease. <http://www.infoplease.com/spot/
 iraqtimeline5.html>

13 Iraq timeline: July 16 1979 to January 31 2004, Guardian Unlimited.<http://
 www.guardian.co.uk/Iraq/page/0,12438,793802,00.html>

14 Iraq timeline: February 1 2004 to December 31 2004, Guardian Unlimited.http://
 www.guardian.co.uk/Iraq/page/0,12438,1151021,00.html

15 Iraq timeline: 2005, Guardian Unlimited.<http://www.guardian.co.uk/Iraq/page/
 0,,1394573,00.html>

16 Countdown to War, 28 April, 2005, *The Guardian*. <http://www.guardian.co.uk/
 Iraq/Story/0,,1472085,00.html>

17 From the Archives- *The Guardian*.<http://www.guardian.co.uk/Iraq/history/
 0,,876851,00.html>

18 Attacking Iraq—Countdown Timeline, Global Sceurity <http://www.globalsecurity
 .org/military/ops/iraq-timeline.htm>

19 Iraq War Timelinehttp://www.nicolaibrown.com/iraq/timeline.html

20 Timeline 1988, Timelines of History. <http://timelines.ws/20thcent/1988.HTML>

21 Timeline 1989, Timelines of History <http://timelines.ws/20thcent/1989.HTML>

22 Timeline 1990, Timelines of History.<http://timelines.ws/20thcent/
 1990A.HTML><http://timelines.ws/20thcent/1990B.HTML>

23 Harak, G. Simon, Why Did Iraq Invade Kuwait? – A Brief History <http://
 mcadams.posc.mu.edu/blog/harak.html>

24 Iraq's Grievances with Kuwait, Persian Gulf War.<http://www.geocities.com/
 iraqinfo/gulfwar/grievance.html>

25 Robert Fisk, "Saddam Hussein: The Last Great Tyrant," *The Independent*, Decem-
 ber 30, 2000. <http://www.globalpolicy.org/security/issues/iraq/2000/
 1230sadm.htm>

26 Set Up of Iraq, Persian Gulf War <http://www.geocities.com/iraqinfo/gulfwar/
 setup.html>

APPENDIX I

Letter from the Permanent Representatives of the UK and the US to the UN addressed to the President of the Security Council

 | **Security Council** | Distr.GENERAL
S/2003/538
May 8, 2003
ORIGINAL: ENGLISH

Excellency:

The United States of America, the United Kingdom of Great Britain and Northern Ireland and Coalition partners continue to act together to ensure the complete disarmament of Iraq of weapons of mass destruction and means of delivery in accordance with United Nations Security Council resolutions. The States participating in the Coalition will strictly abide by their obligations under international law, including those relating to the essential humanitarian needs of the people of Iraq. We will act to ensure that Iraq's oil is protected and used for the benefit of the Iraqi people.

In order to meet these objectives and obligations in the post-conflict period in Iraq, the United States, the United Kingdom and Coalition partners, acting under existing command and control arrangements through the Commander of Coalition Forces, have created the Coalition Provisional Authority, which includes the Office of Reconstruction and Humanitarian Assistance, to exercise powers of government temporarily, and, as necessary, especially to provide security, to allow the delivery of humanitarian aid, and to eliminate weapons of mass destruction.

The United States, the United Kingdom and Coalition partners, working through the Coalition Provisional Authority, shall inter alia, provide for security in and for the provisional administration of Iraq, including by: deterring hostilities; maintaining the territorial integrity of Iraq and securing Iraq's borders; securing, and removing, disabling, rendering harmless, eliminating or destroying (a) all of Iraq's weapons of mass destruction, ballistic missiles, unmanned aerial vehicles and all other chemical, biological and nuclear delivery systems and (b) all elements of Iraq's programme to research, develop, design, manufacture, produce, support, assemble and employ such weapons and delivery systems and subsystems and components thereof, including but not limited to stocks of chemical and biological agents, nuclear-weapon-usable material, and other related materials, technology, equipment, facilities and intellectual property that have been used in or can

materially contribute to these programmes; in consultation with relevant international organizations, facilitating the orderly and voluntary return of refugees and displaced persons; maintaining civil law and order, including through encouraging international efforts to rebuild the capacity of the Iraqi civilian police force; eliminating all terrorist infrastructure and resources within Iraq and working to ensure that terrorists and terrorist groups are denied safe haven; supporting and coordinating demining and related activities; promoting accountability for crimes and atrocities committed by the previous Iraqi regime; and assuming immediate control of Iraqi institutions responsible for military and security matters and providing, as appropriate, for the demilitarization, demobilization, control, command, reformation, disestablishment, or reorganization of those institutions so that they no longer pose a threat to the Iraqi people or international peace and security but will be capable of defending Iraq's sovereignty and territorial integrity.

The United States, the United Kingdom and Coalition partners recognize the urgent need to create an environment in which the Iraqi people may freely determine their own political future. To this end, the United States, the United Kingdom and Coalition partners are facilitating the efforts of the Iraqi people to take the first steps towards forming a representative government, based on the rule of law, that affords fundamental freedoms and equal protection and justice under law to the people of Iraq without regard to ethnicity, religion or gender. The United States, the United Kingdom and Coalition partners are facilitating the establishment of representative institutions of government, and providing for the responsible administration of the Iraqi financial sector, for humanitarian relief, for economic reconstruction, for the transparent operation and repair of Iraq's infrastructure and natural resources, and for the progressive transfer of administrative responsibilities to such representative institutions of government, as appropriate. Our goal is to transfer responsibility for administration to representative Iraqi authorities as early as possible.

The United Nations has a vital role to play in providing humanitarian relief, in supporting the reconstruction of Iraq, and in helping in the formation of an Iraqi interim authority. The United States, the United Kingdom and Coalition partners are ready to work closely with representatives of the United Nations and its specialized agencies and look forward to the appointment of a special coordinator by the Secretary-General. We also welcome the support and contributions of Member States, international and regional organizations, and other entities, under appropriate coordination arrangements with the Coalition Provisional Authority.

We would be grateful if you could arrange for the present letter to be circulated as a document of the Security Council.

(Signed) Jeremy Greenstock
Permanent Representative of the United Kingdom

(Signed) John D. Negroponte
Permanent Representative of the United States

APPENDIX II

Justice is the Foundation of Governance

Al-Waqa'i Al-Iraqiya

Official Gazette of the Republic of Iraq

Law of the Supreme Iraqi Criminal Tribunal *

Number (4006) Forty-Seventh Year

14 Ramadan 1426 Hijri
18 October 2005

Resolution No. 10

In the Name of the People
The Presidency Council

Pursuant to what has been approved by the National Assembly in accordance with Article. 33 (A) and (B), and Article 30 of the Law of Administration for the State of Iraq for the Transitional Period, the presidency council decided in its session of 9 October 2005 to promulgate the following law:

Number 10 of 2005
Law
of the Supreme Iraqi Criminal Tribunal
SECTION ONE
Establishment and Organization
of the Tribunal
PART ONE
Establishment

Article 1:
First: A Tribunal is hereby established and shall be known as The Supreme Iraqi Criminal Tribunal (the "Tribunal"). The Tribunal shall enjoy complete independence.

*Translated by the International Center for Transitional Justice (http://www.ictj.org); questions and comments can be sent to mena@ictj.org. April 12, 2006. *Laws* Al-Waqa'i Al-Iraqiya – Number 4006 (2) 18/10/2005Note: page setup is US letter. Due to variations in length page the numbering in this document does not match that of the Arabic original.

Second: The Tribunal shall have jurisdiction over every natural person, whether Iraqior non-Iraqi resident of Iraq, accused of committing any of the crimes listed in Articles 11, 12, 13 and 14 of this law, committed during the period from 17 July 1968 to 1 May 2003, in the Republic of Iraq or elsewhere, including the following crimes:

A. Genocide;

B. Crimes against humanity;

C. War crimes; and

D. Violations of Iraqi laws listed in Article 14 of this law.

Article 2:

The Tribunal shall have its seat in the city of Baghdad. It may hold its sessions in anygovernorate, pursuant to a decree by the Council of Ministers upon the recommendation of the President of the Tribunal.

PART TWO
Organizational Structure of the Tribunal

Article 3:

The Tribunal shall consist of:

First:

A. An Appeals Chamber with the power to review the rulings and decisions of
the Trial Chambers or Investigative Judges

B. One or more Trial Chambers.

C. Investigative judges.

Second: Prosecutions Department

Third: An administration providing administrative and financial services to the Tribunal and the Public Prosecution.

Fourth:

A. The Appeals Chamber shall consist of nine judges who shall elect one of its members as a President. The President of the Appeals Chamber shall be the senior President of the Tribunal and shall supervise its administrative and financial affairs.

B. The Trial Chamber shall consist of five judges, who shall elect one of them as a President to supervise their work.

Fifth: The Council of Ministers may, if necessary, and on the basis of a proposal by the President of the Tribunal, appoint non-Iraqi judges who have experience in the crimes stipulated in this Law, and who shall be persons of high moral character, honesty and integrity, in the event that one of the parties is a State. These judges shallbe appointed with the assistance of the international community, including the United Nations.

PART THREE
Selection of Judges and Prosecutors and Termination of Service

Article 4:

First: Judges and prosecutors shall be persons of high moral character, honesty and integrity, and shall have experience in the field of criminal law and meet conditions for appointment stipulated in the Judicial Organization Law 160 of 1979 and the Public Prosecution Law 159 of 1979

Second: As an exception to the provisions of paragraph First of this Article, candidates for the positions of judges at the Appeals Chamber and the Trial Chambers, and for investigative judges and prosecutors shall be serving judges and prosecutors. Retired judges and prosecutors can be nominated regardless of age, as can Iraqi lawyers who possess a high level of, efficiency and experience, and absolute competence in accordance with the Legal Profession Law. 173 of 1965, and service ofa judicial or legal nature or in the field of legal practice of no less than 15 years.

Third:

> A. The Supreme Judicial council shall nominate all judges and prosecutors to the Tribunal. Following approval by the Council of Ministers, a decision for their appointment shall be issued by the Presidency Council. The appointments shall be of the first category, as an exception to the provisions of the Judicial Organization Lawand the Public Prosecution Law. Their salaries and remunerations shall be specified through instructions issued by the Council of Ministers.
>
> **B.** The judges, prosecutors and employees appointed in accordance with the law prior to this legislation shall be deemed legally approved as of the date of their appointment according to the provisions of Article (4)(Third)(A) taking into account the provisions of Article (33) of this law.

Fourth: The Presidency Council, upon a recommendation from the Council of Ministers, may transfer judges and prosecutors from the Tribunal to the Supreme Judicial Council for any reason.

Fifth: The services of a judge or prosecutor covered by the provisions of this law shall be terminated for one of the following reasons:

> 1. If he is convicted of a non-political felony.
> 2. If he presents false information.
> 3. If he fails to fulfill his duties without good reason.

Article 6:

First: A committee comprised of five members elected from among the Tribunal's judges and prosecutors shall be established under the supervision of the Tribunal's Appeals Chamber, and they shall select a president of the committee, which shall be called "Judges and Public Prosecutors Affairs Committee". The committee shall operate for one year and shall have the powers stipulated in the Judicial Organization Law and the Public Prosecution Law. It shall review matters relating to disciplinary measures and conditions of service pertaining to judges and prosecutors. Its decisions can be appealed before the full chamber of the Federal Appeal Court where they involve the termination of the services of a judge or prosecutor.

Second: TheCommittee shall, if the appeal before the full chamber of the Federal Appeal Court is rejected, submit a recommendation to the Council of Ministers for the issuance of an order by the Presidency Council to terminate the services of the judge or prosecutor, including the President of the Tribunal if any of the conditions in Article 6 of this Article (sic) is met.

Third: Upon completion of the work of the Tribunal, the judges and prosecutors shall be transferred to the Supreme Judiciary Council to work in the federal courts. Those who have reached retirement age shall be pensioned off in accordance with the provisions of the law.

PART FOUR
The Presidency of the Tribunal

Article 7:

First: The president of the Tribunal shall:

> A. Preside over the hearings of the Appeals Chamber.
> B.Assign permanent and reserve judges to the Trial Chambers.
> C. Assign a judge to a Trial Chamber in case of absence.
> D. Ensure the completion of the administrative work of the Tribunal.
> E. Appoint the Tribunal's Administrative Director, Security Director, Public Relations Director and Archives and Documentation Director and terminate their services in accordance with the law.
> F. Name an official spokesperson for the Tribunal from among the judges or prosecutors.

Second: The President of the Tribunal may appoint non-Iraqi experts to work in the Trial Chambers and the Appeals Chamber to provide assistance in the field of

international law and similar areas, whether international or otherwise. The appointment of these experts shall be undertaken with the assistance of the international community, including the United Nations.

Third: Non-Iraqi experts provided for in paragraph Second of this Article shall be persons of high moral character, honesty and integrity. The non-Iraqi expert shall preferably be a person who has previously worked in the judiciary or public prosecution in his country or in international war crimes tribunals.

PART FIVE
Investigative Judges

Article 8:

First: A Sufficient number of Investigative Judges shall be appointed.

Second: The Tribunal's Investigative Judges shall be responsible for investigating those accused of committing crimes stipulated in Article 1(Second) of this law.

Third: The Investigative Judges shall elect a Chief Investigative Judge and a Deputy from amongst them.

Fourth: The Chief Investigative Judge shall assign cases under investigation to individual Investigative Judges.

Fifth: Each of the Investigative Judges' Offices shall be composed of an Investigative Judge and such other qualified staff necessary as may be required for the work of the Investigative Judge.

Sixth: An Investigative Judge may gather prosecution evidence from whatever source he deems appropriate and to communicate directly with all relevant parties.

Seventh: The Investigative Judge shall act with complete independence as a separate organ of the Tribunal. He shall not be subject to or respond to requests or instructions from any governmental body or any other party.

Eight: The decisions of the Investigative Judge can be challenged by appeal to the Appeals Chamber within fifteen days of the notification or deemed notification of the decision in accordance with the law.

Ninth: The Investigative Judge, after consultation with the President of the Tribunal, may appoint non-Iraqi experts to provide judicial assistance to the Investigative Judges in the investigation of cases provided for in this Law, whether international or otherwise. The Chief Investigative Judge may appoint these experts with the assistance of the international community, including the United Nations.

Tenth: The non-Iraqi experts and observers referred to in paragraph Ninth of this Article shall be persons of high moral character, honesty and integrity. The non-Iraqi expert or observer shall preferably be a person who has worked in the judiciary or public prosecution in his country or at international war crimes tribunals.

PART SIX
The Public Prosecution

Article 9:

First: A sufficient number of Prosecutors shall be appointed.

Second: The Prosecution Department shall be composed of a number of Prosecutors who shall be responsible for the prosecution of persons accused of crimes that fall within the jurisdiction of the Tribunal.

Third: Prosecutors shall elect a Chief Prosecutor and a Deputy from among them.

Fourth: Each Prosecution Office shall be composed of a Prosecutor and such other qualified staff as may be required for the Prosecutor's work.

Fifth: Each prosecutor shall act with complete independence since he is considered as a separate entity from the Court. He shall not fall under, nor receive instructions from, any government department or from any other party. Each Prosecutor shall act with complete independence as a separate organ of the Tribunal. He shall not be subject to or respond to requests or instructions from the government or any other party.

Sixth: The Chief Prosecutor shall assign to Prosecutors cases requiring

investigation and prosecution in court [Literally, presenting the case at the stage of trial] in accordance with the powers granted to the Prosecutors by law.

Seventh: The Chief Prosecutor, in consultation with the President of the Tribunal, may appoint non-Iraqi experts to provide assistance to the Prosecutors with regard to the investigation and prosecution of cases provided for in this Law, whether international or otherwise. The Chief Prosecutor may appoint these experts with the assistance of the international community, including the United Nations.

Eighth: The non-Iraqi experts referred to in paragraph Seventh of this Article shall be persons of high moral character, honesty and integrity. The non-Iraqi expert shall preferably be a person who has acted in a prosecutorial capacity in his country or at international war crimes tribunals.

PART SEVEN
The Administration Department

Article 10:

First: The Administration Department shall be managed by an officer with the title of Department Director who holds a bachelor degree in law and has judicial and administrative experience. He shall be assisted by a number of employees in managing the affairs of the department.

Second: The Administration Department shall be responsible for the administrative, financial and servicing affairs of the Tribunal and the Prosecutions Department.

SECTION TWO
Court Jurisdiction
PART ONE
The Crime of Genocide

Article 11:

First: For the purposes of this Law and in accordance with the Convention on the Prevention and Punishment of the Crime of Genocide, dated 9 December 1948, as ratified by Iraq on 20 January 1959, "genocide" means any of the following acts committed with intent to destroy, in whole or in part, a national, ethnic, racial or religious group as such:

A. Killing members of the group;

B. Causing serious bodily or mental harm to members of the group;

C. Deliberately inflicting on the group living conditions calculated to bring about its physical destruction in whole or in part;

D. Imposing measures intended to prevent births within the group.

E. Forcibly transferring children of the group to another group.

Second: The following acts shall be punishable

A. Genocide.

B. Conspiracy to commit genocide.

C. Direct and public incitement to commit genocide.

D. Attempt to commit genocide.

E. Complicity in genocide.

PART TWO
Crimes AgainstHumanity

Article 12

First: For the purposes of this Law, "crimes against humanity" means any of the following acts when committed as part of a widespread or systematic attack directed against any civilian population, with knowledge of the attack:

A.Willful killing;

B. Extermination;

C. Enslavement;

D. Deportation or forcible transfer of population;

E. Imprisonment or other severe deprivation of physical liberty in violation

of fundamental norms of international law;

F. Torture;

G. Rape, sexual slavery, enforced prostitution, forced pregnancy, or any otherform of sexual violence of comparable gravity;

H. Persecution against any specific party or population on political, racial, national, ethnic, cultural, religious, gender or other grounds that are impermissible under international law, in connection with any act referred to as a form of sexual violence of comparable gravity;

I. Enforced disappearance of persons; and

J. Other inhumane acts of a similar character intentionally causing great suffering, or serious injury to the body or to the mental or physical health.

Second: For the purposes of implementing the provisions of paragraph First of this Article:

A. "Attack directed against any civilian population" means a course of conduct involving the multiple panel of acts referred to in paragraph First of this Article against any civilian population, pursuant to or in furtherance of a state or organizational policy to commit such attack;

B. "Extermination" means the intentional infliction of living conditions, such as the deprivation of access to food and medicine, with the intent to bring about the destruction of part of the population;

C. "Enslavement" means the exercise of any or all of the powers entailed by the right of ownership over a person and includes the exercise of such power in the course of trafficking in persons, particularly women and children;

D. "Deportation or forcible transfer of population" means forced displacement of the persons concerned by expulsion or other coercive acts from the area in which they are lawfully present, without grounds permitted under international law;

E. "Torture" means the intentional infliction of severe pain or suffering, whether physical or mental, upon a person in the custody or under the control of the accused; except that torture shall not include pain or suffering arising from, or related to legal punishments;

F. "Persecution" means the intentional and severe deprivation of fundamental rights contrary to international law by reason of the identity of the group or population; and

G. "Enforced disappearance of persons" means the arrest, detention or abduction of persons by, or with the authorization, support or acquiescence of, the State or a political organization, followed by a refusal to acknowledge that deprivation of freedom or to give information on the fate or whereabouts of those persons, with the intention of removing them from the protection of the law for a prolonged period of time.

PART THREE
War Crimes

Article 13

For the purposes of this Law, "war crimes" shall mean the following:

First: Grave breaches of the Geneva Conventions of 12 August 1949, namely any of

the following acts against persons or property protected under the provisions of the relevant Geneva Convention:

A. Willful killing;

B. Torture or inhuman treatment, including biological experiments;

C. Willfully causing great suffering, or serious injury to body or health;

D. Extensive destruction and appropriation of property not justified by

military necessity and carried out unlawfully and wantonly;

E. Compelling a prisoner of war or other protected person to serve in the forces of a hostile power;

F. Willfully denying the right of a fair regular trial to a prisoner of war or other protected person;

G. Unlawful confinement;

H. Unlawful deportation or transfer; and

I. Taking of hostages.

Second: Other serious violations of the laws and customs applicable in international armed conflicts, within the established framework of international law, namely any of the following acts:

A. Intentionally directing attacks against the civilian population as such or against individual civilians not taking direct part in hostilities;

B. Intentionally directing attacks against civilian objects, including objects which do not constitute military objectives;

C. Intentionally directing attacks against personnel, installations, material, units or vehicles used in humanitarian assistance or peacekeeping missions in accordance with the Charter of the United Nations, as long as such missions are entitled to the protection given to civilians or civilian objects under the international law of armed conflicts;

D. Intentionally launching an attack in the knowledge that such attack will cause incidental loss of life or injury to civilians or civilian damage which would be clearly excessive in relation to the concrete and direct overall military advantages anticipated;

E. Intentionally launching an attack in the knowledge that such attack will cause widespread, long-term and severe damage to the natural environment, which would be clearly excessive in relation to the concrete and direct overall military advantage anticipated;

F. Attacking or bombarding, by whatever means, towns, villages, dwellings or buildings which are undefended and which are not military objectives;

G. Killing or wounding a combatant who, having laid down his arms or having no longer means of defense, has clearly surrendered;

H. Making improper use of a flag of truce, or the flag, or the military insignia and uniform of the enemy or of the United Nations, as well as of the distinctive emblems of the Geneva Conventions, resulting in death or serious personal injury;

I. The transfer, directly or indirectly, by the Government of Iraq or any of its agencies (including, for clarification, any of the agencies of the Arab Ba'ath Socialist Party), of parts of its own civilian population into any territory it occupies, or the deportation or transfer of all or parts of the population of the occupied territory within or outside this territory;

J. Intentionally directing attacks against buildings which do not constitute military objectives, and are dedicated to religious, educational, artistic, scientific or charitable purposes, or against historic monuments, hospitals and places where the sick and wounded are collected;

K. Subjecting persons of another nation to physical mutilation or to medical or scientific experiments of any kind that are neither justified by the medical, dental or hospital treatment of the person concerned nor carried out in his or her interest, and which cause death to or seriously endanger the health of such person or persons;

L. Killing or wounding treacherously individuals belonging to a hostile nation or army;

M. Declaring that no person is still alive[1];

'Declaring that no quarter will be given'.

N. Destroying or seizing the civilian property of an adverse party unless

such destruction or seizure be imperatively required by the necessities of war;

O. Declaring the abolition, suspension or prohibition of access to a court of law, with the intention of depriving the nationals of the hostile party from seeking their rights;

P. Compelling the nationals of the hostile party to take part inmilitary operations directed against their own country, even if they were in the belligerent's service before the commencement of the war;

Q. Pillaging a town or place, even when taken by force;

R. Using poisons or poisoned weapons;

S. Using asphyxiating, poisonous or any other gases, as well as any other similar liquids, materials or devices;

T. Using bullets, which expand or flatten easily in the human body, such as bullets with a hard envelope, which does not entirely cover the core or is pierced

U. Committing outrages upon personal dignity, in particular humiliating and degrading treatment;

V. Committing rape, sexual slavery, enforced prostitution, forced pregnancy, or any other form of sexual violence of comparable gravity;

W. Utilizing the presence of civilians or other protected persons to render certain points, areas or military forces immune from military operations;

X. Intentionally directing attacks against buildings, material and medical units, means of transport, and personnel using the distinctive emblems of the Geneva Conventions in conformity with international law;

Y. Intentionally using starvation of civilians as a method of warfare by depriving them ofmaterial indispensable to their survival, including willfully impeding relief supplies as provided for under international law; and

Z. Conscripting or enlisting children under the age of fifteen years into the national armed forces or using them to participate actively in hostilities.

Third: In the case of an armed conflict, any of the following acts committed against persons taking no active part in the hostilities, including members of armed forces who have laid down their arms and those placed *hors de combat* by sickness, injury, detention or any other cause:

A. Use of violence against life and persons, in particular killing of all kinds, mutilation, cruel treatment and torture;

B. Committing outrages upon personal dignity, in particular humiliating and degrading treatment;

C. Taking of hostages; and

D. The passing of sentences and the carrying out of executions without previous judgment pronounced by a regularly constituted court, affording all recognized and indispensable judicial guarantees.

Fourth: Other serious violations of the laws and customs of war applicable in armed conflict not of an international character. [sic] within the established framework of international law, specifically any of the following acts:

A. Intentionally directing attacks against the civilian population as such or against civilian individuals not taking direct part in hostilities;

B. Intentionally directing attacks against buildings, materials, medical transportation units and means, and personnel using the distinctive emblems of the Geneva Conventions in conformity with international law;

C. Intentionally directing attacks against personnel, installations, materials, units, or vehicles used in humanitarian assistance or peacekeeping missions in accordance with the Charter of the United Nations, as long as they are entitled to the protection given to civilians or civilian targets under the international law of armed conflict;

D. Intentionally directing attacks against buildings dedicated to religious, educational, artistic, scientific or charitable purposes, or against historic

monuments, hospitals and places where the sick and wounded are collected, provided they are not military objectives;

E. Pillaging any town or place, even when taken over by force;

F. Committing rape, sexual slavery, enforced prostitution, forced pregnancy, or any other form of sexual violence of comparable gravity;

G. Conscripting or listing children under the age of fifteen years into armed forces or groups or using them to participate actively in hostilities;

H. Ordering the displacement of the civilian population for reasons related to the conflict, unless the security of the civilians involved or imperative military reasons so demand;

I. Killing or wounding treacherously a combatant adversary;

J. Declaring that no person is still alive;

K. Subjecting persons who are under the power of the other party in the conflict to physical mutilation or to medical or scientific experiments of any kind that are neither justified by the medical, dental or hospital treatment of the person concerned nor carried out in his or her interest, causing death to such person or persons, or seriously endangering their health; and

L. Destroying or seizing the property of an adversary, unless such destructionor seizure is imperatively demanded by the necessities of the conflict.

PART FOUR
Violations of Iraqi Laws

Article 14

The Tribunal shall have the power to prosecute persons who have committed the following crimes:

First: Interference in the affairs of the judiciary or attempting to influence its functioning.

Second: The wastage and squandering of national resources, pursuant to Article 2(g) of the Punishment of Conspirators against Public Safety and Corrupters of the System of Governance Law 7 of 1958.

Third: The abuse of position and the pursuit of policies that have almost led[2] to the threat of war or the use of the Iraqi armed forces against an Arab country, in accordance with Article 1 of Law 7 of 1958.

Fourth: If the Tribunal finds that the special element of any of the crimes stipulated in Articles 11, 12 and 13 of this Law is missing, and establishes that the act involved constitutes a crime punishable under the Penal Code or any other penal law at the time of its commission, the Tribunal shall be competent to hear the case

SECTION THREE
Individual Criminal Responsibility

Article 15

First: A person who commits a crime within the jurisdiction of this Tribunal shall be individually responsible and liable for punishment in accordance with this Law.

Second: In accordance with this Law, and the provisions of the Penal Code, a person shall be criminally responsible if he [or she]:

A. Commits such a crime, whether as an individual, jointly with another or through another person, regardless of whether that [other] person is criminally responsible;

B. Orders, solicits or induces the commission of such a crime, which has occurred or has been attempted;

C. For the purpose of facilitating the commission of such a crime, aids, abets or by any other means assists in its commission or its attempted commission, including providing the means for its commission;

D. Contributing by any other means, together with a group of persons with

a common criminal intent, to the commission or attempted commission of such a crime provided such contribution is intentional and is either:

 1. Made with the aim of furthering the criminal activity or criminal purpose of the group, where such activity or purpose involves the commission of a crime within the jurisdiction of the Tribunal;

 2. Made with the knowledge of the intention of the group to commit the crime;

E. In respect of the crime of genocide, directly and publicly incites others to commit this crime;

F. Attempts to commit such a crime by taking action with the intention of committing it, but the crime does not occur because of circumstances independent of the person's intentions. However, a person who takes an action that precludes the commission or completion of the crime shall not be liable for punishment, nor will he be liable for punishment under this Law if he completely and voluntarily abandons his criminal purpose.

Third: The official position of any accused person, whether as president of the State, chairman or member of the Revolution Command Council, prime minister or member of the cabinet, or a member of the leadership of the Ba'ath Party, shall not relieve such person of criminal responsibility nor mitigate punishment. No person is entitled to any immunity with respect to any of the crimes stipulated in Articles 11, 12, 13 and 14 of this Law.

Fourth: A superior is not relieved of the criminal responsibility for crimes committed by his subordinates, if he knew or had reason to know that the subordinate had committed, or was about to commit such acts, and the superior failed to take the necessary and reasonable measures to prevent such acts or to refer the matter to the competent authorities for investigation and prosecution.

Fifth: The fact that an accused person acted pursuant to an order of the Government or of his superior shall not relieve him of criminal responsibility, but may be considered in mitigation of punishment if the Tribunal determines that justice so requires.

Sixth: Amnesty decrees issued prior to this Law coming into force do not apply to persons accused of committing any of the crimes stipulated in it.

SECTION FOUR
Rules of Procedure and Evidence

Article 16

The Tribunal shall follow the rules of procedure provided for in the Criminal Procedure Law 23 of 1971 and the Rules of Procedures and Evidence appended to this Law, of which it shall be considered an integral part.

SECTION FIVE
General Principles of Criminal Law

Article 17

First: In the absence of provisions in this Law and the rules made thereunder, the general principles of criminal law contained in the following laws shall be applicable in connection with the prosecution and trial of any accused persons:

 A- For the period 17/7/1968 to 14/12/1969, the Baghdadi Penal Code of 1919

 B- For the period 15/12/1969 to 1/5/2003, the Penal Code No. 111 of 1969, which was in force in1985 (Third Edition),

 C- The Military Penal Code No.13 of 1940, and the Code of Military Procedure No. 44 of 1941.

Second: In interpreting Articles 11, 12 and 13 of this Law, the Trial Chamber and Appeals Chamber may resort to the [relevant] decisions of international criminal tribunals.

Third: Grounds for exclusion of criminal responsibility under the Penal Code shall

be implemented in a manner consistent with this Law and with international legal obligations concerning crimes within the jurisdiction of the Tribunal

Fourth: The crimes stipulated in Articles 11, 12, 13, and 14 of this Law shall not be subject to any statute of limitations.

SECTION SIX
Investigations and Indictment

Article 18

First: The Tribunal Investigative Judge shall initiate investigations on the basis of information obtained from any source, particularly from the police or any governmental or non-governmental source. The Investigative Judge shall assess the information received and decide whether there is sufficient basis to proceed

Second: The Investigative Judge shall have the power to question suspects, victims or their relatives, and witnesses, to collect evidence and to conduct on-site investigations. In carrying out his tasks, the Investigative Judge may, as appropriate, request the assistance of the relevant governmental authorities, who shall be required to provide full cooperation with the request

Third: Upon a determination that a *prima facie* case exists, the Investigative Judge shall prepare an indictment containing a concise statement of the facts and the crime with which the accused is charged under the Law, and shall refer the case to the Trial Chamber.

PART ONE
Rights[3] of the Accused

Article 19

First: All persons shall be equal before the Tribunal.

Second: The accused shall be presumed innocent until proven guilty before the Tribunal in accordance with this law.

Third Every accused shall be entitled to a public hearing, in accordance with the provisions of this law and the rules of procedure made hereunder.

Fourth: When bringing charges against the accused pursuant to this Law, the accusedshall be entitled to a fair impartial trial in accordance with the following minimum guarantees:

> A. To be informed promptly and in detail of the content, nature and cause of the charge against him;
>
> B. To have adequate time and facilities for the preparation of his defense and to communicate freely with counsel of his own choosing and to meet with him in private. The accused is entitled to have non-Iraqi legal representation so long as the principal lawyer of such accused is Iraqi;
>
> C. To be tried without undue delay;
>
> D. To be tried in his presence, and to be assisted by counsel of his own choosing, or to be informed of his right to request legal assistance if he cannot afford it; and to have the right to seek such assistance that will allow him to appoint a lawyer without paying the fees;
>
> E. To have the right to call and examine defence and prosecution witnesses, and to present any evidence in his defense in accordance with the law.
>
> F. Not to be compelled to confess guilt, and to have the right to remain silent and not to testify without such silence being interpreted as evidence of guilt or innocence

SECTION SEVEN
Trial Proceedings

Article 20

First: A person against whom an indictment has been issued shall be taken into custody, pursuant to an arrest order or warrant issued by the Tribunal Investigative

Judge, and shall be immediately informed of the charges against him and transferred to the Tribunal.

Second: The Trial Chamber shall ensure a fair and expeditious trial conducted in accordance with this Law and the Rules of Procedure and Evidence annexed it, with full respect for the rights of the accused and due regard for the protection of victims or their relatives, and witnesses.

Third: The Trial Chamber shall read the indictment, satisfy itself that the rights of the accused are respected and guaranteed, ensure that the accused understands the charge or charges against him, and instruct the accused to enter a plea.

Fourth: The hearings shall be public unless the Trial Chamber decides to close the proceedings in accordance with the Rules of Procedure and Evidence annexed to this Law. The decision to close the proceedings shall be exercised on a very limited basis.

Article 21

The Trial Chamber shall provide for the protection of victims or their relatives, and witnesses, in accordance with the Rules of Procedure and Evidence annexed to this Law, including the protection of the identity of the victims or their relatives, and witnesses.

Article 22

Relatives of victims and harmed persons who are Iraqi nationals may bring civil suits against the accused for damages resulting from acts which constitute crimes under this Law. The Tribunal shall have the power to adjudicate such claims in accordance with the Code of Criminal Procedure No 23 of 1971 and other relevant laws.

Article 23

First: The Trial Chamber shall pronounce judgments and impose sentences and penalties on persons convicted of crimes within the jurisdiction of the Court.

Second: The judgment shall be rendered by a majority of the judges of the Trial Chamber, and shall be delivered by the Trial Chamber in public. The judgment shall not be issued except on the basis of a decision to convict, to which the opinions of dissenting judges may be appended.

Article 24

First: The penalties imposed by the Tribunal shall be those prescribed by the Penal Code No. 111 of 1969, except for a sentence of life imprisonment that means the remaining natural life of the convicted person, taking into account the provisions stipulated in Article 17 of this Law.

Second: The penalties for the crimes under Article 14 of this Statute shall be those prescribed under Iraqi Penal Code and other penal laws.

Third: Taking into account paragraphs Fourth and Fifth of this article, the Trial Chambers shall determine the penalties for the crimes under Articles 11, 12 and 13 of this Law

Fourth: A person convicted of crimes stipulated in the Penal Code shall be punished if committed:

 A.Murder or rape as defined under the Penal Code.

 B. Complicity in the commission of murder or rape.

Fifth: The penalty for any crimes under Articles 11, 12, 13 which do not have a counterpart under Iraqi law shall be determined by the Trial Chambers taking into account such factors as the gravity of the crime, the individual circumstances of the convicted person, guided by judicial precedents and relevant sentences issued by the international criminal tribunals.

Sixth: The Trial Chambers may order the forfeiture of assets, property or proceeds derived directly or indirectly from a crime, without prejudice to the rights of the *bona fide* third parties.

Seventh: In accordance with Article 307 of the Code of Criminal Procedure, the Trial Chambers shall have the authority to confiscate any material or goods prohibited by law regardless of whether the case has been discharged for any lawful reason.

SECTION EIGHT
Appeals Proceedings
PART ONE
Cassation

Article 25

First: The convicted person or the Prosecutor may contest the verdicts and decisions by appealing in cassation to the Appeals Chamber on the following grounds:

> a. If the verdict is in contradiction with the law or there is an error in interpreting it.
> b. An error of procedure.
> c. An error of material fact which has occasioned a miscarriage of justice.

Second: The Appeals Chamber may affirm, reverse or revise the decisions taken by the Trial Chambers or the Investigative Judge

Third:Where the Appeals Chamber reverses a verdict of acquittal or release issued by the Trial Chamber or the Investigative Judge, the case shall be referred back to the Trial Chamber for retrial or to the Investigative Judge for implementation of its decision.

Fourth: The period allowed for the lodging of appeals shall be in accordance with the provisions of the Code of Criminal Procedure No. 23 of 1971, unless otherwise provided for.

PART TWO
Retrial

Article 26

First:Where new findings or facts have been discovered which were not known at the time of the proceedings before the Trial Chamber or the Appeals Chamber and which could have been a decisive factor in reaching the verdict, the convicted person or the Prosecutor may submit to the Tribunal an application for a retrial

Second: The Tribunal shall reject the application if it considers it to be unfounded. If the Tribunal determines that the application has merit[4], it may, after hearing the parties, and with a view to amending the judgment:

> a. Send the case back to the original Trial Chamber to review it; or
> b. Send the case to another Trial Chamber; or
> c. The Appeals Chamber reviews the case.

SECTION NINE
Enforcement of Sentences

Article 27

First: Sentences shall be carried out in accordance with the law.

Second: No authority, including the President of the Republic, may grant a pardon or reduce the penalties issued by this Tribunal. Penalties shall be enforceable within thirty days of the sentence or decision reaching finality.

SECTION TEN
General and Final Provisions

Article 28

Investigative judges, Trial Chamber judges, members of the Prosecutions Department, Director of the Administration Department and Tribunal personnel shall be Iraqi nationals, taking into account Article 4 (Third) of this Law.

Article 29

First: The Tribunal and the national courts shall have concurrent jurisdiction to prosecute persons accused of the crimes prescribed in Article 14 of this Statute

Second: The Tribunal shall have primacy over all other Iraqi courts with respect to its jurisdiction over the crimes prescribed in Articles 11, 12 and 13 of this Law.

Third: At any stage of the proceedings, the Tribunal may demand of any other court to transfer any case being tried by it involving any crimes prescribed inArticles 11, 12, 13 and 14 of this Law, and such court shall be required to transfer such case on demand.

Fourth: At any stage of the proceedings, the Tribunal may demand of any other court to transfer any case being tried by it involving any crimes prescribed in Articles 13, 14, 15 and 16 of this Law, and such court shall be required to transfer such case upon demand

Article 30

First: No person shall be tried before any other Iraqi court for crimes for which he has already been tried by the Tribunal, in accordance with Articles 300 and 301 of the Code of Criminal Procedure.

Second: A person who has been tried by any Iraqi court for a crime or crimes within the jurisdiction of the Tribunal may not be subsequently tried by the Tribunal unless the Tribunal determines that the previous court proceedings were not impartial or independent, or were designed to shield the accused from criminal responsibility. When taking a decision to order a retrial, one of the conditions contained in Article 196 of the Code of Civil Procedure and the requirements of Article 303 of the Code of Criminal Procedure must beme[t5].

Third: In determining the penalty to be imposed on a person convicted of a crime under this Law, the Tribunal shall take into account the time served of any penalty imposed by an Iraqi court on the same person for the same crime.

Article 31

First: The President of the Tribunal, the Judges, the Investigation Judges, the Prosecutors, the Director of the Administration Department and the Tribunal staff shall have immunity from civil suits with respect to their official duties.

Second: Other persons, including the accused, shall be accorded such treatment as is necessary for the proper functioning of the Tribunal.

Article 32

Arabic shall be the official language of the Tribunal.

Article 33

No person belonging to the Ba'ath Party may be appointed as a Judge, Investigative Judge, Prosecutor, employee or any of the Tribunal's staff[6].

Article 34

The expenses of the Tribunal shall be borne by the regular budget of the State

Article 35

The President of the Tribunal shall prepare an annual report on the Tribunal's work for submission to the Council of Ministers.

Article 36

The provisions of the Civil Service Law No. 24 of 1960, Personnel Law No. 25 of 1960, State And Socialist Sector Employees Disciplinary Law No 14 of 1991 and Civil Service Retirement Law No.33 of 1966 shall apply to the Tribunal's employees other than the judges and members of Public Prosecution.

Article 37

The Statute of the Iraqi Special Tribunal for Crimes Against Humanity, Law No. 1 of 2003, and the Rules of Procedure issued under Article 16 thereof shall be abolished with effect from the date of the coming into force of this Law

Article 38

All decisions and rules of procedure[7] issued under Law No. 1 of 2003 are considered correct and in accordance with the law[8].

Article 39

In coordination with the President of the Tribunal, the Council of Ministers shall issue[9] instructions to facilitate the implementation of this Law.

Article 40

This Law shall come into force on the date of its publication in the Official Gazette.

Jalal Talabani
President of the Republic

Adil Abd Al-Mahdi
Vice President of the Republic

Al-Shaikh Ghazi Ajil Al-Yawir
Vice President of the Republic

JUSTIFYING REASONS

To expose the crimes committed in Iraq from 17 July 1968 until 1 May 2005 against the Iraqi people and the peoples of the region and the subsequent brutal massacres:
To lay down the rules and punishments to condemn after a fair trial the perpetrators of such crimes for waging wars, genocide, and crimes against humanity;
To establish an national Supreme Iraqi Criminal Tribunal made up of Iraqi judges with high experience, competence and integrity, with the power to try these criminals
To reveal the truth, and the agonies and injustice caused by the perpetrators of such crimes;
To protect the rights of many Iraqis, redress injustices committed against them, and demonstrate heaven's justice as the Almighty God wants it to be.
This law has been promulgated.

ENDNOTES

[1] This is a literal rendering of the Arabic phrase. It is a possible mistranslation of the English
[2] The intended meaning here is 'may lead to…'
[3] The Arabic word used literally means guarantees, but the intended meaning is 'rights'.
[4] Literally, …'that the application is based on convincing grounds...'
[5] The last sentence in this paragraph is ungrammatical, probably as the result of a typing error.
[6] A literal rendition of the phrase.
[7] Translated as 'rules of procedure' although the Arabic reads 'orders of procedures'.
[8] It is not clear if 'the law' here means 'this Law'.
[9] A literal rendering would be 'The Council of Ministers, in coordination with the President of the Tribunal, shall issue…'.

INDEX